IMAGES
of America

NEW YORK CITY
VAUDEVILLE

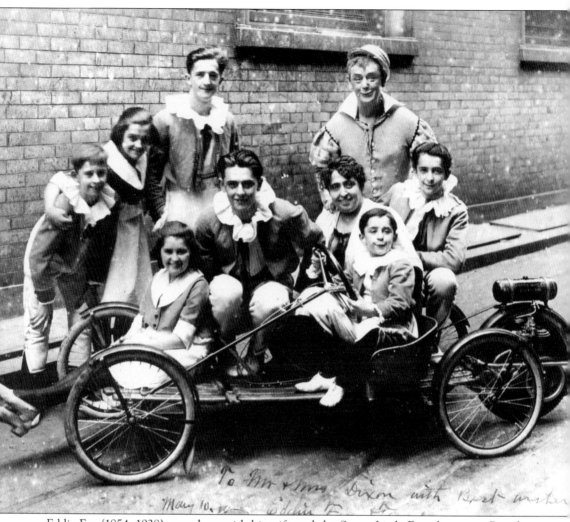

To Mr & Mrs Dixon with Best wishes
May 10, 19— Eddie Foy [?]

Eddie Foy (1854–1928), seen here with his wife and the Seven Little Foys, became a Broadway star in 1901 thanks to his mimicry, pantomime clowning, and eccentric dancing. By 1908, he was touring vaudeville with his seven children, and made his Palace debut in February 1914. Bob Hope plays Eddie in the 1955 biopic *The Seven Little Foys*.

On the cover: John Robinson and His Military Elephants featured Tillie (with a claimed age of 108), who was reported to be "the only talking elephant in the world—20 tons of Animal Intelligence." Aside from talking, the elephants also sang, danced, and play acted and became something of a fixture at the New York Hippodrome in the 1920s. (Courtesy of Anthony Slide.)

IMAGES
of America

New York City
Vaudeville

Anthony Slide

ARCADIA
PUBLISHING

Copyright © 2006 by Anthony Slide
ISBN 0-7385-4562-7

Published by Arcadia Publishing
Charleston SC, Chicago IL, Portsmouth NH, San Francisco CA

Printed in the United States of America

Library of Congress Catalog Card Number: 2006924871

For all general information contact Arcadia Publishing at:
Telephone 843-853-2070
Fax 843-853-0044
E-mail sales@arcadiapublishing.com
For customer service and orders:
Toll-Free 1-888-313-2665

Visit us on the Internet at http://www.arcadiapublishing.com

CONTENTS

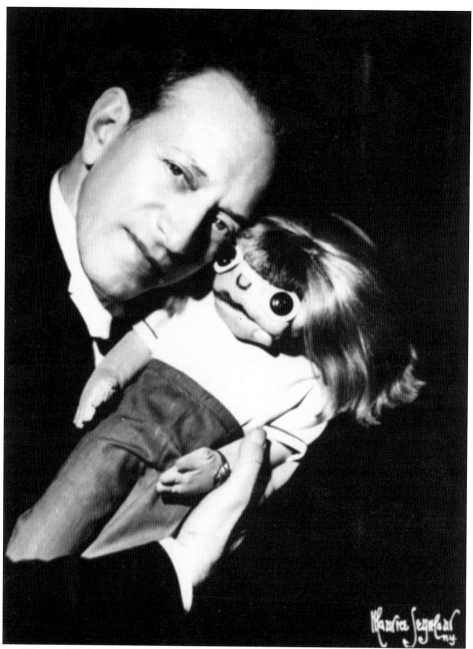

Señor Wences (1899–1999) was the greatest of all comic ventriloquists. Born Moreno Wenceslao, he brightened the waning years of vaudeville, making his New York nightclub debut in 1936 and his vaudeville debut two years later at the Paramount Theatre. He arrived late at the Palace Theatre, in 1951, as a supporting act to Judy Garland. His act was incomparable and unique, usually featuring two characters: a doll created by painting a mouth with lipstick, adding two onyx rings for eyes and a tiny red wig to Wences' left hand and the head only of a Moorish-like man in a wooden box. Additionally Wences would juggle four plates on sticks while speaking in four different voices. Thankfully long after the demise of vaudeville, appearances on television with Ed Sullivan helped to keep the ventriloquist's genius alive.

INTRODUCTION

From the late 1800s through into the early 1930s, vaudeville was a unique American institution, the country's preeminent form of entertainment. It came into prominence before radio and the motion picture were invented, but was ultimately killed by a combination of the two. There was not a city in the United States that did not boast at least one vaudeville theater, usually a B. F. Keith, an Orpheum, or, on the West Coast, a Pantages, but it was New York's Palace Theatre that was the ultimate home of vaudeville with a bill of fare on which all vaudevillians craved a place.

Vaudeville was the people's entertainment, a form of amusement that appealed to the poorest and the richest in American society. The vaudeville theater was visited weekly by a majority of Americans, eagerly seeking original entertainment and knowing that there was small chance of boredom. A typical vaudeville bill might include between 8 and 12 acts, ranging from the comedic to the acrobatic and from the vocal to the dumb. Some of the acts might be bad—and there were a lot of very bad vaudeville acts—but with most averaging 15 or 20 minutes, they could be tolerated by an audience that knew the next performer would be better.

The name "vaudeville" has its origins in 15th-century France, when a miller named Olivier Basselin, in the Valley of the Vire in Normandy, wrote a series of songs he called *Vaux-de-Vire*. They remained popular for 200 years, and the name became corrupted to *voix-de-ville*, or "sounds of the town." From this came the French vaudeville, meaning a ballad or light form of comedy. The American vaudeville had its origins in the minstrel shows of the 1800s and in British Music Hall. Why Americans selected vaudeville as the all-encompassing descriptive phrase is unclear, but vaudeville it was rather than music hall or the British term, variety.

Minstrel shows primarily originated in the South, with white Americans appearing in blackface and performing what were purported to be Negro songs and dances, such as "Jump Jim Crow," introduced by Thomas D. Rice in the late 1820s. The first minstrel troupe to play New York was possibly the Virginia Minstrels, who were seen at the Bowery Amphitheater in February 1843. That same year, the Kentucky Minstrels appeared at the Vauxhall Gardens. Christy's Minstrels made their New York debut at Palmer's Opera House in October 1846, while Bryant's Minstrels were in residence at the Mechanics' Hall from 1847 through 1857.

One of the earliest venues offering what might be described as vaudeville entertainment in New York was the alfresco Niblo's Garden, located in lower Manhattan at the corner of Broadway and Prince Street. It was opened by William Niblo in July 1828 as the Sans Souci, and he renamed it Niblo's Garden and Theatre the following year. In 1866, the theater was home to *The Black Crook*, a dance extravaganza that introduced the chorus girl to the American stage.

In the 1860s, Tony Pastor (1832–1908) was the first to try and refine New York vaudeville, transforming it from a cheap form of entertainment relegated to the city's saloons into something that would be suitable for, and popular with, the entire family. In 1865, he opened Tony Pastor's Opera House (formerly the Bowery Museum), which remained in existence for 10 years, and at which Pastor appeared at every performance. On October 4, 1875, Pastor took over the Metropolitan Theatre at 585 Broadway, and the following year, for the first time, he described the entertainment there as "vaudeville." Pastor's most popular vaudeville venue was his New Fourteenth Street Theatre, which he opened in the summer of 1881, and which became New York's most successful theatrical establishment.

Tony Pastor paved the way for the major vaudeville entrepreneurs of the 20th century: B. F. Keith and E. F. Albee, F. F. Proctor, and Oscar and Willie Hammerstein. The B. F. Keith circuit (founded in Boston in the 1880s and taken over by E. F. Albee in 1918) had as many as 20 vaudeville houses in the city of New York. F. F. (Frederick Freeman) Proctor opened his first New York theater in 1886, and his most prominent, Proctor's Pleasure Palace on 58th Street, in 1895. Oscar Hammerstein, the grandfather of lyricist Oscar Hammerstein II, was the man responsible for the Times Square theatrical district. His short-lived Koster and Bial's Music Hall, on 34th Street between Broadway and Seventh Avenue, which opened in August 1893 and closed in July 1901, is best known not for its vaudeville acts but as the venue for the first presentation of the newly-invented motion picture by Thomas Alva Edison on April 23, 1896. Hammerstein's Victoria Theatre of Varieties was taken over by his son Willie in 1904, and was noted for its many freak acts.

Beginning in 1885, theaters presented programs as "two-a-day" or "continuous vaudeville," starting at 11:00 in the morning and continuing until 11:00 at night. The beginning of the end for vaudeville is generally linked to the closure of the Palace Theatre as a two-a-day vaudeville house in May 1932. Of course, vaudeville lingered on as an accompaniment to motion pictures in so-called presentation houses of the 1930s and 1940s. Many vaudevillians were called upon to entertain American troops during World War II, working through the USO, and early television revived vaudeville, thanks in large part to Milton Berle and Ed Sullivan.

E. F. Albee (1857–1930) was the most influential figure in 20th-century vaudeville, the head of what became the Keith-Albee vaudeville circuit; the creator of the medium's company union, the National Vaudeville Artists, Inc.; and the man who ultimately destroyed vaudeville by selling its theaters in 1928 to Joseph P. Kennedy and RCA, at which point they became movie houses. RKO (Radio-Keith-Orpheum) Radio Pictures was established, simultaneous with the talkie revolution. It was Albee also who summed up vaudeville's appeal, when he wrote in 1923, "In vaudeville, 'there is always something for everybody,' just as in every state and city, in every county and town in our democratic country, there is opportunity for everybody, a chance for all."

One

They Played the Palace

Located at Broadway and 47th Street, the Palace Theatre served as both the flagship of vaudeville and of the B. F. Keith vaudeville circuit. To headline at the Palace was the ambition of every vaudevillian. The theater was built not by Keith but by Martin Beck, who leased the site for the theater on October 21, 1911. But by the time the Palace opened, on Easter Monday, March 24, 1913, Beck had become a minority owner, with 51 percent of the stock controlled by the B. F. Keith vaudeville interests, headed by E. F. Albee.

The theater cost a reported $1 million to build. An average bill in its heyday cost $12,000 in salaries, while the Palace made an average profit of $500,000 per year.

The opening bill consisted of the Eight Palace Girls; caricaturist Hy Mayer; Ed Wynn; a one-act musical comedy titled *The Eternal Waltz*, featuring Cyril Chadwick and Mabel Berra; monologuist Taylor Holmes; Milton Pollock and Company in a one-act playlet, *Speaking to a Father*, by George Ade; a wire walking act called "The Four Vannis"; Ota Gyli, billed as "Violinist of the Spanish Court"; and pantomimist and dancer La Napierkowska. The program was generally criticized, with the trade paper *Variety* particularly scathing as to the seating prices, which were as high as $2.

It was not until May 1913 that the Palace began attracting a large-scale audience, and that was because the headliner was Sarah Bernhardt. By December 1914, *Variety* was describing the Palace as "the greatest vaudeville theatre in America, if not the world." The last two-a-day vaudeville bill at the Palace was the week of May 7, 1932. Vaudeville and films were interchangeable for many years until October 16, 1951, when the Palace again became a vaudeville house, with Judy Garland topping the bill. In August 1957, the Palace reverted back to a movie theater, but reopened as a legitimate house on January 29, 1966, with *Sweet Charity*.

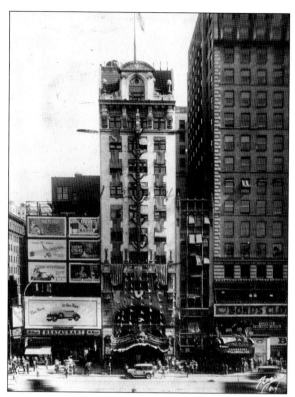

The Palace Theatre is seen here in 1928, the year in which E. F. Albee lost control of the theater to Joseph Kennedy, and the year in which the names of headliners began to appear on the marquee. Fannie Brice was the first headliner, on October 29, 1928. By 1948, it was not the headliners but the film that received top billing on the marquee. Here it is *Canadian Pacific* starring Randolph Scott.

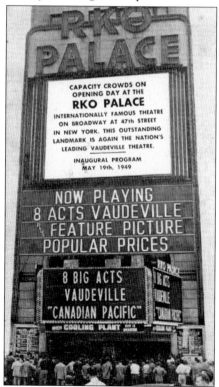

Seen here is a Palace Theatre program for the week of January 9, 1922, on which is featured the headliner Irene Castle. Irene Castle (1893–1969) appeared as a dance team with her husband Vernon in both revue and vaudeville. They first appeared together at the Palace in 1914. He died while serving with the Royal Flying Corps in 1918. This program marks Irene's return to vaudeville with a new dance partner, William Reardon. By 1932, the Palace's printed program had changed to magazine format. The headliner for the week of January 23 is Beatrice Lillie (1894–1989), the Canadian-born unladylike comedienne who had made her stage debut in England in 1913. She made her New York debut at the Palace in 1928 and was also a headliner there in 1929 and 1931. At the former engagement, Lillie shocked the Palace management by using the word "goddam" on stage.

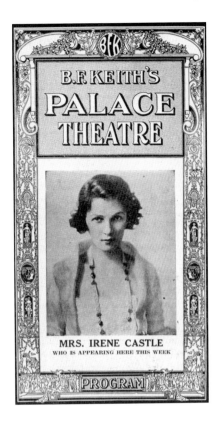

B.F. KEITH'S PALACE THEATRE

MRS. IRENE CASTLE
WHO IS APPEARING HERE THIS WEEK

PROGRAM

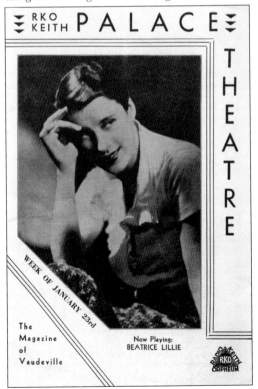

RKO KEITH **PALACE** THEATRE

WEEK OF JANUARY 23rd

The Magazine of Vaudeville

Now Playing:
BEATRICE LILLIE

RKO

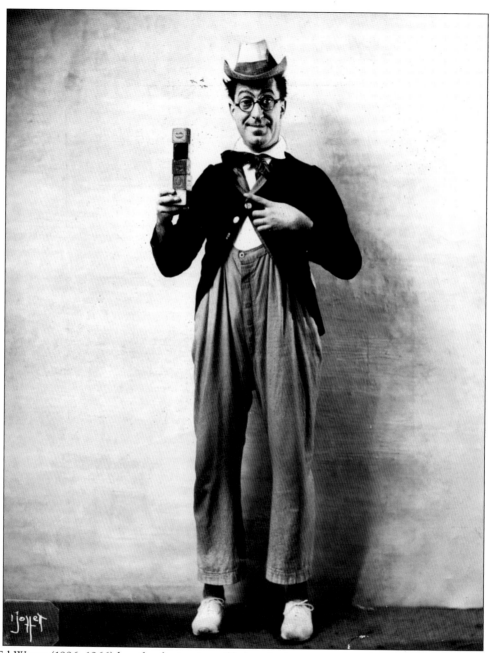

Ed Wynn (1886–1966) has the distinction of being the best-remembered name on the opening bill at the Palace Theatre. His 14-minute spot, titled "The King's Jester," had him in the title role, trying to make the king (Frank Wunderlee) laugh. Known as "the Perfect Fool," after a 1921 musical comedy of that name, Ed Wynn was a comedian with a bespectacled baby face, a silly giggle, and an effeminate walk. His jokes were often corny, but he was a star not only in vaudeville but also in musical comedy, revue, on radio (from 1932 as *The Fire Chief*), on early television (with his own show from 1958 to 1959), and on screen (even winning an Academy Award nomination for his 1959 performance in *The Diary of Anne Frank*). His career began in 1901 and continued until his death.

Sarah Bernhardt (1844–1923) was the individual most responsible for making the Palace a success, when she appeared there at the end of her first U.S. vaudeville tour in May 1913. She was, of course, a major international legitimate stage star, but she toured in vaudeville in 1912–1913 and 1917–1918, drawing large audience despite performing only in French.

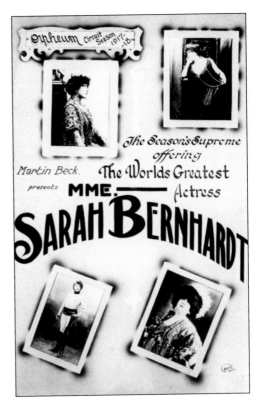

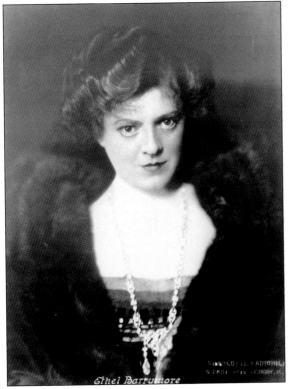

Ethel Barrymore

Ethel Barrymore (1879–1959) was another major legitimate stage actress who enjoyed an extensive career in vaudeville. She generally appeared in the one-act playlet, *The Twelve Pound Look*, by J. M. Barrie, and brought it to the Palace in 1921 and 1926. She always maintained that when she did not have anything worthwhile to do on the stage, she would return happily to vaudeville.

W. C. Fields (1879–1946) was a master juggler with a caustic wit and a mastery of the euphemism. He was in the words of critic Robert Benchley, "just about as grand as a comedian could possibly be." He was also one of the few vaudevillians able to transfer virtually all of his vaudeville routines to film, including the crooked poker game, the pool table sketch, the juggling with cigar boxes routine, and others. Fields made his vaudeville debut in Atlantic City in 1896. By 1900, he was featuring juggling and billing himself as "the Eccentric Juggler." By the time he made his Palace debut in May 1913, in support of Sarah Bernhardt, Fields had toured much of Europe, Australia, and South Africa. He made his first appearance in the *Ziegfeld Follies* in 1915 and was in a number of editions through 1925. He also found time for the 1927 edition of Earl Carroll's *Vanities* and the 1923 musical comedy *Poppy*.

Fritzi Scheff (1879–1954) was an opera singer who had first appeared at the Metropolitan Opera House in 1900. She made her vaudeville debut at the Palace in 1913, returning again in 1916. Her last Palace appearance was in 1930, when she sang the song most associated with her, "Kiss Me Again," which she had introduced in 1905 in the operetta *Mlle. Modiste.*

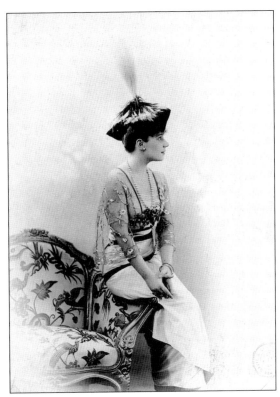

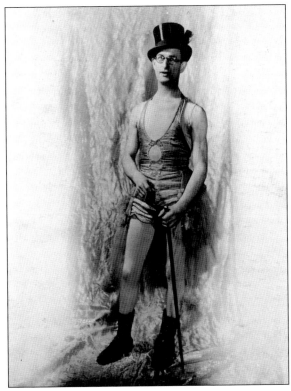

Julius Tannen (1880–1965) was a comedy monologuist, the then-equivalent of a stand-up comic. His Palace debut was in 1913, but on another occasion on stage at the theater, a black cat walked across the stage and settled at his feet. He looked down and commented, "This is a monologue, not a catalogue."

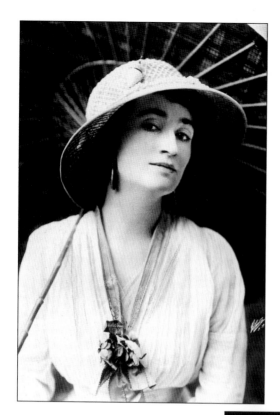

Ethel Levy (1881–1955) is perhaps better remembered as the wife of George M. Cohan rather than as a singer with a great delivery. She was in vaudeville from the late 1890s through the 1920s, appearing at the Palace on many occasions from 1913 onwards.

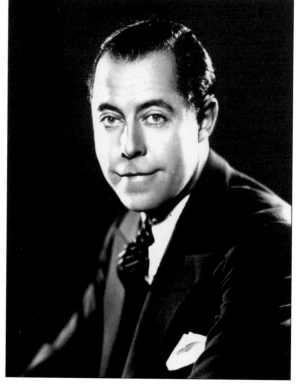

Joe Cook (1890–1959) was of the funniest, and the most forgotten, entertainers in vaudeville, noted for a routine featuring an imitation of four Hawaiians but which had Cook only impersonating two—for fear he would put out of business other performers who could only handle two Hawaiian imitations. He entered vaudeville as a teenager, and made his Palace debut in 1914.

Irene Franklin (1876–1941) was both an impressionist and a comedienne, whose songs, such as "Be Your Age," are laced with venom. She was a child actress on stage before touring Australia and America while still a teenager. She made her American vaudeville debut in 1895 and her Palace debut in 1915.

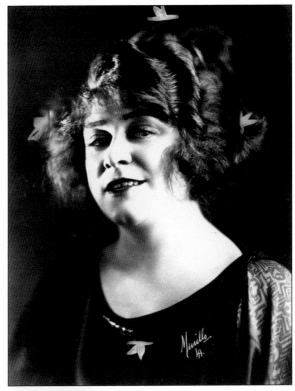

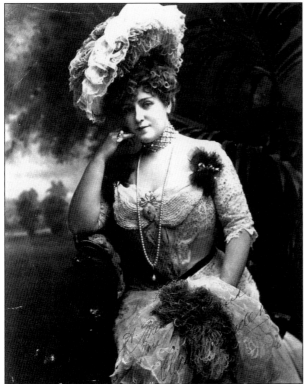

Lillian Russell (1861–1922) was one of the great stage beauties of her day, with a voice that was said to make grown men cry. Tony Pastor discovered her and changed her name from Helen Louise Leonard to Lillian Russell, starring her in 1881 in a burlesque of *The Pirates of Penzance*. She made her vaudeville debut in 1905 and the first of many Palace appearances in 1915.

Cecelia (Cissie) Loftus (1876–1943), whose billings as "the Queen of Mimics" and "That Incomparable Mimic," are indicative of her act. Born in Scotland, she made her U.S. debut at Koster and Bial's Music Hall in 1895 and was popular in both New York and London. She did a sister act with Marie Dressler at the Palace in 1915, and after a long absence from vaudeville returned there in 1923.

Frank Tinney (1878–1940) made his Palace debut in 1915. He was a blackface comic with great delivery of often horrendous humor. Throughout his career, he alternated vaudeville with musical comedy and revue, and by 1920, he had dropped the blackface characterization.

Grace La Rue (1882–1956) made her debut at the Palace in 1913, singing "You Made Me Love You." She was a dancer and a singer of the prima donna variety who first came to prominence in 1906. She was featured in the first two (1907 and 1908) editions of the *Ziegfeld Follies*, and remained active through into the 1930s.

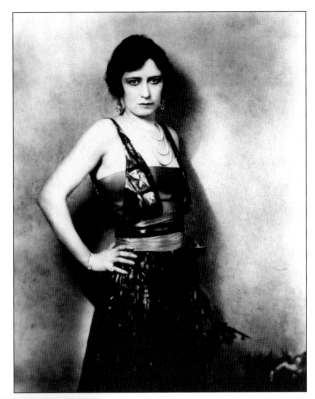

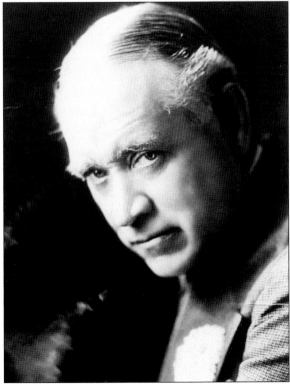

Frank Keenan (1858–1929) was a prominent stage actor from the 1890s onwards who would alternate performances in the legitimate theater with vaudeville engagements, usually starring in two one-act dramas, *Man to Man* and *Vindication*. He was the headliner on the second week's bill at the Palace in April 1913.

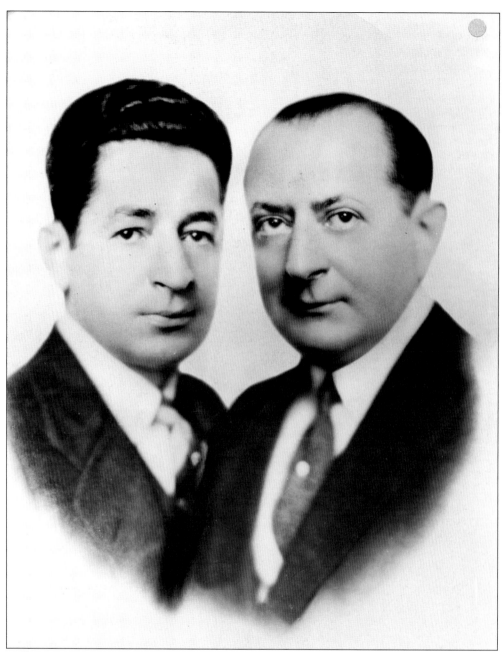

Willie (1886–1949) and Eugene Howard (1881–1965) were perhaps the best Jewish comedy team in the business. Willie was the comic and Eugene the straight man in a double act that began in 1902. Both men were accomplished singers and their act would generally include semi-operatic numbers. They parodied the Metropolitan Opera star with "The Galli-Gurci Rag" and their travesty of *Rigoletto*, and presented a hilarious routine titled "Between the Acts at the Opera." Aside from vaudeville, the brothers were featured in revues, including *The Passing Show*, from its first edition in 1912 through 1922. In May 1930, they headlined at the Palace, billed as "Two Hebrew Humorists Who Hail from Harlem." The couple was equally busy in films until Eugene's retirement in 1940, at which time Al Kelly replaced him.

Blanche Ring (1877–1961) was noted for her audience participation songs, such as "In the Good Old Summertime," "Yip-I-Addy-I-Ay," and her theme song, "I've Got Rings on My Fingers." She had a jovial Irish brogue, and as early as 1902, she appeared on stage with Irish tenor Chauncey Olcott. She first appeared at the Palace in 1914, and in 1925, she was featured on an old-timers bill there.

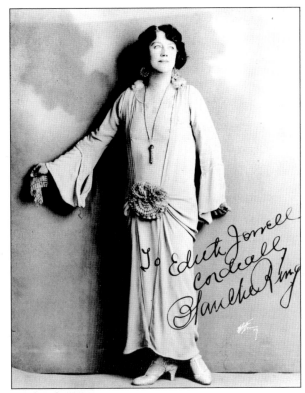

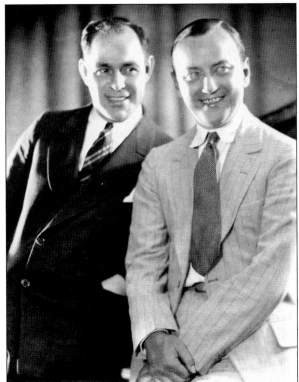

Gus Van (1887–1968) and Joe Schenck (1891–1930) first appeared at the Palace in 1915. Schenck played the piano, while Van sang Italian and Yiddish dialect songs, such as "Hungry Women" and "Pasta Vazoola." Billed as "the Pennant Winning Battery of Songland," they first appeared together as children and might have continued on for decades had it not been for Schenck's untimely death.

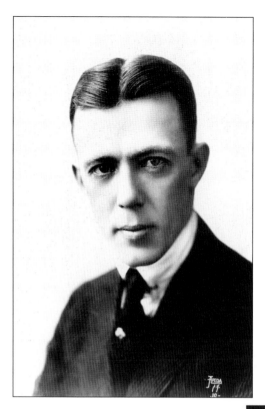

Pat Rooney Jr. (1880–1962) was the premier member of a great Irish family of entertainers. With his diminutive size and pixieish face, Rooney was a tap dancer with the grace of a ballet dancer, whose career lasted from around 1890 until his death. With his son, Pat Rooney III, he appeared at the Palace as late as 1956.

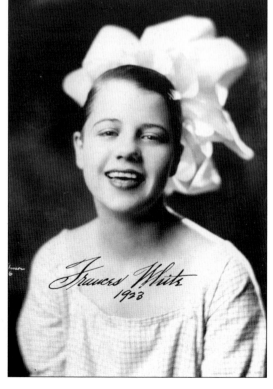

Frances White (1898–1969) began her career as a singer-dancer in partnership with William Rock in 1916 (the same year they made their Palace and New York debut). As a solo performer, she would sing in a lisping, childlike voice, "M-i-s-s-i-s-s-i-p-p-i." She was briefly married to Frank Fay.

Elsie Janis (1889–1956) was a child actress who made her debut in 1897. She was noted for her impersonations and comic songs, and she also enjoyed a major career in musical comedy and revue, beginning with *The Vanderbilt Cup* in 1906. During World War I, she was the first major star to entertain the troops, earning the title of "Sweetheart of the A.E.F." (American Expeditionary Force).

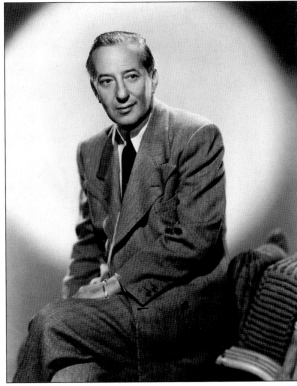

Lou Holtz (1893–1980) was one of vaudeville's great dialect comedians, whose humor often featured Jewish stereotypes. He appeared at the Palace as early as 1917, but gained wider fame from 1919 to 1921 in George White's *Scandals*. In later years audiences knew him for his appearances on television with Jack Paar.

Julian Eltinge (1883–1941) was the best
known female impersonator in vaudeville,
with a career lasting from the mid-1890s until
his death, and including musical comedies
and silent films (in both of which he would
play dual male/female roles). He made his
Palace debut in 1918, and was the only
vaudevillian to have a theater named after
him—the Eltinge opened on 42nd Street
in 1913, and is now the Empire. Eltinge's
glamorous makeup and costumes appealed
to the female members of the audience;
according to W. C. Fields, "women went
into ecstasies over him; men went into the
smoking room."

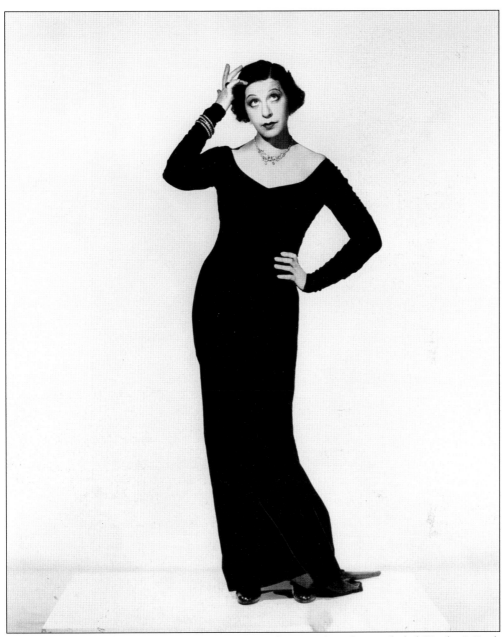

Fannie Brice (1891–1951) was a great singing comedienne, whose hits included "Becky Is Back in the Ballet" and "Secondhand Rose." At the same time, she could "sell" a torch song or tragic number such as "The Song of the Sewing Machine" or "My Man." She was a star not only of vaudeville, but also musical comedy, radio (with her "Baby Snooks" character), the *Ziegfeld Follies* (appearing in the 1910, 1911, 1916, 1917, 1920, and 1923 editions), and motion pictures (beginning in 1928). Born Fannie Borach on New York's East Side, she always wanted to entertain. She made her Palace debut in 1914 and she was a regular there for the next 20 years. *Rose of Washington Square*, filmed in 1939, is a fictionalized account of her life with gangster Nicky Arnstein, but better known are the two film biographies, *Funny Girl* (1968) and *Funny Lady* (1975), starring Barbra Streisand.

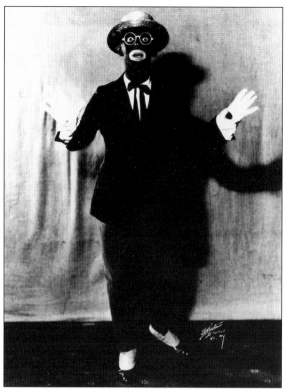

Eddie Cantor (1892–1964) was a comedian noted for both his blackface and Jewish humor. His first big break came in 1912 when he was signed by Gus Edwards to appear in his *Kid Kabaret*, which played the Palace the following year. Cantor moved on to the *Ziegfeld Follies* in 1917, to films in 1926, to radio in 1931, and to television in 1950. His best known songs include "If You Knew Susie," "Making Whoopee," and "Hungry Women."

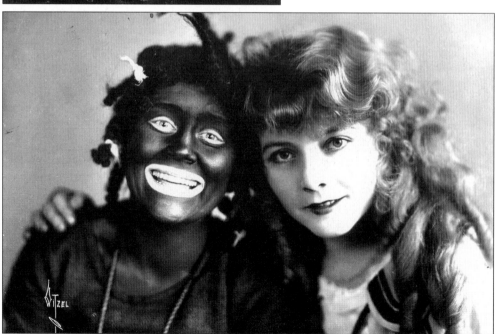

Vivian (1899–1986) and Rosetta (1896–1959), the Duncan Sisters, made their vaudeville debut in 1916, but gained nationwide popularity in 1923 with a jazzed-up version of *Uncle Tom's Cabin*, titled *Topsy and Eva*, with Vivian in the latter role and Rosetta in blackface as Topsy. They played the same characters on and off through the years on stage, in films, and in cabaret.

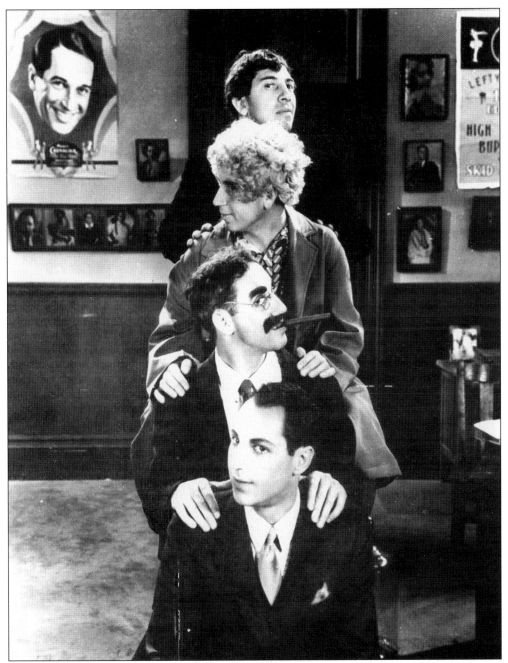

The Marx Brothers—Harpo (Arthur), Groucho (Julius), Chico (Leonard), and Gummo (Milton)—first came together as a vaudeville act around 1912 in a comedy sketch titled "Fun in Hi Skool," written by their uncle Al Shean. By 1914, the act included such staples as Chico's playing the piano and Harpo's playing the harp. They first appeared at the Palace in 1915, returned in January 1917 with a sketch titled "Home Alone," and were back again as headliners in 1920, 1929, 1930, and 1932. With the demise of their vaudeville career in the late 1920s, the brothers made a highly successful transition to films. *Animal Crackers* (1930), *Monkey Business* (1931), *Duck Soup* (1933), and *A Night at the Opera* (1935) have become classics.

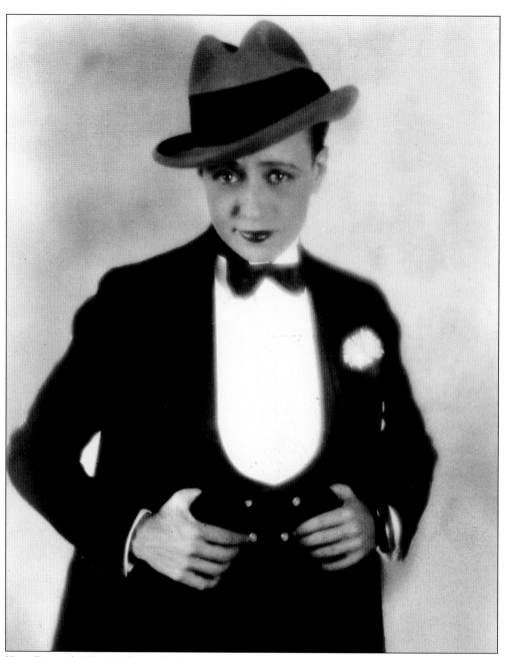

Kitty Doner (1895–1988) was the best known of male impersonators in vaudeville, first appearing at the Palace in 1919. She made her debut in San Francisco in 1912, and between 1914 and 1918, she played opposite Al Jolson in three revues, *Dancing Around*, *Robinson Crusoe Jr.*, and *Sinbad*, and enjoyed a romantic partnership with her costar. Billed as "the Best Dressed Man on the American Stage," Doner never gave impersonations of known men, but created her own, unique characterizations, often based on individuals she had met in the street. On stage, she would sometimes appear in multiple costumes, both male and female, stripping down to a pair of briefs and a bra for a fast change, with a pink floodlight on her to give the audience the impression that she was naked.

Joe Smith (1884–1981) and Charlie Dale (1881–1971) were comedians with immaculate timing and jokes that often seem corny by today's standards, immortalized by Neil Simon in *The Sunshine Boys*. They met in 1898, and were members of the Imperial Vaudeville and Comedy Company and the Avon Comedy Four before becoming simply Smith and Dale in the 1920s.

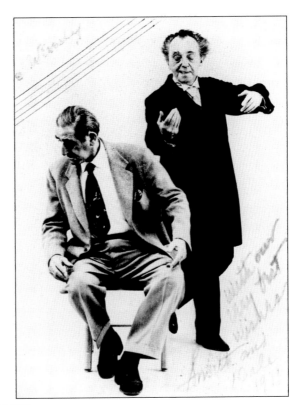

Charlotte Greenwood (1893–1978) began her career in 1909 touring in vaudeville with Eunice Burnham. As a long-legged, awkward dancer, singer, and comedienne, she headlined at the Palace in 1926 and 1927, but really enjoyed greater fame in musical comedy and revue.

Nora Bayes (1880–1928), a singer of popular songs, made her stage debut in 1899 in Chicago, and her New York debut in 1907. After starring in the 1908 edition of the *Ziegfeld Follies*, in which she introduced "Shine on Harvest Moon," Bayes appeared in many Broadway shows, and made her Palace debut in 1913. She had a spat with Sophie Tucker over billing at the Palace in 1927, quit, and the management informed the audience as to her behavior, leaving out only her bad language. Bayes appeared on stage with her second husband, Jack Norworth (1879–1959), a prolific composer whose best-known composition is "Take Me out to the Ball Game." He is seen below with a later wife, Dorothy Adelphi, with whom he appeared in vaudeville after his divorce from Nora Bayes.

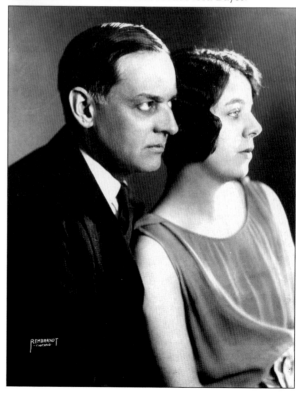

Sophie Tucker (1887–1966) enjoyed a career that outlasted that of Nora Bayes and made her something of an American institution. As her theme song, "Some of These Days" explains, she was the "red-hot mama" of syncopation who became everybody's "big fat mama" as she added on the pounds. Born somewhere on the road between Russia and the United States, Tucker began as a teenager singing in cafes and at amateur nights. As early as 1908, she appeared at Tony Pastor's 116th Street Music Hall. In 1916, she added five young men to her act and billed them as the Kings of Syncopation. In 1922, pianist Ted Shapiro joined her as on-stage accompanist and remained with the act for the rest of Tucker's life. She never stopped working in nightclubs, on screen, and television, while making endless farewell performances.

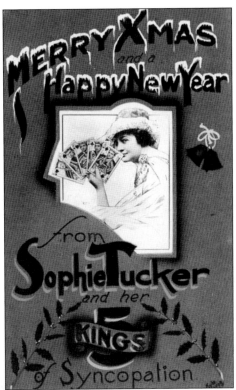

Jimmy Durante (1893–1980) would play the piano, tell a few jokes, and sing a handful of songs in a natural, down to earth manner. His craggy face, huge nose, wide grin, and exuberant personality made Durante an integral part of American entertainment from 1916 until his death. Many of his sayings have become a part of the American vocabulary: "Goodnight Mrs. Calabash, wherever you are," "That's my boy," "Stop the music," and "I got a million of 'em." For much of his career, Durante was partnered with Lou Clayton and Eddie Jackson (with whom he is seen below in later years). In April 1928, the trio headlined at the Palace, broke its box-office record and earned $3,000 a week.

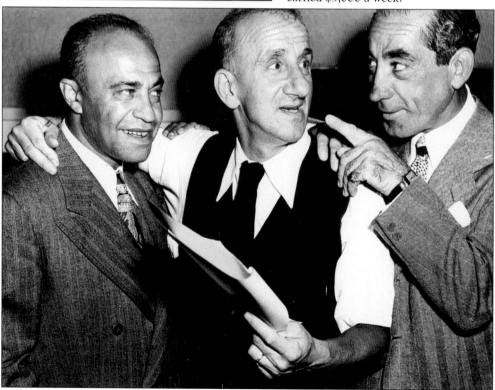

James Barton (1890–1962) was a regular at the Palace from 1928 through 1932. A comic dancer, who would sometimes appear in blackface, Barton made his Broadway debut in *The Passing Show of 1919*. His career changed course with the critical success of his legitimate performances as Jeeter Lester in *Tobacco Road* (1934) and Thomas Hickman in *The Iceman Cometh* (1946).

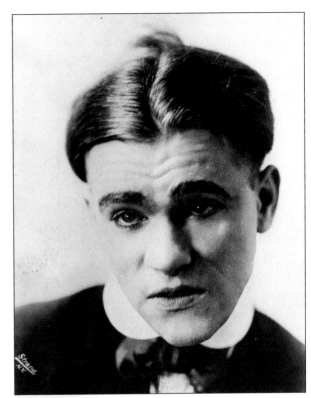

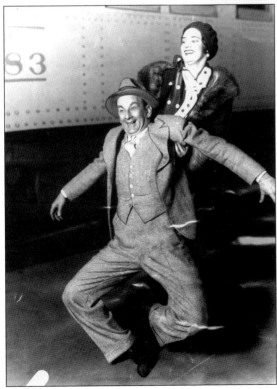

Leon Errol (1881–1951), seen here in 1931 with Sylvia Clifton, utilized acrobatic clowning and his so-called "rubber legs" for his depiction of a comic drunk. Born in Australia, Errol came to New York in 1911, appearing in the *Ziegfeld Follies*. He made his vaudeville debut in 1916, and managed to headline simultaneously at both the Palace and Riverside Theatres in 1919.

Rosie/Roszika (1892–1970) and Jenny/Yancsi (1892–1941), the Dolly Sisters, were to vaudeville what the Gabor family was to a later audience. Both families came from Hungary and both understood the value of publicity. The Dolly Sisters sang and danced at the Palace from 1916 onwards, but the emphasis was more on their attire than anything else.

Ann Pennington (1892–1971) was a dancer most associated with the *Ziegfeld Follies* and George White's *Scandals*. She introduced the "Black Bottom" and proudly admitted to rouging not only her cheeks but also her knees. She was, after all, the "Girl with the Dimpled Knees." She headlined at the Palace in 1930.

Jay C. Flippen (1898–1971) worked as both a white and blackface comedian, but vaudeville audiences preferred him in the latter guise. Billed as "the Ham What I Am," Flippen headlined at the Palace in 1926, 1927, 1928, 1929, and 1931. From the late 1940s onwards, he was familiar to filmgoers as a craggy-faced character actor.

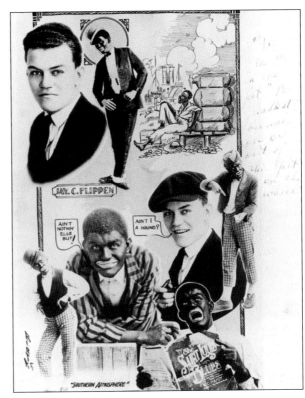

Benny Rubin (1899–1986) was a quintessential Jewish comedian who made his vaudeville debut at the age of 14. In 1932, he appeared at the Palace teamed with Jack Haley, and in 1934, he headlined at the Paramount, teamed with Max Baer. His Jewish-dialect characterizations went out of style in the late 1930s.

Harry Richman (1895–1972) was a piano accompanist for Mae West and the Dolly Sisters in the second decade of the 20th century before becoming a leading song-and-dance man, whose hits included "On the Sunny Side of the Street" and "Puttin' on the Ritz." He was at the Palace as early as 1925, but not a headliner there until 1930 and 1931.

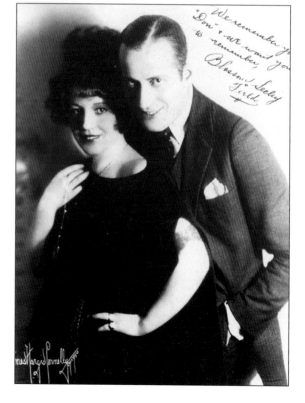

Blossom Seeley (1891–1974) and Benny Fields (1894–1959) teamed up on stage and in life in 1922. She was the "Queen of Syncopation" and his crooning style complemented her work. They headlined at the Palace throughout the 1920s. Betty Hutton and Ralph Meeker portrayed them in the 1952 biopic *Somebody Loves Me*.

Milton Berle (1908–2002) had his greatest success in television from 1948 through 1967, reaching the zenith of his career on May 16, 1949, when he was featured on the covers of both *Time* and *Newsweek*. In 1921, he had teamed in vaudeville with Elizabeth Kennedy, and the pair had opened the second half of the bill at the Palace in May of that year. Berle made his single debut at Loew's State in 1924, and was back at the Palace in 1932.

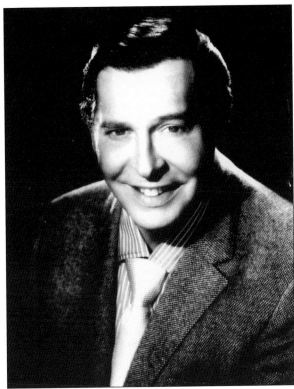

Jack Benny (1894–1974) was another comedian (with his unique "who cares?" philosophy) whose greatest fame came after vaudeville—in radio (from 1930) and on television (1950–1965). He was a regular at the Palace from 1927 through 1931.

Ben Bernie (1891–1943) was an orchestra leader, billed as "the Old Maestro," and known for his greeting of "Yowsah, yowsah." He formed his first band in 1923, Ben Bernie and the All Lads, and was a fixture at the Roosevelt Hotel for six years. He played the Palace in 1923, 1927, and 1929.

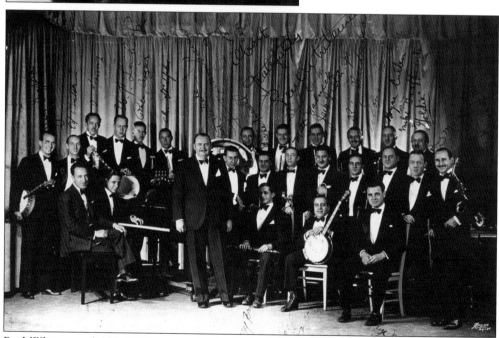

Paul Whiteman (1890–1967) was probably the best known conductor of popular music in the world, paid $7,500 a week to headline at the New York Hippodrome in 1925. Whiteman formed his own orchestra in 1919, introducing "symphonic jazz" with Gershwin's "Rhapsody in Blue" in 1924. He headlined at the Palace in December 1928, and went on to major stardom on radio.

Irene Bordoni (1895–1953) was a chanteuse with a saucy style. Born in Corsica, she made her debut in the chorus of a variety show in Paris at the age of 13, and her first U.S. appearance in 1912. The star of many musical comedies of the second and third decades of the 20th century, Bordoni headlined at the Palace in 1927 and 1930.

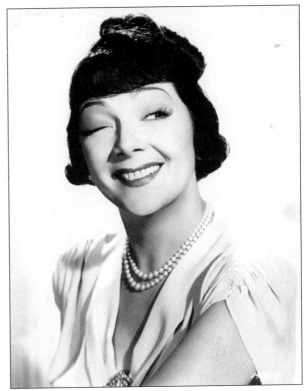

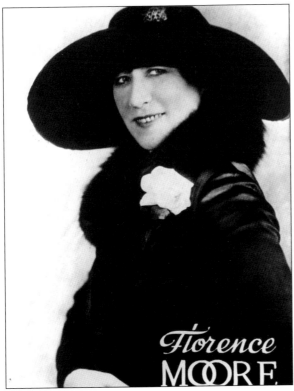

Florence Moore (1886–1935) was a popular comedienne and singer who began her career with her brother Frank and later her second husband, William Montgomery, in the early 1900s. In March 1927, the Palace hired her as its first mistress of ceremonies, and she returned to the theater again in July and December 1928.

Frank Fay (1897–1961) was an arrogant and sharp-tongued comedian, generally disliked by his colleagues. He made his stage debut in 1903 and became a monologuist in vaudeville in 1918. He appeared at the Palace as early as February 1919, and was back as a headliner in October 1924. From 1927 to 1935, Fay was married to Barbara Stanwyck. In 1944, he embarked on a new career as the star of the hit Broadway comedy *Harvey*.

Jimmy Savo (1895–1960), with his baggy pants and pixie-like grin, boasted a unique comedy style, which had to be seen to be appreciated. Charlie Chaplin called him "the world's greatest pantomimist." He began as a juggler, became a headliner in the second decade of the 20th century, and headlined at the Palace in 1926 and 1929.

George Jessel (1898–1981) was a
vaudeville comedian who became
the master of the eulogy. He was
also a Hollywood producer and a
stage and screen actor. Jessel entered
show business in 1907, and in 1920
he put together a revue that played
the Palace. His classic monologue in
which he talked on the telephone to
his mother emerged in the 1920s.

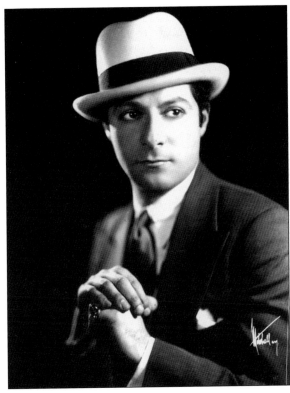

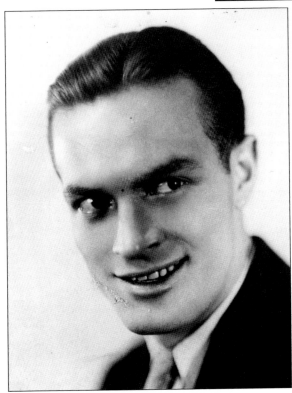

Bob Hope (1903–2003) needs no
introduction. He is an institutional
American show business icon. It was
not until 1928 that Hope became a
solo vaudeville entertainer, dropping
a partner and a blackface routine. As
a result of a May 1932 engagement
at the Palace, he went on to star on
Broadway, in radio, and in Hollywood.

Ted Healy (1896–1937) was a vaudevillian who entered films with his supporting players, the Three Stooges, and saw his career plummet while they became stars in their own right. The act dated back to 1922 and played the Palace in 1930. Healey had earlier appeared at the Palace and elsewhere with his wife, dancer-singer Betty Brown.

Jack Haley (1898–1979) began his career in vaudeville but gained wider fame in musical comedy and, of course, on screen, most notably as the Tin Woodsman in *The Wizard of Oz* (1939). He first appeared at the Palace in 1924 with partner Charley Crafts, was back with a new partner, Helen Eby Rock, in 1925, and last played the Palace as a solo turn in 1932.

William Gaxton (1893–1963) was described by the *New York Times*'s critic Brooks Atkinson as "a sort of a man who sings through his toes as well as his oral cavity." The singer-comedian began in vaudeville but his primary career was on the Broadway stage. Gaxton has the distinction of having one of the longest runs at the Palace in 1931.

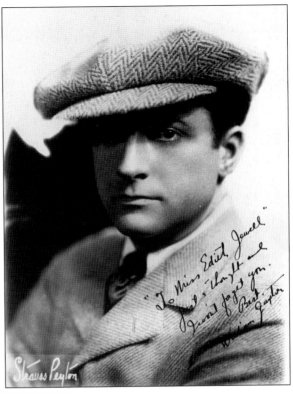

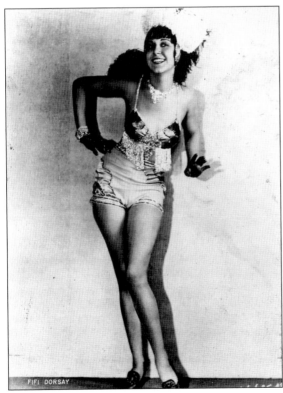

Fifi D'Orsay (1907–1983) was a saucy French bombshell who was actually born in Montreal and who is better known for her work on screen. She came to the United States in 1924 and thanks to a relationship with Ed Gallagher (of Gallagher and Shean), she enjoyed a solo career in vaudeville, primarily working as a mistress of ceremonies. She headlined at the Palace in 1932.

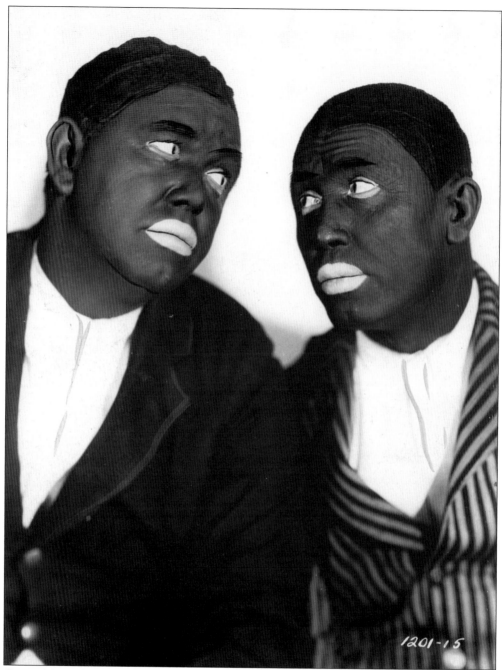

George Moran (1882–1949) and Charles Mack (1887–1934), billed as "the Two Black Crows," were the most popular blackface comedy team in vaudeville after the demise of McIntyre and Heath. Their routine, which was developed in the second decade of the 20th century, was stereotypical and offensive. That did not stop Moran and Mack from headlining at the Hippodrome in 1925, and at the Palace in 1927 and 1932.

Eddie Dowling (1894–1976) was an actor, director, producer, and vaudevillian. He made his Broadway debut in 1919 and would often tour vaudeville with his wife, Ray Dooley. Dowling headlined at the Palace late in his career in 1931. A few years later, he became a serious Broadway actor and a major Broadway producer (most notably of *The Time of Your Life* and *The Glass Menagerie*).

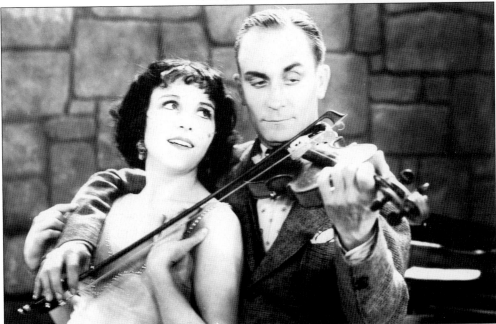

William Demarest (1892–1983) is primarily remembered as the comedian who never smiled. His career dates back to 1904, and includes a large number of film appearances. Television viewers will recall him as Uncle Charley O'Casey in *My Three Sons*. In May 1932, Demarest was one of the acts on the closing bill at the Palace as a two-a-day house.

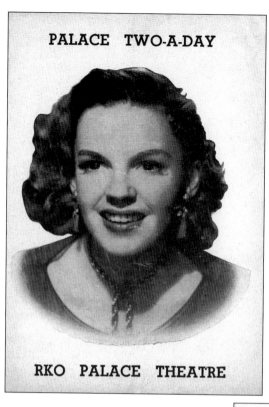

PALACE TWO-A-DAY

RKO PALACE THEATRE

Two programs from the 1950s, when the Palace revived vaudeville, are seen here. Judy Garland made a "comeback" at the Palace on October 16, 1951, playing a four-week engagement that was extended for an additional 15 weeks. Smith and Dale and Señor Wences supported her. Garland returned to the Palace for a further eight-week engagement beginning September 27, 1956. Danny Kaye headlined at the Palace for 14 weeks beginning January 9, 1953. His supporting acts were somewhat lackluster, consisting of European dancers Nicolas Darvas and his step-sister Julia Darvas, band vocalist Fran Warren, chimpanzee Marquis, and the Peiro Brothers from Argentina.

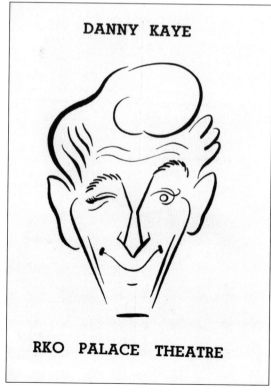

DANNY KAYE

RKO PALACE THEATRE

Two

THE HEADLINERS

Headliner was the term used to describe the star of a vaudeville show, the individual whose name would appear at the top of the bill. The headliner would always be featured as the next-to-last performer on the program, in which was more often than not the number eight spot. If there were two headliners on the same bill, one would occupy the aforementioned position, while the other would accept what might be considered a secondary spot immediately prior to intermission, usually number five on the bill. The headliner would always expect the theater's star dressing room to be on the main floor rather than one story or more above the stage. With two headliners on the same bill, theater managers might often find it more convenient to pretend that the star dressing room was being refurbished, thus resulting in both headliners having to occupy a secondary dressing room.

Honored here are some of the greatest names in vaudeville, many of which might equally appropriately be featured in chapter 1. The type and manner of their acts varied tremendously. Just about the only performers never to make it as headliners were the acrobats and the animal acts.

The headliner with the longest run at the Palace Theatre was Kate Smith, who introduced "God Bless America" and is more appropriately associated with radio. She was there for 10 weeks from August 1 through October 3, 1931. Eddie Cantor, George Jessel, and Burns and Allen played the Palace for nine weeks from October 31 to December 26, 1931. Frank Fay had an eight-week run from May 21 through July 12, 1926, as did Lou Holtz, Lyda Roberti, and William Gaxton from July 11 to August 29, 1931. Curiously, the last headliner at the Palace's last week of straight vaudeville on July 9, 1932, was not a performer at all, but newspaper columnist Louis Sobol. In its final days as a vaudeville revival house, the Palace welcomed Danny Kaye with a 14-week engagement beginning January 9, 1953.

George Burns (1896–1996) and Gracie Allen (1906–1964) were the most beloved of vaudeville teams, who came together in 1922 and were married four years later. He was the straight man and she was the dizzy woman in an act that easily survived vaudeville, and moved on to the screen (1928), to radio (1932), and to television (1950). It might have continued longer had not Gracie decided to say "goodnight" to her fans and retire in 1958. Very similar in performance to Burns and Allen were Jessie Block (1900–1983) and Eve Sully (1902–1990), shown below. Both used the same writer, Al Boasberg, and both couples were close friends. They teamed in 1926, married in 1930, and headlined at the Palace in 1929 and 1930.

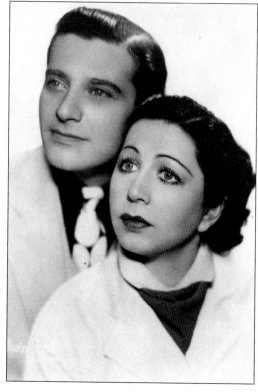

Anna Held (1873–1918) had large, expressive eyes and became a star thanks to her husband Florenz Ziegfeld, whom she married in 1897. Her theme song, appropriately enough, was "I Just Can't Make My Eyes Behave," which she introduced at the Broadway Theatre in November 1906. She had first appeared on stage at Koster and Bial's Music Hall in the 1890s, and first played the Palace in 1914 and 1915. Curiously Ziegfeld featured his wife in only one edition of his *Ziegfeld Follies*—in 1910—and then only in a film interlude. Luise Rainer, who was every bit as ethereal as was Anna Held in her prime but lacked her 18-inch waist, portrayed Anna Held on screen in the 1936 production *The Great Ziegfeld*.

Annabelle Whitford (1878–1961) was a modern dancer of the early years of vaudeville, noted for her exceptional beauty. She was captured on film as early as 1896, performing a flag dance, artist Charles Dana Gibson selected her as his original "Gibson Girl," and Florenz Ziegfeld chose her to be featured in the first edition (1907) of his *Ziegfeld Follies*.

Fay Templeton (1866–1939) was as much admired for her legs, as this photograph illustrates, as for her talents as a singer and comedienne. Her career dates back to 1869 and includes early work with Weber and Fields. By 1903, she was hailed as "the Queen of American Burlesque," and two years later, she starred in George M. Cohan's *Forty-Five Minutes from Broadway*. In 1925, she headlined an old-timers bill at the Palace.

Albert Chevalier (1861–1923), a great British Music Hall comedian, wrote and performed songs of working class life, most notably "My Old Dutch." He made his vaudeville debut at Koster and Bial's Music Hall in 1896 and thereafter was a frequent visitor to the United States.

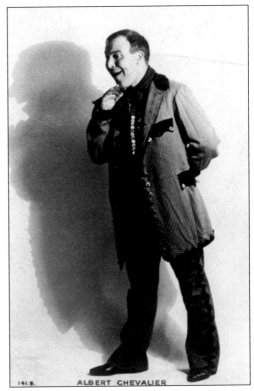

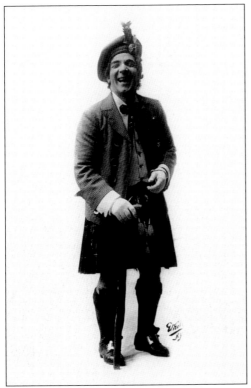

Harry Lauder (1870–1950), a Scottish icon, made his London debut in 1900 and his U.S. debut in 1907. So popular was he that a typical vaudeville appearance would last for 75 minutes. Lauder's best known songs are "I Love a Lassie," "Roamin' in the Gloamin'," "Stop Yer Tickling, Jock," and "The End of the Road."

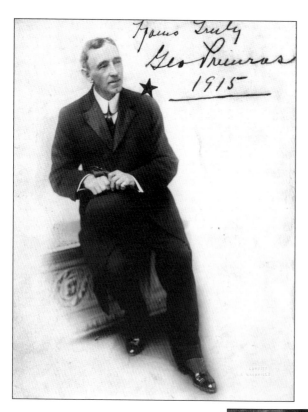

George H. Primrose (1852–1919) was one of the best known of blackface minstrels who began his career in 1867. With William H. West, he formed Primrose and West's Minstrels, which lasted from 1889 through 1898. In vaudeville, Primrose usually appeared with a group of singing and dancing blackface performers. His last appearance was at the Fifth Avenue Theatre in September 1918.

Lew Dockstader (1856–1924) was another leading blackface minstrel who worked with George Primrose from 1898 through 1904. Earlier, in 1895, Dockstader was one of the headliners on the opening bill at Proctor's Pleasure Palace in New York. His vaudeville act consisted of blackface characterizations of prominent figures of the day, but as he grew older, Dockstader abandoned blackface and worked as a monologuist.

James McIntyre (1857–1937) and Thomas Heath (1853–1938) were the most famous partners in blackface minstrelsy, who joined forces in 1874 and became headliners two years later. McIntyre and Heath claimed to have originated ragtime and introduced it to New York at Tony Pastor's Music Hall in 1879. After an enthusiastic farewell tour in 1924, the couple retired.

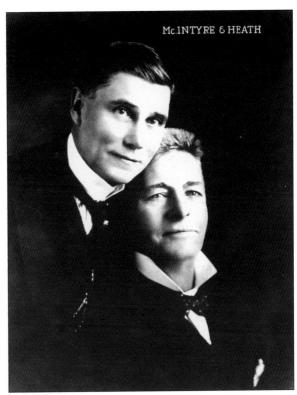

Mc.INTYRE & HEATH

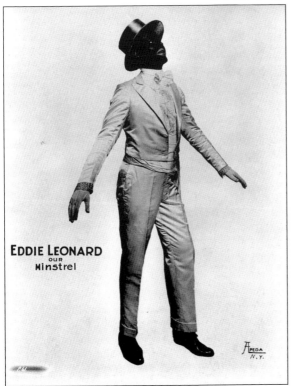

EDDIE LEONARD
OUR
Minstrel

Eddie Leonard (1883–1941) enjoyed a career as a blackface minstrel from the 1890s through the mid-1930s. Billed as "the Minstrel of the Hour," Leonard was a frequent headliner at the Palace, playing there in 1924, 1926, 1927, and 1932. He was equally at home with Negro spirituals and comedy songs, both tender and graceful, and he could never hide the slight hint of an Irish brogue.

53

Joseph Weber (1877–1942) and Lew Fields (1867–1941) are representative of old-fashioned knockabout comedy with German/Dutch dialect jokes that slaughter the English language. Playing the characters of Mike and Myer, introduced in the 1880s, the tall and bullying Fields would physically and verbally attack the innocent Weber. On September 5, 1896, the two opened their own theater, the Weber and Fields Music Hall (formerly the Imperial Theatre), at 29th Street and Broadway, as the world's first burlesque house. It was not burlesque as it is known today, but rather burlesque of popular theatrical productions of the day. In later years, the couple appeared together or solo in musical comedy and revue. Weber and Fields made their Palace debut in 1915 and were the star attraction of the opening bill of Radio City Music Hall in 1932.

Lillie Langtry (1853–1929) was not exactly a great actress, but she was the mistress of Britain's Edward VII and that did not hurt the public's interest in her. Known as "the Jersey Lily," after the Channel Island on which she was born, the actress came to the Hippodrome at the age of 63, somewhat past her prime, and followed it with a couple of lengthy vaudeville tours, with first Alfred Lunt and then Lionel Atwill as her leading man.

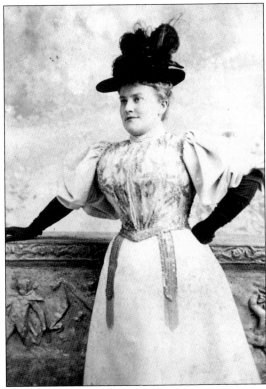

May Irwin (1862–1938) was a singer perhaps more at home in musical and farce comedy than in vaudeville, but she worked for Tony Pastor as early as 1877 and topped the bill at the Palace in 1915. Irwin has gained immortality of sorts as the woman, opposite John Rice, in the 1895 Edison film *The Kiss* (actually a scene from *The Widow Jones*).

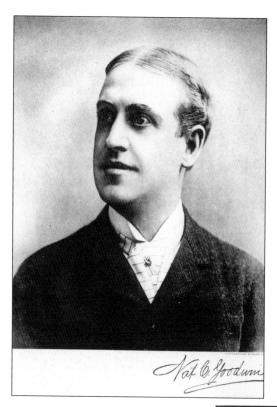

Nat C. Goodwin

Nat C. Goodwin (1857–1919) was a prominent stage actor, most notably in comedy roles. He began his career in vaudeville and returned to the medium in 1909, 1911, and 1916 (when he headlined at the Palace as a monologuist). Goodwin worked on stage with one of his wives, Maxine Elliott, and his best known role was as Fagin in a 1912 stage adaptation of *Oliver Twist*.

Fannie Ward (1871–1952) was an ageless beauty, the "Eternal Flapper," as she was billed, who starred in playlets on the vaudeville stage from the 1890s onwards, and was also prominent in silent films (most famously *The Cheat*, from 1915). In 1926, Ward was headlining at the Palace in the playlet *The Miracle Woman*, in which she played a seemingly young woman with a daughter who looked the same age.

Al Jolson (1886–1950) never played the Palace and was not really a vaudevillian per se, despite the perception of him as the ultimate vaudeville entertainer. Around 1909, he put on blackface and joined Lew Dockstader's Minstrels. He moved on to musical comedy and, on screen, to *The Jazz Singer*. The rest is history.

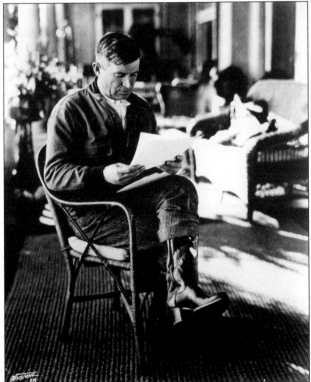

Will Rogers (1879–1935) was a journalist, humorist, newspaper columnist, film star, trick roper, and vaudevillian. He made his New York debut in 1905 at Madison Square Garden as a trick roper, and shortly thereafter began telling jokes as a complement to his roping (which was never that good). From 1915 through 1924, he was associated with Florenz Ziegfeld. He was at the height of his fame when he was killed in a plane crash.

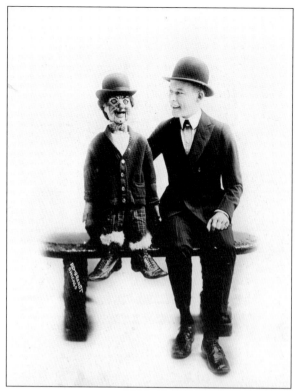

Fred Allen (1894–1956) began his career in the second decade of the 20th century as a nut comedian, often working with a dilapidated ventriloquist's dummy or billed as "the World's Worst Juggler." His first major New York appearance at the Fifth Avenue Theatre in 1918 was a disaster, but by 1921, when he was simply a monologuist, he was a success. In 1927, he married Portland Hoffa, and he and his wife worked in vaudeville together (in a sketch titled "Disappointments of 1927") and also on radio in the 1930s and 1940s. He was noted for a long-running, comic feud with Jack Benny (shown here bent over with laughter).

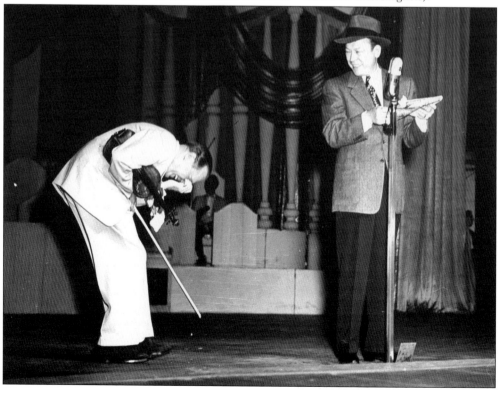

Emma Carus (1879–1927), seen here with one of her dance partners, Carl Randall, was noted for her baby face and large physique. She would usually begin her act with the line, "I'm not pretty, but I'm good to my family." In 1907, she was featured in the *Ziegfeld Follies* and began her vaudeville career.

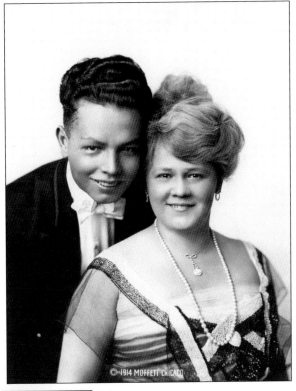

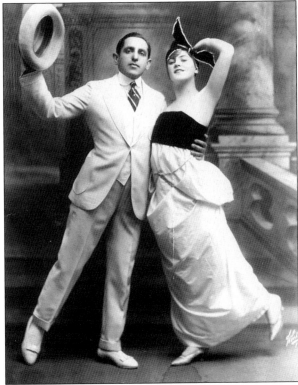

Gus Edwards (1879–1945), seen here with Lilyan Tashman, was both an entertainer and a showman, who discovered many of the greatest names in vaudeville. He and Tashman appeared together at the Palace in 1914 in an act titled "Song Revue," typical of his vaudeville presentations with child performers and nonstop songs.

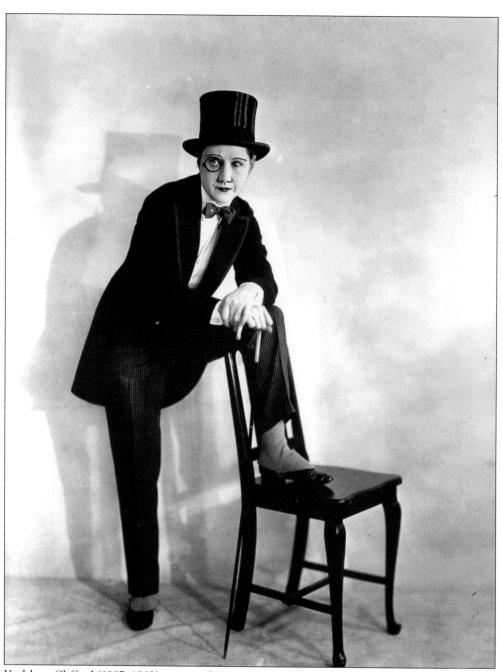

Kathleen Clifford (1887–1963) was a male impersonator, billed as "the Smartest Chap in Town," and usually seen wearing a monocle, top hat, and tails. She began her vaudeville career in 1910 after earlier work in musical comedy. Because British male impersonators were held in such high regard, she always claimed to be English, although, in reality, she was born in Virginia. From 1917 through 1928, Clifford was also in films, but not as a male impersonator. She ended her days as a Hollywood, California, florist.

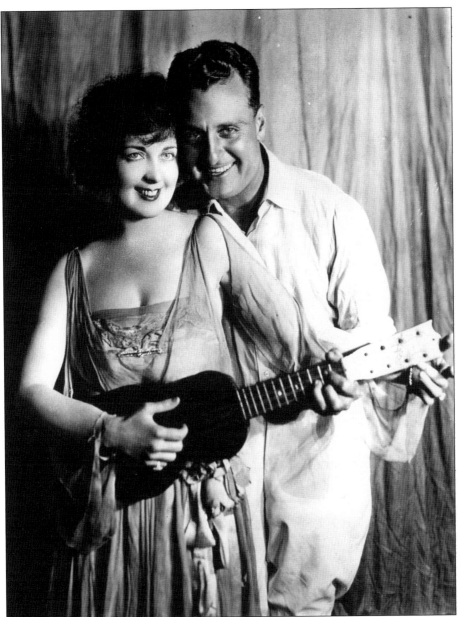

Julia Sanderson (1887–1975) appeared on stage as a child actress before making her vaudeville debut at Keeney's Theatre in 1907, displaying considerable presence and personality, not to mention a strong voice. She enjoyed major success in musical comedies during the second decade of the 20th century before meeting her husband-to-be Frank Crumit (1888–1943) in the 1921 musical comedy *Tangerine* (in which they are pictured here). Crumit had been appearing on the vaudeville stage, singing and playing the ukulele, billed as "A Comedian Who Can Sing, Play Instruments and Tell a Story." He had also written a number of songs, the best remembered of which is "Abdul Abulbul Emir." Sanderson and Crumit teamed up professionally and later personally. They were regulars in vaudeville, headlining at the Palace in 1924. From 1928 to 1933, the couple had the first of their own radio show, *Blackstone Plantation*, which was followed by a number of variety and quiz programs.

George M. Cohan (1878–1942), the symbol of American entertainment in the first third of the 20th century, had been part of his family's vaudeville act in 1889. As The Four Cohans, they were the highest paid quartet in vaudeville. After a dispute with B. F. Keith over billing, the family left vaudeville. Cohan never did play the Palace, although a 1968 stage version of his life story, *George M*, did.

Harry Houdini (1874–1926), the most famous magician and escapologist of all time, became a vaudeville headliner in 1900. In New York, he was generally to be found at the Hippodrome, making an elephant disappear in 1918, and he held over for a record six weeks in 1925.

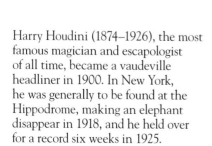

Alice Lloyd (1873–1949) is not as famous in her native England as her sister Marie, but it is Alice who was the major star of American vaudeville. Her voice and dainty demeanor delighted audiences over here from 1907, when she made her U.S. debut at New York's Colonial Theatre, through 1927, when she toured the Pantages circuit. She headlined at the Palace in 1913, 1919, and 1925.

Walter C. Kelly (1873–1939) was billed as "the Virginia Judge," and built his monologues around Southern humor, generally of a racist nature. He first appeared in New York in the early years of the 20th century, and by 1913, he was headlining at the 44th Street Music Hall. He was one of the few vaudevillians known to have objected to sharing a bill with African American entertainers. His niece was legendary Hollywood actress Grace Kelly.

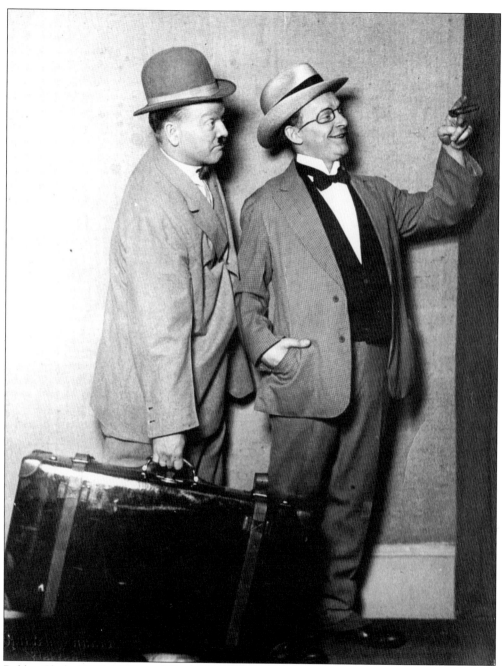

Bobby Clark (1888–1960) and Paul McCullough (1883–1936) practiced a humor that is in some respects similar to that of the Marx Brothers. There are many who believe Clark and McCullough were better. McCullough was the straight man, while Clark was the comedian with black glasses painted on his face, a leer, and a walk that was all his own. The two became partners in 1900, working in circuses and minstrel shows before playing vaudeville through 1917 when they entered burlesque. They did not become headliners at the Palace until 1928; they had first appeared there and at the Hippodrome in 1924. When McCullough killed himself, Clark went into seclusion, but returned as a solo act, most notably touring in *Damn Yankees* in 1956.

Chic Sale (1885–1936) specialized in bucolic humor, playing various types of country characters (often old). If his creations had anything in common, it was a healthy and earthy interest in outside lavatories. In 1929, he published a 31-page book, *The Specialist*, ostensibly the story of Lem Putt, "the champion privy builder of Sangamon County," which sold more than two million copies. He might well be considered the originator of the bathroom humor that became popular in the 1980s.

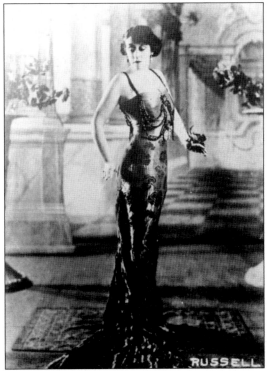

Olga Petrova (1885–1977) was a multi-talented feminist voice, active in legitimate theater, silent films, and vaudeville. She came to the United States from her native United Kingdom in 1912 to star in Jesse L. Lasky and Henry B. Harris's unsuccessful New York cabaret the *Follies Bergere*. A year later, Petrova was a major success in vaudeville with her recitations, songs, and playlets. She made her Palace debut in 1919.

Joseph E. Howard (1867–1961) was notable both as a singer and as a composer. He wrote the music for a number of Broadway shows from the early years of the 20th century, and he was also responsible for such perennial favorites as "Hello My Baby," "Goodbye, My Lady Love," and "I Wonder Who's Kissing Her Now." The last became the title for a film biography of Howard, produced in 1947, in which he was played by Mark Stevens. Howard entered vaudeville at the age of 11 as a soprano, but he quickly gained fame as a ragtime entertainer, always well dressed in evening attire, and boasting of his success with the ladies. Television gave him a new lease on life, and he would often be seen with Ed Sullivan and others in the 1950s.

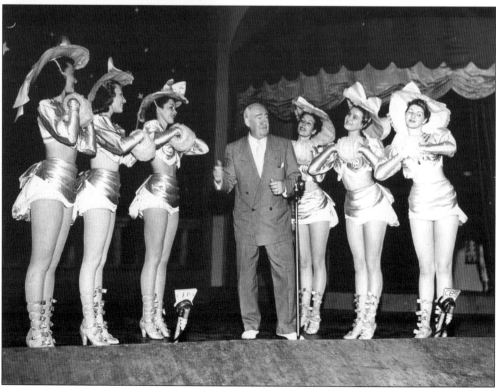

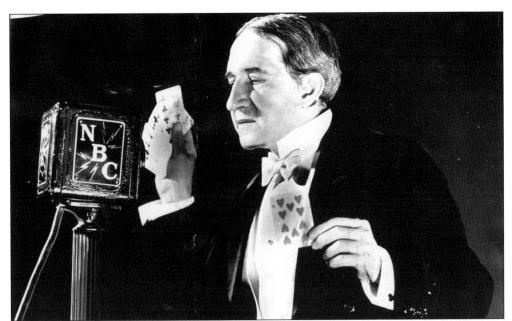

Howard Thurston (1869–1936), always billed simply as Thurston, began his career in 1908 when he purchased the magic act of Harry Kellar. His specialties were the rising playing card, making an automobile disappear, and having a boy vanish after climbing to the top of a rope. In 1913, he had a two-hour show at New York's National Theatre, and in 1924, he was invited to perform for Pres. Calvin Coolidge.

Harry Blackstone (1883–1965), again simply billed by his last name, was a magician, active from 1908, whose best known trick was an intimate one, that of making a handkerchief dance. He was also adept at sawing a woman in half and making a live horse disappear.

67

Joe E. (Evans) Brown (1892–1973) was a comedian with a big mouth and a wide grin who later became a major film entertainer. As an acrobat, he had performed in circuses from the early years of the 20th century. He graduated to vaudeville, working with Frank Prevost in an act titled "A Few Minutes of Foolishness." Revues and musical comedies followed.

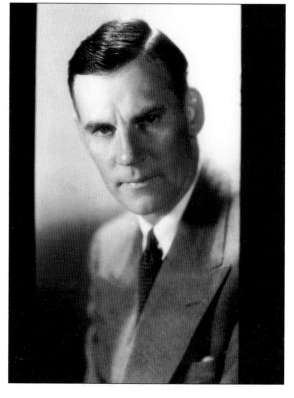

Walter Huston (1884–1950) was such a familiar figure on screen that one forgets he began in vaudeville, teamed from 1909 to 1924 with his second wife, Bayonne Whipple, as Whipple and Huston. They played together in comedy sketches that would often feature both singing and dancing.

Texas Guinan (1884–1933) never did very much of anything, but with her greeting of "Hello, Sucker!" and her New York nightclubs of the 1920s, she was the personification of the prohibition era. As early as 1910, Guinan had been a singer of popular songs in vaudeville, but it was not until 1925 that she headlined with Her Mob at the Hippodrome and 1932, when she headlined at the Palace.

Nick Lucas (1897–1982) was a major recording artist of the 1920s and 1930s, with more than 100 songs to his credit, including "Tip-Toe thru the Tulips." With his soothing voice and accompaniment on the guitar, he would generally be a member of the vaudeville bill supporting a feature film, although he did headline the last all-vaudeville bill at the Palace in 1932.

Helen Morgan (1900–1941) was the quintessential torch singer, perched on top of a piano lamenting her lost man, as with "Can't Help Lovin' Dat Man," which she introduced in the original 1927 production of *Show Boat*. She was primarily a nightclub entertainer in New York in the 1920s, but was first heard at the Palace in 1927 and returned to headline there in 1930 and 1931.

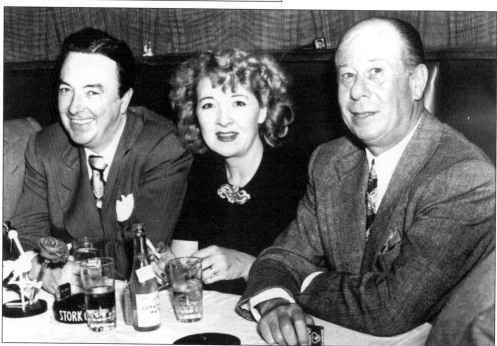

Bert Lahr (1895–1967), right, seen here at the Stork Club in the 1930s with Jack Haley and his wife Flo McFadden, developed a vaudeville routine after World War I with his first wife, Mercedes Delpino, and it led to a solo career in burlesque and vaudeville. He headlined at the Palace in 1931.

Dave Rubinoff (1897–1986) was a Russian-born violinist with an often arrogant attitude towards his audience. He began his career in vaudeville in the 1920s, but gained wider appeal with his radio broadcasts from 1931. Technically Rubinoff was an above-average violinist, but obviously not good enough for the concert hall.

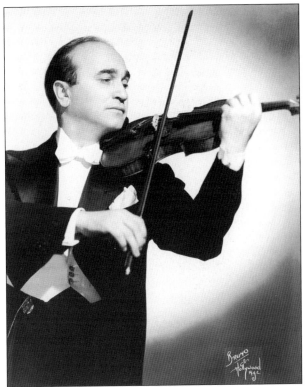

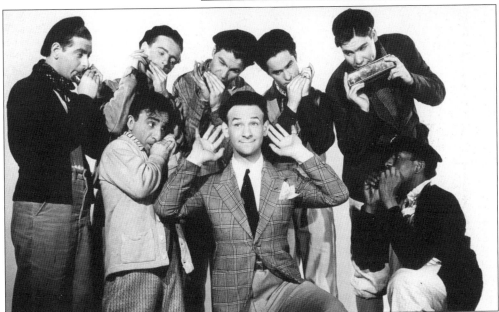

Borrah Minevitch (1903–1955) and His Harmonica Rascals were the best known exponents of the harmonica in vaudeville from the late 1920s through into the 1950s. The style was comic and frenetic, and Russian-born Minevitch also appeared in a number of Broadway shows and on radio. The best known member of the Rascals was Johnny Puleo, who led the group after Minevitch's death.

Ken Murray (1903–1988) was an all-round entertainer, a vaudeville star of the 1920s and 1930s, who once boasted of Bob Hope as his understudy, a star of radio and television, and the winner, in 1947, of a Special Oscar for his all-bird feature film, *Bill and Coo*.

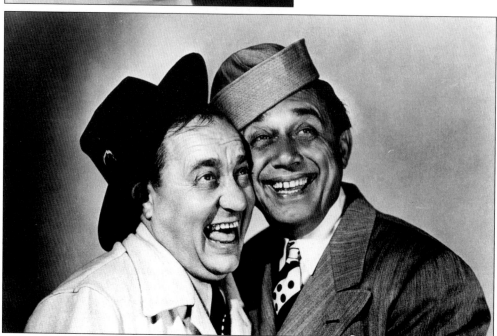

Ole Olsen (1892–1963) and Chic Johnson (1891–1962) were a comedy team in which it was never apparent who was the straight man and who was the comic. Olsen and Johnson were first seen in vaudeville around 1918. There was a lunatic quality to their performance, captured on film in *Hellzapoppin* (1941), based on their long-running Broadway hit, which opened in 1938.

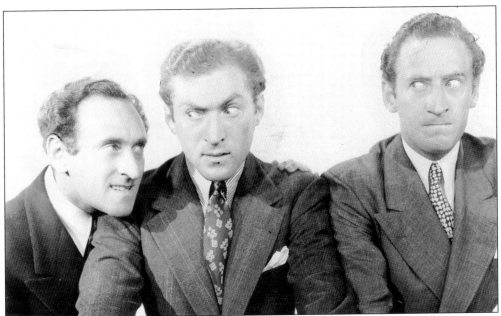

Al (1901–1965), Harry (1907–1986) and Jimmy (1904–1985), the Ritz Brothers, combined slapstick and acrobatic comedy in an act that was both rowdy and robust. Their first vaudeville appearance was probably at the Albee Theatre in Brooklyn in 1925. They headlined at the Palace in 1929 and 1932 and went on to greater fame in motion pictures of the 1930s and 1940s.

Cliff Edwards (1895–1971), a singer and recording star who accompanied himself on the ukulele, headlined at the Palace in 1924 and 1932. When he played the Orpheum in Los Angeles in 1928, he was signed to an MGM contract. As a result, he introduced "Singin' in the Rain" in *The Hollywood Revue of 1929*, and 11 years later, he was the off-screen voice of Jiminy Cricket in *Pinocchio*, singing "When You Wish upon a Star."

Ruth Etting (1896–1978) was a happy singer of sad songs, known as "the Sweetheart of Song." She entered vaudeville in Chicago in the early 1920s, and made her New York debut in 1927 at the Paramount Theatre. She was portrayed by Doris Day in the 1954 biopic *Love Me or Leave Me*.

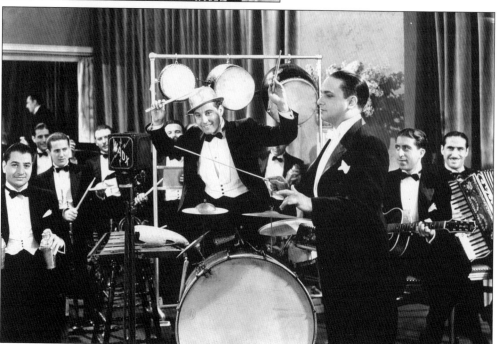

Vincent Lopez (1894–1975) and His Orchestra was the first major band to appear in vaudeville, performing at the Palace in 1923 and the Hippodrome in 1924. In 1925, he opened his own New York nightclub and from 1941 to 1966, he was a fixture at the Grill Room of New York's Hotel Taft.

Rudy Vallee (1901–1986), a major figure in popular music, first began touring with his own dance band in 1927. In 1929, he became a prominent radio star, with his theme, "My Time Is Your Time," and that same year, he began headlining in vaudeville. In 1930, he starred in a vaudeville-style revue at the Brooklyn Paramount.

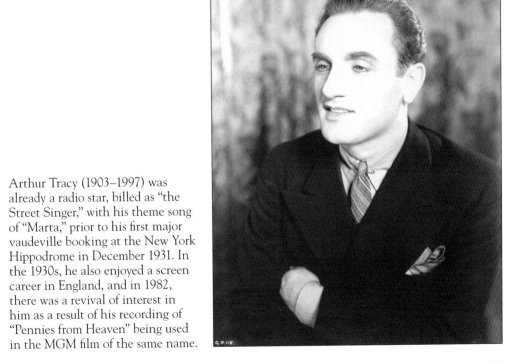

Arthur Tracy (1903–1997) was already a radio star, billed as "the Street Singer," with his theme song of "Marta," prior to his first major vaudeville booking at the New York Hippodrome in December 1931. In the 1930s, he also enjoyed a screen career in England, and in 1982, there was a revival of interest in him as a result of his recording of "Pennies from Heaven" being used in the MGM film of the same name.

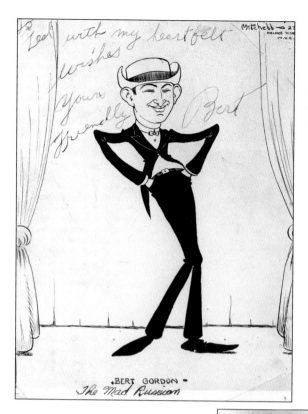

Bert Gordon (1895–1974) was the "Mad Russian" of radio, occasional films, and vaudeville. He began his career at the age of 12, and was noted for his thick Slavic accent and his dialect greeting of "How dooo you dooo." He played the Palace in 1927.

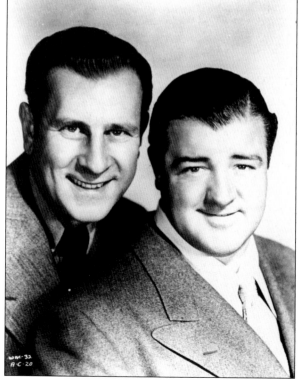

Bud Abbott (1895–1974) and Lou Costello (1906–1959) belong to the waning days of vaudeville or, more precisely, burlesque. It was not until January 1936 that the pair was hired by the Minsky brothers for their New York and Brooklyn burlesque houses. In 1938, they appeared in vaudeville at Loew's State. Abbott and Costello had teamed up in the late 1920s but did not become major stars until entering films in 1940.

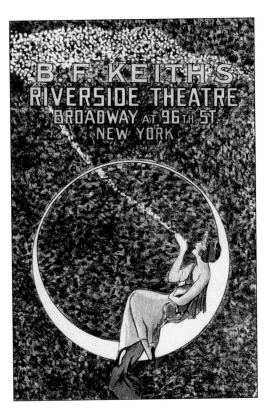

These two programs illustrate the emphasis of vaudeville houses on refinement and good taste. The covers have no connection whatsoever to any aspect of entertainment. Rather, they suggest what might be considered a middle-class concept of art. Headliners are not featured, although Percy G. Williams (1857–1923), a prominent figure in vaudeville management, is. For the record, the headliner at the Colonial Theatre for the week of September 14, 1908, was Eva Tanguay, whose act concludes with "Her Original Version of 'A Vision of Salome.'" At the Riverside Theatre, for the week of June 6, 1927, the headliners are Moran and Mack, who are given two spots on the bill.

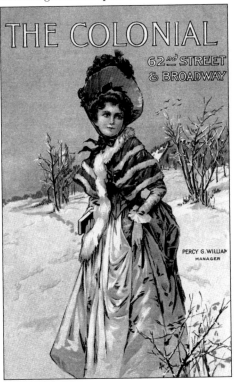

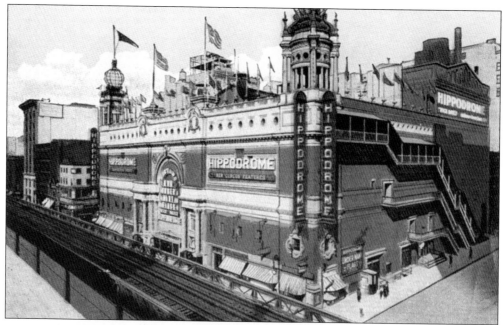

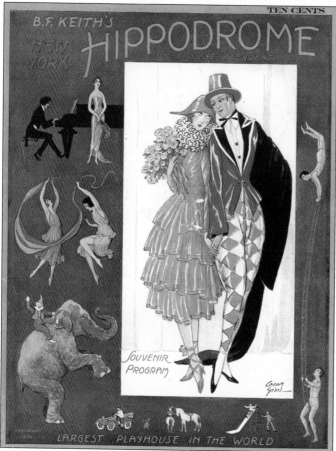

Stretching an entire city block from 43rd to 44th Street on Sixth Avenue, the New York Hippodrome seated 5,200 and its stage facilities included a water tank and hydraulic lifts. The brainchild of showmen Frederic Thompson and Elmer S. "Skip" Dundy, who also built Luna Park at Coney Island, the theater opened on April 12, 1905, with *A Yankee Circus on Mars*. The show was typical of the extravaganzas at the Hippodrome until 1923 when it became a regular vaudeville house. It closed in 1930 but reopened in 1935 with *Billy Rose's Jumbo*. The Hippodrome was demolished in 1939. The souvenir program is undated, but features three headliners, W. C. Fields, dancer Florence Walton, and Frances White.

Three

FULL SUPPORTING CAST

Just as moviegoers would expect a full supporting program of comic and novelty shorts, along with a newsreel, so would vaudeville audiences look forward to a varied program of secondary acts leading up to the appearance of the headliner. The only similarity between the entertainment at the movie palace and at the vaudeville house was the newsreel, often featured at both, and usually occupying the initial spot in vaudeville.

A number of supporting players in vaudeville actually enjoyed wider success in motion pictures. Comedians such as Buster Keaton, Harry Langdon, and Larry Semon are obvious examples of vaudevillians who transposed their brand of humor to the big screen. Carter De Haven and Flora Parker proved as versatile an acting couple on screen as on stage. Buddy and Velma Ebsen were a dancing duo in vaudeville, and the former enjoyed equal success in films and even greater fame on television. Jane and Katherine Lee were a sister act in early films before capitalizing on that fame in vaudeville.

Some supporting acts ran foul of the headliner. Most objected to appearing on the same bill as animal acts. It was not just the animal smells but equally the odor of the food being cooked in the dressing room for the animals. Sarah Bernhardt had no problem with appearing on the same bill as W. C. Fields. She raised no complaint at having to work on a Sunday. But when she discovered that an acrobat act, the Heras Family, was to close the Bernhardt program in Chicago, she made it very plain that she would not be followed by acrobats. And she never was!

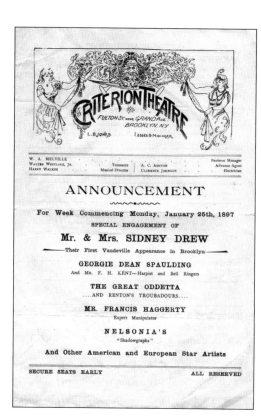

ANNOUNCEMENT

For Week Commencing Monday, January 25th, 1897
SPECIAL ENGAGEMENT OF

Mr. & Mrs. SIDNEY DREW
Their First Vaudeville Appearance in Brooklyn

GEORGIE DEAN SPAULDING
And Mr. F. H. KENT—Harpist and Bell Ringers

THE GREAT ODDETTA
....AND RENTON'S TROUBADOURS....

MR. FRANCIS HAGGERTY
Expert Manipulator

NELSONIA'S
"Shadowgraphs"

And Other American and European Star Artists

SECURE SEATS EARLY ALL RESERVED

Seen here are two typical New York vaudeville bills. Topping the bill at the Criterion in 1897 are Mr. and Mrs. Sidney Drew. He was the uncle of Ethel, John, and Lionel Barrymore and the son of America's foremost comedienne, Mrs. John Drew. The Drews were pioneers in bringing legitimate drama to the vaudeville stage, beginning in 1896. With such legendary stars making their Brooklyn vaudeville debut, the supporting players are merely window dressing. Among the supporting players at the Royal Theatre in 1917 is A. Robins, a clown with a novelty act involving his pulling every known musical instrument out of his clothing. He was to play the Palace in 1918, 1926, and 1930.

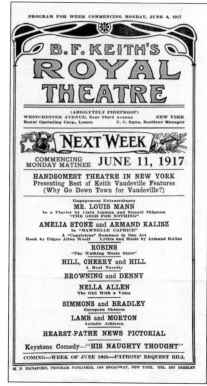

The Royal Gascoignes represent a typical (and minor) supporting act. Mr. Gascoigne literally supports his wife! Nothing is known of the couple except the act dates from the early years of the 20th century.

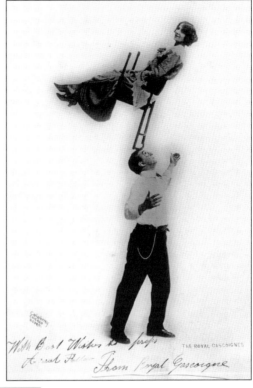

The Equillo Brothers, billed as "Masters of Equilibrium," are equally unknown, and date from the same era. Both the Equillo Brothers and the Royal Gascoignes are what would be called "dumb acts," who never spoke to the audience and who required no special attention from an audience that might well be arriving for the start of the show or getting up to leave at its close.

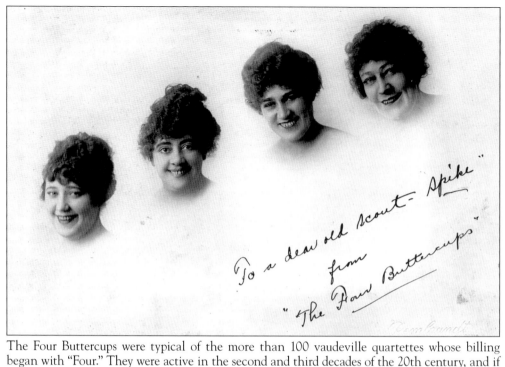

The Four Buttercups were typical of the more than 100 vaudeville quartettes whose billing began with "Four." They were active in the second and third decades of the 20th century, and if this photograph is anything to go by, were probably best seen from a distance.

Ernest R. Ball (1878–1927) was a composer of sentimental ballads, often with Irish themes, such as "Mother Machree" and "When Irish Eyes Are Smiling." He typifies the many composers who took to the vaudeville stage in the second decade of the 20th century, accompanying themselves on the piano. His earliest known appearance was at Hammerstein's Theatre in May 1911, and he played the Palace in 1923 and 1926.

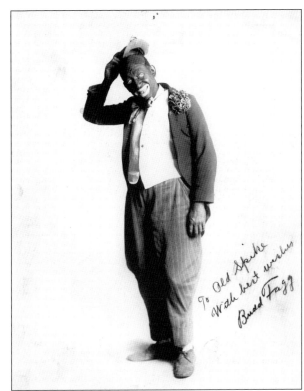

Fagg and White are a forgotten vaudeville act from the second decade of the 20th century and the 1920s with a number of dimensions. Budd Fagg would sometimes appear in blackface, singing comic songs. More unusual was their work in female impersonation. Fagg would appear as the "woman," take off his wig to prove he was female, and then remove the second wig to show he was a man. A similar act was Ray Monde, who appeared as a woman, took off his wig at the end of the act to prove he was a man, and then removed the male wig to display a female hairstyle.

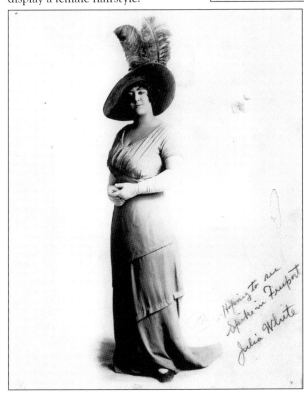

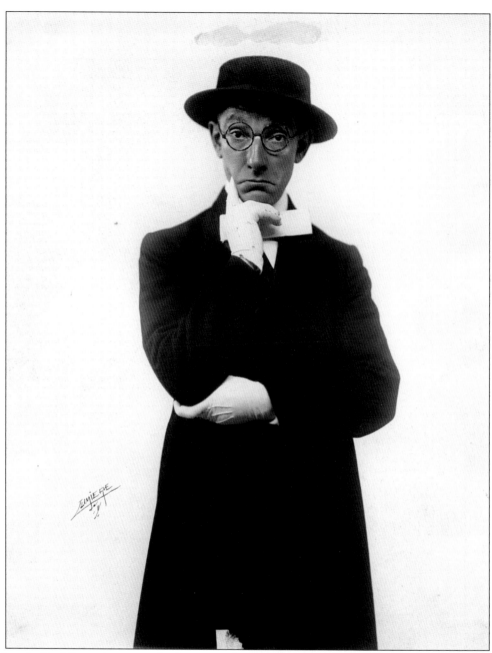

Joseph (Joe) Browning was a deadpan monologuist who always appeared on stage dressed as a preacher. If he did smile, it was with a sickly grin revealing blacked out teeth. His "sermon" was generally on the subject of men and women: "Woman—woe man! Man—meaning nothing! Definition of a female—a wonderful invention. Definition of a man—a flop. Woman—feminine. Man—asinine. Average age of female—who knows? Male—who cares? Average weight of female—about 115 pounds. Above that all scales are wrong! Nature of female—mostly kind. Nature of Man—mostly dumb! Woman stands at the altar and promises to love, honor and obey—Man promises the same thing but reserves the out-of-town rights!" Browning, who also wrote material for other comics, was on stage at the Palace in 1927 and 1928.

Ben Welch (?–1926) was a stereotypical Jewish comic. In 1921, while appearing in a show called *Jimmie*, he began to go blind, and for the last five years of his life appeared on the vaudeville stage relying on his straight man, Frank Murphy, to get him on and off.

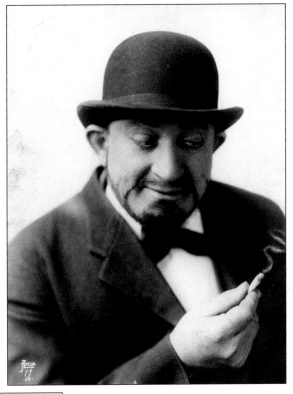

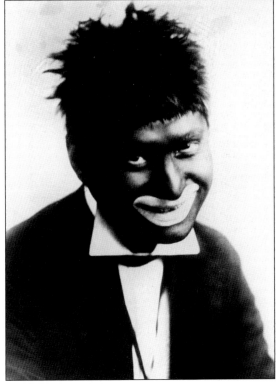

Al Herman (1886–1967), billed as either "the Black Assassin of Grief" or "the Assassin of Grief and Remorse," was a blackface comic who was unusual in that he employed a cigar as a prop. He also had occasional screen roles in the 1920s through the 1950s.

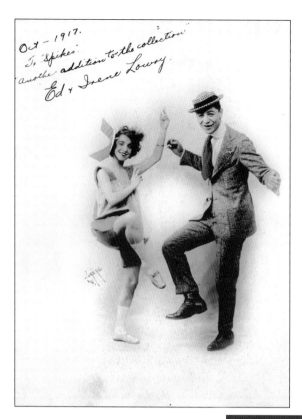

Oct - 1917.
To "Spikes"
another addition to the collection
Ed & Irene Lowry

Ed Lowry (1886–1983) was a comedian who also played the saxophone. He entered vaudeville as a teenager, and achieved his biggest success in the medium's waning days as a master of ceremonies at presentation houses, featuring both vaudeville and motion pictures.

Fay Marbe was a New York society woman who grew bored with her life and decided to enter show business in the chorus of *Oh Boy* in 1917. Thanks to her position and wealth, she was able to generate a massive amount of publicity for her vaudeville appearances as a singer and dancer during the second and third decades of the 20th century. She was at the Palace in September 1920.

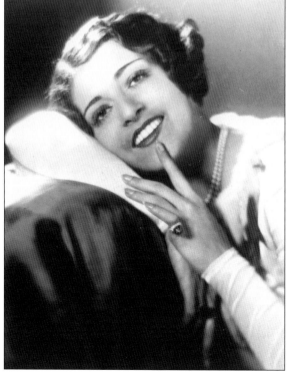

Sam Bernard (1863–1927) specialized in German characterizations that became Dutch with America's entry into World War I. He would appear as both a monologuist and a featured actor in playlets, making his first appearance at the Palace in 1914 and his last in 1926. He died on his way back across the Atlantic to his native England.

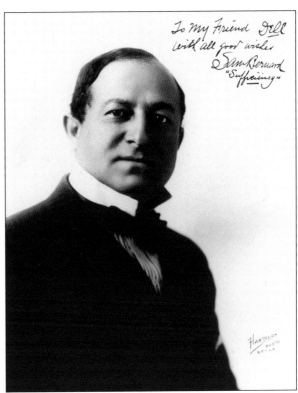

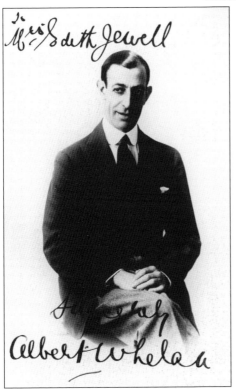

Albert Whelan (1875–1961) was billed as "the Australian Entertainer," and noted for his tuneful whistling and elegant removal of his top hat, white gloves, and cane. He began his career in British Music Hall in 1901, made his U.S. debut in 1908, and his last appearance at the Palace in 1925.

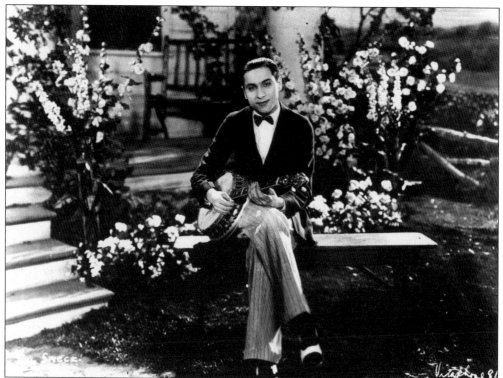

Roy Smeck (1900–1994), a virtuoso of the guitar, banjo, ukulele, and Hawaiian guitar, was active in the 1920s; and in 1930, he played both the Palace and the London Palladium. He is one of the acts featured in the supporting program of film shorts for the Vitaphone sound-on-disc feature *Don Juan* (1926).

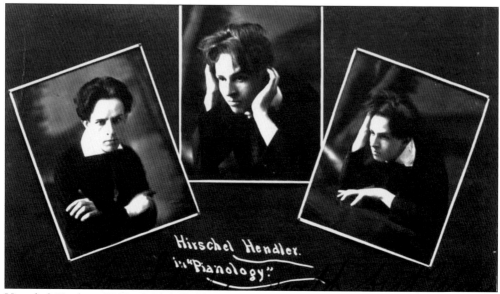

Herschel Henlere (1890–1968) billed himself as "the Poet of the Piano." In 1912, he was an accompanist for Anna Held and in 1914, he appeared with Texas Guinan. He was on stage at the Palace in 1920 and 1925, but in later years was primarily active in the United Kingdom.

Miss Patricola (1886–1965) did little more than play the violin in vaudeville, but her personality was pleasing and her style infectious. In 1919, she was the opening act, but by 1923, she had become the headliner at the Palace, where she returned in 1926, 1927, and 1928. Her brother Tom was an eccentric dancer in vaudeville.

Eddie Peabody (1902–1970) was a leading exponent of the banjo, but he would often play other larger instruments to emphasize his diminutive stature. He belonged to the dying days of vaudeville, but continued to perform on radio and in nightclubs until his death.

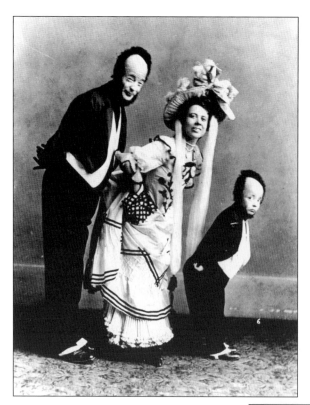

The Three Keatons consisted of father Joe, mother Myra, and son Buster, who was to gain immortality as a silent screen comedian. Buster became a member of the group in 1898, initially as a burlesque-type dancer, but soon became the beating "victim" of a violent routine involving a father and rebellious son. It was a rough and tumble world but one that helped shape Buster's later career.

El Brendel (1891–1964) is best remembered as a screen comedian with a fake Swedish accent and his phrase "yumpin' yimminy." With his wife Flo Bert, he entered vaudeville in 1913, changed his accent from German to Swedish upon America's entry into World War I, and was successful as an eccentric dancer and comic.

Carter De Haven (1886–1977) and his wife Flora Parker (1883–1950) were at Hammerstein's Victoria Theatre as early as 1909 with an act featuring dancing along with comic and romantic songs. They came to the Palace first in 1914; and a year later, De Haven and Parker were appearing on screen in a series of domestic comedies.

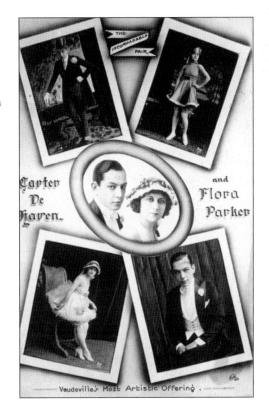

Gaby Deslys (1881–1920) was a celebrated French dancer, who appeared in American vaudeville and revue in the second decade of the 20th century with Harry Pilcer (1885–1961), who was a former male prostitute every bit as beautiful as she was. Wracked with consumption, Deslys died in Pilcer's arms.

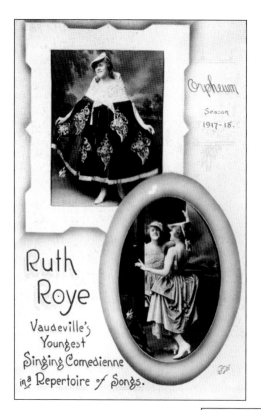

Ruth
Roye
Vaudeville's
Youngest
Singing Comedienne
in a Repertoire of Songs.

Ruth Roye was a singer of ragtime songs, "the Princess of Ragtime" and the "Comedienne of Syncopation," who dominated the vaudeville stage in the second decade of the 20th century and disappeared as quickly as she had arrived. She played the Palace in 1914 and was held over for a second week, at which time she introduced Irving Berlin's "Abba Dabba Honeymoon."

Aileen Stanley (1893–1982) came to the New York vaudeville stage in 1920, when she first appeared at the Palace. She became better known for her many recordings—25 million records of 215 songs—which gained her the title "the Victrola Girl," and which led to a radio career in the 1930s.

Jane and Katherine Lee were child actresses who came to fame on film in 1914. They were winsome and cute, and were persuaded to enter vaudeville in 1920, initially appearing in a playlet and later trying comedy songs. They played the Palace in 1932, and retired a few years later. It is entirely possible that they were not sisters.

Billy Glason was a singing comedian, who billed himself as "Just Songs and Sayings." His heyday was the 1920s and 1930s. He had his own local New York radio show in 1939, and was also a songwriter.

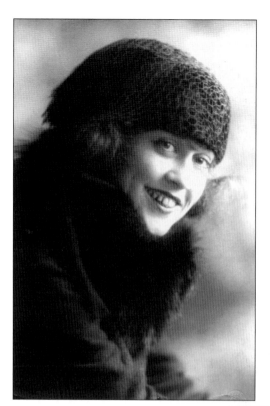

Lee Morse (1904–1954) was a contralto with a low register who proved herself expert at blues numbers. Her vaudeville debut was in 1920, but she gained greater fame as a Columbia recording artist and for her work on radio with her Blue Grass Boys. Typical of the songs that made her famous is "Moanin' Low."

J. Harold Murray (1891–1940) is perhaps best remembered as Jim in the original 1927–1929 production of *Rio Rita*. He entered vaudeville as a singer in 1918; and by 1924, was in number four position on the Palace bill. He was busy in musical comedy and revue and in the late 1920s and early 1930s tried for a film career. In the 1930s, he was president of the New England Brewing Company whose product was labeled Murray's Beer.

Michael Lamberti (1891–1950), billed as Professor Lamberti, had a vaudeville act in which he would play the xylophone while, unbeknownst to him, a woman would appear and perform a striptease. Assuming the audience response was for him, Lamberti would play with greater and greater energy.

George L. "Doc" Rockwell (1890–1978) was a nut comedian, using a banana stalk to illustrate a lecture on the human anatomy. He was on the opening bill at Radio City Music Hall on November 27, 1932. His son was the slain American Nazi Party leader George Lincoln Rockwell.

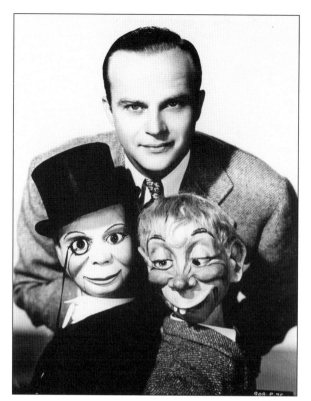

Edgar Bergen (1903–1978) was America's most famous ventriloquist, whose vaudeville appearances in a comedy sketch (including the Palace in 1926) gave little hint of the brilliant comedian he was to become. It was radio in the 1930s and 1940s, whose audience could not see that his lips were moving, that elevated Bergen from supporting player to star.

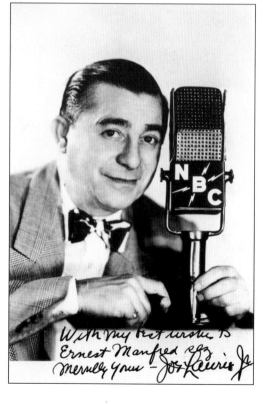

Joe Laurie Jr. (1892–1954) had a long if relatively unimportant vaudeville career as a standard comedian from the second through the fourth decade of the 20th century. His biggest claim to fame is as the medium's biographer with *Vaudeville: From the Honky-Tonks to the Palace* (1953) and *Show Biz: From Vaude to Video* (1951), coauthored with Abel Green.

Marion Harris (?–1944) was a popular singer of syncopated songs in vaudeville and on the nightclub circuit who rose to popularity in the 1920s. She was at the Palace every year from 1926 through 1931. She moved to London in the 1930s, and on a return visit to New York, she was burned to death in a hotel fire.

Rose Marie Curley (born 1923), known as Baby Rose Marie, was first heard on radio in the late 1920s as a unique child performer with a deep, husky, adult voice. Her vaudeville career came about as a result of the need to prove she really was a child and not a midget. Later Rose Marie became a prominent figure on television in *The Dick Van Dyke Show* (1961–1966), *The Hollywood Squares* (1968–1980), and other series.

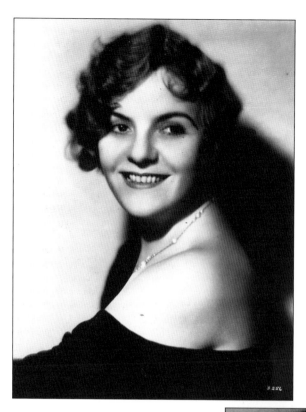

Winnie Lightner (1900–1971) was a flaming redhead with a vivacious personality, best remembered for her films at Warner Bros. in the late 1920s and early 1930s. She had first appeared in vaudeville in 1920, teamed with two other performers as the Lightner Sisters and Newton Alexander, and the act was well received that year at the Palace. As a solo performer, she performed numbers with great zest and speed, becoming known as "the Song-a-Minute Girl."

Pert Kelton (1907–1968) was equally bright and vivacious, a comedienne who joined her parents' act at the age of four while on tour in South Africa. Later she teamed with her mother, Susan, as a sister act, and went on to work in musical comedy, films, and radio. She revived her career in later years with her portrayal of the feisty Irish mother in the Broadway and film versions of *The Music Man*.

Four

AFRICAN AMERICANS IN VAUDEVILLE

At a time when the United States was deeply segregated by race, the vaudeville stage was remarkably color unconscious. African American entertainers could and did appear on the same bills with white Americans. The audiences were segregated, with African Americans usually assigned to the upper balcony, but backstage, it was a relatively democratic society. As early as 1855, black minstrels had appeared on stage; indeed composer W. C. Handy, "the Father of the Blues," began his career in minstrelsy in the 1890s. At the same time, these "colored minstrel troupes" were expected to act out the African American caricatures defined by a white audience. Often African American entertainers were required to emulate white performers by "blacking up," deliberately over-emphasizing the color of their skin.

In the second decade of the 20th century, an all-black vaudeville circuit, the Theater Owners Booking Association (TOBA), was organized by African American comedian Sherman Dudley, and it remained active through the 1920s. Because of the low pay, constant changes in bills and transportation problems, performers would often maintain that TOBA was short for "Tough on Black Actors" or "Tough on Black Asses."

One of the earliest of African American entertainers in mainstream vaudeville was Ernest Hogan (about 1859–1909), billed in the 1890s as "the Unbleached American" and responsible for "All Coons Look Alike to Me" (1896), the most popular of what were described at that time as "coon songs." Such songs, which disappeared from vaudeville with the advent of ragtime around 1915, were unquestionably responsible for fueling negative stereotypes, and it did not help that not only were African Americans composing such songs, but two of the best known exponents of "coon songs" were the first major black performers of the 20th century, Bert Williams and George Walker.

Bert Williams paved the way for the African American on stage, but it was not until the 1920s that the first wave of great black entertainers began to make a name for themselves, albeit solely as singers or dancers. Only after the demise of vaudeville did the comedic styles of the likes of Jackie "Moms" Mabley and Dewey "Pigmeat" Markham find a resonance with both black and white audiences.

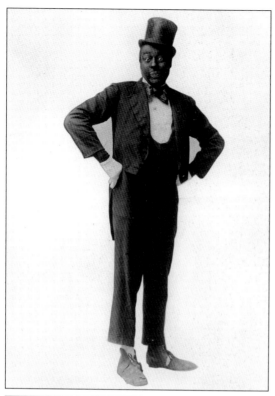

Bert Williams (1874–1922) was one of vaudeville's greatest pantomimists and comedians, whose theme song, "Nobody," brilliantly captures the plight of an African American in a white world. His greatest performance was as a poker player, silently mimicking the gestures from the draw to losing the game. Williams was the only black vaudevillian who could appear on a white bill in Washington, D.C., and the first to play a command performance for Britain's King Edward VII. He was with the *Ziegfeld Follies* almost continually from 1910 to 1919; and in 1917, he and Eddie Cantor appeared together on stage with the latter as Williams' blackfaced son. Cantor described Williams as "close to genius. As a man, he was everything the rest of us would like to have been." From 1898 through 1911, Williams was paired with George Walker, with whom he is seen below, with Adah Overton, in *In Dahomey* (1903).

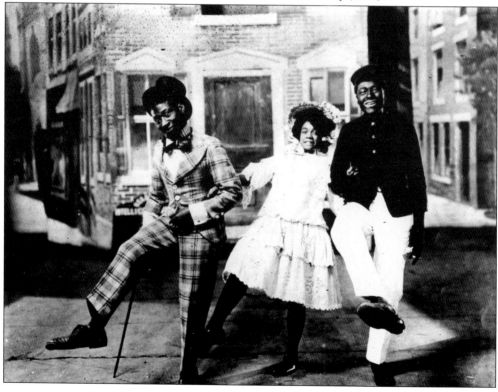

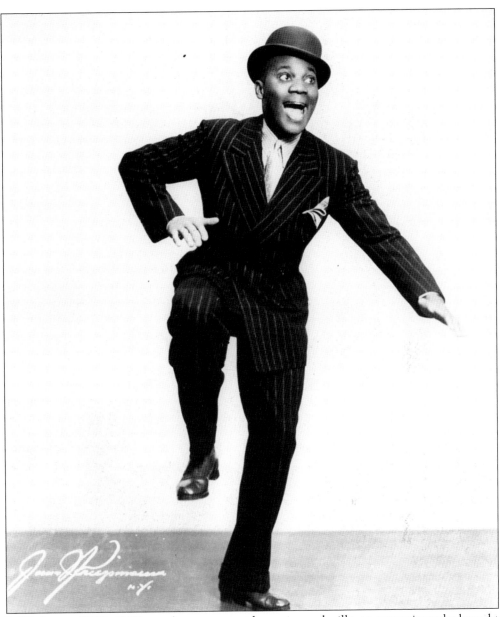

Bill Robinson (1878–1949) was the greatest tap dancer in vaudeville, an entertainer who brought his genius to film in the 1930s, appearing alongside Shirley Temple in *The Little Colonel* (1935) and other productions. Billed as either "the Dark Cloud of Joy" or "the Chocolate Nijinsky," Robinson adopted the nickname of "Bojangles," and invented the word "copacetic" to express his pleasure with the world. The dancer began his vaudeville career around 1914; and by the 1920s, he was a regular at the Palace Theatre. Often he would close the show because no one would go on after him. Robinson became a spokesman for African Americans in the 1930s, but he was nonmilitant and always seemed anxious to accept his position as a black in white America. A white organization named him honorary mayor of Harlem in 1934, but when Harlem residents had the opportunity to select their own mayor in 1948, he was not their choice.

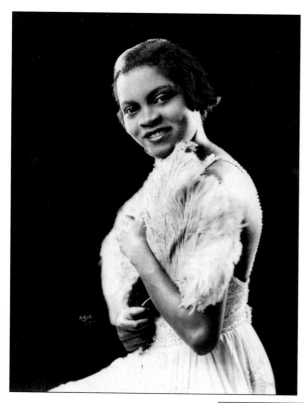

Florence Mills (1895–1927) was a dainty, elfin-like figure with a sweet voice and vivacious personality. She began her career in vaudeville in the second decade of the 20th century, starred in a number of Broadway revues, and headlined as Florence Mills and Company at the New York Hippodrome in 1925. Here she sang her best-known song, "I'm a Little Blackbird Looking for a Bluebird, Too."

George Dewey Washington (1898–?) was a fine bass-baritone, who played vaudeville in the 1920s and 1930s, appearing as a well-dressed gentleman tramp and singing such unlikely melodies as "On the Road to Mandalay." He was also featured in a couple of all-black musical shows, *Old Kentucky* (1932) and *Rhythm Hotel* (1935).

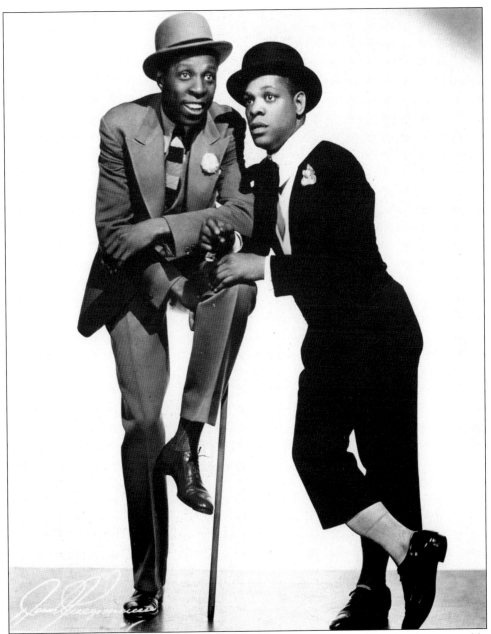

Buck and Bubbles were the stage names of Ford Lee Washington (1903–1955) and John W. Sublett (1902–1986). The two got together while still in their preteens; the former would play the piano while Bubbles danced up a storm, proving himself an expert at syncopated tap dancing and one of the creators of rhythm tap dancing. As headliners, the pair toured the B. F. Keith circuit, starred in their own revue at New York's City Theatre in 1923, and played the Palace in 1928, 1929, and 1932. Most importantly, Buck played Mingo and Bubbles portrayed Sportin' Life in George Gershwin's original 1935 production of *Porgy and Bess*. It was Bubbles who introduced the classic "It Ain't Necessarily So." Following Buck's death, Bubbles returned to the Palace as a single act in August 1967 as part of *At Home at the Palace*. One of Bubbles's last appearances was in *Black Broadway* in New York in May 1980, when he sang Eubie Blake's "Memories of You."

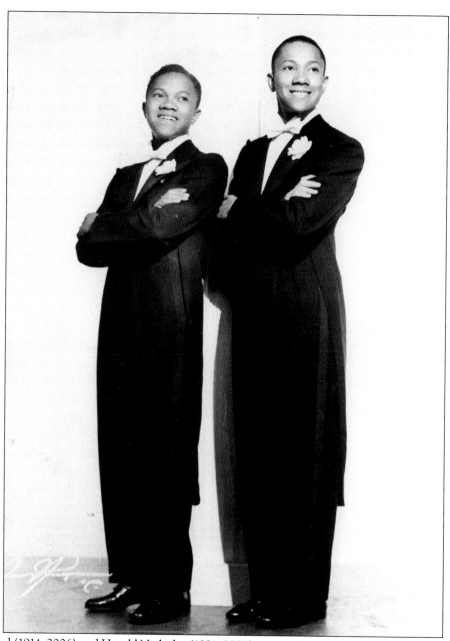

Fayard (1914–2006) and Harold Nicholas (1921–2000) were without question the most explosive black tap dancers of all time. Their acrobatic leaps and splits are so astounding as to be positively painful to watch. Thankfully they have been captured on film in a number of productions, most notably *Stormy Weather* (1943), with the two jumping one over the other in full splits. They were influenced by Bill Robinson, but did not begin performing professionally, along with sister Dorothy, until 1930. Without Dorothy, the Nicholas Brothers became regulars at New York's Cotton Club in 1932. They appeared on the revue stage and as late as April 1939, the brothers were in the last show at Brooklyn's Riviera Theatre. Between 1958 and 1964, Harold worked in Europe, while Fayard toured the United States. In 1991, they were recipients of the Kennedy Center Honors.

Ethel Waters (1897–1977) was a singer who transcended her color, her background, and her venue. To hear her perform "Am I Blue?" or "His Eye Is on the Sparrow" is pure, heart-wrenching genius. She can break her listener's heart with a sentimental ballad like "Cabin in the Sky," and she can make one snigger at the bawdy lyrics of "My Handy Man." Ethel Waters made her vaudeville debut at the age of 17, made her first record in 1921, and her Broadway debut in the musical revue *Africana* in 1927. Also in 1927, she made her first appearance at the Palace Theatre, and three years later, she was back on Broadway in Lew Leslie's *Blackbirds*. There were films, most notably *Cabin in the Sky* (1943) and *The Member of the Wedding* (1952), both based on original Broadway productions in which she had appeared. In later years, she had a religious conversion and would sing only religious numbers, a tragic loss for later generations who had never seen her perform live.

Eubie Blake (1883–1983), seen here with Ethel Waters, was the son of slaves who became a child prodigy on the organ and piano. With his partner, Noble Sissle, he played the Palace as early as 1919. The pair wrote many songs for fellow vaudevillians, as well as such perennial favorites as "I'm Just Wild about Harry" and "You Were Meant for Me."

Josephine Baker (1906–1975) belongs more rightly in a volume on French vaudeville. Her spiritual home was Paris, but she found time for appearances in New York, including the 1936 edition of the *Ziegfeld Follies* and a 1951 vaudeville tour, which led to controversy when she was denied service at the Stork Club because of the color of her skin.

Five

THE ODD, THE WEIRD, THE WONDERFUL

Whatever else might be said or written about vaudeville, it could never be accused of political correctness. Just about anything was possible on the vaudeville stage. Not even common decency could prevent the blackface, racist humor that continued from the late 1800s into the 1930s. Jewish humor was popular with New York audiences and New York vaudevillians who might be excused the use of slurs and stereotyping. It was not so much good taste but rather the rise to power of Adolph Hitler in Nazi Germany that threw into question some elements of Jewish comedy.

Female impersonation flourished, but generally without any homosexual underpinning. Many female impersonators acknowledged their sex at the end of the act by removing their wigs. Most were probably gay, but were often careful to appear on stage with a female accompanist who would be identified as the wife. Julian Eltinge, the greatest of all female impersonators, fought off any question of his masculinity by deliberately picking fights with stagehands and others.

Freak acts flourished, although sadly photographic evidence of many does not survive. There were the physically deformed such as Willard, who managed to grow seven-and-a-half inches in height on stage, or Doss, who could move his hunchback from the rear of his body to the front. There were "little people," most notably General Tom Thumb and his wife and Singer's Midgets. In 1920, Helen Keller played the Palace Theatre, billed as "Deaf But Not Dumb." And there were those who were famous for being famous, including, in 1926, Peaches Browning, a 15-year-old schoolgirl who divorced her aged millionaire husband, and Gertrude Ederle, the first woman to swim the English Channel. Aimee Semple McPherson brought religion to the vaudeville stage in 1933.

Some of the "freak" acts enjoyed relatively long careers—Evelyn Nesbit Thaw whose husband millionaire Harry K. Thaw shot her lover, architect Stanford White enjoyed more than 10 years on the stage—but most did not survive as long as vaudeville, the medium that gave them their equivalent of 15 minutes of fame.

Singer's Midgets consisted of between 15 and 20 performers who were the best known little people in vaudeville. All were from either Austria or Hungary, brought over to the United States in the second decade of the 20th century by Leo Singer, and lived together in a New York brownstone in the West 70s. Their 20-minute act was virtually a vaudeville show in itself with baby elephants, ponies, dogs, a boxing match, and a musical playlet.

Edwin "Poodles" Hanneford (1892–1967) was a clown and bareback rider who appeared with his family as early as 1919 at the New York Hippodrome. In 1928, Hanneford and his family headlined at the Palace. The essence of his success was that he made his equestrian efforts seem easy; his comedic attire and behavior hid true genius.

Lady Alice (seen here without her "Pets") fronted a 1920s act featuring trained dogs, cats, and mice. The act was billed as "the Aristocracy of Animaldom," and *Variety* was particularly impressed by the pets' accomplishments as wire walkers.

The Cherry Sisters (two shown here) were Effie, Jessie, Lizzie, Addie, and Ella, and their name became synonymous with any act devoid of talent. They made their New York debut in 1896 at the Olympia Theatre Roof Garden, with a net placed in front of the stage to catch the vegetables and fish thrown at the women. They retired in 1903, but made a number of comebacks as late as 1924.

Evelyn Nesbit Thaw (1884–1967) came to fame when her husband murdered her lover. For her vaudeville debut at the Victoria Theatre in 1913, she performed three dances, wearing a transparent ankle-length dress and with her hair hanging down her back. She continued in vaudeville into the 1920s and was the subject of a 1955 biopic *The Girl in the Red Velvet Swing.*

Annette Kellermann (1887–1975) made a career out of swimming on stage in a one-piece bathing costume. Born in Australia, she made her U.S. vaudeville debut in 1907 and her farewell American appearance in 1918 at the Palace. She starred in a handful of silent films and was portrayed by Esther Williams in a 1952 biopic *Million Dollar Mermaid.*

Violet and Daisy Hilton (1908–1969) were Siamese twins joined at the spine, who began their career as a freak act in fairgrounds and circuses. Born in the south of England, they were sometimes billed as children as "English Siamese Twins" except in the South of the United States, where they became "American Siamese Twins." The Hilton sisters came to vaudeville in 1925, making their debut at Loew's State Theatre in Newark, billed as "the Eighth Wonder of the World." It has been suggested that the couple relied as much on an audience's sympathy as on talent. On screen, they were seen in *Freaks* (1932) and a so-called biopic *Chained for Life* (1951).

"If we have interested you kindly tell your friends to visit us."

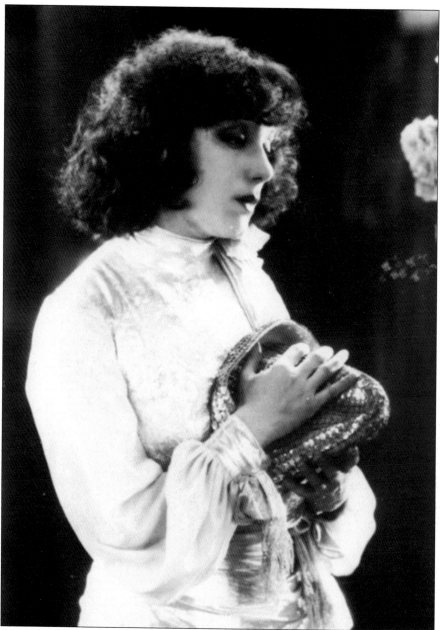

Raquel Meller (1888–1962) was something of an enigma. A somewhat dowdy and overweight chanteuse who seemed to sing in a monotonous and unmelodious manner, Meller was the darling of the American intelligentsia. Chaplin wanted to appear on screen with her as Josephine and him as Napoleon. Critic George Jean Nathan wrote, "She creeps over the footlights like an odourless incense, hypnotically, alluringly. She is like a convent on fire." Meller first came to the United States from her native Spain in the spring of 1926 for a four-week engagement at the Empire Theatre, singing between 12 and 15 songs at each performance. She returned to New York later than same year, to the Henry Miller Theatre, for 13 more performances, followed by a vaudeville tour. Her songs were always of tragedy and joy, and belong very much to another time and another place.

Aunt Jemima (1898–1950) was a plump, jovial singer who was really an Italian American named Tess Gardella, performing in blackface. She never revealed the true color of her skin. Gardella entered show business in 1918 in New York. She appeared at the Palace in 1922 and in 1949 (her last public appearance); and in 1924, she was hailed as the season's biggest hit at the Hippodrome.

Valeska Suratt (1882–1962) nurtured her image as a vamp in vaudeville from as early as 1909 and on screen between 1915 and 1917. Billed as "the Dynamic Force of Vaudeville," she headlined at the Palace in 1920. She appears to have suffered from mental illness and in an unpublished autobiography believed herself to be the Virgin Mary.

Bert Errol (1883–1949), left, and Herbert Clifton (1885–1947), below, were two British-born female impersonators who enjoyed success in the United States. Errol, a familiar figure in vaudeville from 1910 through 1921, caused a sensation when he claimed to have paid $1,000 customs duty on his gowns. For fear of any suspicion of homosexuality, he would have his wife, Ray Hartley, appear at the end of his act. Clifton was billed as "the Male Soprano," and in his 1910 U.S. debut appeared as a ragged street urchin. Somewhat overweight, Clifton was wise to rely more on characterizations than attractive gowns. His wife appeared on stage with him, playing the piano and singing while Clifton made his quick changes.

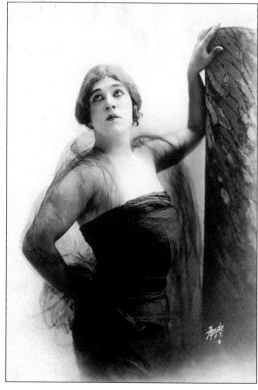

Chaz Chase (1902–1983) was a diminutive and silent comic who would proceed to eat anything he could lay his hands (or mouth) on, including lighted matches, cigarettes, flowers, and a cardboard dickey. He was popular and busy, active from the mid-1920s into the 1980s.

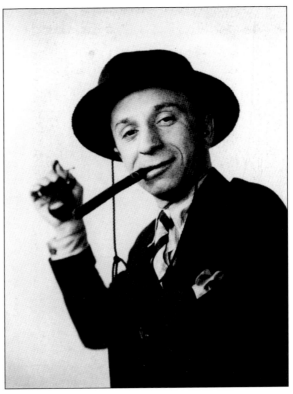

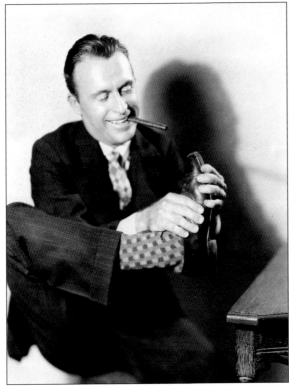

Will Mahoney (1894–1967) was a nut comedian who played the xylophone not with his hands but with hammers attached to his feet. He toured the Western vaudeville circuits before coming to New York in the early 1920s, and was a frequent performer at the Palace in 1925 through 1933.

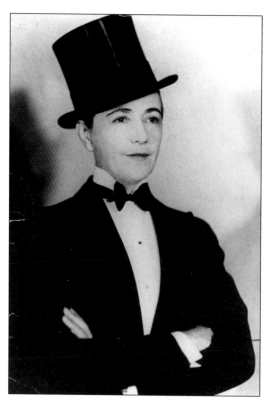

Ella Shields (1879–1952) enjoyed early success as a male impersonator in British Music Hall, although she was actually born in the United States. She made her London debut in 1904, and was generally featured in elegant evening attire, singing her theme song, "Burlington Bertie from Bow." She came to New York and the Palace in 1920 as an unknown but was an immediate hit. As late as 1928, she appeared on an all-English bill at the theater, along with Ada Reeve and Lily Morris. Ella Shields officially retired in 1929, but made endless returns to the stage. An American competitor was the very similarly named Ella Fields (below) who was active, but not as popular, during the same period.

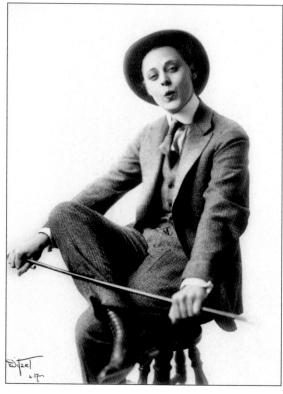

Eugene Sandow (1867–1925) was the best-known strongman in vaudeville. Billed as "the Strongest Man in the World," in 1893, he appeared at the Casino Theatre and was featured at the Chicago World's Fair. He would hold a grown man in the palm of his hand and have three horses walk across a plank over his body. He would also invite woman to pay to admire his fig leaf while feeling his muscles.

Polaire (1879–1939), whose real name was Emile Bouchard, was a darling of the Parisian music halls, who had neither a great voice nor great acting talent, but did boast a 15-inch waist. On stage, she acted in French and, according to one critic, "shook like an infuriated wasp." She appeared as a freak act at the Victoria Theatre in 1910, billed unfairly as "the Ugliest Woman in the World."

117

Eva Tanguay (1878–1947) was one of the wildest acts to headline in vaudeville from 1900 through 1930. She was "the I Don't Care Girl," a human cyclone that burst upon the stage, the bosom bursting out of the bra, the thighs rippling with fat. It was assault and battery upon the audience as Tanguay delivered suggestive songs and dialogue. As she sang in 1913, "It's All Been Done Before, but Not the Way I Do It." In 1910, she was the highest salaried star in vaudeville, earning $3,500 a week, but by 1933, she was destitute and reliant upon charity for support. In 1952, Mitzi Gaynor played her in the biopic titled, appropriately, *The I Don't Care Girl.*

Owen McGiveney (1884–1967), right, and Barbette (1904–1973), below, are examples of the more unusual female impersonators. Barbette, whose real name was Vander Clyde, would perform acrobatics on the trapeze and high wire, and then amaze his audience by removing his wig after taking three or four bows. He made his New York debut at the Harlem Opera House in 1919 and headlined at the Palace in 1927. He was immensely popular in France, a favorite of Jean Cocteau and Man Ray. McGiveney was a quick change artist, playing as many as five roles in a 10-minute act. In 1913, he supported Sarah Bernhard at the Palace, returned to his native England in the 1930s, but was back in the United States in the 1940s primarily as a character actor in films. His son, Owen McGiveney Jr., continued the act.

Karyl Norman (1896–1947) was "the Creole Fashion Plate," known to his fellow vaudevillians affectionately as "the Queer Old Fashion Plate." He made his vaudeville debut in 1919 and was at the Palace in 1923, 1924, and 1931, passing as a woman but at times singing in a masculine voice.

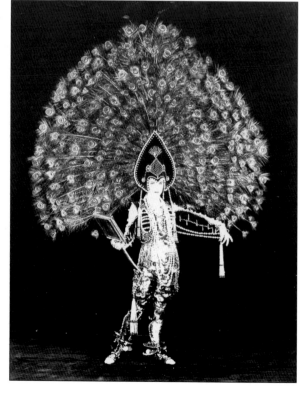

Freddie, or Frederic Kovert, was a female impersonator every bit as beautiful as Karyl Norman, renowned in vaudeville during the second and third decades of the 20th century for his peacock dance. He appears in full drag in the opening reel of the 1925 film version of *The Wizard of Oz*, exciting all the male members of the cast.

120

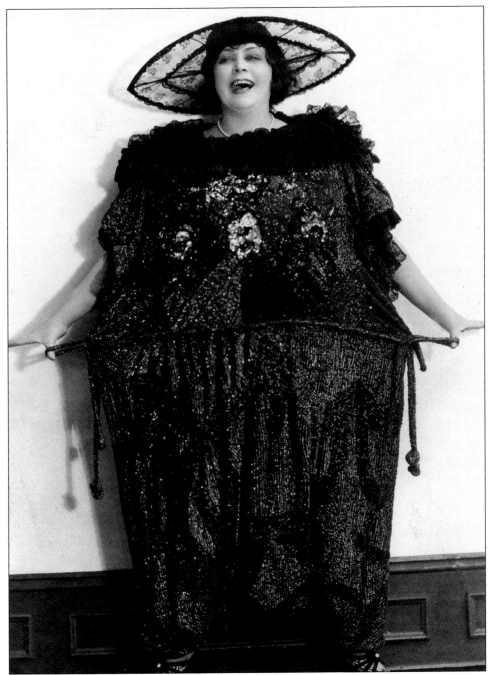

Someone as large as Trixie Friganza (1870–1955) definitely needs a page to herself! Her act, with the title "My Little Bag o' Trix," emphasized her size through comic songs and gentle, deprecating humor. Friganza's career dated back to 1889. She made her vaudeville debut in 1906 at Hammerstein's Theatre, but she was also popular in musical comedy throughout the early years of the 20th century. There were appearances as "the Perpetual Flapper" at the Palace in 1920, 1924, 1927, 1928, and 1929, along with character roles in both silent and sound films until she retired in 1940.

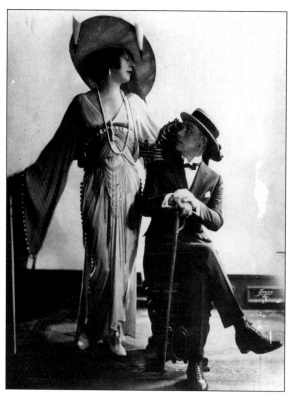

Bert Savoy (1888–1923) and Jay Brennan (1883–1961) presented the most outrageous of female impersonation acts in vaudeville. Brennan was the straight man, always well dressed in male attire, while Savoy was the outrageously camp woman. Savoy would refer to effeminate men of his acquaintance as "she," while everyone else was "dearie." The two teamed up in 1915, many years after Savoy had first appeared in drag, and by 1916, they were appearing at the Palace. Savoy's death was every bit as flamboyant as his lifestyle; after a reference to "Miss God," he was struck dead by a bolt of lightning. One of Savoy's pet phrases was "You must come over," and it is claimed that Mae West (1892–1980), pictured below, who was in vaudeville in the second decade of the 20th century as a solo act or with her sister Beverly, borrowed that phrase, refined it into "Come up and see me sometime," and also adopted Savoy's body language.

Ray Bourbon (1893–1971) was a female impersonator in the waning days of vaudeville, noted for his outrageous material and suggestive dialogue. In 1968, he was sentenced to a 99-year prison term for the murder of a Texas pet store owner—a sorry end for someone who tried to revive his career in the 1950s by claiming to have undergone a sex change operation.

Sally Rand (1904–1979), showing more skin than audiences generally got to view, is synonymous with fan dancing, and took her last name from the Rand McNally atlas. Her career began when she was 13, and she headlined at the Palace in 1928 with an act one critic called "indifferently pleasant." Within a couple of years, she was working in the chorus at the Capitol Theatre, but with the introduction of the fan dance in the 1930s, she was back again as a star.

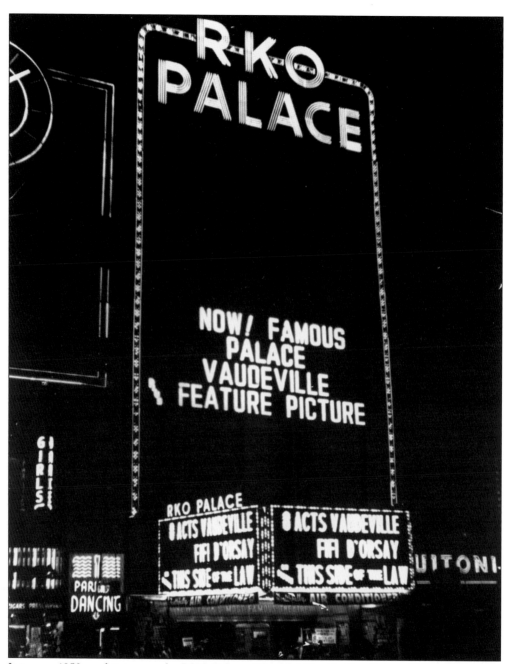

It is now 1950, and it is now the RKO Palace, "Healthfully Air Conditioned." The film is the far from commercially successful, *This Side of the Law*, starring Viveca Lindfors and Kent Smith, but vaudeville is back, and so is Fifi D'Orsay. She had last appeared at the Palace in 1932, but with the return of the policy of vaudeville acts and a feature film, the saucy singer-comedienne is here again, proving she has as much "oomph" as ever. The Palace may be dark, but it is not dead. And neither is vaudeville.

INDEX

ACROSS AMERICA, PEOPLE ARE DISCOVERING SOMETHING WONDERFUL. *THEIR HERITAGE.*

Arcadia Publishing is the leading local history publisher in the United States. With more than 3,000 titles in print and hundreds of new titles released every year, Arcadia has extensive specialized experience chronicling the history of communities and celebrating America's hidden stories, bringing to life the people, places, and events from the past. To discover the history of other communities across the nation, please visit:

www.arcadiapublishing.com

Customized search tools allow you to find regional history books about the town where you grew up, the cities where your friends and family live, the town where your parents met, or even that retirement spot you've been dreaming about.

Nothing Finer

*North Carolina's Sports History and
the People Who Made It*

Edited by

Wilt Browning

CAROLINA ACADEMIC PRESS
Durham, North Carolina

Library of Congress Cataloging-in-Publication Data

Browning, Wilt, 1937-
 Nothing finer : North Carolina's sports history and the people who made it / edited by
Wilt Browning.
 pages cm
 Includes bibliographical references and index.
 ISBN 978-1-61163-608-6 (alk. paper)
 1. Sports--North Carolina--History. 2. Athletes--North Carolina--Biography.
 3. Athletes--United States--Biography. I. Title.
 GV584.N8B76 2014
 796.092'2756--dc23 2014009497
 [B]

Carolina Academic Press
700 Kent Street
Durham, NC 27701
Telephone (919) 489-7486
Fax (919) 493-5668
www.cap-press.com

Printed in the United States of America

Contents

Foreword

By John D. Swofford

A native of North Wilkesboro, John Swofford is the fourth and longest-serving commissioner in Atlantic Coast Conference history and in the process has become one of the most powerful voices in college athletics. A Morehead Scholar, he was the starting quarterback and defensive back at the University of North Carolina-Chapel Hill and served the Tar Heels as athletic director for eighteen years before taking charge and reshaping the conference. John and his wife Nora live in Greensboro and are the parents of three daughters.

The state of North Carolina boasts a proud sports history, one of incomparable athletes and colorful characters, of rich tradition, impeccable leaders and intense competition. It is a story that has long begged to be relayed in its entirety.

That story is finally told in intriguing detail through *Nothing Finer: North Carolina's Sports History and the People Who Made It.* This book is truly a labor of love by nine award-winning journalists whose reporting and commentary have enlightened readers for more than four decades.

As I grew up in North Wilkesboro, North Carolina, sports became a focal part of my life as a participant and a fan. Many fellow North Carolinians — both natives and those from elsewhere who now call our state their home — have been touched in a similar fashion.

As a football, basketball and track athlete at Wilkes Central High School, I shared in the passion for prep sports that resonates throughout the state. I retained a similar passion as I continued on as a student-athlete at the University of North Carolina, and later in my professional career as the Director of Athletics at the University of North Carolina and in my current position as the Commissioner of the Atlantic Coast Conference.

As such, I have been fortunate to observe and to experience first-hand much of the history chronicled in *Nothing Finer,* and I found this book to be engaging and thorough in its scope. It is a must-read for every North Carolina sports fan, and for anyone with a general interest in the history of this great state and its culture.

Nine segments have been written by some of North Carolina's leading sports writers — "The DNA Factor" (Jim Sumner), "Baseball" (Wilt Browning), "Basketball" (Al Featherston), "Football" (Rob Daniels), "Racing" (Lenox Rawlings), "Golf" (Lee Pace), "Preps" (Tim Stevens), "North Carolina's Variety of Sports" (Larry Keech), and

"National Champions" (Bill Hass). I have read and appreciated the work of each of these individuals for many years. They share the aforementioned passion for North Carolina sports and its landscape, and each is uniquely qualified to pen a chapter of its history.

As the story unfolds — from Enos Slaughter to Buck Leonard to Charlie Justice; from David Thompson to Richard Petty to Gaylord Perry; from Arnold Palmer to Harvey Reid to Dick Groat; from Dean Smith to Junior Johnson to Kay Yow — the legendary figures of North Carolina sports and their accomplishments become all the more staggering.

In addition, the teams that brought national championship recognition to our state — the Wake Forest baseball squad of 1955; the NCAA basketball title teams from Duke, N.C. State, and UNC; the Tar Heels' women's soccer dynasty and many more — are chronicled here.

It is only fitting that *Nothing Finer* was produced through the cooperation and in concert with the North Carolina Sports Hall of Fame and made its first public appearance at the 2014 Induction Banquet in Raleigh. For more than 50 years, the Hall of Fame has celebrated excellence and extraordinary achievement in athletics throughout our state, and this book is the perfect complementary piece to that mission.

Please enjoy this book. When it comes to the sports history of our state and the people who have made it what it is, I believe you will join me in agreeing that there is indeed nothing finer.

Preface

By Caulton Tudor

Angier native Caulton Tudor was an award-winning sports columnist for The Raleigh Times *and* The News & Observer *for almost 45 years and is now an on-line columnist for WRAL/Capitol Broadcasting Company of Raleigh. A 1999 inductee into the U.S. Basketball Writers Hall of Fame, Tudor was a recipient of the ACC's Marvin "Skeeter" Francis Award in 2012. Tudor and his tennis star wife Inez (Diz) reside in Raleigh with their young child Copper, a lightning-quick cocker spaniel with a wonderful attitude.*

As an elementary school student in Charlotte during the 1950s, Al Featherston went to bed with strangers.

Don't faint.

He wasn't alone. So did I. Only it was in the small North Carolina town of Angier rather than the sprawl of metro-Charlotte. Like Al, my alternating bed partners were a chorus of diverse, magnetic voices who occasionally had to battle heavy static in order to reach my ears—Ray Reeve, Bill Jackson, Add Penfield, Bill Currie and Jim Reid, a guy who would be elected mayor of Raleigh in 1963.

All were legendary broadcasters of ACC basketball during its infancy, a group of radio pioneers intent on telling the shot-by-shot, pass-by-pass, rebound-by-rebound evolution of Everett Case's emerging creation.

"I recall lying under my covers with that small radio, listening to Ray Reeve, Bill Jackson and Add Penfield doing ACC games," Featherston said. "The first game I remember seeing in person was the 1960 ACC Tournament. I was 11 years old.... We left right before the end of the State-Wake semifinal and I missed the Dave Budd-Anton Muehlbacher fight."

With that same keen appreciation for detail, Featherston has been watching basketball games involving teams from North Carolina and the ACC without fail since. What began with that trip to Raleigh with his father to watch Wake Forest's Len Chappell and Billy Packer, Duke's Carroll Youngkin and Howard Hurt, UNC's Lee Shaffer and York Larese, and N.C. State's "Moose" DiStefano and Danny Englehardt led to a lifetime of game trips.

Like the other authors you will read in this epic undertaking, Featherston's sportswriting work gradually has become a North Carolina treasure. No one has studied and catalogued Tobacco Road basketball more, first for *The Durham Sun*, then *The Durham Herald-Sun* and now as a freelance author and historian.

The seeds of that fertile sports writing career were sown under the warm sheets and blankets of that Featherston family home in Charlotte. Al watched the Tobacco Sports radio network cede much of its popularity to the Jefferson Pilot regional television network and from there to NBC, CBS, ABC, ESPN and beyond. Even so, the attachment to sports through radio has hardly died in North Carolina. That first wave of broadcasters eventually gave way to Woody Durham, Wally Ausley, Bob Harris, Gene Overby and now Stan Cotten, Gary Hahn, Jeff Charles, Jones Angell, their sidekicks and countless others faithfully involved in live game coverage.

* * *

The story of sports in North Carolina is the story of a majestic pine — one with a ceiling as high as a clear summer sky and rooted deeply in proud, fertile soil. This is an elegant, ageless tree with thick, sturdy branches laden with enough memories to cover everyone and everything in its long, stately shadow.

It's a saga that includes some of the most important achievements in sports history. From 19-year-old Babe Ruth hitting his first home run as a professional player (March 7, 1914) in Fayetteville to the NASCAR empire Richard Petty helped spearhead to the recent emergence of Cam Newton as an NFL star quarterback with the Carolina Panthers, North Carolina, its teams and, most of all, its sports fans, have been blessed with an extraordinary assortment of accomplishments.

The countless stars will live on and on through generational lore and journalistic documentation. Fans who never saw David Thompson sink a jump shot will hear about his breath-taking basketball exploits through books such as the one you are now holding.

Christian Laettner's game-winning shot against Kentucky; the coaching brilliance of Mike Krzyzewski, Dean Smith, Norman Sloan, Jim Valvano, Frank McGuire; the artistry of Catfish Hunter's pitching; the moment of ultimate triumph for young golfer Webb Simpson; the relentless will of Dale Earnhardt to rule stock car tracks; the unpredictability of a "Choo Choo" Justice touchdown run; the image of Rod Brind'Amour hoisting the Stanley Cup in a madcap Raleigh coliseum; and the amazing consistency of UNC's women's soccer program are merely a sampling of the lore that will outlive the men and women who created them.

That part of this sports vista we owe to the writers of this book and their many peers over the past 70 or so years. If North Carolina has been blessed with exceptional athletes, it's been just as blessed with men and women with the same sort of journalistic talent and professional pride.

* * *

As sports columnist for *The Winston-Salem Journal* for 36 years, Wilson native Lenox Rawlings earned a national reputation for his ability to take readers to his seat at any event, be it a game, a race, a round, a meet or a backroom policy meeting. If you polled sports writers nationally, there's a strong chance that Rawlings would be cited as the most versatile sports columnist of his era. A brilliant wordsmith and meticulous observer, Lenox could take his patrons from solemn Augusta National to Darlington Raceway's rowdy infield with an effortless, flawless delivery that made him as much of a must-read among his cohorts as the *Journal's* subscribers.

Rawlings covered his first stock car race at the Raleigh track where, a month later, NASCAR's top series ran on red clay for the last time. "I looked through the fence at the Wilson County Speedway a few times as a child and as a teen," Rawlings recalled.

At various times in his career, Rawlings worked for *The News & Observer, The Greensboro Daily News* and *The Atlanta Constitution* before going to Winston-Salem. He was selected president of the U.S. Basketball Writers Association, N.C. Sportswriter of the Year three times and was recipient of the Skeeter Francis Award from the Atlantic Coast Sports Media Association. He is a member of the U.S. Basketball Writers Hall of Fame and the Fike High School Athletic Hall of Fame in his hometown of Wilson.

But some of his fondest memories came when he covered races alongside the late Gerald Martin, perhaps the best automotive reporter/writer. "My favorite moments in racing came with Gerald at my side, showing me something for the first time," Lenox said. "He coaxed me into walking onto pit road near the drivers' entrance to the track at Darlington after the cars had begun their warm-up laps before the Southern 500."

Later, there was another moment closer to home. "Gerald and I also wound up a few feet away from the makeshift stage North Wilkesboro used for driver introductions the day Willy T. Ribbs—a black driver with open-wheel roots—made his debut in Wilkes County.... Gerald, who grew up near Martinsville Speedway, also introduced me to the moonshine men who operated tracks in the North Carolina/Virginia incubator."

* * *

With *The Raleigh Times* and later *The News & Observer*, Garner native Tim Stevens has changed the way high school sports are covered more than anyone in the newspaper industry. A remarkable man of many interests, Stevens took prep coverage far beyond game accounts of boys basketball and football. He expanded coverage to include everyone and has been able to teach his readers that sports participation is just as important as sports success.

On January 13, 2014, readers of *The News & Observer* sports section had the chance to read accounts of the Carolina Panthers' loss to San Francisco and the compelling story of Elizabeth Bohn, a Clayton teenager who had been awarded a sports scholarship to Texas Christian University as an equestrian. Stevens didn't write the story but he assigned it and brought about a newsroom sports culture that welcomed such diversity to its coverage.

* * *

The starting lineup of authors in this book amounts to a who's who of North Carolina sportswriters—Jim Sumner, Rob Daniels, Lee Pace, Larry Keech and Bill Hass. Their contributions to the state's sports culture couldn't be adequately measured if I had unlimited time and space to recount their careers. Keech, a fixture on *The Greensboro News & Record* staff, is a senior citizen who is equally comfortable at a bridge table or bungee jumping off a bridge. Pace is a walking history book of North Carolina golf on one hand and the sideline football reporter for the UNC network on the other.

But behind every lineup there has been a manager and this undertaking has been directed by an industry immortal—Wilt Browning, a man who sat on team buses

beside Hank Aaron and Satchel Paige and whose 1997 book *Deadly Goals* was the first serious piece of reporting on steroid use in sports.

Browning, who resides in Kernersville, covered baseball for *The Atlanta Journal* during a period in which Aaron was chasing the Ruth record for home runs. At various times, he then worked for the Atlanta Falcons and Baltimore Colts. Later, for *The Greensboro News & Record* and *The Asheville Citizen-Times*, Wilt treated his readers to a rare blend of folksy storytelling that was witty and clever, and always on point.

When Carolina Academic Press Editor Linda Lacy and her team reached the decision to put together *Nothing Finer: North Carolina's Sports History and the People Who Made It*, Wilt, who had dreamed for years of such a project, was the obvious choice to organize the mountain of details. There was never any doubt he would make it work, of course. But make no mistake, it was no can of corn.

"I'm not certain, but I think it will be a first of its kind in America," Browning said. "I doubt that any other state has a single-volume sports history as exhaustive as this."

As the late Bones McKinney was fond of saying, "Amen, brother, amen."

Editorial Note

If twenty newspapers assign sports writers to cover the same event, no two reports are likely to read the same. Some of the basics always will be in all versions—including the identities of the winners and losers, and the score of the game, of course—but perhaps little else. Indeed, all twenty writers may view the contest's turning point differently. Some will emphasize how the game, or the race or the match, was won, others may dwell on elements that brought about defeat. In most cases, each newspaper's reading audience also will play a role; in North Carolina, for example, writers understand that most readers are more interested in the ebb and flow of athletic fortunes at Carolina, State, Wake and Duke than those of out-of-state teams, such as Georgia Tech, Miami, Clemson or other out-of-the-region competition.

In every case, what the reader gets is a report of a sports contest based upon the perspective of an individual writer. And that's what you get in *Nothing Finer*, a one-of-a-kind recitation of the sports history of North Carolina from some the most talented of the people who have witnessed more of that history first-hand than any other segment of society—sports writers.

From the beginning of this project, the unique perspectives of the nine writers were important, sought and cherished. From the standpoint of recording history, we hope you will find that *Nothing Finer* offers much more than a mere restating of events and dates; that it also brings to life the stories behind the rich history of sports in the state. In the nine different segments, the perspective is solely that of the author of each section. It reflects his knowledge of what happened and what the historic significance was. You may not meet in these pages every one of the heroes of the past with whom you are familiar, but it is likely you will meet others whom you never knew.

And if, in the process, some of your own memories are reawakened, then there can be nothing finer nor more rewarding for the nine writers of *Nothing Finer*.

The DNA Factor

By Jim Sumner

 Jim Sumner is a Raleigh-based historian and journalist. He has degrees in American History from Duke University and North Carolina State University and was a public historian for the state of North Carolina for thirty years. He is the author of three books on North Carolina sports history and numerous articles in both scholarly and popular publications.

The Roots of N.C. Sports

If you are reading this book, there is a very good chance you are a sports fan.

The term doesn't need much explanation. After all, we live in a sports-obsessed culture and North Carolina is no exception. Crowds of 70,000 or more attend professional football games in the state, while crowds approaching 20,000 regularly show up to watch basketball and hockey contests. The largest crowds of all attend automobile races in the Tar Heel state. Millions follow professional and college sports on television, radio, newspapers, magazines and the internet. Almost everyone has rooting interests, sometimes fierce and highly partisan rooting interests.

Call it entertainment, call it competition, call it fun and games, there is little question that sports is a massive industry in North Carolina. Huge infrastructures have been built to host contests and seat fans, rules are standardized and widely understood and recognized champions are crowned at the national, and even international, level at routine and predictable intervals.

That certainly wasn't the case in 18th and 19th century North Carolina. But that doesn't mean sports didn't exist in North Carolina during this period; it simply means that sports were different. The impulses that lead Duke and North Carolina basketball teams or the Carolina Panthers and Atlanta Falcons to square off in front of a national audience existed long before anyone had ever thought of the ACC or the NFL.

In some form, sports seem to have existed as long as human beings have been human beings. The desire to test one's strength, endurance, courage, speed and skill seems to be part of our DNA. The ancient Olympics date back almost 3,000 years and the ancient Roman Colosseum seated more than 50,000 people to watch gladiatorial contests. Ancient Egyptian hieroglyphs show scenes of archery, boating, and wrestling contests. The Bible has numerous references to athletes. Sports were common in 17th century England, the homeland of many colonial North Carolinians.

So, it's not surprising that sports have existed in North Carolina for centuries. These sporting activities, however, didn't resemble the huge industry we have today. Sports tended to be local and participatory, while lacking such elements of modernity as organizations, standardized rules, paying customers, schedules and records.

Elements of class, race, gender, economics, region and religion have all played a role in the development of sport in North Carolina. Sports frequently have been viewed as a frivolous waste of time, associated with gambling, violence and alcoholism. John Smith complained in early Jamestown, Virginia, that "4 hours each day was spent in worke, the rest in pastimes and merry exercise." But the anti-play attitudes that characterized the Puritans in what we now call New England never spread very far south.

Colonial North Carolina was overwhelmingly rural, with poor roads and a comparatively small leisure class. There were no large cities. Most people in the colony were

small farmers, with limited time or money for recreation. But at public gathering spots such as taverns, elections, courthouses and markets, some leisure time could be carved out for impromptu wrestling matches, boxing matches or footraces. Alcohol and gambling frequently accompanied what could be brutal sporting events.

Cockfighting was widespread, as was a violent form of no-holds-barred fighting known as gouging, so-called because participants sometimes gouged out the eyes of opponents. Scratching with sharpened nails, kicking and punching were all parts of the combative contests. Hunting and fishing were widespread but for most North Carolinians were more practical than recreational, putting food on the table and eliminating bothersome wild animals.

Some sports practiced animal cruelty. One pastime, called gander pulling, involved hanging a live goose from a pole by his feet and seeing which man riding full speed on horseback could first pull off the bird's neck. The goose's neck usually was greased and the riders frequently were intoxicated, prolonging the bird's agony and the amusement of spectators. North Carolinian Thomas Henderson wrote of gander pulling in 1815. "I cannot help recommending this as a most delightful amusement to all lovers of fun."

For the Wealthy Only: Not all animal sports resulted in the death of the animal.

The most popular sport in colonial North Carolina was horse racing. It also was the sport that most closely resembled modern sports.

Many people owned horses in this period, using them for transportation and labor. However, only the well-to-do planters could afford the luxury of using horses exclusively for racing. North Carolina had a small planter class, compared to neighboring colonies Virginia and South Carolina, but it was large enough for a horse racing culture to develop, especially in the counties closest to Virginia, where planters shared business, social and family ties.

As early as 1730, Edenton physician John Brickell would write "Horse-racing they (North Carolinians) are fond of for which they have Race-Paths near each town and in many parts of the Country." A well-known 1769 map of New Bern by C.J. Sautier shows a substantial race course.

Horse racing was enormously popular among the gentry in England and Americans brought that passion with them to the new world. By the middle of the 18th century, many North Carolina planters were importing expensive English thoroughbreds, horses not suited to pulling plows or wagons but well-suited for racing. These horses bred even faster racehorses, making the sport the pastime of those rich enough to afford it.

The most popular form of racing in the colonial period was quarter-racing, in which two horses lined up side-to-side and raced a short distance, commonly one-quarter of a mile. British observer J.D.F. Smyth wrote that Virginians and North Carolinians were "much addicted to quarter-racing ... and they have a breed which performs it with astonishing velocity, beating every other horse for that distance with great ease.... I am confident that there is no horse in England nor perhaps in the whole world that can excel them in open speed."

Money changed hands two ways. Few if any races were contested without bets being wagered. An example is a 1770s race between Willie Jones' horse Trickem and Jeptha

Atherton's Big Filly, in which Trickem's victory made Jones wealthier by 100 hogsheads of tobacco. Jones was a prominent planter and a strong proponent of independence from Britain as a member of the colonial assembly.

Spectators placed side bets with regularity. The more successful horses could either be sold or leased for stud service. The May 8, 1773, issue of the *Virginia Gazette* advertised the successful horse Janus as available for stud service. Janus was born in England and brought to Virginia as a ten-year-old. He was brought to North Carolina in 1772 by Atherton, a Bermuda-born Northampton County plantation owner and racer.

The advertisement stated that Janus "is now very fat, and as active as a lamb, and stands at Northampton County Courthouse." Jones and Atherton were typical members of the racing community, which included Governor Gabriel Johnston (1734–1752), prominent planters and merchants.

The oldest documented sports organization in North Carolina is the Wilmington Jockey Club, founded in 1774 and modeled after the Charleston Jockey Club. The club primarily was a social organization, in which status was affirmed and business contacts solidified. But with so much money changing hands, either through gambling or breeding, it was essential that horse racing begin to standardize ages of the horses, distances of the races, weights carried and other variables. Organizations such as the Wilmington Jockey Club began that process.

Of course, 1774 wasn't a good time to start a jockey's club or anything else in North Carolina. Later that year, the Continental Congress asked colonists to forgo "every species of extravagance and dissipation ... especially all horse racing and all kinds of gaming and cockfighting."

The Wilmington Jockey Club nonetheless scheduled a series of races. The Wilmington Committee of Safety addressed these plans. "As a friend to your country, we have no doubt but you will readily relinquish an amusement that however laudable in other respects, is certainly attended with considerable expense ... and may very justly be condemned at a time when frugality should be one of our leading virtues ... He only is the determined patriot who willingly sacrifices his pleasures on the altar of freedom."

The races were not held and the long struggle for independence put all but the most rudimentary forms of recreation on hold. Traditional sports quickly rebounded following the end of hostilities with Great Britain. Horse racing expanded its hold in the state and nation. National magazines such as *American Turf Register and Sporting Magazine* (1829) and *Spirit of the Times* (1831) helped standardize the sport, schedule events and establish standards for jockeys. In 1823 a huge race between Northern champion Eclipse and Southern champion Sir Henry was contested for $20,000 in Long Island in front of a paying crowd estimated at 70,000. Comparable races were regularly held afterwards.

North Carolina had nothing of this magnitude. The state remained poor and rural, being known by such pejoratives as the "Rip Van Winkle State" or the "Ireland of the Americas." The absence of European immigrants held back development of sports like boxing, which had begun to thrive in Northern states.

But the state did gain a reputation for the quality of its racing and the quality of its horses, again primarily in the northern colonies most closely bordering Virginia, although the establishment of jockey clubs throughout the state did begin the process of

spreading the sport. Some of the most vivid accounts of horse racing right after the American Revolution come from Northern visitors.

Philadelphia's William Attmore visited New Bern and reported the following:

> "I have attended the Races yesterday and today rather from motives of curiosity than any love to this Amusement and think I shall hardly be prevailed on to go ten Steps in future to see any Horse Race. Large numbers of people are drawn from their business, occupation and labour ... much quarreling, wrangling, Anger, swearing & Drinking is created and takes place. I saw it ... prevalent from the highest to the lowest — I saw white Boys and Negroes eagerly betting ½ a quart of Rum, a drink of Grog &c, as well as Gentlemen betting high."

Attmore also described a scene that demonstrated both the danger of the sport and the crudeness of late 19th century horse racing. "One of the riders, a Negroe boy, who rid [sic] one of the Horses yesterday, was, while at full speed thrown from his Horse, by a cow being in the Road and the Horse driving against her in the hurry of the Race — the poor Lad was badly hurt in the Head and bled much."

Attmore wasn't the only Northerner to criticize the alleged slovenly way of Southerners. Charles Biddle, a prominent Philadelphia attorney, gave this assessment of Willie Jones, a prominent North Carolina planter and public official. "In point of talent, he was one of the first men in America, but like most Southern gentlemen, was too fond of horse racing and cards to attend much to business."

Despite the alleged flaws of North Carolinians, horse racing became more sophisticated and organized, as the 18th century turned into the 19th century. Quarter-racing was replaced by longer races, contested around oval or circular courses. These courses could be more easily fenced in, controlling crowds and enabling fans to see an entire race. An admittance fee could be charged. Jockey clubs formed throughout the state. Rules became more standardized. More horses could participate in a given race.

Sir Archy, North Carolina's First Great Sports Star: Perhaps the most prominent racing family in the state was the Johnson family, of Warren County. Marmaduke Johnson built a race track on his plantation, imported expensive breeding stock and helped make Warrenton the center of the sport in North Carolina.

However, it was his son, William Ransom Johnson, who became the state's most acclaimed horseman, so well-known that he became known as the "Napoleon of the Turf." William Ransom Johnson represented Warren County in the North Carolina General Assembly, moved to Petersburg, Virginia, served in the Virginia House of Delegates and moved back to North Carolina.

He was a planter and a politician, but horse racing was his passion. Around 1808 Johnson purchased a three-year-old Virginia horse known as Sir Archy (also called Sir Archie in some references). Sir Archy's father, Diomed, had won the English Derby in 1780. Diomed came to Virginia in 1798 and became a stud, graphic evidence of the high stakes of Southern horse racing.

Johnson had an English-born trainer named Arthur Taylor. The two trained Sir Archy to peak condition, and he defeated the cream of the Virginia racing crop at a

SIR ARCHY.
From an Original Painting in the possession of Charles H. Hall Esq.' of New-York.

North Carolina and Virginia still dispute where Sir Archy is buried. What is not debated is that he established America's greatest thoroughbred dynasties.

series of 1808 races, including a win at the Fairfield Jockey Club over Wrangler, another successful son of Diomed. The last race of his career was the biggest, a match race against a Virginia horse named Blank. Held at Scotland Neck, North Carolina, this was the only meeting between the two horses. A pair of four-mile races was held and Sir Archy won both. In the second, he ran the four-mile course in a time of 7:52.

These would be the only defeats of Blank's career. Johnson issued a challenge, a standing bet of $10,000 that Sir Archy could beat any horse in America. He had no takers. Sir Archy had run out of opponents.

The four-mile distance—the so-called Heroic Distance—became very popular during the antebellum period, in part because the English had shortened their biggest races to distances shorter than two miles. Thus, the four-mile distance supposedly demonstrated the superiority of American horses.

William Ransom Johnson was unusual in his circle in that he was more interested in racing his horses than in breeding them. So, he sold Sir Archy to Revolutionary War hero and former governor General William Davie for $5,000. Davie's son Allen had gambling debts and Sir Archy was sold to one of Davie's creditors, William Amis, also of Northampton County. Amis' plantation was called Mowfields. Sir Archy stood at stud at Mowfields from 1816 through 1831, two years before his death at age 28.

Sir Archy was arguably the most successful stud in American horse racing history. He eventually became known as the "Foundation Sire of the American Thoroughbred,"

siring at least 31 champions among his 400 sons and daughters. Successful 20th century horses such as Man o' War, Gallant Fox, War Admiral and Native Dancer are descended from Sir Archy. Every horse that ran in the 2008 Kentucky Derby had Sir Archy in his pedigree; indeed, it would now be unusual not to have him perched upon the family tree.

Clubs in Washington and Baltimore went so far as to ban Sir Archy's progeny from their races, because they couldn't compete, rationalizing "Do they not perceive that in so doing our Clubs pay them the compliment of considering them invincible?" Most of the Sir Archys, as they came to be known, had their greatest successes outside North Carolina, in Virginia, South Carolina and Maryland. But there were exceptions, including Timeleon, owned by William Ransom Johnson's brother Robert. Timeleon won 13 of 15 races, a number of them in North Carolina.

Salisbury became the seat of racing in the western part of the state. The Salisbury Jockey Club was founded in 1804 and led by John Steele, who built a track on his plantation and hosted a big race and Jockey Club Ball during the Christmas season.

The North Carolina mountains saw rudimentary racing by the end of the eighteenth century and more formal racing in the early 1830s, when Charles McDowell built a race track on his Burke County property, Quaker Meadows.

The state capital got the State Jockey Club, founded in Raleigh in 1838, by Major David McDaniel and Robert Haywood, among others. The club had the announced intention of becoming the "Central Race Course of the Union," a goal it never came close to reaching. Still, the *Raleigh Register* in the 1840s would occasionally carry the results of horse races across the country. In May 1839 an unknown arsonist torched McDaniel's stables, killing his prize thoroughbred Red Wasp. The crime was never solved.

Enter the Barbarians: County fairs began in the late antebellum era and most featured some kind of horse racing.

Less refined sports continued their hold. Cockfighting was hugely popular and hugely controversial. The barbaric pastime was condemned from pulpits, while North Carolina newspapers refused to run advertisements for cockfights by the second decade of the 19th century. But the sport—if it can be called a sport—remained in the spotlight. Writer Porte Crayon—real name David Hunter Strother—profiled North Carolina's cockfighting culture in the prestigious *Harper's New Monthly Magazine* in May 1857.

Crayon visited an unnamed eastern North Carolina county and was impressed by what he saw. "There is an absurd prejudice existing at the present day against this elegant sport. The people one meets at such places are, in all respects, the same as those who, under our admirable system, play the most prominent part in the government of the country."

The cockfighting season started around Thanksgiving and ran through around July 4th. Gamecocks were bred and trained for combat, classified by weight and let loose in a small, enclosed area. Many fights ended only when the loser was dead. Much money exchanged hands after the loser was carted from the ring.

Nick Arrington, of Nash County, was North Carolina's best known antebellum breeder of fighting gamecocks. One visitor to his Nash plantation "was greeted by such

a crowing of cocks as he had never heard in all his life before." Arrington once won a "main" (a series of matches) in Memphis for $5,000.

Historian Elliot Gorn has studied antebellum cockfighting and concludes that its power came because it "reinforced the daily truth that life was brutal, guided only by the superior nerve, power and cunning." The same could be said about gouging, which reached its antebellum peak in the Carolinas, Virginia and Georgia, where champions were cited for their savagery and skill. Many gougers filed their nails or sharpened their teeth.

Isaac Weld in *Travels Through the States of America* (1800) wrote "In the Carolinas and Georgia I have been credibly assured, that the people are still more depraved in this respect than in Virginia and that in some parts of these states, every third or fourth man appears with one eye."

Charles Janson in *The Stranger in America* describes a fight between North Carolinian John Butler and an unnamed Georgian.

> "Fast clinched by the hair, and their thumb endeavoring to force a passage into each other's eyes; while several of the bystanders were betting upon the first eye to be turned out of its socket.... At length they fell to the ground and in an instant the uppermost sprung up with his antagonist's eye in his hand!!! The savage crowd applauded, while sick with horror, we galloped away from the infernal scene."

Butler lost.

Imprint of the Enslaved: Slaves were somewhat involved in North Carolina sports. By the advent of the Civil War, 30 percent of the state's population lived in slavery. Slaves got Sundays off and occasionally Saturdays. Some slave owners used leisure time as an incentive for desired behavior. Slaves filled this leisure time with fishing, dancing and singing. A few slave owners even allowed trusted slaves to use firearms for hunting. Slaves occasionally competed against each other in foot races, wrestling and jumping.

Slaves also were used in horse racing as jockeys, trainers or grooms. Sir Archy's groom was a slave named Uncle Hardy. Willie Jones' slave Austin Curtis Jones was called "the best quarter horse jockey, trainer and groom in the country."

North Carolina received its first centralized site for sports in 1853, when the North Carolina State Fair opened in Raleigh. The fair was established by the North Carolina Agricultural Society; the state of North Carolina did not take over operation of the fair until the 1920s.

Sports was hardly an important component of the fair. Enlightened planters started the event to promote such scientific agricultural concepts as crop rotation, animal husbandry and improved seeds. But the fair always had an entertainment component; bands, parades, concerts and games of chance filled the midway. Not surprisingly, horse racing became a core fixture at the fair. The breeding of racing thoroughbreds was at least nominally a product of scientific agriculture. A central location, a consistent schedule and a steady crowd of fair-goers combined to make the State Fair the center of horse racing in North Carolina.

War Time's "Pastime": The Civil War shut down sporting activity in the state. Even the finest horses were used for cavalry. Approximately 125,000 North Carolina white men enrolled in the Confederate Army and much of the state was either fought over, fortified or occupied.

None of this should be surprising. Ironically, however, the Civil War provided the entry point for the National Pastime into the state. Contrary to the long discredited myth that Abner Doubleday invented baseball in Cooperstown, New York, baseball actually evolved from a British import known as rounders, also called townball. In fact, bat-and-ball games had been around for centuries. No one invented baseball.

Modern baseball was codified in New York City in the decade before the Civil War and spread throughout the northeast. Under the tutelage of New York City fireman Alexander Cartwright, the New York Knickerbockers standardized their local variant with such innovations as playing on a diamond instead of a square, defining a ball hit outside the first or third base line as out of play, or "foul," three strikes constituting an out and three outs constituting an inning.

Competing versions existed in Massachusetts, Philadelphia and other places but gradually coalesced around the New York version of the game, standardizing rules and procedures. The National Association of Baseball Players accepted Cartwright's written rules in 1857. The organization boasted 54 teams in 1860.

Baseball was an inexpensive, fast-paced team sport, which promoted exercise and rewarded skill and practice. Baseball was played in some southern locations, especially New Orleans. But there is no clear evidence that it was played in North Carolina during the antebellum period.

The Civil War brought large numbers of soldiers together and gave them chances to exchange pastimes and recreations. Historian Bell Irwin Wiley wrote that "baseball ... appears to have been the most popular of all competitive sports" in the Union Army. He also wrote that "Next to music Johnny Reb probably found more frequent and satisfactory diversion in sports than in anything else. When leisure and weather permitted, soldiers turned out in large numbers for baseball." Some of the Union soldiers became Confederate prisoners in the early days of the war and some of those were sent to North Carolina's Salisbury Prison Camp, which opened in late 1861. A former cotton factory, the prison was located on 11 acres and housed about 1,400 prisoners by April of 1862. Numerous diaries and letters confirm that Union prisoners regularly played baseball in Salisbury Prison Camp in 1862 and 1863. Charles Carrol Gray, a 23-year-old physician captured at the first Battle of Bull Run, kept a diary, with numerous brief references to baseball games. Typical was this entry from June 6, 1862, "A good state of cheerfulness, thanks to the open space is fairly prevailing. Ball play for those who like it and are able."

An even more detailed account comes from William Crossley, a native of Rhode Island, who arrived at Salisbury in March 1862. Crossley kept a diary that was published in 1903. This is part of his entry for May 21, 1862:

> "And to-day the great game of baseball came off between the Orleanists and the Tuscaloosans with apparently as much enjoyment to the Rebs as the Yanks, for they came in hundreds to see the sport, and I have seen more smiles to-

day on their oblong faces than before since I came to Rebeldom, for they have been the most doleful looking set of men I ever saw and that Confederate gray uniform really adds to their mournful appearance. The game was a tie, eleven each but the factory fellows were skunked three times, and we but twice."

Skunked refers to a scoreless inning.

One of the most famous depictions of 19th-century baseball was drawn by Union Captain Otto Boetticher at Salisbury Prison Camp (see page 33). As the war progressed, the prison became more crowded and there was no room for baseball or much of anything except survival. It is not clear if any Confederate guards actually played baseball and prison records were lost when Union General John Stoneman ordered the prison burned to the ground in the final days of the war. But there is no doubt that these guards watched the game with some interest and likely carried that interest back to their local communities when the war ended.

The "Spirit of the New Age": Post-Civil War America was in a transition from agrarian to industrial, rural to urban. Team sports were extolled as a positive way to stay healthy, breathe fresh air and achieve comradeship with like-minded peers. North Carolina historian Pam Grundy defines the new era. "Sports caught the spirit of the new age. The contests on the field seemed to mirror the competitive conditions prevailing in the society at large, and the discipline, self-assertion and reasoned strategy that sports were credited with teaching meshed neatly with the qualities required for business and political success."

There were other factors at work. The Young Men's Christian Association promoted sports, influenced by a movement called Muscular Christianity. The concept began in England in the 1850s but spread across the Atlantic following the Civil War. English writer Thomas Hughes summarized Muscular Christianity. "It is a good thing to have strong and well-exercised bodies. The least of the muscular Christians has hold of the old chivalrous and Christian belief, that a man's body is given him to be trained and brought into subjection, and then used for the protection of the weak, the advancement of all righteous causes, and the subduing of the earth which God has given to the children of men."

This is a stark contrast to religious leaders who had long condemned sports as a frivolous waste of time. Suddenly, strong and healthy bodies were an important component of society and what better way to obtain them then through organized sports?

Sports benefited from technological advances of the era. Railroads spanned the nation and made it possible to travel from one city to another with a speed and ease previously unimaginable. The development of the telephone in the 1870s enabled results to be transmitted with a detail and precision not possible with the telegraph. The Atlantic telegraph cable was completed in 1866, making it possible to instantaneously distribute news and information to and from Europe.

Compulsory education created more literate consumers. Newspapers began to run results of athletic events. Joseph Pulitzer's *New York World* established the first formal sports section in 1883. National magazines like *The Sporting News*, founded in 1886, and *The Sporting Life* (1883), further created a national sporting culture. Baseball fans

could follow the exploits of major leaguers hundreds of miles away, players whom they had never seen but who still gained national reputations.

A sporting goods industry developed, as consumers needed golf clubs, tennis rackets, baseball bats, bicycles and roller skates. Albert Spalding founded the sporting goods business that bears his name in 1876. The Schwinn Bicycle Company was founded in 1895. The famous Louisville Slugger bat was first built in 1894.

The post-war industrial age required more standardization, more quantification and more bureaucratization and sports reflected that imperative. Regional variations largely disappeared. A baseball game or tennis match in North Carolina largely would have been played under the same rules as one in Pennsylvania or Minnesota. A round of golf became 18 holes, an oval running track 440 yards. Baseball developed a box score and began a devotion to statistical data bases that continues to this day.

Events and organizations that still exist were established during this period. Baseball's National League was founded in 1876, with teams such as the Cincinnati Red Stockings, the Chicago White Stockings and the Boston Red Stockings. This was the same year of Custer's death at the Little Bighorn.

Golf's United States Open began in 1895, while the Kentucky Derby held its first race in 1875. The United States Tennis Association was founded in 1881 and the first US Open tennis tournament was held that year. More and more, sports was beginning to split into participant and spectator spheres.

Baseball was the first team sport to achieve mass popularity in the United States. From a 21st-century perspective, baseball can be seen as a pastoral, bucolic throwback to simpler times. But in the 19th century baseball was viewed as a fast-paced, urban pastime.

By the end of the 1860s baseball was played in numerous North Carolina cities, including Raleigh, Fayetteville, Greenville and Asheville. Baseball was played by laborers, farmers, students and young businessmen. It was affordable, blended team and individual skills and rewarded practice and dedication. It was more socially acceptable to attend a baseball game than a cockfight or tavern brawl. Compared to what would later develop, baseball in this era was organizationally immature, with no formal leagues, schedules or records. But fans were willing to pay money and even travel in order to watch the exciting, new sport.

Garrisoned Union soldiers introduced baseball to Raleigh in 1865. A field overlooking the city was turned into a baseball field as early as 1866. Other fields were established, including a pair located at Moore and Nash squares, only blocks from the state Capitol. Union soldiers stationed at Camp Russell formed the Garrison Nine and played local teams like the Athletics, Swiftfoots and Stars. According to Raleigh historian Elizabeth Reid Murray, there were some integrated contests.

A 1913 reminiscence published in the *Raleigh Times* shows the novelty and attraction of the new sport. The anonymous writer takes us back to 1867.

Inspired by accounts of baseball from up north, a group of young Raleigh businessmen decided to form a baseball organization, which they called the Pioneer Baseball Club. The secretary was given the assignment of procuring bats, bases and balls as quickly as possible. The group scouted Raleigh for suitable sites and settled on a vacant

field owned by Mr. Boylan. "Mr. Buck Boylan cheerfully gave us permission for the club to use the ground but was much amused at the idea of businessmen playing ball."

Eventually the equipment showed up. "The balls, bases and bats arrived shortly after the grounds were laid off. Never having seen the regulation balls, bases and bats, we were anxious to see what they looked like." A curious crowd of onlookers arrived for the first game, asking such questions as "Do you have to run around all those bases every time you hit the ball?", "What are those funny little bags for?" and "Do you throw it at a fellow?"

It didn't take long for the questions to be answered. Baseball spread into outlying parts of Wake County by the 1870s, by which time the college town of Wake Forest had two squads, the Tar Heel and Farmers teams. At first, admission generally was free for games but collections were taken for uniforms and equipment. On some occasions, the winning team would keep the game balls.

The games had sub-themes. Amateur teams used games as fund raisers and social events. Factories and other businesses had teams. In Raleigh, for example, impromptu games featured such contrived rivalries as married men versus bachelors, barbers versus butchers or druggists versus doctors.

Community Pride: There were black teams in Durham and Raleigh as early as the 1870s. The Nationals—a local Raleigh black team—were playing by 1884 and the team was referred to in local papers as the pride of Raleigh's black community. A crowd reported at 1,000 saw them play the Durham Orioles in Raleigh in 1884. The team lasted at least until the late 1890s. The re-segregation of virtually every part of North Carolina society following the end of Reconstruction doomed any efforts at integrated contests, baseball or otherwise.

College students also began to play baseball among themselves before trying to go formal. Trinity College (now Duke University) founded a formal baseball team in 1889, Wake Forest in 1891. But contests were irregular until the 20th century.

University of North Carolina students played their first recorded game in 1867, when they defeated a Raleigh all-star team, 34–17. The program's next recorded games were played in 1891. The University sponsored a varsity intercollegiate baseball program on a regular basis from that season onwards. North Carolina A&M (now North Carolina State) students played baseball from its founding. In 1894 the school's first team played Guilford, Oak Ridge and Wake Forest. Faculty reaction ranged from disinterest to hostility and the game didn't take hold at A&M until the 20th century.

Faculty hostility was a logical reaction to a sport that struggled with under-the-table payments and "tramp" athletes, players with only a marginal involvement in a school's academic curriculum. Quality pitchers and catchers across the state were routinely paid for showing up and representing a college team, only to disappear quickly after the game.

Will Wynne, a Wake Forest graduate, was a pitcher and outfielder so gifted that he made the major leagues for a single game, pitching for the Washington Senators in 1894. But Wynne dominated the local scene, along with catcher Joe Riddle, reputed to be the only man in North Carolina who could catch Wynne.

The establishment of the professional National League was followed by the creation of minor leagues, like the Southern League and the Virginia League, both of which were founded in 1885. But despite improvements in transportation and communication, North Carolina did not have cities large enough to support professional sports teams until the early part of the next century. Charlotte and Winston-Salem were members of the short-lived South Atlantic League in 1892.

A semi-professional league, the North Carolina Baseball Association, played in 1895, with teams in Wilmington, Goldsboro, Durham, Winston, Oxford, Henderson, and Raleigh. Professional players were limited to two per club. Shaky finances doomed the league. The Durham Athletic Association formed in 1890s eventually led to professional baseball in that city in the early part of the 20th century.

The rise of baseball, however, didn't automatically doom all the antebellum sports.

More Than Farming: Following the Civil War, cockfighting went underground, while gouging largely disappeared. But horse racing maintained some popularity. The North Carolina State Fair continued to be the focal point of the sport in the state.

Horse racing and agricultural fairs went together. Horses were part of the state's agricultural fabric and racing them continued to provide entertainment to large numbers of paying customers. The North Carolina Agricultural Society built a newer, larger site, which opened in west Raleigh in 1873. This site included bigger grandstands and a larger track. The three-story grandstand measured 300 feet by 44 feet and seated 6,000, certainly the largest permanent sports-related facility in North Carolina until the 20th century. The track was a half-mile oval. Races were held on numerous days but the biggest crowds were on Thursday, the biggest day of the fair. Standing-room-only crowds in excess of 10,000 were common.

The new race track was designed by George Wilkes, the influential editor of the *Spirit of the Times*. Following the first races in 1873, Virginia horse racing expert John Belcher proclaimed it the "finest fair grounds in America and the best half mile track he ever saw." The sport still was associated with wealthy planters. The Raleigh *News & Observer* wrote during the 1898 fair:

> "A horse race appeals to more men than any other sport … and it is not at all to the discredit of the men. When the horses faced the flag yesterday, accordingly the fence for nearly half the track length was lined with men to see the trial of speed while the grand stand held a number of the feminine lovers of horse flesh."

A typical fair racing season would have around fifteen horse races, with three to five horses per race. Purses ranged from $50 to $500 and most races were in the one-mile range. By this point, horse racing at the fair had become highly bureaucratized. Races were run under rules of the American Jockey Club, with the less-frequent trotting races held under National Trotting Association guidelines. The races were sufficiently well-regarded that owners brought horses from throughout the eastern seaboard.

Horse owners included such notables as Durham planter Bennehan Cameron and Alamance County textile magnate L. Banks Holt. Orange County planter James Nor-

wood entered eight thoroughbreds in assorted 1879 races. There were critics of the sport and most focused on the pervasive gambling that was endemic to horse racing. In 1878, *The News & Observer* wrote "if the highly moral would only stand back and give us sinners a chance to see there would be less grumbling and more charity and good will."

The sport began to fade in the 1890s, as team sports became more popular. At the national level, horse racing had become increasingly dependent on pari-mutuel gambling, in which bettors move the odds up or down. Informal gambling had always been a key part of horse racing in North Carolina but the conservative state would not allow it to be a formal part of the legal code. As a result, the center of gravity of the sport moved to northern states more conducive to this type of gambling. The best races, best horses and best trainers increasingly were absent from North Carolina.

The State Fair gave other sports an opportunity for wide exposure. Target shooting, gymnastics, bicycling, race-walking and track events were all contested. Baseball was played at the fair as early as 1873. Target shooting was even a team sport at the State Fair. During the 1870s local drill clubs such as the Fayetteville Light Infantry, the Raleigh Light Infantry, the Bingham Cadets, the Asheville Gun Club and the Hornet's Nest (Charlotte) Gun Club competed for target-shooting supremacy.

In the 1880s and 1890s Cherokee Indians from the western part of the state demonstrated at the fair an ancient sport we now call lacrosse. One 1889 account maintained "the Indians played with spirit and created as much excitement and enthusiasm as an intercollegiate foot ball game ever did."

The New American Sport: Baseball has maintained a hold on college campuses well into the 21st century. But by the end of the 19th century it had been bypassed by a newer, rougher, more regimented and much more controversial sport.

Like baseball, football evolved over time from English antecedents, including soccer and rugby. Unlike baseball, football first reached mass popularity as a spectator sport on college campuses. In fact, no other major American sport has its origins so closely aligned with academia. The sport first flourished at a number of elite Northeastern universities, including Harvard, Yale, Columbia and Princeton. Rutgers and Princeton played what is generally acknowledged to be the first intercollegiate football game in 1869, although this game had some soccer-style elements that were quickly pruned from the new game.

There was widespread concern that America's educated youth, transitioning into a life of work in banks and offices, were growing soft and indolent. Future president Theodore Roosevelt became a famous spokesperson for the benefits of robust sports like football. In an 1890 essay entitled "Professionalism in Sport," Roosevelt laid out the benefits of physically demanding sports.

> "There is a certain tendency to underestimate or overlook the need of the virile, masterful qualities of the heart and mind.... There is no better way of counteracting this tendency than by encouraging bodily exercise and especially the sports which develop such qualities as courage, resolution and endurance."

Football was regarded as the antidote to the perceived softness of the northeastern elite. The sport was the perfect blend of regimentation, organization and physicality, springing up at a time when Americans embraced both the demands of the new industrial age and its responsibilities as an international power.

Football games on campus at first were intramural contests between classes at a particular school. Schools quickly decided to test their mettle against opposing schools and it went from there. Participants were astonished to find out that these impromptu contests drew the attention of fellow students, alumni and interested observers, in numbers previously unimaginable.

The sport took its modern form with a series of crucial rules changes. The first football fields were 140 yards long and 70 yards wide, forward passes were illegal, the ball was advanced by kicking and tackling below the waist was prohibited. Harvard and Yale formed the Intercollegiate Football Association in 1876 and adopted new rules that allowed running with the ball and replaced the round, soccer-style ball with an oval-shaped one. By the early 1880s a clear line of scrimmage had been established and the field was reduced to 110 yards by 53 yards. Three downs were allowed to gain five yards and maintain possession. The number of points awarded for touchdowns and field goals changed several times during this period. But the impact of these rules changes was to further distance American football from its European roots and create a distinctive new American sport. The game quickly spread into the Midwest and the South. In 1889 Casper Whitney of *Harper's Weekly* selected the first All-America team and published it in a New York periodical called *The Week's Sports*. One of the honored was Princeton quarterback Edgar Allen Poe, grand-nephew of the famed poet of the same name.

Mentions of football played on the UNC campus appear as early as 1878, when the *Carolina Magazine* noted "A few weeks ago foot ball engrossed the attention of the students but 'kicking a bag of wind' is no longer indulged in." In 1883, a team representing the freshmen and senior classes at the University of North Carolina defeated a team comprising sophomores and juniors. Students at Wake Forest College — then located in Wake County — played intramural football games as early as 1882.

Modern football came to North Carolina in the 1880s, introduced by John Franklin Crowell, the new president of Trinity College, which later became Duke University. Crowell had studied at Yale, the pre-eminent football power of the day, and wrote about the sport for the *Yale Daily News* and the *New Haven Morning News*. Crowell came to Trinity in 1887 and quickly introduced football to the school. Crowell was a determined advocate of football. He liked the exercise, discipline and healthy diet that were a by-product of football. But he most valued what he called its moral values. Crowell argued that football promoted virility, self-control, daring and leadership. Best of all, it broke down social barriers. "It breaks up cliques … and brings everybody face to face to stand on its merits." Football, Crowell argued, was "first among those sports in which the qualities of the soldier are capable of being developed."

Football was new to the South and Crowell knew more about it than almost anyone, certainly anyone at Trinity. So Trinity's new president became Trinity's first football coach. North Carolina, Wake Forest and Trinity got together and formed the North

Carolina Intercollegiate Football Association in 1888 for the purpose of standardizing rules, scheduling games and promoting the sport.

The honor of first intercollegiate game played in North Carolina depends on definitions. In 1888, the sophomore class at UNC boasted that it was "getting ready to challenge anything that walks — their usual attitude." This class defeated the other three classes at the school and then challenged the sophomore class at Wake Forest for a game. Signals got scrambled and Wake Forest showed up with a team representing their entire school. The game was played October 18, 1888, on an improvised field in the horse racing oval at the North Carolina State Fairgrounds.

The field wasn't the only thing improvised. The two teams agreed on a set of rules that included 15-man teams. Wake Forest won 6–4 and the contest received some publicity. The Raleigh *News & Observer* covered the event and called it "Decidedly one of the most interesting features of the whole fair. The game was exciting and was played by excellent teams on both sides." A "tremendous crowd" witnessed the game.

Both teams claimed unfamiliarity with the rules. After the game, UNC football advocates formed the University Football Association — eighty-nine strong — led by captain Steve Bragaw. UNC challenged Trinity to a Thanksgiving contest, also held at the Fairgrounds, although long after the fair had ended. The teams agreed to play by the rules of the American Inter-Collegiate Association and further agreed to ask Wake Forest to join them in establishing an organization. Unlike the earlier game against Wake Forest, this UNC team represented the entire school. Played under standard, accepted rules, this game thus became the first true intercollegiate football game played south of the Mason-Dixon Line.

It was obvious that something was going on. *The News & Observer* promoted the game for weeks prior, promising a "strictly scientific game, entirely different from the 'rough and tumble' and lovers of amusement will find it equally as interesting as the adored baseball." The paper promised "fleet running, bold and plucky charges, rough tackling and good kicks."

Both teams had new uniforms, admission was set at twenty-five cents, fifteen cents for the ladies. Approximately 600 fans found it worth their while. Trinity won 16–0, with Stonewall Durham and Tom Daniels scoring touchdowns. Good cheer was shared after the game, according to *The News & Observer*. "The very finest of feeling prevailed between the two teams … and at the close of the game the University gave three cheers for Trinity which were returned with a will."

John Franklin Crowell wrote about this game in 1939.

> "That single game probably did more than anything else to send into limbo the age-long habit of the condescending attitude with which certain friends of that venerable institution [UNC] were inclined to look upon denominational colleges in general and Trinity College in particular. That long talked-of victory added not only to the athletic reputation of Trinity throughout the State but it gave to the college an indefinable prestige of a general but most effective kind."

The North Carolina Intercollegiate Football Association was formally organized shortly afterwards, on November 29, 1888. Three games were played later that season.

The most telling took place on March 1, 1889, when North Carolina met Wake Forest. Stung by their unexpected loss to Trinity, Carolina hired former Princeton All-American Hector Cowan to teach them the finer points of the game, especially Princeton's signature V formation, a moving triangle of interlocked players protecting the ball carrier. Cowan only stayed a week but his time there was maximized when school president Winston excused the team from classes for two afternoons.

North Carolina player Charlie Mangum later shared his experiences.

> "We played football morning and afternoons, on frozen ground and without pads. We had no uniforms to start with, so the experience was hard on both skin and clothes. I remember one afternoon when Mr. Cowan took the ball to show us how to carry it. He was a big man and fast. Quite a large number of spectators were present, some of them in family carriages. They had crowded in too close and as Cowan sped down the line with the whole squad at his heels, the ladies screamed and the horses reared and plunged and tried to run away, and one old gentleman had a heart attack. An exciting event for Chapel Hill."

It worked. North Carolina won 33–0, in front of a crowd of 500. Wake Forest complained that Cowan was a "hired hand," while a Trinity observer conceded "the real game as taught by Cowan was something entirely outside of our experience." Cowan's brief but successful tenure in Chapel Hill illustrates several points. The fact that such a brief tutorial period could result in such dramatic improvement demonstrates the rudimentary nature of football in the state during this period. But it also demonstrates that even at this early stage, football had begun to matter.

A week later, a crowd of 700 saw North Carolina jump to a 17–4 halftime lead over Trinity. But star player Bragaw broke a leg and Trinity surged back for a 25–17 win. "The arrival of the two foot ball teams … created quite a ripple," *The News & Observer* wrote. "Both the Trinity College and university teams came arrayed in full uniforms, accompanied by strong delegations from both points. A half-dozen street cars came up from the depot laden with the crowd."

The final game of the season was between Trinity and Wake Forest. After their decisive defeat by UNC, Wake Forest took a page from their book, importing former Lehigh star Wallace Riddick. Riddick apparently was as good a teacher as was Cowan. Wake Forest won 32–0. The victors were met on campus by a victory parade and a banquet was held in their honor.

This may seem like a promising first year for college football in the state. But problems manifested themselves from the beginning. The teams bickered among themselves about officiating, coaching, scheduling and rules. More serious were challenges from outside the football community. As early as 1889 portions of the UNC faculty complained that it "did not comport with the dignity of the Institution to play before the public and have gate receipts." Attempts were made to ban off-campus games. Unsuccessful attempts, but sobering none the less.

A telling critique came from Raleigh business leader Paul Cameron in 1889.

> "For one I want all this Inter-Collegiate games broken up; they will end in bitter rivalrys, bitter words & perhaps hard blows. Besides it occupys so much

time that should be given to books & imposes expenses & charges on the boys that many of them can't afford—I wish to see all their contest to be for intellectual superiority, not of foot exploits. Let them take as much exercise as they please on their own campus—but not go off to exhibit as gladiators."

The games continued. Attempts were made to add Davidson to the association but the Mecklenburg County school was too distant. None of the three original teams could gain permanent ascendancy over their two rivals. On November 22, 1889, Wake Forest defeated UNC 18–8, using the so-called rolling rush, a soon-to-be-banned formation in which blockers got a moving start prior to the snap. The team was greeted by "torches, horns, bells, drums, fire-works and speeches" upon their arrival back home.

A few days later, on Thanksgiving, at Raleigh Athletic Park, Trinity edged Wake Forest 8–4, with Trinity stopping a Wake drive at the Trinity 3 as time expired. Wake lost a touchdown when the ball was ruled not to have been placed in play by the referee and they complained vociferously. They also claimed that Trinity's squad had several players who were "not bona fide students" at Trinity. Crowell responded with certificates of authenticity. Claims and allegations continued through the winter. Wake Forest journeyed into Virginia, where it lost to Virginia 36–4 and defeated Richmond 32–14. After the loss to Virginia, Wake Forest claimed "it would be a great injustice to the umpire not to accredit him with at least five of these touchdowns."

One 1889 conflict still lingers. Trinity and UNC tried to schedule a game but there was confusion about time and place. Amid much acrimony, both teams claimed a forfeit for the non-played game. Almost 125 years later, both schools still claim the forfeit. The association was unable to withstand these controversies. Trinity withdrew in March of 1890, followed shortly by Wake Forest, which called itself "sick, and tired, and disgusted with Inter-collegiate Association, tricks, maneuvers and subterfuges."

The three founding programs faced increasing scrutiny. The Wake Forest faculty banned the sport for the 1890–91 academic year. UNC's trustees questioned the sport and university president Kemp Plummer Battle blasted football in an address to the trustees. Battle recognized and praised the sport's benefits, including exercise and relief of boredom. But he also asserted that

> "the necessary evils do not overbalance the benefits ... an incitement to drinking and rowdyism.... Football is brutal and dangerous ... [and] this brutality and danger are greatly increased under the furious rivalry engendered by contests in the presence of numerous spectators and especially in populous towns."

Battle was opposed by prominent UNC faculty, including F.P. Venable, Eben Alexander and Horace Williams. On December 5, 1890, a group of students petitioned the faculty on behalf of football. The faculty agreed to allow the sport but only under firm faculty control. Williams was named chairman of the University Athletic Advisory Committee, whose purpose was to oversee athletics.

Wake Forest reinstated football in 1891 but discontinued in 1895. Cited reasons included injuries, academic irregularities, expense and opposition from conservative Baptist clergy. Football did not return for good until 1908. Crowell faced the strongest opposition. Trinity was a Methodist school and the Yankee transplant faced opposition

to many of his innovations, football among them. Under Crowell, Trinity moved eastward to Durham in 1892, a move that estranged the school from Methodist ministers in the western part of the state. The Raleigh-based Methodist weekly, the *Christian Advocate*, mounted an implacable opposition to football, which it called "blood-curdling … [which] unduly excites and cultivates the *animal.*" Many of the school's trustees turned on Crowell. He continued to defend football but it was a losing fight. Crowell was dismissed and football was banned at Trinity following the 1895 season. It would not return until 1920.

The University of North Carolina wasn't subject to church oversight and was therefore able to expand its football program. In November of 1892, the team took its first prolonged road trip, playing three games in five days. The schedule was ambitious but incredibly the team won all three contests, defeating Auburn 64–0 in Atlanta, Vanderbilt 24–0 in Nashville and Virginia 26–0 again in Atlanta.

The University of North Carolina traveled to New York City, in 1893, the first North Carolina team to travel to that part of the country. They received a rude reminder that the sport was still in its infancy in the South. Lehigh handled them easily, 34–0. The *New York World* wrote "If these Southern men had any scientific knowledge of the game, they would have easily beaten Lehigh. All their gains were made by sheer force and brute strength."

Again, the school looked north for coaching upgrades. Vernon Irvine, another Princeton man, was brought in and helped North Carolina to a 6–3 mark in 1894. He was replaced by yet another Princetonian, "Doggie" Trenchard. Carolina went 7–1–1 in 1895, the sole loss being 6–0 to Virginia, a loss blamed on the Virginia crowd, which occasionally ran onto the field when a Carolina player threatened to break a long run.

Another epic road trip took place in 1895, two games in Atlanta, one in Nashville and one in Sewanee, Tennessee, over a one-week span, three wins and a tie against Sewanee. By the end of the decade, there was little doubt that North Carolina had the best football program in the state, a status that would be maintained well into the following century.

Two of the state's first three college football schools ended the century on the sidelines. But they were replaced by North Carolina A&M, Davidson and Guilford. Lessons were learned. A&M had its first football team in 1892, only three years after opening its door. According to historian Doug Herakovich, "Faculty members considered the need for regulation of college-supported teams, the amount and manner of financial support, the eligibility requirements for student participation in athletics, the sports and number of contests to be sponsored, and the relationship between extracurricular activities and the academic program of the college."

Informal football games were part of the A&M campus culture from the beginning. The first formal game was played in the spring of 1892 against the Raleigh Male Academy. A&M won 12–6. *The News & Observer* wrote that the game was "very interesting and was played pleasantly, being free from any disputes or injury."

The article further noted that the high-school team averaged 125 pounds per player, while the A&M squad averaged a comparatively robust 160 pounds. The Farmers, as

they were called at the time, opened the 1893 season with a 12–6 win over Tennessee. It was their first game against a college team.

A&M defeated a so-called scrub team from UNC in 1893 but played its first match against the UNC varsity the following season, absorbing a 44–0 drubbing. The more advanced program in Chapel Hill won the first six contests against A&M before the agricultural school broke through in 1899 with an 11–11 tie. This contest was not without controversy. North Carolina scored the apparent game-winning touchdown from a yard out only to be told by the official that time had expired before the beginning of the play. The tie was regarded as a victory in Raleigh. "With drum and bugle and flags," *The News & Observer* wrote, "they paraded the streets, leaving a perfect din in their wake and stopping now and then to give the college yell."

A&M had to wait until 1920 before they could boast of a victory over North Carolina. The schools did not play at all between 1905 and 1919 because of disputes over eligibility rules. A&M hired John McKee in 1899, the first professional coach at the school.

With Trinity and Wake Forest on the sidelines and A&M still building their program, North Carolina's biggest rivalry was with the University of Virginia. The schools met twice in 1892, each winning once. North Carolina's 26–0 victory that season was their only triumph in their first seven games against Virginia. The five-game losing streak ended with a 6–2 North Carolina win in 1898. That 1898 UNC team went 9–0 and outscored opponents 187–8. Victims included Georgia, Auburn and Virginia.

The sport held on despite an appalling safety record that wouldn't be adequately addressed until United States President Theodore Roosevelt threatened to have football abolished in 1906. An all-too typical account comes from an 1898 game between UNC and Virginia. A North Carolina player, Vernon Howell, scored the winning touchdown on a play in which he supposedly had two fingers "split down to the web." The attending physician taped them back together and Howell completed the game.

A First Anywhere: Other college sports had their beginnings in this period. Tennis was played at UNC as early as the 1880s. There were 15 tennis courts on the campus by 1895. Wake Forest and North Carolina built gymnasiums in the 1880s, more for physical education classes than intercollegiate competition. Track and field was contested on intramural level during the 1890s.

A&M had intramural track competition as early as 1895 and a formal team for one season, 1898, before a gap of seven years. African American colleges and universities opened across North Carolina after the Civil War. Educating a newly emancipated populace left little time for what many considered frivolities like organized sport.

Still, several African American colleges made tentative forays into organized sports at the end of the 19th century. Shaw University was founded in Raleigh in 1865, the first historically black college in the South. Johnie Jowers, a chronicler of the school's early athletic history, demonstrates the problems Shaw faced in the athletic arena.

> "Intercollegiate athletics may have been in the minds of some of the students but there was a lack of bare necessities for such competition. There was neither

money nor facilities and equipment nor competent personnel to direct an athletic program. There was no gymnasium for indoor sports nor athletic fields adequate enough for outdoor sports."

Undaunted, students persevered. Students played sports such as football, baseball and tennis among themselves, while pushing for intercollegiate programs and official funding. Chapel Hill natives Will Hackney, Sam Jones and [unknown first name] Tuck learned the rudiments of football from watching UNC games and managed to recruit a team by 1897. Football and baseball games were played against nearby schools such as St. Augustine's and Kittrell. Meager gate receipts were supplemented by faculty donations. Money remained sparse, according to Jowers. "Competition with out-of-state teams was very rare, because the teams had to travel by train. Before 1900, all of Shaw's athletic contests were local affairs."

It was similar at the other end of the state. Charlotte's Biddle University—which became Johnson C. Smith in 1923—played Livingstone College in Salisbury on a snowy December 27, 1892. It was the first intercollegiate football game played anywhere between two black colleges. Biddle students had started their program in 1890. Equipment was minimal and money was tight. But the experience paid off, when Biddle won 4–0. Shortly afterwards, the Biddle faculty banned the game because of complaints that it was too brutal. Students continued to play an intramural game every Thanksgiving. It was never explained why intramural football was less brutal than intercollegiate football. Football wasn't reinstated at Biddle until 1912.

Biddle students played baseball among themselves at the South Atlantic Baseball Park, located across town from the campus. Intercollegiate contests began in 1902. Students at Greensboro's North Carolina A&T had begun to play on campus by the end of the 19th century. The school's first intercollegiate team suited up in 1901. Livingstone students tried to start a baseball team in the early 1890s but school administrators converted the field into vegetable gardens, vivid proof of the school's priorities.

Merely an "Athletic Distraction"? Basketball was conspicuously absent from the North Carolina college sports scene. Basketball was invented in 1891 by James Naismith, an instructor at the YMCA Training School in Springfield, Massachusetts, as an indoor sport suited to brutal New England winters. Naismith's "athletic distraction" succeeded beyond his wildest dreams. Local YMCAs were the point of entry for basketball into the state. Many collegians played the sport for fun but formal college teams didn't appear until the 20th century.

Recreational sports such as roller skating, bicycling and swimming became popular activities during this period. However, North Carolina was left behind in some areas. During this period the state had relatively few European immigrants. Sports such as boxing, gymnastics and pedestrianism (competitive walking) were popular with immigrant communities in the urban northeastern and midwestern portions of the United States but found little favor in 19th century North Carolina. Big-time boxing was further constrained by the same bias against formalized gambling that held back horse racing.

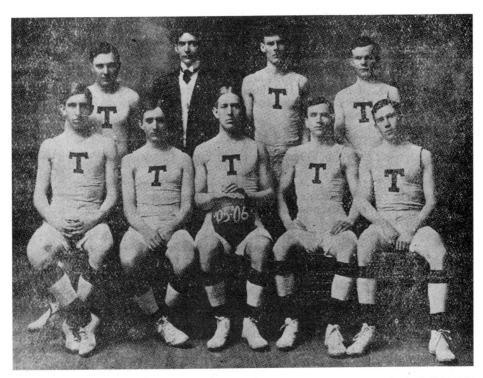

This Trinity team began a tradition it could not have imagined — Duke basketball. This 1906 team includes (front row, left to right) B.S. Womble, C.R. Claywell, T.G. Stem, Garland Greever, and L.G. White, and (back row) C.R. Pugh, Coach W.W. "Cap" Card, T.M. Grand, and T.A. Holton.

The Feminine Touch: American women made their first, tentative steps into the sporting arena in the final decades of the nineteenth century. Working class and small-farm women had always worked long and difficult hours on farms and in factories, but middle and upper class women were constrained by the so-called Cult of Domesticity which ascribed four virtues to women: piety, purity, submissiveness and domesticity.

None of those virtues led to athletic fields. These women were told that exercise was unhealthy, unnatural and unfeminine. The fight to overturn those stereotypes was part of a broader women's rights movement, the most important part of which was the struggle for suffrage, or the right to vote.

The development of the modern safety bicycle in the 1880s proved important to the evolving view of women and exercise. The high-wheel bicycle was regarded as too dangerous for all but the boldest young men. Its replacement ushered in a bicycle craze that swept the nation. Women could and did ride the newer bicycles, in large numbers, very publicly, usually wearing the bloomer or some other more comfortable attire.

This might seem trivial to a modern viewer but comfortable, form-fitting clothing was a challenge to an old order more accustomed to seeing upper-class women wearing clothes that were more fashionable than practical.

Susan B. Anthony, the leader of the suffragette movement, was one of many observers who associated the bicycle with the New Woman. "Let me tell you what I think of bicycling," she said. "I think it has done more to emancipate women than anything else in the world. It gives women a feeling of freedom and self-reliance. I stand and rejoice every time I see a woman ride by on a wheel … the picture of free, untrammeled womanhood."

The bicycle was not the only source of exercise for women. What is now the University of North Carolina at Greensboro opened in 1892 as the State Normal and Industrial School for Women and was renamed the State Normal and Industrial College for Women in 1896. The women-only school's primary purpose was to educate the teachers who would educate the state.

From the beginning the school had a formal Physical Education program, including calisthenics and gymnastics and the school encouraged walking around campus, both for exercise and the social benefits of meeting fellow students and faculty. The school's first annual report noted that "many chests increased in girth, shoulders straightened, arms became stronger, and the general bearing much improved." This was a significant turn from the Cult of Domesticity.

Outsiders noticed. In 1901 the *Salisbury Daily Post* gave its approval.

> "The 'old maid' has entirely disappeared completely, and in her place we have the breezy independent, up-to-date, athletic and well gowned bachelor girl, who is succeeding in business life or a profession and asks neither pity nor favors from her fellow men."

By the end of the century Woman's College students were engaged in tennis, golf and especially basketball. As a new sport with no established tradition or hierarchy, basketball was particularly appealing to the New Woman.

Female physical education professionals made early attempts to modify the rules for women. In 1901 Spalding published modified rules established by Senda Berenson, the athletic director at Smith College, in Newton, Massachusetts. That year Berenson wrote "basketball is the most popular game women play." But women would play the game for much of the 20th century under rules designed to limit exertion and contact.

Basketball was played on the campus of the Woman's College as early as 1898, when the junior class challenged other classes to competition. By 1900 it was said that at the school "The enthusiasm ran so high over basket ball in the spring that a determined few lent themselves to the task of cleaning and preparing the grounds. The athletic spirit spread until now every class in the school plays basket ball."

But there were limits, as noted by a student in 1896. "We were not allowed even to so much as to walk out in the halls with a gym suit on, cumbersome and all-consuming though it was. No papas nor even any grand papas were allowed to be present." The concern for modesty carried over into the new century. In 1900 the school's board of directors authorized the construction of an outdoor playing field, with the proviso that an evergreen hedge be built to shield the field and its women from public gaze.

With a few exceptions, serious competition for women largely lay in the future. The first US Open women's tennis tournament was held in 1887 in Philadelphia, while the

inaugural U.S. Women's Amateur Golf Tournament took place in 1895. Women participated in the Olympics as early as 1900, although in only a handful of sports. The American Amateur Union didn't conduct national competition for women until 1916. There was at least one exception. In 1889 a team of Raleigh men lost a baseball game to a team of traveling women, the Chicago Female Nine, by a 24–17 score. One local reporter called the event "a sad commentary upon the elevation of woman in the nineteenth century to record such degradation."

From a 21st-century perspective, these athletic endeavors may seem unimpressive. But these tentative, baby steps matured into the modern sporting world we all know. By the end of the 19th century, North Carolinians competed in a wide variety of team and individual sports, at increasingly high levels. It had become apparent that a large number of North Carolinians would train and practice to achieve athletic skills and larger numbers of North Carolinians would follow their skills, building facilities, reading about their hero's exploits and, most of all, spending money to watch other people compete in assorted athletic events.

We now largely define sports in terms of spectator sports. North Carolina saw an explosion of spectator sports in the 20th century but the seeds were sewn in the 19th century, seeds waiting to sprout and be harvested.

Baseball

By Wilt Browning

Wilt Browning has spent more than three-quarters of his life writing sports and has served both the *Greensboro News & Record* and the *Asheville Citizen-Times* as sports editor and sports columnist. He is a five-time Sports Writer of the Year in North Carolina and earlier covered the Atlanta Braves through the team's first six seasons in the South for the *Atlanta Journal*. Wilt's resume also includes sports writing stints in Topeka, Kansas; Greenville, South Carolina; and Charlotte. He spent five seasons as the public relations director for the Atlanta Falcons and one season in the same capacity for the Baltimore Colts. He is a member of three halls of fame, the North Carolina Sports, Guilford County Sports and the South Atlantic League Baseball.

A Longing for Home

On a national scale, no sport ever demanded the sort of communal reverence that seems stitched into baseball. It is the kind of reverence that has through the ages captured the imagination of all of us and has inspired some of us to attempt to quantify that reverence through the written word. It is a challenge not only taken up by writers of sports, but by others as well, including poets and academicians.

In the introduction to *The Armchair Book of Baseball II*, published in 1987, and taken from the outline of a speech to a women's club, the late A. Bartlett Giamatti, former president of Yale University and later president of the National League and finally the Commissioner of Baseball, took his swings at describing the soul of the game. In part he wrote:

> "… What is baseball, and indeed so much of the American experience, about but looking for home? *Nostos,* the desire to return home, gives us a nation of immigrants always migrating in search of home; gives us the American desire to start over in the great green garden, Eden or Canaan, of the New World; gives us the concept of a settled home base and, thus, the distance to frontiers; gives us a belief in individual assertion that finds its fulfillment in aggregation; a grouping with the like-minded and similarly driven; gives us our sentimental awe of old ways; gives us the game where the runner runs counterclockwise for home plate.
>
> "The hunger for home makes the green geometry of the baseball field more than simply a metaphor for the American experience and character. The baseball field and the game that sanctifies boundaries, rules, and law, and appreciates cunning, theft, and guile; that exalts energy, opportunism, and execution, while paying lip service to management, strategy, and long-range planning, is finally closer to an embodiment of American life than to the mere sporting image of it…."

Giamatti was writing for the benefit of those of us in North Carolina only in a collective way. Yet, the impact of baseball upon the passion for sports of all kinds in this state had its genesis in the team sport that in its simplest form begins merely as man against man—the pitcher against the batter—standing roughly 60 feet, six inches apart.

Almost without question, if it were possible to probe the root inspiration for the prodigious North Carolina passion for sports competition, we would find baseball deeply imbedded in its genes. And that passion can be traced at least as far into the past as the time of the Civil War, and perhaps well beyond. An interest in competition based upon athleticism is perhaps as old as the lineage of *homo sapiens,* but only in the last

century and a half has sports competition found a prominent and passionate place in the lives of most of us, especially the citizens of North Carolina.

And we have baseball to thank for that.

There is a place in the heart of North Carolina where the grass seems always green and lush, where powerful ancient trees stand guard on the rolling hillsides, where a Union soldier carved in stone is stoically at rest eternally atop a tall monument, and where white gravestones, gleamingly pristine and all alike except for the letters etched there, including those spelling "Unknown," stand in perfect file. It is a cemetery. Not just any cemetery. A National Cemetery.

But there is more here than meets the eye. Far below the remains of those whose resting places are marked in perfect array, we are told, are the bones of others who were not so carefully or reverently sent to their eternal slumber, and whose numbers are not known. Optimistically, there are *only* about 5,000 men buried there in 18 mass graves, each about 240 feet long, most of the dead lying one on top of the other without crypts or coffins. In our worst nightmares, there perhaps are many more of them, all now merely bones if, indeed, even those remain in the depths of the red clay of Rowan County.

There are among those thus interred Confederate deserters, run-away slaves, Quakers and other pacifists, Union sympathizers from the western reaches of the state, and common criminals. But most are Union soldiers, and they remain to this day unnamed — the unknowns — in ground that once was an extension of the Confederate prisoner of war camp at Salisbury. Early in the war, the camp, one of 13 authorized by the Confederacy, was easy duty as POW camps go. Indeed, it was commanded in the beginning by Dr. Braxton Craven, the president of Trinity College (later to become Duke University) and patrolled by the friendly Trinity Guards who were students from the college then located in nearby Randolph County. Eight other men would follow Dr. Craven as commandant as the 16-acre compound grew from a pastoral setting to one of horror.

Indeed, as the war dragged through the 1860s, the camp earned the name by which it would be known — the Dark Hole. Dysentery, pneumonia, smallpox, dengue fever and eventually starvation ravaged the camp in the final two years of the war and the death rate was so great that the blacksmith shop was converted into the "dead house." There, the newly deceased would be daily brought to be counted and stripped naked of their meager clothing. Beginning at 2 p.m. each day, they would be taken eight at a time by carriage drawn by a single horse to be dumped into open pits where corn fields once had thrived. There they would be entombed one shovelful of Southern soil at a time. Even the outlines of the trenches where the dead lie now are almost lost visually to time along the rolling hills within walking distance of downtown Salisbury and less than two miles from the steady hum from the eight lanes of rushing traffic on Interstate 85. The Confederate POW camp at Andersonville in Georgia remains the ultimate symbol in American-upon-American human degradation though the Rebel government had no monopoly on cruelty; the Union maintained a dozen camps for Confederate POWs including one at Elmira, New York, that became known as Hellmira. Nevertheless, the death toll at the Dark Hole became the highest by percentage in the

Confederate system, higher even than the percentage of dead to living at Andersonville; by the late months of the Civil War, half of those held in Salisbury would not live to hear of the meeting of Generals Robert E. Lee and Ulysses S. Grant at a place called Appomattox Courthouse in Virginia. Disease or starvation would send them too soon to the death trenches and to their eternal armistices.

Of the nine commandants assigned to the Salisbury prison during its brief history, the most notorious was Major John Henry Gee. When the war was over, only two Confederate POW camp commandants were charged with war crimes and stood trial. Gee was acquitted. Major Henry Wirz of Andersonville was found guilty and was hanged.

The reality of what life in the death camp at Salisbury must have been like is left mostly now to our imaginations. Still, from the distance of more than a century and a half, it rumbles uneasily like far away, faint cannon roar through the souls of those who have delved very deeply into what happened there.

A Place of Birth: Yet, incongruous as it may seem, there is another aspect of the story of the Confederate prisoner of war camp at Salisbury. For all the death that is interred there, these acres also are a place of birth.

In 1862, 46 Yankee soldiers captured at Manassas in Virginia became the first prisoners assigned to Salisbury. Some, it is written, arrived there with homemade bats and handmade balls among their knapsack possessions. Among the first wave of prisoners was Captain Otto Boetticher. And when the *U.S.S. Union* ran aground off the coast of North Carolina, 73 captured sailors were shipped west to more than double the prison's population.

As prisoner of war camps go, Salisbury seemed a soft assignment in those early months. The prisoners spent their days reading beneath the trees, playing poker, trading buttons and other pocket treasures, staging amateur theatrical productions and printing and distributing their own newspaper, *The Stars and Stripes in Rebeldom*.

They also played baseball.

Prussian immigrant Boetticher, a commercial artist by trade and training, was 45 years old when he accepted a commission as a captain in the 68th New York Volunteers in 1861. His son, whose name also was Otto, signed up on the same day as a private. To that point, the elder Boetticher's most successful painting had been one entitled "Seventh Regiment on Review, Washington Square, N.Y."

As an officer of the 68th, Boetticher saw action at Manassas where in March 1862 he was captured by Confederate troops. The exact circumstances of his having fallen into enemy hands remain murky. It was written, however, that it happened "while straggling without authority beyond the outposts of the Army." It was a carelessness that would land Boetticher first in Libby Prison in Richmond, Virginia, and then Salisbury.

In a unique way, Captain Boetticher would become one of the camp's best-known inmates along with an imposter who used the name Rupert Vincent but who actually was Robert Livingstone, the son of the African missionary Dr. David Livingstone. Captain Boetticher earned his fame by doing what he had done in New York before the Civil War, painting.

Indeed, one of his paintings is not only artistically important, but historically significant. It is the depiction of a baseball game being played within the confines of the prisoner of war camp at Salisbury. Because it was painted in 1862, "Union Prisoners at Salisbury, N.C." is perhaps the earliest record of a game akin to modern baseball being played in North Carolina.

In the retrospect of post-Civil War America, the painting is a stunning contrast to the public perception of armed conflict, a conflict that is heightened by its setting, a prisoner of war camp. One early critic noted accurately that the scene is less reminiscent of a jail than of "the Elysian Field of Hoboken." The emotional conflict the Boetticher painting inspires in those who gaze upon it has been diminished not at all by the passage of time.

It also makes possible at least an uncertain timeline for the arrival of an early version of the game we know today in the South. Though a version of the game existed throughout the state and much of the South prior to hostilities, the game played in the mellow painting from Salisbury was known as "the New York game" and that was relatively new to the South.

By the time of the Civil War, for example, the first indication that an interest in "the New York game" had taken root south of the Mason-Dixon Line came in Houston, Texas. A group of local businessmen, most of them wealthy and almost all New York and New England transplants, met to form the Houston Base Ball Club. The date was April 11, 1861. Among them were the Rice brothers, Frederick Allyn and William Marsh, the latter reputed to be the wealthiest man in Texas prior to the Civil War. William Marsh Rice would later endow a Houston educational institution. We know it today as Rice University.

The day after the Houston group met to form a "base ball club" based upon "New York rules," Confederate batteries opened fire on Fort Sumter at the entrance to Charleston harbor in South Carolina.

Chermany, Anyone?: There is a disputed theory that, as tragic as it was, especially in states from Virginia through Georgia and westward to beyond the Mississippi River valley, the Civil War served to spread the gospel of baseball through the region as detainees whiled away their hours by playing games in prisoner of war camps such as that at Salisbury. The theory holds that rebel soldiers on guard duty looked on and sometimes even participated as players, thus learning the nuances of what was then a relatively simple game.

At the same time, of course, Rebel soldiers also were being captured and interned in prison camps, such as Hellmira, in the North, there to at least occasionally participate in "New York rules" games of baseball. Seeds that would sprout after the war were being planted.

If there is truth in that theory which is supported by the Boetticher painting, it would apply to what became perhaps the earliest version of the modern version of the game

Opposite: This lithograph dates the modern game of baseball in the state to at least 1863. Otto Boetticher, *Union Prisoners at Salisbury, N.C.* 1863. Courtesy of Reynolda House Museum of American Art, Winston-Salem, North Carolina.

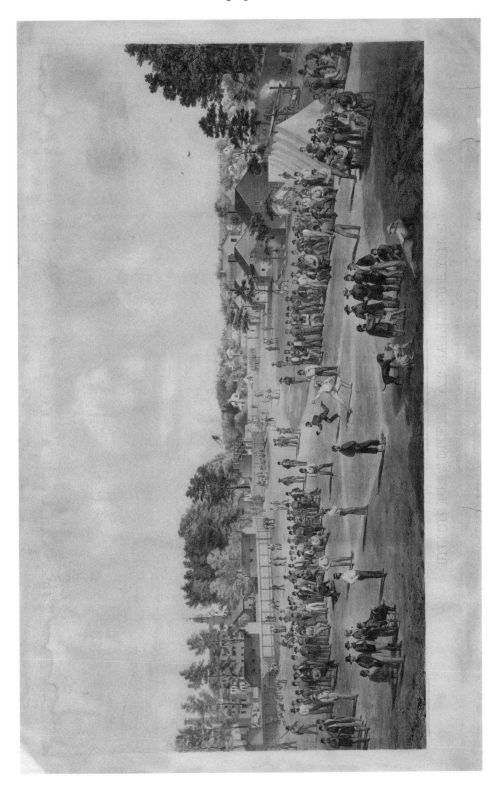

played by "New York rules" to take place in North Carolina. Only months prior to the commencement of hostilities and for the first time, a printed list of rules had been published outlining the game in just 14 simple tenets compared to the complicated book of regulations by which the modern game is governed. According to those early rules, for example, home plate was to be 42 paces from second base, with third base separated from first by the same distance so that those four points would form a square or a diamond, depending upon one's view. How far 42 paces would have been would depend upon the stride of the person doing the pacing.

But the legacy of baseball in an even more basic form certainly predates the Civil War and perhaps much of modern history. Other sports, including basketball, football and auto racing, came into being at relatively specific points in the last century and a half. Not so with baseball. There was a wide variety of "ball" games played across the country, including the South, in pre-Civil War days and they were known by almost as many different names. None of those games was the result of inspiration by Abner Doubleday, the man once regarded as the inventor of the game (Doubleday himself never claimed to have invented baseball though he was the inventor of something almost as magical—San Francisco's marvelous cable cars). Children and young adults in North Carolina before the first shot was fired upon Fort Sumter (where Union Captain Doubleday was posted at the time and who aimed and fired the first cannon and thus the first Federal shot of the war in response to the Rebel attack) would have played versions of the game called "long-town ball," "chermany," "round cat" and others. Posts or stones and sometimes trees served as the bases and the number of players on the field at any one time could vary widely. A form of the game in which hitting a runner with a thrown ball consisted of an out, and with as many as nine outs to an inning, was still being played in some parts of the South into early World War II years. Games of that kind usually lasted two such innings.

But for history buffs, it is likely that the germ of the modern game is as ancient as the pyramids. There are ancient Egyptian carvings that indicate that a form of a game that included striking a ball with a club or stick and running from one pre-determined point to another existed before the birth of Christ. It is known that Russia had a more recent version of such a game called *lapta* dating to the 14th century, and that *schlagball* was played in Germany earlier than the start of the American Civil War. If there is definable linage for the American game of baseball, scholars point most often to rounders, a competition akin to cricket. In an 1829 publication entitled *The Boy's Own Book*, a crude field diagram is featured with specific locations for four stones, or stakes, forming the unmistakable form of a diamond. Players advanced around the bases in clockwise fashion and outs were recorded when a batter attempted to hit the pitched ball three times without success, or by being hit by a thrown ball while attempting to advance between bases.

Perhaps because the "New York game" was among the first to be played in accordance with written rules, it is probable that it was that game that Boetticher memorialized in his Salisbury painting and which is the forerunner of the modern game of baseball now performed at its ultimate level by multimillionaire players.

Whether the New York artist was, therefore, a witness to the first modern baseball game ever played in North Carolina is debatable. Despite Boetticher's artistic evidence

of 1862 from Salisbury, the Society for American Baseball Research currently lists Asheville as the most likely site of the first baseball game ever played in North Carolina. The year, according to SABR, was 1866 and the account is contained in *Baseball in Asheville* by Bill Ballew, published in 2004. According to Ballew's account, the game was played "on Smith's 118-acre tract, also known as the Barn Field...."

The Post-Civil War Boom: If the Civil War and the 13 Confederate prison camps and those of Federal forces became the unusual sole incubators for modern baseball in the South, the development of the sport was on shaky ground. But the role of Reconstruction and the subsequent migration of cotton manufacturing from New England to the South in the decades immediately after the Civil War was the engine that certainly by early in the 20th century drove the sport into virtually every community in what had been the Confederacy. Once the shift of the industry from New England to the South began, cotton mills were built beside almost any stream in the South with water flow strong enough to power massive, complicated machinery. And around those mills, new towns popped up constantly altering the map of the South, many of the companies bringing Northern place names with them, such as Lowell, Burlington, Lexington and Concord. By the turn of the century, coal-fired mills also became commonplace as the South was transformed from a strictly agricultural region to an economy that mixed farming and manufacturing. Ironically, one of the South's earliest cotton manufacturing plants, a three-story building with an attic, stood within the confines of the Salisbury prisoner of war camp and was converted to a prison within a prison. Its cupola can be seen in the distance in the Boetticher painting. The mill's uppermost reaches were reserved for the hardened criminal element in the prison population. (A once modern and now abandoned textile mill, formerly a part of the Cone chain, stands hard against the stone wall surrounding the National Cemetery at Salisbury. But it was built long after the original three-story mill had disappeared and at a different location.)

What drove the migration of cotton manufacturing after the war was a combination of factors, perhaps the most important being that the soil and the weather in America best suited for the growing of cotton lies in what was the Confederate South, in a wide agricultural arc from Petersburg, Virginia, and sweeping south and southwest to the cattle country of Texas.

Another factor was the availability of a ready work force free of the growing organized labor movement to toil as doffers and spinners in an industry in which wages, while meager, still were better and more reliable than that that could be gleaned from the fickle agriculture economy of the South. In order to lure workers out of the fields and out of the hills of Appalachia in large enough numbers to operate the machinery in cotton mills, owners constructed villages around their manufacturing plants. Most of the wood frame houses consisted of four rooms and could be rented in most areas in the first third of the 20th century for about 25 cents a room per month, including electricity when that became widely available, and water, though many of the early mill villages depended upon hand-dug wells. Some of the houses also included rudimentary furnishings, such as beds, tables and chairs. Almost all had outdoor toilet facilities.

Early mill owners almost always paid in script that could be spent only at the company stores located conveniently in the center of the villages. Indeed, life in the new mill villages of the South was communal in almost every way. In most mill villages, the homes were built in front close to the patchwork of streets cut from the red clay soil with generous open spaces behind the homes theoretically to provide acreage for family gardens. It was not unusual for a modest spread of pastureland to be set aside nearby where workers could maintain dairy cattle to fill the domestic need for milk. The homes were so close to the humming mill that no surface transportation was needed, and the mill superintendent (called "the super") controlled almost every facet of life in the village. Disputes between neighbors were arbitrated by "the super," and villagers inclined to drink to excess or to disorderly conduct were expelled not only from their jobs but from their homes, and there was no appeal process. Mill owners built the community church buildings—usually Baptist, Methodist and one fundamentalist denomination—and frequently hired and paid the wages of the pastors who served the mill worker flocks.

But the owners also encouraged community activities. Most mills had their own uniformed brass bands through much of the first half of the 20th century, but many of the ensembles began to disappear during the Depression years and most of the rest were gone by the time of World War II. However, as late as 2012, one reorganized mill band was still in existence in the Greenville area in South Carolina and was still staging occasional concerts, heavy on Sousa.

The owners also encouraged the organization of community baseball teams, and textile league baseball in many areas of the South grew to be of high quality until it disappeared almost completely in the mid-1950s, giving way to the availability of black-and-white television for entertainment and a more mobile social structure fueled by the proliferation of automobiles parked at the curb of almost every home in the village.

Sports Giants Among Us: Even with the 20th century still young, important baseball events were taking place in North Carolina, though it would perhaps take a few generations for the general public to understand their significance. And two of those events involved two of the greatest names ever in sports in America. If there were a Mount Rushmore for American athletes, it is likely that these would be two of the faces carved there.

The first of those was Jim Thorpe, a Fox and Sac Indian from Oklahoma who had become an early football All-American at Carlisle Indian School in Pennsylvania in 1908. He would later play professional football and major league baseball after honing his skill for baseball in the spring and summer of both 1909 and 1910 by playing the game for the Rocky Mount Railroaders in North Carolina. The Railroaders competed in the Eastern Carolina League that also included teams representing Fayetteville, Goldsboro, Raleigh, Wilmington and Wilson.

Thorpe would make an even bigger splash in the sports world in 1912 by winning two gold medals in the Summer Olympics in Stockholm, Sweden, in the grueling decathlon and the pentathlon. After his stirring performances, Thorpe was greeted by

Sweden's King Gustav V. "Sir, you are the greatest athlete in the world," the king told Thorpe. Few in the past one hundred years have disputed the king's assessment of Thorpe.

Within a year of Thorpe's twin triumphs in Sweden, the United States Olympic Committee discovered that Thorpe had spent two seasons playing baseball in North Carolina for as much as $25 a week and, sticking to the letter of the rules then barring any encroachment upon amateur status, even in sports other than those in which Olympic competition had come, stripped Thorpe of his gold medals.

The committee's action was the subject of sports controversy for years to come. Personally for Thorpe, it was a depressing development for the man who would wind up in several major Halls of Fame in athletics. He tried for years to get his medals back but died in 1953 still reportedly broken-hearted over the issue. Thirty years later, in 1983, when true amateurism had clearly become passé in the Olympics, Thorpe's medals were returned to his children.

Thorpe, a pitcher and an outfielder, has been one of the most popular baseball players of his time. Youngsters received free admission to Rocky Mount's games by returning balls that presumably had been hit fair or foul beyond the fence surrounding the ballpark. Thorpe, though, was in a habit of tossing a handful of balls over the fence so that more children would be admitted to the games. It was an era in which many college athletes, including two of Thorpe's Carlisle teammates, would play minor league baseball during the spring and summer using fictitious names to protect their amateur status for football; Thorpe, however, used his real name.

In 1910, Thorpe continued to take his turn on the mound for Rocky Mount despite a developing sore arm. He finally was traded to Fayetteville. There his popularity once again was established in that Eastern Carolina League town, but Thorpe and the team manager were not compatible and the famous Indian did not return to North Carolina as an athlete after the 1910 season.

Jack Dunn's "Babe": Only four years later, Fayetteville would have yet another brush with sports stardom, though no one knew the magnitude of the star at the time.

Jack Dunn, who owned the minor league Baltimore baseball franchise long before the St. Louis Browns moved to town and became the Orioles, signed an incorrigible teenager who years earlier had been placed in Saint Mary's Orphanage because his parents could not control him. The ink on the contract was barely dry when Dunn and his new signee, George Herman Ruth, headed south bound for Fayetteville to begin spring training for the approaching 1914 season, the rookie's first.

Ruth had never been out of Baltimore before and even then seldom had ventured into the city center. So, when he and Dunn arrived at their Fayetteville spring training headquarters hotel, the LaFayette, the young baseball player was so spellbound by elevators, which he had never before seen, that he spent most of the first day joyously riding from floor to floor.

At the ballpark, Ruth stayed close to Dunn, usually walking four or five paces behind the team owner, and it was this unusual sight that prompted one of the Baltimore players to observe quietly to other players, "There goes Dunn and his new babe." With

that observation, no more than an aside at the time, one of sport's most enduring nicknames was born.

Not only had a nickname been branded upon history yet to come, but a glimpse into the life of the rotund teenager came as well. In one of the early squad games, one played on March 7, 1914, the new kid on the team, Babe Ruth, hit his first home run, albeit it in a practice game, as a professional athlete. Local old-timers would until their own dying days remember it as a gargantuan blow.

In the 1990s, a man who had served the team as a batboy and reportedly had witnessed the home run recalled that the ball easily cleared the outfield barrier and landed in a marshy area well beyond the fence. The ball, he said, was never recovered and perhaps lies there still, a relic of history interred in the primordial ooze of central North Carolina.

George Herman, the future "Babe," was not the only prized talent Dunn brought to Fayetteville that spring. It was a team that also included Ernest Grady "Ernie" Shore, the second of the five sons of Henry and Martha Shore of East Bend, North Carolina. The team was, writers claimed for years, the greatest minor league team ever assembled, and the baseball histories of Ruth and Shore would forever be intertwined. At the time, Shore had had a brief fling with major league baseball, but had returned to North Carolina to ponder his possible future away from the game. He had hoped to become a civil engineer, and obtained a degree from Guilford College where he would teach math during baseball's off-season. But after playing for Greensboro in the North Carolina State League in 1913, Shore signed on with Dunn and met Ruth for the first time as spring training began in Fayetteville.

But Dunn was facing business pressure from the new team in Baltimore that would become a member of the Federal League, organized to become a third major league, and the fan base for the Orioles was eroding so drastically that Dunn decided to sell his two best pitchers, Ruth and Shore, together to the Boston Red Sox. Shore was for a time considered the key to the sale from the Red Sox's point of view. Indeed, the North Carolinian immediately became one of the team's starting pitchers while Ruth was shipped back to the minor leagues at Providence.

Ruth, of course, would be back, but in the meantime, Shore's press clippings could not have been more glowing. Cleveland manager Joe Birmingham called Shore "the greatest young pitcher who has broken into the big show since Walter Johnson. I believe Shore's fast ball is just as fast as was Johnson's when Walter came east from Idaho. Shore right now possesses a better curve than Johnson."

One season later, in 1915, Shore and Ruth were the aces of the Boston pitching staff. They had identical records of 18–8 though Shore's earned run average of 1.64 was better than Ruth's respectable 2.44. They even shared living quarters until Shore discovered that Ruth was using Shore's shaving brush (some sources say it was his toothbrush), and asked the big left-hander about it. "That's all right, Ernie," Ruth replied when challenged, "I'm not particular."

Whether over the shaving brush spat or not, Shore moved into the home of Boston's legendary mayor, John Francis "Honey Fitz" Fitzgerald, to whom a grandson would be born during the time Shore was living in the mayor's home. The grandson would be

given the mayor's last name as his middle name — John Fitzgerald Kennedy. But history was far from finished with Shore and Ruth as a twosome.

The Babe was the starting pitcher in the opening game of a doubleheader in Fenway Park against the Washington Senators on June 23, 1917. Umpire Brick Owens called Ruth's first three pitches to Washington leadoff hitter Ray Morgan balls, and Ruth was furious. And when his fourth offering also was called a ball, Ruth charged the umpire, fists flying. There were those who insisted that Ruth never struck Owens, but in his own autobiography, Ruth claimed to have "really socked him — right on the jaw." Whether any of Ruth's swings found their target, Ruth was quickly thrown out of the game. Boston player-manager Jack Barry summoned Shore from the bench.

Rushed into the game, Shore was permitted only five pitches to warm up. On his first official pitch, Morgan, hoping to take advantage of all the commotion and the unprepared nature of a new pitcher, broke for second on a steal attempt only to be thrown out by Boston catcher Sam Agnew. Shore got outs two and three on a total of just five more pitches and while his teammates were hitting in the bottom of the inning, Barry dispatched Shore to the bullpen to warm up properly. He returned to the mound in the top of the second and for eight innings was perfect retiring in order the remaining 24 Washington batters he faced.

Mathematicians have calculated in the years since that Shore threw fewer than 75 total pitches in the game that some record books for years called a "perfect" game, and Shore himself was regarded as the only man in baseball history to have pitched a "perfect" game in relief, theoretically an impossibility. Shore himself would call it the easiest game he ever pitched.

But the debate over whether he had pitched a "perfect" game continued for years. "I realize you can make a good case for the game not being perfect since I didn't pitch a complete game," Shore said long after his baseball career had come to an end. "But how complete is complete? You have to get 27 men out. I got 26 of them out and the other was retired while I was pitching. No other pitcher retired a single batter."

Shore would later be traded to the Yankees in the first blockbuster deal to which the dismantling of the Red Sox of the time would be traced. Ruth would follow as part of a later trade. In his career, Shore never had a greater believer than Ruth himself. The Bambino said after World War II that he thought Shore "was going to be the best pitcher in baseball. He went away to the last war (World War I) and came home with a dead arm." Shore had volunteered for the Navy, was assigned to officers' school at Harvard, and became the only big leaguer to earn an officers' commission during the war.

The debate over what to call the game of June 23, 1917, finally was settled in 1991, 11 years after Shore died, by an eight-member statistical committee headed by baseball Commissioner Fay Vincent. It was officially removed from major league baseball's list of "perfect" games and instead became a combined no-hitter with Ruth. It was the committee that at the same time removed Harvey Haddix's no-hitter for 12 perfect innings against Milwaukee before losing in the 13th inning, and also removed the controversial asterisk from Roger Maris' single season home run record. (The asterisk indicated that Maris hit 61 home runs in 1961, but in more games than Ruth had at his disposal in hitting 60 homers in 1927.)

For 34 years following his baseball career, Ernie Shore served as the sheriff of Forsyth County and often greeted nationally known visitors to Winston-Salem, including Jackie Robinson in 1954 and President-elect John F. Kennedy, who hugged Shore. And he would lead efforts in Forsyth County to raise money for the construction of a new baseball stadium. It came to be known as Ernie Shore Field, and was the home of the Winston-Salem Carolina League team until yet another new stadium was built and opened for play in 2009.

Hometown Heroes: While Jim Thorpe's name frequently appeared in the newspapers of the early 20th century in North Carolina and throughout the nation, if not the world, almost no one through the first decade and a half of the hundred years had yet heard of George Herman Ruth.

It was far more likely at the time that the first sports heroes with whom many Southern children identified were the men who played baseball for the local teams representing the mills or the towns in general. Indeed, many Southern towns spawned numerous baseball teams, each frequently supported by the local cotton mills. From the formation of the "New York rules" for the game, and perhaps long before, baseball was the breeding grounds for not only heroes through the ages, but for a long list of characters, good and bad, with each seemingly forever branded with descriptive, one-of-a-kind nicknames.

For the most talented mill company baseball players, life was good. They were employed as mill workers, but usually were assigned to "outside" jobs that were less demanding than those requiring the long hours their neighbors spent bent over spinning frames, and at more lucrative pay. Most textile league teams were allowed a limited number of "outsiders" on their rosters so that it was not unusual for an area school coach still on the active side of youth to dress out in the hot flannel uniform of the local team, and drives to league championships in late summer frequently were bolstered by area college stars recruited for a few appearances during summer vacations from studies.

Textile baseball not only was a breeding ground for young baseball players, but for budding sports writers as well, among them Furman Bisher, one of America's foremost sports columnist through the last 60 years of the 20th century and well into the 21st. Bisher grew up in Denton, in southern Davidson County, and was intimately associated with the local team. "I was the batboy and the statistician," he once wrote. "I traveled with the team, enjoying equal status with them all on the back end of a logging truck."

Among the players bouncing across North Carolina on the bed of the logging truck was a man known as Nappy who served as the playing manager, an agriculture teacher from the local high school called Bull, and an outfielder who seemed to catch everything hit his way and thus was known as Tarbucket.

It also featured two young players named Bobby Wilkins and Max Lanier, both of whom made it to the major leagues, a rare though not unheard-of accomplishment for members of textile and town teams. Wilkins became a part-time infielder for two seasons with the Philadelphia Athletics. Lanier would become better known. A right-hander from birth who became a left-handed pitcher after twice breaking his favored arm,

Lanier would pitch the clinching game of the 1944 World Series for the St. Louis Cardinals against crosstown rival, the Browns, and then turn baseball on its ear by jumping to the Mexican League. Lanier would finish with 108 big league victories that included 21 shutouts and 91 complete games. And his son, Hal Lanier, would follow in his footsteps, but as an infielder and for a time as a big league manager.

So, even as a mere child, Bisher was exposed to an acceptable level of baseball skill, and before he was a teenager had become an authority on the rules of the game, presumably the "New York" version. Even as a mere lad not yet old enough to shave, Bisher was the team's expert on the fine points of baseball rules. When Bisher's mother once demanded that he mow the family lawn before going to the local ballpark, a chore that could not be completed in time for the start of the game, young Bisher pulled out the reel mower and obediently if not enthusiastically went to work. Across town, the game was starting and was barely two innings along when a sequence of events, the details of which now are lost to time, took place on the field that left the players, managers and umpires bewildered.

There were long discussions involving umpires, managers and players and the exchanges grew heated from time to time. Then, Nappy had an idea. "Let's go ask Furman," he suggested. Two umpires, Nappy and his counterpart for the visiting team piled into the back of a truck and were driven to the Bisher home where the lawn was by then a bit more than half mowed. They climbed from the truck, huddled with the sweaty man-child, explained in detail what had happened on the rutted diamond across town and asked for a ruling. Bisher quickly instructed the four men in the proper rules that applied to the case they had cited and what the resolution should be. He returned to mowing the grass, and they returned to the delayed game where proper order was restored and the game continued.

The mill games, usually two a week, were well-attended and when a local star made a great play, or pitched well, hats were passed through the crowds and the cash proceeds awarded to the day's heroes. Local barbershops offered free trims for outstanding play and local automobile service stations anted up free oil changes and lubrications for stellar performance.

The combination of cotton mill wages, meager though they were, and the generosity of adoring fans and supportive neighborhood businesses was payment enough that even the most talented textile leaguer found that the lure of attempting a climb through the minor leagues to possible big league fame and the limited fortune of the time had little appeal.

Legacy of the Rocks: There were, of course, exceptions. One of the most dramatic of those came in the early 1950s in Granite Falls.

In most ways, Granite Falls was the quintessential Southern textile town of the era. Seven cotton mills stoked the area economy. The Main, the local theater, featured cowboy movies most Saturdays along with long-running serials that drew customers back week after week. And the tracks of the Carolina & Northwestern Railroad dissected the town running northwest to southeast. Locals knew the line as C&NW, or "the old Can't and Never Will."

On its meandering journey from the foothills of the mountains, the Catawba River touched the most remote reaches of the small town and separated Granite Falls from the larger Hickory less than 10 miles away. In an important way, however, Granite Falls had not become typical when it came to baseball success. The town's semi-pro team, sponsored primarily by Shuford Mills, won championships for three consecutive years— 1948, 1949 and 1950—in one of the state's most competitive textile leagues. It was enough to inspire six town businessmen to band together in an effort to field a team in the professional Class D Western Carolina League in 1951.

The idea was born around a green felt-covered table in the town's smoky pool hall. Even among the racks, cue sticks, chalk and the clicking together of billiard balls, the six had no idea how large the gamble would be. Three of the men who would own the Granite Falls team were local grocery store proprietors. Tode Yount owned South Main Street Grocery, J.S. Rayfield was the proprietor of Rayfield's Grocery, and M.B. Killian operated a competing grocery that bore his name. They were joined in the venture by Harvey Wynn, owner of the local taxi service and the Main Pool Room and Café, the birthplace of the plan. Of the remaining two, John Warlick owned Falls Manufacturing Company, one of the seven mills that formed the then solid economic foundation for the working class community, and Finley German, the town's Chrysler-Plymouth dealer. German would be the team's president and Killian the business manager.

Together, the six capitalized the new team with a total of $2,000, and $800 of that was shipped off right away to George Troutman, president of the minor leagues at the time, as membership dues required to field a team in the low minors. Before the first players were signed, therefore, 40 percent of the capitalization pot had been shipped north.

"I was full of enthusiasm," German said years later. "I had seen Wayne Davis hit four home runs in one game for Granite Falls in both 1949 and 1950, and that was enough for me. I was convinced we could gather enough players to put together a good team." Davis, Pete Fox and Jack Clark, who had been working his way through the minor leagues 10 years earlier when the Japanese attacked Pearl Harbor, became the rocks around which the team would be structured. Among the best-known players joining Davis, Fox and Clark were Tim Holt, Cut Cozart and Radio Jaynes.

But the dream of the six businessmen could not have come at a worse time. Already, a national trend was underway; the minor leagues were withering on the vine all across the country as stars, such as Jack Clark, were beginning to age out of competitive trim after returning from the war and seeking to pick up their playing careers where they had left off, and public interest was being eroded for local baseball teams. Only three years earlier, 48 different minor league teams had been active in North Carolina, a state in which 81 different communities from Albemarle to Zebulon have fielded minor league teams.

By 1951, however, minor league baseball seemed to be in steep decline. Fifty-eight minor leagues had operated across the United States in 1950. Eight of those would die away over the winter and one of the survivors would be the Western Carolina League. Simply getting the season underway, however, was no assurance for struggling franchises. The entire Class C Border League closed down in mid-season in 1951 and

four other Class D Leagues, the level at which the Western Carolina League operated, were forced to finish the 1951 season with severely reduced memberships. Winning was no guarantor of success at the gate. The Pittsburg, California, team was leading the Far West League on June 13, 1951, and was out of business on June 14. Newark won the first half of the Ohio-Indiana League split season, but for fiscal reasons could not answer the bell for the second half.

Thirty-five teams, including Granite Falls, opened the season in 1951 as minor league operations in North Carolina. Greenville and Tarboro of the Coastal Plain League folded in June, ironically just five days after Tarboro put on one of the most remarkable offensive displays in minor league history. Playing at home against the visiting Wilson Tobacconists, Tarboro rang up a 31–4 victory, getting 24 of its runs in a single inning. 25-year-old shortstop Bill Carr went to the plate four times in that inning, getting a home run, two doubles and a walk. Twenty-five batters went to the plate for the Athletics before the first out in the half inning. In all, there were 17 hits in the inning, good for 35 total bases.

Five days later, the Coastal Plain League shrank from eight to six members. The Tarboro Athletics and the Greenville Robins were no more.

Unlike Tarboro, Granite Falls' futility would cover an entire season in which the team name would officially be changed, some would say fittingly, from the Graniteers to the Rocks. Even before the team's first manager had been hired, the Granite Falls businessmen, who dealt on a daily basis in cars, groceries, games of pool and cotton manufacturing, signed five players out of Red Sherrill's Carolinas Baseball and Umpires School at Newton. They were second basemen Walter Hollan of Swissvale, Pennsylvania, and Ed Shepps from Brooklyn; pitchers Charlie Hunt of Westfield, New York, and George Drum of Newton; and catcher Richard L. Strong of Norfolk, Virginia.

None survived more than a few appearances once the games began. In that, they were perhaps fortunate. In its season that began as a dream and morphed into a nightmare, Granite Falls won just 14 of 110 games, finished 57 games out of first place and 26 games out of seventh in an eight-team league.

The Graniteers/Rocks lost their first seven games of the season. It was a team that failed to win a game in August and lost its last 33 games and 59 of its final 60. Over the course of the dismal season, five men — local favorite Charles Bowles (an ex-major leaguer known as "Major" Bowles after a man by that name who ran a talent show on national radio), Ralph Barnardini, Fred Dale, Wallace Carpenter (who became a college professor) and Robert Pugh — took the reins as managers. All but Bowles remained active as players as well. The final manager, Pugh, owns the distinction of perhaps being the losingest manager in American professional baseball history. Under his direction, Granite Falls won just one game and lost 41, including the final game of the season in 14 innings to Morganton, a game in which the Rocks cemented an ignoble place in baseball history.

With that loss, Granite Falls displaced the old Cleveland Spiders of 1899 as the losingest professional team in baseball history.

Max Sinclair Deal, once the hard-of-hearing oratorio coach at Granite Falls High School, whose main building overlooked the ballpark that bore his name and in which

the Rocks played, had in his youth been an outstanding athlete, fast afoot and with a quick bat. What he had not had in his prime was the sort of physique the legendary Branch Rickey had hoped for when he was building the highly talented and respected St. Louis Cardinals minor league system.

"Bulk up to … oh … 165 or 170," Rickey suggested to Deal, "and give me a call." Deal finally bulked up, but was past 50 by the time he weighed enough for Rickey.

By 1951, Rickey's challenge had long been invalid, and well past his prime Deal, who lived almost all of his life in Granite Falls, found himself patrolling centerfield for the Rocks. To his back beyond the eight-foot chain-link centerfield fence on most nights were a handful of townsfolk who brought their own chairs and thus avoided paying admission to the games. Night after night, they urged Deal and his teammates on, frequently using colorful language in their exhortations.

Finally, even the non-paying customers were growing weary of the losing.

"Max!" one of the non-payers roared to Deal during warmups for one of the games of summer of '51. Deal wandered over to speak to the man he had known for years.

"When you guys gonna start winning some games?" the free fan asked Deal like a preacher asking a sinner when he's going to stop sinning.

"I don't know," Deal answered honestly. "We're trying."

"Well, if you guys don't start winning a few games, know what's going to happen?" the man outside the fence asked in a threatening manner.

"What?" Deal asked.

"We're gonna stop coming, that's what."

If the fans beyond the fence kept their promise to stop watching for free, they missed the most remarkable accomplishment of the team, though they were not alone in that oversight. Indeed, it was a team with one singular accomplishment that went virtually unknown for close to half a century and remains mostly ignored.

With the dismal season winding down and players defecting right and left, German worked to keep a team on the field and made history in the process. But when Leo Kantorski, a star at nearby Lenoir-Rhyne College, pitched and won both ends of a double-header for the Newton-Conover Twins against Granite Falls, the fact that the color line in athletics in North Carolina had been shattered in the game played on August 26, 1951, was relegated to the second paragraph of the story and to second billing under the small headline:

Leo Kantorski Pulls Iron Man Stunt
With Two Wins; Negroes Make Debut

In the second paragraph of the story appearing in the *Hickory Daily Record* of August 27, the new players were mentioned.

> The first Negro players to see action in the Class D Western Carolina league played for Granite Falls. All three of the colored men to play hail from Ridgeview at Hickory. Russell Shuford worked behind the plate the major portion of both games for the Rocks. Christopher Rankin pitched two innings of the first game and two and two-thirds innings in the second game. Gene Abernathy, one of Ridgeview's top all-around athletes, went in as a pinch-hitter in

the first game and played center field in the second game. Neither of the trio got a hit and Shuford was charged with two errors.

Not until two days later did the newspaper again mention black players, who now numbered five, and this time the headline was the same size as regular newspaper body type, set in all capital letters and listing only the score of the game.

MARAUDERS 10, ROCKS 3

With four negroes in the lineup—the first to play on a white baseball team in North Carolina—the Granite Falls Rocks went down in favor of Marion's Maurauders, 10–3. The negroes were Bill Smith of Newton, a catcher; Boney Fleming of Asheville, formerly a pitcher for the Negro Asheville Blues; Christopher Rankin of Hickory, a right-handed pitcher, and Gene Abernathy of Hickory, an outfielder. Another negro, Russell Shuford, a catcher, is also with the club, but not in action after suffering a broken finger. The Maurauders jumped on the Rocks for sixteen hits and a big five-run third inning to win Thursday night.

By 1992, when a book, *The Rocks*, was written documenting the dismal season at Granite Falls in 1951, all five of the players who made history by integrating a North Carolina sports team apparently were deceased. And the only known confirmation of their place in the social history of the state lies in the microfilm files of the Hickory newspaper. With 16 games left to play to the end of the season, the official scorer for Granite Falls quit apparently out of frustration with the team and was not replaced. No scoring reports ever were submitted for those games and, therefore, no official documentation is available in the files of minor league baseball. From an official point of view, the games never happened, the newspaper reports notwithstanding.

In the early 1990s, after scanning the book, noted national radio commentator Paul Harvey aired a segment on the little-known historic accomplishment in his *Rest of the Story* series. It received mention almost nowhere else.

"We weren't trying to make history," Finley German said years later. "We were trying to finish the season." Yet, it would be another decade and a half before integration began to take root in North Carolina's public venues, including sports. Neither German nor any of the five black players would ever be hailed as social heroes in the state.

A Free Man Named Free: It would be most of another decade, and a decade and a half after Jackie Robinson broke the color line in the major leagues, that baseball clearly became an integrated sport in North Carolina. And when that line finally was broken, one of the pioneers was Greensboro-born Ken Free.

Free would spend a lifetime in sports in North Carolina, including 18 years (1978–1996) as the first fulltime commissioner of the predominantly black collegiate Mid-Eastern Athletic Conference which included his alma mater, North Carolina A&T State University.

That Free was destined to be a pioneer in baseball was not a matter of choice, he said with a smile in a 2013 interview. "I was cut by the football team and the basketball

team at Dudley (High School in Greensboro)," he said. "Baseball was the only other sport available at the time."

Perhaps Free was fortunate in that. By the time he had made a name for himself as a slick-fielding infielder at Dudley, he was drawing the attention of the Greensboro Red Birds, an all-black team of the 1950s. But he also was getting feelers from the old Raleigh Tigers, a Negro League franchise with whom he signed in time to join the team for spring training in 1959.

Free was chosen for the Black East-West All-Star game in Chicago's Comiskey Park and wound up barnstorming with the colorful Satchel Paige through part of the 1960 season. Barnstorming would be no one-time experience for Free who wound up touring with the Newark Indians, Philadelphia Stars, Memphis Red Sox, Kansas City Monarchs, Detroit Stars and the Brooklyn Cuban Giants, all noted black teams of the era.

By the end of 1960, Ken had signed to play for Hickory of the Western Carolina League only weeks after another member of the league, Lexington, had signed two black players. And a year later, he and Wayne Coleman of Asheville became the first two black players to appear as members of the Raleigh team in the Carolina League just a season after Carl Yastrzemski had been a star in the state capital. With Enos Slaughter managing the team and Free playing second, Raleigh wound up playing Wilson, managed by Burlington resident Jack McKeon, for the league championship.

Wilson would win the series, 3–2, but in one of the Raleigh's victories, by a 2–0 score, Free accounted for both runs. He tripled and scored on a passed ball for one run, and later singled and drove home the second run.

"It wasn't easy," Free said in 2013. "Wayne and I had to spend the whole day when we got to Raleigh just trying to find a place to live. All the white players were taken care of; they stayed in really nice living conditions at the Sir Walter Raleigh Hotel.

"You know, when the team bus would stop on trips so the players could get something to eat, Wayne and I just stayed on the bus. And some of the white players stayed on the bus, too, because we had to.

"It was interesting to me. A lot of (black) guys couldn't adjust to the conditions. But I could adjust. I had this belief that if I had not reached my goal, nothing was going to stop me from doing that. Stopping would have been a crutch, and it would have crippled me for the rest of my life, and that just wasn't acceptable to me.

"So, I learned to focus on my goals and my endeavors, and to focus on the good people around me, and there were a lot of them including Enos.

"The thing is, you had to be perfect, and even then it wasn't enough sometimes."

Free smiled about some of the difficult times still locked in his memories. "I played in Dade City one night," he said. "They had a sign in the outfield that said that if you hit a home run over that sign, you get a steak.

"Well, I hit a home run over that sign. Do you think I was going to ignore that steak just because blacks weren't allowed to have dinner in that restaurant? Even if I had to go to the back door of the restaurant—which I did—I was going to get that steak."

In looking back, Free said he was not aware at the time that he was cast in the role of a sports pioneer. "We just spent our time helping each other," he said in the interview. "We were close with all of our teammates. I know I helped a lot of guys partly because

I was more stable when it came to coping than some of them. I had gotten my education and I had been in the military, and I knew how to stay cool."

One time, however, at Salisbury, Free came close to losing control of his temper. Playing third base that night for Hickory, Free was subjected to constant verbal abuse from a cluster of fans sitting back of a rope separating one small section of the stands from the playing field near third base.

"It was awful," Free said. "And by the time the game ended, I'd had enough and I didn't care what happened, I was going to go over there and have it out with anybody who wanted to take me on."

As Free drew close to the rope, most of those who had been so merciless verbally through the game came to their feet. "That's when I realized that this wasn't smart," Free said with a smile. "The numbers weren't in my favor. But I was there; what could I do?

"Just as I reached to move the rope out of the way, most of the people who had been in that crowd reached their hands out to shake mine. 'We just want to tell you that you're the best infielder we've seen all season,'" one of them said. The anger rapidly dissipated even if the abuse still stung.

In his late 70s and facing health problems in 2013, Free still believed that in his youth he was talented enough to play the game at the big league level. Indeed, he watched another player who he felt was less talented leave his team for a spot on the early New York Mets roster when the team, managed by Casey Stengel, played in the old Polo Grounds while Shea Stadium was under construction.

"I know I could out-hit the player they called up, but that's the way it goes," Free lamented.

Free would return once again to collegiate athletics when his baseball career had come to an end. He guided the MEAC from Division II and into the NCAA's top classification and became the first black commissioner to serve on the prestigious Men's Basketball Committee, whose primary charge is to select the teams that play for the NCAA championship.

By the time Ken Free had played a key role in breaking the color line in baseball in North Carolina, generations of black players had known the frustration of blessed talent but almost no opportunity. Among that group, as well, was Carl Long, a North Carolinian by choice though not by birth. The Rock Hill, South Carolina, native was a star in the mid-century Negro Leagues and played professionally literally all over North and Central America. But in 1956, he and Frank Washington broke the color line in the Carolina League as teammates at Kinston.

In his first season at Kinston, Long drove in 111 runs and no Kinston player had yet eclipsed that mark through the 2013 season. Long broke barriers in Kinston in other ways after his playing days had come to an end. He became the city's first black bus driver as well as Lenoir County's first black deputy sheriff and detective. In 2013, he still lived in Kinston and was an active traveler in promoting the Negro League Baseball Museum.

There is a long history of black teams playing barnstorming schedules, frequently to the entertainment of white paying customers, and a history of black teams occasionally being matched up against white "all-star" teams. If such events were intriguing curiosities for white baseball fans, they also were important showcases for black

players. Among the displays at the North Carolina Baseball Museum in Wilson is a copy of a poem obviously written by a black poet entitled *To Our Negro Ball Players*.

Get in there and go to town.
Bust those Jim Crow fences down.
Demonstrate what you can do.
Prove you're "Big-Time" players too.

Put your heart in every play
For Sunday is your "Judgment Day."
Every word and act of yours
May either close or open doors!

Is the Negro player fit?
Can he pitch, field and hit?
Has he guts and dignity?
And does he use diplomacy?

Can he smile and do his stuff
When he finds the going tough?
To these questions, you're the key;
Boys, what will your answer be?

Creative Math: Through the Great Depression and the years leading up to World War II, North Carolina was considered a national hotbed for player development through the minor leagues system, a status noted by *Greensboro Daily News* Sports Editor Laurence Leonard in editions of July 23, 1938.

Leonard wrote:

> "You will travel many miles in other states without finding the baseball hotbeds noted in North Carolina. I doubt there are any communities in other states with populations comparable to those in Mayodan, Reidsville, Mt. Airy, Leaksville, Newton-Conover, Cooleemee, Landis, Snow Hill, Kinston, Tarboro, Goldsboro, Williamston, New Bern, Ayden and Greenville with enthusiasm as keen as in those towns.
>
> "North Carolina not only leads in leagues and enthusiasm, but it also does rather well in contributions to organized baseball. I think players like John Allen, Rick Ferrell, Wes Ferrell, Monte Weaver, Buddy Lewis, Lew Riggs, Pep Young, Mace Brown, Ray Hayworth and a number of others are quite a contribution from any area. Tar Heelia gave them all. And that's something.
>
> "In addition to the natives, baseball has developed many stars in this locality. Among them are Bill Lee, Johnny Mize, Fred Oustermueller, Hank Greenberg, Johnny Vander Meer, Frank McCormick, Pie Traynor and many of the other stars who are far too numerous to enumerate.
>
> "We are in the hotbed of outstanding baseball development...."

Indeed, in those years when college football in North Carolina was yet to reach its zenith and college basketball still was a developing game in many ways, the pro-

liferation of minor league baseball in the state bordered on the remarkable, if not the absurd.

Remarkably, for four seasons through 1939, Snow Hill hosted an independent minor league baseball team in the Class D Coastal Plain League. It was the smallest town in America ever to have its own professional minor league team. Census figures from 1939 established the Greene County town's population at 928.

Almost all of the teams in the various leagues in North Carolina played on mostly bandbox baseball fields with wooden grandstands located back of home plate. But a new era in the minor leagues as the 21st century dawned would bring modern facilities that would have been beyond the possibility of dreaming in pre-war years. By 2013, only one of those old wooden stadiums remained in North Carolina. Hicks Field in Edenton was constructed as part of the Works Progress Administration in 1939, and though changes and improvements have come over the years, Hicks is the only baseball field in North Carolina with its wooden grandstand still intact almost as it was in 1939. It still is used by the John A. Holmes High School Aces and the Edenton Steamers of the Coastal Plain League, now a college summer league. Hicks Field was placed on the National Register of Historic Places in 1995.

The original Coastal Plain League in which Edenton competed for a time also was the league and the era that gave minor league baseball in the state perhaps its most absurd historic footnote on August 1 and 2, 1939, and the Snow Hill Billies played a significant role in the strange development.

By rule, teams in the Coastal Plain League could employ a limited number of what were called "class" players, competitors who had seen action in 10 or more games as parts of teams in higher classifications. When it was discovered that three teams, Williamston, Greenville and Goldsboro, had exceeded the limit on "class" men, league president J.B. Eure made an executive decision to penalize the three offending clubs by invalidating the results of games each of the teams had already played while using more "class" players than permitted by rule.

The plot thickened when it was discovered that not only Williamston, Greenville and Goldsboro had violated the "class" rule, but all the teams in the league had gone beyond the rule's limitations at one point or another.

In an effort to restore order, one of the directors made a motion that the games in question for Williamston, Greenville and Goldsboro be restored and the season be allowed to continue as though no rules had been broken.

But another rule, that any action taken by the league must be unanimous, became a roadblock to that solution. And Snow Hill was strongly opposed to giving back the games in question because when the league standings were recalculated following Eure's penalty against the three teams, Snow Hill had magically moved up in the league standings from dead last to third place.

The argument continued until three in the morning when, according to the *Greensboro Daily News*, "the adding machine was forgotten and games were strewn here and there in the standings." The result was that Goldsboro, Greenville, Ayden and Williamston were left in a dead heat for fifth place each with records of 41–38. Snow Hill, once dead last, lost its temporary hold on third place but slipped only to fourth

with a record of 49–30 just a half game behind Kinston at 50–30. New Bern rested in second place at 52–30 and Tarboro led the league at 54–28.

The revisions not only left every team in the Coastal Plain League with winning records and in the running for playoff positions with the season winding down, but it also left the league with an overall record of 360 games won and only 270 lost, a mathematical impossibility in what was considered baseball's eternal .500 world.

Fiscal solvency not only of teams, but managers and players as well, always was tenuous in the low minors, especially through more than the first half of the 20th century when many teams, especially those in the lowest classifications, were independently operated and were, thus, without the backing of major league organizations.

Folding teams and disappearing leagues became commonplace following the peak years immediately following World War II, and the demise of teams and leagues was fueled primarily by independent minor league operations that became insolvent.

The boom years for professional baseball when virtually all teams would be backed by major league organizations were still decades away in 1951 and the struggle to succeed financially was a part of existence in the minors. That sort of frustration was confirmed in a letter from Frank L. "Bull" Hamons to George Troutman, the president of baseball's national association, a title that made Troutman in essence the commissioner of the minor leagues.

Hamons had spent the post-war years of 1946, '47 and '48 as the manager of the Tarboro Tars, an independent team in the Coastal Plain League. In 1950, he signed on with the Cincinnati Reds to manage the Wilmington Pirates. But by June, 1951, he was back in the Coastal Plain League as manager of the Rocky Mount team as the replacement for the legendary Jim Mills, and by that autumn when the season had come to an end Hamons was apparently awaiting payment for his services.

In an undated hand-written letter to Troutman, Hamons appealed for assistance in collecting money he felt he was due. The letter, on display at the North Carolina Baseball Museum in Wilson, makes the case.

> In June Mr. Frank Walker, President of the Rocky Mount N.C. team of the Coastal Plain League hired me to manage his club. I was at that time at my father's home in LaGrange, Ga. Mr. Walker ask (sic) me to go on a scouting trip through Georgia, South Carolina and part of North Carolina, looking over semi pro leagues to try to sign the players necessary to get the Rocky Mount team out of the cellar. He wired me fifty dollars ($50) for expenses. This did not cover the trip as it cost me more than $50 plus the use of my car. He never said anything about settling up with me until Aug. 15 when he released me and deducted the $50 from my pay. He claimed the money he wired me was an advancement on salary and that no club is required to pay a manager transportation from his home to the club.
>
> It is about 650 miles straight through from LaGrange to Rocky Mount and I drove a little over 1000 miles hunting players and coming up, plus hotel bills. I think that he should pay me at least 5 cents a mile for my car over the $50 he sent me. Please let me hear from you regarding this matter soon. Thanking you I am, Sincerely yours, Frank L. "Bull" Hamons.

It is not recorded whether the matter was ever settled.

But at the time of Hamons' letter, the minor leagues as North Carolina had known them for half a century were fading from the scene. Small towns such as Snow Hill no longer were part of the professional baseball landscape and the minor leagues in the state would dwindle down to a low point in the mid- to late-1950s.

When Organized Baseball, as the national minor league system was known, redesigned its structure in 1962 and 1963, independent teams existed no longer except in a few well-organized independent leagues centered mostly in New England and the upper Midwest.

Where Good Players Became Great: Even if much of minor league baseball in North Carolina operated on a shoestring, or less, the years immediately following the war were halcyon days in the dusty ballparks of the state.

Laurence Leonard in his pre-war column in which he referred to major league stars who had at one time played the game in North Carolina was accurate, of course. A part of the appeal of the minor leagues was then and continues to be the opportunity for baseball fans a long way from Yankee Stadium or, later, Candlestick Park, for example, to get a look at stars on their way to the big leagues.

If anything, that opportunity would increase in the years following the war and still is an honored tradition to this day. Minor league teams in North Carolina have fitted their uniforms upon thousands of baseball players, many of whom never became famous or long remembered. But old-timers still remember that Eddie Mathews played for High Point-Thomasville before he launched his Hall of Fame career with the Braves. Earl Weaver managed in Winston-Salem before he became the tempestuous umpire-baiter in Baltimore as the field boss of the Orioles. Carl Yastrzemski's name was mispronounced in Raleigh long before he became simply Yaz in Boston. Rod Carew, Curt Flood, Harvey Haddix, Harmon Killebrew, Don Mattingly, Willie Stargell, Sparky Anderson, Eddie Murray, Bobby Bonds, Curt Schilling, Todd Helton, Derek Jeter and hundreds of other names baseball fans would recognize because of their later big league careers have worn uniforms representing North Carolina towns and cities.

Yet, some of the biggest of North Carolina's minor league stars never made it to the big leagues, or played there relatively briefly if they did. One of the best-known, non-major league baseball players ever in the Greensboro and Winston-Salem area was Walter (Tee) Frye, who played for seven seasons in the Carolina League at Leaksville, Winston-Salem and Reidsville. Frye, who coached both basketball and baseball at Oak Ridge Military Academy through the years in which he starred in the minors, still holds the Carolina League record by appearing in a total of 953 games in which he went to bat 3,629 times and had 929 hits, both also Carolina League records. The Frye Award still is given to outstanding athletes at Oak Ridge Military Academy.

Lawrence Columbus Davis was a fixture around Greensboro until his death in 2001 at the age of 82. Like so many baseball players of his era, his career was interrupted by the onset of World War II, just after he had won a spot on the roster of the Philadelphia Athletics. He had carried with him a nickname that had been his since at age 14 he collided with a teammate as both attempted to catch a fly ball.

Crash Davis never made it back to the big leagues when the war was over, but played for Durham of the Carolina League while seeking a graduate degree at Duke University. Kevin Costner played the role of Crash Davis in the popular baseball movie, *Bull Durham*.

"Relax, all right?" Crash said in the movie. "Don't try to strike everybody out. Strikeouts are boring! Besides that, they're facist. Throw some ground balls—it's more democratic."

After the movie was released, the real Crash Davis' celebrity status in North Carolina increased immeasurably thanks to Costner than it had ever been in hitting .230 in 148 games for Philadelphia. And perhaps he enjoyed it even more. After the release of *Bull Durham*, Davis' friendship with the movie's director, Ron Shelton, led to a bit part for Davis in *Cobb*, the Shelton-directed movie based upon the life of the controversial baseball star of the first half of the 20th century, Ty Cobb.

Almost as appealing was Moonlight Graham, a Fayetteville native who played in one game in the major leagues for the 1905 New York Giants, but never came to bat. But he found fame in W.P. Kinsella's novel, *Shoeless Joe*, and later in Kevin Costner's *Field of Dreams*. The real Moonlight Graham wound up as a family medical doctor in a small Minnesota town for 40 years.

Falling into the trivia category also is Luke Stuart of Alamance County. The Guilford College product appeared in three major league games in 1921 for the St. Louis Browns and had a career total of three at-bats. But he is one of just two men who have hit inside-the-park home runs in their first big league trip to the plate. The homer by the Burlington native came off Walter Johnson.

Cue the Mills Brothers: If, however, there were ever a North Carolinian for all seasons in baseball, it would have been Jim Mills of Apex. Jim and his twin brother, Joe, were teammates for a time at Raleigh where Jim starred in 1946 and 1947 and led the Caps to victories over Durham for post-season championships both years.

Jim became player-manager at Concord in 1948 and held the dual position through the 1953 seasons at Concord, Mooresville and Rocky Mount in the North Carolina State League, the Coastal Plain League and the Tar Heel League. He won 308 games and lost 255 as a manager and finished with a career minor league batting average of .310.

But Jim's career wasn't finished. He went on to become a general manager, an umpire, a roving expert and league president. He also found time to sell sporting goods and became one of North Carolina's top football and basketball officials spending 18 seasons officiating high-pressure Atlantic Coast Conference basketball games.

The Mills Cup is awarded annually to the winner of the Carolina League post-season championship.

The Remarkable Woody Fair: The effect that the United States' involvement in World War II had on the talent pool at the major league level has been well-documented over the years. The same, of course, was true in the minor leagues and perhaps no one felt it more keenly than Woody Fair.

At 5-feet-10 and 165 pounds, Fair was not the image of the quintessential professional baseball player even in the pre-war years and, indeed, spent five seasons in the low

minor leagues in the late 1930s before ascending to within a step of the big leagues at Toronto, then a triple A member of the International League. But Fair spent 1944 and 1945 putting together B-29 bombers in Wichita, Kansas, and spent some time there playing semi-pro baseball.

By the time the war came to an end, Fair at the age of 32 seemed past his best years as a major league prospect and became one of the most feared hitters ever in the Carolina League, playing for Durham. In 1946, he hit .348 including a Carolina League record for doubles that still stands, 51, and belted 24 home runs. Remarkably, he not only scored 161 runs that season, but also drove in 161. In 601 career games in the Carolina League, Fair had a batting average of .324, hit 123 home runs and drove in 559. In his total minor league career, he also stole 263 bases, but was never able to make the run to the big leagues.

A Legend Called Muscle: Leo Cleveland Shoals was born in the sawmill town of Gauley, West Virginia, on October 3, 1916. Almost a century after his birth and almost a decade and a half after he died in 1999, he still is the stuff of legend in minor league baseball, particularly in Reidsville.

By the time he arrived in Reidsville to join the Luckies after losing four baseball years in World War II while fighting his way across some of the islands of the Pacific, he already had a nickname, Muscle. Given to him by members of St. Louis' famous major league "Gas House Gang" in the pre-war spring of 1938, it was, like so many baseball nicknames, perfectly chosen. Shoals weighed close to 230 pounds with muscles that rippled, and he apparently never backed away from a fight.

A left-hander, he began his baseball life as a catcher with the mitt on his right hand, but then moved to first base where he was stationed for almost all of the remainder of his playing days. As a youngster, Shoals and his father once traveled to Washington where he saw Babe Ruth play in a doubleheader against the Senators, and he pinned photos of Ruth clipped from magazines over the walls of the room back home in which he slept until there were no empty places on the bedroom wall of the saw mill town house.

What young Leo could not have known at the time was that he would become known as the "Babe Ruth of the minor leagues." Even that reputation wasn't enough to get Shoals to the big show. He never made an appearance at the major league level other than in spring training with the Cardinals. But he was certainly Ruthian with the Reidsville Luckies. Shoals played only one full season and, later, part of another, when his career was winding down, in North Carolina and both times it was as a Luckie. But that was enough to solidify legendary status. In 1949, the best year of his career, he belted 55 home runs for the Luckies, which still stands as a Carolina League record and was only once challenged. The challenge came from Tolia "Tony" Solaita, the only player from American Samoa to play in the big leagues, who hit 49 homers in 1968 for High Point-Thomasville.

Shoals also led the Carolina League in runs batted in during 1949 and missed winning the batting title by a mere .002. The pinnacle of his season probably came against Greensboro on June 12 when he hit three home runs and singled off the top of the out-

field wall inches from a fourth home run, a feat never achieved in the Carolina League. He had 15 total bases for the game.

His 1949 season was the one that once again put him on the radar in the big leagues. Both the Pittsburgh Pirates of the National League and the St. Louis Browns of the American sought to sign him to a major league contact. He turned both down. Tired of traveling by then, Shoals told the Browns that he could not afford to take a cut in pay to play in the big leagues, in part because his wife was pregnant with the couple's first child. He knew he would be needing the proceeds from the passed hats still prevalent in the low minor leagues at the time and the occasional $20 post-game hand-shakes.

He never played in the big leagues, not only because of the pay cut he had said he would have to take, but because he became known as a manager's nightmare. At New Iberia, Shoals claimed that field manager Garrison Wickel called him a "bad name" and refused to take it back "so we had a real good one in the clubhouse." And in 1939, Shoals got into a physical confrontation in a roadhouse during the off-season and was shot and seriously wounded by the bartender, but recovered.

At the age of 39, Shoals hit a remarkable .362 for Kingsport, led the league with 33 home runs and drove in 134. In 15 seasons, Shoals had played in exactly 1,800 games. He took his uniform off and never played again. In a later interview, he told one reporter that "I did hell around, there was no question about it. Any advice I'd give a ballplayer today would be lay off them bars at night."

Five years after his death, the "Babe Ruth of the minor leagues" was honored in his hometown when the Washington County Park Authority dedicated a Department of Recreation playground in his memory. His name was misspelled on the marker.

The Duke of Spero: Perhaps North Carolina's most remarkable minor league career, however, was that of Jesse Morgan "Rube" Eldridge. Born in Glenola in 1888, Eldridge made his professional pitching debut for the Greensboro Champs of the Carolina Association on July 16, 1909. In that game Eldridge won the first of 285 minor league victories he would record with a six-hit 3–1 victory over the Anderson Electricians in front of a remarkable, for the times, crowd of 800 fans at Cone Field in Greensboro.

In all, Eldridge, a left-hander, would pitch for a quarter century and end it in much the same fashion as it began, with a nine-hit, 9–3, victory for Greensboro over the Richmond Colts relying mostly on what he called "my usual slow ball." In between, he wore the uniform of 11 different minor league teams, pitched an incomparable 4,496 minor league innings including 15 seasons with 200 or more innings pitched, and he would have 20-win seasons seven times including a 26–9 record in 1922 with the High Point Furniture Makers.

Along the way, he became known as the "Duke of Spero."

Eldridge was so popular that when High Point brought back the aging lefty, which the team called "a relic from baseball history" in its hype for the occasion, for one final appearance after two years of barnstorming, a riot ensued after he was removed from the game with a three-run lead. Police had to be called in to quell the uprising by most of the 500 fans in attendance.

Again and again during the peak of his career, Eldridge was approached by the legendary manager Connie Mack in attempts to sign him to a contract to pitch for the Philadelphia Athletics. Again and again, Eldridge refused to leave his beloved North Carolina even for big league fame.

His explanation always was the same. "I don't want to play anywhere I can't walk home," he said.

He seldom did.

The Judge Lays Down the Law: The strong man behind the men of minor league baseball not only in North Carolina, but throughout America, for much of the critical seasons of the 1930s and 1940s was William Bramham who ruled organized baseball from Durham, first from his law offices and then from offices set aside specifically for the administration of his national minor league duties.

A lawyer and a judge, Bramham was the third president of the National Association of Baseball Leagues, the popular umbrella name for all the minor leagues in America. The former president of the North Carolina State League, the Piedmont League, the South Atlantic League, the Virginia League and the Eastern League, Judge Bramham brought stability to the minor league game and shepherded it through the near-fatal World War II years. In those positions, he had seen teams and leagues come and go.

In order to bring stability to minor league baseball, Judge Bramham designed business measures to eliminate what he referred to as "shoestring operators" from the game. He insisted that owners demonstrate moral integrity and back up their operations with guaranteed financial deposits. He so adamantly held all clubs to those standards that Judge Bramham become known as "the czar of the minor leagues." But his plan worked, stability improved during his 14-year reign, even through the lean war years when the 41 leagues nationwide dwindled to just nine by 1943.

Through it all, the judge became a staunch supporter of umpires and issued directives to league presidents to protect the game's arbiters from physical and especially provocative verbal attacks from both uniformed and non-uniformed personnel. Until Bramham's edicts, umpiring had been a risky business, and for a time even after the judge's edict remained so.

On June 2, 1951, for example, with the Danville Leafs in Durham to play the home-standing Bulls, umpire Emil Davidzuk was "knocked flat on his face" when Leafs shortstop Mike Romello was called out for leaving third base early on an apparent sacrifice fly by his teammate, Johnny Stefanik. In the stands that night was A.R. Wilson, judge of Durham's Recorder's Court, who immediately ordered an assault warrant for Romello. At nine o'clock the following Monday morning, Romello entered a guilty plea and was fined 25 dollars.

Carolina League President Ted Mann then suspended Romello for the remainder of the season. Mann said that Romello had violated league rules and that his conduct in the game had been "detrimental to the best interests of baseball," a ruling that had come into being during Judge Bramham's years at the head of the national minor league organization and continues to be a catch-all rule.

Judge Bramham would not live to see his defense of umpires everywhere work in the Romello case. He announced his retirement as the "czar of the minor leagues" on

the eve of the 1946 winter meetings, but agreed to remain in the role of consultant to the new president, George Troutman. But his duties as Troutman's consultant were not to be; Judge Bramham died within months of turning over the reins to Troutman.

Never on Sunday: Collegiate athletic competition began in a sputtering fashion in the nineteenth century in the years following the Civil War when football clubs were formed on campuses across the state. But when Trinity College, later to become Duke University, under pressure from the school's sponsoring Western Carolina Methodist Conference, banned football in 1894 because of the sport's brutal nature, the move perhaps gave rise to one of the great rivalries in college sports history. Hoping to justify the ban beyond the brutality explanation, Trinity officials also pointed to a concern for what they perceived as the encroachments of professionalism, and pointed to the then-recent success of the football program at nearby UNC as an example.

The charge brought on a cold war between the two neighboring schools. The two schools met occasionally in tennis and multi-team track competitions, but refused to launch UNC-Trinity competition in the sports that already mattered even in the second decade of the twentieth century—football, baseball and the new sport, "basket ball." But it was baseball that brought about a thaw in the sports cold war. In the spring of 1919, the Carolina baseball team traveled to East Durham to face Trinity in the first major athletic competition in 21 years. Ironically, the two teams played for 15 innings and settled for a 0–0 tie when descending darkness made further play impossible. A week later, UNC returned to the same field, left muddy by rain, and took home a 3–2 victory. One of the most heated rivalries between major sports programs was thus born long before the birth of the Atlantic Coast Conference.

Once the basketball rivalries involving four schools, Carolina, Trinity/Duke, North Carolina State and Wake Forest, grew white-hot, baseball from the point of view of fan passion took a back seat.

In the early years of the 21st century, baseball at the four schools has been on solid footing and in 2013, both N.C. State and Carolina wound up in the College World Series in Omaha, Nebraska, with the Tar Heels going in as the national No. 1 seed, a placement that the team would not be able to sustain. It was the Tar Heels' sixth trip to Omaha in eight seasons while it was the Wolfpack's first trip to the Series since 1968.

The two ACC schools are not alone, however, in post-season success. James Mallory coached East Carolina to the National Association of Intercollegiate Athletics championship in the spring of 1961. And on display in the North Carolina Wesleyan trophy case are NCAA Division III national titles for both 1989 and 1999, the first under the direction of Mike Fox who moved on to Carolina in 1998 and since has taken the Tar Heels to six College World Series, and the second led by Charlie Long as coach.

Wesleyan remains the only school in the state with two national baseball championships.

As had Duke and Carolina earlier, Wake Forest also had developed a solid baseball program through the 1930s and in the years immediately following World War II and had sent several players to the big leagues, among them pitchers Tommy Byrne and Ray Scarborough.

Indeed, it was Wake Forest that gave North Carolina and the young Atlantic Coast Conference its first national collegiate championship of any kind when it won the 1955 College World Series title with a 7–6 victory over Western Michigan.

It was an event that in an earlier round had shattered the Sunday silence in the town of Wake Forest, then the home of the school's main campus. In the hours ahead of the quarterfinal game half a country away in Omaha, summer school students on campus rigged up a loud speaker system "and the Omaha radio announcer's voice rang out to all corners of town," according to a newspaper report.

It was a moment of euphoria for many Wake Forest followers, but an event that was not greeted with great acceptance by everyone, particularly Baptists who disdained any sort of sports competition played on Sundays. Indeed, it is likely that the dramatic voice on the campus loud speakers did nothing to sooth offended churchmen.

"If I had known about this Sunday game, I would never have given my permission for it to be played," Wake Forest President Dr. Harold Tribble was widely quoted in newspapers across the United States. Rev. Dennis Hockaday, pastor of Durham's First Baptist Church, sharply criticized the playing of the national title game on a Sunday during his weekly sermon. He also dispatched a pointed telegram to Dr. Tribble in which he wrote that "forfeit of the game is preferable to forfeit of the principles of Christianity."

The team itself, meanwhile, seemed to have little concern for the theology of the moment and was caught up in the euphoria of the chase for the title that would prove successful the following Thursday. And when the team defeated Western Michigan, the Wake Forest coach, Taylor Sanford, boldly predicted that Wake Forest would be in the Series field again the following season. The Deacons, he pointed out, had won the 1955 crown with a team whose only senior, Tommy Cole, had been injured early in the Omaha competition and had missed the final run to the championship.

Only two weeks earlier, there had been a question whether Sanford himself would return for the 1956 season. Newspapers in North Carolina were speculating that the Omaha trip would be Sanford's last as Wake's coach, and through the early days of the national tournament baseball coaches who coveted the job were known to be submitting their resumes.

Sanford and his players were greeted as heroes when they arrived at Raleigh-Durham airport with the championship trophy in hand.

The Men in the Hall: By the autumn of 2013, almost 400 North Carolinians had played major league baseball, some as briefly as a single at-bat and some long enough to leave permanent imprints upon the game. Seven of them are enshrined in the National Baseball Hall of Fame in Cooperstown, New York.

Luke Appling: The first of those was the late Luke Appling, considered a North Carolinian by birth but a Georgian in reality. Appling, who would become a star shortstop for the Chicago White Sox and win two American League batting titles, was born in High Point on April 2, 1907. He was only months old when his family moved to Georgia where the man who became known as "Old Aches and Pains" spent most of the rest of

his life. Interestingly, his name is not listed for consideration for induction into the North Carolina Sports Hall of Fame, a plight he shares with other noted members of the sports world not known as North Carolinians despite the fact that they were born in the state. Among those is the late broadcaster Howard Cosell and baseball's Mark Grace, both of whom were born in Winston-Salem.

Buck Leonard: Because of Appling's tenuous link to North Carolina, for a dozen years Walter Fenner "Buck" Leonard, who was voted in by the Negro League Committee in 1972, was considered the only North Carolinian to be enshrined in the Baseball Hall of Fame. Leonard's linage was without question; he was born in Rocky Mount on September 8, 1907, died there November 27, 1997, and spent much of his life in Tarboro.

Known as "the Lou Gehrig of the Negro Leagues," Leonard was a slick-fielding, smooth-hitting first baseman first for the Brooklyn Royal Giants and then for 17 season, longer than anyone in history, as a member of the dynastic Homestead Grays, considered the finest of the Negro League teams and one stacked with players, including Leonard, who could have been stars in the big leagues but for segregation. Leonard's Grays roommate was the incomparable Cool Papa Bell, considered the fastest man ever to play the game. Other Grays included the legendary catcher Josh Gibson, among the game's greatest hitters, and equally legendary pitcher Satchel Paige.

"Trying to sneak a fastball past him was like trying to sneak a sunrise past a rooster," Hall of Famer Monte Irvin, one of major league's first black players after the arrival of Jackie Robinson, once said of Leonard. Interestingly, Leonard earned his high school diploma when he was 52 years old because his hometown, Rocky Mount, had no high school for African-Americans when he grew up.

Enos Slaughter: Enos Bradsher "Country" Slaughter was known as baseball's premier hustling player long before Pete Rose popularized the term in the 1960s and 1970s. Though he hit .300 or better in 10 of his almost 20 years in the big leagues, Slaughter is most remembered for one play. It was Slaughter's mad dash from first base on a double by Harry "The Hat" Walker that gave St. Louis its 1946 World Series championship over the Boston Red Sox.

Slaughter managed in the minor leagues, including at Raleigh, when his playing career had ended and spent much of the remainder of his time raising tobacco on his Roxboro farm and campaigning for induction into the Hall of Fame, finally being voted in by the Veterans Committee in 1985.

Hoyt Wilhelm: Huntersville native Hoyt Wilhelm had a career as unpredictable as the pitch that got him into the Hall of Fame, the knuckleball. The right-hander didn't reach the major leagues until he was 28, but threw his last knuckleball at the age of 50 on behalf of the Los Angeles Dodgers, his ninth and final big league team.

He threw his first for the New York Giants in a game in which in his first big league at-bat Wilhelm belted a home run. He appeared in a then-record for pitchers of 1,069 games primarily as a reliever and never hit another home run but wound up winning 143 games, 124 of them in relief. In 1958, the Baltimore Orioles pressed Wilhelm into

service for one game as a starting pitcher, and he threw a no-hitter against the New York Yankees.

Like many of his baseball contemporaries of the time, the knuckleballer served in the military during World War II and received a Purple Heart for injuries he suffered in the Battle of the Bulge. He was elected to the Hall of Fame in 1985.

Catfish Hunter: James Augustus Hunter, nicknamed "Catfish" by Athletics owner Charlie Finley, was arguably the most dominant pitcher of his time. The Hertford native pitched for the A's in Kansas City and Oakland from 1965 through 1974, then finished his career as the ace of the New York Yankee staff from 1975 to 1979. He pitched a perfect game in 1968 and won 21 or more games five years in a row before arm trouble brought his career to an end when he was 33.

Finley invented the story of Hunter's nickname as a backwoodsy young man who spent his free time catfishing. In reality, Hunter was an avid fisherman, and was said to have mentally mapped all the best fishing waters on the Perquimans River near his home, but for bass, not catfish. He died in 1999 of ALS, the disease commonly known as "Lou Gehrig's disease" after another of its victims, Yankee legend Lou Gehrig.

Gaylord Perry: Another eastern North Carolina town, Williamston, produced a pair of brothers, Gaylord and Jim Perry, the only siblings to both win Cy Young Awards. And Gaylord became the first man to win the top pitching award in both leagues, for Cleveland in the American League and later for the San Diego Padres of the National League. Jim was the star on the staff of the Minnesota Twins.

Gaylord reached and surpassed two magical pitching milestones with 314 wins and 3,534 strikeouts. He won 20 games or more five times and finished his controversial career with a lifetime 3.10 earned run average. The controversies centered around charges at the time that Gaylord, whose unusual mannerisms on the mound seemed at times a distraction to hitters, occasionally threw a "spitter," an illegal pitch that seems to dive at the last second as it approaches the plate. "You just have to hit it on the dry side," Atlanta catcher Joe Torre once advised his teammates. When he announced his retirement, Perry joked that "the league will be a little drier now, folks."

Gaylord played for eight different major league teams and was voted into the Hall of Fame in 1991.

Rick Ferrell: The election of Richard Benjamin "Rick" Ferrell to the Baseball Hall of Fame in 1984 is in essence the story of baseball in North Carolina through the first half of the 20th century. Ferrell was one of seven brothers born and raised on a dairy farm between Greensboro and Colfax, and three of the seven played baseball at a level at least as advanced as the minor leagues. And there always was parental pressure on the baseball-talented Ferrells to spend less time perfecting their games and more tending the dairy herd and accomplishing other farm chores.

Rick already was having an impressive minor league career when the Great Depression hit, and the pressure, particularly from his father, to return to the farm, became even more intense. Feeling that from a baseball point of view he was being held

The seven baseball-playing Ferrell brothers: (left to right) Ewell, George, Hall of Famer Rick, Kermit, Marvin, Basil and accomplished major league pitcher Wes.

down on the farm, as minor league systems are known, too long in baseball, Rick appealed to the commissioner, Judge Kennesaw Landis, and Landis agreed. In essence, he made Rick baseball's first-ever free agent, granting him permission to sign with any major league team that would carry him on the big league roster.

Among the teams interested was the St. Louis Browns of the American League who offered Rick what was then a record signing bonus of $28,000. With the contract signed and the money in his pocket, Rick traveled home to Guilford County, gave the entire signing bonus to his father, perhaps saving the farm during the Great Depression in the process, and headed off to his first major league spring training.

He caught 1,806 major league games, a record that stood for 40 years. By the time of his induction into the Hall of Fame, Rick had moved through the Detroit organization as a scout, farm director and finally as the team's general manager and was one of the men credited with building the Tigers into a World Series contender and a perennial power in the American League.

Injuries perhaps cost George, one of Rick's brothers, a shot at big league baseball, but he still spent 20 years in the minor leagues as a player and manager. But there has

never been a brother combination such as that of easy-going, level-headed Rick, a catcher, and quick-tempered Wes, a pitcher. So accomplished was Rick behind the plate that he drew an assignment as the No. 1 catcher with the Washington Senators of doing what few catchers have ever been asked to do, catch four starting pitchers for whom the dancing knuckleball was their "out" pitch.

He was so highly regarded in an era of excellent catchers that Connie Mack made him the starter for the first-ever Major League All-Star game and he caught all nine innings. Wes at the same time became one of the major leagues' best pitchers. He also belted out 39 home runs, more than any pitcher in history.

Rick Ferrell died in Bloomfield Hills, Michigan, in 1995 and lies buried in a plot at New Garden Friends Cemetery in Greensboro near other members of his famous family. A baseball, weathered and devoid of its cover, lies beside Rick's modest marker. No more than a perfect bunt away, the spot marked by yet another unobtrusive chunk of granite, lie the remains of Wes. Their resting places are covered with a healthy stand of grass kept manicured at about infield depth and their graves are shaded through much of sunny days by tall hardwoods that already were structures of majestic strength when the childhood brothers Ferrell—all seven of them—played baseball in farm fields not far from where Wes and Rick now rest next to close kin. Across the busy College Avenue from where the Ferrells are interred is the picturesque campus of Guilford College where Rick once honed his skills as a collegian.

Baseball had been the Ferrell brothers' passion and they coupled it with another game which had no particular name. It was a game of brother trying to outdo brother with each marking the places where distant well-struck line drives had come to rest. "Move that stake if you can," one Ferrell brother would challenge the other. And there the stake would remain until a driven baseball had traveled yet farther. Then the stake would be moved and a fresh challenge offered.

Moving the stake was a game that survived even when Rick and Wes became major league baseball stars and played their games in places called Cleveland, Boston, Washington, New York and Brooklyn. And the childhood game survived as brothers again and again used it to measure themselves against their siblings even though Rick was a catcher and Wes a pitcher who were doing their measuring in the major leagues.

Though Rick and Wes played on the same major league teams for much of their careers, there was the summer afternoon in 1933 when Rick, then a catcher for the Boston Red Sox, tapped his bat on home plate as he stepped up to take his turn in the order. He looked out at the mound where his brother, Wes, was glaring in as the starting pitcher for the Cleveland Indians.

Though Rick was not known as a power hitter, he could feel the sweet click of the bat against the baseball when he connected with one of Wes' offerings and he knew instantly that he had hit it well. As he hurried toward first base thinking he had a double or triple, Rick watched the ball disappear beyond the left field fence for one of the 28 home runs he hit in his entire major league career. Rick could feel Wes' eyes glaring as he slipped into his home run trot just past first base. By the time Rick reached second, he had something to say to his brother who still stood on the mound glowering.

"Hey, Wes, go put a stick up for that one," Rick called out his challenge, a smug feeling engulfing him. Wes didn't put up a stake though he certainly did it emotionally as he kicked the mound again and again.

That was one of the ways Wes and Rick were very different. Though Rick was known on rare occasion to vent his feelings in the course of a game, Wes was known for his outbursts and even was fined and suspended once when he left the mound because he felt his teammates weren't trying hard enough. Wes had what would in later years be called a very short fuse. And it was smoldering when Rick drilled the home run off Wes, but younger brother kept his emotions under control for once.

"Wes came to the plate the following inning," Rick recalled years later, "and he hit a home run. As he crossed home plate, he looked at me with a big smile on his face. I knew what was coming."

"OK, Rick," Wes said, "looks like you're gonna have to go move the stick."

Wes still holds the major league record for home runs by pitchers who are not known for playing any other position. Though he was one of the best-hitting pitchers on record, Wes became the first pitcher ever to win 20 games or more in each of his first four seasons in the big leagues. He had six 20-win seasons in his 15-year career and led the major leagues in victories with 25 in 1935. Rick was Wes' catcher in all 25 of the victories and in 141 of his major league starts.

Indeed, Rick perhaps played a role in prolonging Wes' big league career. Once a pitcher feared for his fastball, by the end of 1933, Wes had suffered through his second season with the Cleveland Indians with a sore arm. Though he compiled an 11–12 record on the mound, by late in the season, he seemed so washed up as a pitcher that the Indians tried him as an outfielder because of his hitting ability. Defensively, the experiment was a disaster and Wes faced a winter in which there may be no spring training for him on the other side of the chill. But during the winter, Wes pitched to Rick behind the barn back home on the dairy and some of the old fire seemed to be there to the point that he was demanding a raise from Cleveland to $18,000 and made it clear that he would not report to spring training for less.

When Boston owner Tom Yawkey asked Rick about acquiring his brother, Rick had a quick response. "I told him to grab Wes quick, even if it cost him lots of money," Rick said years later, according to *Rick Ferrell, Knuckleball Catcher*, a 2010 book written by Rick's daughter, Kerrie Ferrell. Even if Wes' blazing fastball no longer was as fearsome as it once had been, Rick was convinced that his brother still could win in the big leagues.

The test would come on May 30, 1934, when Wes was called in from the bullpen with two out in the bottom of the eighth against the Athletics in Shibe Park in Philadelphia. Rick remembered:

> "That day in Philadelphia, I thought it was going to be just a matter of minutes before Mr. Yawkey fired us both," Rick said. "Wes started throwing his six warmup pitches and the ball didn't have enough on it to break out a cellophane wrapper. God knows what happened to that fastball he showed me in Greensboro during the winter, but I swear I could throw the ball back to him left-handed with more stuff than he was throwing me.
>
> "Eric McNair was up and here comes Wes' first pitch, and it looked as fat as a balloon, and I say to myself, 'Here's where we both get canned.' And then we got lucky. McNair popped it straight up over the plate and I took it for the third out and we were out of the inning. Wes shut 'em out in the ninth."

From that point, Rick became Wes' pitching manager to an even greater degree than in the case with most catchers. He understood that his brother no longer was a thrower, but now perhaps could become a pitcher in the classic sense of the word. With Rick calling all the shots, Wes learned the fine art of pinpoint control and keeping batters off balance.

"He could throw more junk up to the plate than any man I ever caught," Rick said. "He threw slow curves, and slower ones, and dipsy-doodles and knucklers and gave them nothing good to hit."

Wes already had four seasons of 21 or more victories before Rick talked the Boston owner into signing his brother. With Rick calling the shots, Wes would win 25 games in 1935, second only to Dizzy Dean, and 20 in 1936 and in three straight seasons of 1934, 1935 and 1936, he would work 322⅓ innings, 301 innings and 281 innings. By the time his career had come to an end as both a pitcher and the most prolific home run-hitting pitcher in history, Wes had had what many considered a Hall of Fame kind of career as well. He was never selected.

In his final words during his induction ceremony in 1984, Rick's eyes grew moist and he paused to take a deep breath. "I guess what I'm doing here," Rick said, emotion heavy in his soft voice, "is putting up a stick for Wes." A large bronze plaque honoring the Brothers Ferrell is one of four affixed to the sidewalk wall just beyond the grassy knoll in foul territory beyond the right field foul pole in New Bridge Bank Ball Park, the home of Greensboro's minor league Grasshoppers.

Narron's the Name: But few families can match the Narron family of central North Carolina when it comes to playing baseball.

Sam Narron of Middlesex was a career minor league catcher except for six games with the St. Louis Cardinals scattered over the seasons from 1935 and 1943. His brother Milton and his nephew John also played in the minor leagues. Another nephew, Jerry, was a major league catcher for eight seasons with the Texas Rangers and Cincinnati Reds, and Sam Narron's grandson, whose name also was Sam, pitched one game for the Rangers in 2004. And the line was continuing in professional baseball into the second decade of the 21st century. Jerry's son, Connor, was drafted by the Baltimore Orioles in 2010 and, despite a series of injuries that perhaps slowed his progression, was still in that team's system during the 2013 season.

One Day, Three Teams: Nine Catawba College athletes have played in the big leagues, but no one has the distinction that former Catawba catcher and Rockwell native Clyde Kluttz claimed in 1946. In one day, he was owned by three major league teams, going from the New York Giants in a morning trade with the Philadelphia Phillies for outfielder Vince DiMaggio, then two hour later being traded by the Phillies to the St. Louis Cardinals for infielder Emil Verban.

It wasn't a difficult travel day for Kluttz. He had arrived in St. Louis for the Giants-Cardinals series and merely moved to the other clubhouse when the dust had settled. He earlier was traded for future Hall of Famer Joe Medwick.

Kluttz remained in baseball following his playing days and as a scout for the Kansas City Athletics convinced team owner Charles Finley to sign star North Carolina high school pitcher Jim "Catfish" Hunter. Hunter got $75,000 to sign.

A Very Good Day: Like Wes Ferrell, Tony Cloninger was a power pitcher. Like Ferrell, he had power with a bat in his hands as well, though he didn't come close to challenging Ferrell's best-ever 39 home runs by a player who was only a pitcher (Babe Ruth, of course, also had been a pitcher). But Cloninger had a game at the plate that no other major league pitcher has ever had.

On Sunday, July 3, 1966, midway through the Braves' first season in the South, Cloninger was the starting pitcher in Candlestick Park against the Giants' Joe Gibbon. Cloninger had been the Braves' starting pitcher in the first major league game ever played in the South, the season-opener against the Pittsburgh Pirates in which Cloninger went the distance in losing, 3–2, in 13 innings. Years later, Cloninger would point to that season opener as a turning point in his career; his arm never again was as strong as it had been in 1965 when he won 24 games for the Braves in their final season in Milwaukee.

But he was about to prove that there was nothing wrong with his bat. Entering the game and a mediocre 8–7 record, Cloninger never got a chance to face Gibbon, his opposing starter who lasted less than an inning. But Cloninger would hit two grand slam home runs in the game, the first against Bob Priddy in the first inning and the second against Ray Sadecki in the fourth.

The Cherryville native remarkably would come to the plate later in the game with the bases once again loaded, and once again he would send a pitch on a line drive trajectory beyond the fence in left field, but foul by no more than 10 feet for what would have been, incredibly, a third grand slam.

After drilling the ball beyond the fence in foul territory, Cloninger singled, driving home his ninth run in the 17–3 victory over the Giants. On the day, no Giant collected more than one hit except infielder Hal Lanier, a Denton native.

No major league pitcher has ever matched that two-grand-slam, nine-RBI day.

From Bell Hop to Phenom: Nor did any pitcher ever make it to the major leagues using the route taken by Lenoir's Johnny Allen.

Allen, then a bellhop in a Sanford, North Carolina, hotel, was asked to escort a group of fans to the room of Yankee scout Paul Krichell, the man who had found and signed Lou Gehrig, Bill Dickey and Phil Rizzuto for the Bronx Bombers, and in the process Allen seized his opportunity to tell Krichell that he had been a pitcher back home in Lenoir. Krichell was known for discovering diamonds in the rough from a baseball point of view; he had signed Rizzuto, for example, after the man who would become known as "Scooter" had been turned down by both the Brooklyn Dodgers and New York Giants as being too small. And in Allen, Krichell hit paydirt once more.

Following a tryout in the alley behind the hotel, Allen turned in his bellhop uniform for Yankee pinstripes and was an immediate success. A fierce competitor with a quick, fiery temper, he won 17 games and lost only four with a 3.70 earned run average in his rookie season for the 1932 world champion Yankees. He continued to be one of the mainstays on the New York pitching staff until a sore arm and demands for more money led to his being traded to Cleveland prior to the 1936 season.

It was a trade the Yankees would regret for a time. In his first season with the Indians, Allen was a 20-game winner, losing 10, then won his first 15 games in 1937, falling just one game short of Walter Johnson's record streak of victories when Allen lost his 16th game, 1–0, on an unearned run. It was enough for *The Sporting News* to name the former bellhop its Major League Player of the Year.

A season later, in 1938, Allen again started off hot, winning his first 12 games and being selected to the American League All-Star team. But during the All-Star break, Allen suffered a mysterious injury that some claimed happened when he slipped on a bar of soap in his shower. He was never again the dominant pitcher he had been, though he continued in the major leagues for six more seasons, retiring as a player in 1944.

Allen did not retire from the game, however. He became a minor league umpire and eventually became the umpire-in-chief for the Carolina League until he died in Florida at the age of 54.

The Managers: A North Carolina native and two adopted sons of the state have played major roles as big league managers over the last half century. Goldsboro's Clyde King, who pitched for the Brooklyn Dodgers and was the roommate and life-long friend of Ralph Branca, who threw Bobby Thomson's "shot heard 'round the world" home run pitch, served as manager of the San Francisco Giants, the Atlanta Braves and the New York Yankees.

King's career spanned more than 60 years but his most significant role perhaps was that of special baseball advisor to George Steinbrenner, the late owner of the New York Yankees. As the man who had Steinbrenner's ear perhaps as none other, King played a key role in rebuilding the Yankees into an American League powerhouse once again and sustaining that level of competition through much of the almost 30 years he served the New York organization.

Dave Bristol also had a colorful career as a manager. A native-born Georgian, Bristol has for decades made his home on a farm near Andrews where in retirement he trained championship cutting horses. But as a major league manager, he had something of a roller-coaster career as the boss of the Cincinnati Reds, Milwaukee Brewers, Atlanta Braves and San Francisco Giants.

He was named manager of the Seattle Pilots in 1970 only to discover near the end of spring training that year that the team was to move immediately to Milwaukee and become the Brewers. Later, as the manager in Atlanta, during a losing streak, Bristol was sent on a "scouting" mission and replaced in the dugout by team owner Ted Turner, a move that was nullified a day later by National League President Chub Feeney.

But Bristol's greatest contribution to the history of baseball is as one of the leading architects of what became Cincinnati's "Big Red Machine." Bristol managed most of the key players that would make up the parts of the "Machine" through the minor leagues at Macon and San Diego, and then he became their third base coach in Cincinnati. When the team faltered, he was moved into the manager's office replacing rookie manager Don Heffner.

Bristol managed the Reds through three and a half winning seasons, but was dismissed following the 1969 campaign. His replacement, Sparky Anderson, would

Dave Bristol, a "Big Red Machine" Operator. Jack McKeon, never too old.

eventually be inducted into the Hall of Fame as the leader of the "Big Red Machine," which Bristol had helped develop.

Another adopted son, Jack McKeon, is one of the most colorful managers ever in major league baseball. Born in South Amboy, New Jersey, McKeon has lived in Elon for most of his life after breaking into professional baseball as a catcher for Burlington of the Appalachian League.

During his minor league managerial career, McKeon handled teams from Vancouver to Wilson and at almost every level of minor league baseball.

Known as "Trader Jack," McKeon, an Elon University graduate, managed major league teams at Kansas City, Oakland, San Diego, Cincinnati and Florida and was the National League Manager of the Year in 1999 and 2003. But it was as manager of the Florida Marlins that McKeon made his most remarkable mark in baseball.

The Marlins had lost more games than they had won when in the middle of the 2003 season McKeon was called in to become the team's new field manager. He turned the program around quickly and took the team to the World Series championship becoming, at age 72, the oldest manager to win a Series. It came against the Yankees, the team McKeon had watched so closely as a child in South Amboy. In all, McKeon led Florida to three of the six winning seasons the team has had in its history through 2013.

On June 20, 2011, Edwin Rodriguez was released as the manager of the Marlins and McKeon once more was brought back to the dugout as the manager on an interim basis. "I don't need this job, but I love it," he told the gathered, startled press.

He was 80 years old, the second oldest manager in major league history to only Connie Mack.

The First Great Slugger: Before there was a George Herman Ruth, there was Charles Wesley Jones. Long before there was a Henry Louis Aaron, there was Charles Wesley Jones.

His name is not among those honored in the Baseball Hall of Fame at Cooperstown, yet Charles Wesley Jones is regarded by some as baseball's first great slugger and the first North Carolina native to reach star status in the big leagues, and the first from the South.

Jones played in the formative years of major league baseball and, indeed, was the starting right fielder on May 4, 1876, in the first game the Cincinnati Reds ever played. A colorful character surrounded by mystery and controversy, Jones became one of Cincinnati's favorite players and, long after his death and with some of the mystery solved, he remains a member of the team's Hall of Fame.

The mysteries begin with his very name. He was born Benjamin Wesley Rippay in Alamance County, to Abel and Delilah Rippay on April 30, 1852. But while still in his youth he moved to Princeton, Indiana, to live with an aunt and an uncle upon the deaths of his parents in the early 1860s. He adopted that family name and changed the remainder of his name, becoming Charles Wesley Jones.

In 1879, playing for the Boston Red Caps, Jones shattered the major league home run record with nine in an era when home runs were rare because of field dimensions and the quality of baseballs used in games. In the process, he picked up the nicknames, "Long Charley" and "Baby." He had hit almost twice as many as the previous record holder, George Hall. It was Jones' best year as a major league star. He led the National League in home runs with nine, RBI with 62, had 22 doubles and 10 triples and shared the clubhouse with the major leagues' second-most prolific home run hitter, Lip Pike. It was the first of only three times that the top two home run hitters of all time were on the same team, shared only with Harry Stavey and Dan Brouthers of the Boston Reds and later Babe Ruth and Lou Gehrig of the New York Yankees.

Jones became the first major leaguer to hit two home runs in the same inning, his pair coming on June 10, 1880.

Jones was blacklisted for two years after the 1880 season for refusing to play, though Jones contended that he had not been paid for his work in 1879. He sued for his salary and even had the local sheriff attach Boston's share of the gate at a game in Cleveland on May 14, 1881. Though it would be most of a century before collective bargaining would come to baseball under labor lawyer Marvin Miller, Jones' battle over his salary still is seen as the opening shot in the war over player contracts and grievances in major league baseball.

He also was a man ahead of his time in another way. Jones negotiated one of professional sports' first-ever endorsement deals, making an agreement with Cincinnati clothier Sprague & Company to wear their creations. The same press that had chastised him for his carousing began referring to Jones as "The Knight of the Limitless Linen." A Philadelphia newspaper called him "the best dressed man in the profession."

According to research and reporting by Robert Boyer, Jones "drank alcohol like brewers and distillers might quit making the stuff, and his romantic escapades were legendary." He became entangled in an affair in which a jilted husband twice tried to blind Jones with Cayenne pepper, partially succeeding one time and temporarily derailing Jones' major league career. He also suffered a business failure as a part-owner of a laundry, and in July 1887 was traded by Cincinnati to the New York Metropolitans for $1,000, the largest sum ever paid for an outfielder at the time.

Mystery dogged Jones even after his dying days. He spent his twilight years in New York and as late as 1907 a Cincinnati baseball executive reported that Jones was "doing the Sherlock Holmes act for a New York hotel." It is known that his health failed rapidly and the August 1909 edition of *The Sporting Life* reported that the old home run hitter was "an invalid and in need of assistance." Old players organized fund-raisers for Jones in his final years.

Yet, no one in baseball seemed to know for years if Jones remained alive or dead, and not until 2012 did dogged research uncover a death certificate that confirmed that Charley Jones died in New York on June 6, 1911.

The North Carolinian Who Changed the Game: A North Carolina native who never struck out a batter with the bases loaded in the seventh game of the World Series, who never homered in the bottom of the ninth to win a game, who never turned a double play nonetheless has the distinction of having a greater impact on baseball over the last half century than any man alive in 2013.

Frank Wilson Jobe was born in Greensboro on July 16, 1925, the son of a man who walked a route every day, rain or shine, delivering the mail. From late spring and through most of the summers in the mid- to late-1930s, with his family and the rest of America struggling to recover from the Great Depression, young Frank walked to town in Greensboro laden with home-grown tomatoes to sell to help support his family.

He began his education in Greensboro's public schools but later transferred to a highly academic boarding school, a move paid for out of family savings and the money young Frank could earn by milking cows in pre-dawn hours before hurrying away to school. Soon after graduating from high school at the age of 18, Frank was drafted into the Army and saw action in some of the bloodiest battles in Europe from 1943 to 1946 as an airborne medical corpsman for the 101st Airborne Division, known as the Screaming Eagles.

"I got drafted right at 18," Jobe told Will Carroll, lead writer for the publication, *Sports Injuries*. "I was healthy, and we didn't have many of those left. All the strong men had already gone to war."

Jobe's primary job in the war was to deliver medical supplies to the front by bringing them in on gliders. "I got to know the doctors. At the end of the war, one of the doctors asked me what I was going to do, and I didn't know. I was 20. He suggested I try medical school, and so I did."

He earned a Bronze star, the Combat Medic Badge and the Glider Badge and went home with a plan. "He left home only because he was forced to," Carroll wrote, "put on a path that would lead to his life's achievement."

Home from the war and eligible for backing from the GI Bill, Frank enrolled at Southern Junior College in Chattanooga, Tennessee, and after his freshman year transferred to La Sierra University in Riverside, California. It was a move that would change not only family history, but the history of baseball.

He earned his degree in 1949, then did his post-graduate work at Loma Linda University, where he received his medical degree in 1956, completing his internship at Los Angeles County-USC Medical Center before spending three years as a general practice

physician. Urged by his friend and future partner, Dr. Robert Kerlan, Dr. Frank Jobe returned to his studies and completed his orthopedic residency at LAC-USCMC.

Together, Doctors Jobe and Kerlan, launching an unique concept in the fledgling field, concentrated on sports medicine and supervised medical treatment for the Los Angeles Dodgers, the Los Angeles Rams, the Los Angeles Lakers, the California Kings, the Anaheim Ducks and the jockeys at Hollywood Park, Santa Anita and Del Mar.

On September 25, 1974, Dr. Jobe made sports history as he prepped for surgery on Dodger pitcher Tommy John. In the course of the surgery that was about to begin, Dr. Jobe invented and performed the first ulnar collateral ligament reconstruction in history. It became known as Tommy John Surgery.

It transformed baseball to the very bone.

John had taken himself out of a Dodger game because of the pain in his left arm, pain that to some extent always had been there, though he did not know at the time that he had pitched his entire career with a ligament so damaged it perhaps was completely torn. When John walked off the mound in pain, he had won 13 games and lost just three for the Dodgers and was the ace of the team's post-Sandy Koufax pitching staff. He also was 31 years old and already had thought of coaching as a post-playing career. On the day of his surgery, John had won 124 big league games. After spending 18 months in recovery and rehabilitation, he won 164 more and was 46 years old when he threw his last pitch.

Nothing has ever transformed baseball as has Dr. Jobe's invention of Tommy John Surgery. More than a thousand baseball players have had the reconstruction performed by Dr. Jobe and the surgeons who have perfected the procedure in the years since 1974. Countless pitchers have had their careers extended and even others, including star relief pitcher Mariano Rivera, were given careers they perhaps would never have had.

The game-changing surgical procedure is so common now that a survey taken in the middle of the 2013 major league season revealed that almost a third of all pitchers in the big leagues then had been the beneficiaries of Tommy John Surgery.

It came too late for others. "If you'd have thought of it a couple of years sooner," Sandy Koufax once told Dr. Jobe, "they'd be calling it Sandy Koufax Surgery now."

Bad News, Good News: North Carolina's love affair with baseball, therefore, covers every aspect of the game and, like many love affairs, has grown alternately warm and cool. Yet the state's fascination with the modern game—the "New York rules" version—has been going on for close to a century and a half and shows no signs of waning.

It was that perceived public affinity for baseball that was once the inspiration of Don Beaver, the developer of the Rock Barn Golf and Spa Resort near Hickory, and a Greensboro dreamer and doer, Michael Solomon. Together with a list of wealthy North Carolinians, the two attempted to put the state on the major league map in the 1990s.

Beaver and his consortium were willing to put $150 million into the project and the voting public would ante up the remainder of the $250 million to $300 million needed to bring major league baseball to North Carolina's Triad. Solomon would direct the initiative as the executive director of an organization called North Carolina Baseball.

Close to 50 years old at the time, Solomon understood the Triad love of sports and had been an important man behind the scenes for years first as one of the most active

This was North Carolina's "Field of Dreams," a major league stadium that never arose from the Forsyth-Guilford County soil.

Greater Greensboro Open golf chairmen when the Greensboro Jaycees drove the annual PGA stop in the Triad, and later as the man behind successful efforts to gather public support for the expansion of the Greensboro Coliseum once again into the major player it remained in 2013 as the most frequent home of the Atlantic Coast Conference Basketball Tournament and other important events.

When voters underwrote the almost $44 million bond issue for the Coliseum and the ACC immediately began booking the ACC Tournament in the building well in advance, Solomon was joyous.

"I've got three sons," he said, "and I'm going to take them out on Saturdays and we're just going to stand there and watch the workers lay bricks."

Now as the man in charge of efforts to bring major league baseball, Solomon was asking the public for perhaps five times the $44 million it approved for expansion of the Coliseum.

Once the major league baseball initiative was launched, Solomon said it became clear that once built, the new stadium would have a resident, probably the Minnesota Twins. "There were a number of talks with the Twins, and some others, while we were working to get public backing," Solomon confirmed.

More than $1 million was spent in the effort to gain public support, a site for the major league stadium was chosen and an architectural firm, working with Solomon who is a civil engineer, went to work putting together detailed plans for the place where the team would play.

"It would have been fantastic," Solomon said in a 2013 interview. "As you look at the site, there's a small hill on the left and another on the right with a little valley between. The stadium would have been placed on the side of the hill on the left and

parking would have been provided on the other hill with a beautiful pedestrian bridge between that would have looked like a mini-Golden Gate.

"The site also was planned so that a competitive swimming venue could be created and there would be room for other things, including a large Ferris wheel." One of the strongest proponents of the plan was Wake Forest athletic director Dr. Gene Hooks. "He wanted to share the facility with UNC Greensboro," Solomon said. "It would have helped a lot with Title IX (the national referendum requiring athletic opportunities for collegiate women equal to those for men)."

Solomon worked day and night, even enduring a lawsuit for allegedly attempting to lobby influential politicians without the proper credentials from the state. He turned to a firm that had been successful in participating in the creation of the Colorado Rockies as an expansion National League franchise and in securing public support for a new stadium for the Cleveland Indians. Officials of that firm said they saw the Triad location as perhaps the most fertile in the nation for a new major league franchise location and joined the effort to work their magic.

Again and again, under Solomon's direction, comparisons were made to population areas for existing major league locations versus the Triad. It was estimated at the time that 6,478,200 potential baseball fans lived within 100 miles of the Greensboro-Winston-Salem-High Point metropolitan area. That was a million more than the population available to the newest member of the National League, the Florida Marlins, and greater than the 100-mile populations surrounding Tampa, Minneapolis, Pittsburgh, Phoenix and Milwaukee and almost three times as many as the new Colorado Rockies had to spin their turnstiles.

"But we knew on the day of the vote (August 7, 1997) that we were losing when we heard that it was mostly older people who were going to the polls," Solomon said in the 2013 interview. "All along, we thought we had a chance if young people voted. But young people stayed home and older people went to the polls."

The referendum for public financial support for a major league baseball team in the Triad was solidly defeated by almost 2-to-1. "It hurt a bit for a day or two," Solomon admitted. "But the good news is, it was defeated.

"If we had been successful, it probably would have been doomed to failure. The stadium was designed with 40 skyboxes, which was a key element to the income well into the future. Can you imagine us trying to sell 40 skyboxes today, in today's economy?"

In 2013, more than 15 years later, the population figures within that 100-mile footprint certainly have grown and so has the traffic on Interstate 40 West en route from Greensboro to Winston-Salem. Every day, thousands of vehicles buzz beneath the Sandy Ridge bridge westbound and see ahead the split where Interstate Business 40 veers off slightly right as the interstate itself swings left. Few people pause to remember now that the land wedged into that split is the site where dreamers dreamed that a major league stadium would rise before the turn of the century. "You certainly could have seen the stadium from Sandy Ridge Road," Solomon said.

Still lying fallow, that spread of land on the Forsyth-Guilford County line once was North Carolina's real field of dreams.

Solomon, indeed, may have been wise in his surprising gratitude that the major league initiative for which he fought so tirelessly was defeated by voters in the 12-county area known as the Triad. The failure to win support for major league baseball in North Carolina was hardly the sport's death knell. Though only nine minor league teams operated in the state as late as 2013, far fewer than the more than 50 at its unwieldy zenith, baseball seemingly has never been healthier from the mountains to the coastal plain. In 2013, more than 2,158,000 paying customers, a figure many major league franchises would envy, watched minor league baseball being played in North Carolina.

Interestingly, the two metropolitan areas that would have bracketed the site of Solomon's major league stadium on the Guilford-Forsyth County line, Greensboro and Winston-Salem, counted a total of 663,640 fans in attendance for the two Class A franchises. Greensboro, with 362,274 in attendance at its low Class A operation, finished the year second only to Triple A Durham, which had almost a half million customers.

At every level of the game, from amateur to professional, North Carolina remains, from a baseball point of view, what Bart Giamatti saw as the "great green garden."

Basketball

By Al Featherston

Alwyn Featherston is a native of Durham, who grew up in Greensboro and Charlotte. A 1974 graduate of Duke University, he is a 35-year veteran sports writer for the *Burlington Times-News*, *The Durham Sun* and the *Durham Herald-Sun*. Featherston attended his first ACC basketball game in 1960 and has worked at every ACC Tournament since 1968 — the conference's longest active streak. Since retiring from the *Herald-Sun* in 2005, Featherston has covered ACC basketball for a number of publications. He currently writes a monthly column for *Basketball Times Magazine* and is a major contributor for the *Blue Ribbon Basketball Yearbook*.

Featherston is the author of three books — two focused on ACC basketball: *Tobacco Road and the History of the Most Intense Backyard Rivalries in Sports* and *Game of My Life: Duke Basketball*.

From the YMCA to the Front Page

The crowd started arriving at the Raleigh-Durham Airport early Sunday morning, even though the flight they were meeting wasn't due until late that afternoon. The trickle of fans turned into a flood as the arrival time approached. The cars overflowed the airport's designated parking area and a sea of people surged through the terminal and out onto the apron surrounding the landing strip.

At the last moment, the Eastern Airlines Constellation carrying North Carolina's newly crowned NCAA basketball champions had to break off its landing pattern and circle the airport as thousands of fans breached the police barriers and swarmed over the runway. When the plane finally did get down, the crowds prevented it from taxing to the terminal and instead carried their heroes across the tarmac.

Neither Lennie Rosenbluth, the star who had flown to New York to appear on the Ed Sullivan Show, nor Coach Frank McGuire, who stayed in Kansas City to coach an all-star game, were on the plane. But the delirious crowd—estimated at more than 15,000 people—quieted to hear a few words from Pat McGuire, the wife of the triumphant coach.

Wilt Chamberlain (left) is only a spectator as UNC's Lennie Rosenbluth rolls in a layup en route to a national title.

"I just wish Frank were here to see this," the coach's wife said. Turning to the players behind her, she added, "If you live to be 95, you'll never see another demonstration like this."

Today, more than a half-century after that tumultuous March afternoon, Pat McGuire's prediction is still valid. North Carolina has never seen anything to match the spontaneous demonstration that greeted the return of that legendary basketball team from Kansas City. It was a pivotal moment in the state's sports history. It was evidence that basketball, long a secondary sport, had achieved a special status in North Carolina. The long struggle to promote basketball in the state came to full fruition on that glorious afternoon in 1957.

Indeed, North Carolina's 1957 triumph and all the hoopla that surrounded it serves as the perfect dividing line for the slightly more than a century of basketball history in the state. Before the '57 Tar Heels came the pioneers, building the game and capturing more and more of the state's sports consciousness. After '57 would come an almost unmatched parade of triumphant teams, players and coaches as North Carolina wallowed in basketball glory.

Basketball was invented by Dr. James Naismith at the Springfield (Massachusetts) YMCA in 1891 as a way for rowdy young men to burn off excess energy inside during the bone-chilling winter months when it was too cold to exercise outside.

The game was spread internationally through the YMCA and was quickly modified from Naismith's original game, which featured nine players to a side and peach baskets as goals. In the early days of the 20th Century, collegians who had learned the game at the YMCA organized the first collegiate teams. At first, these college teams played local YMCA opponents. In 1905, a Guilford team managed and captained by W.G. Lindsay twice defeated the Winston-Salem YMCA.

Richard "Red" Crozier, a Wake Forest student in charge of the school's gymnasium, formed a team in 1906 and began looking for other college teams to play. Crozier tried to line up a game with Trinity College (the future Duke University), but Wilber "Cap" Card, who actually learned the game directly from Naismith while doing graduate work at Harvard, asked for a month to train his new team. In the interval, Crozier found another opponent. On February 6, 1906, in the first college basketball game played south of the Mason-Dixon line, Wake Forest lost 26–19 at Guilford College as center "Hick" Hobbs and forward John Anderson dominated for the Quakers. A month later, the "Battling Baptists" finally got to play Trinity, beating Card's team 24–10 as forward Vanderbilt Crouch scored 14 points to single-handedly outscore the Methodists.

North Carolina and Trinity/Duke were slow to ignite what would become the greatest rivalry in college sports. The neighboring schools engaged in an athletic cold war for almost a quarter-century after Trinity dropped football in 1895. The two schools wouldn't meet again in a major sport until the spring of 1919, when UNC and Trinity met for the unofficial state championship in baseball, in a game that ended anticlimactically in a 15-inning scoreless tie.

That ended the athletic war between the two schools. The next season, UNC traveled to Durham and met Trinity in basketball for the first time. Playing in the same Angier

B. Duke Gym where Wake Forest and Trinity had first played 14 years earlier, the visitors scored a stunning upset as Durham native Billy Carmichael led UNC to a 36–25 victory in front of a crowd that was described as "several hundred fans."

Basketball was still struggling to gain popularity in a state that cherished baseball and football. The opener of the 1921–22 college season appears to have been the first basketball game that attracted significant attention on what would one day be known as Tobacco Road. A very promising North Carolina team—featuring brothers Billy and Cartwright Carmichael and big man Monk McDonald—took on a powerful Durham YMCA team, led by big man Myril "Footsie" Knight. According to newspaper accounts, a crowd of "more than a thousand spectators" watched as Knight and company dominated the UNC five, 41–18.

Knight would become one of the pivotal figures in North Carolina basketball history, heading the Durham YMCA for more than four decades, where he mentored generations of basketball talent. He also served as director of basketball officials for both the Southern Conference and the ACC.

His court presence must have been significant too—the 1922 North Carolina team that he dominated traveled to Atlanta and won the inaugural Southern Conference championship. The event was open to all schools in the South. To win its first title, North Carolina had to beat such diverse schools as Samford, Newberry, Georgia, Alabama and Mercer on successive days.

The 1924 Southern Conference championship was the first to limit the field to conference members. That still included 22 schools—most of the modern Atlantic Coast and Southeastern conferences. North Carolina beat Kentucky, Vanderbilt, Mississippi State and Alabama to claim the 1924 championship and to wrap up a perfect 26–0 season.

The triumph, reported by telegraph, touched off a wild celebration in Chapel Hill. Students petitioned the university to send the team to Kansas City to compete in the AAU Tournament—the only thing resembling a national championship event in that era. But the faculty complained about missed class time and the team was not given a chance to compete against the best teams from other regions of the country.

That disappointment would lead to one of the first great basketball controversies in North Carolina history. Eighteen years after the 1924 season ended, the Helms Foundation would retroactively designate North Carolina as the 1924 national champion. The university has embraced that award, treating the Helms championship on a par with its five NCAA championships. Rivals scoff at the title and argue that Butler University, which defeated a nationwide field to win the 1924 AAU title, has a better claim to the championship.

The Explosion: Everything changed in 1938.

The trigger for the change was external. Before the 1937–38 season, the NCAA eliminated the center jump. Up until that point, every made basket was followed by a jump ball, slowing the game and giving teams with a good big man an almost insurmountable advantage. That rule change would essentially create the modern game by allowing the up-and-down flow that characterizes basketball today. Adaptation to

the new rule was sporadic—many schools were slow to realize the possibilities inherent in the new rules.

Durham, North Carolina, somehow became one of the leaders in the exploitation of the new rules. The humble mill town saw a remarkable synergy in the days just before World War II. A few miles from the Duke campus, young basketball genius John McLendon, a Kansas product who learned the game directly from James Naismith, joined the staff at the North Carolina College of Negroes (now North Carolina Central University) and began experimenting with a fast break offense and the fullcourt press on defense. Across town at the Durham YMCA, "Footsie" Knight began training a remarkable crop of young players in many of the same tactics. Several of Knight's protégés took his innovations across Duke Street to Durham High School, where under Coach Paul Sykes, they dazzled crowds with a brand of basketball unlike any ever seen before. That Durham High team would win 71 straight games over the next three years, winning tournaments as far away as Glen Falls, New York, and Jacksonville, Florida.

"They are a team of basketball professionals masquerading under the name of Durham High," a sportswriter from Daytona, Florida, wrote after Durham routed the Florida state championship team 54–14. Later that season, Sykes's team traveled to Glen Falls, where Durham defeated three of the top teams in the East and was proclaimed the nation's best high school team.

Durham's biggest star, Horace Albert "Bones" McKinney, was larger than life, a curious amalgam of basketball ability and comic presence. Bones was a six-foot, six-inch forward whose weight varied from between 174 and 210 pounds, "depending on how much I was a' sweatin'," he said. His slender frame had nothing to do with his nickname, which was derived from a character he played in a school play. "I don't remember exactly when people started calling me Bones," he recalled. "But with a name like Horace Albert, the sooner the better, right?"

After his high school days, Bones traveled 20 miles southeast to Raleigh and helped turn an N.C. State team that had been 6–9 in the previous season into a 15–7 contender that earned a spot in the Southern Conference championship game. The rest of those Durham High stars would end up playing for Eddie Cameron at Duke. Yet, even before the arrival of the Knight/Sykes contingent, it became obvious that the Blue Devil coach was aware of the revolution taking place in his hometown. The 1938 Duke team began the season with almost no expectations, but ended up as the school's first championship team—labeled the "Never a Dull Moment Boys." Early in the 1938 season, an anonymous Associated Press reporter reported on Duke's home opener against Mississippi State. "Practically a full house was on hand to take a look at the new streamlined game. While last night's contest was slow at times, they saw the possibility of plenty of excitement in future engagements." That was an astute prediction. Over the course of the 1938 season, interest in the four Southern Conference teams in the Raleigh/Durham area reached unheard of levels.

"The only drawback to North Carolina basketball this season is the lack of space in which to properly handle interested customers," columnist Fred Haney wrote in the *Durham Morning Herald*. "Interest in the popular sport has increased at an amazing pace during the last few years and has caught all of the schools unprepared."

The growing interest led to a building boom on Tobacco Road. North Carolina's 6,000 seat Woollen Gym opened in 1939. A year later, Duke unveiled its unparalleled Indoor Stadium—designed by African-American architect Julian Adele (a fact that wasn't generally advertised in that racist era). Its capacity of 8,800 seats made it the largest on-campus arena in the country. N.C. State prepared to match Duke's basketball Taj Mahal with a facility of almost exactly the same design, but soon after the steel frames for the new gym were erected, the coming of World War II halted construction.

The war also put a damper on the budding basketball interest in North Carolina. Bones McKinney—easily the most popular and recognizable player in the state—enlisted in the Army Air Force and spent the war years playing for a service team in Fayetteville. Quite a few other players were shifted around by the military. One prominent example was Ed Koffenberger, a star prep athlete from Wilmington, Delaware, who enrolled in the Navy and was sent to the V-12 program at the University of North Carolina. But after Koffenberger appeared in several football games for UNC, the Navy transferred him to Duke to study engineering. There, he became as basketball standout, leading the Blue Devils to the Southern Conference championship in 1946.

Life started to return to normal in 1946, but the transition wasn't easy. North Carolina appeared to have the state's strongest team after a northern trip that saw the White Phantoms upset Eastern powers NYU and St. Joseph's. (UNC's basketball team was known exclusively as the White Phantoms until 1948, when they were known as both the White Phantoms and Tar Heels for a year, before finally settling on the Tar Heels.) But in early January, UNC was stunned at home by a Duke team led by John Seward, who had only joined the team days before the game. Seward, an All-Southern Conference player before the war, had served in combat in Europe and spent 79 days in a German prisoner of war camp. He was discharged in December, in time to help the Devils surprise UNC in overtime.

But before the rematch six weeks later, UNC got its own reinforcements—and it was a familiar face. Bones McKinney decided that he wanted to study physical education and when he was discharged from the service early in 1946, he enrolled at UNC. His presence in the middle was too much for Duke to handle.

"Bones McKinney can look back to February 16, 1946, as the day he defeated Duke University in basketball," Durham sportswriter Hugo Germino wrote. "Bones was clearly the margin of victory. He played the whole game and scored 21 points, but his main forte was in feeding the ball to his teammates and in controlling the ball off the backboards."

Significantly, the Duke-UNC rematch in 1946 was the first time Duke Indoor Stadium was filled for basketball—making it the largest crowd to ever see a basketball game in the South to that point. And the rivalry between the two schools led to the first NCAA controversy on Tobacco Road.

The NCAA Tournament debuted in 1939 and Wake Forest earned a spot in the first eight-team field. Two years later, North Carolina was invited to the tournament. However, neither invitation attracted much attention—UNC's 1941 bid was reported on the inside pages of both the Durham and Raleigh newspapers.

That wasn't the case in 1946. After North Carolina was upset in the semifinals of the Southern Conference Tournament, Duke won the championship and expected the bid.

There was considerable controversy when North Carolina was picked to represent the region (which included both the SEC and Southern Conferences) in the 1946 tournament. "What does a team have to do to earn an invitation to the N.C.A.A. (sic) Tournament?" Jack Horner, the sports editor of the *Durham Morning Herald*, wrote. "I don't see how the committee can afford to pass up the conference champion and select another team from the same loop."

It seems likely that the 1946 controversy led to a change in the NCAA selection process. While there is no written evidence of any behind-the-scenes maneuvering, it should be noted that Duke's Eddie Cameron was a power in Southern Conference basketball circles. One hint that Cameron forced a change in the selection process occurred the next season when N.C. State completed a dominant regular season performance but was merely offered a "conditional" NCAA bid — depending on whether the Red Terrors, as they were known that first season, won the conference championship.

The '46 White Phantoms justified the committee's decision by making a deep run in the NCAA Tournament. Led by McKinney and All-Americans James Jordan and John "Hook" Dillon, UNC routed New York University in the first round and edged Ohio State in overtime to reach the NCAA championship game in Madison Square Garden.

The championship contest turned into a showcase for Oklahoma A&M's Bob Kurland, college basketball's first dominant seven-footer. Kurland started slowly against McKinney's aggressive defense. The White Phantoms were within three points when Bones fouled out and Kurland was able to take over. The Oklahoma giant scored seven straight points and the Aggies held on for a 43–40 victory over the first Tobacco Road team to reach what would become known as the Final Four.

North Carolina's NCAA quest attracted considerable interest in the state, indicating that the state's pre-war interest in basketball was returning. But college football was also enjoying its Golden Age in North Carolina. With Duke's Wallace Wade back from the war and with Charlie "Choo-Choo" Justice leading North Carolina to national recognition, attention on the gridiron sport was never higher.

But the man who would change that was on his way.

The Man Who Changed the World: N.C. State made a conscious decision to pursue basketball greatness. The land-grant institution had despaired of competing with Southern Conference football giants Duke and North Carolina. A faculty committee decided in the days before World War II that it would be cheaper and more practical to challenge the two rivals in basketball.

Before those plans could be implemented, the war intervened. After the Wolfpack endured a miserable 6–12 record in 1946, H.A. Fisher, the chairman of the school's athletic council, was anxious to re-start the school's basketball commitment as soon as possible. He wanted to resume construction of N.C. State's new arena and to find a new coach capable of guiding the Raleigh school to national prominence.

Fisher took his lead from a Duke graduate. Dick Herbert, the editor of Raleigh's morning newspaper, suggested that Fisher seek out Chuck Taylor, a former semi-pro

basketball star who had made a career of traveling the country and selling Converse products directly to coaches and their teams. In turn, Taylor told Fisher (as related in a 1951 story in the *Saturday Evening Post*), "The best basketball coach in the country is a lieutenant commander in the U.S. Navy. His name is Everett Case."

Case was already famous in Indiana, where he had been one of the most successful and controversial high school coaches in the history of that hoop-crazy state. Hired at age 22 to coach hapless Frankfort High School, he led the "Frankfort Hot Dogs" to four state titles in the next two decades. The brilliant and controversial coach spent the war coaching service basketball teams. Lt. Commander Case was thinking about remaining in the Navy when he was approached by Fisher in the spring of 1946 and offered the chance to build the program at N.C. State. He accepted the job without ever visiting the campus, demanding a one-year contract so that he could escape town quickly if the new job didn't work out.

Case was to spend the rest of his life in Raleigh.

The man who would soon be known as "The Gray Fox" was 46 years old when he arrived on Tobacco Road. The first thing Case did in Raleigh was to demand the re-design of the arena that existed only as a rusting steel frame just below the railroad tracks that cut through the campus. He didn't want a carbon copy of Duke's now six-

Everett Case, the man who made basketball a state passion.

year-old facility. He wanted something bigger. His experience in Indiana had taught him that the school with the biggest gym hosts the postseason games.

The problem is that the new design had to encompass the already existing steel frame. The only way to increase capacity without prohibitive cost was to extend the two end zone areas. As a result, William Neal Reynolds Coliseum would end up looking like an elongated shoebox with a handful of excellent seats on the sidelines and thousands of bad seats in the end zone.

Still, those seats were there—12,400 of them in all. When finished in 1949, it would become the largest on-campus facility on Tobacco Road—and would remain the largest for 37 years, until UNC completed the Dean E. Smith Center in 1986. Case would use his huge new coliseum to showcase basketball to a growing audience in North Carolina.

Case's sudden success precipitated the immediate move of the Southern Conference Tournament from Raleigh's inadequate Memorial Auditorium to Duke's larger Indoor Stadium in 1947. In one season, Case turned a 6–12 team into a 26–5 juggernaut. The impetus for the change was six Indiana high school products, including a number of service veterans that Case had discovered during his stint in the Navy. The best of these was 6–1 Dick Dickey, a Navy veteran from Alexandria, Indiana. He was the key to the pressing, fast-break style of ball that Case installed in Raleigh.

In his first game against North Carolina, Case engineered a 48–46 overtime victory in Chapel Hill over a UNC team that still included All-American Hook Dillon and two other starters off the 1946 Final Four team. The victory snapped N.C. State's eight-game losing streak to its rival—indeed, UNC had won 25 of the previous 28 meetings. The 1947 rematch in Raleigh was never played. On the night of February 25, when the game was scheduled, fans rapidly filled the tiny Walter Thompson Gym on the N.C. State campus. Even after the doors were closed and locked, desperate fans broke windows into the basement and used a ladder to breach an unguarded window on the second floor. Finally, one of the locked doors was ripped off its hinges. When the extra fans refused to leave, the Raleigh Fire Marshall cancelled the game.

The next morning, Case called Duke's Eddie Cameron and urged him to move the upcoming Southern Conference Tournament from Raleigh's Memorial Auditorium (with a standing-room only capacity of 5,000) to Duke's Indoor Stadium (which seated 8,800). Cameron, who chaired the league's basketball committee, agreed to the move and switched the tournament site barely a week before the event was scheduled to open. N.C. State and North Carolina finally got their rematch in the Southern Conference title game, played in front of a sellout crowd at Duke's arena. The Red Terrors edged UNC for the second time, 50–48, to claim the school's first championship since 1929.

Case's revolution radically changed the landscape of the Southern Conference. The University of North Carolina had dominated the first two decades of league play, winning eight of the 25 tournament titles awarded between 1921 and 1945. Duke, buoyed by its superior new stadium and by Cameron's early adoption of the modern full-court game, had blossomed in the decade before Case's arrival—winning five of the nine league titles between 1938 and 1946. No other Southern Conference school had more than two titles.

The new N.C. State coach changed that in a hurry. He won conference titles on Duke's home court in 1947, 1948, 1949 and 1950. When the Southern Conference predictably moved to N.C. State's newer and larger Reynolds Coliseum, Case's team—now nicknamed the Wolfpack—continued to win championships. Victories in 1951 and 1952 gave N.C. State six straight league titles—a dominant run unmatched in Southern Conference history.

But even though Case had turned N.C. State overnight into the dominant power in the state, that was just a small fraction of his accomplishment. In a very real sense, the Gray Fox taught North Carolinians to love basketball. He built on the foundation of interest laid by pioneers such as Crozier, Knight and McKinney, but he took the sport to another level.

"People do not understand what a terrific promotional man he was, promoting his basketball team, the conference, showing everybody the right way of selling basketball," his protégé Vic Bubas said. "The Raleigh Chamber of Commerce gave him a reward that I think was quite remarkable. The Chamber of Commerce voted him Salesman of the Year. Now, you've got to think about that."

Case's product was basketball and his market was the fan base on Tobacco Road that had grown up worshipping football and baseball. He showed them just how thrilling basketball could be. Much of it was his pressing, fast-breaking style of play—a far more entertaining version of the sport than the sedate tempo that was in vogue before the war. He played the same game as Indiana coach Branch McCracken developed in Bloomington—a style that earned his team the nickname of "Hurryin' Hoosiers."

"Indiana permeated everything he brought here," Bucky Waters, who played for Case in the mid-1950s, said. "His dream was to build up basketball in North Carolina to the point that there would be a basket in every driveway in the state." Case turned himself into an ambassador of the game. He traveled the back roads of North Carolina, speaking to civic groups, helping high schools raise money for modern gyms and occasionally stopping to give away a basketball or one of the hoops that he kept in his trunk of his Cadillac.

The wily coach wasn't content to let basketball sell itself. He was a promoter who introduced dozens of frills that we now take for granted. He started the first pep band in the South and filmed his games in color, which came in handy when he would later show highlights on the first television coaching show in the country. When N.C. State won the 1947 Southern Conference Tournament, Case introduced Tobacco Road to an Indiana high school tradition—cutting down the nets to celebrate a championship. That is believed to be the first collegiate example of what has become a standard post-championship celebration at every level.

Perhaps his greatest sales tool was the Dixie Classic.

The idea was suggested by Raleigh sports editor Dick Herbert, the same Duke grad who steered N.C. State to Chuck Taylor and hence to Case. His scheme was a three-day holiday tournament—always held between Christmas and New Year's Day—that matched the four Tobacco Road powers (N.C. State, UNC, Duke and Wake Forest) against four national powers.

Long-time Case assistant Butter Anderson suggested the name, which appealed to the regional pride of fans who came to boast of the dominance the local teams showed

in the tournament. The high point came in December of 1958 when No. 2 Cincinnati with Oscar Robertson and No. 7 Michigan State with "Jumpin' Johnny" Green came to Raleigh for the Dixie Classic. The Bearcats survived a tough opening round test from Wake Forest, but fell decisively to N.C. State in the semifinals. The next afternoon, the Big O and Cincinnati lost the consolation game to North Carolina, hours before the Wolfpack beat "Jumpin' Johnny" and the Spartans in the title game.

Future Duke coach Bucky Waters played on N.C. State's Dixie Classic championship team in 1955. He remembers the role regional pride played in the event. "What really solidified the Big Four was the Dixie Classic," Waters said. "I remember we all pulled for each other—we'd even pull for Carolina and Duke and Wake Forest. There was a real synergy to Tobacco Road." Every one of the 12 Dixie Classics were won by a member of the North Carolina Big Four. Not only did the Tobacco Road teams defend their turf successfully, but Case's primary reason for starting the tournament—selling the game to local fans—succeeded beyond his fondest dreams. The three-day holiday tournament became a sold-out phenomenon, even challenging the postseason conference tournament in interest.

"I think in some regards at that time, it was bigger," said Bubas, who played in the first Dixie Classic as a junior at N.C. State and coached in the last one in his second year as the head coach at Duke. "I think in people's minds, maybe it was because it was between Christmas and New Year's. Maybe it was because it became the thing to do. People began to build their season to include the Dixie Classic."

The NCAA and the ACC: As interest grew in Case's program—and basketball over-all—North Carolina's teams still struggled to earn national recognition. The N.C. State coach refused that first "provisional" NCAA bid in 1947, opting to play in the NIT in-stead. The New York-based tournament, established one year before the NCAA event, was at least equal to its NCAA rival in the 1940s and some years boasted a more pres-tigious field.

N.C. State opened the event with a narrow victory over St. John's, but fell victim to top-rated Kentucky in the semifinals. The Red Terrors bounced back to beat second-seeded West Virginia in the third-place game. Ironically, the NCAA Tournament that year was won by Holy Cross—a team N.C. State had trounced by 16 points in Indi-anapolis just after Christmas.

Kentucky's 1947 NIT win over N.C. State would be the only meeting between Case and Wildcat coach Adolph Rupp. However, the two Hall of Fame coaches would be bitter rivals on the recruiting trail. Their 1950 duel for an NCAA bid would change the face of college basketball.

Rupp's famous "Fab Five" team captured back-to-back NCAA titles in 1948 and 1949, but the members of that legendary squad were gone in 1950. Replacing them was another talented group of players, led by 7–0 center Bill Spivey. Both N.C. State and Kentucky boasted powerful teams that year—Case's Wolfpack were 25–5 and ranked No. 5 nationally after routing Duke in the Southern Conference title game; Rupp's Wildcats were 25–4 and ranked No. 3 nationally after routing Tennessee in the SEC Tournament finals in Louisville. That caused a problem. Under the rules at the time,

just one team from each of the nation's eight regions was selected for the NCAA field and both the Southern Conference and the SEC were in Region 3.

Virginia athletic director Gus Tebell, the chairman of the Region 3 selection committee, suggested that the two contenders play a one-game head-to-head playoff to determine the region's NCAA representative. N.C. State's Case immediately agreed to play Kentucky "any time and any place." But when Kentucky's Rupp refused to even consider a playoff game, the committee voted to offer the bid to N.C. State.

At least, that was what Tebell, a former football and basketball coach at N.C. State, told reporters. Rupp offered a different take. "No one from the committee or from the NCAA consulted us about a playoff," the angry coach said, adding, "A playoff on the basis of the teams' record would have been ridiculous."

Tebell responded with a statement that stopped just short of calling Rupp a liar. "I don't intend to get in a big controversy," Tebell said, "but you can say that I did not make up the story about the playoff."

As it turned out, both Kentucky and N.C. State both fell victim to the City College of New York in postseason. Nat Holman's powerful CCNY team routed the Wildcats 89–50 in the first round of the NIT, then after taking that championship, marched to the NCAA title as well—edging N.C. State 78–73 in the NCAA semifinals after guard Vic Bubas missed a potential go-ahead shot in the game's final minute.

The 1950 Kentucky/N.C. State controversy helped spur the NCAA to change its selection format. After that season, the NCAA expanded its tournament from eight to 16 teams and—more significantly—designated 10 conferences to receive automatic bids. For the first time, conferences were allowed to select their own representatives for the NCAA playoffs, while the selection committee retained the right to choose six at-large participants from among independents and conferences that did not receive an automatic bid.

Nine of the 10 conferences that received automatic bids elected to send their regular season champion. The one exception was the Southern Conference. The league, which grew to 17 teams with the addition of West Virginia in 1950, was simply too large to play a balanced regular season schedule. The tournament was the only fair way to determine a champion—and with the tournament moving to N.C. State's home court in 1951, Case's powerhouse would have a huge postseason advantage.

"Some team will sneak up on State every once in a while," Duke coach Hal Bradley said in 1955, after losing to N.C. State in the tournament for the second year in a row (and the fourth time in five years). "But nine times out of 10, they'll win on their home floor."

One team did "sneak up on State" during this era. It happened in 1953, when an upstart Wake Forest team edged the Pack 71–70 in the championship game. That 1953 title was the first Southern Conference championship for Wake Forest in what turned out to be the last Southern Conference Tournament to include the future ACC schools. Two months after Wake coach Murray Greason hoisted the trophy, seven of the Southern Conference's strongest athletic members met at the Sedgefield Country Club outside Greensboro to form a new conference—the Atlantic Coast Conference. Virginia, which had dropped out of the Southern Conference in 1936, became the new league's eighth member the next fall.

Although the ACC was formed with an eye towards devoting more resources to football, basketball would explode in the new conference. Since the new ACC members were the schools that had dominated the old Southern Conference, there was not much of a change when the first ACC Tournament was held in 1954. The new event was played in the same arena as the old one and even featured the same two contenders in the championship game.

By retaining the traditional tournament format, the ACC sowed the seeds of controversy. It made sense for the 17-team Southern Conference to choose its champion via a tournament. There was no fair way to do it otherwise—regular season schedules were too unequal to even approximate fairness. But the new ACC was an eight-team league and, starting in its second season, adopted a balanced, home-and-home regular season schedule. Several coaches—most vociferously North Carolina's Frank McGuire and Maryland's Bud Milliken—argued that the league's top regular season finisher should be designated as the ACC's official champion. That idea was opposed by N.C. State's Case, who championed the tournament, claiming, "The tournament is a banquet and every game a feast." He found support from Cameron, the head of the basketball committee.

In hindsight, it's easy to see that the ACC Tournament was both the genesis of the league's basketball greatness and a major contributing factor to the state of North Carolina's passion for the game. The ACC Tournament provided a showcase for the league's basketball—a sport that was still secondary to football in most of the country. Every March, all eight ACC teams would gather in one location—usually in North Carolina—to play out their dreams. It was an entire season distilled into seven games in three days.

The First Superstars: The secret of Everett Case's success was his ability to bring in the best talent in first the Southern Conference, then the ACC. Case started his program with Indiana prep products, but one of his earliest recruits would expand his recruiting horizons.

Vic Bubas, a sandy-haired Croatian from Gary, Indiana, was a member of Case's second N.C. State recruiting class. He arrived in Raleigh with another Gary star—future All-American Sammy Ranzino—and promptly moved into the starting lineup as a freshman. When Bubas completed his playing career in 1951, he stayed on as Case's assistant coach, making N.C. State the first team in the South with a three-man coaching staff. Bubas rapidly proved himself as a dynamic recruiter—opening up the landscape in the pursuit of talent.

That wasn't the case when Bubas began his efforts. Recruiting was a haphazard endeavor in that era. For instance, two of the state's greatest stars in the early 1950s were recruiting afterthoughts. Dick Groat, a 6–1 guard from western Pennsylvania, went to Duke to play baseball. Since the school didn't give baseball scholarships, the multi-sport standout accepted a basketball scholarship instead. While Groat did develop into a baseball All-American and lead Duke to its first College World Series appearance, he had his greatest impact on the hardwood.

Groat credits future NBA Hall of Famer Red Auerbach with transforming his game. Auerbach arrived at Duke in the fall of 1949 with the idea that he would replace Blue

Devil coach Gerry Gerard, who was dying of cancer. Auerbach, who later said that he couldn't sit around and watch Gerard die, left before the season to return to the NBA, but during his brief time in Durham, the future Boston Celtics coach spent many hours working with Groat, polishing his game.

"We used to work out every day," Groat said. "I learned more basketball from him in those two and a half months than I learned the rest of my time at Duke." Groat put Auerbach's training to good use. By his junior year, he scored more points than anyone in college basketball, while unofficially leading the nation in assists. He engineered a rally from a 32-point deficit against Tulane in the Dixie Classic—still the greatest comeback in NCAA history. As a senior, Groat was even better, winning every major national player of the year award.

After Groat's graduation in 1952, he was replaced as the state's best player by Dickie Hemric, another recruiting fluke. In the spring of 1951, the powerful 6–6, 220-pounder from rural Jonesville, North Carolina, attended a tryout camp at N.C. State, hoping to earn a scholarship. When he was passed over by Case, Hemric enrolled at Wake Forest. Deacon coach Murray Greason asked recently retired NBA standout Bones McKinney—who was on campus pursuing a theological degree—to help tutor the awkward young big man.

McKinney helped turn Hemric into the biggest star on Tobacco Road, while earning himself a spot as Greason's top assistant. As a sophomore in 1953, Hemric would lead the Deacons to the Southern Conference championship. As a junior in the first ACC season, Hemric was the league's player of the year and was named tournament MVP, even though the Deacons lost to N.C. State in the title game. As a senior in 1955, Hemric repeated as ACC player of the year and finished his career with a scoring total that would stand as the ACC record until 2006.

Bubas helped Case stay on top despite the Hemric mistake. In his first test as a recruiter, he traveled all the way to Denver and beat out Kentucky's Rupp for celebrated prep star Ronnie Shavlik. Two years later, he traveled to Philadelphia and beat out more than 100 schools for prominent big man John Richter. While there he discovered unheralded point guard Lou Pucillo playing against the School of the Deaf. His last coup for Case was to march into Lexington, Kentucky, and steal guard Jon Speaks from under Rupp's nose. "Vic taught us all to recruit," UNC coach Dean Smith said.

It's possible that the best class Bubas ever put together was that first one at N.C. State. Not only did it include the 6–9 Shavlik, but it also included future All-ACC guard Vic Molodet, a superb swingman in Phil DiNardo, plus outstanding guard Whitey Bell and promising forward Lou Dickman. By 1956, that senior class (minus Bell, who took two years off for military service before returning in 1957–58) formed the nucleus of Case's greatest team.

The 1956 Wolfpack finished the regular season at 21–3 with Shavlik, the ACC player of the year, and Molodet earning All-America honors. There was considerable speculation at the time that N.C. State had the best chance to knock off defending national champions San Francisco—especially when it was learned that the undefeated Dons would have to compete in the NCAA Tournament without All-American guard K.C. Jones.

But as postseason arrived, it looked like the Wolfpack would also be without a key player. In N.C. State's last regular season game at Wake Forest's tiny Gore Gym, Shavlik

broke his wrist. The first reports were that the Wolfpack All-American would miss the rest of the season, but in the week before the opening of the ACC Tournament, Dr. Eugene Harer, an orthopedic surgeon from Raleigh, designed a leather sleeve to protect the wrist and allow Shavlik to play.

The awkward device severely inhibited his offensive game—in three ACC Tournament games, Shavlik missed 19-of-23 field goal attempts—but he was able to contribute defensively and on the boards (he had 16 rebounds in the semifinal win over Duke and 17 rebounds in the title game against Wake Forest). Guards Vic Molodet and junior John Maglio provided the offensive spark to drive the Pack to another conference title. The courageous tournament performance made Shavlik a national hero. Before the team embarked on its NCAA quest, Shavlik flew to New York to appear on the Perry Como Show. The three wins in Raleigh also lifted N.C. State to No. 2 in the national polls, increasing the speculation about a matchup with Bill Russell and No. 1 San Francisco. Unfortunately, Case's dream of a national title ended with a bitter four-overtime defeat to Canisius in the first round of the NCAA Tournament at Madison Square Garden. Shavlik, still wearing his brace, was superb with 25 points and 17 rebounds, prompting Canisius coach Jack Curran to say, "I would hate to see Shavlik with two arms."

N.C. State had the game all but won in the final seconds of the fourth overtime. The Pack was up one with seconds left when Maglio, the team's best free throw shooter, went to the line for a one-and-one. But the junior guard had played every second of the four overtime game and his fatigue may have contributed to his miss. Canisius rebounded, made a long pass ahead to Frank Corcoran, a little-used sub who was so obscure that his name wasn't even included in the game program. His 25-foot, running one-hander from the right side swished to give Canisius the 79–78 victory.

"I believe this is the toughest one I ever lost," Case told reporters after the game. "We had it and we let it get away." The bitter defeat marked the end of Case's first decade at N.C. State. In those 10 years, he had won nine conference titles—and missed the 10th by a one-point loss in the championship game. He was to have future success, but nothing like that 10-year run. More importantly, Case had transformed basketball into a major sport in North Carolina. But it would be up to a bitter rival to take basketball to the next level.

The Underground Railroad: Everett Case's decade-long run of success at N.C. State College was hard for the University of North Carolina to accept. The older, more-established state university was accustomed to dominating its rivalry with a school it derisively dismissed as the "Cow College." Throughout the 1920s, '30s and through the mid-'40s, UNC consistently defeated State College in the major sports—winning 44 of 53 basketball games from its rival between 1921 and 1946.

All of that ended with dramatic suddenness after Case's arrival in Raleigh. The Indiana-bred newcomer won his first game against UNC in overtime to snap an eight-game losing streak to the White Phantoms. Later that 1947 season, the Red Terrors won a second thriller from UNC in the Southern Conference title game—the first time an N.C. State basketball team had beaten North Carolina twice in one season since 1932.

As Case stretched his winning streak against the White Phantoms/Tar Heels to 15 straight games, the once proud UNC program went into decline. North Carolina finished with back-to-back 12–15 seasons under Coach Tom Scott in 1951 and 1952. Scott was a respected coach who would become an even more respected administrator. But he was clearly not getting the job done. There was pressure to find a coach who could make UNC competitive again and stand up to Case.

The Tar Heels found their man in Reynolds Coliseum.

UNC athletic director Chuck Erickson was sitting in the stands at Reynolds on March 21, 1952, when St. John's of New York knocked off N.C. State's newly crowned Southern Conference champions in the East Regional semifinals. He was in the same seat 24 hours later, when St. John's defeated Kentucky's defending national champions.

Erickson was impressed by St. John's passionate young coach, Frank McGuire. In the space of less than 48 hours, the fiery Irishman had just beaten Case on his home court, and then followed that up with a victory over Adolph Rupp and his mighty Wildcats. And even if St. John's did lose to Kansas in the NCAA championship game, McGuire had proved he could compete at the highest level of college basketball. That's what North Carolina wanted.

When McGuire first arrived in Chapel Hill, the Tar Heel faithful didn't quite know what to make of him. The son of an Irish cop, McGuire had grown up in Queens—if not quite on the mean streets of New York, his bedroom window overlooked them. McGuire used basketball to claw his way up the social ladder, first at Xavier High School then at St. John's. He affected the veneer of a successful businessman. His hand-tailored suits and his flashy cufflinks were his trademark. But the tough, combative New York street kid was never far from the surface.

McGuire ended UNC's 15-game losing streak to N.C. State in his very first game against Case and the Wolfpack. By almost sheer force of will, he guided the Tar Heels to a 70–69 victory in Reynolds Coliseum. The cocky Irish coach celebrated his unexpected triumph by throwing Case's favorite tradition back in his face—cutting down the nets in Reynolds. Case would bounce back from that early defeat to beat McGuire six times in a row—including two lopsided wins later in the 1953 season, but that first encounter gave promise of what was to come. The real challenge would have to wait until the new UNC coach upgraded his talent.

McGuire, like Case, was a charismatic salesman. And just as Case mined his homeland of Indiana for talent, McGuire stocked his first Tar Heel teams with the best players his home city of New York had to offer. He benefited from a falling out between N.C. State's Case and veteran New York City talent scout Harry Gotkin. Gotkin switched his allegiance to McGuire, first convincing Lennie Rosenbluth to attend UNC, then helping the new Tar Heel coach land celebrated Catholic League big man Joe Quigg. That opened the floodgates for other New York Catholic League stars to follow—guard Bob Cunningham, point guard Tommy Kearns and forward Pete Brennan.

"The reason I went to North Carolina was Frank McGuire," Kearns told author Art Chansky. "In those days, the priests at the Catholic schools up north were reluctant to send transcripts to schools in the South. My parents were worried about it too. Coach McGuire convinced them that we'd be missionaries, going South to convert the Baptists."

It's not likely that McGuire's "Yankee Tar Heels" converted many in the South to Catholicism, but an entire generation of perhaps mostly Baptist schoolboy basketball players on Tobacco Road did grow up making the sign of the cross before shooting free throws in emulation of McGuire's New York imports. McGuire's pipeline—dubbed by *Sports Illustrated* as his "Underground Railroad"—would later bring down such stars as Doug Moe, York Larese, Larry Brown and Billy "The Kangaroo Kid" Cunningham, but it was that first wave—labeled "four Catholics and a Jew"—that became the heart of McGuire's first great team.

Their first season together in 1955–56 was an odd combination of accomplishment and disappointment. After nearly a decade of mediocrity, the 1956 Tar Heels emerged as a power again. But there was no question that UNC was still looking up at N.C. State. UNC lost two of three games to the Wolfpack, including a humiliating 82–60 blowout in the championship game of the Dixie Classic. And McGuire's young team was devastated by its unexpected knockout by Wake Forest in the ACC Tournament semifinals. McGuire would have to wait one more season to complete his rebuilding effort. Going into 1956–57 season—his fifth year in Chapel Hill—the Tar Heel coach finally had the combination of talent and experience to surpass Case's graduation-depleted team.

UNC returned all five starters from its 18–5 team in 1956. Rosenbluth, the slender Jewish forward from the Bronx, had averaged 25.5 and 26.7 points in his first two varsity seasons. Kearns was emerging as a dynamic playmaker, while the 6-foot-6 Brennan blossomed into another reliable scorer and a strong rebounder. Cunningham was the team's defensive stopper and Quigg provided solid play in the post. McGuire didn't have much of a bench, but that was by choice. He liked to ride his starters as far as they could go.

UNC began the 1957 season ranked No. 6 in the first AP poll. The Tar Heels climbed to No. 2 in the rankings after a northern swing that saw UNC beat New York University in Madison Square Garden, then sweep Dartmouth and Holy Cross at the Boston Garden. The Tar Heels improved to 11–0 after defeating Utah, Duke and Wake Forest to win the 1956 Dixie Classic. UNC was 16–0 and ranked No. 1 for the first time in school history when the winning streak appeared to be coming to an end on a cold February night at Maryland. Down four points with two minutes left, McGuire called timeout and told his players to take their first loss like men.

"I want you to go down like a true champion," McGuire said ... or at least that's what he told reporters two days later that he said. "Be a good loser and the people will think just as much of you."

But UNC didn't lose. Cunningham scored to cut the lead to two. Maryland missed a free throw and Kearns scored to tie the game at 63. The Terps missed a last-second game-winner in regulation and fumbled away another chance to win at the end of the first overtime. Rosenbluth scored eight points in the second overtime and UNC escaped College Park with another victory.

"That game was the turning point of the season for us," Kearns told author Ron Morris. "It gave us the lift we needed in the close ones that followed. When things got bad after that, we just reminded ourselves that we did it at Maryland and we could do it

again." The fans on Tobacco Road, long mesmerized by Case's magic act in Raleigh, were starting to get excited about the unbeaten Tar Heels

"They had nice players, but they weren't imposing defensively," Bucky Waters, a junior that season at N.C. State, said. "They did nothing flashy. It just seemed like Rosenbluth was always getting a basket when they needed it. There was nothing commanding about them. We always felt we could beat them … we just never did."

The pressure on the Tar Heels—and the excitement on Tobacco Road—continued to build as UNC completed the regular season at 24–0. But that would mean nothing if McGuire's team didn't win the ACC Tournament. The Tar Heel coach seemed haunted by that possibility as the tournament approached. "Now, a letdown is to be expected," he warned. "We'll probably lose to Virginia or Clemson in the first round of the tournament next week, but the kids will still be happy. This is what we've worked for."

The undefeated Tar Heels had no trouble in the first round, disposing of Clemson with ease. But it was a different story in the semifinals against Wake Forest. Assistant coach Bones McKinney, who was taking over more and more of the coaching load from Murray Greason, knew his team needed just the smallest edge to get over the hump against the Tar Heels after three close losses in the regular season. To get that edge, he took the Deacon players to familiar Gore Gym on the abandoned Wake Forest campus for a Friday morning practice session. There, behind closed doors, he tweaked the "Fruit Salad" zone defense that had given UNC so much trouble in the 1956 ACC Tournament semifinals.

As it turned out, his plan didn't quite stop the Tar Heels, but it did slow the UNC offense down. When Deacon center Jim Gilley sank two free throws with 55 seconds left to put Wake on top 59–58, UNC's dream season was in jeopardy. Years later, Waters would attend a coaching clinic when another young coach asked McGuire what tactics he used in late-game situations with his team behind.

"He said, 'Very simple, get the ball to Lennie,'" Waters recalled.

That's what the Tar Heels did in their crisis against Wake Forest. Cunningham got the ball to Rosenbluth, who turned and dribbled into the lane. Deacon sub Wendell Carr tried to defend the play and collided with the UNC star just as the shot went up. Referee Jim Mills blew his whistle as the ball swished through the net. The 12,400-plus fans in Reynolds held their collective breath, waiting for Mills to make the call. Although McKinney (and thousands of Wake Forest fans) would contend that Rosenbluth should have been called for charging on the play, Mills called Carr for blocking and Rosenbluth added a free throw to give UNC the 61–59 win.

UNC's victory over Wake Forest would turn out to have historic consequences, far beyond the Tar Heels' later success that season. Sitting in the Reynolds Coliseum stands that night was a young, independent television producer named C.D. Chesley. He had produced several experimental football telecasts the previous season, but watching the drama of UNC's narrow victory over Wake Forest would inspire him to focus on basketball instead of football.

Chesley would produce telecasts of UNC's NCAA tournament games later that month for a regional network of five North Carolina stations. His productions helped fuel the Tar Heel mania that swept the state. His telecasts introduced basketball to thousands—

tens of thousands—who never set foot in Woollen, Reynolds or Duke Indoor Stadium. Audiences watched as UNC got past Yale, Canisius and Syracuse to earn a trip to the Final Four.

Hysteria gripped the state as UNC prepared for the trip to Kansas City and the Final Four. Even McGuire was taken aback when he showed up for practice one day only to find his office buried in mail from adoring grade school students. "This is something," McGuire told reporters. "It's one thing when we get the adults excited. But when second graders take it this seriously, I'm wondering if it's good to keep winning?"

Every major newspaper in North Carolina followed the team's flight from North Carolina to Washington, then on to Kansas City. Governor Luther Hodges planned to join the team on Saturday, arranging to make the trip in a corporate DC3 owned by Burlington Industries. Saturday night was to be the big showdown—No. 1 North Carolina against No. 2 Kansas. Just as national writers had speculated about a potential matchup between N.C. State and San Francisco in 1956, all the talk before the '57 Final Four was about the possibility of the unbeaten Tar Heels facing the hometown favorite Jayhawks—with Wilt Chamberlain—in the title game.

But Michigan State, which had upset No. 3 Kentucky in the Midwest Regional finals, almost got in the way of that dream matchup. Foddy Anderson's Spartans, with young star "Jumpin' Johnny" Green in the middle, turned out to be a surprisingly difficult hurdle for the Heels in the semifinals. The Spartans almost won in regulation, but Jack Quiggle's miraculous shot from midcourt was ruled to have been launched just after the buzzer. Green had a chance to clinch the win in the first overtime when he stepped to the free throw line for two shots with the Spartans up two points and with 11 seconds left. A Michigan State guard sidled up to UNC's Kearns and whispered, "Thirty and one ain't bad." But Green missed both free throws. Brennan rebounded the second miss, drove the length of the court and sank a 15-footer from the foul line to tie it up again with three seconds left. Rosenbluth scored four straight points in the third overtime to give UNC a 72–68 lead, then came up with a steal that reserve Bob Young converted into a basket and the Heels were able to hang on for a heart-stopping 74–70 victory.

Although UNC was unbeaten at 31–0 and ranked higher than its opponent in the title game, the No. 2 Jayhawks were 10-point favorites in the betting line. Not only was Chamberlain perceived as an unstoppable force in the middle, UNC's starters were supposed to be weary after the 55-minute marathon against the Spartans. However, McGuire's warriors were used to playing long minutes without relief and he ordered his normally fast-breaking team to run a patient, semi-slowdown game to conserve their legs.

"I told them, 'We're not playing Kansas, we're playing Chamberlain,'" McGuire said. "I told them 'Kansas can't beat you … Chamberlain can beat you.' We had the whole team playing Chamberlain." The wily Irish coach also neutralized the intimidating Kansas big man with a stunning psychological ploy, one suggested by assistant coach Buck Freeman. When the two teams lined up for the center jump, the Kansas giant found himself facing, not the 6-foot-9 Quigg, but 5-foot-11 Tommy Kearns.

"Wilt looked 10 feet tall towering over Tommy," McGuire said. "They made such a ridiculous figure that Chamberlain must have felt no bigger than his thumb. That's the

state of mind we wanted to get him into. We wanted him thinking, 'Is this coach crazy? What other tricks does he have up his sleeve?'"

The bizarre start did seem to unnerve Chamberlain, who was not much of a factor early as UNC jumped to a 9–2 lead. The Tar Heels shot almost 65 percent to maintain that advantage through the half, but foul trouble sent first Quigg, then Rosenbluth to the bench, allowing the Jayhawks to fight back and take a 40–37 lead. At that point, Kansas coach Dick Harp made a tactical blunder of epic proportions, pulling the ball out to give McGuire some of his own slowdown medicine. But McGuire, with two key players on the bench beside him in foul trouble, was delighted to shorten the game. He let Kansas hold the ball for five minutes before extending his zone. In the closing minutes, the Tar Heels fought back to tie the game at 46, even as Rosenbluth fouled out with 20 of those 46 points. For the second straight night, UNC went into overtime, then into a second overtime, then into an incredible third overtime. Most of the state of North Carolina was watching Chesley's black-and-white telecast as Gene Elston hit two free throws to put Kansas up 53–52 with 25 seconds remaining in the third extra period. But with Rosenbluth on the bench with five fouls, to whom could McGuire turn?

It turned out to be Joe Quigg, who took the ball on the right side and drove the baseline. Before he could challenge Chamberlain at the basket, Kansas defender Maurice King was whistled for a foul. There were six seconds left when McGuire stunned onlookers by calling timeout at the risk of icing his own free throw shooter. But the Irish magician had one more psychological ploy up his sleeve. In an eerie foreshadowing of the words Gene Hackman would speak a quarter century later in the film *Hoosiers*, McGuire confidently told his team, "AFTER Joe makes the shots, we'll go to a zone."

That's exactly what happened. Quigg made both free throws to give UNC a 54–53 lead. Then he dropped back in the zone and deflected a pass meant for Chamberlain towards Kearns, who grabbed it with two seconds left. The final image, seen by the hundreds of thousands of fans watching Chesley's telecast, was Kearns throwing the ball towards the rafters to run out the final two seconds. The pandemonium that followed on the court in Kansas City was nothing compared to the hysteria that rocked Tobacco Road.

The Breakthrough: UNC's 1957 national title was a landmark for North Carolina basketball. After decades of national skepticism, the Tar Heels had finally proved that the state could produce a championship team. Where Case's great teams had consistently failed, McGuire's Yankee Tar Heels had not only earned the ultimate title, they did it in the most dramatic fashion possible in front of a state-wide television audience. After all of Case's hard work to sell basketball on Tobacco Road, North Carolina's magical run had lifted the sport past football in the hearts of North Carolina's sports fan.

That much was evident when UNC returned to North Carolina to be greeted by that spectacular crowd at the Raleigh-Durham Airport. And the legacy of UNC's run to the title would result in the first regular season regional basketball telecast in the nation. The success of his NCAA telecasts convinced Chesley to sit down with the ACC and negotiate a Game-of-the-Week package for 1958 that would bring the new league into the television age years ahead of its rivals. Chesley's telecasts would feed the growing

passion for basketball on Tobacco Road and turn ex-coaches such as Bones McKinney and Billy Packer into TV superstars.

"I have a feeling that it might help college athletics in the long run," Duke's Cameron said after negotiating that first TV deal. "I may be wrong. Time will tell. But it helps the public to get to know our athletes and see what we've got to offer. I'd rather for the fans to be watching an ACC game than Mickey Mouse or some cowboy show."

The Saturday afternoon telecasts helped maintain the momentum generated by UNC's 1957 title run. However, basketball suffered a major setback at one Tobacco Road location. Everett Case, who saw his 10-year dominance of basketball in the state ended by UNC in 1957, was smacked by the NCAA for recruiting violations.

Case, who had long battled Indiana prep authorities over his recruiting practices at Frankfurt High, first ran into problems when he beat out Kentucky's Adolph Rupp for Ronnie Shavlik. Rupp's complaints about Case's tactics brought an NCAA investigation which failed to find any wrongdoing in the Shavlik recruitment, but did uncover evidence that Case was running illegal tryout camps. That violation earned N.C. State probation and a one-year NCAA ban for 1955.

That problem became magnified in 1957, when N.C. State landed Louisiana prep star Jackie Moreland. The celebrated 6–7 talent drew NCAA interest because Texas A&M athletic director Bear Bryant, who was still trying to hire a basketball coach at the time, offered Moreland illegal inducements. Kentucky's Rupp, who also pursued Moreland, reportedly blew the whistle again. In September of 1956, Moreland met in a Raleigh hotel with NCAA representative Walter Byers and ACC commissioner Jim Weaver. The prospect signed a statement that admitted he had received illegal benefits from Case. Moreland later repudiated the statement, and then still later he admitted that it was true.

Moreland was ruled ineligible to play at N.C. State. Worse, because that was Case's second violation in two years, the NCAA levied a crushing penalty on N.C. State—a four-year post-season ban in all sports. The penalty prevented the Wolfpack's 1957 ACC championship football team from going to the Orange Bowl. And it was to lead to one of the most bizarre basketball games ever played in North Carolina. That game—the 1959 ACC championship game—was the culmination of the bitter feud between UNC's McGuire and N.C. State's Case.

Or was it really that bitter?

As far as the public knew, Case versus McGuire was one of the decade's longest-running stories. However, long after the fact, sources close to both coaches claimed that their early battles were nothing more than a publicity ploy and that the Case-McGuire feud was a fraud. "Case told him, we can turn this into something," Bucky Waters said. "If we don't shake hands, that will be the lead in the papers for three days."

Dean Smith, an assistant under McGuire for three seasons, insisted that he never saw the two coaches act like enemies off the court. "I know when I was there, Frank and I went over to Everett Case's house for dinner on several occasions and we'd laugh and tell stories," he said.

In public, the two ripped each other on every occasion. When Case was hit with his NCAA penalty, he complained that the NCAA was ignoring McGuire's illegal contacts

with New York street agents. McGuire argued that N.C. State should not compete in the ACC Tournament since the Pack could knock out a potential NCAA champion.

That set the stage for the '59 title game—between an N.C. State team that couldn't compete in the upcoming NCAA Tournament and a UNC team that was already assured a spot in the playoffs. In the moments after UNC's semifinal victory over Duke—which clinched the NCAA bid—McGuire mused to reporters that he might hold his starters out of the Saturday night title game to rest them for a Tuesday NCAA game in New York City. In the end, he decided to start his regulars, but his comments planted a seed. When McGuire subbed much more frequently than normal, many courtside observers wondered how committed he was to winning the conference championship game. Those questions turned into outrage when with just over 10 minutes left, Lou Pucillo sparked N.C. State to a 10-point lead and McGuire responded by clearing his bench.

The crowd showered the Tar Heels with boos. One angry fan took it further, sneaking into the basement at Reynolds, kicking down a door and flipping off the lights—plunging the sold-out Reynolds Coliseum into darkness. The lights were turned back on after a brief delay, but a few minutes later, there was another blackout and another delay. Finally, with just four seconds left before N.C. State could celebrate its 80–56 victory, a Wolfpack sub called timeout. Case later apologized, but noted that calling timeout late in a sure win was a tactic McGuire liked to employ. In the UNC locker room, McGuire got into a heated argument with reporters questioning how hard UNC tried to win the game.

After all the furor, UNC's second-place ACC team traveled to Madison Square Garden 72 hours later and fell flat in a 76–63 loss to a Navy team coached by former UNC coach Ben Carnevale.

A Changing of the Guard: North Carolina wasn't the only school frustrated by N.C. State's decade-long dominance. And when the Tar Heels also emerged as a superpower in 1957, it left the other two Big Four powers on Tobacco Road looking for answers. Wake Forest, which had just moved its campus 90 miles westward from just outside Raleigh to the outskirts of Winston-Salem, responded by promoting dynamic assistant Bones McKinney to head coach after the '57 season. Duke took a different route when coach Hal Bradley left after the 1959 season. The Blue Devils hired Everett Case's right-hand man, Vic Bubas.

Both young coaches were to make their marks on the recruiting trail. McKinney struck first landing big man Len Chappell and Pennsylvania guard Billy Packer in the spring of 1958. McKinney later claimed that he only started recruiting the two future stars after a visit to the office of Duke's Bradley, where he saw the Blue Devil recruiting list on a backboard. It's a good story, but the truth is that Chappell was a celebrated prospect who was recruited by almost every major program in the East. He picked Wake Forest because of McKinney's NBA connections and his reputation as a big man coach. Packer was more obscure—so obscure, in fact, that when he tried to commit to Duke, the Blue Devil coaches weren't ready to offer him a scholarship. Angered by the rejection, Packer committed to Wake Forest because he knew the Deacons would get to play the Blue Devils at least twice a year.

Bubas began his talent searches later, but still got off to a torrid start on the recruiting trail. Within months of his selection, he convinced Long Island schoolboy sensation Art Heyman, the nation's top prospect, to renege on his commitment to UNC and attend Duke instead. The bullish 6–5 forward always said his parents made him switch—his stepfather soured on the Tar Heels after he got into a fight with Frank McGuire at the Carolina Inn.

"I had to step in between them," Heyman said. "My stepfather called Carolina a basketball factory and McGuire didn't like that. They were about to start swinging at each other."

Bubas was ready to step into the breach. "He charmed my mother and stepfather," Heyman said. "They made me go to Duke. All my friends from New York were at Carolina. If Duke hadn't picked me up at the airport, I would have gone down the road and started school there."

Heyman would prove to be the trigger to what became the greatest rivalry in college sports—at least he triggered the transformation of what had been a nice, regional football rivalry into the nation's best basketball rivalry. The future Duke star was still playing freshman basketball in 1959–60 when Chappell and Packer made their debuts for Wake Forest. The two young stars burst onto the scene by leading Wake Forest to its first Dixie Classic championship. Packer won tournament MVP honors as the Deacons edged UNC 53–50. After the game, McKinney and retired coach Murray Greason danced a jig together at midcourt of Reynolds Coliseum. Tragically, Greason would be killed in a traffic accident less than a week later.

The Deacons built on their Dixie Classic triumph by tying North Carolina for first place in the ACC regular season, and Chappell was the leading vote-getter on the All-ACC team. Packer earned second-team honors. Bubas did not make much of an impression in his first regular season. He guided the junior-dominated Blue Devils to a 7–7 ACC finish, good for fourth place. But something amazing happened when the former N.C. State assistant coach brought his team to Raleigh for the ACC Tournament. It became known as the Year of the Big Snow as two late-season storms combined to dump more than 20 inches on the state. The inclement weather didn't bother Bubas' inspired team. Their first-round victory over South Carolina was no surprise, but on Friday night, Duke stunned top-seeded North Carolina—after losing three regular season games to the Tar Heels by at least 22 points each—when Winston-Salem native Carroll Youngkin dominated ACC player of the year Lee Shaffer. One night later, Duke upset Wake Forest in the championship game as junior center Doug Kistler outplayed Chappell and Packer missed 9-of-11 shots from the floor.

Bubas used the occasion to pay homage to his mentor. "I am deeply grateful to Coach Case for the training he gave me that made this possible," Bubas said. "No words I can say will thank him enough. He put so many pages in my book, I can never call it my own."

After a decade of dominance by N.C. State and then North Carolina, the state was about to see Duke and Wake Forest become the reigning powers on Tobacco Road. Part of it was the brilliant work of Bubas and McKinney. They were helped when N.C. State's program, struggling to recover from the Jackie Moreland scandal, was joined on pro-

bation by North Carolina, after UNC coach Frank McGuire was hit with a one-year penalty for undocumented recruiting expenditures.

The Tar Heel coach did have one more memorable season before the departure of stars Doug Moe, probably the league's best all-around player, and York Larese, the best shooter in the ACC. For much of the 1961 season, the Tar Heels battled Duke for supremacy in the state.

The battle revolved around Heyman — and it wasn't always pretty. The ugliness started the year before when a UNC-Duke freshman game played in Siler City ended in a brawl provoked when UNC's Dieter Krause cold-cocked Heyman. The fight moved to the varsity a year later. The two teams managed to play a tough, competitive game in the finals of the Dixie Classic that UNC won when Moe put the defensive clamps on Heyman. That game inspired the Duke sophomore for the rematch, played February 4, 1961, at Duke Indoor Stadium. An ice storm had shut down much of the state, creating a huge built-in TV audience for the Saturday night showdown — the first time the two rivals had ever met when both were ranked in the top 5 in the national polls.

Heyman was magnificent, en route to a 36-point performance, but the atmosphere soon got out of hand. There was a near-fight — with Heyman confronting Moe and Krause — near the end of the first half. As the teams ran off the court at the break, Heyman collided with a UNC male cheerleader in a minor incident that turned major when a UNC fan in the stands filed assault charges against the Duke star (the case was quickly thrown out of court). Duke was en route to a hard-fought win when, in the final seconds, UNC's Larry Brown raced in for what would have been a meaningless layup. Heyman grabbed his former playground rival to prevent the basket. Brown responded by throwing the ball at Heyman, then throwing a punch. Before Heyman could react, UNC reserve Donnie Walsh — like Brown a future NBA executive — came off the bench and slugged Heyman from behind.

That touched off a wild scene as students poured out of the stands and flooded the court in a widespread brawl that took 10 minutes and more than a dozen Durham policemen to bring under control. It wasn't the only brawl on Tobacco Road in that era, but it was the worst — by far. And thanks to the state-wide TV telecast, the most famous.

ACC commissioner Jim Weaver eventually suspended Brown, Walsh and Heyman for the rest of the ACC regular season. That meant the end of the year for the two UNC guards, since McGuire had responded to his one-year NCAA ban by announcing that UNC would not participate in the ACC Tournament. That was taken at the time as a rebuke for Case and N.C. State for competing during their probation years (and winning titles in 1955 and 1959).

Heyman did rejoin the Blue Devils for the tournament, but even though he played well (averaging 27 points a game), Bubas' team wasn't a match for McKinney's Wake Forest powerhouse. Getting 33 points and 14 rebounds from ACC player of the year Len Chappell, the Deacons reversed the outcome of the 1960 title game and won their first ACC championship.

Writers noted that Wake Forest had struggled early in the year before finishing strong. "It's not how you start, it's how you finish," McKinney said. "I would have liked to have a better record — but so would Napoleon."

That was two titles in a row for Tobacco Road's two private schools. Their dominance was to be solidified by the 1961 point shaving scandal. The New York-based gambling scandal that had percolated in the press during the 1961 postseason exploded on Tobacco Road that spring. Warrants were issued for the arrest of three N.C. State basketball players—team captain Stan Niewierowski, Anton Muehlbauer and Terry Litchfield. As the case developed, 1960 Wolfpack graduate Don Gallagher was also implicated for shaving points during the 1958–59 season. Lou Brown, a little-used reserve guard at North Carolina (and no relation to his more famous teammate, Larry Brown) admitted his role as a conduit between the gamblers and the players.

The scandal provoked a strong reaction. It started with North Carolina Governor Terry Sanford, who suggested that the Consolidated University of North Carolina (which included both UNC and N.C. State College) should "give careful consideration to a de-emphasis of basketball." William Friday, the president of the Consolidated University, formed a study group with UNC Chancellor William Aycock and N.C. State Chancellor John T. Caldwell.

Their report—delivered to the university trustees before the end of May—rocked the basketball world. Friday's group ordered: both UNC and N.C. State must reduce their regular season basketball schedule to no more than 16 games; no more than two scholarships a year could be given to players from outside the ACC region; and the Dixie Classic would be cancelled.

The latter punishment drew the most immediate ire as fans and officials screamed about the loss of the popular Christmas tournament. "The sad thing about the Dixie Classic, it broke up on account of the scandals in college basketball," Vic Bubas said. "That was a shame because the Dixie Classic was not responsible for the scandals back then. It was a byproduct of the legal process."

The state's basketball fans were stunned again a few months later when on August 3—without any hint or warning—Frank McGuire called a press conference to announce that he was leaving the University of North Carolina to coach the Philadelphia Warriors in the NBA. The timing was more a shock than the news itself. The previous spring, when news of the gambling scandals and the UNC de-emphasis of basketball were in the headlines, there were rumors than McGuire was about to bolt for the NBA. But the Tar Heel coach emphatically denied an Associated Press report that he would become the head coach and general manager of the Knicks, insisting that he was staying in Chapel Hill.

Chancellor Aycock was unhappy with several aspects of McGuire's program—specifically the frequent episodes of on-court violence, the violation of NCAA rules and several instances where McGuire's recruiting pushed the university's academic envelope. Aycock wrote McGuire a letter in April, telling him that things had to change. McGuire wrestled with his options, but when Eddie Gottlieb of the NBA Warriors made him a generous offer to coach Wilt Chamberlain's team, he was receptive to the opportunity.

Dean Smith's Bumpy Start: McGuire was replaced by his self-effacing assistant coach, Dean Smith. At the time, little was known about or expected from the 30-year-old

Kansas graduate. When Chancellor Aycock introduced Smith as the new Tar Heel head coach, he had to go out of his way to assure the media that the unknown assistant coach was actually replacing the flamboyant McGuire and not just stepping in as an interim coach.

"In a few years, he's going to be viewed as one of the best coaches in the country," McGuire said of his former assistant. That would turn out to be a remarkably prescient comment—but Smith had to endure a rough initiation before he established his greatness.

In truth, Friday's restrictions on the UNC and N.C. State programs made it unlikely that either school would be able to compete for several years. In Raleigh, Case publicly vowed to fight through the penalties and restore his program to the level of dominance it had achieved in the late 1940s and early 1950s. Privately, he was a lot less optimistic. He invited the new UNC coach over for dinner one night and explained the bleak future facing both programs.

"Ol' Bubas and Bones are licking their chops now," Smith quoted Case as saying in his autobiography. "With the limitations we have on us, Duke and Wake will have it all to themselves. We won't be able to recruit and our real troubles will surface a couple of years from now, when our current players are gone and we won't be able to replace them." It would take Smith six seasons before he challenged for the ACC title. Case rebuilt a little faster, putting a championship contender on the floor in 1965.

By that time, Bubas ruled Tobacco Road.

McKinney enjoyed one more championship season as the Chappell and Packer combo—joined by slender guard Dave Weideman—rose to the top in 1962. The burly Chappell enjoyed one of the great seasons in ACC history as he averaged 30 points and 15 rebounds. That Deacon team fought its way to the 1962 Final Four, losing a semifinal game to the Jerry Lucas/John Havlicek Ohio State team, but bouncing back to edge UCLA in the consolation game.

That victory would prove to be very important. Under the NCAA rules at the time, several conferences got first-round byes into the regional semifinals. The byes were determined by all-time conference performance in the tournament. Without a bye, the ACC champion had to play a first-round game in New York or Philadelphia—usually 48 or 72 hours after finishing the grueling conference tournament. By beating UCLA, McKinney's Deacs earned the ACC a bye. "It's the first time a consolation game has ever given me consolation," Bones said, adding with a smile, "Tell Vic Bubas we did it for him."

McKinney knew that with Chappell and Packer graduating, he wouldn't have the talent to keep up with the powerhouse that Bubas was building in Durham. A year after adding Heyman to his lineup, Bubas inserted future All-American Jeff Mullins and big man Jay Buckley. A year later, he added another gifted big man in Hack Tison. That class could have been even better—he had a commitment from Missouri prep star Bill Bradley, who reneged at the last moment to go to Princeton.

Even so, Bubas' 1963 team was ranked No. 2 in the nation and reached the Final Four after dominating the ACC. The Blue Devils were eliminated in the semifinals by Loyola of Chicago. Even without Heyman a year later, Duke again ruled the ACC, re-

turned to the Final Four and this time reached the NCAA title game before losing to UCLA—the first of John Wooden's 10 title teams in 12 years.

Bubas' Blue Devils were expected to continue their reign in 1965, but the season would instead revolve around Everett Case's swansong. The legendary coach was diagnosed with cancer in 1962. Although in its early stages, Case knew his time was running out and he was determined to restore the program before his exit. Handicapped by the lingering effects of his NCAA penalty (which was technically over after 1960) and the draconian recruiting rules put in place after the 1961 point shaving scandals, Cases patiently rebuilt his roster.

The End of an Era: Physically, his health was failing, but he was determined to coach the 1964–65 season because he thought he finally had a team that could challenge Duke. The Wolfpack was led by 6–6 Army veteran Larry Lakins and sophomore Eddie Biedenbach, a hard-nosed guard from Pittsburgh. However, two games into the season, Case knew he couldn't go on physically. After a loss at Wake Forest, he told the staff that he was quitting. He turned the team over to assistant coach Press Maravich.

Maravich, who had guided Clemson to the 1962 ACC championship game, had been brought in a year earlier with the idea that he would eventually replace Case. His hiring brought an added bonus to North Carolina basketball—his son, Pete, transferred to Raleigh's Broughton High School, where he dazzled audiences with his skills, becoming the most charismatic Tar Heel prep star since Bones McKinney before World War II.

The elder Maravich guided N.C. State to a second-place ACC finish, one game behind Duke. In the ACC Tournament, the Wolfpack easily handled Virginia and Maryland to reach the ACC title game—against a Duke team going for its third straight championship.

Seated at courtside was Case, in his lucky brown suit. The ailing coach had been too sick to attend the first two rounds of the tournament, but his presence for the title game proved to be an inspiration to his old team. Still, the difference in the game turned out to be 6–5 reserve Larry Worsley, who grew up in Oak City as a Wolfpack fan. He wanted to play at N.C. State, but for a long time, his only college offer came from East Carolina. That finally changed when Case—forced to largely restrict his recruiting in-state— came up with an offer. "We were on probation and we were just scratching around, trying to get anybody we could," Case recalled.

Worsley never became more than a supporting player—except for that one night in March of 1965. Coming off the bench against the heavily favored Blue Devils, the unheralded sub proceeded to decimate Duke with his long-range gunnery. Worsley finished with 30 points on 14-of-19 shooting, earning the ACC Tournament MVP Award which had just been renamed the Everett Case Award. Worsley became the first—and only— player to receive the award from Case himself.

There was an even more poignant moment during the postgame celebration, when Case was hoisted on the shoulders of his former players to cut down the nets—his last experience with the tradition he had brought to Tobacco Road. "This is the happiest I've ever been in my life," Case said. "The last taste is the sweetest."

Breaking the Line: Duke bounced back in 1966 to win another ACC title and to reach the Final Four for the third time in four years as the trio of Jack Marin, Bob Verga and Steve Vacendak turned the Blue Devils into a powerhouse. The Blue Devils traveled to College Park, Maryland, for the Final Four as one of the co-favorites—along with the Kentucky team that Duke would meet in the semifinals.

"Duke is the best team I've seen all year," UCLA's John Wooden said. "But I haven't seen Kentucky. Let's just say [the champion will be] the winner of Duke-Kentucky." Unfortunately, Duke entered that game with a severe handicap. Verga, the All-American shooting guard, was battling a throat infection. He came out of the hospital to try and play against the Wildcats, but was ineffective. Without the star guard, Duke lost an 83–79 heartbreaker to "Rupp's Runts."

That loss would have historical significance one night later, when Rupp's all-white Kentucky team was manhandled in the title game by an all-black Texas Western team. The game is usually cited as the turning point in college basketball's battle with segregation. Would it have had the same impact if the matchup had been against Duke's all-white team?

Basketball—like all sports in North Carolina and, indeed, all of North Carolina society—was scarred for the first six decades of the 20th Century by the segregation. It was not only custom—it was the law. There is no way to determine how many great basketball players went unrecognized by the state's newspapers and the white fan base. For instance, Sam Jones—who played his prep basketball in Laurinburg and was a three-time all-conference pick at North Carolina College in Durham—was almost a total unknown when he was drafted by the Boston Celtics in 1958. Red Auerbach later admitted that he had picked the future NBA Hall of Famer strictly on the recommendation of Bones McKinney.

Billy Packer got a taste of media blackout during his time at Wake Forest. One day, the celebrated Wake Forest star traveled across Winston-Salem to take in a Winston-Salem State game. He was dazzled by guard Cleo Hill—virtually unknown even in his home city. "I realized," Packer later told author Joe Menzer, "that he was better than anybody in the ACC."

The father of black basketball in North Carolina was John McLendon, a Kansas native who learned the game directly from James Naismith at the University of Kansas. He arrived in Durham in 1937 as an assistant coach for almost every sport sponsored by the North Carolina College for Negroes. He succeeded William Burghardt as head basketball coach before the 1940–41 season.

McLendon was one of several coaches to experiment with fast-break basketball when the NCAA eliminated the center-jump after made field goals in 1937–38. He was ahead of the pack in developing defensive strategies for the full-court game. McLendon is generally credited with perfecting the full-court press and the full-court zone press. He also developed a delay game that later became famous as the Four Corners when UNC's Dean Smith tweaked it and used it in the mid-1960s.

McLendon's 13-year tenure in Durham was fabulously successful. His record was 239–68—a .779 winning percentage (better than Case, Bubas or Dean Smith). He helped organize the first CIAA Tournament in 1946. The CIAA was a confederation of

historically black schools in the South, founded in 1912 and included half a dozen North Carolina schools. For decades, the CIAA functioned for black basketball fans as the Southern and then the ACC did for whites. In hindsight, it's difficult to compare the quality of basketball played in the black league and the white leagues, but the future dominance of black stars would suggest that in the segregation era, the quality of basketball in the CIAA was very close—and maybe better—than the Southern/ACC.

There are a few clues to support that suggestion. In 1944, McLeondon's best NCC team finished the season at 18–1. With no conference or national tournaments available the season appeared to be over. But *New York Times* writer Scott Ellsworth discovered in 1996 that McLendon helped his team arrange a secret game against a powerful intramural team from the Duke Medical School—a team largely composed of former college players.

The "Secret Game" was played March 12, 1944. The game had to be secret because it was illegal at that time. But the black players from NCC and the white players from Duke met at the NCC gym and staged their segregation-busting game in private. McLendon's CIAA champs routed the Duke intramural stars, 88–44. The two teams then split up and played a truly integrated game—with whites and blacks playing on both teams. The tragedy is that McLendon's '44 champs couldn't face off against Duke's varsity, which won the 1944 Southern Conference title. It would be more than 20 years after the Secret Game that a major North Carolina university would field an integrated team.

The Big Four powers were quite willing to play against integrated teams in an era when most Southern colleges and university refused such games. N.C. State faced a CCNY team with three black starters in the 1950 Final Four. Duke hosted an integrated Temple team in the 1951–52 season opener, giving Sam Sylvester—Temple's black starter—a gracious ovation. UNC had to defeat a succession of black stars en route to its 1957 national title, including Johnny Green at Michigan State and Wilt Chamberlain at Kansas.

But no Big Four coach was willing to break the color line in state. Even Frank McGuire, who coached black All-American Solly Walker at St. John's, refused to recruit any black stars at North Carolina. Everett Case joked about recruiting Chamberlain out of Philadelphia, but there's no evidence he ever actually pursued the talented big man. Case did look at some in-state black talent after his out-of-state recruiting was restricted by the 1961 point-shaving scandal. He pursued big man Walt Bellamy out of New Bern and shooting guard Lou Hudson out of Greensboro, but neither had the requisite 800 SAT score required for admission to the ACC.

That academic hurdle also prevented Dean Smith from breaking the color line. Smith, who had participated in civil rights demonstrations while an assistant coach in Chapel Hill, reports that hours after replacing McGuire as head coach, he got a call from his friend and pastor Bob Seymour of the Binkley Baptist Church reminding him that now he was in position to integrate the ACC. But Smith could not find a prospect with both the talent and the grades to fit the bill.

The reluctance of the Big Four to break through, combined with that pesky 800 rule, led directly to a golden age of basketball for some of the smaller schools in North Carolina. At Winston-Salem State, Coach Clarence "Big House" Gaines guided the Rams

Winston-Salem State's Clarence "Big House" Gaines built a dynasty and became a legend.

to the 1967 NCAA Division II national title as his senior star Earl "The Pearl" Monroe averaged an incredible 41 points a game. Gaines would win 828 career games in his 47-year career.

The Carolinas Conference especially benefitted with stars such as Gene Littles at High Point and Bob Kauffman at Guilford. The Quakers won an NAIA national title in 1973 with future pros Lloyd Free, M.L. Carr and Greg Jackson. The duals between 6–2 Henry Logan of Western Carolina and 5–8 Dwight Durante of Catawba are legendary. Logan, the first black to play for a predominately white school in North Carolina, averaged 30.1 points a game for his career and was a first-round pick in the ABA draft. Durante, who came a year later, averaged 32.1 points in his career and absolutely dominated the 1968 U.S. Olympic trials. Yet, despite averaging 44 points a game in the tryouts, the tiny guard was bypassed for the team—a rejection that convinced Durante to pass up the NBA and sign with the Harlem Globetrotters instead.

There, he joined two other North Carolinians on the roster—NCC grad Tex Harrison and the Clown Prince of Basketball, Meadlowlark Lemon. Lemon's career illustrates some of the hurdles black basketball players had to endure in that pre-integration era. Growing up in Wilmington and unable to play on the public courts (reserved for whites), Lemon had to fashion his own goal out of an onion sack and a coat hanger. His first "ball" was an empty Carnation Milk can. The facilities were only slightly better at Williston High School (a school chosen in his senior year to test the separate but equal fiction that ruled in North Carolina at the time). Even though Lemon led Williston to a black state title in 1952, there were no college offers and he served two years in the Army before finally hooking up with the Globetrotters.

The Big Four finally cracked its doors open in 1965–66, when Duke landed C.B. Claiborne, an African-American guard from Danville, Virginia. That same year, Bones McKinney tried very hard to recruit New York prep star Lew Alcindor. He missed on the future Hall of Famer, but landed his prep teammate, Norwood Todmann, as the first black player at Wake Forest.

UNC's Smith finally landed a black star when Charles Scott, a New York native who was attending prep school in Laurinburg, backed out of his commitment to Davidson after he and his coach were denied service in a Davidson restaurant. Scott would arrive on the varsity in 1967–68—two years after Maryland's Billy Jones broke the color line in the ACC and a year after Claiborne became the first black to play in the Big Four. But the slim, 6-foot-6 UNC standout proved to be the ACC's first black superstar.

And in that role, Scott had to endure a barrage of racial obstacles, including endless ridicule over his first name—Scott wanted to be called "Charles" but the state's media insisted on dubbing him "Charlie." The worst storm came in the spring of 1969 after the Tar Heel star was beaten out by South Carolina's John Roche for ACC Player of the Year honor. Scott, an Olympic hero in 1968 and a first-team All-American in '69, had led UNC to the ACC regular season and tournament titles—yet five All-ACC voters left him off the first team. When Scott voiced his displeasure, the issue became front page news.

Curiously, UNC coach Dean Smith first dismissed claims of racism. "I don't think it's racial," he told reporters. "It just shows the lack of basketball knowledge of those writers. I don't see how anybody could leave him off."

Three decades later, Smith changed his tune. "It was transparently racist," the UNC coach wrote in his autobiography. "The real telltale sign of what happened was that five voters did not put Charles on their all-conference team—despite the fact that he was an Olympian and a first-team All-American. It was a clear insult."

Scott contemplated quitting school and turning pro. Instead, he answered the racists on the court with spectacular postseason performances against Duke in the ACC Tournament and against Davidson in the NCAA East Regional title game.

As ugly as the racial explosion was in the spring of 1969, it seemed to clear the air as far as basketball in North Carolina was concerned. Scott was the last black basketball player on Tobacco Road to deal with that kind of racial firestorm. Racism would not disappear overnight, but the black stars who followed Scott would usually be treated fairly as basketball players. Two years after Scott's blowup, Wake Forest guard Charlie Davis—like Scott a product of Laurinburg Institute—would become the first African-American to earn ACC player of the year honors, beating out senior John Roche.

He would not be the last. North Carolina would produce a flood of black talent for the ACC over the next decade, from Phil Ford and Walter Davis at North Carolina to John Lucas and Buck Williams at Maryland to the greatest of them all—N.C. State's David Thompson.

The Other Outcasts: Blacks weren't the only ones denied a place in the state's basketball spotlight. Women began playing basketball at the turn of the century—almost at the same time as the men picked up the sport. The first women's college

matchup—between Elizabeth and Presbyterian colleges in Charlotte—came in 1907, barely a year after that historic Wake Forest-Guilford game.

Women played basketball with great enthusiasm but earned little attention in the era before World War II. The sport was stronger at the small colleges and rural high schools—the major universities didn't have teams and the North Carolina High School Athletic Association refused to sponsor a state tournament for the women.

That began to change in the days after the war. There was an explosion of public interest in women's basketball. Crowds increased and the state produced one of the great dynasties in the sport—the Hanes Hosiery women's team. Many of North Carolina's textile mills sponsored semi-pro teams for both men and women. The players would be employed in the mills during the day, but would play before large crowds at night. Several of the mill teams featured former college stars and competed on even terms with some of the best Southern Conference teams in the state.

But no mill team ever achieved the success of the Hanes women. The Winston-Salem based team was coached by Virgil Yow, a former men's college coach. As the coach at High Point College during the war, Yow took the bold step of adding a woman to the men's team. He started Nancy Isenhour in three games during the 1945 season and played her in several more.

"He told her to just stay outside and shoot the long shot and not to get mixed up in the tough stuff under the boards," Yow's cousin Debbie Yow related. "First play, there's a rebound and Nancy is right in there, crashing the boards." That spirit would animate women players, who constantly had to battle the prevailing cultural perception that women were frail and that "ladies" shouldn't be involved in competitive sports.

Yow's Hanes Hosiery teams would challenge that perception. Led by tiny guard Eckie Jordan and towering center Eunies Futch, the Hanes women earned three straight AAU national championships (1951–53) and at one point won 102 straight games. In 1955, they formed the core of the U.S. team that won the Pan Am Games Gold Medal in Mexico City.

During this era, interest in women's basketball exploded. A state tournament for girls was established in Southern Pines in 1950 and by 1952, the girls' finals out-drew the NCHSAA-sponsored boys' finals. Unfortunately, the early 1950s were a false dawn for women's basketball. A political movement to squash competitive women's sports gained strength. The North Carolina Legislature banned the women's prep tournament. Yow retired as the coach of the Hanes team and new management at the mill de-emphasized its support for basketball. Many colleges dropped women's sports. By the middle of the decade, women's basketball had been marginalized.

But women's basketball refused to die. It continued to thrive—under the public radar to be sure—in small, mostly rural high schools and at a few colleges. During this era, the women made the transition from the six-on-six game that was the norm for the first half of the 20th Century to the modern five-on-five game, much like the men's game.

The Sisters Yow: "Growing up in the '50s and '60s, if you were an athletic female, you wanted to attend a county high school," Debbie Yow explained. "The county schools

Kay Yow, an international legend.

were very progressive regarding women's athletics. Conversely, if you went to a city school, in most cases you didn't have any varsity sports allowed."

Yow was the second of three basketball-crazy sisters who would spearhead the revival of women's basketball in North Carolina. They grew up in Gibsonville, a small community about midway between Burlington and Greensboro. The Yow sisters were fortunate. Not only did Gibsonville feature a strong women's program, but they came from a family with strong basketball roots. Both parents played the game and their father's first cousin was the same Virgil Yow who had played Susan Isenhour at High Point in 1945 and guided the Hanes Hosiery women to three straight national titles.

"We all worked for [Virgil] in North Myrtle Beach," Yow said. "He owned one of the original sports camps. I went there for majorette camp ... for cheerleading camp ... and eventually for my love of basketball. It was the place to be in the '50s, '60s and the early part of the '70s."

The oldest sister, Kay Yow, began the parade, starring at Gibsonville High, then at East Carolina. She began coaching at Allen Jay High School in High Point, where she coached against Gibsonville when Debbie Yow was the team's star player. To avoid that kind of sisterly competition, Kay Yow moved back to Gibsonville, where she could coach Susan, the third—and best—of the Yow sisters. When Kay got her first college job at Elon, Susan went along with her. Debbie, who had started her college career at East Carolina, transferred to Elon and all three sisters were briefly reunited.

Susan was named to the first-ever Kodak Women's All-America team in 1975 at Elon. She made the team in 1976 too, but at another school. In 1975 both N.C. State and

North Carolina had upgraded their women's basketball programs. Wolfpack athletic director Willis Casey hired the successful Elon coach to build the program. Kay Yow was an immediate success in Raleigh, helped by her youngest sister Susan, who transferred in order to play her final year at N.C. State.

The sudden establishment of women's basketball programs was largely a product of Title IX—a U.S. government act that mandated equal opportunities for women in all phases of college life, including sports. The first national governing body for women's sports—the AIAW—was founded in 1972, the same year as Title IX's passage. It would be another decade before the NCAA, long the national organization of men's sports, supplanted the AIAW and began to administer women's sports. Not only did the major colleges finally begin to compete in the sport, but basketball gained a foothold even in the city high schools that had long resisted women's competition.

The ACC's first women's championships were offered in 1978—and not surprisingly Yow's N.C. State team won the regular season title. Over the next three decades, her Wolfpack program would rank among the nation's elite. She won 737 games, the fifth most in college basketball at the time of her retirement. Kay Yow's crowning achievement came in 1988 when she led the U.S. Women's National Team to the Gold Medal in the Seoul Olympics.

Kay Yow was inducted into the Basketball Hall of Fame in 2002. She died in 2009 after a long and courageous battle with cancer. Just as Everett Case's success in the 1950s provoked UNC to hire Frank McGuire to meet the challenge, Yow's success forced the Tar Heels to hire successful small-college coach Sylvia Hatchell in 1986. The Carson-Newman graduate lead UNC to the pinnacle of the women's basketball world, winning the NCAA championship in 1994 on a dramatic, last second game-winning shot by Charlotte Smith.

Sylvia Hatchell took the UNC women to the top.

Duke, which got off to a late start in the women's basketball competition, began to challenge N.C. State and UNC under Gail Goestenkors in the mid-1990s. She guided the Duke women to four Final Fours in less than a decade and had four 30-win seasons.

Kay Yow's two younger sisters followed her into coaching. Susan has coached for 35 years at a variety of colleges and in the WNBA. Debbie Yow was a college head coach for eight years at Kentucky, Oral Roberts and Florida. She left coaching to focus on administration and is now the Director of Athletics at N.C. State University. The Yows rank as the first family of women's basketball in the state—and the careers of the three Yow sisters encompass the rise of women's basketball from obscurity to prominence.

The Smith Era: Dean Smith was not an overnight sensation. When the former Kansas benchwarmer was named to replace Frank McGuire in the summer of 1961, few basketball fans—or writers—knew who he was. Unlike Bones McKinney, or Vic Bubas, who had captured headlines as assistant coaches on Tobacco Road long before becoming head coaches, Smith's first four years on UNC's bench were spent in the shadow of the flamboyant McGuire.

Smith, the son of a teacher and coach, grew up in Emporia, Kansas. He played basketball for Phog Allen in Lawrence, but was a marginal player for the Jayhawks. After graduation, Smith coached at Topeka High School, then worked for Bob Spears at Air Force. He got to know Frank McGuire when he and Spears shared a hotel room with McGuire at the 1957 Final Four. The young assistant so impressed UNC's coach that he hired Smith to replace his long-time aide Buck Freeman.

As the eventual successor to McGuire, Smith took over the UNC program at a tough time. In a half-decade when all three of his Big Four rivals were winning ACC titles, Smith failed to reach the tournament title game. He never won more than 16 games in his first five seasons, nor ended up in the national rankings. True, Smith had to deal with the draconian de-emphasis rules imposed by UNC president William Friday. But N.C. State had overcome the same handicap to win the 1965 ACC championship and return to the finals the next season.

The soft-spoken Tar Heel coach had earned the respect of his coaching peers with some of his savvy tactical maneuvers, but the UNC fan base was starting to get impatient with the young coach's inability to win at the level to which they had become accustomed under Frank McGuire. The fan frustration peaked in the early morning hours of January 7, 1965, when Smith's fourth UNC team returned to Chapel Hill after suffering a lopsided 107–85 loss at Wake Forest. The defeat was Carolina's fourth loss in a row and dropped the team to 6–6 on the season. As the team bus pulled up in front of Woollen Gym, about a hundred students gathered across the street, surrounding a dummy of Smith that was hanging from a tree.

Smith ignored the scene, but senior Billy Cunningham raced off the bus, grabbed the dummy and ripped it down. The Tar Heel players walked past in silence, several pausing to kick the effigy of their coach in disgust. "You never forget a thing like that, ever," Smith wrote in his autobiography. "But it wasn't as traumatic for me as it has been made out to be over the years. My standard response was that I was glad there

was an interest in basketball here and I'm just happy they used a dummy and not the real thing."

Smith answered his critics just three days later, when he took his reeling Tar Heels to Duke and stunned the No. 6 ranked Blue Devils on their own home court with a beautifully executed game plan. It's easy to portray that moment as a turning point for Dean Smith. But it wasn't. Four days after the win at Duke, UNC lost at home to N.C. State and, afterwards, Smith was again hanged in effigy.

UNC's coach—like Case and McGuire and Bubas and McKinney before him—had to win his battles on the recruiting trail before he could begin to win with any real consistency on the court. His early stars were the last products of McGuire's Underground Railroad—even Billy Cunningham was on board before McGuire's departure.

Smith got lucky in 1963 when Duke's Vic Bubas passed on Bob Lewis, a slender 6-foot-3 prep star from Washington, D.C. Bubas thought Lewis was too frail to play forward and not enough of a ball-handler to play guard. But he could shoot and as a junior at Carolina, Lewis led the ACC in scoring, averaging 27.4 points a game. The real breakthrough came in the spring of 1964, though, when Smith went head-to-head with Bubas for celebrated Pennsylvania prep star Larry Miller, beating the recruiting master at his own game. "Miller was the first guy we got that Duke wanted," Smith said.

Of course, Miller couldn't do it alone, any more than Heyman could for Duke. But Smith was able to maintain his recruiting momentum the next spring. He followed up on his initial success when he signed a five-player class that would join the varsity for the 1966–67 season. The quintet included three players from North Carolina, including 6-foot-11 Rusty Clark from Fayetteville, 6-foot-8 Bill Bunting from New Bern and 6-foot-5 Joe Brown of Valdese. He filled out the class with Dick Grubar from Schenectady, New York—a 6-foot-3 prep center that Smith believed could play point guard in college—and 6-foot Gerald Tuttle from London, Kentucky.

Smith's recruiting efforts were helped immeasurably when the North Carolina legislature approved funds for a new basketball facility to replace ancient Woollen Gym. It was a difficult political fight. Many legislators couldn't see spending money for a sport that was being de-emphasized in the wake of the point-shaving scandals. The result was an odd compromise. Technically, Carmichael Auditorium wasn't a new facility at all. Instead, it was billed as an "extension" of Woollen Gym, a three-sided structure that shared one wall with the old building. It was designed to seat 8,600 fans, but jamming a few extra seats in boosted capacity to exactly the same 8,800 that could pack Duke's Indoor Stadium.

A Hole in the Ground: Smith didn't wait until Carmichael Auditorium was completed in the summer of 1965 to put it to use. He brought recruits to view the hole in the ground and told them that's where they would play.

When Smith's 1965 recruiting class joined the varsity in 1966–67, three sophomores were in the starting lineup—Clark, Bunting and Grubar—along with Lewis and Miller. That quintet carried UNC to its first conference championship since 1957 (and just its second since 1945). Miller proved the key—he scored the winning basket against Duke

in Durham and a month later, he hit 13-of-14 shots from the floor and scored 32 points in the Tar Heels' ACC championship game victory over the Blue Devils.

It would be the first of three straight ACC titles for Smith—and the first three years of a 19-year stretch in which UNC won nine ACC titles and finished either first or second in the regular season every year. Over the next two decades, challengers to Smith's dominance would come and go—sometimes achieving temporary success against him—but it was two decades before another North Carolina coach challenged him on a consistent basis.

Smith established himself in the late 1960s, just as Bones McKinney and Vic Bubas, who had dominated the early 1960s, were wrapping up their careers. McKinney resigned after the 1965 season, claiming a case of burnout. Bubas quit after 1969 to move into athletic administration. By that point, Smith was king of the of the basketball hill.

His first challenge came from an unlikely direction. Davidson basketball had fallen on hard times after the tiny, academically respected school was left behind when its four North Carolina neighbors broke off to form the ACC. Before that split, North Carolina papers had talked about the Big Five—including Davidson along with UNC, N.C. State, Duke and Wake Forest. After the split, it became the Big Four and Davidson declined into irrelevance on the state's sporting scene.

At least that was the case until Tom Scott, who had been an unsuccessful coach at UNC, hired an energetic Virginia high school coach to revive the Davidson program. Charles "Lefty" Driesell had been a marginal player at Duke, most famous for earning a suspension in 1954 "for being a fancy dan."

It didn't take Driesell long to make Davidson a force to be reckoned with. In his first game in 1960, he engineered an upset of the Wake Forest team that would win the ACC. Two years later, he knocked off a Duke team that would finish 27–3 and play in the Final Four. Driesell proved a relentless recruiter—sometimes sleeping in the back of his van to stretch a miserly recruiting budget. He found quality players such as Dick Snyder and Terry Holland and scored a major coup when Duke's Bubas didn't have room for Washington, D.C., star Fred Hetzel. Instead, the powerful 6-foot-8 post performer went to Davidson and became an All-American.

In 1966, he landed 6-foot-7 Mike Maloy, a burly post player from New York City, and the first black athlete at Davidson. Maloy was supposed to join Charles Scott in a class that also included standouts Doug Cook and Jerry Kroll. Even after Scott changed his mind and wound up at UNC, the Maloy-Cook-Kroll class would dominate the Southern Conference and carry Davidson to the brink of greatness.

Unfortunately, waiting there at the brink was UNC—with Scott, the black superstar who was lost to Driesell because a Davidson restaurant owner wouldn't serve the black prospect and his high school coach. Scott had 18 points and six rebounds, hitting the game-clinching shot with 10 seconds left to help North Carolina edge Davidson 70–66 in the 1968 East Regional title game. A year later, as UNC and Davidson prepared to meet in the 1969 East Regional title game in College Park, Maryland, Driesell couldn't contain his emotions. "I'd rather die than lose to North Carolina again," he told reporters.

But he did lose again, thanks to Scott, who poured in 32 points, including the game-winner at the buzzer—a high, arching dagger from the top of the key. That would

prove to be the last game Driesell would coach for the Wildcats. When his team flew up to College Park for the regionals, the Davidson coach drove, stopping in Durham to try and get an interview for the Duke job that had just opened up when Bubas retired. Unable to win consideration from his alma mater, Driesell toured the campus at the University of Maryland after the loss to UNC. The next week he was introduced as the new coach of the Terps. He would continue to challenge Smith, but he would do it from outside the state.

A Storm with an Attitude: However, there was a new challenge rising on Tobacco Road—coming from an old, long-forgotten figure.

Norm Sloan was a member of Everett Case's first crop of Indiana recruits in 1947. He quit the Wolfpack basketball team in 1949 when he saw his playing time dwindle with the arrival of Vic Bubas. He tried to switch to football for his final year in Raleigh. Sloan went into coaching, eventually becoming head basketball coach at The Citadel and then at Florida, where his furious battles with football coach/athletic director Ray Graves earned him the nickname "Stormin' Norman."

Sloan was eager to return to Raleigh when the job opened up in 1966. Press Maravich had done a very good job in his two seasons at the helm, but when N.C. State refused to match a lucrative offer from LSU, he decided to leave. There was another factor in that decision—his son, Pete, a spectacular high school player at Raleigh Broughton High, wanted to play for his father, but could not qualify for admission to N.C. State. Even after a year in prep school, the younger Maravich couldn't crack the ACC's 800 barrier. Playing for his father at LSU, "Pistol Pete" Maravich became the highest scoring player in college basketball history.

Sloan had to rebuild from scratch. He kept the Wolfpack competitive with lesser talent—perhaps his most famous early win (and certainly, considering his rivalry with Bubas, his most satisfying) was a 12–10 victory over Duke in the 1968 ACC Tournament semifinals. It was the lowest scoring game in ACC history. Sloan also willed N.C. State to an unexpected ACC title in 1970, engineering a double-overtime victory over South Carolina—a Gamecock team coached by former UNC mentor Frank McGuire that had finished 14–0 in regular season ACC play. The MVP of the tournament was Vann Williford, an unheralded recruit from Fayetteville. But Sloan's real challenge to Dean Smith's in-state dominance came with a new crop of Wolfpack stars. It started with Tommy Burleson, a slender 7–4 prodigy from the mountains of North Carolina. A year later, Sloan added another western North Carolina product—David Thompson, a 6–4 superman from Boiling Springs, near Shelby. Thompson, nicknamed "Wiedeman" by his brothers (after the former Wake Forest star), grew up a fan of Charles Scott and North Carolina. But he was won by the persistent recruiting efforts of N.C. State assistant Eddie Biedenbach and his friendship with the Wolfpack-bound Burleson. In the end, two schools—Duke and N.C. State—would earn NCAA penalties for the Thompson recruitment, although in both cases, the penalties were for minor (even picayune) violations.

Thompson would shift the balance of power on Tobacco Road and help change the shape of college basketball. As a freshman playing freshman basketball, he was so spectacular that Fred Schaus, who had coached Jerry West at West Virginia and in the NBA,

proclaimed, "Thompson is better right now than Jerry West was as a college senior. Thompson is one of the 10 best basketball players in the nation, pros included."

The glare of publicity surrounding Thompson in 1971–72 helped the NCAA push through a rule change that would allow freshmen to play varsity ball. It wouldn't help Thompson, but starting in 1972–73 players could go straight from high school to the varsity level. When Thompson did reach the Wolfpack varsity in December of 1972, his impact was astonishing. He averaged 35.9 points in N.C. State's first four games. When he scored 29 points and pulled down 12 rebounds in a victory over Wake Forest in Greensboro, a newspaper called it "a disappointing" performance.

The nation was introduced to Thompson on Super Bowl Sunday. The matchup between No. 3 N.C. State and No. 2 Maryland was significant, but what really made the game important was that at the suggestion of N.C. State athletic director Willis Casey, C.D. Chesley put together a nationwide package of affiliates to broadcast the game a few hours before the Super Bowl. The contrast between the thrilling college basketball game and the dull-as-dust Washington-Miami Super Bowl couldn't have been more striking. When the numbers came in, showing an audience in excess of 25 million, TV executives took note—leading directly to NBC's decision to offer a college basketball game of the week starting in the 1973–74 season.

Thompson was again at the center of a basketball revolution as he snatched the spotlight on Super Bowl Sunday game. The high-flying Wolfpack star scored 37 points, including the game-winning basket when he came soaring out of the rafters to rebound Burleson's missed jumper and drop in the follow shot at the buzzer. Thompson, teaming with Burleson and 5–7 mighty mite Monte Towe at point guard, would lead N.C. State to a perfect 27–0 season, but because of the NCAA penalties, the Pack was not allowed to compete in the NCAA Tournament. A year later, N.C. State was even better, sweeping through the ACC unbeaten and finishing the season ranked No.1 in the nation. However, the Wolfpack—much like UNC's No. 1 team in 1957—had to survive a monumental test in the ACC Tournament. No. 1 N.C. State and No. 4 Maryland dueled into overtime in the championship game. The Wolfpack finally prevailed 103–100, thanks to 38 points and 13 rebounds from Burleson, in what has been proclaimed the greatest game ever played.

Deciding More Is Better: The contest between the two brilliant teams caught the attention of the nation and helped the NCAA Basketball Committee—spearheaded by new member Willis Casey—decide in the offseason to open the NCAA Tournament to more than one team per conference. However, Maryland was denied a chance to compete for the title in 1974, leaving N.C. State to pursue the championship. The Wolfpack, still enjoying the bye won by Wake Forest in 1962, won its first two NCAA games to earn a Final Four matchup in Greensboro against mighty UCLA.

N.C. State, despite its No. 1 ranking, was the underdog against a team that had won seven straight NCAA titles (and nine of the last 10). Thompson's status was unclear after a horrific fall in the East Regional title game against Pittsburgh. And UCLA already owned a victory over N.C. State, beating the Wolfpack in St. Louis in December—N.C. State's only loss in two seasons.

This time the two national powers dueled on even terms with Burleson battling UCLA center Bill Walton and Thompson imposing his will in the final seconds of the

double-overtime game. Twice—at the end of regulation and at the end of the first over-time—N.C. State missed shots that would have knocked off the Bruins. In the second overtime, UCLA took a seven-point lead, but the tiny Towe sparked a comeback and with less than a minute remaining, Thompson elevated over All-American Keith Wilkes to bank in a short jumper to give the Wolfpack the lead. When UCLA missed at the other end, Thompson rebounded, drew a foul and sank the two free throws that clinched N.C. State's 80–77 victory.

David Thompson (44) skies to block a high-percentage shot by UCLA's Jamal Wilkes (52), and Bill Walton (left) can only watch.

"Before the season began, I told our team that we had a chance to be one of the greatest teams of all time," Sloan said. "I'm not making that claim now, but we beat one of the greatest of all time." The victory over UCLA did not give N.C. State the national title—the Wolfpack still had to defeat Marquette in the title game, but with Thompson clinching the Final Four MVP Award with a 21-point performance, N.C. State won 76–64 and claimed the second of the state's two Division 1 national titles.

Debut of the Pro Game: The popularity of big-time college basketball in North Carolina was challenged in 1969 by the arrival of the Carolina Cougars of the American Basketball Association. The genesis of the team was actually an article in *Sports Illustrated*. Writing in the fall of 1968, Frank Deford proposed the idea of a regional sports franchise. He noted that North Carolina—the eleventh most populous state in the union at that time—lacked the large metropolitan area usually required for a successful pro team. But, he noted that the state was filled with medium-sized cities with good arenas and a proven passion for basketball.

His idea eventually clicked with a trio of Rocky Mount businessmen, headed by former congressman Jim Gardner. They originally planned to seek an ABA expansion franchise, but when the Houston Mavericks came on the market, Gardner and his partners acquired the team and used the offseason to trade every 1968 team member for a collection of players with North Carolina ties—Bob Verga from Duke; Doug Moe, Bill Bunting and later Larry Miller from UNC; Gene Littles from High Point. However, it was Deford's opinion that the most brilliant move was hiring Bones McKinney to coach

Bones McKinney rolled up his sleeves and became the ringmaster of the Carolina Cougars.

the newly renamed Cougars. McKinney had first found fame as a high school player in Durham; had excelled as a player at both N.C. State and UNC; had starred in the NBA; had guided Wake Forest to the greatest era in its history; and had carved out a new career as a popular commentator on the ACC television network. He was the perfect North Carolina icon to guide the state's first major professional franchise.

The Cougars—true to Deford's concept—spread their games out around the state. The team was based in Greensboro, but also played in Charlotte, Winston-Salem and Raleigh. With Verga (a first-team All-ABA pick in '70) and Moe (a second-team pick) leading the way, the new team won 42 games and qualified for playoffs. Fan support was outstanding. But competition—both in the rapidly improving ABA and in a state still in love with college basketball—was tough. The Cougars slumped in their second season (1970–71). As the record slipped, fans turned back to the successful programs at UNC and N.C. State. McKinney resigned halfway through the season and was replaced by Jerry Steele.

After a disastrous 1971–72 season, the Cougars brought in Larry Brown as coach with Doug Moe as his assistant. The team signed former UNC star Billy "The Kangaroo Kid" Cunningham away from the NBA, to team with former Atlanta Hawks star Joe Caldwell. Suddenly the Cougars were a power. In 1972–73, the team finished with the best record in the ABA as Cunningham won the league MVP Award. The popularity of the team surged again. Unfortunately, the Cougars lost a seven-game series to the Kentucky Colonels in the East finals. The next year, injuries caused a drop-off in the Cougars' performance and with a slip in record, the attendance slipped too. The entire ABA was on shaky ground in its challenge to the established NBA. After the 1974 season, the Cougars moved to St. Louis and became the Spirits.

The Cougars would be the first of three attempts to implant professional basketball on Tobacco Road. The team's five-year experience would reflect the future experience of the Charlotte Hornets (1988–2002) and the expansion Charlotte Bobcats who began play in 2005. The two NBA teams would enjoy sporadic success and generate sporadic fan support, but to this day, no North Carolina pro basketball franchise had won a title— and no team has reached the division finals since the Cougars' 1973 loss to the Colonels.

The Four Corners: Big-time basketball in North Carolina always featured one curious aspect—the delay game. John McLendon invented a delay game in the 1940s that was adopted by a number of coaches around the country. Usually, it was a late-game tactic. But not always. On the first day of the first ACC Tournament in 1954, Frank McGuire outraged thousands of fans when his UNC team tried to hold the ball for most of the game against favored N.C. State.

It was McGuire's replacement, Dean Smith, who took the delay game to a new level. The young UNC coach first came up with the tactic in his first year as head coach, when one day in practice Larry Brown misread a defense and went to the spread offense designed to combat a zone press against a man-to-man. Smith was shocked to see that the spread worked just as well against the man-to-man as against the zone press.

The scheme put four players in the far corners in the half-court with a ball handler in the middle of the floor. If the defense didn't pressure the four "corner" men or tried

to double-team the man in the middle, the ball handler always had an easy outlet pass. If the ball handler was quick enough to beat his defender, he could drive for an open layup. If one of the baseline defenders came over to help, UNC's cornerman on that side of the court would break for the basket, usually getting an open layup. Smith dubbed the tactic "the Four Corners."

After the Four Corners became nationally famous, Smith was credited with inventing the scheme. But he insisted that he merely tweaked a tactic that many other coaches—including McLendon, Babe McCarthy, Chuck Noe and his old boss at Air Force, Bob Spears—had used with success. "If there was an innovation at Carolina, it was that we put our best ball handler in the middle, rather than a big man," Smith wrote in his autobiography.

For his first four years at UNC, Smith used the Four Corners in late-game situations to protect a lead, but earlier in the 1965–66 season, UNC used the Four Corners almost the entire second half in a victory over Ohio State. Later that season, he opened an ACC Tournament game against No. 3 Duke in the Four Corners, hoping to pull the Blue Devils out of their zone. But Bubas refused to chase and the game devolved into a deep freeze. Duke finally won 21–20 on a late free throw by big man Mike Lewis. It was the greatest slowdown game in ACC history ... for two years.

In the semifinals of the 1968 ACC Tournament, a rebuilding N.C. State team was matched against another strong Duke team. Second-year Wolfpack coach Norm Sloan wasn't planning to hold the ball—he merely wanted to pull Duke out of its zone. But Bubas' team was big and slow, so he refused to budge from under the basket. The game dissolved into the most famous slowdown in the history of the state—at one point, UNC radio voice Bill Currie famously observed, "this is as exciting as watching artificial insemination." Duke led 4–2 at the half, but N.C. State prevailed 12–10. Three weeks later, when North Carolina faced mighty UCLA in the national title game, Smith elected to open the game in the Four Corners—a tactic that failed to have any impact on the Lew Alcindor-led Bruin juggernaut.

There were demands for an NBA-style shot clock, but while there were tweaks in the rules, the delay game remained a feature of big-time basketball in North Carolina throughout the decades of the 1970s. In fact, that decade became the heyday of delay basketball as all manner of teams used Smith's tactic—although they usually gave it different names. At Duke, when the Blue Devils used it to upset No. 3 Maryland in 1973, Coach Bucky Waters called it "The Mongoose." When Norm Sloan's great teams used it with Towe or Thompson in the middle, the Wolfpack coach called it "The Tease."

But the Four Corners remained the focus of attention—both good (if you were a UNC fan) and bad (if you rooted for anybody else). Smith used it with regularity, protecting narrow leads over the last two or three minutes. When the UNC point guard would cross midcourt and hold up four fingers, audiences would go berserk—both those for and against.

The arrival of Phil Ford in 1974 would raise the Four Corners debate to another level. The 6-foot-2 point guard was from Rocky Mount. He was the consummate point guard, with wonderful quickness, brilliant judgment with the ball and a deadly jump shot. Ford, who was regarded as one of the nation's premier recruits, actually had a

disappointing freshman season. But in the 1975 ACC Tournament, he came into his own. UNC survived three brutally close games, thanks to Ford's performance at the point, especially in the Four Corners. He ran the delay game for most of the overtime in a first-round victory over Wake Forest. He ran it for the final 11 minutes of regulation and in overtime against Clemson in the semifinals. And in the finals against defending national champion N.C. State—crippled by an injury to superstar David Thompson—he ran it for most of the second half.

"The Four Corners was unfair with Ford," Smith said several years later. "He could drive, take it in, bring it out and pass it off. He was unstoppable." The freshman won the Case Award as the ACC Tournament MVP. And over the next three seasons, he drove opponents—and opposing fans—nuts with his ability to direct the Four Corners. An injured Ford carried UNC to the brink of a national championship in 1977 when, ironically, a mistake in the Four Corners cost the Tar Heels control of the game with Marquette. UNC, after trailing most of the game, had finally taken the lead when Ford raised four fingers and UNC went into its delay. Unfortunately, star forward Mike O'Koren was at the scorer's table, waiting to check back in. While he waited, Ford drove the lane and dished to O'Koren's sub—Bruce Buckley—who missed the layup. Marquette scored at the other end and UNC never again regained the lead. That was the one blemish on Ford's career, which also included quarterbacking the 1976 U.S. Olympic Team—coached by Dean Smith—to the Gold Medal in Montreal.

Even after Ford's graduation in 1978, debate over the delay game continued in the state and in the ACC. Things reached an absurd point when UNC played at Duke in 1979 and Smith tried to pull the Blue Devils out of their zone. Like Bubas in '66 and '68, Duke coach Bill Foster refused to come out and chase, leading to a ludicrous halftime score: Duke 7, UNC 0. The two teams played the second-half normally and Duke won 47–40.

Such games continued to fuel demands for a shot clock. But it wasn't until the 1982 ACC championship game in Greensboro that the issue finally exploded. No. 1 North Carolina—with stars such as James Worthy, Sam Perkins and freshman Michael Jordan—was dueling No. 3 Virginia—with Ralph Sampson in the middle. With just under eight minutes left, UNC led 43–42 when Smith ordered his team to pull Virginia out of its zone. "I thought we'd have a good chance to dictate the end of the game with our Four Corners because it might lure Sampson out from beneath the basket," Smith later explained.

But Cavalier coach Terry Holland elected to sit back and let UNC shorten the game. For almost seven minutes, a national television audience was treated to another dose of "artificial insemination" rather than a thrilling game between two of the nation's most talented teams. UNC would win 47–45 after a series of free throws in the final minute and would go on to win the school's second national title a month later, but the spectacle of all that talent standing around, doing nothing, would change basketball forever.

The ACC finally adopted an experimental shot clock for the next season and pressure on the NCAA to do the same began building. Smith, whose Four Corners was so much at the center of the debate, actually advocated a shot clock, but argued that it needed to

be coupled with a 3-point shot to give less talented teams a chance. The NCAA eventually agreed—adding a shot clock in 1985–86 and the three-point shot one year later.

The New Challengers: When Vic Bubas resigned at Duke in the spring of 1969, Dean Smith became the dean of ACC basketball coaches. By the spring of 1980, the North Carolina coach had become the biggest basketball icon in the state. Smith had outlasted such challengers as Bubas at Duke, McKinney at Wake Forest, Sloan at N.C. State and Bill Foster at Duke. Driesell was still around, but the former Davidson coach was now mounting his challenge from distant College Park, Maryland—and even though the flamboyant Lefthander had vowed to make Maryland "the UCLA of the East," he was consistently losing ground in the race with the Tar Heel sage.

Both Sloan and Foster gave up after the 1980 season. Sloan, whose program had slipped a notch after the graduation of Thompson, returned to Florida to coach. Foster, who had put together a powerful team that matched UNC from 1978–80, could see the end of his challenge coming with the graduation of gifted big man Mike Gminski and the imminent departure of dynamic forward Gene Banks. Within the space of a week, Duke and then N.C. State added young coaches to try their luck against Dean Smith.

When Tom Butters introduced Army coach Mike Krzyzewski to the media it was much like the press conference 19 years earlier when William Aycock had introduced unknown Dean Smith as the new UNC coach. In one way, this was worse—at least nobody had trouble pronouncing Smith's name.

He started slowly, but the young Duke Coach Mike Krzyzewski would wind up winning more men's Division I games than anyone.

The new Duke coach was a tough Polish kid from Chicago who had learned basketball from Bobby Knight at West Point. After his service in the Army, Krzyzewski returned to the U.S. Military Academy as head coach. His five-year record there was not impressive on the surface—73–59, including a 9–17 mark his last year. Maybe that's why his name never popped up in news reports of the Duke coaching search.

But former Duke standout Steve Vacendak, who was about to become the school's assistant athletic director, had met Krzyzewski and was blown away by the intense young coach. When he promoted the Army coach to Butters, the Duke AD called Knight for a recommendation. Butters had already called the Indiana coach to offer him the job but, failing that, mostly to get recommendations of candidates. Knight had not mentioned Krzyzewski, but when Butters called again, Knight was enthusiastic, explaining that he didn't suggest Krzyzewski at first because he didn't think Duke would hire such a young coach with such a mediocre record. "Knight's comment was, 'If you like me as a basketball coach, here's a man who has all my good qualities and none of my bad ones,'" Butters said.

Almost exactly a week after Duke introduced the 33-year-old Krzyzewski, N.C. State named 34-year-old Jim Valvano to replace Sloan. Valvano was an Italian kid from Long Island who had played guard at Rutgers. He was not quite as unknown as the new Duke coach, thanks to a two-year NCAA run at Iona, where he had parlayed the presence of big man Jeff Ruland into 47 wins in 1979–80.

The two young coaches could have picked a better time to break into the ACC. Virginia, bolstered by three-time national player of the year Ralph Sampson, was about to embark on the best three-year run in school history, Maryland was still very good under Driesell, Wake Forest had a top 20 team under Carl Tacy and even Clemson was playing at a high level under Bill Foster—no relation to the former Duke coach of the same name, but a Kentucky native who was very familiar to North Carolina basketball fans after leading a new program at UNC Charlotte to the 1977 Final Four. Still, the greatest challenge the two new coaches faced was competing with Smith's juggernaut in Chapel Hill. As the '80s opened, Smith was about to assemble his greatest team.

It started with James Worthy, a much-publicized recruit from Gastonia, whose career was temporarily derailed his freshman season in Chapel Hill when he broke his leg. But Worthy returned the next season to team in the post with freshman Sam Perkins, a long-armed big man from Latham, New York. Along with senior forward Al Wood, they helped lead UNC to the 1981 ACC championship and a spot in the national title game—beating Sampson and Virginia in the semifinals. Although the Tar Heels fell short against Indiana in the championship contest, the promise for 1982 was so strong that UNC's four returning starters wound up on the cover of *Sports Illustrated*'s preseason basketball issue.

The magazine had wanted to add the team's fifth projected starter to the picture, but Smith refused permission. He always insisted that his freshmen prove themselves in game action before receiving any publicity. Michael Jordan was no exception. Jordan was famously a late bloomer, cut from his high school team as a sophomore. Even midway through his junior year at Wilmington's Laney High School, Jordan was a little-known prospect. UNC had an edge, however. Although Jordan grew up idolizing N.C.

State's Thompson, he attended Smith's summer basketball camp. He looked so impressive there in the summer before his senior year at Laney that Tar Heel assistant coach Roy Williams arranged for the unknown wing player to attend Howard Garfinkel's famous summer camp in Pennsylvania.

Williams later joked that Smith almost fired him by giving Jordan such exposure. After two weeks of spectacular play in front of the nation's top coaches, Jordan suddenly became the nation's hottest prospect. In the end, UNC's early start paid off and Jordan ended up at North Carolina, where he became the perfect player to step in for graduated forward Al Wood.

Jordan, of course, would later become one of the great players in basketball history — a Hall of Famer who many consider the greatest player in the history of the sport. But Worthy and Perkins were the stars on that '82 Carolina team. Indeed, Worthy was a consensus first-team All-American and Perkins made the consensus second team. Jordan was ACC rookie of the year as UNC finished 32–2, edged Virginia for the ACC title and won the national championship. Even though Worthy was the Final Four MVP, Jordan made his mark on basketball history in New Orleans. With UNC down one to

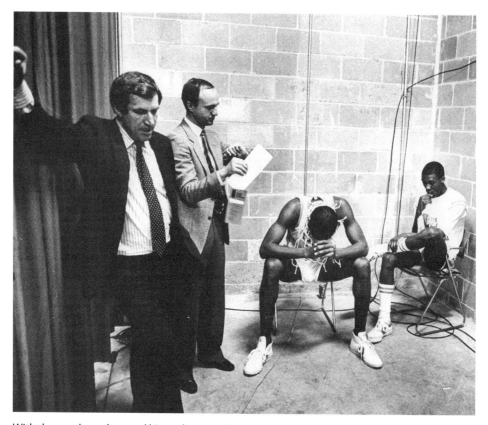

With the net draped around his neck, James Worthy seeks solitude while he, Jimmy Black (right), Dean Smith (left) and UNC SID Rick Brewer silently await the post-game national title press conference in New Orleans. It was Smith's first NCAA championship.

Georgetown in the final seconds, Smith called on his freshman star to take the game-winning shot. Jordan calmly elevated in front of the UNC bench and sank the 20-footer that gave Smith his first national title.

Jordan would emerge as a national player of the year contender in his sophomore season (although he wouldn't win it until his final year at UNC in 1984). He led the Tar Heels to 28 wins and top 10 finishes in each of his next two seasons, but never won another championship. Indeed, the decade following the '82 title proved remarkably frustrating for Smith and his program. The Tar Heels averaged 27.2 wins a year between 1983 and 1992, finishing in the top 10 in eight of those seasons. But that span included just two ACC titles and just one more trip to the Final Four. And the two young coaches hired in the spring in 1980 had a lot to do with Smith's frustrating decade.

Valvano got in the first blow with a remarkable postseason run in 1983. The young Wolfpack coach inherited a trio of talented players from Norm Sloan. Guards Sidney Lowe and Dereck Whittenburg, who had played together since junior high school, joined slender forward Thurl Bailey as the senior leaders on Valvano's third N.C. State team. The Pack started the season with high expectations — No. 16 nationally in the preseason AP poll. But when Whittenburg broke his foot in early January, the team slumped and fell out of the rankings. Few noticed when the stocky guard with the ACC's sweetest shooting touch returned at the end of the regular season. Notice did come when Whittenburg helped N.C. State stun No. 5 North Carolina in the semifinals of the ACC Tournament in Atlanta. Then he and Lowe teamed up to shock No. 2 Virginia in the title game.

Suddenly, the Wolfpack was a national story. CBS-TV elected to show the late night Thursday NCAA opener in Corvallis, Oregon, between N.C. State and Pepperdine nationally. Late in the game, the Wolfpack seemed on the verge of defeat, but Valvano unveiled a bizarre tactic — intentionally fouling instead of trying to play defense. Twice, Dane Suttle — a career 83.5 percent free throw shooter — missed the front end of one-and-ones. The Pack was able to erase a six-point deficit in 30 seconds and pull out a double overtime victory. Valvano told his kids, "Hey, we may be destined to win this thing."

That was the birth of the Cardiac Pack, a name that became harder and harder to escape as N.C. State's amazing run continued. Valvano's kids edged No. 6 UNLV in the second round as Bailey outplayed All-American Sidney Green. After beating Utah in the third round, the Pack drew a rematch with Virginia. The No. 4 ranked Cavs had beaten N.C. State seven straight times before that ACC title game upset. They looked forward to the rematch, blaming their loss in Atlanta on the officiating and on the ACC's short, experimental three-point line.

"With a day off and an old ACC rival we've played three times, we'll be all right," a very confident Terry Holland, the Virginia coach, told reporters before the game. But even without ACC refs and a 19-foot three-point line, the Cardiac Pack hung in the game. Low scoring sophomore Lorenzo Charles hit two free throws to give N.C. State the lead with 17 seconds left and when Virginia couldn't find Sampson on the final play, the Pack was on its way to the Final Four.

N.C. State's semifinal matchup in Albuquerque was supposed to be against another old rival — North Carolina. But the Tar Heels, the top seed in the East Regional, were

upset by Georgia in the East championship game, leaving Valvano—and not Smith—the last Big Four coach standing. The Wolfpack made short work of the Bulldogs in the first national semifinal game, but the victory was overshadowed by the amazing second semifinal between No. 1 Houston and No. 2 Louisville. The top-ranked Cougars—celebrated as Phi Slamma Jamma—were prohibitive favorites going into the championship game.

"It was like we didn't have a chance," Lowe said. *Washington Post* columnist David Kindred summed up the feeling of many when he wrote: "Trees will tap dance, elephants will ride in the Indianapolis 500 and Orson Welles will skip breakfast, lunch and dinner before N.C. State finds a way to beat Houston."

Valvano threatened to hold the ball as Sloan once did to Bubas, but when the game started, he was content to control tempo. The national TV audience and the sellout crowd at The Pit were stunned to see N.C. State seize a 33–25 halftime lead with what Valvano called "almost a perfect half of basketball." But with future All-NBA stars Akeem Olajuwon and Clyde Drexler cranking up the fast break, Houston outscored N.C. State 17–2 to start the second half and take a 42–35 lead with 10 minutes to play. At that crucial moment, Houston coach Guy Lewis tried the same tactic that Dick Harp attempted after his Kansas team had caught and passed UNC in the 1957 title game—he slowed the game down with a stall of his own. And just as it did for Harp, the slowdown blew up in his face.

Given a chance to catch their breath, N.C. State fought back. Late in the game, Valvano started fouling and, once again, the Pack's opponent choked at the free throw line. Michael Young and Benny Anders, a pair of Houston stars, missed seven of nine

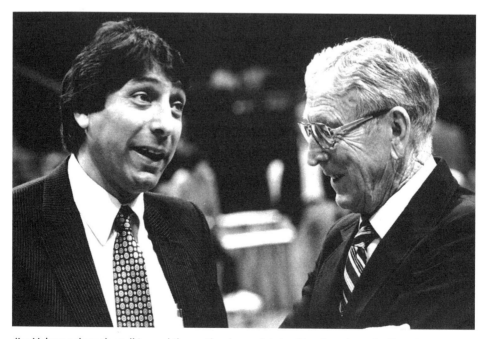

Jim Valvano does the talking, while another legend, John Wooden, does the listening.

free throws, allowing N.C. State to tie the game at 52 with just over a minute left. Rather than let Houston hold for the last shot, Valvano ordered an immediate foul of freshman point guard Alvin Franklin. When he missed the first of a one-and-one, N.C. State was able to set up the last shot.

It didn't go exactly as Valvano drew it up. He put his team in Smith's four corners, telling Lowe to drive, then dish off to Bailey, Whittenburg or sharpshooter Terry Gannon for a jump shot. But Lowe started his drive too early and when he got the ball to Bailey on the baseline, the veteran forward decided it was too soon to shoot. He whipped the ball back outside to Whittenburg, who nearly lost it. Whittenburg came up with the ball, but with time running out, he had to launch a desperation 35-footer that was well short.

Olajuwon misread the arc of the shot and moved into the lane to rebound the carom off the rim. That left Charles, a relatively unheralded 6–7 forward from Brooklyn, to grab the ball almost like it was a lob pass and dunk it through just before the buzzer sounded, touching off one of the most famous postgame celebrations in basketball history. For the second year in a row, a Big Four team claimed the national title, but this time it was somebody other than Dean Smith.

"K" Had Them Concerned: Smith bounced back strong in 1984 with a team led by national player of the year Michael Jordan, All-American Sam Perkins and two future NBA lottery picks, center Brad Daugherty and freshman point guard Kenny Smith. The mighty Tar Heels started the season ranked No. 1 in the nation and except for one week in early December, spent the entire year atop the polls — even after the dynamic Kenny Smith was injured in late January. But UNC's express would be derailed by the Big Four's other young coach — Mike Krzyzewski.

It took Duke's Coach K longer than Valvano to get his program off the ground. He managed an NIT trip with Bill Foster's leftovers in 1981, but a frustrating recruiting year that offseason — Krzyzewski finished second for players such as Chris Mullins, Bill Wennington, Uwe Blab and Jimmy Miller — left the 1982 Devils near the bottom of the ACC. A year later, K had more success on the recruiting trail. Still, even with prep All-Americans Johnny Dawkins, Mark Alarie and Jay Bilas in the starting lineup, the 1983 team still limped home at 11–17.

Just as Dean Smith had faced a fan revolt almost two decades earlier, Krzyzewski's two lackluster seasons led to problems with his fan base. He was never hanged in effigy, but athletic director Tom Butters had to deal with an organized anti-Krzyzewski group that styled itself "Concerned Iron Dukes." Butters stood by Krzyzewski and in 1984, his fourth season in Durham, the young coach broke through. His 1983 freshmen had matured — Dawkins and Alarie were All-ACC caliber as sophomores — and the addition of freshman point guard Tommy Amaker, a slender, but ultra-quick ballhawk, solidified K's man-to-man defense.

Duke won 24 games and cracked the AP rankings for the first time under Krzyzewski. The Blue Devils endured two frustrating losses to No. 1 UNC in the regular season, including a double-overtime game in Chapel Hill, but when the two rivals met in the ACC Tournament semifinals in Greensboro, Krzyzewski's kids did what Valvano's Cardiac Pack did a year earlier — they took down Smith's champions.

"I remember being in the huddle," Alarie told author Dick Weiss, "and Coach K said, 'Okay, when we beat these guys, let's pretend like we've been there before.' He told us to be calm because we were going to win." And Duke did win, 77–75. "The horn sounded and I'm thinking, as excited as we are, let's pretend that we've been there before," Alarie said. "And then I look over at Coach K—and he's jumping all around like a little kid."

Later, the Duke coach told ESPN that the 1984 ACC Tournament win over UNC was the breakthrough for his program. Krzyzewski still had a ways to go to get Duke where he wanted it to be. The Blue Devils, emotionally drained and physically exhausted by their triumph over Carolina, had nothing left for Maryland in the ACC championship game. And Krzyzewski's first NCAA experience proved to be a short one as Duke lost to Washington in Pullman, Washington.

Krzyzewski's 1984 accomplishment wasn't as dramatic as Jimmy Valvano's 1983 breakthrough, but it would prove to be more lasting. Never again would Duke fans question Coach K's fitness for the job. The Dawkins-Alarie class would win the ACC in 1986, winning 37 games and reaching the NCAA title game before losing a heartbreaker to Louisville. That was just the start of a remarkable run—a stretch of seven Final Fours in nine seasons that was highlighted by back-to-back national championships in 1991 and 1992.

It was during this stretch that the Duke-North Carolina rivalry achieved epic national status. Unlike Driesell at Davidson (and briefly at Maryland), McGuire at South Carolina, Sloan at N.C. State, Holland at Virginia, Foster at Duke and Valvano at N.C. State, Krzyzewski became the first coach to challenge UNC's Smith … and to sustain that challenge. The new all-sports network ESPN made the two (and sometimes three) annual matchups between the two Triangle superpowers the centerpiece of its college basketball coverage.

The back-and-forth duels between Duke's Danny Ferry and UNC's J.R. Reid were larger-than-life in the late 1980s. Both schools made it to the 1991 Final Four. UNC answered Duke's back-to-back 1991–92 national titles with Smith's second national championship in 1993. A year later, with the NCAA Final Four on North Carolina soil for the second time, the Tar Heels finished the season ranked No. 1, but Duke reached the title game, losing a heartbreaker to Arkansas in Charlotte. And in 1995, ESPN chose the first Duke-UNC game to launch a new network—ESPN2. Even though Duke was struggling in the temporary absence of Krzyzewski (who took a leave of absence that season due to back problems), the two rivals staged a game for the ages with No. 2 UNC finally winning in double-overtime to give the new network a memorable launch.

It helped that the rivalry was played at such a high level. Between 1980 and 2013, the two Tobacco Road teams combined to win eight NCAA titles and to play in 22 Final Fours—more than any conference (other than the ACC) managed.

The Lasting Legacy: Valvano kept his program as a high level through the end of the 1980s, but his program was brought down by a so-called "scandal" that alleged massive improprieties in Raleigh. An NCAA investigation did find minor problems that led to one-year of probation (although the lead NCAA investigator in the case publically defended Valvano). More damaging were allegations of academic improprieties that led

to some draconian self-imposed sanctions that would force Valvano to resign and set the N.C. State basketball program back for more than a decade.

There was a tragic coda to the Valvano story. Soon after the former coach resigned to pursue a career as an ESPN commentator, he was diagnosed with cancer. Valvano's courageous battle against the fatal disease won widespread admiration. His "never give up speech" at the 1993 ESPY Awards—less than two months before his death—became an icon of sports oratory. He established the V Foundation to fight cancer. In its first 20 years, the organization raised more than $120 million and awarded more than 450 research grants to fight cancer.

As N.C. State's program slipped, Wake Forest stepped into the power vacuum under the leadership of Dave Odom, who was almost as deeply ingrained as a North Carolina basketball product as Bones McKinney. The Goldsboro native had played college basketball at Guilford and coached at Goldsboro and Durham high schools and at East Carolina before succeeding the unsuccessful Bob Staak at Wake Forest. Odom revived the downtrodden program with recruits such as Durham's Rodney Rogers and Maryland native Randolph Childress. His real recruiting coup came in 1993, when he landed an unknown prospect from the Virgin Islands. Tim Duncan would become the best big man in college basketball and was the driving force behind Wake Forest's greatest seasons since Lennie Chappell and Billy Packer were stars.

The Deacons claimed back-to-back ACC championships in 1995 and 1996—the '95 title coming in overtime versus UNC as Childress completed one of the great three-day tournament runs in ACC history. But like so many other challengers to UNC's dominance over the years, the Deacon run was short-lived and the program slipped. There was a brief revival under Skip Prosser, who guided homegrown players such as Josh Howard and Chris Paul to the top of the ACC heap, but Prosser's tragic death in the summer of 2007 forced the Deacons to rebuild.

In the end, only Duke and North Carolina remained as college basketball superpowers.

A Passing of the Torch: Vic Bubas coached 10 seasons at Duke. Bones McKinney burned out after eight seasons as head coach at Wake Forest. Norm Sloan left N.C. State after 14 seasons. Lefty Driesell lasted 17 years at Maryland. Even Everett Case had to quit two games into what would have been his 19th season in Raleigh.

Dean Smith entered his 36th season at North Carolina with no signs of slowing down. In the previous six years, he had won his second national championship and coached in three Final Fours. His 1997 team—built around stars Antawn Jamison and Vince Carter—would give him his thirteenth ACC title and his 11th Final Four. More significantly, the '97 Tar Heels would make Smith the winningest Division 1 Men's basketball coach in history. Smith had always claimed that topping Adolph Rupp's career win record was never a priority for him, but legions of his former players begged the soft-spoken coach to pursue the record.

He tied Rupp's record of 876 career wins in the first round of the NCAA Tournament in Winston-Salem, then broke it two days later against Colorado in the second round. The Tar Heels won two more games in the East Regional before falling to Arizona in

the NCAA semifinals in Indianapolis. That left Smith's career total at 879 wins—and that became the final total when Smith announced his retirement the next fall. He turned the job over to longtime assistant Bill Guthridge, who promptly won the 1998 ACC title and led the Tar Heels to two Final Fours in his three seasons at the helm.

But Smith's real successor as the Dean of ACC coaches was his toughest rival—working eight miles away in Durham. When Smith stepped down in the fall of 1997, Duke's Mike Krzyzewski already had two national titles and seven Final Fours to his credit. With the UNC program temporarily slumping as Guthridge was succeeded by Matt Doherty, Krzyzewski embarked on a period of ACC dominance that resembled Everett Case's conference run from 1946–56. Krzyzewski's Blue Devils won five ACC championships in a row (1999–2003), then after losing the 2004 championship game in overtime to Maryland, the Blue Devils won two more titles to make it seven in eight years.

Krzyzewski won a third national title (2001) and added three more Final Fours during that streak. His win total also mounted, even as the return of UNC alum Roy Williams revived the UNC program and re-ignited the UNC-Duke rivalry as the best in college sports. Between 2005 and 2011, either Duke or UNC won every single ACC title and between them, they collected three more national titles (UNC in 2005 and 2009; Duke in 2010).

As the second decade of the 21st century opened, Krzyzewski's longevity began to approach Dean Smith's 37-year reign. Smith's record win total had been passed by Bob Knight in 2007, but early in the 2012 season, Krzyzewski reclaimed the win record for the state of North Carolina when he beat Michigan State in Madison Square Garden for his 903rd career victory.

Krzyzewski also followed Smith's career path in another way. In 1976—four years after the United States had suffered a shocking loss to the Soviet Union in the finals of the Munich Olympic Games—Smith took over the U.S. Olympic team and led it to the gold medal in Montreal. Krzyzewski also inherited the U.S. Olympic team following a disastrous performance in the 2004 Athens Games. Krzyzewski led a team of NBA all-stars to the gold medal in Beijing in 2008 ... then repeated that feat in the 2012 Olympics in London. Like Smith (and later Roy Williams), Krzyzewski was inducted into the Basketball Hall of Fame as an active coach, joining an amazing parade of North Carolinians to earn Hall of Fame recognition—from John McLendon to Bones McKinney to Frank McGuire to Everett Case to Vic Bubas to Big House Gaines to Kay Yow to Sylvia Hatchell.

They are the architects of North Carolina's basketball greatness. And while the future is unknowable, the state's love affair with the sport is not likely to change. That much was demonstrated on the night of February 1, 2014, when Duke faced Syracuse in a dramatic game that deserves a place in the pantheon with 1957 Wake-UNC or 1974 N.C. State-Maryland or 1992 Duke-Kentucky.

Ever since the ACC was founded in 1953, the Big Four North Carolina powers have dominated the league. Between them, the Tobacco Road schools have won 49 of the first 60 ACC championships. At least one of the four has played in 59 of 60 title games. There have only been two seasons in which a Big Four team failed to win either a share

of the regular season title or the tournament title—and in both of those seasons (1990 and 2013) a Big Four team ended up going deeper into the NCAA Tournament than the non-Big Four champ.

The expansion of the ACC to 15 teams threatened to change that. The Saturday afternoon of January 11, 2014, was symbolic in that regard—on that day, all four Big Four teams lost on the same day—the first time that had happened in ACC history. The simultaneous slumps of UNC, Duke, N.C. State and Wake Forest triggered widespread commentary that the ACC's old powers had been surpassed by the league's newcomers.

But that judgment was premature. Both North Carolina and Duke began to win again at a high rate. The Blue Devils, especially, recovered from that January 11 loss at Clemson to post five straight impressive victories heading into a nationally televised game against unbeaten and No. 2 ranked Syracuse in the Carrier Dome—a game played in front of the largest on-campus crowd in basketball history. It was a game that lived up to the hype, featuring spectacular play by both teams and some incredible drama. Although Syracuse held on for a 91–89 victory in overtime, it was evidence that Duke— and by extension North Carolina's Big Four powers—was not ready to surrender control of the ACC.

And it was a reminder of why basketball remains the most popular sport in North Carolina.

Football

By Rob Daniels

Rob Daniels covered ACC business administration, six colleges and minor league baseball for *The News and Record* of Greensboro from 1997–2008. His assignments included 10 NCAA Final Fours, two Super Bowls, two U.S. Open golf tournaments, the ACC expansion process in 2003 and Wake Forest's 2006 ACC football championship. Daniels' work has been recognized by the Associated Press Sports Editors, the United States Basketball Writers Association and the North Carolina Press Association, and he served as executive director of the Atlantic Coast Sports Media Association from 2009–12. A native of Baltimore and an incorrigible Orioles fan, he resides in Greensboro.

Kickoff in Dixie

They won't like this in South Carolina. Or Georgia. Or Alabama.

The Old North State beat them all to the punch, the tackle and the Flying Wedge.

Just as a Canadian invented basketball and the English may have been the forebears of baseball, North Carolina had intercollegiate football before every other former member of the Confederacy. It even preceded Ohio, defender of Midwestern values and arguably the epicenter of the sport's entire history.

North Carolina's only geographical competitor in the eyes of a historian would be Virginia, in which Virginia Military Institute and Washington and Lee met in an 1873 competition some call "the first college football game in the South." That designation has a small problem: Neither school recognizes it as such, citing the continuous presence of 25 (and occasionally more) players on the field for each team.

So let the record reflect that when Wake Forest College and the University of North Carolina got together on Thursday, October 18, 1888, they formed a rivalry that predated Army-Navy, Ohio State-Michigan and Auburn-Alabama. The game they played that day bears little resemblance to the modern sport, but it's enough to qualify for official recognition by both schools.

It hasn't always been smooth. For a variety of reasons, most of the early adopters took a break from competition at some point. Duke, in fact, dropped the game for more than two decades, citing religious objections. Of the nearly three dozen four-year colleges in North Carolina that have claimed a football team at some point, only North Carolina State and Davidson started in the 19th century and have played at least one official game in every year since they first teed it up.

The first game came about due in no small part to the advocacy of William Carey Dowd, Wake Forest Class of 1889 and apparently a persuasive fellow. Before he turned 40, Dowd would own three newspapers and would cast votes in two Democratic National Conventions for William Jennings Bryan. In 1911, he became Speaker of the North Carolina House of Representatives. Dowd generated enthusiasm for the sport on the Wake Forest campus, then located 16 miles north of Raleigh, and talked it up—as well as 19th-century technology could allow—among his associates elsewhere.

And so the teams convened at the Raleigh Fair Grounds on Thursday, October 18, the next-to-last day of the 1888 festivities. There is no physical object marking the spot, which is covered these days by a strip mall and the back end of a bowling alley just across the street from N.C. State University.

The young college athletes shared the day's docket with Honeysuckle, Bequest, Melville Chief and at least two other racehorses, who entertained the masses by dashing around the track. Neither football nor horse racing was the best explanation for the attendance, which *The News & Observer* of Raleigh estimated at 10,000 or more. That distinction belonged to beloved U.S. Senator and Civil War hero Zebulon Baird Vance, who embraced a populist theme when he decreed, "Down with class legislation and all laws which take the benefits from the many and confer them upon the few. Down with the unjust laws which impoverish the masses and enrich those already wealthy."

Only a Beginning: It was the first close association of politics and football in the state's history. It would not be the last. Wake Forest won by the currently odd score of 6–4. The *Wake Forest Student*, the college's student newspaper, offered a glowing review of the athleticism and the sport in general. The journalistic legitimacy of the account is in question. After all, W.C. Dowd was assistant editor of the paper.

Four years later but more than half a century before *Brown v. Board of Education*, two colleges played in obscurity and ushered in the first football game between two black colleges anywhere in America. Livingstone College and Biddle University, later and currently known as Johnson C. Smith University, faced off on December 27, 1892. The account from T.M. Martin, now part of a website dedicated to the rivalry's history, says female students at both schools made the players' uniforms and that the clubs squared off on "the front lawn" of Livingstone's campus in Salisbury.

Snow began to fall during the game, and as Biddle held to a 5–0 lead in the final stages, it fumbled. A Livingstone player recovered and ran the ball in for an apparent touchdown. Biddle's players contended that the ball rolled out of bounds before the recovery and that the officials had missed this important fact because snow had covered whatever boundaries had been drawn on the turf. Upon considerable review, which predated video analysis by more than a century, the arbiters agreed with Biddle and invalidated the touchdown. So this wasn't simply the first black college football game on record; it was also the first well-chronicled officiating dispute.

Who's No. 1? Duke: Ask a robust number of culturally attentive people what comes to their minds when they think of Duke University, and most will mention at least one of these three: nationally esteemed institution, tremendous basketball program, and bitter rival. To virtually anyone born after the early 1960s, football will rate only as a punchline written by a series of losing seasons, a few of which were winless. But the entirety of history tells a different story.

Through 2013, no football program in North Carolina had won more conference titles than Duke's 17. Thanks to its amazing run at the start of this century, Appalachian State finally caught the Blue Devils in 2012. The Duke program has also produced North Carolina's only two players inducted into both the College and Pro Football Halls of Fame—Clarence "Ace" Parker and George McAfee. And Duke played in two Rose Bowls, one of which it hosted.

The glory days—and they were among the most glorious of any program in that span—came under the auspices of Wallace Wade, who coached that Duke-hosted Rose Bowl, promptly joined the Army and returned to the sidelines after a three-year hitch, his second in the military.

It is not an exaggeration to say that Duke pulled off one of the biggest coups in college football coach-hiring history when it secured Wade's services. Two factors made this astonishing. One was the state of the Crimson Tide, which Wade had guided to a 61–13–3 record in eight seasons. Three of those eight teams (1925, 1926, and 1930) would later be credited with national championships, a phrase that didn't gain any semblance of credibility until the Associated Press started its survey—and real-time declaration of national supremacy—in 1936. Wade had earned his stripes as an assistant at Vanderbilt. At Alabama, he inherited a program of solid but not national stature. Years later, no less an authority than Paul W. "Bear" Bryant himself would repeatedly declare that Wade's construction of the program, which included a 24-game unbeaten streak from 1924–27, inspired the Bear's love of it. Wade won 81.2 percent of his games on the Crimson Tide sidelines; Bryant's

percentage was 82.4. So leaving Alabama might seem odd by itself. But leaving Alabama for Duke? Take the shock factor and double it. When Wade made the move, his future employer was better known for not playing football than for winning or losing.

In 1887, John Franklin Crowell, a 29-year-old Pennsylvania native educated at Yale, Columbia and the University of Berlin, accepted the job as president of Trinity College, a Methodist institution in rural Randolph County, North Carolina. In short order, Crowell cultivated a relationship with tobacco magnate Washington Duke that was even more fertile than the fields that produced the golden, addictive leaf. Duke offered plentiful land in Durham and with it the opportunity for the college to expand. The school moved 70 miles east in 1892, was ultimately renamed in honor of the Duke family and has become one of America's finest universities.

Two years after orchestrating the great relocation, one that has defined the institution, Crowell was out of a job, felled by religious politics with an assist from football. Crowell had started his professional career as, of all things, a sportswriter for the *New Haven* (Connecticut) *Morning News*, for which he reported on this new game with considerable zeal. When he became president of Trinity, he also became its first football coach.

Like its new neighbor, Wake Forest College, Trinity was governed by the state convention of a major denomination. Wake Forest was Baptist; two-thirds of Trinity's Trustees were appointees of the Methodist hierarchy. In his presidential papers, Crowell hinted that he had overcome considerable angst from trustees who hailed from Greensboro and points west to make the move to Durham in the first place. Having failed to block the relocation, they went to war over football, he said.

An "Unfit" Competition: Religious pundits said the game turned young men into animals and that it attracted unsavory characters from gamblers to unchaste women in appalling numbers. And then there was the inherent violence of the sport, which had already become apparent and would lead to the creation of the NCAA in 1906. Out went Crowell, the Yalie. In came a Southern Methodist, John Kilgo, who allowed a previously scheduled game to go on but banned the game altogether, effective in 1895. Football, he said, was "unfit to be played at a Christian college." The game didn't resume at the school until 1920.

So when Wade came to Duke in early 1931, many alumni had no warm feelings for the sport because they never had a team to root for while they were in school. Why, then, would Wallace Wade go from Broadway to dinner theatre? Several years later, he said he was attracted by Duke's status as a private school, which he said was a better fit for the Brown University graduate. As he had done at Alabama, he would coach football and would serve as athletics director. Of course, the raise he received—$12,000 to $20,000— was nice, and it provided an especially princely sum for the day and for college athletics, in which professional coaching was far from ubiquitous.

The X Factor may have been a tenuous relationship with University of Alabama President George Hutcheson Denny, whose daily attendance at practice rankled Wade. The allegedly substandard seasons of 1928 and '29, both of which produced 6–3 records, apparently aggravated the relationship between the two men. In that sense, the story of the Wade-Alabama split is nothing new.

One part of it is inconceivable by modern standards: Before the 1930 season, Wade actually announced he had accepted Duke's offer but that he would honor his contract and coach the 1930 Tide team. And both schools let him do it. Wade got the last belly laughs, guiding the team to a 10–0 record and another (later to be awarded) national title.

"This team will go down as the greatest ever seen in the South," Denny admitted at a banquet commemorating the team's acceptance of a Rose Bowl bid. "Greatest in exemplifying and illustrating the correct ideals of character, fine spirit, scholarship and devotion to duty in the daily walks under these old oak trees we love so well."

Here's one indicator of the rarity of the Wade move: Since the AP poll's creation in 1936, only one coach, Johnny Majors (Pittsburgh to Tennessee in 1976), has left a college he has just led to a title for an immediate appointment at another school.

The Wade Legacy: Wade did at Duke what he had achieved at Alabama. Maybe even more. At Duke, Wade coached seven future members of the College Football Hall of Fame. Of Wade's first 11 teams, 10 had at least one future Hall inductee.

The most renowned of the bunch was Parker, whose career in sports connected three centuries. As the Blue Devils' chief runner and passer, he finished sixth in the second Heisman Trophy balloting in 1936. He also played basketball and baseball, and by the spring of 1937, he was living out every American kid's dream at the time. He was a Major League Baseball player.

Parker made his debut as a pinch runner on April 24, 1937, for the Philadelphia Athletics. Six days later, he finally got his first plate appearance and made the most of it, becoming the third player in Major League history to hit a home run in his first at-bat. The long ball came in Fenway Park against the fraternal battery of pitcher and Greensboro native Wes Ferrell, an All-Star that season, and his Hall of Fame brother Rick Ferrell, who was born in Durham. The rest of the season didn't go so well for Ace, who hit .117 in 94 at-bats. Perhaps wondering about his future on the diamond, he asked the Athletics if he could play football that fall. Sure, they said.

So Parker suited up that season for the football team known as the Brooklyn Dodgers. He returned for one final baseball season in 1938 and then headed to full-time football duty. He led the NFL in total offense in 1938 and was the league MVP two years thereafter when he threw 10 touchdown passes, caught two others, made 19 extra points and tied for the league lead with six interceptions on defense.

Parker ultimately was named to the Pro Football Hall of Fame as well as the College Hall. He and one of his immediate Duke successors, George McAfee, are the only North Carolina collegians to earn enshrinement in both. Upon joining the professional group in Canton, Ohio in 1972, Parker said, "I never expected to be selected for this, but since I have been selected, I'm sure glad it happened while I'm still around." He was 60 that day. He lived to be 101. He died in his hometown of Portsmouth, Virginia, on November 6, 2013. In his life in sports, Parker played Major League Baseball for manager Connie Mack, who was born six months before the battle of Gettysburg. Parker scouted for NFL teams until 1987, when the draft's first choice was quarterback Vinnie Testaverde, who played until 2007.

Parker played his last Duke game in 1936, but the program went on just fine without him. The 1938 team was the third straight Duke squad to feature three future Hall of Famers: end McAfee, center Dan "Tiger" Hill and halfback Eric "The Red" Tipton. And they didn't let much slip past them. They didn't allow a point the entire regular season, a feat only two teams have matched in the history of the sport. That is in part a testament to football of the era, a sport of tortoises compared to today's gazelles and one without mass substitutions. But playing nearly an entire year without letting down still resonates.

The regular season came down to what still stands as one of the most anticipated games

in this state's history. Pittsburgh came into town ranked fourth in the country. Duke was third. A crowd estimated at 50,000 and called by media outlets the largest to watch a football game in the South saw Bob (Bolo) Perdue block a fourth-quarter punt in a scoreless tie and light snow. That play facilitated the 7–0 Duke victory and a resulting Rose Bowl invitation. In Pasadena, California, the streak of defensive perfection ended with a last-minute UCLA touchdown and a 7–3 Bruin victory.

Roses and a "Choo-Choo": Three seasons later, the Devils were again headed to Pasadena, invited by the Rose Bowl committee to play Oregon State. But it wasn't that easy or that final. The Rose Bowl first offered Fordham the opportunity and leaked word that the Rams were coming. The committee didn't know, however, that the school had already accepted a bid to the Sugar Bowl. So they proceeded to Duke and Wade, who had participated in the game six previous times as a player or coach.

That was December 1, 1941. The world knows what happened six days later on a seemingly perfect Sunday morning at Pearl Harbor, Hawaii. With no disagreement—the hysteria over a presumed second Japanese attack was such that the U.S. government would start locking up its own citizens of Japanese ancestry six weeks later—the Rose Bowl moved to Durham. Washington and Chicago offered to host, but Wade lobbied harder and successfully when he convinced his neighbors, the University of North Carolina at Chapel Hill, State College (now N.C. State) and Wake Forest College (now Wake Forest University) to lend him 15,000 temporary bleachers between them.

As for the actual game, Oregon State was considered a heavy underdog because of its cross-country train voyage and the Blue Devils' home-field edge. But the Beavers started strong and never let Duke in control, claiming a 20–16 victory. The crowd of 56,000 would stand as the largest in North Carolina for decades.

Shortly thereafter, Wade, who had served in the U.S. Army during World War I but was not shipped overseas, again amazed the public. Only weeks short of his 50th birthday, he enlisted in the Army again and begged to go abroad. He earned the Bronze Star from his own country and a medal from the people of France for his service at Normandy. He returned to his Duke gigs in 1946. While his final five Duke teams didn't reach the national standing of the pre-war versions, Wade's return was another element in a period of growth for the sport in North Carolina.

While recruiting-based websites have introduced prospects—whether legitimate or alleged—to the masses before those players' NCAA debuts, they have yet to create a Choo-Choo Justice. Only war could do that. Justice was a college football star before he was a college student.

Charles Ronald Justice graduated from high school in Asheville, North Carolina, in 1943, enlisted in the military while declaring an inability to swim and was assigned to the Navy anyway. He was sent to the Bainbridge Naval Air Station, a ragtag base in humdrum northeast Maryland that had been in operation for less than a year when he arrived. (In spite of its nondescript location, the place did become the temporary home of several other famous people. Stan Musial, Bill Cosby, actor Tony Curtis and future TV weatherman Willard Scott are among its alumni.)

A dynamic running back in high school, he found himself on a service academy team filled with collegians of considerable achievement. (All but three of the 38 players on the 1944 Bainbridge team had college experience.) Although one of the youngest on the team, he was probably the best.

The nickname was born, as legend has it, when a Naval officer, watching another long

Justice touchdown run, made an off-hand comment to his buddy, who happened to be an editor at the *Baltimore Sun*. Accounts differ on the precise language, but it compared Justice to a runaway train and suggested the moniker "Choo-Choo."

Playing a seven-game schedule in 1943, the Commodores faced six fellow service teams and only one college, the University of Maryland. The Commodores beat the Terrapins 46–0. They defeated their comrades in arms a combined 267–7. Justice, for his part, averaged 10 yards a carry and the Commodores, eligible for AP poll consideration, finished 17th. That may have been an injustice to Justice et al. College teams routinely discussed playing the Commodores only to get cold feet. In 1944, they were only slightly less dominant. Again going unbeaten, they dispatched their opponents by a 331–70 collective score. That meant that in his past three seasons, including his final year of high school play, Justice's teams had outscored the other guys by a total of 1,044–83.

Justice was assigned to Hawaii in 1945 and became the subject of an intense recruiting battle between UNC, Duke, South Carolina and others more than 5,000 miles away as his military service wrapped up. Justice felt strongly that athletes should play in the states in which they intend to live their adult lives, which eliminated most of his suitors. And he had one further request—that he be permitted to enroll as a beneficiary of the G.I. Bill and that any forthcoming football scholarship be assigned to his wife. Only the University of North Carolina and its coach, Carl Snavely, agreed, and Sarah Justice matriculated at Chapel Hill on a football scholarship.

When Justice arrived in Chapel Hill, the locals were ready for him. Having read idyllic newspaper accounts—back when newspapers were actually primary sources of information for a majority of the populace—of the Bainbridge Eleven, students and residents could hardly wait to see this one-time boy among men. More than 1,000 of them turned out in February cold for an exhibition game against Guilford College, a small school in Greensboro.

In the fall of 1946, Justice was ready to begin his fourth season of competition against college players. And he was a freshman academically. He didn't let anybody down. He ran for 170 yards on 17 carries in his debut and kept going. Statistically, Justice did it all except catch passes. He ran, threw, returned punts and kickoffs and punted. His career record for total offense stood for more than 50 years. Justice predated the ACC era, but his totals would still be good enough (through the 2012 season) for ninth in punt-return yards, third in yards per punt return and 14th in yards per punt. His total of 1,521 all-purpose yards in 1946 wouldn't be surpassed by an ACC player for 20 years.

Justice led the Tar Heels to three bowl games in his four years. That's commonplace today but rare in the 1940s, when bowls were few, elite and reserved as rewards for the truly superior teams. There were no Poulan Weed-Eater Bowls among them. The Heels went to two Sugar Bowls and made one appearance in the Cotton. In the process, Justice became the most acclaimed college football player from North Carolina of his era and perhaps of all time. He was runner-up in the Heisman Trophy balloting twice—in 1948 to Doak Walker of SMU and to Leon Hart of Notre Dame in 1949. And as crazy as this sounds in an era in which the South and football and supremacy are rhetorically intertwined, that was a remarkable feat at the time. For its first half-century of existence, college football was dominated in the public consciousness by the Midwest and Northeast, which controlled national media markets by virtue of the power of the printed word and the infancy of national television. Through the Heisman's first 13 years of existence, only two players from the Southeast finished in the top three of the balloting. They were both

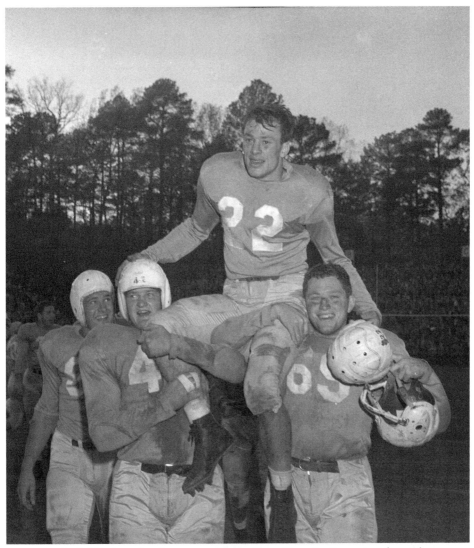

In the jubilation of a victory over Duke, Choo-Choo Justice gets a free ride.

University of Georgia Bulldogs, 1942 winner Frank Sinkwich and 1946 runner-up Charlie Trippi. Through the 2012 award, Justice was still one of only 10 players from anywhere to finish in the top two on multiple occasions.

Justice broke through the clutter and earned national fame that transcended the sports media and the field of competition. On October 3, 1949, the nation went to its newsstands to find Choo-Choo Justice on the cover of *Life* magazine, which claimed three million subscribers and more than 13 million total weekly readers. Among other cover subjects that year: Joe DiMaggio and the Sistine Chapel. Yes, the quarterback from Asheville was getting close to god status.

Benny Goodman and his orchestra recorded "All the Way, Choo-Choo" in Justice's senior season of 1949. The cover of the sheet music has Justice right there in his UNC

uniform, a practice the NCAA probably would not permit today. As if that was insufficient, Justice led a collection of college all-stars to a 17–7 win over the defending NFL champion Philadelphia Eagles in 1950. He caught a 40-yard touchdown pass and set up two other scores with long runs.

In a 2000 interview with *The Charlotte Observer*, Justice humbly suggested the extent of his fame was due in part to the post-war era in which he played. "It was the perfect time," he said. "Carolina needed a star. Everyone had been through a war. Confined. There had been gas rations. The war was over, and people wanted to turn it loose a little."

Hooray for the Cloudbusters: The Justice story sheds some light on a segment of organized football that is not easily classified. You might say it's de-classified, however.

The military's use of the sport for its own recruitment efforts and general morale of the populace was a national strategy that took hold in the Old North State. But just what do you call military base football outfits?

This wasn't quite professional football. The players were paid, but officially, they were compensated in return for service to their country in wartime preparations. It wasn't high school quality because so many of the players had participated in college ball. And it wasn't truly college football because the servicemen at each base weren't spending much time in classrooms or learning about a multitude of subjects, as they would at Annapolis or West Point. (By the time the U.S. Air Force Academy moved to Colorado Springs in 1958, the military had shuttered most operations on established college campuses and abolished the concept of the base-specific athletic squad.)

This was a World War II thing, and in places such as Chapel Hill, it was a curiosity and a launching pad for a few interesting football careers. In the immediate aftermath of Pearl Harbor, the U.S. Navy put out feelers among the nation's elite public universities in search of locales for flight training centers. UNC President Frank Porter Graham didn't merely volunteer; he campaigned for his school's inclusion and backed it up by refurbishing 10 existing dorms and building entirely new recreation and physical education facilities to accommodate the 1,875 servicemen who were on his campus within six months of the Japanese attack. Among those eventually assigned to North Carolina Pre-Flight School were two future Presidents of the United States, Gerald Ford and George H.W. Bush.

Just as it did with the Great Lakes Naval Air Station near Chicago, the Navy ordered the creation of a football team, and it found several promising men to play and coach. (Ford, an All-American center at Michigan, turned 29 in the summer of '42 and had aged out of competition.) It also came up with a great nickname, the Cloudbusters.

And bust they did. Under the direction of former Fordham coach Jim Crowley, one of Notre Dame's "Four Horsemen" in his playing days, the team went 8–2–1 in 1942. The Cloudbusters pitched six shutouts and never had the luxury of playing a true home game. They did, however, play in three major league baseball parks after the main tenants' seasons had ended: Griffith Stadium (Washington Senators), the Polo Grounds (New York Giants) and Yankee Stadium.

After a nondescript 2–4–1 season in 1943, the Cloudbusters were back in top form in 1944 with the assignment of former Northwestern University quarterback and future pro star Otto Graham to the school. The club began 6–0–1 and zoomed to No. 2 in the national rankings before none other than Justice and his Bainbridge team came calling in Chapel Hill. Offering a bit of a preview, Justice led the Commodores to a 49–20 victory. In the end, the Cloudbusters spent the final six weeks of their season in the polls and finished 6–2–1.

The 1945 campaign also looked promising. Lt. Commander Paul William Bryant, a 31-year-old Arkansan who had been a Cloudbusters assistant the year before, was ready to run his own squad as the summer of '45 arrived. You might say they were ready for Bear in Chapel Hill.

They didn't get the chance to see it. In August, the war ended — a good thing, by the way — and the Navy closed the Pre-Flight school. By the first week of September, Bryant had a new job as the head coach at the University of Maryland. On September 20, he received his discharge papers in Norfolk, Virginia, and headed for College Park, where his roster would receive a boost the next day with the enrollment of 14 former Cloudbusters. Almost as quickly as it started, the story of military-sponsored, quasi-college football in North Carolina and everywhere else concluded.

As for that Bryant fellow, he did OK for himself. Starting off with a 60–6 victory over the visitors from Guilford College, his one and only Maryland team went 6–2–1. A spat with the administration drove him to Kentucky, which lost him to Texas A&M, which lost him to his alma mater, Alabama. You know the rest. You may not have known it almost started in the Old North State.

A Man Called "Peahead": In the pantheon of great nicknames of college football, it's hard to beat the one affixed to Douglas Clyde Walker. They had called him "Peahead" since his boyhood, for reasons unclear but well appreciated by media and historians.

Peahead's sporting life was every bit as unique as his moniker. He bounced from Birmingham Southern College to Vanderbilt and to Wake Forest, for which he played one game in 1920. By then, his academic status was so muddied that he was listed in the 1920–21 College Bulletin as "unclassified" rather than as a freshman, sophomore, junior or senior. And he wasn't done. He moved on to Howard College, now known as Samford University, and graduated in 1922.

In 1921, he began a 14-year career as a minor-league baseball player and manager. His teammates on the 1924 Rochester Tribe included 35-year-old Fred Merkle, known as "Bonehead" since the age of 19, when he made a base-running blunder that cost the New York Giants an important game against the Cubs in the 1908 pennant race. The 1924 Tribe therefore included a Bonehead and a Peahead.

For 10 years — as a player from 1926–32 and as a manager from 1937–39 — Walker pulled double duty. He'd coach college football in the fall (Atlantic Christian, Elon and Wake Forest) and head off to locales near (Winston-Salem, Wilmington and Wilson in North Carolina) and far (York, Pennsylvania; Bloomington and Decatur, Illinois) in the springs and summers. Peahead became the Demon Deacons' coach in 1937 and didn't know stability until the early 1940s. Once he got it, he made the most of it.

In his 14 seasons, he guided the Deacs to 77 wins, a total that stood alone as the school record until November of 2013 when Jim Grobe, near the end of his 13th season at the school, won his 77th game as Wake Forest's head coach. Included in the run under Peahead were two bowl appearances and the only success of any measure for more than a half-century at the school. In his 13 seasons and in an era in which post-season invitations were far more numerous, Grobe took his teams to five bowl games.

Walker did his magic while an already small college absorbed a war-related male enrollment hit. In 1943–44, the school didn't field a basketball team, but Peahead's squad suited up. There were still no more than 400 men in the undergraduate populace in the fall of 1944, when Walker's team went 8–1. Duke, a 34–0 winner over the Deacons, was the only team to score more than 13 on Wake Forest.

D.C. "Peahead" Walker, 77 wins at Wake.

Walker's impact on his institution transcended football. Today, Wake Forest's ACC membership is taken for granted. It was one of six league members among the Top 35 national universities in the September 2013 *U.S. News & World Report* rankings, after all. But consider the school's place in the world when the ACC came into being in May of 1953. The University of Maryland had eight times the total enrollment of Wake Forest in that ongoing 1952–53 academic year. That's an even greater discrepancy than anything existing between two current league members.

So it was still small. More than that, it was in the process of leaving the neighborhood of its longtime rivals UNC, N.C. State and Duke. In 1946, the North Carolina Baptist Convention, which essentially governed the institution, accepted a magnanimous offer of land from Richard Joshua and Katharine Babcock Reynolds and agreed to move exactly 100 miles west from the town of Wake Forest to the tobacco hub of Winston-Salem. The full transfer didn't happen until the summer of 1956, but it was coming.

Duke was the only other private school in the original group of seven. The bigger schools could have easily left behind Wake Forest, which, while given an opportunity at reinvention by the Reynolds gift, still had millions of dollars in new construction to fund at the expense of its endowment growth.

And Peahead wasn't even around anymore. He wasn't even coaching in the United States. He left Wake Forest after the 1950 season for the timeless reason, a dispute with the administration, and was head coach of the Canadian Football League's Montreal Alouettes by 1952. But his achievements were still conveniently memorable. His final team's only defeat in nine games was a one-point affair with Clemson. His successor, Tom Rogers, produced winning seasons in his first two seasons. Nobody in that room could call Wake Forest a pushover. And a guy named Peahead was largely responsible for that.

Football Behind ACC's Birth: Time would only add to the esteem in which he was held. But even as Demon Deacon teams lost with alarming frequency in subsequent decades, their school was not about to be evicted from the ACC. Simply put, the ACC had to be.

Its charter members came from the Southern Conference (SoCon), which, while geographically contiguous, was the United Nations when NATO would have been sufficient. Founded in 1921, the league had 23 members from 1928 until 1931, when the Deep South and deeper pocketed members formed the first splinter group, the Southeastern Conference.

But totals of 15, 16 or 17 members were still too high. While the round-robin format was impossible with such large numbers, there were still some bizarre ramifications of excessive size and insufficient governance. Clemson and Maryland were SoCon members for 31 consecutive years yet never met in football. Although located in the same state, Davidson didn't play UNC, Duke or Wake Forest in any of the schools' final seven seasons of common SoCon membership.

The league couldn't even ensure that everybody played the same number of conference games. In 1952, North Carolina played three Southern Conference games; Virginia Tech teed it up for eight. Duke (5–0) won the title while facing only one of the other four teams to finish with winning league records, Wake Forest. And this was with the respected Wallace Wade serving as commissioner.

By this point, a schism was becoming apparent, and the cause, financial disparity, is timeless. Those schools that could fund big-time football played each other regularly. The lesser-resourced institutions had their own thing going. Seldom did the two groups meet. Nationally, the debate over the sport's influence on higher education was raging. In 1951, Maryland and Clemson had bowl offers on the table. The 17-member SoCon met and voted 14–3 to forbid the Terrapins and Tigers from accepting, citing the corruptive influence of cash and imminent academic conflicts. (Never mind that Maryland's first-semester exams didn't occur until the end of January.)

Although joined by only one other member, Clemson's bitter rival South Carolina, the upbraided institutions ignored the mandates and went to the bowls anyway. For this, they were barred from SoCon title eligibility in 1952. Under such conditions, an association such as the Southern Conference could not last.

In the spring of 1953, the Southern Conference conducted its business meetings at the Sedgefield Inn in Greensboro. Seven dissidents—UNC, N.C. State, Duke, Wake Forest, Maryland, Clemson and South Carolina—showed up as SoCon members and left on their own. On May 8, they convened among themselves to form a new, smaller union. (Virginia, which led the rhetorical charge against big-time football and had a blanket policy against bowl games, had left the SoCon in 1938 and was an independent at the time of the ACC's formation. It vacillated on an invitation before joining the fold on Dec. 1, 1953.) The scheduling issues couldn't be immediately resolved in their entirety. In 1953, co-champions Maryland (3–0) and Duke (4–0) didn't play each other. But the Atlantic Coast Conference ultimately solved the glaring disparity problems and solidified the relationships and rivalries of the members who would become known as the "Big Four."

There is no other quartet of major-conference brethren as geographically close as North Carolina, N.C. State, Duke and Wake Forest. Only 92.6 miles separate the Wolfpack in the east from the Demon Deacons in the west. The two in the middle, the Tar Heels and Blue Devils, are 8.78 miles apart as the crow flies between the schools' most revered landmarks, the Old Well at UNC and the Duke University Chapel. With South Carolina's ac-

ademically motivated abdication for independence in 1971 and Maryland's financially driven switch to the Big Ten in 2014, the North Carolina schools represent 80 percent of the conference's remaining charter members.

Duke thrived in the ACC's early days, winning or sharing six of the first ten conference titles under the direction of Bill Murray, who arrived from Delaware in 1951 to succeed Wade. The Blue Devils played in three bowls, winning the Orange following the 1954 season and the Cotton post 1960. Through 2013, the program hadn't won a postseason game since.

Although the benefits of membership were not immediate, N.C. State gained more from the new deal—relative to its past—of any of the four. The Wolfpack went 63–108–14 (.378) in Southern Conference games; that winning percentage stood 33rd among the 41 football members in league history through 2012. State never won an officially awarded SoCon championship. (The 1927 squad had the best winning percentage in league play at 4–0 over Georgia Tech's 7–0–1, but the conference didn't begin recognizing champions until 1933.)

Wagering on the Ponies: The cover of the 1957 N.C. State media guide would never fly in the 21st century, in which the NCAA disdains gambling references. "We're Bettin' on the Ponies," it decreed, referencing the collective nickname of all-star backfield mates Dick Christy and Dick Hunter.

The allusion is amazing in its context. It was only six years removed from the CCNY basketball point-shaving scandal, one of the events that contributed to the ACC founding fathers' angst about the vast size and potentially compromised oversight of the Southern Conference. But State fans didn't bat an eye. They embraced the Ponies, who reciprocated with a compelling race to the ACC title.

Even by 1950s standards, the Wolfpack's defense was dominant. It allowed only 41 points in the season's first nine games and gave State a shot at its first conference title in any league. The Pack entered the finale at South Carolina at 4–0–1 in ACC play while Duke was 5–0–1 with one game to play. (The schedule discrepancies remained.) The Gamecocks became the only team to make N.C. State score big to win, and the Wolfpack did so. To be more specific, Christy did it. Having already accounted for all 29 Wolfpack points by touchdown and kicking, Christy told coach Earle Edwards that he could make a 46-yard tie-breaker on what would be the game's final play.

Today, we think nothing of a 46-yard field goal. In 2012, NCAA kickers across all divisions—not just the Football Bowl Subdivision—made 57 percent of their attempts from 40–46 yards. But in 1957, even considering such things was folly. In 590 major-college games that season nationwide, only 64 field goals were successful. From any distance. A dozen years thereafter, when the NCAA compiled accuracy statistics for the first time, the national success rate from 40–49 yards was still only 29.4 percent.

But Christy was persuasive. When he converted, the Pack had a 29–26 victory. Shortly thereafter, North Carolina upset Duke and the Pack had its first official championship in any conference.

The 1960s were even better for the Pack, which won or shared the ACC title in 1963, '64 and '65 and achieved national stature soon thereafter. And defense was again the driving force. Anchored by lineman Dennis Byrd, who would be inducted into the College Football Hall of Fame in 2010, the Wolfpack held each of its first eight opponents in 1967 to 10 or fewer points. The eight-game streak remained tied for the longest in ACC history through 2013.

The string included a dominant 16–6 win over No. 2 Houston in the Astrodome, then in its third year of existence and considered "The Eighth Wonder of the World." Through 2013, the victory remained the best—as measured by Associated Press ranking—by any ACC team on the opponent's home field. That result and four subsequent victories elevated the Wolfpack to No. 3, a standing that remains tied for the highest by any North Carolina school. (UNC equaled it in 1981 and 1983.) The run was brought to an end by Penn State and its second-year head coach, Joe Paterno. Down 13–6, the Pack drove to the Nittany Lion 1 yard line before being stopped. The Lions took a safety to account for the 13–8 final score.

Although starting 17 seniors in 1967, N.C. State again won the ACC in 1968 with a 6–1 record in league play.

Too Many Marys: The 1970s brought the arrival of a self-described goofball from West Virginia who spoke a mile a minute, charmed prospects and the general public and won everywhere he coached. In November of 1971, he took on the challenge at N.C. State. Asked why he had left the College of William & Mary, which he had led to a bowl game a year earlier, Lou Holtz said, "Too many Marys. Not enough Williams."

Holtz immediately infused the program with enthusiasm, turning a 3–8 team the year before his arrival into an 8–3–1 squad. "The greatest thing coach Holtz has done is to convince us that we can play on an even par with anyone, yet he still cusses and throws his clipboard," linebacker Bryan Wall wrote in the University's 1973 yearbook.

And with that, a run began. N.C. State became the first ACC and North Carolina school to go to bowl games in four consecutive seasons (1972–75). That 1975 season represented the debut of the last major gift to the program of the Holtz era, which ended when the coach accepted—and almost immediately regretted—the task of leading the New York Jets on February 10, 1976.

Ted Brown, a running back from High Point, stands 5-foot-8, a fact that dissuaded every major program save one. Even in recruiting Brown, Holtz said he didn't like to play true freshmen and probably wouldn't make an exception in this case. As Brown told *The News & Observer* of Raleigh in 2012, he decided he'd simply compel the coach to change his ways. Mission accomplished.

He ran for 913 yards as a rookie and kept going in a career defined by four-year consistency. Brown amassed 4,602 ground yards for the Wolfpack, and his best season produced 1,350 of them. That's only the 16th-highest total for any single season in ACC history. More remarkable is the longevity of Brown's achievements. His career total has been the ACC record since he made his final run on Dec. 23, 1978. In the next 35 years, 14 players had better statistical individual seasons than Brown's best campaign, but none caught his career standard. Through the 2013 season, Brown's was the longest-running active career rushing mark of any Football Bowl Subdivision conference. And 35 years is a long run by any measure. Case in point: the Big Ten. Archie Griffin's mark in that august league lasted 24 years.

Furthermore, contrast Brown's record with the ACC career passing yardage standard. Duke's Ben Bennett achieved the record in 1983 and has been surpassed by five individuals since. (Among them is another Wolfpack player, Philip Rivers, who threw for an astounding 13,484 yards, a total 34 percent higher than the No. 2 man, Duke's Thaddeus Lewis.) Through 2013, Brown also held the ACC's marks for career rushing touchdowns (49) and 100-yard games (27). His average of 107 yards per game stood until 2012.

Brown led the Pack to three bowl games—one under Holtz and two under Bo Rein, who proved a worthy successor. With Brown starting a long and productive NFL career,

Rein guided the Wolfpack to the ACC title in 1979 and accepted the LSU job shortly there-after. Tragically, Rein died in a plane crash while on one of his first recruiting trips for LSU.

Tailback U.: As Brown was cranking things up for the Wolfpack, UNC was in a ground-based renaissance of its program, one that would produce ACC titles in 1971, '72, '77 and '80.

The Tar Heel running game enjoyed its first national greatness under Don McCauley, a bruising rusher with a linebacker's mentality, from 1968–70. McCauley's total of 1,720 yards in 1970 was good for an NCAA record, and it helped secure his place in the College Football Hall of Fame. As the 1970s got going, the tradition continued with a string of ex-cellence that few programs have ever matched. UNC had at least one player rush for 1,000 or more yards in every season from 1973–84. And in three of those years (1974, 1980 and 1983), two Tar Heels did it. Coach Bill Dooley started the tradition, recruiting Mike Voight (1973–76), James Betterson (1973–75) and Amos Lawrence (1977–80) to Chapel Hill. After Dooley left for Virginia Tech following the 1977 season, Dick Crum kept it rolling with Kelvin Bryant (1979–82), Tyrone Anthony (1980–83) and Ethan Horton (1981–84).

The running game had a partner in driving opponents into the ground. His name was Lawrence Taylor, who showed up as a defensive lineman and became one of the most feared players in college or pro football history when he moved to linebacker. Tackles for loss and other defensive statistics were sparsely and irregularly kept on a national basis in the 1970s; if stat-tracking adhered to current standards, there's no telling how the legend of LT would have developed in his college days. Although a member of the Pro Football Hall of Fame, Taylor is not in the College Hall.

With the continuous supply of rushing talent, Carolina cracked the top six in the AP poll in portions of every year from 1980–83. No ACC program had been to that territory in four straight seasons since Maryland's presence there in the league's first four years of existence. The best of the highs came in 1980, when Carolina went 11–1 and won the conference title as Lawrence and Bryant both topped the 1,000-yard mark and Taylor recorded 16 sacks. Perhaps the best testament to Taylor's excellence is his selection as ACC Player of the Year; only four defensive players earned the honor from 1981–2012.

The Heels held their first seven opponents to 13 or fewer points; the only one to get in double digits, curiously enough, was Football Championship Subdivision foe Furman. That run elevated them to sixth in the polls and set up a showdown at No. 16 Oklahoma, which treated the Heels the way they treated most people in those days, with a 41–7 beating. The pollsters dropped the Heels to 14th and never forgave them for the Oklahoma game. Although they won their final four contests, they advanced only to No. 13. Their winning percentage that season is still the best by any FBS program from this state.

A New ACC: Although every team has had its highlights over time, the total truth says the four North Carolina schools have underperformed, mathematically speaking, through-out ACC history. From 1953–91, they fielded 47 percent of the conference's teams but won 32 percent of the championships. And it wasn't going to get easier as the 1990s dawned. When Florida State gave up independence for ACC membership in 1992, every-body's window of opportunity closed. UNC hasn't won the conference title since 1980. N.C. State's most recent title came in 1979.

The moments of supremacy or close to it were therefore more noteworthy with every passing year. And "passing" was the operative word in 1989, when Duke and its

innovative, provocative coach, Steve Spurrier, shocked the ACC. The season turned on three consecutive weeks of September and October. Virginia did a number on the Blue Devils 49–28, but Duke responded the following week with a 21–17 upset of Clemson, which turned around and defeated the Cavaliers, as it had never failed to do to that point, 34–20. The stalemate continued throughout the season with the Cavs and Devils tied at 6–1 in league play. The Tigers absorbed their second loss of the conference season on October 14.

The Blue Devils punctuated their share of the championship with a 41–0 victory at suddenly inept UNC after which Spurrier hustled his troops in front of an auxiliary scoreboard at Kenan Stadium and posed for a photo. The coach also authored a classic quote that sought to explain why his team, which had dispatched monolithic Clemson, should be considered the best team in the league.

"If you're going to be the champ, you've got to beat the champ," he said. "You have to beat Mike Tyson. You can't just beat some 'Bonecrusher' guy." And in one rhetorical swoop, James "Bonecrusher" Smith, who held the world's heavyweight championship for three months and lost the belt in his first defense in 1987, became forever linked to ACC football. Spurrier was off to Florida, his alma mater, at season's end. The Blue Devils enjoyed just one winning season in the next 23.

Mack Brown was on the losing end that day in Chapel Hill, and the combo of losing to the hated rivals who then yukked it up on their turf would prove to be the nadir of the program. This one wasn't on Brown, who was quietly and patiently building a winning operation in the still-smoldering ashes of the Crum administration even though the record charged to his service was 2–20 on that November day of 1989. "They've already named a highway for me in North Carolina—U.S. 220," Brown would later tell booster clubs along his rubber chicken tours.

Relations between the state's high school coaches and Carolina football had soured in Crum's final years, and Brown was bent on changing that. A personable fellow from Tennessee, Brown took on the political portion of the reconstruction process much like an actual politician had done. Early on, Brown made good on a vow to visit every one of North Carolina's 350 high schools in his first year in office. If not knowingly derived from politics, the move rang remarkably similar to the electoral strategy of Bob Graham, who served in the Florida state legislature while Brown was a student and an assistant coach just down the street at Florida State University in Tallahassee in the early 1970s. In his successful 1978 gubernatorial campaign, Graham worked statewide in conventional eight-hour workdays in a wide variety of jobs. He ultimately worked 102 such days to put himself in touch with the populace and engender curious media coverage throughout. In his first year at Chapel Hill, Brown patterned his embrace of high school programs throughout the state on Graham's example.

By the early 1990s, the Tar Heels were working their way back to bowl games and earning the university's seal of approval on a desperately needed construction project. Since the 1920s, the football operations had been based out of a facility with seven-foot-high ceilings and peeling paint.

As the middle of the century's last decade hit, Brown was enrolling recruiting classes of national stature—particularly on defense. In 1996, the Tar Heels finished 10–2 overall and 6–2 in the ACC—two games behind Florida State, which had lost all of one conference game in its five seasons of membership. Carolina held seven of its opponents to 10 or fewer points. Nobody got more than 20. The Seminoles, who torched the rest of the league to the tune of 43 points a game, managed 13 on the Tar Heels.

Things promised to be even more interesting in 1997, and they were. The ACC schedule-makers, aware that the Seminoles would always be nationally viable and that the Tar Heels had almost everybody returning from an outstanding 1996 team, placed the clubs' meeting on November 8, the next-to-last possible date. (The regular-season finale was spoken for on both sides: Florida-FSU and Duke-Carolina.)

What resulted was the biggest ACC football game ever played in North Carolina: a meeting of the No. 3 Seminoles and the No. 5 Tar Heels. It marked only the second involvement of a North Carolina team in a contest of Top-10 ACC clubs and was the state's first game in 40 years in which two ACC teams entered undefeated after five or more starts. It was also the first game that two ACC teams entered with active winning streaks of eight or more games (the Heels had won 10 in a row dating back to the regular-season finale of 1996).

UNC officials worked unknown hours of uncompensated overtime to accommodate demands from the local and national media and from NFL scouts, who had an astounding number of prospects to study. Just by itself, the defensive side of the ball that night produced 34 future NFL players—19 Seminoles and 15 Tar Heels. In all, 46 of the game's alumni logged time at the highest level.

The 'Noles were entirely unwilling to permit the competition to match the hype. In a remarkably dominant defensive effort, they sacked Carolina's quarterbacks nine times and held the Heels to 73 yards of total offense, their lowest such figure since 1950. Only three of UNC's 13 offensive possessions produced a first down. The 20–3 final score didn't indicate the extent of the Seminoles' dominance.

"They are on the right track and are getting the depth and the athletes and the coaching staff to do it, but we were a couple of steps ahead of them," Florida State linebacker Daryl Bush said. Years later, UNC fans were left to wonder what might have happened if their team had won that game and if a few other pieces had fallen into place. The work of a 10–1 regular season was impressive but short of a title, and Brown took the University of Texas job in early December.

He was not wooed by cash. He turned down a more lucrative counter offer from Carolina. He was not wooed by facilities. Although the Longhorns' infrastructure is astonishing, the UNC program was only a few days away from moving its operations into its own shiny, new facility, a towering structure in the end zone that remains Brown's tangible legacy in Chapel Hill. What moved the chains for Brown was the Longhorns' heritage and their status as the flagship institution in a football-obsessed state. And that was going to be hard for UNC to overcome regardless of the status of its program in December of 1997.

The Private Disparity: From the inception of the Atlantic Coast Conference, it was the state-supported universities that most often dominated the football scene with few exceptions. Through the 2013 season, the conference's two private institutions, Wake Forest and Duke, had won or shared just six of the 59 championships. (One by Georgia Tech was vacated.)

Wake Forest, whose only other title season had been in 1970, finally broke through for a second crown under Jim Grobe in 2006. Duke was a power in the young conference with football championships in 1954, 1960, 1961 and 1962 and shared the title with the University of Virginia in 1989.

It would take another two decades and a bit more for the Blue Devils to rise toward the top once again, but the ascension that began in 2011 put Duke into potential position

for its second title in more than half a century. To discuss the matter at any time before 2013—even in the immediately previous season, which had produced the Duke program's first bowl bid since 1994—might have seemed silly and might have exposed Blue Devils coach David Cutcliffe to looks of incredulity at best.

Turns out, as ACC fans learned in 2013, that Cutcliffe promised recruits they'd play for an ACC championship if they signed on with him and his fledgling Duke outfit. In the magical autumn, several Blue Devils could tell the tale while they wrote a new one and converted observers from cynics to skeptics to suspicious onlookers and finally to believers. "Why not Duke football?" Cutcliffe asked when he took the gig in December 2007 and several times thereafter. It was a challenge that demanded an answer better than the obvious response, which went something like, "Because it's impossible."

The Blue Devils' coach had the imprimatur from the Mannings, Peyton and Eli, whom he had tutored as Tennessee offensive coordinator and Ole Miss head coach, respectively. He had the belief. And he had the background, having worked as a volunteer student assistant at Alabama for Bear Bryant, who said the excellence of Wallace Wade at Alabama helped make him a Crimson Tide fan.

Then he had the job, and that was not necessarily a blessing. The Blue Devils' run of ineptitude included separate losing streaks of 22 and 23 games and a grand total of 22 victories in the 150 contests before Cutcliffe, who was available after his inexplicable firing at Ole Miss and later the end of his second Tennessee coordinator stint. In a nine-year stretch, the Devils won consecutive games once. And one of the victories was over hapless Western Carolina, an FCS program.

But athletics director Joe Alleva, in one of his final major acts before taking the LSU job, convinced Cutcliffe to assume the responsibility. The coach took one look at his new team and proclaimed it the fattest, most out-of-shape assemblage of football players he had ever had the misfortune of seeing. He challenged them to lose 1,000 pounds between them in the coming months.

But the new guy took a liking to his players and, mindful of the academic requirements at Duke, did something unique: He scheduled morning practices so players would be fresh. Winning took a bit longer, but the breakthroughs started in 2012 with a victory in the final seconds over North Carolina, which the Devils uncharacteristically played in the middle of the season. Duke bolted to a 6–2 record that secured bowl eligibility, but the Devils proceeded to drop their final five, including a bowl game in which they were tied and about to score the go-ahead touchdown in the final minutes but wound up losing by 14.

Going bowling wouldn't be enough. As 2013 began, Cutcliffe had the feeling he had recruited enough speed to compete, and that's the thing that nobody believed. When Duke had won in the past, it had done so with Steve Spurrier's cool wrinkles and a viable target here and there. The running game was an afterthought.

If not track stars, the 2013 club had half a dozen legitimately fast guys to run and catch passes from Anthony Boone, the quarterback from Weddington, North Carolina, who became a geographic face of the program. With Boone's arrival, Duke suddenly began mining a 25-mile radius of Charlotte for talent. High school teammates and wide receivers Jamison Crowder and Isaac Blakeney of Monroe were joined by running back Jela Duncan of the Queen City, and the Devils had the personnel to run a balanced offense.

The defense put together an in-season turnaround that made Duke a solid club. After getting bludgeoned for 58 points (in a three-point loss) to an otherwise unremarkable Pittsburgh offense, the Blue Devils spotted Virginia a 22–0 lead but shut the door thereafter and earned a comeback victory. The following week, they held Virginia Tech to 10 points

in earning the program's first road victory over a ranked opponent in more than 40 years. They were on a roll. Trailing Miami 10–0 early on, they regrouped and outran the Hurricanes 48–30. Yes, Duke and Miami played football and Duke looked faster.

The Devils took the ACC's Coastal Division lead and could secure the title by winning their final three games, but few seemed to consider it would be that simple. Tiebreaker scenarios were the subjects of blog posts and other media entries, and one including five of seven Coastal teams at 5–3 was possible at one point. But it really did get easy. Sort of. In the regular-season finale at UNC, Duke trailed the Tar Heels on three separate occasions, overcoming the last of the deficits on Ross Martin's field goal with 2:22 left. The victory wasn't secure until DeVon Edwards snared an overthrown pass to thwart UNC's final attempt. Three weeks earlier, Edwards intercepted consecutive N.C. State passes and returned them for touchdowns; this third pick was even bigger.

"We've got some better players than people might think—some good athletes, some good speed, good ball skills. We've got a lot of weapons," Cutcliffe said after the 27–25 victory. "But all that said, the reason they're Coastal Division champions is who they are." They fell to No. 1 Florida State in the ACC championship game the following week but earned a bowl trip against Texas A&M in short order.

Nothing about this was short or smooth, but it came to pass. And run.

Outside Looking In: The East Carolina Pirates have not been the renegades that the Oakland/Los Angeles/Oakland Raiders have been to the NFL. But if not outlaws, then the Pirates have surely been outsiders. And they have taken on that persona so long and so well that it's difficult to imagine how they'd react if they were ever invited to join the establishment.

At the outset, they lacked imagination. The first football teams of the East Carolina Teachers College were known as the Teachers. Bored by the nickname, students pushed for something to capture the history of the region, in which the residents occasionally included the infamous pirate known as Blackbeard. His real name, by the way, was Edward Teach. So as hard as they tried, the enterprising and newly christened Pirates couldn't entirely escape the whole didactic thing.

The institution began to take off in the 1960s under the direction of President Leo W. Jenkins, who turned ECTC into East Carolina University, a comprehensive college offering schools in business, music, nursing, allied health and, most importantly, medicine. The UNC System initially opposed the concept of a medical school at ECU, fearing the state couldn't sufficiently fund a second school and hospital. Jenkins often suggested that the Pirates' improvement in football—particularly in a hard-fought loss in Chapel Hill during the debate—helped grease the skids for the change of heart.

With the growth, the university aspired to build a football program that could help inform the rest of the state and the region what Jenkins was accomplishing. But it was in an odd place literally and figuratively. Tucked between the Triangle and the coast, Greenville is a self-contained area without major external industry. Having come of age after the formation of the ACC, it was locked out of that league. There simply weren't enough viable regional partners with which it could form a new conference.

So ECU was stuck in independence, a position that was viable for a time in college football. With flexible scheduling, the Pirates wanted to play the big guys from the ACC, who didn't always oblige. The Pirates were welcome to play N.C. State and UNC. If, of course, they were willing to travel to do it. There also were occasional barbs from the national media. Discussing East Carolina's appeal as a bowl team, ESPN pundit Beano Cook

allegedly said of bowl-bound Pirate fans, "They bring a $10 bill and one clean shirt, and they don't change either."

East Carolina had become dangerous in the 1970s, posting eight straight seasons with seven or more wins. This gave the ACC schools the nothing-to-gain, everything-to-lose argument. Other obstacles cropped up. A nasty fight broke out at Carter-Finley Stadium after a decisive Pirate victory at N.C. State in 1987. The teams didn't face off again in the regular season until 1996. Two unidentified men were shooed out of the UNC law library, which overlooked the Tar Heels' practice fields, the week of the teams' meeting in 1981. They drove away in a vehicle tied to a dealer that provided comp cars for the Pirates' coaches. The Heels and Pirates didn't get together again until 2001. The resumption of occasional hostilities and their occasional presence in Greenville can be reasonably linked to a 1997 act of the state legislature, which tied support for bond initiatives assisting UNC Chapel Hill and N.C. State to the beneficiaries' willingness to play the Pirates on a more frequent and equitable basis.

Another issue for East Carolina was its perception as a stepping-stone program for coaches. Mike McGee coached the Pirates for one season before leaving for his alma mater, Duke. McGee was replaced by Ulmo Shannon "Sonny" Randle, who held the job for three years before leaving for his alma mater, Virginia. Next up was Pat Dye, who stuck around for five seasons and headed for Wyoming, of all places, in what became a one-year pit stop. (Dye headed for Auburn thereafter.) ECU got a semblance of revenge when it pried Bill Lewis from Wyoming, and Lewis took the program to its greatest heights: an 11–1 season in 1991. The Pirates dropped a 38–31 decision at Illinois but never dwelled on it. The rest of the way, they dispatched three teams from the newly formed Big East but didn't get to play anybody from the ACC. That changed in bowl season, when the Peach Bowl became matchmaker, pitting the Pirates against N.C. State in Atlanta on January 1, 1992.

Down 34–17 in the final nine minutes, the Pirates put together a remarkable charge behind quarterback Jeff Blake, who capped the surge with a 22-yard scoring toss to tight end Luke Fisher with 1:22 left. ECU celebrated the 37–34 win when the Wolfpack's last-second field goal, which would have forced a tie in an era without overtime, missed the mark. "We've been called a Cinderella story all year," Pirates center Keith Arnold told *The Daily Reflector* of Greenville. "Cinderella went to a ball tonight and got married. She's queen now. The feeling's unbelievable. Now I guess we know who's best in North Carolina."

The joy was soon mitigated. Five days later and less than three miles up the road, ECU lost another coach when Georgia Tech hired Lewis, who, like others, would learn life wasn't always better elsewhere. He lasted less than three seasons on the Yellow Jacket sidelines. And by that time, his successor was rebuilding the Pirate ship.

Steve Logan endeared himself to the Pirate populace with a commitment to their spirit and to his iconoclastic nature. He intended to win and to stick around. It was therefore somewhat ironic that Logan's tenure coincided with the inadequacy of independence nationally. Conference affiliation and postseason participation were becoming linked, and although they had both reveled in their status while hoping to be embraced, they took the opportunity to join a league.

Conference USA was and is an amalgamation of previous football independents that had lacked the opportunity to make regional connections. It stretched from Greenville, North Carolina, to El Paso, Texas. It was odd. But it was something for ECU, which joined in 1997. It proved to be the Pirates' ticket to scheduling stability and identity. The string of success began with the 1999 season, a rare bird in that it remains beloved even though its ending wasn't great.

In the season's first three weeks, Logan's Pirates, who always played with their coach's intensity, defeated foes from the Big East (West Virginia), the ACC (Duke) and the SEC (South Carolina). Never mind that those three teams would finish the season with a combined record of 7–26. This was still East Carolina's way of reminding everybody that it could play. Up next was the biggest home game in school history. Miami was on its way. The program had already won four national championships in the previous two decades, and it was two years removed from another one.

But as the football Hurricanes were headed toward Greenville, so was an actual storm. Hurricane Floyd made landfall on September 16, 1999, two days before ECU played at South Carolina. Their home turf was under elemental siege. Arriving on the heels of Hurricane Dennis only a week earlier, Floyd deposited 17 inches of rain on Pitt County and did $346 million in damage. Five ECU campus buildings, including a dining hall and a dormitory, were flooded to varying degrees. Some parts of the county were under water for two weeks. It was the worst natural disaster to hit North Carolina.

Their own Dowdy-Ficklen Stadium out of commission, the Pirates turned to an old foe to help, and N.C. State delivered by providing Carter-Finley, site of the brawl a dozen years earlier, for the game. The Pirates, meanwhile, stayed in Columbia, South Carolina, and practiced there.

A crowd of 45,900—nearly 3,000 people more than the published capacity of Dowdy-Ficklen at the time—turned out, and they saw Miami take a 23–3 lead in the third quarter. For ECU to simply be playing, they reminded themselves, represented a triumph of spirit. What followed was even more amazing. Led by future NFL star David Garrard, East Carolina ripped off the final 24 points, getting the winning touchdown when Garrard hit Keith Stokes from 27 yards out with 4:51 left.

"This week and this win brought us together as a team," Stokes said. "No matter what we went through, when it comes to the game, the Pirates come to play. We got this win for us and our fans." Four men who played for the Pirates that day went on to NFL careers. The Hurricanes roster produced 24 future pros who combined for 86 seasons as starters through 2012. That group included safety Ed Reed, running back Clinton Portis and wide receivers Reggie Wayne and Santana Moss.

The 1999 season did not produce a Conference USA title, but it did deliver a bowl berth, the first of 10 in a stretch from 1999–2013. The Pirates fell after the inexplicable firing of Logan, let go after a 4–8 season in 2002, but they rebounded with the help of running back Chris Johnson, who ripped off 1,423 yards in 2007. The Pirates won the Conference USA title in 2008 and 2009.

To the big guys, East Carolina often seems like the annoying kid who jumps up and down and says, "Look at me." While the Pirates haven't been national powers, they've carved their niche and were scheduled to gravitate to the American Athletic Conference, formerly known as the Big East in football, in 2014.

Changing Partners: The weather in North Carolina's High Country was refusing to change with the times—at least those dictated by the calendar, which said spring had arrived a few days earlier—when Appalachian State University convened a press conference on March 27, 2013. Winter hung on in the High Country, depositing some fresh snow on emissaries of the Sun Belt Conference, a New Orleans-based league that occupies the lowest rung of the highest level of intercollegiate football. Unlike the weather, the visitors were offering a change. They were making official what many had suspected—most with excitement, some with resignation, all with varying levels of trepidation—for years: that

App State was moving up in class from the NCAA's Football Championship Subdivision to its Football Bowl Subdivision.

The move of the Southern Conference stalwarts was the latest in a series of metaphorical seismic shifts that had coincided rather eerily with a literal shaking of the ground in the region 17 months earlier. Just as an earthquake registering 5.8 on the Richter scale and centered in Virginia was causing tremors as far away as New York City, the ACC was in the process of securing agreements with Syracuse and Pittsburgh to leave the troubled Big East effective in 2013. Associated conference transfers multiplied, and the dominoes fell to the point that if the Sun Belt was going to survive, it would have to seek out schools for promotion out of the FCS ranks. There were no lateral-move candidates left. (SBC Commissioner Karl Benson knew the necessity of this very well. He was running the WAC when that league shut its doors as a football entity in light of the departures.)

Boasting more than 17,000 students and a reputation as a leading regional college in the South, Appalachian had some institutional characteristics that made it attractive. In football, it had bigger home crowds than one-third of the nominal big boys claimed. So it had the numbers to justify the move. But in taking the leap, it was still acting on faith that the future gains would justify the abdication of its FCS royalty.

Guided by Jerry Moore, a strict Texan of unimpeachable integrity, Appalachian had climbed a mountain several times over and had put itself in position to be noticed. As a new century dawned, they began making a national impact. The Mountaineers first broke

Jerry Moore, the man who climbed to the top of the football mountain at Appalachian State.

through for real in 2005 with a 21–16 NCAA championship victory over Northern Iowa. Trailing most of the game, they won it when Marcus Murrell sacked the Panther quarterback, inducing a fumble that Jason Hunter took back for a TD with nine minutes left. The following year, they unleashed a left-handed freshman from South Carolina, and Armanti Edwards, who picked Appalachian in part because of a chance to play quarterback, earned his gig and held it without threat for four seasons.

Edwards is the one of the best collegiate QBs of any style or division in this state's history. As a dual-threat performer, he is unequaled. He finished his career with an NCAA-record 14,753 yards of total offense—10,392 through the air, 4,361 on the ground. He accounted for 139 touchdowns. He could have done anything asked of him.

Making things more unreasonable for Mountaineer opponents was the presence of tailback Kevin Richardson, who rushed for 4,804 yards and 66 touchdowns as Edwards' running mate in 2006 and 2007 as Appalachian again won the national title in both seasons. ASU was and—through 2013—still is the only North Carolina school to win even one NCAA-sponsored football title. And that run, while remarkable, still isn't the program's marquee achievement.

September 1, 2007, was going to be another day in the Big House. For the 201st straight game, the Michigan Wolverines attracted a six-figure home crowd to their in-ground pool of opponent doom. They announced the attendance at 109,218—more than twice the population of Appalachian's home county of Watauga. ASU had accepted a $400,000 paycheck to provide the opposition to the program with the highest win total in college football history, 860. At that point, the Wolverines had won 35 more games than Appalachian had played. The Mountaineers would fly in, participate and fly home with thanks and pats on the back from Wolverines praising their effort and wishing them the best of luck against whoever they'd play in whatever conference it was that they occupied. At least that was the presumption. An advance on the game by the normally buttoned-up Associated Press said the Mountaineers were "almost certain to lose badly." Except that the visitors didn't comply. Edwards, operating against a secondary with three future NFL players, had open men and hit them. Incredibly, ASU led 28–17 at halftime and the Big House was nervous.

Michigan Stadium exhaled when Mike Hart, who had run for more yards than any player in the history of high school football, bolted for a 54-yard touchdown to put his team up 32–31 with 4:36 to go. ASU later blocked a field goal and Edwards guided his team down the field for the go-ahead score, a 24-yard field goal with only 26 seconds to play. Boone started going crazy.

And then it got quiet. A defensive breakdown helped Michigan complete a 46-yard pass that put the ball on the Appalachian 20 with six seconds to go. For the third time in a matter of minutes, dreams dissipated. All that remained was an easy field goal and Michigan would escape. It wasn't easy. ASU's Corey Lynch blocked the kick and the Mountaineers were victorious.

The knee-jerk assumption in such cases is that the big dog was simply not very good and on its way to a wretched season. Not in this instance. The Wolverines won nine of their final 11 games after an 0–2 start. They were No. 5 in the country on September 1 and finished 18th. In all, 12 players who suited up for Michigan that day went on to NFL careers, including offensive tackle Jake Long, the No. 1 pick of the following spring's draft.

Shortly after the game ended, Appalachian's online merchandise store crashed, its temporary demise undeniably hastened by connections and orders from Ohio, where Buckeyes

fans reveled in the Wolverines' demise. The nascent Big Ten Network, airing its first live game, was overwhelmed with callers demanding service. It routed the masses to their local cable or satellite providers, many of which had balked for months about carrying a niche channel. The Mountaineers had unintentionally entered the dispute-resolution business.

A year later—and considerably ahead of projections—the channel had achieved its goal of carriage on the "extended basic" service level in all Big Ten markets. The big-picture effect played out over the next year.

Intercollegiate athletics are often called "the front porch of the university" for the visibility they provide. They do not account for the most important things that go on under the auspices of American academia, but for the vast majority of the schools in Division I, they are the best sources of advertisement. This is especially true of institutions such as Appalachian State, which has been classified as an esteemed but undeniably regional university. Its mission is to serve the people of North Carolina; it has not aspired to supplant its fellow member of the UNC System, the Top-35 national university in Chapel Hill, in fame or national reach.

Some figures from the months following the Michigan game cannot be dismissed out of hand. Consider these nuggets from the applicants who were high school seniors in September 2007 and deciding where to attend college in the fall of 2008:

- In the 2007–08 admissions cycle, ASU experienced an unprecedented, 15-percent spike in applicants from the previous year. The total of 13,182 applications has not been surpassed since.
- The class that entered in 2008 had the highest average SAT score of any group on record. That, too, has not been broken.
- More than 14 percent of freshmen entering in 2008 were out-of-state students. That's a whopping 46-percent increase from the previous year, and it's important because out-of-staters paid $10,000 more than their in-state comrades to attend. It amounted to $2.1 million in windfall in that year alone.

The most compelling evidence of the impact of this one game is that most of the changes in admissions and enrollment data have slid back to their levels before the exposure of that day in Ann Arbor. In short order, the university began investigating a move to a higher league.

The shifts of the college landscape may have driven ASU to go to the next level regardless of the Michigan game. But the combination of the shaking and the miracle in Ann Arbor greatly increased the likelihood that the Mountaineers would find life on the other side too enticing to pass up. Will it really be such a great deal? The program's ineligibility for the 2013 Southern Conference title, the immediate consequence of the self-promotion, is hardly the most pressing question here. Neither is the departure of Moore, who retired or was forced out after the 2012 season with more wins (215) than any coach in the history of college football in North Carolina. Conference affiliation and NCAA divisional alignment are matters of the long term. One soured season won't bug anybody if the university continues to move up the food chain.

For the larger picture, consider for a moment what the school is giving up. Aside from its continuing relationship with Georgia Southern, which is joining ASU in the move from the SoCon to the Sun Belt, the Mountaineers are trading rivalries with Western Carolina, which they first met in 1932; Elon (1937); Wofford (1960); Furman (1971); and Chattanooga (1977) for a gallery of football nomads and neophytes with whom they have

little to no history. Two of their new and alleged rivals, Georgia State and South Alabama, did not have football teams as recently as 2008. Those with slightly more endowed pedigrees include Troy, Louisiana-Lafayette, Louisiana-Monroe, Texas State, New Mexico State and Idaho. Between them, those schools have made eight appearances in the AP poll, the most recent of which came on September 10, 1961.

Appalachian State membership in such a conference will mean that the school will surrender the chance for an NCAA championship (albeit at a nominally lower level) for a ceiling painted with the GoDaddy Bowl, the R&L Carriers New Orleans Bowl or the Camellia Bowl. Not exactly the Sistine Chapel of postseason football.

The schedule will, of course, have room for non-conference tilts created to balance the Sun Belt schools' budgets. This is the plan. But even that much was uncertain as 2013 came to an end and the five most powerful and commercially viable conferences started mumbling about unhitching themselves from the Sun Belts and the MACs of their diverse world. Members of this theoretical Division IV may one day feel skittish about playing a Louisiana-Monroe or an Appalachian State, fearful that such a game might hurt their strength of their schedules in the eyes of the College Football Playoff's selection committee.

It is an undeniable gamble that discards tradition in the name of geographically wider distribution of the Appalachian "brand," a business term that has infiltrated sport to annoying levels. Come December one of these years, will loyal and proud Mountaineers really be excited about a trip to the Camellia Bowl? Or will they wish they were headed to the FCS national championship game? To put it another way, will they wish they had followed Winston-Salem State's lead?

A Football Reverse: Aspirations of institutional advancement are as old as the institutions themselves. It is therefore no surprise that Winston-Salem State, a historically black school and a long-standing member of the Division II Central Intercollegiate Athletic Association, began pondering a move to Division I in the early 2000s. In 2005, the university announced it would indeed take the plunge. The decision would elevate the football program to what was then known as Division I-AA (now the Football Championship Subdivision). The university would join the Mid-Eastern Athletic Conference, a FCS football and Division I basketball league founded in 1970.

This, WSSU Trustees were told, would double athletics spending but would boost the overall institutional profile. It would be a good deal. If MEAC member North Carolina A&T, a longtime rival 30 miles away, could do it, then why couldn't the Rams? Winston-Salem State made the requisite initial upgrades in an NCAA-mandated transitional phase. It added four sports and general athletics staff. But then the economy began to tank. A bid to hike already burdensome student athletics fees, a common tactic in schools lacking national TV revenue, was disallowed by the UNC System. And the financial folly became apparent. Revenue didn't come particularly close to matching the promised doubled expenditures. By the end of the 2008–09 fiscal year, the cumulative debt of the transition phase exceeded $6 million and was on its way to $12 million.

So at this point, Donald Reaves, who had inherited the situation upon becoming chancellor in 2007, had two choices: cut academics or cut his losses. On September 11, 2009, he elected to cut his losses. "The resources to complete the reclassification simply were not available, currently nor prospectively, in sufficient amounts," Reaves said in a written statement. "If there were any reasonable way to complete this transition without diverting resources from competing academic priorities, I would have recommended that we stay the course."

The announcement was diplomatic, but it was still difficult. WSSU was admitting to previous fiscal myopia. Reaves hadn't been around for the initial decision, but he had to be the one to acknowledge it had occurred. He was also a realist who had been Chief Financial Officer at two academic heavyweights, Brown University and the University of Chicago, before coming to Winston-Salem State. At Chicago, he balanced a $2 billion budget and oversaw a $1.2 billion (36 percent) growth of the endowment in his final fiscal year of service, in fact.

So he wasn't going to be swept into delirium by promises of $60,000 men's basketball paydays. He took a pass on rhetoric and looked into the future. It was too ugly to contemplate. Secretly, dozens of trustees and administrators let out sighs of relief and gestures of gratitude to the heavens and the Twin City. Reaves had the guts to do what no other leader of a Division-I bound Division II school had ever done: He stopped the train, backed it out of the tunnel and called ahead.

Alumni who hoped to take on A&T and the Aggies' conference rivals were taken aback. And there was another question: Could the Rams really go back home again? As it turned out, the CIAA was happy to have the Rams back in the fold. And as for competition, that answer was an even more resounding success. Legendary former coach Bill Hayes, fired by A&T when it was flirting with a move to Division I-A and presumed Hayes was too old for the challenge, became athletics director at Winston-Salem State. He hired Connell Maynor, owner of no previous head coaching experience but a smart tactician, to run the football program. And the Rams went back to their roots and owned the CIAA. In the process, they delivered one of the best three-year runs by any college football program in North Carolina's history.

WSSU won the CIAA in 2011, repeated the title a year later and entered the NCAA Division II playoffs as an undefeated favorite. After a first-round bye and a relatively easy second-round victory, the Rams needed a touchdown with 3:51 left and a defensive stand on its 5-yard line in the final minute to escape with a quarterfinal win over Indiana University of Pennsylvania. A decisive triumph at West Texas A&M put the Rams in the Division II title game.

The on-field architect was quarterback Kameron Smith, who played two years at the U.S. Naval Academy but transferred to WSSU in time for the somewhat awkward reconciliation year of 2010, the Rams' first back in the CIAA. Except for the occasional injury, he never let go of the offense, and by the time the Rams advanced to the Division II championship game against Valdosta (Georgia) State, he was already ensured of a special place in history. His touchdown pass in the finals gave him 96 (in three seasons, mind you) and surpassed the four-year total of N.C. State's Philip Rivers for second place in state college football history. The record, a preposterous 124, is held by Josh Vogelbach, who played for Guilford from 2005–08.

In his senior season of 2012, Smith threw 43 TD tosses. One of every five completions went for a score. All told, Smith and Maynor were 31–4 in their time together. While that didn't end with a championship — Valdosta State held Smith in check in a 35–7 victory — they made Ram fans forget about the aborted and financially specious mission for alleged advancement. They appeared on national television in the finals and were good emissaries for the university. They were 14th among Division II teams in attendance, drawing twice the CIAA average but 22 percent short of the MEAC norm. In other words, they were in a good place.

The athletics department has yet to break even, but its annual debts declined by 50 percent in year-over-year figures upon the decision to stay at Division II. "I don't know

if it justifies it, but I know winning solves a lot of problems," Maynor told the *Winston-Salem Journal* about WSSU's staying in Division II. "People like winners. And if you win, that will make the people who wanted us to stay I-AA kind of forget about it and say, 'That's all right; this is pretty cool.'"

But for Maynor, he apparently could not forget about it. If the WSSU athletic program was not moving to Division I, Maynor was. Following the 2013 season, he accepted the head coaching job at Hampton Institute in Virginia. His new team competed in the MEAC and would from time to time face North Carolina A&T.

Hayes' Place in History: The Rams' run was the most recognized but hardly the first by a historically black college or university from North Carolina. That history dates to the Livingstone-Biddle snow game of 1892 and includes outright or shared HBCU national championships in seven seasons by four schools.

The black national title distinctions have been handed out by several organizations over the years. The most prominent of them have been the *Pittsburgh Courier*, a newspaper; the American Sports Wire; and the Sheridan Broadcasting Network. The *Courier* acclaimed Shaw University in 1947 and N.C. A&T in 1968, ASW chose the Aggies in 1990 and 1999 and Sheridan picked A&T in 1999, N.C. Central in 2006 and Winston-Salem State in 2011 and 2012.

At or near the center of much of the modern history stands Bill Hayes, a Durham native known as "Wild Bill" for his enthusiastic playing style. But the colorful moniker doesn't do Hayes justice. In 1973, he became the first black assistant coach in ACC history when Wake Forest's Chuck Mills hired him to direct running backs. After a three-year stint in that job, he got his first head coaching assignment when Winston-Salem State hired him.

Over the next dozen seasons, he coached the Rams to an 89–41–2 record that included NCAA playoff appearances in 1978 and 1987 and the majority of WSSU's excellence in the 1980s. For the decade, the Rams went 73–34–1, the eighth-best winning percentage (.681) of any NCAA Division II program. Hayes was in charge for eight of those seasons, the most interesting of which was probably 1986. Long before coaches were credited for emphasizing special teams, Hayes made them a calling card. The 1986 squad blocked an NCAA-record and preposterous total of 27 kicks. On one day, the Rams blocked five N.C. Central punts, a total not likely to be touched.

Hayes left Winston-Salem State for Triad rival N.C. A&T following the 1987 season and made his mark on the Aggie program as well. Under Hayes' direction, the Aggies went 79–35 (.693) in the 1990s; that winning percentage was good for 11th in all of Division I-AA for the decade, and it's the second-best on record by any North Carolina college in any NCAA division. Only Appalachian State, which won 75.4 percent of its games from 2000–09, has done better over a specific decade.

The 1999 Aggie team became the first North Carolina school to win the black college title outright. A&T secured the distinction with a 24–10 victory over previously unbeaten Tennessee State in the first round of the NCAA playoffs; the win was only the second for the Mid-Eastern Athletic Conference since 1982.

Hayes was forced out under bizarre circumstances following the 2003 season. A&T, in the midst of a capital campaign and kicking the tires on its own move to I-AA football, parted ways with its coach without so much as a press conference. He left coaching with more victories than any coach in North Carolina history (195). Appalachian State's Jerry Moore ultimately passed him at 215, but Hayes was still comfortably in second place through 2013.

While Hayes was working on big things in Greensboro, Richard Huntley was rushing for 6,286 yards at Winston-Salem State from 1992–95 and working his way to the NFL. Huntley's figure stands as a state record. Some of the biggest individual statistical achievements out of the Old North State came from N.C. Central quarterback Earl Harvey, whose totals of 10,621 passing yards and 86 touchdown tosses were state records when he played his last down in 1988. While they couldn't withstand the stats produced in an era of pass-happy offenses and liberalized rules, the touchdown mark did survive until N.C. State's Philip Rivers broke it in 2003. Harvey therefore had 15 years of relative fame rather than the clichéd 15 minutes.

Football Title Teams: Years before Winston-Salem State flirted with a national title awarded by a sanctioning body, two North Carolina schools broke through at the NAIA level.

Lenoir-Rhyne College enjoyed one of the best eight-year runs of any college in any league or state when the Bears won 76 games, lost six and tied four from 1955–62. All but the last of those seasons came under the direction of Coach Clarence Stasavich, who moved to East Carolina in 1962. The string included a 25-game unbeaten streak away from home as well as one of the most bizarre determinations of victory in college football history.

In the 1960 NAIA Eastern Regional final, Lenoir-Rhyne pulled even with visiting Northern Michigan 20–20 on a last-minute touchdown. When regulation time expired, the 6,500 fans didn't know what to think, and the NAIA officials on site weren't all that certain

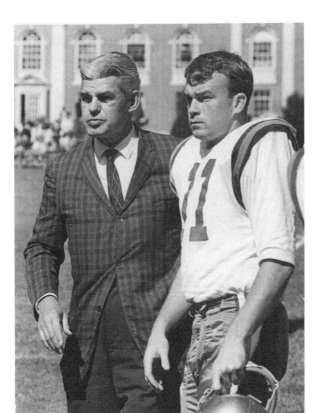

Coach Clarence Stasavich and Lenoir-Rhyne gave North Carolina its first national football championship.

themselves. Less than two years had passed since the NFL had decided its 1958 championship game with an extra period of play. The Baltimore Colts' victory over the New York Giants provided drama to the relatively new medium of television, but the overtime wasn't truly necessary because no other teams would have been inconvenienced by a declaration of co-champions. The NAIA had no such luxury at Lenoir-Rhyne on December 3, 1960.

At about the same time as the Bears and Northern Michigan were trying to guess what would happen next, Humboldt State College of Arcata, California, was playing Whitworth College of Spokane, Washington, for the Western title and resulting spot in the NAIA championship game in St. Petersburg, Florida, the following week. And the Western winner would have to play somebody; the East had to have a representative.

Apparently unwilling to put amateurs through additional paces, the NAIA decreed that the tie would be broken by statistics: the team with the higher total offense figure would prevail. And so the official scorer or scorers went about the task of adding and subtracting, holding two teams' fates in pencil marks. In 1960, college football stats were barely compiled or maintained at the NAIA level. There were no fantasy football teams or other publicly pressured reasons for knowing anything beyond the score. Certainly nobody stepped into the press box that day believing he'd have a role in the game's outcome.

The word came down that the Bears had outgained the Wildcats 294 yards to 269, but that doesn't do the whole story justice. As it turned out, the Bears didn't claim that edge as much as the Wildcats, believing they had to score in order to win, lost it. Lenoir-Rhyne's Ron Turner sacked Northern Michigan quarterback Dick Novak on the game's final two plays, resulting in 27 yards in negative yardage.

Things were more conventional but just as dramatic a week later. Freshman Marion Kirby's fourth-quarter field goal delivered the Bears a 15–14 victory, the first NAIA or NCAA championship by a North Carolina college. Nearly 40 years later, Kirby had a hand in another first when he coached the inaugural team at Greensboro College in 1997.

A half-century after its first championship, the Bears of Lenoir-Rhyne made another run in 2013. Emphasis on run. Operating the triple-option and spreading the wealth, six Bears averaged 50 yards per game on the ground as the team set the NCAA record for rushing yards in a season. And one of those six was a quarterback who as late as November figured he had played in the last of his eight career games.

Josh Justice was the third-team QB most of the season. Having redshirted as a true freshman, he'd have another year of eligibility in 2014, but he told *The Charlotte Observer* he had essentially decided to graduate in four years and move on with his life. The Bears were rolling in midseason when the top two signal-callers suffered injuries. Normally, of course, such attrition kills off a season, but the Bears couldn't just bail. They were good enough to dream of an NCAA Division II title.

Although obviously inexperienced, Justice had the benefit of a solid group around him and an implicit mandate not to screw it up. But that's not such an easy dictate in the triple-option, a high-risk, high-reward offense in which timing is everything and breakdowns often mean turnovers rather than simply lost yardage. Backs Isaiah Whitaker, Jarrod Spears and Graham Duncan worked well with Justice, and the Bears kept going and put a North Carolina school in the Division II title game for the second straight year. The run ended with a 43–28 loss to Northwest Missouri State in Florence, Ala., but the Bears set an NCAA record with 5,563 rushing yards on the season.

Back-to-Back Titles: The NAIA was still the residence of many North Carolina small colleges in the 1970s and 1980s when the Fightin' Christians of Elon College, now known as the Phoenix of Elon University, created a buzz with consecutive titles.

Still two decades away from its own on-campus stadium, Elon played its nominal home games at Williams High School in the adjacent town of Burlington. Facilities did not pose a recruiting obstacle for coach Jerry Tolley, who had played under Stasavich at East Carolina. "Coach Tolley taught me an important lesson in life: that it is more important to be respected than to be liked," center Harold Hill said in a video produced by the school. "Coach Tolley was tough. He ran the team much like a CEO would run a business."

The offense was led by Bobby Hedrick, an explosive running back who rushed for 5,605 yards, a total that remains third in state history, in his career. Quarterback John Bangley, a transfer from Division I-AA VMI, was a stabilizing influence. Elon lost its second game of the season but none thereafter, earning the right to host the title game. It claimed a 17–10 victory over Northeastern Oklahoma State.

While the Christians had to travel a bit even for a nominal home game, the field was at least familiar, and it may have been a factor in their second national title. Pittsburg State's kicker missed four field-goal attempts and Elon therefore needed only Phil Renn's chip-shot kick early in the fourth quarter for a 3–0 victory over the Gorillas and the 1981 championship. Tolley left the job shortly thereafter and did it on the highest of possible notes. He didn't leave the public eye, however. He later served as the mayor of the town of Elon.

The Elon football program grew with its institution, which joined the NCAA and became a leading liberal-arts college with an increasing regional and national profile. New facilities, including a stadium, began popping up as Elon garnered national acclaim for general campus beauty. As a football program, the Phoenix wouldn't make big noise until the middle of this century's first decade, but when it did, it put up absurd offensive totals. Catching passes from Scott Riddle, who threw 13,264 yards worth of career completions, Terrell Hudgins smashed the 25-year-old NCAA Division I-AA receiving yardage record of Mississippi Valley State's Jerry Rice. Hudgins finished his Phoenix career with NCAA standards for receptions (395) and yards (5,250).

From Peahead to Grobe: As football ignoramus William Shakespeare put it, the dog will have his day. And the Deacon. And the Devil, too. *Hamlet* didn't get into the Wake Forest Demon Deacons or the Duke Blue Devils, but both managed to climb away from ineptitude.

Between the departure of Peahead Walker after the 1950 season and the arrival of Jim Grobe a half-century later, Wake Forest football was often astonishing. And not in a good way. In 1963, for example, the Demon Deacons had a run of frustration that seemingly came out of the Old Testament: 42 days and 42 nights—six games' worth—without a single point. Blanked seven times in 10 games, they managed 37 points for the season. Or, to put it another way, fewer than they permitted to Duke (39) and Army (47). But, lo and behold, 20 of those 37 points did come in one afternoon, and they delivered a 20–19 win over South Carolina.

Remarkably, the Demon Deacons did something similar 11 years later, when they were shut out in five consecutive outings. That stretch included perhaps the most brutal three weeks any college football team has ever encountered: road games with No. 2 Oklahoma (0–63), No. 15 Penn State (0–55) and No. 18 Maryland (0–47).

The Deacons had some company in getting shut out and losing by 47 or more points in three straight games. It had happened in 1939 to the University of Chicago, which responded by dropping the sport entirely a few weeks later. The Deacons were not so lucky.

Overseeing this in 1974 was the irrepressibly frank Chuck Mills, who ultimately coached at seven schools and found success with several. Wake Forest was not among them. Asked by the Pittsburgh *Post-Gazette* if he hoped for a "revival" of Deacon football, Mills quipped, "No, I wouldn't say a revival. Resurrection is a better word. Revival means you are breathing. I think we're dead." And this was *before* the Penn State game.

Although never to those absurd depths, Wake Forest often found itself at or near the ACC's cellar in the decades that followed. Following the 2000 season, the university found a gem in Grobe, who had taken over a program at Ohio University similar in historical ineptitude to Wake Forest and had made it viable.

Sure, there was no recent tradition at Wake Forest, but at least the fan base wasn't hard to please. When Grobe's third, fourth and fifth teams went 5–7, 4–7 and 4–7, the populace wasn't begging for another change; it was energized enough to fund a $40 million stadium project with luxury boxes and other seating amenities. The Deacs, after all, had won four or more games in three straight seasons for the first time since the 1980s.

The 2006 campaign didn't start well. The top quarterback, Ben Mauk, suffered a season-ending shoulder injury in the opener. The Deacs only got past Duke, which would go winless for the fourth time in an 11-year span, when the Blue Devils' kicker smacked a line drive into a Deacon's hand on the game's final play. Directed by redshirt freshman Riley Skinner, the offense was hampered by injuries to its top three running backs. It averaged only 307 yards a game and was outgained for the season. Its average of 4.4 yards per play was the same as Duke's. Yet the Devils were winless and the Deacons wonderful.

Opponents could call them whatever they liked. As long as they admitted, on the first Saturday of December in a rainy day in Skinner's hometown of Jacksonville, Florida, that Wake Forest was playing for the ACC championship. The game came down to the end in a 6–6 tie as Steve Justice stood over the ball. While in high school, the center from Florida had a conditional, tentative offer from the University of Central Florida and interest from Boston College. He had nothing firm until the Deacons told him they wanted him.

Justice snapped the ball to Skinner, who could have been excused if he had been thinking of Hawaii at that moment. The coaches at the University of Hawaii once said they'd consider taking him, but he couldn't make an official visit first. The program was wary of East Coast kids who expressed interest only to use it as a ruse to get a free trip to paradise. Miami of Ohio was curious. Samford, a Division I-AA school that served as the final academic resting place in the student days of one "Peahead" Walker, was serious in its offer. But that was it. Skinner didn't see a scholarship paper from Wake Forest until a week into the signing period, by which time absolutely nobody noticed the formal and binding commitment of the future ACC Rookie of the Year. And that only happened because the player's high school coach had essentially taken Grobe and one of his assistants, Tom Elrod, hostage and had jokingly threatened to lock them in a storage closet until they agreed to give Skinner serious consideration.

Finally, in Jacksonville, Skinner threw one long and down the middle of the field for Willie Idlette, a high school track champion in Tennessee. A private school high school track champion. The player's smarts and his academic pedigree were probably enough to dissuade several potential suitors. Idlette picked Wake Forest over Middle Tennessee State and nobody else. He caught Skinner's 45-yard pass and the Demon Deacons were in field-goal range.

In came Sam Swank, from nearby Jacksonville Beach, who had been told he could pay out-of-state tuition at Clemson for two years, after which the coaches would evaluate his standing and decide whether he deserved a scholarship. Gladly dissenting from this view

of Swank was Billy Mitchell, Grobe's associate head coach and a specialist in finding and judging kickers and punters. As it would turn out, his recommendation of Swank was perhaps the difference-making decision in an entire season. It wasn't Mitchell's first rescue mission. As a pilot and navigator in the U.S. Air Force, he helped get hundreds of fellow servicemen out of Southeast Asia in 1973. Neither was it Swank's first nerve-wracking assignment on Florida's First Coast. As a lifeguard in Jacksonville Beach, he once saved a woman from drowning. This kicking thing, therefore, was relatively simple: a 22-yard field goal. With 2:55 left, he delivered and the Demon Deacons had a 9–6 victory over Georgia Tech and only their second ACC championship.

It was fair to say this one was a bigger deal than the first, which came in 1970, highlighted a 6–5 season and didn't even produce a bowl berth. The 2006 title put the Deacons in the Orange Bowl, in which a 24–13 loss to Louisville didn't damage an 11–3 season.

By the end of the 2013 season, Grobe had had enough of his gallant struggles to keep a small-school (relatively speaking) football program competitive in a dynamic Division I conference. He resigned as Wake Forest's football coach and exited with his reputation as a gentleman unblemished.

A Cat of a Different Stripe: In the mid-1930s, with the Great Depression still fresh on the minds of most Americans, George and Mary Richardson of Fayetteville, North Carolina, were getting by. He was a barber, she a store clerk. And on July 18, 1936, their family grew to number three when their only child, a son, Jerome J. Richardson, was born. Surrounded through his early years by a cadre of buddies his age, at least six of whom became friends for life, Jerry, as he became known, grew tall and angular and athletic. By the time he was a ninth-grader, Jerry had begun to excel at high school athletics, especially football under the guidance of coach Bob Prevatte.

A graduate of Wofford College, Prevatte prevailed upon coaches at his old Methodist school in Spartanburg, South Carolina, to take a close look at his senior star, and Richardson went packing off to become a Terrier on a $250 football scholarship. He also was about to meet another football player whose impact upon Jerry's future would go far beyond the intricacies of a perfectly thrown down-and-out pass. In 1956 at the start of Jerry's sophomore season at Wofford, Charlie Bradshaw transferred from the University of Georgia.

Bradshaw-to-Richardson was a match made, if not in Heaven, then certainly on the football field and in future business board rooms. The passing combination became the talk of small college football nationwide. Both were selected for the National Association of Intercollegiate Athletics All-American team. Now his old high school football coach Bob Prevatte did not have to work the phones to get Richardson noticed; the world champion Baltimore Colts of the National Football League had been paying attention and drafted him off the Wofford campus. He was selected in the 13th round, but there was nothing unlucky about the choice.

Indeed, it could be said that the move paid off more for the Colts than for Richardson. He played only two seasons for the Colts, and with Raymond Berry at wide receiver and Richardson at tight end as passing targets for the legendary Johnny Unitas, the combination was almost unstoppable. A fourth-quarter Unitas-to-Richardson pass for 12 yards and a touchdown was the deciding score in Baltimore's 1959 NFL championship victory over the New York Giants. It was the last touchdown pass Richardson would ever catch. In off-season contract negotiations, Richardson sought a raise of $250 (ironically, equal to his Wofford football scholarship for one season) from the $9,750 he was paid for

the championship 1959 season. The Colts refused and Richardson retired as a player. What he perhaps did not know at the time, nor did anyone, was that he was not through with professional football and the NFL. Not by a long shot. But the rest of that story would have to wait years.

When Richardson's old college quarterback, Charlie Bradshaw, signed an agreement to open the first-ever Hardee's Hamburger restaurant in Spartanburg, Richardson wanted to once again team up with Bradshaw. Richardson had spent not a penny of the $4,744 he had collected as his share of the 1959 NFL playoff money, and he invested it all into the new business. It was the birth of Spartan Foods. Richardson was in literally up to his elbows. His shirt rolled up, Richardson became known as a hands-on part-owner as he worked behind the counter cooking and selling 15-cent hamburgers.

Spartan foods boomed. Before Richardson and Bradshaw had reached their 40th birthdays, they set their sights on getting their company listed on the New York Stock Exchange. It happened on June 22, 1976. Less than a year later, Quincy's Steakhouse became a part of Spartan Foods holdings and within two years the two old college football players accepted an offer of $80 million from Transworld Corporation for their fast food and restaurant empire with the understanding that both would remain as executives with the new owners.

It was a Cinderella story, but it was far from midnight for Richardson.

Denny's franchise was added to the TW menu with Richardson taking on the challenge of converting the struggling chain once more into a profitable business. By 1995, Richardson's Flagstar Corporation was the largest publicly held company based in South Carolina. But as early as 1989, Richardson had begun his quest for a National Football League franchise for the Carolinas. As part of his effort to demonstrate the interest in the professional game in both North and South Carolina, he scheduled a series of three pre-season NFL games, the first of which was played in late summer of 1989 at North Carolina State's Carter-Finley Stadium.

At halftime of that game, a sports columnist for the *Greensboro News & Record* drew Richardson aside for a brief one-on-one session about Richardson's NFL dream. "Are you concerned about the timing of your project?" the columnist asked, pointing out that voters across the Carolinas were more and more turning down bond issues to build or expand sports facilities.

"I am aware of that," the soft-spoken Richardson responded. "That's why I have set aside $350 million of my own money to build a stadium if necessary."

Four years later, the NFL awarded its 29th franchise to Richardson, who paid the league $210 million for the right to become the first former player since the legendary George Halas of the Chicago Bears to own an NFL team. The Carolina Panthers had been born.

The NFL didn't have to wait long to determine the appetite for pro football in the Carolinas. On June 3, 1993, Richardson announced a precedent-setting plan to privately finance the 72,300-seat stadium he had planned using a concept called Permanent Seat Licenses. They went on sale on July 1, and 15,000 pieces of mail flooded in on the first day. That quickly, all 8,314 club seats, all 104 luxury boxes and 41,632 stadium seats were sold, even before the franchise had officially been approved by the NFL.

Was it too great a gamble? Some published reports in the early part of the second decade of the 21st century placed the franchise's value at no less than $900 million and the rejuvenation of the team behind dynamic quarterback Cam Newton and what late in the 2013 season was rated as the league's best defense perhaps pushed it beyond the $1 billion mark.

The Panthers' first year of competition came in 1995 with a promise from Richardson that the team would reach the Super Bowl within ten seasons. It was a bold prediction. For example, the Panthers' closest NFL neighbor, the Atlanta Falcons, took 33 years from their 1966 birth to reach the Super Bowl and didn't have a winning season until 1971, that a 7–6–1 mark.

Born the same season as the Jacksonville Jaguars, the Panthers, on the other hand, won seven of 16 games in their first season, 1995, the best performance ever for a first-year NFL team. A year later, they were 12–4, won the NFC West Division, defeated the Dallas Cowboys in the divisional playoffs then lost in the NFC championship game to eventual Super Bowl winners, the Green Bay Packers.

The team's record slipped thereafter, but finished the 2003 season with 11 victories and five losses and fulfilled Richardson's promise of reaching the Super Bowl within its first decade, losing to the New England Patriots in Super Bowl XXXVIII, 32–29. It was one of the most dramatic championship games since the Baltimore Colts defeated the New York Giants in the famous overtime championship game in 1958. National sports writer Peter King called it "the greatest Super Bowl of all time."

As is the case with most National Football League franchises, success on the field has at times been difficult for the Panthers. But as the 2013 season, which included the team's all-time best string of victories, including a dramatic one against the Patriots, wound into its late stages, a victory over New Orleans in a North Carolina rain storm and a triumph over the Atlanta Falcons gave the once 1–3 Panthers the NFC South championship and a bye in the first week of the playoffs. The team of the Carolinas was once again considered to be in robust health.

So was Richardson, who, known by the Panther players as "The Big Cat," continued to watch the game he once played after apparently overcoming major health problems, including a heart transplant. We are left to wonder if this segment of North Carolina sports history would have been different had the Baltimore Colts caved in and given tight end Jerry Richardson his $250 raise all those years ago.

Racing

By Lenox Rawlings

Lenox Rawlings covered his first race in 1970 at the Raleigh track where, a month later, NASCAR's top series ran on red clay for the last time. After graduating from the University of North Carolina, he left *The News & Observer* to write for the *Greensboro Daily News* and the *Atlanta Constitution*. He joined the staff of the *Winston-Salem Journal* in 1976 and stayed 36 years, the first two as state political correspondent and the rest as sports columnist. Rawlings was selected president of the U.S. Basketball Writers Association, N.C. Sportswriter of the Year three times and recipient of the Skeeter Francis Award from the Atlantic Coast Sports Media Association. He is a member of the U.S. Basketball Writers Hall of Fame and the Fike High School Athletic Hall of Fame in his hometown of Wilson.

A 'Shining History

On a sunny Sunday morning in October 2013, Junior Johnson found himself wedged between a white concrete wall and stacks of fresh racing tires, talking about his children. He had come to Martinsville (Virginia) Speedway, the oldest and shortest track on the NASCAR Sprint Cup circuit, to resume his customary role as the oldest and most colorful stock-car legend still running. The ceremonies preceding the 500-lap race around the paperclip-shaped oval would end when Johnson, the grand marshal, commanded 43 drivers to start their engines. A grand marshal assumes few other duties, so the 82-year-old Johnson passed the unscripted hours swapping ancient stories with broadcaster Barney Hall, greeting friends and updating acquaintances about the flow of family life, including how his daughter Meredith, a high school senior, would soon join her brother Robert Glenn Johnson III at Duke University.

Standing in a narrow passageway beside the infield media center, Johnson explained the practical advantages of early admissions. Two substantial middle-aged fellows wandered down the path, looking for the restroom. They recognized Johnson and stopped on the spot, like drivers hitting the brakes while diving into Martinsville's bottleneck first turn. "I'd give a hundred dollars for a Sharpie right now," announced the first fan, with Christmas-comes-early joy in his voice.

Johnson's eyes sparkled. "What about a blade?" he said playfully.

"I've got one of them," the second fan replied at the precise instant Johnson whipped out a felt-tipped pen and reached for something to autograph. They all laughed.

"Hey, Junior, how you doing? Still in the game, huh?"

"I'm in the liquor business," Johnson shot back, a wise half-grin creasing his tanned face. They shared a deeper laugh, the big old boys complimenting Johnson on his supersonic wit as they shuffled toward the restroom door.

"You ain't too far from where we make it," Johnson shouted over their shoulders. He meant the Piedmont Distillers Inc. plant in Madison, North Carolina, that produces Midnight Moon. The certified, fully taxed moonshine comes in seven flavors and one octane (80 proof), based on the Johnson family recipe.

The manufacturer's sales campaign emphasizes how Johnson outran and outsmarted every federal agent on the treacherous mountain roads of Wilkes County and beyond, until the revenuers caught him starting the fire for his father at a backwoods still in the middle of the night on May 2, 1956. Johnson served nearly half of a two-year sentence in the federal penitentiary at Chillicothe, Ohio, and then refired one of racing's most successful and diverse careers. The Midnight Moon ad slogan ("Any more authentic and it would be illegal") and its web site (with jailhouse mug shots of the 24-year-old Johnson, front and side views) capitalize on the classic double-edged appeal of a widely admired outlaw who wielded a 1939 Ford standard coupe to dodge tax laws and make money during sparse times.

Among the various historic roots in North Carolina's stock car garden, many petrified in red clay, nothing captures the imagination quite like the bootlegger legend. Hollywood exposed the fictional characters in black-and-white exaggerations such as *Thunder Road*, which sold enough theater tickets in the South to delay its release on video for 25 years. Tom Wolfe's 200 mph account ("Junior Johnson Is The Last American Hero. Yes!"), published by *Esquire* magazine in March 1965, put a polished finish on the visceral vehicle known as New Journalism while introducing the story—the genuine story—to a new generation, right down to the physical nuances of Johnson's notorious bootleg turn:

> "If the Alcohol Tax agents had a roadblock up for you or were too close behind, you threw the car into second gear, cocked the wheel, stepped on the accelerator and made the car's rear end skid around in a complete 180-degree arc, a complete about-face, and tore on back up the road exactly the way you came from. God! The Alcohol Tax agents used to burn over Junior Johnson."

Moonshining wasn't the beginning of racing in the South, and it won't be the end, but the connection between liquor and racing was a steel cable that towed the emerging sport through the ample midsection of the 20th century, the automotive century. The illegal liquor business, a growth industry during America's 1920–1933 Prohibition and well beyond the repeal of the 18th Amendment, served as the incubator for the fastest cars, slickest drivers and shrewdest mechanics. In many instances, liquor provided the money for building tracks, fielding cars and putting on shows, which paved the road for unimagined legitimacy.

The dusty days seem prehistoric now, at least to anyone born later than Dale Earnhardt, the last authentic hard-charging, blue-collar champion. Stock-car racing rose out of the iron-rich red clay of the Southeastern Piedmont and the crushed-shell sands of the Florida beaches, out of the muck and the ruts and the mill towns, out of the country stores and textile looms and furniture factories, out of the dirt-poor classes presumed bound, like their ancestors, to the dirt. The liberating car gave them a way out, and the exploits of those race car boys allowed them a revitalizing escape from the monotonous grind of modern times and a consuming passion they could call their own, once a week.

The images of showroom Chevys and Fords with their headlights taped over fade in the rear-view mirror now, like the faintly orange dust clouds they kicked up on Saturday nights and Sunday afternoons. The racing present rounds the turn with an in-car camera capturing the intense superspeedway lights and shimmering paint jobs. Everything looks so bright, from the glass towers and world's biggest HDTV screen at Charlotte Motor Speedway to the neo-Guggenheim interior of NASCAR Hall of Fame in downtown Charlotte to the flashy trucks on the interstate hauling $130,000 cars to the next event.

Stock car racing, with NASCAR's Sprint Cup series on the pole, dominates American auto racing. Attendance for the 36 Cup races peaked in 2005 at 4.7 million, an average of 129,733, and dropped significantly during the recession. NASCAR put the figure at 3.5 million for 2012 but announced in early 2013 that it would stop disclosing attendance. TV ratings and admissions revenue sank more than 40 percent from 2005

through 2012, yet NASCAR negotiated new TV deals with Fox and NBC that will pay $8.2 billion over 10 years, starting in 2015. The Triad market of Greensboro/Winston-Salem/High Point ranked No. 1 nationally in NASCAR viewership again in 2013, with the Charlotte market third on Fox broadcasts and fifth on ESPN.

Racing has about a $5 billion impact on the North Carolina economy, according to a 2005 study by the University of North Carolina at Charlotte's Urban Institute. A study commissioned by the N.C. Motorsports Association, an industry trade group, found that 88 percent of all NASCAR jobs are in North Carolina, mostly around Charlotte. *Forbes*, basing its rankings on assets through 2012, valued the foremost racing team, Hendrick Motorsports, at $357 million, which included $125 million from sponsorships. That more than doubled Joe Gibbs Racing ($168 million), Roush Fenway Racing ($166 million) and Richard Childress Racing in Davidson County ($139 million). Average value of the top nine teams: $143 million.

The price has escalated since racing began with chariots or camels or square-wheeled carts powered by dinosaurs—those modified flatfooted Flintstone-mobiles. Who can really say? Henry Ford, father of the automotive century, promoted his grand motor plan by driving one race in 1901, two years before founding the company that delivered his Model T to the masses through assembly-line production. He won, but Ford disliked speed's ragged edge. He never raced again.

Others did. The American Automobile Association—that AAA—sponsored races in the early 20th century, mostly in open-wheel cars. In the era when only affluent folks could afford cars, sporty racing belonged primarily to American and European elitists. William K. Vanderbilt, Jr. ditched his yachts for a ground-hugging racer and set the land speed record of 92.3 mph in Florida despite the aero drag of a triple-thick mustache and beret.

The industrialized North hosted most of the races, but the hard Florida sands of Daytona Beach and Ormond Beach that Vanderbilt mastered appealed to drivers chasing glory and high-end tourism. Auto racing spread across the South, in fits and starts, a progression detailed by Randal L. Hall in the August 2002 edition of *The Journal of Southern History*. Hall describes how local leaders adopted the socially desirable AAA races to promote civic images worthy of investment, particularly after Asa G. Candler, Jr. of the Coca-Cola empire spent vast sums in 1909 building a two-mile track with 40,000 seats outside Atlanta. The deteriorating track faded after 1912.

North Carolina racing remained essentially local, private and invisible until Charlotte bolted into the big time in 1924 with construction of a 1¼-mile banked board track just south of town on Old Pineville Road. An advertising poster screamed: "Thrills! Thrills! Thrills! Opening the Charlotte Speedway. World's Best Drivers."

A 1949 retrospective published by *Speed Age—The Motor Racing Magazine* estimated construction costs at $380,000 (about $5.2 million in 2013 dollars), and a 1960 *Charlotte News* story put the figure at nearly $500,000 (about $6.8 million now). The project employed 300 workers, most of them carpenters, and used 4 million feet of green Carolina pine two-by-fours, plus 80 tons of nails and spikes, according to Deb Williams' *Charlotte Motor Speedway History: From Granite to Gold*. That's why tickets cost $2 for general admission ($27 in 2013 dollars) and $8 ($109) for the top luxury box seat.

On October 25, 1924, Tommy Milton averaged 118 mph over 250 miles to beat road-sters competing for $25,000 in prizes ($341,500). The first race drew 30,000 customers, and attendance rose to 50,000 when the hotshots returned in 1925 as the final prelude to the Indianapolis 500. By 1927, however, nature had weathered the splintering track beyond usefulness, according to a *National Speed Sport News* article in June 2009, and volunteer workers had to dodge cars while trying to nail down loose boards. The circuit dropped Charlotte. The track was demolished during World War II, with some lumber recycled.

Racing took a fortuitous turn in 1934, when a Washington, D.C., mechanic and high-school dropout named Bill France loaded his wife (nurse Anne Bledsoe of Nathans Creek, North Carolina, 35 miles from North Wilkesboro) and their young son Bill Jr. into the family Hupmobile along with his toolbox and headed to Florida, searching for a sunnier future. In Sylvia Wilkinson's landmark *Dirt Tracks to Glory: The Early Days of Stock Car Racing as Told by the Participants*, a mostly oral history published in 1983, France described how he loathed fixing dead batteries during D.C. winters. As a teen, he secretly raced his father's Model T on the banked board track at Laurel, Maryland, and, staring into the face of paternal bewilderment, never let on why the tires wore out so fast. France left all that behind, hitting the road with $25 in his pocket and $75 in the bank. The young family settled in Daytona Beach, where France worked as a shop mechanic until buying a gas station. People noticed him. France was 6-5. He spoke loudly and drove adroitly, finishing fifth in the first 250-mile Daytona stock-car race that ran north along the beach and south along highway A1A.

France learned from the early promoters and became a master of the craft. Daniel S. Pierce, in his exhaustive 2010 history *Real NASCAR: White Lightning, Red Clay, and Big Bill France*, wrote that France saved Southern racing after the messy 1936 event cost Daytona Beach $22,000 and prompted a political backlash. The city grudgingly permitted a 50-mile stock-car race on the 1937 Labor Day card, paying a paltry $100. It ran smoothly and colorful bootlegger-barkeeper Smokey Purser won, introducing the sport's outlaw-as-hero character, replete with howling fans.

Up the road in Georgia, moonshiners poured another enduring foundation. Raymond Parks grew up in a liquor-making family in Dawson County, a moonshine capital on par with Wilkes County, and left home at 14. Parks' story, elegantly told by journalist Neal Thompson in *Driving with the Devil: Southern Moonshine, Detroit Wheels, and the Birth of NASCAR*, became the often unacknowledged parallel history of NASCAR's incubation. At 16, Parks moved to Atlanta and worked as a daytime mechanic at his uncle's service station. He hauled liquor from Dawson County to Atlanta at night, making enough money to start his own end-to-end operation. Parks invested the profits in lucrative vending machines, a lottery and a legal liquor store, sustaining his enterprises during a nine-month term in the federal pen.

Parks took up with the racing crowd, a substantial group given Lakewood Speedway's primacy as a 1930s track. Parks joined forces with Atlanta's incomparable Ford V-8 me-chanic, Red Vogt, curiously enough a childhood friend of Bill France in D.C. Parks em-ployed his daredevil cousins, absurdly talented Lloyd Seay and forever reckless Roy Hall, in both driving businesses. With Vogt engineering and war veteran Red Byron driving

despite shrapnel in his withered left leg, owner Parks won the first championship following NASCAR's December 1947 formation (with a modified Ford V-8) and, in 1949, won the first strictly stock championship.

As North Carolina's appetite for oval racing grew, cities turned fairgrounds horse tracks into red-clay car tracks. Between 1939 and 1941, according to historian Pierce, bootlegger-promoter Joe Littlejohn sponsored a stock car race at the Salisbury fairgrounds, Bill Thompson promoted the South's first night race at the Greensboro fairgrounds, and Ralph Hankinson lured 10,000 fans to Charlotte's Southern States Fairgrounds. High Point opened a 10,000-seat speedway.

World War II shut down the sport, but when the soldiers came marching home, they chased a faster, louder rhythm. H.A. "Humpy" Wheeler, who became racing's preeminent promoter at Charlotte Motor Speedway, has researched the liquor-racing relationship for years, befriending many practitioners. He observed:

> "They didn't want to settle for working in the cotton mill or furniture factory or sawmill. They wanted something else to light their life up.... These adults still wanted more action, so what evolved was that we'd see these rumbling cars—'37 to '40 standard Fords—that were so plain looking. They did not have a chrome grill. They were 100 pounds lighter than the other cars, and you'd see them on the road because they were bootleg cars. They were totally stock on the outside, but those of us who knew anything about mechanics knew what was going on: big-time engines. They would drag-race people all the time, with all sorts of bets going on. It was teenagers driving these cars. The bootleggers probably had driven the cars at one time.... When they got to be 19 or 20, they went to the still and stayed there, and they hired these kids to drive. They knew these kids had these really quick responses and would take chances the adults wouldn't take."

Junior Johnson, born in 1931, was too young for the war, but few teens got an earlier start hauling liquor from the Wilkes County hills to the Piedmont cities. His father, Robert Glenn Johnson Sr., was a major operator whose prominence can be summarized by one statistic: When agents raided the family's Ingle Hollow home in 1935, with 4-year-old Junior running around barefooted, they found 7,200 cases of liquor stacked everywhere—the largest seizure of homemade 'shine in history. Mr. Johnson had crammed the liquor into all but two rooms of the frame house. The agents put boards over the second-floor stairs so they could slide the cases down. Junior and a brother jumped on cases and rode them like sleds, ticking off the revenuers, who cussed at the kids and ordered them to get out. Junior said the boys cussed back and told the feds, "You get out." His father went to prison, where he spent about one-third of his life.

In an interview on October 27, 2013, Junior Johnson recalled:

> "I was about 15 when I started. My father, he was in the moonshine business, and my two brothers were driving two cars and hauling for my dad. As time went along, I started driving the cars. I started about 12 years old, driving. I got a little better with it and a little better with it until I was as good as my two brothers was, driving the fast cars. Along about 16, that's when they started

North Wilkesboro Speedway. Bill France Sr. came in, and there was about eight people in the whiskey business. It was very profitable. They made a lot of money and were big operators. France was counting on them to build a speedway."

That's what they did in 1947, hard by U.S. 421. With France riding shotgun, the group headed by Charlie Combs and Enoch Staley, the business-minded son of a substantial Wilkes moonshiner, built a dirt track only ⅝ of a mile long with a bedrock quirk that affected the grading. The backstretch climbed uphill and the frontstretch went downhill. North Wilkesboro Speedway, an overnight smash, was paved in 1958.

Johnson said most of the original investors weren't looking for personal profit: "'Just get my money back and I'll be satisfied.' It drizzled down to two people, Jack Combs and Enoch Staley, and then Jack sold his part to Bruton Smith."

In 1995, Smith, the boss of Speedway Motorsports Inc., and Bob Bahre, who owned the New Hampshire track, bought out the Staley and Combs families, then harvested the two valuable NASCAR dates, taking one to Texas and the other to New Hampshire. The new owners, having stripped away the marketable assets, abandoned the track after the last Sprint Cup race in September 1996 and let weeds grow out of cracks in the pavement. (Rockingham, originally called North Carolina Motor Speedway, opened in 1965 and hosted Cup races until 2004. The Rock's two race dates were transferred to California and Texas, leaving the state with just one major league track.)

France executed a similar Martinsville deal in 1947 with H. Clay Earles, who used liquor proceeds for construction, according to research cited in Pierce's *Real NASCAR*. This time, though, France wound up as 49 percent owner. ISC, controlled by France's heirs, bought out Earles' descendants in 2004.

France, Combs and Staley formed a partnership in 1948 to build a dirt track outside Hillsborough, in Orange County. Occoneechee Speedway, named for a Native American tribe, was a prominent landowner's horse track when France spotted it from his low-flying plane. The track, just a shade under one mile long, was renamed Orange Speedway in 1954 and stayed on the NASCAR schedule through 1968, when Richard Petty won the last race. Preservationists put the property in trust and had it listed on the National Register of Historic Places, enabling it to function as a public park.

With those three liquor-connected tracks and the Daytona Beach road course thriving, promoter France assembled many of disorganized racing's most organized practitioners at the Streamline Hotel in Daytona Beach on December 12, 1947. The group included France partner Alvin Hawkins, who would become promoter at Winston-Salem's city-owned Bowman Gray Stadium, a paved quarter mile. After three days of consultation and liquor-laced hospitality, France led a business meeting and achieved the result he had plotted: a new racing organization—the National Association for Stock Car Auto Racing, the name suggested by Red Vogt—with France as president and chief money manager.

NASCAR continued running modified stock cars in 1948 but abruptly switched to strictly stock cars in the summer of 1949, evidently because rival promoter Bruton Smith, a native of Stanly County, just east of Charlotte, had announced his 1949 strictly stock plans for the National Stock Car Racing Association. The France-Smith feud out-

lived two France generations and continues today at the corporate speedway level, ISC vs. SMI.

France's first strictly stock schedule involved just eight events, beginning with the June 19 race at the old Charlotte Speedway near the former board track. Moonshiner Glenn Dunaway finished first, but France disqualified him for using an illegal part and named runner-up Jim Roper the victor. The other 1949 sites: Daytona Beach, Hillsborough, Martinsville, North Wilkesboro, two tracks in Pennsylvania and another on Long Island, N.Y.

Enoch Staley played a major role at Hickory Motor Speedway, still known as "Birthplace of the Stars" because so many emerging giants polished their skills on the .363-mile track, including locals Ned Jarrett, his son Dale Jarrett and Bobby Isaac (who died in 1977 and was buried at the hillside cemetery in the distance). The speedway opened as a dirt track in 1951 and converted to asphalt in 1968.

Ned Jarrett, who raced that first season, knew all about the principal owners.

> "Charlie Combs and the Staleys were involved with the North Wilkesboro track. Charlie came over and talked to some businessmen in this area. One of them was halfway between here and North Wilkesboro, a guy by the name of Grafton Burgess. He was a big-time moonshiner. He went far beyond making it in the stills or even just transporting it. He had tractor trailers. He and his brother went up into the Northeast—I think Baltimore was their primary source of buying bonded whiskey—and they'd bring it down here by the tractor trailer loads."

Jarrett traces his original love affair with racing to his father, H.K. Jarrett, a farmer who waded into the lumber business and raised six kids with his wife, Eoline. As soon as 14-year-old Ned saw the North Wilkesboro and Charlotte dirt tracks, there was no turning back, even though H.K. Jarrett didn't envision those drivers fitting into the Protestant-dominated Southern culture of the early 1950s. Ned recounted:

> "They were good people—that was not the point—but they had the image of being a bootlegger. My dad was a Christian individual and he never drank any, as far as that part was concerned. He didn't condemn those who did, but family image was very important to him. Most of them were involved in that business. Junior Johnson, Gwyn Staley—I don't remember all the people, but I'd say half of them in any race had some connection to the moonshine industry."

Curtis Turner, a Virginia bootlegger and longtime buddy of Bill France, was a hard-driving, hard-partying 1950s star who relished bumping rivals out of the way. His knack for attracting photographers and flashy women—not necessarily in that order—was unrivaled. He loved planes, fast lanes and faster money, his considerable talent surpassed only by his fanciful ambitions. With France's 2.5-mile Daytona track joining Darlington as the sport's second major speedway in 1959, Turner concluded that he could make the biggest splash by building his own monument to speed north of Charlotte. Promoter Smith had the same dream, different site. The headstrong men settled on a practical solution: merger.

Their vision outstripped their resources by a country mile and a half—the length of Charlotte Motor Speedway, then and now. As detailed in *Charlotte Motor Speedway History*, the stunning discovery of a granite mountain under the soil added about $500,000 to a $1 million budget. The dynamite bill soared—$70,000 worth to blast out the first turn alone. Smith and Turner needed emergency loans, fake checks, guns and gall to manipulate unpaid contractors and keep crews working. France sanctioned the World 600, which ostensibly would compete directly with the 1960 Indy 500, and then he approved the three-week delay when the original deadline became unattainable.

On June 19, they held the race … and held it … and held it. For five and one-half hours, the 60 cars battled engine fatigue and a crumbling track. Pavement chunks and rocks slammed into windshields and protective wire screens placed over radiator grills. Potholes swallowed tires. The contending pack dwindled to a handful with 50 laps left. Jack Smith looked like a sure thing until a flying asphalt boulder ruptured his gas tank. Joe Lee Johnson, driving one of the slowest cars, won the $27,150 check. Charlotte entered the big leagues on two good wheels and a whim, and it has stayed there—despite the harrowing bankruptcy just around the first turn—ever since, North Carolina's anchor in NASCAR's ocean.

The bootlegger residue lingered for decades after alcohol regained legal status. Richard Childress, a driver from Winston-Salem born in 1945, worked his way into ownership and a partnership with Dale Earnhardt that yielded six of Earnhardt's seven championships. After Childress dropped out of high school to earn money, he worked at an all-night gas station where bootleggers delivered their liquor. Childress took the moonshine to rowdy local establishments, case by case. Childress told sportswriter Ed Hinton that he saw "people coming out of those places with their guts hanging out—all sorts of fights. Then I saw a guy get blown apart.… One came up with a shotgun and blew guts and blood everywhere."

Childress promptly quit the business, and today he prefers glossing over the subject. "I had some experiences with moonshiners back in the day," Childress said during an October 2013 interview. "I delivered it the next morning for the moonshiners to the different liquor houses. I'd rather not talk about it right now."

Lee Petty, a late starter and fast bloomer during NASCAR's early years, went from driving a bakery truck to bagging three championships. He won the first Daytona 500 in a photo finish and founded the first family racing dynasty in Level Cross, North Carolina, a community near Greensboro named for the level ground where several roads intersect. Son Richard won 200 races and seven championships. He won acclaim as the sport's finest ambassador, signing autographs and treating strangers like relatives. His outsized toothy smile, oversized cowboy hat, thin mustache and wraparound shades became calling cards. In the midst of a 35-year run, fans started calling him The King. They still do.

Lee Petty's younger son, Maurice, had childhood polio but became an engine-building royal, the horsepower hoss behind 212 NASCAR victories. In 2013, Maurice followed cousin/crew chief Dale Inman as the fourth member of Petty Enterprises elected to the NASCAR Hall of Fame. In the beginning, the regal Pettys were simply

country folks trying to scratch out a post-Depression living. Lee Petty made his debut in NASCAR's first strictly stock race at Charlotte.

Maurice said:

> "He had done a lot of road racing before that. As far as what he was road racing, he was outrunning the law, you know. I used to ride with him when he made deliveries. I remember me and Richard my brother in, like, a back seat. He had some blankets over it, and we'd ride right through the middle of Greensboro and everywhere. He'd go out to the area of town that he had some stops at and unload it—a case here and a case there. I've seen him put 'em under a bush and leave 'em. I mean, it was mighty trustworthy back then."

Hinton, who has covered racing for several newspapers, *Sports Illustrated* and *ESPN.com*, said that Lee Petty denied hauling liquor. Hinton quoted contradicting evidence from former Petty Enterprises driver Bob Welborn: "All I know is, I used to take 50 gallons a week over to his house. I don't know—maybe he drank it himself."

Richard Petty confirmed the link in an October 2013 interview.

> "My dad and my uncle, they messed with that stuff and that's why they were mechanical minded and why they built their first modified car. They knew a little bit about trying to make a car run better and handle better just through their experiences there. If you go back and you look at the names of the drivers and the car owners of the early days—especially back in the modified deal, because after World War II, see, you had these guys in our area that had never been out of our area and when they come back, the adrenaline was flowing, so they got things flowing here. They were haphazard or whatever, looking for adventure, like Junior Johnson and the Flock boys and all, Jack Smith. They came through the liquor era, and then as the liquor era got tougher and tougher, they branched out and said, 'We can use our knowledge from this over in the racing.'"

Taking a Shine to the Legend: The moonshiner narrative works now, in product placement and in serious accounts of racing history. It wasn't always that way. Bill France Sr., NASCAR's first and foremost dictator, tried to hide the unvarnished truth under piles of dirty oil rags and sanitized images. He was no Victorian carny barker, having raced against moonshiners and snap-tempered ruffians, many of whom became lifelong business partners, but France wanted the biggest crowd possible, and commercial pragmatism meant creating the appearance of legal conformity.

Long after Prohibition, North Carolina laws still restricted the places and methods of sale. Many counties remained dry, and counties that voted to approve state-controlled liquor stores, wine sales and beer sales—so-called wet counties—still couldn't permit the sale of liquor by the drink until the 1970s. There were Sunday blue laws. For much of the 20th century, moonshiners filled a vacuum.

The premise that NASCAR or anyone else can camouflage moonshiners' vital influence on the sport is implausible. NASCAR now agrees, but only up to a point. That point sits on the top floor of the Hall of Fame in Charlotte, a replica of the

Johnsons' still with an explanation of how steam mixes with fermented corn and becomes white lightning. While visitors study the cooker and copper tubing, they can hear Junior Johnson's voice explaining why he usually had the fastest car around: "You just knowed if you got caught you was going to jail."

The Hall of Fame doesn't adequately recognize the Georgia boys, especially Raymond Parks. His 1939 Ford coupe that Red Vogt modified and Red Byron drove to victory in NASCAR's first 1948 race is on display as patrons enter the winding auto exhibit that rises like a banked curve, but Parks was notably absent from the first five inductee classes, totaling 25 contributors.

"I think NASCAR felt for a long time that it was bad for their image," Jarrett said, "but in recent years they have embraced it, because everything has a start somewhere and it's interesting how it comes from one point to another. France did some racing himself, and he promoted events." Jarrett said promoters would sometimes disappear with the money or not come close to matching the announced purses—practices that France used as leverage when he maneuvered to form NASCAR. "So that's sort of the birth of NASCAR—whatever the advertised money was for running the advertised distance," Jarrett said. He added, "You couldn't make any money at it back then. What it did for bootleggers in this part of the country was that it legitimized what they were just doing on their own. They didn't get any money unless they bet, and I'm sure they did bet against each other."

Richard Petty seems amused that two France generations—Bill Sr. and Bill Jr., who ruled NASCAR from 1947 until 2003—lived in public denial of the sport's country boy, illegal liquor heritage, but now NASCAR sometimes acknowledges some facts.

> "They tried to stay away from that, because they were trying to go to the next level. They were trying to get interest in their sport, so they downplayed that as much as they could. As that history got away—60 years ago—then it's a sprinkling of something different they don't mind throwing in there. It isn't degrading at all. They say, 'This is where we started, guys, and this is where we are now.' It's the same way with trying to take down the rebel flag. Hey, this happened, guys. You can't change history. And you've got Hitler's flag. You can't hide it, man. It's there. We wouldn't be where we are today if stuff like that hadn't happened. And the deal is, I always look back at this: What my daddy done or my granddaddy done, I'm not responsible for it—you know what I mean? I'm responsible for what I did, and I'll answer for that, but I'm not answering for any of my kin people."

To brother Maurice Petty, the bleached versions of backwoods racing history smell antiseptic. "That's where it came from," he said. "Like it or not, that's the way it was. But moonshiners weren't like the dopers are today. Back then, it was for a living, for people making a living, but now they do it for the glory. They make the money to piss it away."

For many chroniclers of racing history, the clean-hands fantasy that Bill France Sr. and his corporate clan perpetuated rubs the wrong way because intellectual dishonesty comes with the package. In his introduction to *Real NASCAR*, Pierce disputes academics

skeptical about the moonshiners' influence:

> "Sociologist Jim Wright offers no qualifiers when he argues, 'The idea that NASCAR was created by or was at least a tolerant, much less congenial home for a gang of wild-eyed whiskey runners is nonsense.' NASCAR founder Bill France Sr. regularly downplayed the alleged connection between moonshining and NASCAR's founding, and NASCAR itself has consistently ignored accounts that attempt to show a link to the illegal alcohol business. Early on in this project, I would have argued that such tales vastly exaggerated the role of moonshining and bootlegging in the sport's origins and early years. On closer inspection, however, I have discovered that, if anything, NASCAR's connection to the manufacturing, transportation, and sale of illegal alcohol has been both underestimated and misunderstood. Indeed, the deeper I looked into Southern stock car racing's early history, the more liquor I found."

The progression from running liquor to driving race cars is well-established.

> "What most chroniclers of stock car racing and NASCAR have failed to note, however, is that a larger percentage of the early mechanics, car owners, promoters and track owners had deep ties to the illegal alcohol business. It would not be an exaggeration to say that the sport was built on the proceeds of the manufacture, transport and sale of hundreds of thousands, if not millions, of cases of white liquor—and legally produced but illegally sold bootleg 'red' liquor—in the Piedmont region of the South and its adjacent foothills."

In *Driving with the Devil*, Neal Thompson pointed out that racing pioneers Parks, Red Byron, Red Vogt, Seay and Hall rarely appear in print.

> "Maybe that's because of NASCAR's dirty little secret: moonshine. The sport's distant, whiskey-fueled origins are usually wrapped into a neat, vague little clause—'... whose early racers were bootleggers ...'—about as noncommittal to the deeper truth as crediting pigs for their contribution to football.
>
> Today, if the fans know anything about NASCAR's origins, they might know the name Bill France. The tall, megaphone-voiced racer/promoter from D.C. deftly managed to get himself named NASCAR's first president in 1947, then eventually bought out the organization's other top officers and stockholders to make himself sole proprietor of a sport that became his personal dynasty. France is often referred to as NASCAR's 'founder,' which is oversimplification bordering on fiction. Largely forgotten from the NASCAR story is this: Bill France used to race for, borrow money, and seek advice from a moonshine baron and convicted felon from Atlanta named Raymond Parks ... NASCAR certainly succeeded far beyond anyone's wildest postwar expectations, thanks in large part to the moonshiners who were its first and best racers. But France held a deep disdain for the whiskey drivers who nurtured NASCAR's gestation in its early years. He worked hard to distance his sport from those roots and was not above blackballing any dissenters, as Parks and both of the Reds discovered. In striving to create squeaky-clean family entertainment, to the point

of downplaying NASCAR's crime-tainted origins, France buried the most dramatic parts of NASCAR's story beneath the all-American mythology he preferred."

It's in the Dirt: As the early chapters unfolded, from the late 1930s through the late 1950s, there was another vital natural element: the Earth's crust.

James Naismith invented basketball by hanging peach baskets from the gym balcony in Springfield, Massachusetts. He used what he had. Racing worked much the same way. Automotive forefathers put their magical machines where they could run free — on the pulverized coquina shells of firm Florida beaches and the salt flats of the American West, on settled topsoil and converted horse tracks, on distorted ovals carved out of the countryside.

In North Carolina, which stretches from the Blue Ridge mountains to the Atlantic Ocean, the finest organic racing surface fell approximately in the middle: red clay. The Piedmont cuts through the Southeast like a crescent moon, from central Virginia down to Alabama, a swath packed with dense red clay. Nothing can match clay's utilitarian qualities, which meant everything to a sport that started with almost nothing. Red clay didn't take much equipment to move around or shape into banks, and it didn't take much upkeep other than water trucks to maintain the proper consistency while suppressing dust clouds. Red clay retained its firmness, unlike the loamy soil to the east and the looser Daytona Beach dunes.

Consequently, dirt tracks sprouted everywhere. During NASCAR's first 22 seasons, up until the top series staged its last dirt race at the N.C. State Fairgrounds Speedway in Raleigh September 30, 1970, the circuit frequently ran on dirt tracks at Charlotte, Hillsborough, North Wilkesboro, Hickory, Asheville-Weaverville, Wilson, High Point, Shelby, Concord and Moyock (Dog Track Speedway, on the Virginia border near Currituck Sound). Because they usually raced more than once a week in those years, the big-time drivers also ate dust in Spring Lake, Greensboro, Jacksonville, Fayetteville, Asheville, Gastonia, Salisbury, Monroe, Randleman and Harris (near Rutherfordton). The schedule peaked at 62 races in 1964. R.J. Reynolds Tobacco Co. of Winston-Salem started sponsoring NASCAR's foremost series, Winston Cup, in 1972 and reduced the schedule from 48 to 31 races.

Promoter Wheeler found the proliferation of post-war dirt tracks just as interesting as the moonshiners.

"You always had one person in the county, some rural guy that might have finished the eighth grade, but he had a brain on him, a really good brain," Wheeler said. "Most places, they'd call this guy Slick—a smart country boy. Well, old Slick would find some good red clay, which isn't hard to do, and go to the farmer, old McClinna. He'd say, 'Mac, I've got a business venture you got to be a part of. We're going to build a speedway.' 'We are?' 'Yep.' 'Where you gonna build it?' 'I'd love to build it right here and make you a part-owner.' He'd always say OW-ner real hard because what he's trying to do is put the land up for a third. Slick, he had a third because it was his idea. After he got the land, he needed one more thing. He needed to build a structure. That meant going to

Clem at the sawmill. He'd say, 'Clem, how'd you like to own a speedway?' Old Clem, he ain't never owned anything except something that made more sawdust than he ever wanted to see the rest of his life. He's so tired of sawdust he couldn't see straight, and blades that were busted. 'What you mean?' 'Well, if you put all the lumber up for the fences and seats and bathrooms and the walls, we'll give you a third interest in it.' Clem thought that was a pretty good idea ... Slick would always find a piece of land that was a cut-and-fit. It's a pasture that went up. He'd just take that hill, level it out for parking, bring the dirt down and make that track out of that dirt. He didn't have to haul any in. So, he had a track and there were these boys around that wanted to go racing."

They went racing, and the best racers learned how to manipulate the natural qualities of dirt to their advantage. Driving in the dirt is different than driving on top of it. Richard Petty said:

"Dirt racing was different than asphalt because I always felt the driver was more important than the car. You got to figure these were pretty stock cars and they didn't handle nowhere anyway. You know what I mean? But you had a Curtis Turner or a Junior Johnson who just excelled on a dirt track, running sideways and all that kind of stuff. You know what I mean? When I started, all the tracks would be dirt and then every year there would be less dirt and finally it went away. The last race we run was in Raleigh — yeah, we won it. So, that give me training for the asphalt. The reason they quit running so many races was RJR. When they came in, they said, 'Look, we're going to spend all this money, but why do we need to advertise a Thursday night show and a Saturday night show? Let's do a big show on Sunday, and we'll spend all our money and we'll get more publicity out of that than we will splitting it up.'"

A Track to Learning: Jarrett considered himself fortunate to live near the ferociously competitive Hickory track, where co-owner Combs used a pencil stub to sketch the blueprint in the red clay.

"A lot of the half-mile tracks in particular would get rougher in the turns because you'd carry more speed into the turns and dig the dirt up and then holes would come in bigger than this table here," Jarrett said, "so you had to learn to drive around those or at least position yourself into the turns. You wanted your left wheels to hit the holes if possible because most of your traction was on the right wheels, so if they were hitting holes you weren't going to keep control of the car very long or get much traction. The first thing I figured out myself was you had to drive around those holes. Sometimes, it was impossible to miss it with all four wheels, but if you had to hit it with two wheels, make it be your left wheels.... It was sheer driving on dirt. First of all, you didn't have power steering. It just took a lot of physical ability. Of course, having grown up on the farm and working at the sawmill helped me in that respect. And those guys like Junior and them that did the moonshine thing, they were

in a similar position. I mean, they worked hard. They did a lot of physical labor, loading and unloading and driving the car."

Drivers adapted dirt-track techniques to Daytona's new superspeedway, using controlled slides in turns. On dirt, drivers worried about overheating because rear wheels would sling mud into the radiators of trailing cars, and air couldn't flow through. NASCAR allowed extra screens in front of the radiator. Jarrett said:

> "We finally got to the point where it was a shaker screen. You'd have a frame that had a big screen on it, but you'd have a swinging type screen that would go out farther. You had to have iron around the edges of it to frame it out. You had to have it beat back against the frame that you built so it would shake a lot of the mud off of there. Red clay, it'd just stick. You could make a ball out of it and it would be hard. Then we got to where we would also put multi-layers of screen on there and have a wire that ran to the driver. He could pull that top screen off when it did cake up, and that helped. It would just rip it off and it would fall somewhere on the track. It didn't matter. There were rocks and all sorts of stuff out there."

Jarrett used windshield wipers to scrape some of the clay off. "I can't fathom now how we were able to see and drive those things the way we did," he said. "I think your eyes adjust to it a lot."

Childress got his driving start on the paved Bowman Gray track and ventured out to nearby dirt tracks. When grandsons Austin Dillon and Ty Dillon took up racing, Childress put them through dirt training. That paid off for Austin in 2013 when NASCAR returned to dirt for the first time in 42 years and he won the truck race at Eldora Speedway in Ohio. Childress maintained:

> "Dirt track racing was probably the most fun I had racing. I think it teaches today. I think it's taught my two grandsons to be better race drivers because you've got to learn car control with dirt. You've got to learn how to use the throttle, use the brakes, set the car. If you get too far out, you've got to understand how to bring it out of a slide."

Dirt is dirt, but the dirt scene of the 21st century is tamer. As Childress said:

> "We'd go to a dirt track somewhere and there would be a local favorite, and if you got into it with him, you'd better be ready to fight. Most of your dirt tracks back in the day, you'd go in there and end up having to fight your way out, usually. Sometimes you'd want to stay in the car and drive it outside the gate before you got out. It was just a rough crowd back in the day. It's not like that today."

Dirt is also dirty, and clay cakes up on skin. Jarrett rode home muddy and hosed down outdoors. He said:

> "In my early days, we didn't have running water to take a shower. My dad had a 55-gallon barrel out behind one of the buildings—I think it was the

woodshed. He'd fill it up the first part of the week and let it get warm for Saturday when you had to take your bath. I had to take my bath a little bit more often, so I'd get under that shower. That was in the very, very early days. After that we got running water, so you'd hose yourself down and get cleaned up before going inside. It was a social outing for a lot of people in the beginning. They'd come out in their white dresses and hairdos and all that. That didn't last long."

Petty also grew up in the country, not far from the famous Seagrove pottery community. He can still taste the residue of dirt racing.

"You'd spit up dirt for two days. You'd go home and take a bath, and if you had to blow your nose, it was just...." He shakes his head. "But you didn't think anything about it because everybody was working under the same circumstances, so you never had anything any better to compare it with. That's like life. I'd always went to the woods to use the bathroom, but once I got an indoor bathroom, ain't no way I'm going to the woods now. You know what I mean? Basically, from my standpoint as a driver, dirt tracks were a lot more fun to drive because I felt like I was more involved in the situation. On asphalt, if you drive any harder, the car spins out or doesn't stick. Then you can't go anywhere. On dirt, you're sliding around anyway, so you just try to slide less than anybody else."

The sport slid on into the future, the progression heavily driven by North Carolina characters. These are a few of their stories.

Junior the Pioneer: Junior Johnson, just 17, was walking barefooted behind the mule and plowing the garden beside the family home that afternoon in 1948 when the car rolled up the driveway. His brother L.P. wanted Junior to hurry over to the North Wilkesboro Speedway and answer the promoter's call for some local drivers to fill out the field for a preliminary race on the almost-new dirt track. Junior nodded and changed out of his overalls and drove his first formal race. He finished second.

He was a natural, which folks in Wilkes County had deduced from his early start hauling his father's moonshine down to Piedmont cities, setting out about 3 o'clock in the morning and never getting caught on the open highway or the hidden back roads.

Once Johnson applied his bootlegger skill and guile on a track, he never looked back. He won five races his first full NASCAR season, 1955, and early the next year the feds surrounded him at his father's still. Out of prison by 1958, Johnson roared back with 11 wins over two years.

In a natural sort of way, Johnson discovered one of the enduring scientific truths of stock car aerodynamics. If one car tightly follows another at high speeds, the combination reduces wind resistance and allows both to go faster in tandem than alone. They call it drafting.

They didn't call it anything before Johnson pulled off his superb upset in the 1960 Daytona 500. Johnson showed up with a year-old Chevrolet and prospects so meager

that he debated whether to return home. During practice, though, Johnson slipped in behind Fireball Roberts' state-of-the-art Pontiac and mysteriously accelerated. He couldn't figure out why. When his car faltered in the 500, Johnson dropped in behind Cotton Owens and the magic happened again. "I didn't know what it was, and I don't think anybody else did," Johnson said. "Ray Fox was my crew chief, and I thought maybe he had got the car running better."

After a pit stop for new tires, Johnson fell in behind Jack Smith.

> "He had the fastest car in the race, and I could still run with him. I was running all over Jack down in the first turn. I kept doing it, kept doing it, kept doing it. If I wouldn't have, I'd gone straight to the back. When I'd go out and run by myself, it wouldn't run … The Pontiac people had figured out what I was doing with about 20 to 30 laps to go."

By then, Smith had lost too many laps through pit stops, but the Pontiac sharpies sent him out to help the brand's contender, Bobby Johns, by mimicking Johnson's technique. Johns soon took the lead, but when Junior got back in line, another disturbed-air miracle occurred. He recalled:

> "I dropped back in, and it pulled the back glass out of Johns' car. The wheels came off the ground, and he went to spinning. There was about 10 to 15 laps to go, and I went on to win the race. For a while I had it by myself, but they had figured it out before the race was over. Until the race was over with and people was talking about it and all that, it was notable what I had done, but honest to God, I didn't know really what it was until the race was over. I just know I could run faster behind somebody."

As for any counterclaims, competitor Ned Jarrett said, "Junior, far as I know, was the first one." Johnson drove 14 years in NASCAR's top series, but he ran close to a full schedule only nine times. Johnson won 50 of his 316 races, a 16 percent success rate surpassed only by Richard Petty's 17 percent. Jimmie Johnson won 15 percent of his starts through his sixth title season, 2013. Dale Earnhardt, who matched Petty's seven championships, won 11 percent.

Junior Johnson led 24 percent of his 51,988 laps, a testament to his relentless style of running out front or blowing up trying. "I didn't have sense enough to ride around and stroke like the rest of them," he said. "I'd run wide open all the time."

Johnson is quite likely the greatest driver who never won a championship. He pulled his ample torso through the window for the last time at 35. "I wanted to work on the cars and see if I could make better cars than anybody else," he said. "Work on 'em and drive 'em and do the whole thing—you couldn't do that."

As an owner, he won six championships, the first three in record-setting succession (1976–78) with Cale Yarborough driving and the other three with Darrell Waltrip.

Johnson introduced lots of innovations: shoulder harnesses, chrome steel in roll bars, carbon fiber brakes that weighed half as much as steel, cutting-edge wheels that he had manufactured in California, racing slicks on the diabolical Talladega pavement when NASCAR still mandated treaded tires. Johnson was always dancing along that

Junior Johnson (left) finds a comfortable place to talk strategy with his driver, Cale Yarborough.

fine line. "Me and Bill France Jr. didn't see eye to eye sometimes," Johnson said. "When I came up with some kind of safety piece, it was cheating. It wasn't in the rule book, and they didn't have no rule book. They made it up."

Johnson demonstrated superior political skills. President Reagan pardoned the moonshine conviction, and North Carolina's governor rode to Wilkes County for ceremonies renaming that bootlegger stretch of U.S. 421 the Junior Johnson Highway.

During a period when Johnson and his engine-building foil, Smokey Yunick of Florida, were running Fords, they agreed to share some discoveries. "We both had engines to build for the circuit," Johnson said. "I built an engine, and Smokey said, 'Bring your engine down here and we'll see which one we need to copy and stuff, and we'll start building engines for the Ford people.'"

Johnson hauled his engine to Yunick's shop. They tested both engines. Johnson said:

> "I didn't think nothing about it. Mine was 35 horsepower better than his was. I said, 'Here's what I've got done.' He didn't take that for the truth, so when I went back in there the next morning to pick my motor up, it was laying on four tables. He tore it all to pieces. I looked at that thing—everything I had, heads and all that stuff—and I said, 'You son-of-a-bitch.' I was about to kill him. We went on down the road. Smokey was a smart, brilliant guy."

Promoter Humpy Wheeler considered them two of America's craftiest engineers. "If NASA had put Junior and Smokey Yunick together," he said, "we'd have been on the moon a long time before we were, because they were so smart."

Johnson wasn't the first owner to field more than one team, but he broke ground in making it work, briefly, when he paired Waltrip with Neil Bonnett. After Waltrip left, Johnson got top-five seasons out of Terry Labonte, Geoff Bodine and Bill Elliott. When the really big ownership money showed up — Rick Hendrick, Jack Roush, Roger Penske, Joe Gibbs — Johnson read the books perfectly and walked away for good in 1995. He had touched every lever. Johnson was a savvy businessman who raised chickens and cattle while running the race team. In those years when NASCAR lived on gate receipts and promotional fees from automotive products, Johnson recruited nearby Holly Farms, a poultry processing operation, as a major sponsor. His persistent search for a stronger financial model unearthed the golden egg that rescued NASCAR from the doldrums.

Johnson talked to a close friend at Hanes hosiery about support, but Hanes preferred sponsoring an event. Johnson, aware that the government was banning cigarette ads on TV, asked a Hanes executive how he could get R.J. Reynolds Tobacco Co. involved.

> "So he got me an appointment and we set up a meeting. All the big honchos was there that ran Reynolds Tobacco Co. They said, 'Well, Mr. Johnson, how much do you need to sponsor your car?' I said that at that time it was not a lot. I said, 'I need about $800,000.' And I forget which one of them said, 'Well, hellfire, that's peanuts to us. We've got a $575 million budget and we've just been taken off television. We're sitting here with all this damn money and can't do nothing with it.'"

Johnson: "You can give it to me and let me run race cars with it."

RJR exec.: "We're interested in getting into racing because they're going to give us one event. That's all."

Johnson: "You give me your number and I'll call Bill France Sr. and give it to him and tell him the story."

Simple as that. "I called him and they did a deal," Johnson said. "That's how they got it."

France renamed the Grand National series Winston Cup. RJR created a special events department, painted the red and white Winston colors on every track, put the Winston name in front of Talladega and California races and essentially became NASCAR marketing, with Ralph Seagraves leading the enterprise. Johnson already had a good relationship with Seagraves, a friendly fellow from Wilkes County who had become a salesman and lobbyist for Reynolds Tobacco, working Washington's marble halls to shore up support for the industry.

Richard Childress said:

> "When Ralph Seagraves and Junior Johnson brought in R.J. Reynolds, that changed the whole landscape of the sport. If you go back and look at the whole history of NASCAR, there are some major things that made the biggest difference and put NASCAR on the map. That was one. When R.J. Reynolds got into marketing the things around the race track, they spent millions of dollars

taking us from what I would call, back in the '60s, a redneck sport to a high-level sport with lots of top corporations involved. I hate to use the words 'redneck sport,' but it kinda was back in the '60s. When Reynolds got into it, it put us on a whole 'nother field. The next big thing was when they paid the Winston Million dollars. It put us on a level with other athletes and other sports. Bill Elliott won that first million in '85."

At the outset, Seagraves was the driving force. Nat Walker, who moved from Reynolds corporate P.R. to manage racing P.R., said Seagraves "had more personality than any 10 people you see. He could get away with nonsense because of his personality. Once Ralph was involved, it got going in a big way."

Seagraves spouted many homilies. Walker's favorite: "He who do not tooteth his own horn does not get his horn tooteth."

T. Wayne Robertson commandeered the Winston Cup show car, wearing an outlandish white driver suit while visiting tracks and shopping centers. Within a few years, he presided over Sports Marketing Enterprises. *The Sporting News* named him one of the 50 most powerful people in sports. He worked behind the scenes with all the influential players and had such an impact that business cohorts and beat reporters expected him to run the Winston Cup tour whenever France Jr. retired. But Robertson, 48, and five other duck hunters died while on a 1998 trip to Louisiana when their boat collided with an oil crew's boat during a rainstorm just before dawn, when visibility was only one mile.

Bob Moore, the first Winston publicity manager, was certain Robertson was going to succeed France Jr. "He would have," Moore said. "It was all lined up to happen. If Wayne had lived, if Dale Sr. had lived, this sport would have been radically different. It would be so far ahead of where it is."

The Winston partnership lasted until 2003, when further government restrictions on mentioning tobacco products and bottom-line issues prompted RJR to walk away, replaced by Nextel communications.

Johnson was involved in so many ways. Childress saw Johnson race at Bowman Gray Stadium and, after wading into the game as a low-budget independent, sought Johnson's advice. Years later, Johnson gave him something even better. "I'm the one that put him and Earnhardt together," Johnson said. Childress had employed Earnhardt for the last 11 races of 1981 but realized he needed more money to field a contender. He let his friend Earnhardt sign elsewhere and hired Ricky Rudd for the next two years. By 1984, Johnson had sold 50 percent of his team to developer Warner Hodgdon so he could afford to pair Waltrip with Bonnett.

Johnson said:

> "Warner had a Wrangler sponsor deal for Darrell and Coors for Neil. Budweiser come along and said, 'We'll give you twice as much money and two cars.' So I went back to Richard and told Richard, 'Get your ass in gear and get Earnhardt and I've got you a sponsor.' I said, 'I've got Wrangler right now, but I'll turn 'em loose and let you have 'em and Earnhardt can run their cars. We'll give Bill Elliott Coors.' Everybody thinks, 'Well, damn, them people are smart as hell getting all them sponsors.' We had all the sponsors and then Budweiser come in and said, 'We'll give you twice as much money.' Hell, I wasn't going

to let that get away. It turned out to be a good thing for Richard. It put him on the map, and you know where he's at today."

Moore has watched Johnson from close range for more than 60 years, first as the son of a driver-mechanic, then as a *Charlotte Observer* sportswriter. He noted:

> "Junior has played the role of country hick. Junior's one of the smartest human beings you're ever going to meet. He understands every part of this sport—the race car driver's side, the car owner's side, the promoter's side, the big-money side, the sponsor side. He understands all those roles. Played 'em all. He's made more money than almost anybody. It's because he understood what his role was. This sport can't pay Junior enough money for what he's done for the sport."

While some people never adjust to change, Johnson has adapted in every way imaginable, through heydays and dark days. He divorced his widely adored wife Flossie and left Ingle Hollow a generation ago. He remarried—Lisa Johnson is 35 years younger—and built a 150-acre estate in Yadkin County, just west of where I-77 crosses U.S. 421, and raised two children. They're at the center of everything. Junior tutored Robert III on summer racing circuits. Johnson reinjured his back operating a forklift in 2012, underwent surgery at Duke and then had a life-threatening staph infection. He decided that he didn't want to run a farm where the workers did everything, so the Johnsons auctioned off the estate for $2.3 million and moved to Charlotte.

"I had kept 150 head of cattle and had all sort of stuff going on, the country ham business, a lot of irons in the fire," he said. "I said I'll get rid of the farm and maybe that'll help a little bit, do the stuff I need to do to make money the easy way. I've been lucky."

At 82, Johnson was leaving the past behind again and plowing into the future. "You know, I've never been a person who wouldn't give up something for something that's better. Things never seem to stay in one place. You just have to go with the flow and do what you think is best, live your life the best you can. I've had a good life, enjoyed it, worked like a dog all my life. It's still good."

He's still smiling, the blue eyes are still sparkling, the motor's still humming. He's still Junior Johnson, running up front.

Jarrett, the Gentleman Racer: Ned Jarrett, so shy that he looked down while talking to strangers, so determined that he silently planned his driving debut while listening to braggarts at the country store, changed the tone of stock car racing. He ventured into a 1950s dirt track culture defined by thrill-seekers, womanizers, boozers and brawlers, a culture built on bootlegging, betting and never forgetting.

The bootleggers he could tolerate without blinking. They were all around. Jarrett grew up on a farm outside Hickory in Catawba County, which borders Alexander County, which borders Wilkes County. Few enclaves ever produced more moonshine. Bootlegger coupes came rumbling down the hills, rattling jars and delivering goods, and moonshine money built Hickory Motor Speedway in 1951.

"It was a big thing in the community here," Jarrett explained during a September 2013 interview at his Newton home. "I rode about seven miles from here to the country store on a rainy day. When you couldn't work on the farm or at a sawmill, that's what

most people did back then. There were farmers and sawmillers sitting around talking: 'Wait until they get that thing built. I'll go up there and show them how to drive.'"

Jarrett made the field, which fulfilled his vow but violated his father H.K. Jarrett's church-oriented establishment instincts. "I did so without talking to my dad," Jarrett said, "but I was 19 at the time, so I'm old enough to do what I want to do. He came to me and we sat down and had a long talk."

At the end of the father-knows-best session, Ned accepted the logic that racing's racy image could taint the family's reputation and decided that his partner John Lentz—they had put up $100 each for the car—would drive from then on. That worked fine, but one night Lentz was sick. The boys didn't look very hard for another driver. In the darkness of the infield, they swapped shirts, with Jarrett removing his plain shirt and putting on Lentz's bolder plaid. Jarrett said:

> "We both had big noses, and once I put the helmet on, nobody would know. I drove under his name that night. I finished second. He hadn't done that well before, so we said I must be the best driver, so we'll keep on doing this. We did it for four or five weeks, I guess, and finally lucked up and won a race. Then the word began to get out in the community, and my dad came to me and said, 'If you're so determined to drive one of those things, go ahead and use your own name and get credit for any accomplishments you might have along the way.' That sorta opened the door for me."

He only needed one crack. Jarrett held his own while learning, and then he just took off, winning the national Sportsman division championship in 1957 and 1958. He boldly jumped into the big league, NASCAR Grand National. He won the 1961 championship, finished third, fourth and second the next three seasons, and won a second title in 1965.

With sponsor Ford pulling out of the sport and a family to support, Jarrett retired at 33. He was the first—and so far only—driver to walk away wearing a crown. He also was among the first drivers to haul his wife and kids to the tracks and motels along the tour, among the first to raise a racing family without raising hell. He was absolutely the first stock car driver New York sportswriters ever saw wearing a suit and tie to a press conference. He was the first driver to complete the Dale Carnegie speaking course, which he did after stumbling through a civic club talk. Jarrett thus set himself up for a second career in radio and TV.

There have been quite a few voices of NASCAR, but Jarrett's voice is the one most folks remember because he reached the biggest platforms, CBS and ESPN. He worked the first live broadcast of the Daytona 500 in 1979, when an East Coast blizzard sent novices to their TVs just as contenders crashed and Richard Petty snatched another trophy and Cale Yarborough slugged it out with the Allison brothers, fist for fist. That scene made stock car racing a national sensation. Jarrett made the emotional call when son Dale Jarrett won his first Daytona 500. Jarrett shared the booth with President Reagan when Petty won No. 200.

In a very tangible way, Jarrett narrated NASCAR's evolution from the first decade to the digitized 21st century, an extended trip for someone who grew up on a 300-acre farm full of cotton, corn and sweet potatoes.

His parents came from large families—combined, 21 children survived infancy—and they had six kids themselves. At 9, Ned kept hounding his father about driving, and his father let Ned practice in the front yard. "I'd drive it around there, so he'd let me drive it to Sunday school. It burned my older brothers. They had to sit in the back seat while I was up there driving."

He attended Blackburn School with his siblings—all the grades under one roof. His principal, who also owned the Chevrolet dealership in Newton, saw right away that Ned was outstanding at math, primarily due to his background counting lumber at his family's sawmill. The principal would walk into his ninth grade math class and tell Ned to take over. "I knew where he was going," Jarrett said. "He was heading over to that dealership.... So, a kid that age, you get to thinking, 'Well, I'm smarter than the teacher. Why am I spending my time here going to school?'" His older siblings graduated from an 11-grade school, but the system added the 12th grade just as Jarrett got there. He quit. "I thought I could be serving my time in a lot better way than this, which was the wrong thing to do, but that's the way that it was."

Ned counted lumber, did the invoices and kept the books. He was a married father at 17, Hickory speedway champ at 23 and two-time national Sportsman champ at 26. When no Grand National owners offered him a job and his car broke, Jarrett concocted a long-shot plan. He wasn't a betting man, but he was a gambler. A '57 Ford Junior Johnson had driven was for sale, right there in Newton. The price—$2,000—was way out of Jarrett's range but well within the limits of his imagination. There was a race Saturday night at Myrtle Beach and another Sunday afternoon at Charlotte, both paying $950 to win. He figured that he could write a check for $2,000 right after noon on Saturday—that's when the banks closed—and win two races and scrape up the other $100 so he could cover the check Monday morning. Buddies called him foolish. "But," Jarrett said, "I was dead serious about it."

He negotiated a deal for the car and took off for Myrtle Beach. Jarrett wound up in a match against Bob Welborn, whose wheel broke. Jarrett won, but he was injured. Back then, drivers wrapped the thin steering wheels with foam rubber and electrical tape for a better grip that prevented hand and finger cramps. That night, however, Jarrett discovered during the race that the tape had been wrapped backwards, with the sharp edge of the overlapped tape cutting his hands as he constantly turned left. He required a tourniquet on his right arm to stop the bleeding so he could accept the trophy. He headed straight to the Conway hospital for treatment, but after he drove a few laps in the Charlotte race the next afternoon, he couldn't grip the wheel. Relief drivers Joe Weatherly and Johnson guided the Chevy to victory. Jarrett got the money and made the deposit at 9 a.m. Monday. He was in the game.

At some basic level, they were all in the game together, exchanging equipment or ideas or favors. Jarrett sold Wendell Scott a car at a steep discount and even loaned him $500 to travel across the country for the season-opening Riverside race in 1963. The next year, at Jacksonville, Florida, Scott drove that car while becoming the first—and so far only—black driver to win a top-series race.

Chevrolet slipped money under the table to Rex White, the 1960 champ, and asked about finding a second driver. White recommended Jarrett. "Man, I was broke," Jarrett

said. "I couldn't go any further. I had to have help because I was dead in the water." Jarrett then beat White for his first title in 1961.

The second championship required more than money. Jarrett survived a June 1965 wreck at Greenville-Pickens (South Carolina) Speedway and was transported to the local hospital by ambulance. He instructed the driver to ditch the siren and slow down so his wife Martha, with the kids aboard, could keep up. X-rays revealed a broken back. "I said if my back is broken so I can't drive next week, then I'll quit," Jarrett said.

His young doctor's plan—two weeks in the hospital, three to six months of rehab—didn't suit Jarrett, who advocated around-the-clock rehab. About 72 hours later, with the staff cheering, Jarrett left the hospital. He took his back brace home and then to Myrtle Beach for the Wednesday night race. The broken bone never healed, and Jarrett still exercises daily to compensate, but he won the Southern 500 by 14 laps—still the largest NASCAR speedway margin—and another championship.

Jarrett and Johnson were involved in the 1964 wreck that mortally injured Fireball Roberts. Jarrett got out of his car and approached Roberts' car, which was upside down, with the fire raging and Roberts pleading for Ned to pull him out. He did, but Roberts later died from the burns.

These were the giants of the sport when they all were young: Richard Petty (left), Ned Jarrett (center) and Glenn "Fireball" Roberts.

When Ford boycotted the tour again in 1966, Jarrett lost his sponsor.

> "I was leading the points standings when they pulled out, so it was a tough pill to swallow. I had broken my back in 1965, but the big thing I was missing out on was my children and their lives.... You couldn't see a secure future in racing. There was not much money flowing through it at that time. It took me until '64 to pay that man back his $10,000 that I borrowed in 1960 to get into the sport."

His debts covered, 50 wins in the book, Jarrett returned to Catawba County. He announced races with the Universal Racing Network team of Bob Montgomery and Hank Schoolfield, which led to other media gigs. "I just happened to be at the right place at the right time to be involved in the start of radio and the absolute ground floor of television work," he said.

Jarrett bought 25 percent interest in the Hickory track and managed it. He watched son Glenn dabble in racing and son Dale play high school ball. Dale wasn't a racer, but around his 20th birthday, two friends started building a car: Andy Petree, who became a crew chief and broadcaster, and Jimmy Newsom, who became a tire dealer. They made Dale an offer: "If you can get an engine, you can drive it in that first race."

Ned secured an engine from one of his wife's cousins. Dale got behind the wheel.

"Once he drove it, he was hooked," Ned said. Dale won 32 Sprint Cup races, three Daytona 500s, the 1999 championship and $61.5 million in purses. He now analyzes races for ESPN. On those Sundays when almost-retired Ned stays home from the track, he sits in a den of antiquity that's full of trophies, trinkets and TV screens. He watches different camera angles and monitors back-channel communications, crew chief conversations with drivers and the live feed. He listens to his son do what he did first.

In a rare quiet moment, Ned can look out the picture window, across the golf course, and visualize the past just down the road. All these laps later, the gentlest man in the world's noisiest sport is still comfortable right at home.

Humpy Wheeler, Racing's Barnum: In a serene world, racing makes little sense. The monstrous machines are louder than a metal band in a one-car garage, and if they're running on red clay in dry heat, the dust clouds will destroy Sunday shirts or Saturday night eyes faster than pestilence. It's hard to see every corner of massive speedways, and nigh impossible under the faint yellow bulbs of country bullrings. The restrooms are sardined. The food, generally greasy. The beer costs too much. And you happened to buy a seat behind a dimwitted drunk who feels compelled to stand, thrust his sleeveless arm—pit included—into the air and scream, "Reel him in, Junior" every time the 88 car rides by.

For all racing promoters, for all time, the deal has involved overselling the magnetic energy of rampaging horsepower and underselling the mundane hassles of public congestion. Few, if any, promoters ever did it better or longer than Harold Augustine "Humpy" Wheeler, the Charlotte Motor Speedway ringmaster for 33 upwardly mobile years. Surely nobody ever did it more creatively or audaciously. As an amateur boxer,

Humpy Wheeler, the man who set the stage.

Wheeler won the light heavyweight Golden Gloves and made the Carolinas Boxing Hall of Fame. As a promoter, he was all brass.

Wheeler specialized in the pre-race extravaganza. In 1987, he hired a daredevil with a school bus and aimed ads at children and their parents. The bus chugged around the track and reached maybe 75 mph just as it rode onto a huge ramp and took off like a clunky ski jumper. The bus hurdled a row of trashed cars, then crashed—grill first—and wobbled to a standstill on top of the cars. The crowd went wild.

After the 1983 U.S. invasion of Granada, a Caribbean island ruled by a communist-tinted government, Wheeler staged a replay with choppers, stormtroopers and exploding movie-set encampments. When the smoke cleared, the Americans had prevailed once more over the smallest independent country in the Western Hemisphere. The crowd roared.

Sometimes, negotiations triggered spontaneity. He pushed CBS for a live broadcast of the World 600 when networks relied on delayed, edited tape. CBS wanted a two-fer but wouldn't bite on his suggested 300-mile Saturday prelim. He came up with a novelty: a taxi race using pit road and the front stretch, with a toll booth and a cop car to pursue violators. Humpy winged it, and CBS bought it. When R.J. Reynolds wanted to move the All-Star race to a fresh town, sports marketing boss T. Wayne Robertson stated his case and headed for the exit. Wheeler blurted out, "What about if I install lights and run a night race?" Robertson bit. The track leased the lights and saw the future dawn.

Wheeler wanted the planet's biggest available celebrity on the bill in 1977. He settled for actress Elizabeth Taylor, aging somewhat gracefully. Wheeler brokered the deal through her boyfriend, John Warner, a wealthy U.S. Senate candidate from Virginia. Warner stepped out of a gold convertible wearing white patent leather loafers—sockless—to match his off-white suit. Taylor, adorned in a loose white pantsuit that shouted "Queen Elvis of Vegas," basked in the warmth of her largest audience.

It's doubtful than any stunt jerked larger ego chains than Wheeler's parody of a feud between hotheaded Cale Yarborough and mouthy Darrell Waltrip. About the time *Jaws* broke box-office records, the drivers tangled on the track and Yarborough called Waltrip "Jaws" because he flapped his so incessantly. Wheeler phoned a shark fisherman in South Carolina and placed an order: "The biggest one you can find." They packed the 300-pound shark in ice and transported it to the track for pole day. Because Yarborough drove for Junior Johnson in the Holly Farms chicken car, Wheeler bought a hen and jammed the deceased bird into the shark's mouth, feathers hanging out. A wrecker parked in front of the infield scoreboard with the shark dangling from its hook, devouring lunch. The joke angered Yarborough and Waltrip but served Wheeler's higher goal: an AP photo that circled the globe.

What sort of mind would resort to such ribald silliness? A bored mind.

Wheeler traces his childhood romance with racing to boredom. He lived in a mill town west of Charlotte. In an August 2013 interview, he remembered:

> "Belmont. There was literally nothing to do. There weren't many cars. Ford and Chevy were all they had. We'd go down on Sunday to Highway 29. It sounds strange, but we wanted to see what the new cars looked like. You couldn't see them in Belmont. No Cadillacs. No DeSotos. We got into all sorts of arguments sitting on the bank as kids. Then I started seeing these cars come by with numbers on them, and that really got me stirred up. They were towed by another car or pickup truck. They weren't even on a trailer. They were going over to Charlotte Speedway, only six miles away. My mother never thought anything about me thumbing somewhere when I was 10, 11 years old, so I'd thumb over there. If you were under 12, you could get in free if accompanied by an adult, which nobody ever paid attention to."

He got in and got a job selling Cokes. "It was a place people could go where there wasn't gray and white. It was color. The cars were all colored up, and that was just neat."

When that track bored him—which didn't take long—Humpy thumbed to Hickory, Rock Hill and Charlotte Fairgrounds. He inherited the nickname from his father, who had played football with Red Grange at Illinois and later became coach-athletics director at Belmont Abbey College. The Illinois coach caught his father smoking Camel cigarettes. Teammates nicknamed him "Humpy," and the moniker soon transferred to the next generation as "Little Humpy."

Everywhere he went, younger Humpy asked questions. He asked Doc Gordon why he left trees in the Charlotte Fairgrounds infield that blocked the view, sparking his first argument with a grown man. Wheeler said:

> "Later on, I learned a lot from him. I had some great mentors. He was one of those guys, guys who were right out of the comic books. They were right out of Charles Dickens. It just happened to be 1950. They were true promoters. They were red-nosed, and most of them were fat, smoked cigars. They had a knack for getting people's attention for what they were doing, so I learned from these characters. They always had a great P.A. announcer. That was a key thing. Buddy Davenport, he was good. When the race started, he would always say

the same thing: 'Here they come out of the fourth turn, lined up like grandma's onions....'"

Wheeler did a demographic study, panning the grandstands at all the tracks. He got the same reading every time: blue collar.

> "They worked in the mills—furniture mils, textile mills, didn't matter. Or they worked in the garage and they'd come there just like they left, with blue and gray pinstriped coveralls or the full deal on, complete with all the grease they had accumulated that week because they didn't wash them 'till Sunday or Saturday morning, you know. They'd be smoking those big cigars and having fun and drinking liquor."

As a youngster, Wheeler wanted to shake things up and scoop up the loose change. He learned mechanics from local repairmen. He talked his mother into letting him open a bicycle repair shop and negotiated for garage rights. She gave him half. Wheeler promoted bike races but didn't charge an entry fee. This was the promotional mind blossoming. Without the fee, more people would enter his races, which he staged for free at the Belmont Abbey field. With more people racing, more bikes would break down. He would fix the bikes.

His parents made Wheeler attend the Catholic prep school attached to the college, which he disliked because the school didn't play football. He took up boxing, learning how to take care of himself. He was good enough—40–2 as an amateur—to rate a scholarship at Michigan State, but an intervening boxing tragedy prompted the NCAA to drop the sport. Wheeler still contemplated boxing as a career until the Belmont Abbey basketball coach, Al McGuire, took him to New York and showed him the darker side: old fighters with battered ears and addled brains, wasting away in dank gyms. Wheeler spent his senior year at a Charlotte school, playing football and earning a scholarship to South Carolina. In college, he played beside Jim Hunter, later a sportswriter, Darlington Raceway president and NASCAR vice president. Wheeler interned at the Darlington track. He broke a vertebra in his back and retired from football before his senior season. He considered law school but couldn't stomach the boring books. He drove race cars but crashed a lot, until Cale Yarborough said one of them was going to have to retire. It wasn't Cale.

Eventually, armed with sage advice from Darlington P.R. mastermind Russ Catlin, Wheeler took over Gastonia's Robinwood Speedway from Marvin Panch, a former Daytona 500 winner who was losing money. Humpy the promoter kicked in.

> "I'd put a speaker up on top of a car. I'd go through neighborhoods on Thursday and Friday and have my P.A. announcer make it sound so interesting you just had to be there, wherever there was. Being dull places where mill towns were, this livened it up little bit. Basically, you're doing carnival barking is what you were doing. Then you'd do something that today would land you in Leavenworth or Texas Federal Prison: dropping leaflets from an airplane. There wasn't a damn thing legal about it, but you're in a gray mill town." He ordered a stack of race leaflets in seven colors, which fell like confetti. "The

best time to drop 'em out was about 30 minutes after a shift change. Then we got creative and began to drop little peanut logs. If they landed on somebody, they wouldn't hurt anything. Aw, man, children would come out there and just go crazy."

Inside the gates, lubricated by liquor, the adult customers fought like crazy. Wheeler hired 300-pounders to control crowds. One night, after a disputed finish angered the drivers and their friends, Wheeler and his brother drove into the infield, gate receipts on the seat. He placed his .38 pistol on the dash for all the potentially volatile guys to see, cracked the window and passed out the prize money.

"They were rough, tough places," he said. "Even today, there's a sign down at the Cherokee Speedway in Gaffney, which I believe is one of the seven roughest towns, probably, in the entire world. The sign says: 'Cherokee Speedway, The Place Your Mother Warned You About.'"

Wheeler closed Robinwood after a car lost a wheel that bounced over the fence and killed a 6-year-old boy. Another car's dislodged wheel broke the arm of a man who won a $150,000 legal judgment. Debts mounted. He married Pat Dell Williams. He spent time promoting a Monroe track and briefly held a job at Charlotte Motor Speedway, the Bruton Smith-Curtis Turner creation that had lapsed into bankruptcy. He worked as Firestone tire's racing rep. Finding himself at a middle-age crossroad, Wheeler wrestled with a job offer from Smith, a domineering bull who had overcome personal financial setbacks by moving away, working for a car dealership and then becoming a dealer himself. Smith built a showroom network and hatched his scheme to recapture the Charlotte track, buying up shares until he got marginal control. Although wary, Wheeler accepted the job because he loved racing action. The relationship was often tempestuous, but Wheeler says Smith allowed him creative freedom and managerial independence … except when he didn't and resorted to long-distance micromanagement.

They went back and forth, but mainly they went up. When Wheeler took over as speedway president and general manager in 1976, the stock-car game had changed. Moonshine was essentially dead as a commercial product, and most of the lingering moonshiners had evaporated over by the start/finish line. Reynolds Tobacco Co. poured millions into the sport and, at the Winston Cup level, fled the dirt tracks. The factory money had dried up. NASCAR and car owners recognized the value of helping corporations hawk stuff women could buy in grocery stores.

Wheeler sold to women, using clean restrooms and cordial ushers as incentives. He sold to businesses, arranging suites for race day entertainment. In the biggest move of all, Wheeler and Smith sold themselves to Charlotte's growing banking industry — specifically to Luther Hodges Jr., chairman of NCNB (which became Bank of America). Hodges Jr. was the son of North Carolina's foremost business governor, Luther Sr., who had been present at the 1959 birth of the Research Triangle Park and had been appointed U.S. commerce secretary by President Kennedy.

It took Wheeler a while to crack that safe and expand the track, located on the edge of Concord. The bank even seemed insecure about loaning money to cover the purse on the two big race weekends.

"Gee whiz," Wheeler said, "we'd get $300,000 on Friday and the following Monday I'd get a call, always at 9:30: 'Ahhh, we don't have the $300,000 back yet.' Well, my gosh. I used to think, 'YET!? YET!?' It was two entire days."

They decided to make a run at Hodges, requesting $2.2 million, long term. "We knew we wouldn't get it," Wheeler said. "We left. About two hours later we get a call from one of the bank VPs saying, 'What account do you want us to deposit this in?' Really, I never fainted in my life, but I came close to doing it." The speedway added 10,000 seats, built 17 better suites and a women's restroom.

CMS repaid the loan in two years and borrowed $5 million more. During Wheeler's career, CMS capacity grew from 75,000 to 167,000. The track broke new ground by constructing condos. Wheeler deflected the credit for that one—it was Smith's idea all along—and Wheeler remained skeptical because Bill France Sr. preached that you shouldn't transfer any speedway property because of legal complications.

In the early 1990s, other banks joined the game, two of them assigning specialists to handle racing loans. "And, all of a sudden, the whole boom came about because of cash flow," Wheeler said. "That's when Bruton and I sat down and decided that we needed to go public. Well, harder done than said. Not one investment house in Charlotte would take us on." A Richmond firm did, insisting that the salesmen tour Europe first because they badly needed overseas investors. The tip worked, and Speedway Motorsports Inc. sold 19 percent of the original stock offering to Europeans. Smith didn't want to travel, so Wheeler and his wife met a French banker in a brown tweed suit who served wine—lots of wine—at 9 a.m. The banker regaled them with unique interpretations of the French impact on World War II. Five glasses later, they had lunch.

Wheeler said:

> "I was really blotted. I didn't know where in the hell I was. I knew I was in Paris, but I didn't know much more.... Well, he bought as many shares as he could. Later we found out, I think, it was 300,000 shares. We got a great, great reception over there. It was because, as I found out, those guys can see the forest for the trees. We can't, in our own country, see as well as they can because they're not looking at all the mishmash."

The Wheelers scored again in Switzerland.

> "In Zurich is when it hit me. Here is this sport started, really, in the mountains and foothills of North Carolina, in the most unsophisticated way you can possibly think, and it has now come to the attention of the Swiss money managers who control vast, vast sums of dollars. How could this happen? Then I started thinking about it: This happens. The textile business wasn't any fancy deal when it got started. It's just business in its early pioneer days, and it's not fancy. We certainly weren't. We were colorful, though."

Smith's speedway company rode the '90s wave, acquiring Atlanta, Sonoma, Bristol and Las Vegas, as well as building Texas and, in 2006, Kentucky. The boom peaked about then. The recession landed like an anvil. SMI's value sank from a per-share

high of about $40 in 2007 to below $12 in 2009, then rebounded to about $20 in 2013.

Wheeler's heart landed in his stomach when he walked into the executive tower in 2008 and found workers constructing an office for Smith's son, Marcus. This was news to him. Humpy and Bruton had argued over many issues, especially Smith's idea for a drag strip and his behavior once Cabarrus County interrupted construction based on residents' noise concerns. Smith demanded a lower tax bill and incentives for the drag strip. He wanted the I-85 connector road renamed Bruton Smith Boulevard. He threatened to ship one of his two races to Las Vegas and, incredibly, to move Charlotte Motor Speedway.

Smith told the *Charlotte Observer* that he had learned to ignore Wheeler's advice. "I was the one taking the financial risks, and I was the one always sticking my neck out," he said. "He wasn't, and I wouldn't expect him to. He was an employee."

Wheeler can laugh about their testy debate now. "I asked him, 'What kind of big damn trailer hitch do you have? Because I know just those condos alone, you'd have to pay $50 million to get that satisfied—and then where in the hell you going move this thing to?' 'Well, South Carolina, down below Rock Hill.'"

Wheeler ripped that idea. "You couldn't do it," Wheeler said. "They just called his bluff, is all the county and the city did. They said, 'We'll give you the $80 million, but you're going have to pay us out of taxes and it's going take 60 years.' I said, 'Bruton, you'll be 143 years old.' He got so mad about that he couldn't see straight."

Richard Petty reports no particular reaction from Smith whenever Petty delivers his standard greeting: "Bruton, every time I see him, I just tell him he's just a used car salesman that got into a different business."

Wheeler's temper flared when the construction crew showed up in 2008, and he argued with Smith before announcing his retirement, at 69, the Wednesday before the 600. He had planned to retire soon anyway and expected Marcus to take over. Bruton Smith wanted an immediate transition.

Although he wanted to stay a year as track ambassador, Wheeler said:

> "It didn't bother me. It was that simple, despite the fact that I knew Bruton, being who he is, I would never get any money like most presidents who have been there 34 years and built the place would have gotten. I got two weeks severance—two weeks pay for 34 years. Bruton argues, of course, that what happened is I did do well with the stock—mainly because we made money with it. I put a little annuity program in for all the guys that I knew Bruton couldn't break. I got nothing, really, at the end. That gnarled on me because the economy was still good then. The president or CEOs of a company our size were getting anywhere from $5 to $12 million dollars when they left, and so that didn't happen.... A thing like that, you can't get mad and stay mad and let it ruin your life because you didn't get what you want. He turned around and told everybody he made me a multi-multi-millionaire. Well, I said, I don't remember him doing a whole lot of work. I remember him flying in his airplane a lot and so forth. He was a very creative guy and he actually had a real passion for racing. He did do a lot for racing."

Wheeler's friends filled newspapers with testimonials. "Humpy was a step out of the box," said NASCAR's Hunter, now deceased. "Even if he laid an egg, it was successful. There'll never be another Humpy Wheeler."

Eddie Gossage, who learned the trade under Wheeler long before becoming president of Smith's Texas track, said that "Humpy Wheeler has been as important to shaping NASCAR as the France family, as Richard Petty and Dale Earnhardt ... We wouldn't be a major league sport without Humpy Wheeler."

In partial retirement, Wheeler now directs his energies toward racing's minor leagues. He started a company with his son and daughter that hopes to help 1,200 small tracks survive by uniting their purchasing power and reducing costs. In the end, as in the beginning, the man of a thousand ideas returns to places where cars line up like grandma's onions.

Back to the Roots: Stock cars often spin their wheels and short-track drivers often spin out of control, and if you could stand in the middle of the Bowman Gray Stadium infield on a steamy Saturday night, the panorama of timeless racing chaos would spin around you.

That's the way it was in May 1949, when Alvin Hawkins and Bill France Sr. introduced NASCAR modified racing to Winston-Salem. Sweet tobacco aromas from R.J. Reynolds' downtown cigarette factory drifted across an urbanized ravine and settled over the stadium bowl two miles below.

That's the way it was in June 2013, when France's great-grandson, Ben Kennedy, won the K&N Pro Series East race in the presence of his mother, Lisa France Kennedy, the president of International Speedway Corporation. "We were just trying to keep the fenders on it," said Kennedy, a University of Florida student.

The fenders, metal and metaphorical, have been falling off and scraping the asphalt around the flat quarter-mile track for 65 years, sometimes followed by a breakdown in driver decorum. Vows of retribution spiked during *Madhouse*, a 2010 History Channel reality show that followed Junior Miller, Tim "The Rocket" Brown and brothers Burt and Jason Myers through the 2009 season. The trail of tourists continues years later.

Saturday night racing at Bowman Gray has survived television, social convulsions, recessions, pop culture, the Braves and more than one gas shortage. In fact, Johnnie Hawkins Pinilis, daughter of the original stock car promoter, wouldn't change a thing. "The gas crisis did the opposite," she said. "People couldn't go to Bristol or the beach. It helped us rather than hurt us."

She was born in 1953. As soon as she could leave home, Alvin and Eloise Hawkins put their baby, gussied up in a white dress, on a table in the fieldhouse. The drivers, heading to their cars for the night's action, walked by and touched Johnnie for good luck. By the time her father waved the green flag, her dress was basically black, smudged with fluids of the trade. She has been there every Saturday night since, April through August, carrying on the work with husband, salesman Dale Pinilis, son and publicist Loren Pinilis, nephew and competition director Gray Garrison and a slew of other relatives. Ticket prices remain the best marketing friend: $10 for adults, $2 for ages 6–11, free for younger kids and $2 on ladies' nights. Parking is free. The price structure and alcohol policy—drinkers occupy

a separate area—reinforce the family theme. The stadium runs a short schedule crisply, mindful of the 11:30 p.m. city curfew, which gets folks home at a reasonable hour. They're located off U.S. 52 near Business 40, and close to I-40.

The promoters make money while many North Carolina tracks struggle but, the promoters insist, not too much money. "It's a family business," Johnnie Pinilis said. "We all have real jobs, so it's more of a passion."

Passion, in many forms, accounts for much of Bowman Gray's appeal and its role as a welcoming front door since the top NASCAR series left in 1971. Richard Childress, now a wealthy car owner, first walked through the gate in the early 1950s with barely a quarter to spare. "I loved what I saw," he said during an October 2013 interview. "I asked my stepdaddy if we could go back over there. He said, 'Yeah, if you wanna walk.'"

The five miles seemed like a stroll, especially with friends in tow and his folks picking him up afterward, Childress said.

> "We'd get there early and hang out with the race drivers. I just thought that was a cool lifestyle. I liked what I saw, so that's what I did. I bought my first race car for the $99 Claiming Division at Bowman Gray. That's what they called it. I didn't have $99 to go buy one, so me and a buddy built one. Went and bought an old taxi cab for $20 and built my first race car, a '47 Plymouth. I was probably 18 or 19. If you wasn't 21, you had to have your parents sign. I remember someone forged their name so I could get my NASCAR license."

David Hoots, race director for the Sprint Cup tour, spends 38 weekends a year somewhere in America. As a kid growing up two miles from Bowman Gray, he knew where he'd be every Saturday night, along with all sorts of folks sitting in the same seats. "They haven't changed," Hoots said. "It's three or four generations of families indoctrinated to the same thing."

Indoctrination takes many forms. The winner of the stadium's first modified championship, Tim Flock, sometimes raced with his pet monkey Jocko Flocko in the car. Richard Petty won No. 100 at the stadium in 1969. Curtis Turner stirred up one ruckus after another while battling the local Myers brothers, Billy and Bobby. But that isn't Hoots' fondest Turner memory. "He flew his plane into Smith Reynolds Airport for the races," Hoots said. "He would buzz between the light standards at the stadium to let them know for a crew member to go over to the airport and pick him up."

The Myers family line is woven throughout. Bobby and Billy combined for four of the first six track championships, but tragedy struck. Bobby slammed into Fonty Flock's stopped car during the 1957 Southern 500 and died. His son, Danny "Chocolate" Myers, raced at the stadium, attained celebrity status as gas man on Dale Earnhardt's pit crew and now works for Childress.

Billy, who won the 1955 national modified title, died of an apparent heart attack during a Bowman Gray race in 1958. His son Gary competed at the stadium much of his adult life but seldom battled nerves like he did August 24, 2013, the season finale and the stadium's 971st racing show. Son Burt protected his points lead against son Jason and won a sixth championship. "I'm glad that's over with," Gary said, exhaling.

Back in 1948, Hawkins and France wondered if NASCAR could thrive on a paved quarter mile. The Works Progress Administration built Bowman Gray Stadium in 1937, with the family of deceased Reynolds president Gray paying the city's share of the $100,000 project. The first event was a 1938 football game between Duke and Wake Forest, then located two hours away in Wake County. Midget cars raced on a dirt track surrounding the football field at first, and in 1947 a promoter talked the city into paving it. He skipped town without paying the bill, and nobody was racing anything when sports editor Frank Spencer of the *Winston-Salem Journal* told Hawkins and France about it.

After testing the track, they promised to pay off the paving bill over time. Hawkins moved his family to Winston-Salem from South Carolina and stayed. Hawkins sat at the head table, two seats from France, during the 1947 meeting that created NASCAR's framework. In 1950, Hawkins and France bought a Plymouth in Winston-Salem that Johnny Mantz drove to victory in Darlington's first Southern 500. Mantz credited a blue-eyed baby doll that another Hawkins daughter, Diane, had given him. The doll rode shotgun.

Promoter Humpy Wheeler, who works with local tracks now, calls Bowman Gray "the premier short track in the United States. It got that way simply because it's a municipally owned facility that was kept up quite well and had 17,000 seats because it was a football stadium." Winston-Salem State University, located across the street, also has paid rent and shared the stadium. Under a deal approved by the N.C. General Assembly, the city will sell the stadium and 94 surrounding acres to WSSU for $7.1 million. The racing rights will be extended through 2030, which guarantees America's liveliest short track another 17-year lease on life.

The Men Behind the "3": Dale Earnhardt and Richard Childress beat all the established odds.

Growing up in different Piedmont North Carolina cities after World War II, the boys dropped out of high school, never to return. In different yards and on different short tracks, they broke into a game that breaks nearly everyone without a backer. In different banks full of different factory owners' fortunes, they took out smallish loans to keep outlandish dreams alive, to put modest race cars on immodest ovals in the pursuit of extremely modest paydays.

This was not a formula for greatness, nor even solvency. Somehow, Earnhardt and Childress—six years older—found a route around conventional obstacles. They found each other, which solved the mystery of the secret variable, and then won six NASCAR Sprint Cup championships. Earnhardt already had one, driving for Rod Osterlund in 1980. They were riding high, with 67 wins together and seven titles overall, worth a share of Richard Petty's record, when Earnhardt slammed into the Daytona wall in 2001 and slumped over.

He died that February afternoon, at 49, and a part of racing died with him—a part that will remain forever lost, the part that existed only because Earnhardt did, ducking and smirking and riding rear bumpers until the unfortunate obstructions cleared. Because of his workingman roots and his sardonic joy in rooting competitors out of their momentary comfort, Earnhardt inspired loyalists numbering in the millions. The bond

was so strong, and NASCAR's parallel marketing strategy of emphasizing non-Earnhardt demographics so wrong, that the resulting void damaged the sport at its core.

He was the classic Southern blue-collar hero of his time. He had a car, the means to freedom. Driven by a rebellious streak, he resisted intrusions on his turf. He was alpha, the cockpit descendant of Junior Johnson and Curtis Turner and his old man, Ralph Earnhardt, the roughest bull in the red clay bullrings of the Piedmont. But Earnhardt was more than that. He was also the villain, the man in Goodwrench black, the cowboy gunslinger who, symbolically, might have to shoot up the joint just to get his way. Earnhardt didn't formally apply for the role—he wasn't naturally formal—but he recognized where it came from and played it to the hilt, especially when dissidents bathed him in spit-laced boos.

Sometimes during driver introductions, with the insults arriving in a muffled audio wave, he couldn't contain the big smile under his mustache, which stirred up the fans even more. He wore a devilish grin that served as a warning of possible mischief—mostly playful mischief, off-stage—because that was Earnhardt. He didn't advertise his charitable nature, didn't invite cameras to film him baling hay on his property. He let the racing speak for itself.

The part that transcended the dramatic tension between Hero Dale and Villain Dale was the big picture: Earnhardt wasn't merely the star of the show; he was The Show. Love him or hate him, he was the main event, which made him wealthy beyond comprehension and valuable beyond calculation. Then, in the last turn of 2001's first race, with his employees Michael Waltrip and Dale Jr. leading the rush to the checkered flag, he left without saying goodbye.

For a time, driver Dale Earnhardt (left) and team owner Richard Childress (center) ruled the sport.

Ned Jarrett, a two-time champion and broadcasting pioneer, still noticed the repercussions 12 years later. "Losing Earnhardt was a tremendous blow to the fan base," he said. "I have people almost every week tell me, 'I just lost interest when Earnhardt died.'" For a time, Earnhardt's departure drained Childress' reservoir. He contemplated pulling out, but then he remembered hunting conversations about carrying on if either died. They were pros who knew the risks. After buddy Ernie Irvan almost died in a wreck that waylaid his career, Earnhardt bluntly said that if it could happen to Ernie, it could happen to him. After friend Neil Bonnett died during a Daytona practice, Earnhardt said that you hurt like hell, but you move on.

Childress moved on. He kept the car running, with Kevin Harvick in the seat and No. 29 on the door rather than 3. "Actually, in 2001 I sold a little bit of the company to investors because I just didn't feel good about racing," Childress said seven years later. "I had lost the drive, had lost the desire. I had lost one of my best friends. I just didn't even want to be going to the races."

He rekindled the spirit and revamped the company's operations. He hired his grandsons, Austin Dillon and Ty Dillon, and groomed them on NASCAR's developmental car and truck circuits. Yet, Earnhardt still looms larger than life. In an October 2013 interview, Childress said:

> "I miss him today just like I did then. He was a good friend and drove the race car for me. He did so much for the sport. I was fortunate to be right along with him back in the early '80s. He still has a tremendous amount of fans out there today, a following that's no different than Elvis Presley or John Wayne. He's still got a good following. He was a legend, you know. Time heals everything. That's what I've always said. Whether it does or not, I think it does for me. Time heals everything, and situations heal things. I think about Kevin Harvick winning the third race after that in Atlanta and seeing all the fans up there holding the 3 up. That was a healing moment. I think the best one for me personally was when Dale Jr. won Daytona in July, and we come back in 2002 and we won the 300 with the 3 car. Those were healing moments. You still have the fans come up and get choked up sometimes talking about it, so that's part of the deal."

Years before there was any Earnhardt-Childress ticket, this racing line sprouted roots. The name was Ralph Earnhardt, and if anyone wonders where Dale found such unyielding determination, the answer was Ralph Earnhardt. His steel will inspired a nickname, "Ironheart." (When young Dale trampled veterans indiscriminately, Darrell Waltrip and other side-swiped regulars called him "Ironhead.")

Ralph won the Late Model Sportsman national championship in 1956. He did what he could, but he wanted more for his wife and 5-year-old Dale. That's why he leaned on Dale to get an education and rise above the earnings scale of Kannapolis' textile mills. Dale abhorred school, though, and pulled the plug after two laps around the ninth grade. Dale married twice before his 21st birthday and had three kids (plus, much later, another daughter with his third wife, Teresa). Dale hounded Dale Jr. about finishing school. Junior made it, but he departed high school disappointed because his dad was a no-show at graduation.

Ralph Earnhardt earned his reputation honestly. He was what he was, a man of few words. His cars roared, though. Everyone heard him coming through the field at Hickory, Jarrett's home track. Jarrett said:

> "He was probably the toughest competitor I ever raced against. He was some kind of tough. He was a do-it-yourself type of individual. He built his own cars. He did make a living out of it back then, so he couldn't afford to hire anybody. He was a hard charger all the way, and he didn't mind knocking you out of the way to get a win. He did usually wait until the last lap or next-to-last lap before he'd tap you out of the way if you were leading the race and he was running second. That way, you couldn't get him back that night. In the next race, even if it was the next night somewhere, you'd have cooled off, knowing that you needed to finish races to get the points. But I don't know how many times Ralph Earnhardt might have wrecked me. If he wrecked me 50 times, I probably wrecked him 25. He was always ahead of me. I could never catch up to him, but he'd come put his arm around you. 'Ned, my brakes give way. I didn't mean to hit you.' He'd always have an excuse. You'd just shake your head and go on. That's all you could do. But I'm glad I got to race against him because he made a better driver of me."

Before he was the sport's greatest star, young Dale Earnhardt worked on his own Sportsman engine in his father's dusty garage.

Son raced father once, when Dale won a prelim and qualified for the main event. Ralph got way out in front, which gave him sufficient cushion to play the last lap his way. He rammed Dale's bumper hard enough to push him across the finish line ahead of the fourth-place car. The purse paid three spots.

Ralph died of a heart attack in the kitchen, at 45. Dale was 22. Dale's mother, Martha, transferred the titles on the two race cars to him. He kept on racing and running hard at night and doing things his own hardheaded way. Promoter Humpy Wheeler, who knew Ralph well, occasionally offered Dale advice: quit driving every lap with reckless abandon and learn how to drive on asphalt. Wheeler escorted Osterlund to a short track so the California developer could watch Earnhardt smoke the field. Osterlund hired him, and Earnhardt followed a fine rookie season with the 1980 title. Osterlund suddenly sold the team. Working in the background, Junior Johnson persuaded Childress to stop driving and hire the dangling Earnhardt for the last 11 races of 1981.

Childress was a month short of his 35th birthday, the same age at which idol Johnson stopped driving.

> "When I decided to get out of the car, he [Johnson] and I met at the Days Inn at Anniston, Alabama, the day before I was supposed to go meet with Earnhardt's people. He said, 'There's a lot of good race drivers out there, but there's not many car owners. You'll make a good car owner because you've had to do it the hard way.'
>
> "I took his advice, left that hotel that evening and went up to the Downtowner in Anniston and put a deal together with Earnhardt. I would've liked to have drove a little more because I really enjoyed the driving part of it, but I could see with all the money coming in — J.D. Stacy, Rod Osterlund, Harry Ranier, Warner Hodgdon, that whole influx in late '70s, early '80s — that I was getting pushed back a little all the time by these money people. I wasn't happy running 15th. I like to run a little better. I had some bad finishes because I broke a lot. I didn't have good equipment, blew a lot of engines and stuff, but I had some good finishes for an independent."

Childress had better stuff than anyone who started out like he did, with nothing. He was born in Winston-Salem the month Japan surrendered, 1945. His father, Robert Reed Childress, died five years later.

Childress said:

> "I never really knew him. I heard a lot about him through people that knew him, like my uncles. I tell people I had to become a man at 5 years old. I had to fight my own fights back in the early days. If someone come picking on you, you couldn't go home and say, 'Daddy, this boy's picking on me.' You had to settle it yourself, and we did a few of them."

His mother, Virginia, remarried. She already had five kids, and then had three more sons with Kenneth Hodge. "She was a great woman, the greatest in the world, in my opinion," Childress said.

Childress, the spitfire, figured the best thing he could do was bring home some money. "I'm not proud of it, but I dropped out of school in the ninth grade," he said. "It was one of those things that I'm definitely not proud of, but it's a fact of life." By then, working was hardly a novel concept. Right after Richard started school, his stepfather unveiled another slice of life at nearby Bowman Gray Stadium. He was mesmerized. He was also employed, peddling popcorn and peanuts while watching the 1950s stars.

Later, he took on more dangerous work at an all-night filling station where bootleggers unloaded their cases of moonshine. Childress delivered them to illegal liquor houses around town until the mortal reality of bloody violence shocked his sensibilities. He got out before someone shot him.

Childress started racing in the $99 claiming division at Bowman Gray. He didn't have $99, so he formed a partnership with a friend, pooled resources and purchased an old taxi for $20, a '47 Plymouth. When that thrill wore out, he marched into Wachovia Bank with a straight face and a straight-sounding story: "Need to borrow $400 for some remodeling at the house." He got the loan and bought an old modified racer, which his brothers helped him fine tune under a shade tree.

Childress managed to field a car on a shoestring budget and then caught his first significant break. NASCAR drivers boycotted the 1969 race at the new Talladega superspeedway. He recalled:

> "I ran both races, and Bill France gave me some money to run in both. I probably left there with 10 grand and felt I'd never have to work again. Little did I know. I took that money and bought another race car and built a shop over on Highway 109. You get a lot of breaks in life, but that was probably the first one I got that I really took advantage of."

Driver Childress bought the skeleton of a team from his employer, L.C. Newton, and took care of the equipment. He never won. The cars weren't strong enough to knock off Cale Yarborough, Petty, Wilkes County's Benny Parsons and the rest, but Childress finished fifth in the 1975 points race and stayed among the top 11 for the next five years.

> "I made some financial gambles that paid off. When I put Dale in the car, I was in debt almost $150,000 and Wrangler bailed me out of a little bit of it, but it still took me a couple of years to pay it off. My sponsorship wasn't but $10,000 for Wrangler. We got Goodyear to give us some tires. Dale didn't charge me nothing but just a percentage of the purse and our winnings, but I went out and hired a lot of guys from Osterlund—head engine guys, cylinder head guys—and their salaries were more than I got in sponsorships. I knew I had to gamble it. We went out and really ran good and almost won a couple of races, and it opened people's eyes that we could do it."

Childress realized he didn't quite have the operation to support Earnhardt right then, pointed Earnhardt to Bud Moore's team and worked out a Piedmont Airlines sponsorship for Ricky Rudd. Childress and Earnhardt stayed close, and they reunited in 1984.

The beautiful friendship also became a perfectly pitched concert on the track. In his autobiography, Wheeler attributed the synergy to Childress' easy manner, which enabled him to harness Earnhardt's instincts and keep the full-bore charger around for the final charge: "Richard knew how to stay up front but also how to conserve the race car, and he instilled in Dale the ability to do that—which is the hardest thing for a young driver to learn, particularly one with the competitive drive that Dale had.... Richard was a brilliant, brilliant coach, something most race car drivers never really get."

They conquered the world, and then that world imploded. Earnhardt's death had enormous public implications, but he was also a husband and father. Dale Jr. spent more time with his dad after entering the business. Dale showed Junior how to ease off the throttle on the stretches at Bristol and glide into the corners, and Junior credited that advice for his 2004 win. They joked around. The sarcasm spilled over the week before Dale died, when Junior told reporters how his father defined their driving relationship: "He keeps on and on about 'we've got to work together,' but his idea of working together is him in front and me behind him."

When death came, the laughter stopped. Childress said:

> "It was rough the first couple of years. You could see it. Junior wouldn't come out much. He would stay in. But, again, I think time heals everything. They lost their father, and that's a tremendous loss to anyone. How's that old Hank Williams song go? 'It's hard living in the shadows of a great, great man.' When I hear that song, I think of Hank Jr. living in the shadows of Hank Sr. He's done his own thing. Dale Jr., at first, I think it was tough. It was hard living in the shadows, and now he's accepted it. I think it affected him the first couple of years. He was so overwhelmed. He was getting a huge following even before he lost Dale. He missed not having his dad. He missed having him there when he needed him to talk to. His dad wasn't there to come up and give him that big old bear hug. I'm sure those were things he missed. It's no different than what I'd go through. You had to settle it yourself. I'd be somewhere fishing or hunting, and Dale would go with me. You'd always expect him to be there, and then he wasn't. Or the phone would ring the first year. He'd call me at night and say, 'I know you're having that glass of wine.' And we'd talk a while. The phone would ring the first few months there and you'd think, 'Aw, shoot, this is Dale.' And then all of a sudden it wasn't. Those are the things that make it tough on someone when they lose someone."

Time rolls on, and Childress rolls with it. He owns a winery and 100 acres of grapes, a business his daughter Tina Dillon heads. He owns a Lexington golf course. He and wife Judy donated $5 million to start the Childress Institute for Pediatric Trauma at Wake Forest Baptist Medical Center, addressing the No. 1 killer of American children 18 and under.

And then there are the grandkids. "When Ty turned 13, he called me and said, 'Pop-Pop, you said if we're ever ready to go racing to give you a call. We're ready to go racing.' 'All right, come on over and we'll talk about it.' That was the most expensive call I've ever had, but it has been worth it."

Austin, born in 1990, won the truck series championship in 2011 and the second-tier Nationwide car series in 2013. Ty, two years younger, finished fourth in trucks in 2012 and second in 2013. Austin received the No. 3 car on the 2014 Sprint Cup tour, replacing Harvick.

Childress observed:

> "They are the future of RCR if they keep doing as well as they're doing. They're really good spokesmen for the sport. Austin and Ty realize they owe the sport something. I told them, 'Leave the sport better than when you came, and if you do that, you've accomplished something.' They have talent. They're good with the sponsors and fans—I'm proud of all that—and they've got a pretty good business head on them for their age."

Few people ever developed a better business head with less education than Childress. The ninth-grade dropout now employs 500 people working in 15 buildings on a 70-acre campus, including four aero/fuel scientists and 35 engineers with doctorates. "I'm a doctor, too," Childress said, smiling. "I got my doctorate from the University of Northern Ohio—doctor of law."

He dodged the law and the odds, and he fought through the losses. Now, Childress entertains governors and gives speeches with a common theme: "Only in America could a kid with a $20 race car do what I've been able to do."

Only a rare kid could do that, a kid who stopped being a kid at 5 and went to work.

The Pettys of Level Cross: The benign autumn sun warms the pavement in the parking lot outside the Petty Enterprises shop. Only two cars and a transfer truck take up space in the lot, separated by a chain-link fence from the utilitarian offices and by half a century from the bustling wood-frame homeplace of the glory days, the days when just-retired legend Lee Petty watched son Maurice and nephew Dale Inman prepare the marauding blue low-riders and hemi-birds that son Richard would glide into victory lane more often than anyone in history, by 90 percent.

Petty blue. The color even looked fast. And when they put that 43 on the side, and the STP sticker, well, that was about all she wrote. Those were the days.

But those days are gone. King Richard turned 76 in 2013, although you couldn't tell it from his dark mustache or boundless energy or machine-gun ruminations. *You know what I mean?* Wound up and fully engaged, Petty drops a *you know what I mean?* or a *know what I mean?* at the end of every few sentences. Some people interpret that as a bizarre speech pattern common to caffeinated country boys from Randolph County, but that isn't the case at all. Petty is merely letting the listener ponder the last burst and catch up, because he has just driven the language of ideas through heavy traffic, dropping down to the apron and shooting up the embankment to take the high line into the turn and then sliding back left in front of the dull lapped car. *Know what I mean?*

He knows what he's doing. On this particular day, he's doing whatever comes next. Unannounced visitors show up at Petty Enterprises, which now does some business as Petty's Garage, revamping muscle cars and trucks to make money. King Richard gives the tour while two office assistants handle his public business and his daughter organizes

a stack of paperwork that he didn't sign the last time he was home. His business day flows like a Saturday night sidewinder at Bowman Gray Stadium, circa 1968, all braking and lurching and racing down the backstretch, only to brake and lurch again.

He won a lot of races braking and lurching. He also won a lot of races at warp speed while wearing a winged spoiler on his Petty blue tail, because that's what it took to hold off sly David Pearson, the fox waiting for the right spot, often near the end, when he could raid the chicken coop without much fear of reprisal.

Man, did they have some wars. Pearson won 105 races. Petty won 200 of them, the last with President Reagan gazing down from the Daytona TV booth on the Fourth of July, 1984. Petty knew Reagan. Petty knew politics, at least the local kind. He was a county commissioner for 16 years, and his wife Lynda was on the school board 16 years. "I told her when we got through with that, we're through, OK? We've done our little deal on that."

Petty waltzed to the Republican nomination for N.C. Secretary of State in 1996. It would have been perfect for a racing man, with low-voltage bureaucratic duties, little power and no tough political decisions. North Carolina's not going to war again. But Petty blew his shot. A motorist complained that Petty bumped him from behind on I-85 in Cabarrus County and drove away. Petty was charged with reckless driving and hit and run. Newspaper editorialists and bump-averse drivers objected, and Democrat Elaine Marshall won, 53 percent to 45. "If I had known I was going to lose," Petty said, "I wouldn't have run."

If the episode stung him, he didn't let on. He had more presidents to meet. The string began with Nixon. "I've been up there with every president since then except Clinton, because back in the summer we went up and seen the guy we got up there now. That was a NASCAR deal, so I went along with it."

Meeting a president was like greeting a potential sponsor for The King but a significant event for Lynda. Petty said:

> "The first time we was invited to the White House, my wife was all excited and all that. It was just another day to me, so I get all dressed up and put my boots on. 'You can't go to the White House in boots,' she said. I said, 'You know, the only difference between the president and me is, he's got a different job. He puts his britches on like I do. He puts his shoes on like I do. He eats like I do. He's just got a different job. To me, he's not special. He is special—don't get me wrong—but not that far above me or you.'"

Most of the time, Petty filled a virtually presidential role. He was, after all, The King. People flocked to see those wraparound shades (which guarded his light-sensitive eyes), those feather-plumed cowboy hats, those pointy boots and that magnetic smile. They came to get one of those fancy autographs he practiced in the garage before he even became a prince. He behaved like a really earthy good guy—an impression made permanent by his cheerful willingness to hang around signing things until the last person was satisfied. He started that routine after a 1958 convertible race.

> "I think maybe one or two people come up to get an autograph. I thought it was great. Then you go to the next race and give a few more, and then all of a

sudden it dawns on you: these guys are paying the bill. So, like when I sign Richard Petty, I say, 'Thank you. Thank you for buying a ticket.' Because, at that time, we had no sponsors. Mother was paying all the bills. *See what I mean?* Those guys, they buy a $5 ticket and then when the race was over, you got your 25 cents out—or whatever it was—out of that ticket, so it was a natural progression. That's the way it is, guys, and once you get in the habit of doing that, it carries on."

Ted Williams went through life hoping that people would cross his path and say, "There goes the greatest hitter that ever lived." What's it like when millions of folks look at you though that lens, and some maybe even worship The King? Petty answered by saying:

"It was a gradual deal. You just learn to live with it. You don't think anything about it. I don't. That's just the way it is with the hat or the glasses or the boots or whatever it may be. What you see is what you get. And I've never looked at it any different than that. That's just the way it is, guys. Some people put you on a pedestal. You're not on a pedestal. The only difference between me and the guy that's thinking that is, we've just got a different job, and I did my job fairly good to be able, with all the circumstances and all the people around me, to make it work."

When NASCAR closed the door on that huge chunk of Petty-Pearson history (with a little Cale Yarborough, Bobby Allison, Darrell Waltrip thrown in there), and opened the floodgates for consumer products to outspend STP and the Detroit factory boys, more drivers got enough funding to get in the game, and the game changed.

King Richard still played the game until 1992. Petty drove his final race in Atlanta the same day Alan Kulwicki reached the pinnacle of NASCAR independence. Kulwicki, a university trained engineer from Wisconsin, built his lonely operation into a formidable team and ran the table, an improbable championship that faded to tragedy when he died in a plane crash the next year. Some racing folks still ache for Kulwicki and Davey Allison (who crashed a helicopter he was learning to pilot at Talladega) and, of course, Dale Earnhardt. They died younger than most, but nobody died younger than Adam Petty, Kyle and Pattie's boy, an absolute gem of a 19-year-old with clear eyes and gentle grace and more talent than half the garage.

"Adam's just Adam, and that's just great," Kyle said the year before, prouder of his son's unaffected personality than his talent. Another time, way back, Kyle saw Adam and The King engrossed in a racing conversation and turned to his mother and said, "Richard Petty finally got the son he never had."

The dynasty, born on the day of NASCAR's first official strictly stock race in 1949, had a succession plan—and then it was over. Kyle won eight times in 30 seasons, zero times during the final 13. The King went 0-for his final eight seasons. The dynasty was beyond over; it was history.

Petty figures he hung around far beyond his useful competitive life, mainly to help Kyle.

"It was tough, OK? Where it was tough was, I was still doing pretty good in the race car and he wanted to start running. He wanted to start running and, naturally, we wanted him to come along and take up the gap later on. But what hurt us, we didn't really have the monetary deal to run two first-class cars, so it hurt my career and his because it took some stuff away from me to get him going and we couldn't give him first-class stuff either. Again, it just wasn't meant to be.... Driving a car was my hobby, OK? Doing the work on it and all this stuff like that, that was my job—the P.R. stuff. I still do all that part of the deal. I just don't participate in my hobby. So I had to change and say, 'This is my hobby now.' I drove probably five or six years longer than what my ability was. Then we was out trying to get the monies in so we could help Kyle, and I had to help bring that in. If you had it to do over again, you'd probably have done it different, but in the long run this is the way it was supposed to be. That's just the way it was."

There could be no plan. Circumstances changed. The King said:

"Kyle was supposed to come along and take the deal to the next step. Then we had Adam come along. Adam basically was a lot more interested in the racing part than Kyle was. Kyle, if he had ever put his mind to it and said, 'I don't want to play the guitar, I don't want to ride motorcycles, I want to go racing,' he could've really, really, really been good. But it wasn't a passion. To my dad, I think it was a passion. To me, it was a passion. It wasn't a passion to Kyle.

"Then, when Adam come along, it was a passion with him. He would've made it with no trouble, just because of his experiences and stuff. He had all the tools—the personality to get along with people, driving ability, understanding the car—because it was a passion for him. It was going to be a hobby for him, but the good Lord didn't see fit that that was the way it was going to be, so we had to regroup. When you look at the timeline and all that stuff, up until that time everything was trucking along pretty dadgum good, and that just throwed a monkey wrench in everything. I think a lot of our interest slowed down for a while, and when we did pick it back up, we was already behind. But the one good thing that did come out of it was the Victory Junction camp (for children ages 6–12 with serious illnesses). So, no matter what all this other stuff that's gone on with him, I just look at that, and that evens things up."

The way The King remembers it, his grandson blossomed almost overnight.

"You ought to have known him for about the first 15 years: smart-aleck kid. He was the typical deal, but somewhere down the line things just clicked. I mean, in six months his whole personality changed. All of a sudden he focused, and when he did, he wasn't interested in having fancy cars or dating. As far as he was concerned, that was sideline stuff. It was that race car. He'd come in and work on that race car, go running, crash it and come back in to work on it. He wasn't just going to be a driver. The mechanical part, too."

But Adam crashed during practice at New Hampshire, May 5, 2000. Distraught friends and fans leaned flowers, notes and other memorials against the chain-link fence at the Level Cross complex. They drove up and down that road, and then they'd turn around and drive by again, all the while crying for the Pettys' pain more than for their own. It was so devastating that public mourners couldn't speak, couldn't cough out a single mortal cliché. People were empty, the breath sucked right out of them. There was nothing to say. Adam was dead, and the Petty dynasty with him.

The Pettys had come so far, beginning with Lee, late to racing at 35 because racing hadn't reached the station until after the war, when he was delivering moonshine and bread, perhaps both at the same time. Maurice remembers his father spreading a blanket over the cases of moonshine jars in the back seat of a coupe and letting the boys sit on top of them while he made the rounds in Greensboro.

Lee didn't talk about stuff like that, didn't talk much to outsiders about anything. Later, Richard refused to advertise beer brands "because my mother would come back and haunt us all if she'd seen it on our car."

Elizabeth Toomes and Lee Petty didn't really have time for hobbies, clawing for a living in meager times. They lived on a dirt road. Richard said:

> "They had no telephones. We didn't have any electricity. They had an outhouse out back. All the neighbors were the same way, so we thought that was the world. But then when we started traveling with my dad we found out, man, they've got indoor plumbing. Can you believe that? I mean, you'd never seen paved streets. You didn't have TV and magazines coming to the house, so you didn't know there was another world."

Maurice, a year younger than Richard, had polio as a child (but overcame it sufficiently to play football and then work on cars until his legs started giving out in his 60s; he now gets around on a motorized scooter). He recalled:

> "We had an old what they call a shotgun house. You could see all the way through it. One morning when it was cold, mother and daddy got up to build a fire and somehow or another she poured kerosene on it and that burnt that house down to the ground. I mean I was real small then, five years old. Then we moved back in with my grandparents and dad bought an old trailer. I mean, it was an old house trailer back then. I lived there until '52. My grandparents and all died, and the family sold the property off."

On the Friday evening before the sale, the heirs decided that anyone who could come up with enough money by Monday could buy the house. "Lee was lucky enough," Maurice said. "He liked to gamble and he went and played cards all day and all night, and he come up with enough money to buy the rest of the family—brothers and sisters—out." He caught himself gambling again when faced with a life-threatening aortic aneurism in early 2000. Lee told his sons that he'd keep sitting in his chair if it was left to him, but because of the family, he would do something.

"He was a good gambler, I guess," Maurice said. "I know before he died, he went into the hospital. They were going to operate on him. They come in. He was supposed

to sign the papers. They told him, 'Well, there's a 50-50 chance, Mr. Petty.' He said, 'Hell, let me sign it. I've gambled all my life; 50-50 chances is pretty good odds.' I can remember that just as good as anything."

Lee survived the operation and responded well, but a month later, there was a staph infection. He died April 5th.

Lee got his start dabbling in racing. In late 1948, he teamed with his brother Julie to fix up a 1938 coupe. They ran three races, finishing among the top three each time but still losing money. Richard remembered:

> "They give that up. Then, in 1949, daddy hung out at a service station up there in Greensboro. They read in the paper that Bill France was going to have a strictly stock race in Charlotte, Wilkinson Boulevard. There was a couple of guys there, they had a '46 Buick. It run fast on the road, had two carburetors. It was a really high-buck deal, so daddy talked them into letting him borrow the car. Then daddy and mother, me and my brother Maurice drove the car to Charlotte.... We went in a Texaco service station. They put it up on the rack, jacked it up, greased it, changed the oil in it, took the muffler off of it. Took the hubcaps off of it. I think they taped the number on the side of the car. I don't remember whether it had a seat belt in it or they put it on it. And then we went to the race. He drove about half the race, broke something on the car, turned it over and tore it to pieces. My uncle Julie was there, so we rode back home with him and then the next day they took a flatbed truck and went back and got it. I don't know what they ever told them boys from Richmond. So, that was my introduction."

As France sponsored more races, Lee got more involved. He bought a '49 Plymouth coupe. "That was the cheapest thing he could get," Richard said. "I think it was $999. The family got in the car and drove it to Hillsborough, and then when the race was over, we got in it and drove it home."

Maurice remembers the transaction. "At M&J Finances there in Greensboro, he went and got it financed. He'd go in on a Monday morning, whenever they came in off the road, and he'd go pay the finance charges. Once a week—that's the honest-to-God truth."

Lee got the boys involved. He'd point at tools or parts, and they'd hand him what he needed. The garage, held up by cedar poles, had a dirt floor. "First time we ever had anything on the floor of a garage, Richard and myself mixed the cement in a wheelbarrow and poured it ourself," Maurice said. "We have come a long way.... The toilet was in the woods. It wasn't hot water. There wasn't even no water."

They had their first garage floor—Lee insisted on marking the date in every cement slab from then on—and they had a foundation. Lee was inventive, and pretty soon he invented a new career, winning championships in 1954, 1958 and 1959. He won the inaugural Daytona 500 in 1959. France declared Johnny Beauchamp the victor on the spot, but after studying pictures of the finish taken by photographers and fans for three days, he gave Petty the nod. That was the same year rookie Richard joined the tour, after turning 21 and clearing the age restriction imposed by Mr. Lee (the title Maurice

bestowed on the patriarch). Richard, a high school athlete who had attended business school in Greensboro, got right down to the business of winning. He celebrated his first one on a short track, but his pleasure was premature. The second-place driver, Lee Petty, protested the scoring. Officials ruled in his favor, and Richard needed a few more weeks to nail down No. 1. Folks wondered how Mr. Lee could do that to his son. He grunted. "I would have protested even if it was my mother," he said.

They didn't really race each other often, Richard said, because his father had a higher skill set then. Junior Johnson called Lee the equal of any driver in his time. But the unexpected exit came swiftly. In 1961, Lee went to Daytona with a win already in the books. During a 100-mile qualifier, his airborne car cleared the guardrail in the fourth turn and traveled about 100 feet, landing in a parking lot. The wreck punctured a lung and severely broke a leg. He spent 11 weeks down there in the hospital, with engine man Maurice driving the second Petty car. Lee returned but drove only six races over the next three seasons, leaving for good in 1964. When Lee returned to the garage after that final race, Richard saw a different man.

"He got out and he said, 'Y'all can have it. It ain't fun no more. It's like work.' So, he quit." Lee left with NASCAR records for most wins (54) and most titles (3), which lasted only until his son caught up.

Richard took the first of his seven championships that fall. He peaked in 1967, probably the best year anyone ever had: 27 wins in 49 starts, including 10 straight from Winston-Salem on August 12 to North Wilkesboro on October 1, driving a Plymouth Belvedere. That's when he became The King. The run went on and on, enabling cousin Inman to set crew chief records (he won an eighth title with Terry Labonte) and pushing Maurice into record territory for engine-builder wins (he added 12 more with other drivers). All four have been elected to the NASCAR Hall of Fame.

The King said:

> "In the scheme of life. I look back and say, why me? Born to Lee Petty, who was in racing. Getting a little bit of talent to be a driver, and all those people around me to make me shine. OK? Get me a wife and family and all that kind of stuff, and give me opportunities to travel all over the world, meet presidents and meet people in the street—thousands and thousands of people—and these circumstances. Go to the White House or go to the poor house or help with the camp. All the things that has happened in your life, you just look back and look up and say, 'Good Lord, why'd you pick me? Why'd you give me this many opportunities?' Where I grew up and went to school with a lot of people, and some of them never been out of North Carolina. And they're happy as June bugs, and that's OK. My lifestyle just happened to be different than yours or some of the people we grew up with. But even though we've had a lot of bad fortunes—everybody did—why did so many good fortunes, good opportunities come along to us to accomplish what we've had? It's like the universe. There's no end to it."

There was an end to Petty Enterprises, a hard end. Richard sold the guts of the business to an investment firm, and Kyle thus lost his ride. The company became Richard

Petty Motorsports, based in the Charlotte area with The King as front man. Those plays upset Kyle and Maurice. Asked about his emotional reaction, Maurice shook his head. "You don't want me to tell you," he said. "You might not never find out. It wasn't a good one, let's put it like that. It just wasn't a good thing. Time evolves. As time goes by, stuff evolves."

Kyle showed up before the 2009 Daytona 500, which wouldn't include a Petty for only the second time. Richard boycotted in 1965 after NASCAR banned the hemihead engine. Kyle didn't like anything about the sale, even though he knew his time would end soon regardless. "Look, there is no Petty Enterprises," he said. "Let's be real honest. There's Richard Petty Motorsports or whatever y'all want to call it, but there is no Petty Enterprises. Petty Enterprises ceased to exist when it left Level Cross, North Carolina." The new company fielded a replica of the car Kyle drove in his first victory, ostensibly in tribute. Kyle didn't take it that way. "I was crushed," he said. "I was hurt, and I'm not going to get over it for a while."

That deal morphed into an arrangement with international sports mogul George Gillett, and that turned sour when debts devoured the new owners. Petty made another move to a financial firm that gave him more day-to-day influence (and cost him a substantial investment). The latest operation has taken a few strides but hasn't been especially competitive, with his two drivers finishing 18th and 22nd in 2013. The King cites the tilt, over the past generation, toward team owners who amassed wealth before joining Sprint Cup. He mentions Rick Hendrick, Jack Roush and Roger Penske.

> "Junior Johnson, the Wood Brothers, Petty Enterprises—we didn't have that world to work in. We were racers. We didn't have nothing to offer those people but the race car, so finally, over a period of time, we all basically went out of business. We're still in business, but nothing like we were. Junior went out of business. Bud Moore and the Wood boys, they piddle with it like we do. Back when it was strictly racing and the racers went out to get things, they were your teams because they produced. They won races and they done their P.R., and they done all that. It went to the next stage to get bigger and we didn't get no bigger because we didn't have the tentacles out there to reach out to people."

His succession plan now is strictly the legacy business. He likes the garage and loves the nearby Victory Junction Gang Camp, a year-round enterprise. He bought the homeplace from his father's estate and intends to incorporate it with the museum, which is returning from Randleman.

"It can still be a Petty compound," he said. "I have a futuristic idea that my dad, my son, my grandson and myself spent 60, 70, 80 years here. At least the next generation will be able to be involved in it, even though they didn't know us. *Know what I mean?*"

He has worked through the logic and the numbers. Although forever restless and worried that he might go crazy without daily racing chores, Petty also tries to accept blunt realities and let go of some things while pursuing a peace accord within himself.

"That's life," he said. "That's life. My dad, his big deal was, if you work hard enough long enough, you can overcome all obstacles except fate. He says you cannot overcome

fate. If you're after something and fate's on your side, you'll get it. If fate says no, you can't work hard enough to get it."

The King chuckles.

> "That's my philosophy of life. I guess when you cut through all the rest of it, that's it. They've got that song, 'Whatever Will Be, Will Be.' My whole deal is, I live on a 90–10 situation. Ninety percent of the stuff that happens, we've got no control over it. So we take that 10 percent — whatever, I'm just using those percentages — and get the best for us and our family and our situation that we could get. I'm needing a sponsor, OK, and I go in and talk to the sponsor and tell him what we're going to do and stuff. 'I'm doing 10 percent–90 percent.' He says yes or no, OK, and when he says yes or no, I take my 10 percent and go do a deal with him or go get me another deal. I mean, if you get up in the morning and decide to mow your yard and it's raining, whatcha do? In other words, 90 percent of your deal is gone, you're gone. So it's kind of a screwball philosophy, but the more you think about that, one of these days something will come along and you'll say, 'He was right.' We don't have near as much control as we think we have, and it's probably a good thing. Now I go through setbacks. I look at life as 100 percent. As long as I'm 51 percent, I'm OK."

He smiles a wan smile and shuts the mental motor down and lets the idea idle right there in the middle of the room. The room, a bit stuffy, becomes still and silent, frozen in a moment of utter clarity, with all pretenses stripped away. Petty stares straight ahead. What do his eyes say? They're hidden behind layers of time and glory and pain, behind the dark shades of his persona, and it's impossible to know whether the windows to The King's soul are smiling or sad. But it's not hard to guess. *You know what I mean?*

Golf

By Lee Pace

Lee Pace has written about the North Carolina golf scene for three decades from his home in Chapel Hill. His most recent book is the 2012 coffee-table book, *The Golden Age of Pinehurst*. That was his fourth book documenting the story of Pinehurst. The others were *Pinehurst Stories*, the first edition of which was published in 1991 and the second edition in 1999, and *The Spirit of Pinehurst*, which followed in 2004. Pace wrote and coordinated the production of the Carolinas Golf Association's centennial book in 2008 and wrote and edited a 2013 coffee-table book for Forsyth Country Club in Winston-Salem. He has written about North Carolina golf for a variety of magazines, including *GOLF*, *Links, Golfweek, Private Clubs, Delta Sky Magazine* and *US Airways Magazine*. Today he writes a monthly golf column for *Pine Straw* magazine. Pace is a 1979 graduate of the University of North Carolina.

The Game of Games

Three years into the birth of his wintertime resort offering a mild climate, recitals, card games, dancing, walking, carriage rides and a croquet-style game called roque, James Tufts found himself at a crossroads. The visitors from New York, Boston and other northeastern towns had embraced the village named Pinehurst he created from scratch in the North Carolina Sandhills, and now he wondered if he should expand the nine-hole golf course he built and opened in early 1898. Tufts inquired of Allen Treadway, the manager of the Holly Inn in Pinehurst, if Treadway thought nine more holes would be a good idea.

"Save your money," Treadway answered. "Golf is a fad and will never last."

Tufts' instincts and better advice from others in his circle convinced him otherwise, and soon Tufts embarked on the expansion of the fledgling resort that would lead to

Hugh Morton took thousands of photos of golf courses in the mountains of North Carolina prior to his death in 2006. This is one of his earliest — a man and two boys teeing off at Linville Golf Club in the 1930s.

Pinehurst becoming an early beacon to the growth of golf in America, to amateur scion William C. Campbell comparing Pinehurst with the home of golf itself, Scotland's own St. Andrews, and to Pinehurst as recently as 2007 being named the No. 1 golf resort in America by *Travel & Leisure Golf* magazine.

Tufts later observed:

> "Everybody can play golf. Some excellently, others indifferently, still others very badly, but all enjoyably. It keeps the player out in the open air; it keeps him moving over wide spaces; it exercises all his muscles and all his wits. It is an ideal sport for the maintenance of bodily and mental health."

A.W. McAlister, a leader in business and civic circles in Greensboro, was on a fishing vacation in Canada in 1908 when he was first introduced to golf. McAlister tried the game, liked it and bought five sets of clubs to bring home to Greensboro. He wrote to his wife:

> "There really isn't much to do up here when you are not fishing. The local people play a new game called golf. They use a club which looks something like a shinny stick to hit a small hard, rubber ball just as far as they can. Then they try to find the ball and hit it into a hole in the ground."

McAlister would help found Greensboro Country Club and in 1911 penned a book entitled, *The Eternal Verities of Golf.* He dedicated his book to the "comeliest thing in the world, a brand new golf ball," noting it was "clean as the ivory of a little child's tooth; fair as the dimpled hand of a maiden; elusive as the liquid note of the wood robin." He remarked over the "similitude between right living and right playing of the ancient game" and believed that golf, correctly played, is a complete philosophy of life.

McAlister wrote:

> "Golf is a health-giving diversion in God's out of doors which refreshes and rejuvenates and during the hours of play excludes all things else, politics, business, love, and for that reason it is the game of games for busy men of strenuous life. It is full of discipline and philosophy and wisdom."

The game, as Tufts and McAlister divined, is one thing.

The course and the landscape are another world of fascination as well.

The 53,821 square miles of land occupied by the state of North Carolina were cobbled together millions of years ago in Paleozoic times—the land folding, contracting and eroding, the seas receding into a geographical structure unique on the Eastern Seaboard. Today in North Carolina along the Atlantic Ocean is a chain of barrier islands, sandy beaches and windswept dunes forming the coastal region. Further inland is a vast plateau comprising the Sandhills and the Piedmont where vibrant cities and commerce thrive and swift-moving streams course toward the coast. And to the west are the rolling hills and the dramatic cliffs and slopes of the mountains.

North Carolina's vast palette of geography makes for an unrivaled golf experience, one that has grown from the crude layouts as the 1900s dawned to a $5 billion-plus industry more than a century later with more than 400 courses from Manteo to Murphy.

"It's almost like you can get a taste of the entire country in this one state," says Tom Fazio, the noted golf architect who moved his family and his design headquarters from Florida to Hendersonville in 1987. "You've got a little bit of everything ranging from the mountains to Pinehurst to the coast. In other areas of the country, you have to *create* features. In North Carolina, they come naturally.

"I refused to go around the world in the eighties during the golf boom," Fazio adds. "I had no interest in going to Japan and Asia. My response when someone said, 'Why not?' was to say that I had all the opportunities I could ever want in my own backyard."

From such a natural and fertile environment for the playing of the game has sprouted a formidable cast of some of the golf's greatest practitioners. The state has spawned its share of outstanding players—amateurs such as Billy Joe Patton (Morganton), Harvie Ward (Tarboro) and Estelle Lawson Page (Chapel Hill) and professionals such as Raymond Floyd (Fayetteville), Charlie Sifford (Charlotte), Clayton Heafner (Charlotte) and Johnny Palmer (Badin).

Others came to North Carolina and spread their wings—including Arnold Palmer, who came from Pennsylvania to play collegiately at Wake Forest, and Peggy Kirk Bell, who grew up in Ohio and has become a giant in golf teaching and resort circles at her family's Pine Needles Lodge & Golf Club in Southern Pines.

The state has been a magnet for top competitive events since the days that Tufts created the North and South Championships in Pinehurst in the late 1800s.

Pinehurst was the site of the old North and South Open, an event considered in the first half of the 20th century as one of the "major championships" in golf in that era and the site of Ben Hogan's first professional win in 1940. The North and South Amateur lists golfers the ilk of Patton, Ward, Jack Nicklaus, Bill Campbell and Curtis Strange on its championship plaque. Pinehurst was the venue for the 1936 PGA Championship

Arnold Palmer first learned about North Carolina golf in the 1940s when, as a teenager, he visited the course at Pinehurst with his father, Deacon (right).

(won by Denny Shute), the 1951 Ryder Cup Matches (won easily by the U.S. over Great Britain and Ireland) and one of the most famous shots in golf, that 15-foot putt Payne Stewart made to win the 1999 U.S. Open.

Payne Stewart reacts as his winning putt falls on the final stroke of the 1999 U.S. Open at Pinehurst No. 2.

Sam Snead follows the roll of his putt during one of his eight wins in the Greater Greensboro Open.

Greensboro has a rich tradition in professional golf as the Greater Greensboro Open and its offspring (known today as the Wyndham Championship) have enjoyed a date on the PGA Tour calendar since 1938. Sam Snead won eight times in Greensboro, and a young Spaniard named Seve Ballesteros burst onto the scene with a victory in 1978.

Charlotte's Quail Hollow Club was the site of the Kemper Open on the pro tour from 1970–79 and in recent times since 2003 has been the venue for one of the modern era's most prestigious events, with Tiger Woods, Rory McIlroy and Vijay Singh among the winners at the Tour's annual May visit to the Queen City, known today as the Wells Fargo Championship.

No matter if you're Payne Stewart holing a putt to win the U.S. Open or a 12-handicapper doubling the bet at the turn, the fascination of the game has remained constant for more than a century across North Carolina.

The Addiction Factor: Dan Hill III's family moved to the Hope Valley neighborhood about two miles southwest of downtown Durham in the 1950s and settled into a home alongside the twelfth fairway of Hope Valley Country Club. Hill, nine years old at the time, knew nothing about golf and knew no other boys on his street. One June morning,

he attended a junior golf clinic conducted by head pro Marshall Crichton and Duke University golf coach Ellis "Dumpy" Hagler. "I remember not being able to figure it out," says Hill. "Then I hit one shot and it got up in the air with a little draw and it went right at the 125-yard marker. I remember it like it was yesterday. 'Oh my God, that was something!' That was the light bulb for me."

The triggers and hooks are different from one golfer to the next. But each falls under the spell of the game, generally for life, and sets off on an insatiable quest to master his mind, his body, his equipment, the wind and the rain, the tucks and rolls and hills of the terrain. The passion flows in the old-money private clubs and throughout the daily-fee enclaves across the state as well. Two of the most ardent golfers over the years at Asheville Municipal Golf Course were Billy Gardenheight and the course's long-time starter, Cortez Baxter.

"Golf is like drugs, it's addictive," Gardenheight said in 2006. "You can play from cradle to graveyard. Most sports you have to give up. This one you play as long as you want to. I'm seventy-two and I've been playing since 1945."

"Once you pick up the clubs, that's it. You're done for," Baxter added.

The seed of North Carolina golf was planted in Asheville in November 1894 when a group of men met to create a club that would cater to their desires to go fox hunting and provide an enclave for playing poker, drinking whiskey and smoking cigars. The Swannanoa Country Club, named for one of the rivers bisecting Buncombe County, was also called "The Hunt Club" and was headquartered in a clubhouse in the center of Asheville. Its members socialized there and traveled to the club's hunting grounds located about five miles west of the city. Within a year, the club decided it needed to accommodate the growing interest in golf. A committee chiseled several holes out of the terrain and the membership took kindly to the game. The same committee soon built a new five-hole course, and in 1896 the club's name changed to accommodate this new priority—Swannanoa Golf and Country Club. The club would later become the Country Club of Asheville and today is the oldest continuously running country club in North Carolina and the second-oldest in the South—behind Palmetto Golf Club in Aiken, South Carolina.

The club moved its rudimentary course three times thereafter, each time trying to get a more convenient location to town. One of the locations was a sublease from a group of butchers using a parcel of open land for hog and cattle grazing. A local newspaper noted with some degree of amusement: "The swellness, elegance, verve and spirit comprising the cream of Asheville society was mixing with—shall we dare say it—swine."

One of the city's prominent citizens, George Willis Pack, gave the club the land it needed in November 1898 to construct a more sophisticated golf facility. The club started with five holes designed by committee and opened in February 1899 on the site just off Charlotte Street north of downtown, and it built a new clubhouse with showers, locker rooms, lounges and game rooms.

The club bought and purchased additional acres over the next decade in order to expand to nine holes and then eighteen. According to research by club member Kempton Roll, the club's board in 1909 floated the idea of asking Donald Ross of Pinehurst to

look at the course and offer his thoughts on expanding to eighteen holes. For unknown reasons, the board rejected the idea and turned to another Scotsman finding fertile ground in American golf-course design — two-time British Open champion Willie Park Jr., who took the existing nine, added nine more and presented a full eighteen-hole layout to the club in 1910.

The club did in fact eventually summon Ross, who is credited with a 1924 redesign of the course. This venue remained the Country Club of Asheville until 1976, when it was purchased by the Grove Park Inn and became an amenity of the ancient stone hotel perched at the top of Sunset Mountain. The Country Club of Asheville purchased another Ross course, the former Beaver Lake Golf Course (opened in 1928), built a new clubhouse and relocated several miles north of the city.

The MacRae family of Wilmington has direct ties to the Isle of Skye in the Scottish Highlands, and the clan was a moving force in getting golf started in Linville and Wilmington. Donald MacRae Sr. had extensive land and business holdings in Wilmington and Florida following the Civil War and also developed enterprises in the mountains of Western North Carolina — in mineral springs and spas in Iredell County and in iron and mica mining in Mitchell County. It was during trips into the mountains in the late-1800s that he made the acquaintance of Samuel Kelsey, the founder of the town of Highlands in the far western extreme of the state and a man who believed another attractive settlement could be launched in the Linville Valley at the base of Grandfather Mountain.

MacRae and Kelsey were officers in the Linville Land, Manufacturing and Mining Company, a corporation formed in 1888. Soon the company spent $22,000 to build the Eseeola Inn, which opened amid the fanfare of bagpipe music and oxen races during a lavish grand opening on July 4, 1892. "The Eden of the United States, a Fairy Land without a peer," crooned an early advertisement for Linville and the Eseeola.

It wouldn't take long for golf to become a part of the Linville recreational menu. Hugh and Donald Jr. were MacRae's two sons, and both knew and understood golf from their visits to the homeland across the Atlantic. Both saw the game having a bright future in America. Hugh talked with friends in Wilmington about forming Cape Fear Golf Club in the winter of 1895–96 and told them golf was already being played in Linville. Letters from his wife, Rena, who was spending summers in Linville, indicated golf was certainly being played by the summer of 1897. Details of the pre-1900 Linville golf course are sketchy. Apparently there was a nine-hole layout, and in 1900 Donald Jr. personally supervised and paid for construction of five new holes that gave Linville a fourteen-hole layout — with four holes played twice, from different tees, to constitute an eighteen-hole round. This stood as the Linville Golf Club until Ross came in 1924 and built a new eighteen-hole course.

Hugh and Donald Jr. were among the driving influences to establish a golf club in Wilmington during the same period. Another Wilmington golfer was Col. David Heap, who was known to amuse his Fourth Street neighbors by hitting a golf ball down Fourth, Dock and Front Streets in downtown Wilmington each morning. Cape Fear Golf Club was christened at a meeting at Heap's home in March 1896 with an initiation fee set at one dollar and annual dues at twenty-five cents.

The City of Wilmington had created a public park four years earlier on the property of the old Hilton Plantation north of town, and a seven-hole course was laid out soon after the organizational meeting. The site doubled as a baseball diamond, and during the summer two holes yielded to the baseball field and golfers played a five-hole layout. Hugh MacRae, chief stockholder in the Wilmington Street Railway system, provided one of the system's buildings for use as a clubhouse. The initiation fee was doubled to two dollars and dues increased to seventy-five cents in 1899 to create funds for capital expansion, and a new clubhouse was built and opened in October 1899.

The *Wilmington Messenger* heralded the opening of the new clubhouse with a reference to the spreading popularity of golf: "There are now flourishing golf associations in Raleigh, Asheville, Charlotte, and Winston, as well as in Wilmington, and a movement is on foot for the organization of a North Carolina Golf Association, with a view of establishing a state championship." (Details on golf in Raleigh, Charlotte and the town that would later become Winston-Salem are sketchy, but no official clubs had been formed by 1899, and any ideas of creating a statewide association were fruitless until 1909.)

The Cape Fear Golf Club had its detractors, however, as some citizens opposed public property being used for a private club. Hugh MacRae had an answer to those concerns. He revealed plans in 1901 to buy the Wilmington Seacoast Railway, a steam railroad line running from Wilmington east to Wrightsville Beach. The line would be converted to faster electric cars, and neighborhoods were planned on sites near the tracks. He formed a syndicate of club members to buy a new tract for the club. The group bought fifty-six acres for $1,400 south of the trolley tracks, two miles east of Front Street. A nine-hole course of just over 3,000 yards was laid out, the greens fifty-foot circles of clay sprinkled with sand. Seven of the greens were guarded by trenches zigzagging across the fairways; they were left over from the Civil War and the Confederate troops who took cover in them from enemy fire. A tennis court was built, the original clubhouse was moved and the name was changed from "golf club" to "country club." The club exists on this site today, though additional land was added over the years and Ross would visit Wilmington in 1946 to redesign the modern Cape Fear course.

Tufts' Sandy Turf: James Walker Tufts had no designs on golf when he bought approximately 5,000 acres of arid land in south-central North Carolina in 1895. Tufts had made his fortune in Boston in the manufacturing of soda fountains and related products and, at the age of sixty, looked south to create a resort where those like him of frail health could retreat during the harsh New England winters. Within a year, Tufts planned and built the Holly Inn, a general store, several boarding houses and sixteen cottages. He hired the landscape architecture firm headed by Fredrick Law Olmsted (of New York's Central Park fame) to craft a village rich in evergreens through the winter and resplendent in color in the spring.

By the fall of 1897, one of Pinehurst's guests had imported some golf clubs and balls to the Sandhills and deployed them around the dairy field. Tufts later received reports from an employee that the flying golf balls were agitating the cows. Tufts inquired about

this odd pursuit and learned that golf was growing in popularity, that it likely had a future in America. Tufts knew that a friend in Southern Pines, Dr. LeRoy Culver, had traveled to Scotland to play golf and asked Culver to lay out nine holes for Tufts' guests.

In February 1898, *The Pinehurst Outlook* reported:

> "A nine-hole golf course has been laid out after the famous St. Andrews, near Edinburgh, Scotland. Mr. Tufts is giving his personal attention to the construction and we may expect as fine a links as there are in the country. The spot selected is an ideal one, situated upon the hill south of the Village Commons. The grounds cover sixty acres of thoroughly cleared land, well fenced in, and covered with a thick growth of rye, which will be kept short by a flock of more than a hundred sheep."

The course proved popular with Pinehurst guests and was expanded to eighteen holes at a length of 5,127 yards in 1899. British Open champion Harry Vardon toured America in 1900 for a series of exhibition matches, concluding with a triumph in the U.S. Open, and Pinehurst and Aiken, South Carolina, were on his schedule in March. Vardon played four rounds in Pinehurst, and the appearance of such an expert at the game stimulated interest among the Pinehurst regulars. "The visit was Pinehurst's first taste of big-time golf, the flavor was good and the new resort wanted more," Tufts' grandson Richard reminisced years later.

In the fall of 1900, James Tufts made one of the most important decisions in the history of Pinehurst and the development of golf in North Carolina. The first Pinehurst professional was John Dunn Tucker, a descendant of the Scottish golf clan that produced Willie Dunn Jr., one of the earliest Scottish professionals to come to America. Tucker served two seasons in Pinehurst beginning in 1898. Tufts, spending time during the summer of 1900 at his home in Medford, Massachusetts, had heard of an enterprising young professional who had immigrated from Dornoch, Scotland, and was now employed at Oakley Country Club in nearby Watertown.

Tufts Sells Ross on Pinehurst: Donald Ross was born in 1872 in the village of Dornoch on the northeast coast of Scotland. He became a caddie at Dornoch Golf Club as a youth, worked as a carpenter's assistant and learned the business of greenkeeping. Ross was assumed by local lore to have been among the onlookers when Old Tom Morris came to Dornoch in 1886 to meet with club secretary John Sutherland and redesign the golf course. Ross spent a year in St. Andrews at the age of 20 as an apprentice to Morris and to clubmaker David Forgan. When he returned to Dornoch, he was hired at the age of 21 as head professional, clubmaker and greenkeeper.

A visitor to Dornoch in 1898 was one Robert Willson, an astronomy professor at Harvard University and a member at Oakley Country Club. Willson told Ross that golf was morphing in popularity in America and that someone who knew the game and could shepherd the nation's growing legion of golf enthusiasts could make a nice living—perhaps even get rich. Ross took Willson's suggestion to heart, boarded a ship and arrived in Boston in April 1899. Ross looked Willson up and soon Ross had found a job as professional and greenkeeper at Oakley. Ross set out to remodel the club's

eleven-hole layout. He staked out a new course, arranged for labor and began working toward a projected opening in the fall of 1900.

The Scotsman learned as November rolled into December that the winter weather of New England was significantly harsher from that of his homeland, so Ross was pleased to meet Tufts and learn of an opportunity to ply his trade in a warmer climate during the New England off-season. He moved to Pinehurst in late 1900 and was delighted with the landforms in the Sandhills. The earth was gently rolling and sandy, similar to what Ross knew from Dornoch. Rainwater flowed through the sandy soil at Dornoch; it did so as well in Pinehurst, allowing for a golf designer's dream environment. Soon

Golf architect Donald Ross is shown hitting from the scruffy turf at Pinehurst in the early 1900s. Ross designed the original four courses at Pinehurst Resort & Country Club.

Ross's attention was focused on rebuilding the resort's single golf course and adding to the inventory. He remodeled and expanded the original nine-hole design; he unveiled the stout No. 2 course as a full eighteen-hole layout in 1907; and he introduced in 1910 the No. 3 course, one that would prove popular with women and seniors with its shorter holes and small greens. Pinehurst No. 4 was introduced in 1919.

The Tufts family and Ross proved to be shrewd promoters and businessmen. They created under the "North and South" banner an array of amateur competitions to draw guests and golfers to Pinehurst and instituted a professional event that attracted the top players of the day—the Walter Hagens, Jim Barneses, and Macdonald Smiths. A New York advertising agency created the popular "Golf Lad" character that adorned ads, brochures, posters and calendars. As World War I ended in 1919, the United States economy grew and golf rode its coattails into the "Golden Age of Golf Course Design."

The Tufts were getting more business at their resort than they could handle during the winter "high season"—more than 100,000 rounds a year were being played in the mid-1920s—and joined investors to create one new private club and one new resort operation in nearby Southern Pines. Ross designed the courses at Mid Pines (1921) and Pine Needles (1928), and both courses remain in business today essentially as he designed them. He also built twenty-seven holes at Southern Pines Country Club during this period; eighteen of those holes remained in operation in 2013 under ownership of the Benevolent & Protective Order of Elks.

By 1910 Ross had taken a keen interest in design and developed a flair for the craft; he was devoting almost all of his time to golf-course architecture. Golfers visited Pinehurst, liked the quantity and variety of golf and hired Ross to visit their cities and build courses there.

The game's popularity in the early 1900s prompted a group of golfers in Charleston, South Carolina, to invite golfers from the known clubs in two Carolinas to a competition at the Country Club of Charleston in October 1909. Following the golf, a meeting was held at the Carolina Yacht Club to organize what would become the Carolinas Golf Association. Nine months later, the CGA had seven member clubs, and seventy players gathered at Sans Souci in Greenville, South Carolina, in June 1910 for the inaugural Carolinas Amateur. The CGA celebrated its centennial in 2009 and is headquartered in the Moore County village of West End, with plans to build a new facility in Southern Pines. It is the second largest golf association in the nation with 685 members clubs representing some 150,000 golfers.

Charleston's Fred Tyler wrote to Richard Tufts in 1934:

> "At that time there were very few active golf clubs. Pinehurst, Summerville and Aiken were then only run in the wintertime as tourists' courses. A golf club was being organized in Spartanburg, but the ones at Charleston, Columbia and Greenville were the only active all-the-year-around clubs in South Carolina. In North Carolina, at that time, the only active clubs were at Wilmington, Raleigh, Charlotte, Kanuga Lake, and Asheville."

Venture into each of the cities and mid-size towns in the Carolinas in the early years of the twentieth century and you'll find the barons of commerce leading the way to

turn cow pastures and corn fields into grounds for playing golf. And many of them turned to Ross to grace their towns with modern golf courses.

John Sprunt Hill was a key influence in the development of Durham and the University of North Carolina at Chapel Hill. He learned to play golf in Pinehurst, and Hill and his father-in-law, George Watts, were frequent visitors to the Sandhills. Hill raised cows and various crops on farmland he owned west of downtown Durham, and by 1908 he had staked off a parcel just north of Hillsborough Road for a nine-hole golf course so he and Watts would have a place to play locally. There was a valley running through the area and a stream bisecting the course, so Hill named it "Hill 'n Dale," which would eventually be condensed into the course's name, "Hillandale." Ross provided a more sophisticated nine-hole routing for a course that opened in April 1912. Nine more holes were added in 1915. The course was relocated to a nearby tract of land in 1961 with George Cobb designing the new 18-hole layout.

Alexander W. McAlister, who founded Pilot Life Insurance Co. in Greensboro in 1903, was a prominent developer of elegant neighborhoods like Irving Park and was first exposed to golf on a fishing trip to Maine in 1908. He was so intrigued by the sport that he returned home, built five holes on the corner of Summit Avenue and Dewey Street south of St. Leo's Hospital and allowed anyone to play at no charge. Ross soon came to Greensboro and built eighteen holes for Greensboro Country Club.

The Blend of Tobacco and Textiles: The Reynolds and Hanes families were the guiding lights in industry and society in the early days of Winston-Salem, the Reynolds forging a fortune in tobacco and the Hanes at the vanguard of the textile industry. Members of each family were among the original five stockholders in a new club founded in 1913 that would become Forsyth Country Club, the enterprise an extension of a rudimentary group of golfers known as the Twin City Golf Club that had gathered as early as 1897 to play in a cow pasture near the intersections of 12th and Liberty Streets. Forsyth opened with a nine-hole course west of town in 1918 designed by A.W. Tillinghast. Then R.J. Reynolds donated fifty acres of adjoining property and he and Huber Hanes paid to have water lines extended from town to the new club, and the club hired Ross to take the original nine holes and expand it to a full eighteen-hole layout that opened in 1924. "The course is splendidly turfed, splendidly kept, and so designed that it is both fascinating and difficult," the Winston-Salem *Sentinel* observed in its July 16, 1924, edition. "There are long holes and short holes, blind holes, and open holes, but above all there are eighteen as pretty greens as can be found anywhere."

Fred Laxton Sr. was an electrical engineer and founder of Charlotte's first radio station, WBT, and was one of the leaders of a group of men who in 1910 chartered Mecklenburg Country Club, which would change its name to Charlotte Country Club seven years later. Laxton produced the first radio broadcast south of Pittsburgh from his home near the first tee and was among the original Mecklenburg members who helped design the course's first nine holes. He later became one of the Carolinas' top players of the early twentieth century (winning the CGA Amateur in 1921, '22, and '23). Ross redesigned those holes in 1913 and added nine more, which opened in 1915. The course was restored by Ron Prichard in 2008 and has hosted three USGA champi-

onships: the 1972 U.S. Amateur, the 2000 Senior Men's Amateur, and the 2010 U.S. Women's Amateur.

George Vanderbilt discovered the beauty and charms of western North Carolina in an 1888 visit to Asheville and gave birth to the idea of a majestic country estate. The Biltmore House was constructed over six years and opened in 1895 with 250 rooms, sixty-five fireplaces and four acres of floor space. The Biltmore Estate Company was formed in 1920 to develop 1,500 acres adjacent to Vanderbilt estate into one of the finest residential parks in the country. According to legend, Edith Vanderbilt, George's wife, had been insulted by members of the Country Club of Asheville for not allowing her to smoke on club premises, so the idea of Biltmore developing a club of its own was a major part of the new Biltmore Forest village plan. Ross was commissioned to design the golf course, but the developers ran short of funds during construction and Cornelia Vanderbilt, the only daughter of George and Edith, stepped in to rescue the club with an infusion of capital. Biltmore Forest Country Club opened on July 4, 1922, and remains one of the state's finest clubs; it has hosted the 1999 U.S. Women's Amateur and 2013 Women's Mid-Amateur.

Ross ventured east to Rocky Mount in 1922 to design Benvenue Country Club and southeast to Wilmington in 1926 to create Wilmington Municipal. He chiseled Roaring Gap out of the mountains an hour northwest of Winston-Salem in 1926 when the Tufts created a private community for summertime escape from the heat. An introductory press release pegged Roaring Gap as "the Pinehurst of the mountains." Also opening in 1926 was Sedgefield Country Club in Greensboro.

The Depression in the 1930s and World War II in the early 1940s took the teeth out of the expansion of golf as a pastime, and Ross and other architects found little work during that fifteen-year period from 1930–45. The only new course Ross designed during that period was Carolina Pines Golf Club in Raleigh in 1932, a course that is now abandoned. One of the first places Ross visited after the war was Charlotte and Myers Park Country Club. Myers Park opened with nine holes in 1921 and followed with nine more in 1927, both nines designed in-house by members. Club records indicate that Ross consulted on the design as early as 1924 and visited again in 1936 to suggest possible land purchases and expansion of the course.

Ross visited Myers Park in May 1945 and completed plans for a new course that would, when it opened in July 1948, overlay the existing routing as well as use new land purchased by the club. Columnist Jake Wade of *The Charlotte Observer* noted following Ross's visit that Myers Park's membership was passionate about golf and that the club should be congratulated for "not sitting still." Wade described Ross as a "white-thatched, aristocratic looking supreme commander of golf at Pinehurst" and noted that Ross had maintained his membership in the PGA of America though he had essentially been a full-time golf architect for more than three decades.

"Mr. Ross looks like a banker and indeed must be quite a wealthy man," Wade wrote. "Yet with his dignity and reserve and gentleness of manner and easy, aristocratic touch, he still likes to be known as a golf professional." Ross was seventy-three years old at this time and certainly beginning to slow down, particularly given the difficult nature of auto and train transportation of the day. He would complete five more courses in North

Carolina prior to his death in April 1948. Highland Country Club in Fayetteville opened in 1945, followed in 1946 by Alamance Country Club in Burlington, Catawba County Club in Hickory and Cape Fear in Wilmington. The last course designed by Donald Ross was Raleigh Country Club. It opened in 1948, just after Ross's death, and was built under the supervision of Ellis Maples.

Raleigh CC was in financial arrears in early 2002 and was on the precipice of being purchased by a developer who planned to raze it for a housing development. In stepped entrepreneur John McConnell, a single-digit handicapper with a keen appreciation for the value of an original Ross course. McConnell had made a fortune in selling a medical records software company and bought the club in 2003; over three years he shepherded a $3 million-plus renovation and revitalization of the club. McConnell said:

> "I feel like I had one of those divine interventions. It said, 'Hey, you need to get involved with this club, because the last thing the city needs is to see this place become something other than a golf club.' I knew it was a special deal. It was just one of those things, with the legacy of Donald Ross and all the club's history—from a marketing standpoint alone it had a special value in regard to remaking the club's image."

The purchase of Raleigh CC was the first of six North Carolina clubs McConnell would buy over the next decade under the umbrella of McConnell Golf LLC, the others being the Cardinal Golf & Country Club in Greensboro, Treyburn Country Club in Durham, Old North State in New London, Sedgefield Country Club in Greensboro, and TPC at Wakefield Plantation north of Raleigh.

No. 2 Once Again in the Ross Tradition: Ross's legacy would be polished and refurbished in another manner as well when Pinehurst officials hired architects Bill Coore and Ben Crenshaw to restore the No. 2 course in 2010–11. Pinehurst President and COO Don Padgett II, a former PGA Tour player, came to believe as the first decade of the 2000s evolved that Ross's *tour de force*, regarded as one of the top layouts in the nation, had lost its essential character as it had gotten greener, more manicured, more lush and more defined on the perimeters by heavy, uniform Bermuda rough. Officials at the USGA, which had conducted the 1999 and 2005 U.S. Opens and would return again in 2014 for a unique double-header of the men's and women's Opens on successive weeks, agreed with Padgett.

Coore, a native of nearby Davidson County, had played No. 2 frequently as a youth and as a collegian at Wake Forest University, and had treasured it for its width, bounce, strategic nuances and its natural character beyond the fairways of native hardpan sand, wire grass, pine needles, pine cones and other donations from Mother Nature. Working from the paths of the original irrigation lines and from 1940s aerial photography, Coore and Crenshaw stripped out football fields worth of rough and restored the original fairway dimensions, leaving the course with the feel and flavor it exuded back in its glory days in the mid-1900s. Coore said:

> "Mother Nature invented golf. But look around everywhere in this country, and you'll see every artificial contrivance imaginable. Pinehurst No. 2 had

become too neat, too perfect, too refined. Our goal was to take it back to the look and feel that Mister Ross knew from Scotland and knew from Pinehurst many decades ago."

Oklahoma native Perry Maxwell tired of the banking business and by the early-1930s had found work in golf course construction and architecture, spending three years with Alister MacKenzie on-site at Augusta National. When MacKenzie died in early 1934, Maxwell was left to continue the fine-tuning of the infant course that had opened in late 1932, working closely with Augusta co-founders Bobby Jones and Clifford Roberts. Roberts liked Maxwell and his work and helped him land an important assignment in Winston-Salem.

A group of Forsyth Country Club members began considering a new club in 1938 when they felt their course was getting crowded. The movement was directed by Charlie Babcock, who managed an investment firm, Reynolds & Company, which was head-quartered in New York and listed Clifford Roberts among its partners. Roberts suggested to Babcock that he should talk to Maxwell about building the new course, leading to an interview and Maxwell landing the design assignment for Old Town Club. Maxwell then created one of the Carolinas' gems on 170 acres of farmland owned by Babcock and his wife, Mary Reynolds Babcock of the R.J. Reynolds tobacco family. The course opened in November 1939.

Maxwell's trademark was his heavily contoured greens fraught with rolls, bubbles and nooks and his irregular shaped bunkers that took on a weathered look. He created a unique double-green concept for the eighth and seventeenth greens, the idea supposedly coming from Roberts and heartily accepted by Maxwell, who loved the double-green concept so prevalent at St. Andrews. The green of the par-three second hole is surrounded by seven bunkers, and its appearance eerily favors the seventh green complex at Augusta National. The course was restored in 2012–13 by architect Bill Coore, who knew the course intimately from his days at Wake Forest University in the late 1960s. Just as he and Crenshaw had done at Pinehurst No. 2, Coore took an Old Town course that had become green and smooth and straight-edged and returned it to its rough-hewn and brown-accented roots.

Alongside Ross for many of his steps in Pinehurst was Frank Maples, whose family had a huge influence in the business of golf course construction and maintenance over the 1900s. Maples traveled from his home in Pine Bluff as a sixteen-year-old in 1902 to take work at Pinehurst on the maintenance crew. He worked his way up, becoming the director of grounds and maintenance and working until his death in 1949. Maples supervised the construction of the four golf courses at Pinehurst Country Club as well as the ones at Pine Needles, Mid Pines and Southern Pines Country Club. He also worked with Ross on literally hundreds of experiments to develop better turfgrass, construction and maintenance procedures. "I remember when D.J. and my dad changed the greens on No. 2 from sand to grass," Ellis Maples, one of Frank's two sons, said in 1960. "They didn't have a single blueprint. They did it all from their head."

Frank and brothers Angus and Walter spawned an impressive family tree of sons and grandchildren who have had considerable impact in the North Carolina golf world. Angus Maples helped build the Pine Needles course and then became its superintendent,

Architect Ellis Maples surveys a fairway clearing beneath the peaks of Grandfather Mountain during construction of the Grandfather Golf & Country Club in the late 1960s.

and his son Palmer was a career golf professional. Of his three children, Palmer Jr. is retired from his career as a golf superintendent in Georgia. Nancy is an accomplished amateur golfer living in Southern Pines and is a former board member of the North Carolina Women's Golf Association. Willie is a teaching professional in Palm Springs, California.

Both of Frank's sons, Ellis and Henson, would go into the golf business. Henson worked thirty years as golf superintendent at Pinehurst Country Club, and his two sons followed in the golf business as well. Gene is retired as executive director of the Turfgrass Council of North Carolina, and Wayne has held several positions in golf maintenance. Ellis had two sons — Dan, a golf architect, and Joe, retired after serving as head professional at Boone Country Club.

Ellis Maples created more than seventy golf courses around the Southeast over the three decades from the early 1950s, including Forest Oaks in Greensboro, Bermuda Run in Clemmons, Grandfather Mountain in Linville and, with Willard Byrd, the Dogwood Course at the Country Club of North Carolina in Pinehurst. Ellis passed the design torch to son Dan, who was helping build the courses as a teenager and has gone on to design courses from Pinehurst to Spain, from Germany to Japan.

Two More Southern Gems: The 1960s saw two of the most significant events in the modern age of Southern golf—the inception and creation of two of the region's golf gems and most exclusive residential communities, Grandfather Golf & Country Club in the mountains and the Country Club of North Carolina in the Sandhills.

Dick Urquhart, a partner in a Raleigh accounting firm, learned in 1961 of a pristine piece of land that sat perfectly in the center of a triangle formed by the towns of Pinehurst, Southern Pines and Aberdeen. The land had been owned for some forty years by a Philadelphia inventor, industrialist and sportsman named John Warren Watson. His company manufactured stabilators, the forerunner to the modern shock absorber, and Watson's wealth allowed him to pursue two of his passions, golf and nature. Watson was a regular visitor to Pinehurst in the early twentieth century, and in the 1920s, he bought 900 acres of virgin pine forest. He dammed up the streams running through the property to create a sixty-acre lake and built a vacation home and boat house.

Watson died in 1961, and the executor of his estate contacted Urquhart to see if he knew of anyone who might be interested in purchasing the land. Urquhart called his good friend, Greensboro businessman and politician Hargrove "Skipper" Bowles, and they drove to Pinehurst in a sleet storm and walked the property in miserable conditions. "We didn't have a nickel's worth of sense between us," Urquhart said.

Urquhart's vision was to create a true private club not only for the Pinehurst area but the entire state of North Carolina. "What could be better than a good club centrally located for nearly all of us, ideally suited for golf, horses, hunting or just plain socializing?" Urquhart asked in a 1962 letter to charter members.

Willard Byrd earned a degree in landscape architecture from N.C. State in 1948 with an emphasis on land planning and hung his shingle in the land planning business in Atlanta in 1956. He was retained to create the master plan for the Country Club of North Carolina, which would include just under 300 residential lots averaging two acres in size apiece. The golf course was routed at the outset, with the lots arranged around the best land for golf. Much discussion ensued at the beginning over the issue of wrapping nine holes of golf around Watson's Lake, thus eliminating some premier lakefront building lots.

At the time, Byrd was not a golf architect *per se*, so Ellis Maples was retained to collaborate on the creation of the golf course, to be named after the preponderance of dogwood trees on the property. The original plans have both the names of Byrd and Maples on the blueprint for each hole. Byrd created the routing and Maples designed the features—the green shapes and undulations, bunkers and placement of hazards.

The original course opened in the fall of 1963, and the par-three third hole featured an island green some twenty years before Pete Dye and the seventeenth at the TPC at Sawgrass became famous. The course was one of the original members of *Golf Digest's* 100 Greatest Golf Courses and stayed in the rankings until 1999, when it was muscled out by the many outstanding new courses from the last two decades. By 1968, the membership had grown enough to accommodate nine more holes. Byrd's business had evolved into full-time golf-course design, and he created the new nine, which opened in 1970 and was named for the Cardinal, the state bird of North Carolina. Robert Trent Jones designed nine more holes in 1980 to create a full 18-hole course,

with Byrd's holes comprising Nos. 1–5 and 15–18 of the new course and Jones' holes fitting in at 6–14.

Grandfather Golf & Country Club was the idea of Agnes Morton Woodruff, a champion golfer of the mid-1900s who won four Carolina Women's Amateur titles from 1948–58. Her grandfather, Hugh MacRae, was one of the visionaries in the development of Avery County and passed along parcels of land to his two grandchildren, Agnes and Hugh Morton, upon his death in 1942. Hugh Morton used his inheritance to create the Grandfather Mountain tourist attraction. Agnes's land sat at the base of Grandfather Mountain, undeveloped for two decades until the idea for a golf club sprouted. The genesis for the new club was a common theme among golfers: She fretted over the crowded conditions at nearby Linville Golf Club and determined the area needed more golf. "I was sitting around with a couple of friends and said, 'You know, it's about time I built my own golf course,'" she said. "I was kind of joking. But then I got to thinking about it."

Agnes knew of Donald Ross's work and respected it very much. Since Ross was nearly twenty years dead, she went to a member of the Ross architectural family tree, Ellis Maples. She was good friends of Maples' cousin, Nancy, and had played Maples' outstanding new course at CCNC. Agnes invited Maples to the mountains to survey the site, and they crawled on their hands and knees through the underbrush and splashed through the streams as they envisioned the course. "I told Ellis I wanted to use enough land so that no hole would be close enough to another that you'd see other people," Agnes said. "I didn't want you to be able to hit a ball onto another fairway. I didn't want any hole to remind you of another on the course. He said, 'I think I can do it.'"

The course was built over two years from 1965–67 and opened in September 1967 with an exhibition match between head pro Bob Kletcke (the head professional at Augusta during the winter months), football hero Charlie "Choo Choo" Justice, tour professional Chi Chi Rodriquez and local amateur maestro Billy Joe Patton. "Grandfather was one of my dad's favorites," Dan Maples said in 2006. "That golf course couldn't be built today—there are too many environmental regulations. How can you put a value on that?"

The Baby Boom Boon: The Baby Boom generation has been compared to a pig moving through a python. Any product, service or cultural phenomena related to the stage of life of these 78 million Americans born from 1945–64 has been huge—whether you're talking about Gerber Baby Food in the 1950s, the Barbie Doll introduction in 1958, Beatlemania spreading in 1964 or the counterculture apex with Woodstock in 1969.

So it would be with the sport of golf as the 1980s dawned. The leading edge of the Boomer generation was in its mid-thirties when Ronald Reagan was sworn in to the office of President of the United States in January 1981. That summer tax rates were slashed. During the second half of 1982, the Dow Jones Industrial average hit a trough at 777 before beginning a monster bull run to 2,722 five years later. The prime lending rate fell from over 20 percent in July 1981 to under eight percent in August 1986.

Combine a thriving economy and millions of Americans maturing to an age where a game like golf has immense appeal and you have the recipe for an explosion in the

game. "You had a huge group of people with money to spend coming of age in the eighties," says Mike Sanders, a former director of golf at Pinehurst and among the original developers of National Golf Club in Southern Pines and Governors Club in Chapel Hill. "They can't play all the active and contact sports they played in high school and college. Golf was the perfect sport. Golf was becoming 'cool' in the eighties."

North Carolina became white-hot for golf development. One of the earliest in this development surge was Elk River Club in Banner Elk. Brothers Harry and Spencer Robbins had developed Hound Ears Club nearly two decades earlier, and several members there told the Robbins they'd be interested in backing them if they ever wanted to do another club. Hound Ears was a resort operation; Elk River would be an exclusive private club. They bought 1,300 acres just to the west of Banner Elk for $1.4 million and hired Jack Nicklaus to design the course. Construction commenced in the spring of 1982 and the course opened in the summer of 1984. Spencer realled:

> "In 1981, Jack Nicklaus was easily the biggest name in golf. We called him and asked if he'd be interested in doing a golf course in North Carolina. He said his son, Jackie, was in school at Chapel Hill and he'd love to do one here. He flew up and we spent the weekend looking at the property. We had a plan and a deal by Sunday morning."

The result was a course offering remarkable variety, the front nine routed through a valley featuring the Elk River and acres of wildflowers and the back nine climbing and descending the mountain slopes.

Fazio's Day Job: Tom Fazio was smitten by the charms of western North Carolina in the mid-1980s when he traveled from his home in South Florida to Cashiers to design Wade Hampton Golf Club—so much so that he and wife Susan moved their family of six children to Hendersonville. The Fazios liked the school system and thought the lifestyle conducive to raising six children; Susan Fazio looked at all the camps in the area and said, "Why not live in a camp environment all year?" So they made the move in 1987. In 1991, Fazio said:

> "There's an airport close by, and I get home for dinner most nights. My day is built around my kids' activities—soccer, dancing, golf, whatever the season might be. Some people said I was crazy when I moved from Jupiter to Hendersonville. It was all about lifestyle and family. And I'm in the middle of some pretty good country to build great golf courses."

If Donald Ross was the maestro of Carolinas golf design in the early half of the twentieth century, Tom Fazio was certainly his bookend at the other end. His fingerprints are in every corner of North Carolina—with seventeen courses his own and an extensive re-design of Quail Hollow Club in Charlotte.

"Some people knowledgeable in golf have called Tom Fazio a modern-day Donald Ross, a guy who designs classic-looking and feeling golf courses, playable for every level of golfer," said Pat Corso, the president and CEO of Pinehurst Inc. from 1987–2004. *Golf Digest* described his work this way in the early 1990s as Fazio's popularity was

soaring: "The regal settings of Fazio's designs, relying on ornate blends of woods and waterscapes, provide instant charm."

Wade Hampton has been the most widely acclaimed of Fazio's North Carolina works, nestling at No. 22 in *Golf Digest's* 2013 list of America's Greatest Golf Courses. Also in the Top 100 were Eagle Point in Wilmington at No. 67, Diamond Creek in Banner Elk at No. 89 and Mountaintop in Cashiers at No. 92. The magazine's rankings of the Top 20 in each state included those four as well as Champion Hills in Hendersonville, Forest Creek North and South in Pinehurst, Pinehurst Nos. 4 and 8, and Old North State Club in New London. "There's nothing loud, just soft, rolling, curving lines," says Wade Hampton developer William McKee. "Tom simply has this uncanny ability to create courses that have an evolved appearance, courses with instant patina."

"A Man Can't Ask for More": The venues are one defining element of the North Carolina golf story. The people plying the clubs and negotiating the wonderful golf courses throughout the state over more than a century are a fascinating chapter as well.

Ben Hogan came from Texas and won his first professional golf tournament in North Carolina in 1940. Arnold Palmer came from Pennsylvania and spent four years at Wake Forest College and had a special place for the state of North Carolina throughout his life. And Payne Stewart came from Missouri by way of Florida to strike one of the most famous shots in U.S. Open history, his 15-foot putt to win the 1999 Open at Pinehurst.

But it was a pair of native sons who best captured the spirit of golf and the amateur game of the mid-1900s—Billy Joe Patton and Harvie Ward. One came from a small town in the western part of North Carolina, one from a small town in the east. One

Billy Joe Patton was known for his fast swing and his affable personality on the golf course during his sparkling amateur career in the mid-1900s.

was a Wake Forest man when the Baptist institution was located in northern Wake County, the other a Tar Heel from the University of North Carolina. Both played golf with flair and color. They talked to the galleries and regaled the news media, their pictures appearing in national magazines (one of them smiling on the cover of *Newsweek*) throughout the 1950s. Both had outstanding short games and were deadly putters. They won five Carolinas Amateur Championships between them.

Each flirted with winning major professional championships in golf. Billy Joe Patton led the Masters on the final day in 1954 before twice hitting into Augusta National's creeks and ponds and finishing third. Harvie Ward was tied for the lead in the 1957 Masters on the final day before hitting into the pond on eleven, making double-bogey and fading as Doug Ford raced to the victory.

Patton led the U.S. Open after one round in 1954. Ward won the U.S. Amateur in 1955 and '56. They played on eight Walker Cup teams (Patton five and Ward three). And both at the height of their amateur careers rejected the idea of turning professional.

"As it is now, I get a terrific kick out of playing golf," Ward said in 1955. "It's a pleasure, rather than work. I like it that way."

"I've had a good life," Patton said in 1994. "I've been happy. I've enjoyed my golf. I've enjoyed my friends. I've enjoyed my family. I've enjoyed my work. I've spent a lot of time doing the things I wanted to do. A man can't ask for much more than that."

Patton was born in April 1922 to Nollie and Margaret Patton of the mountain town of Morganton. Nollie was the vice president of a local bank and had been a scratch player at one time, and Margaret played golf as well, so it was only natural that William Joseph and his two brothers would play golf. The Pattons lived only half a mile from Mimosa Hills Country Club, so Billy Joe could walk over and spend summer days playing forty or fifty holes. "My mother had pictures in my baby book of me holding a golf club at age five or six," Billy Joe said. "I guess that's how I got to be good at golf— I played from a very early age."

Patton's style was established as a youngster. He began swinging hard and never looked back. "I wanted to attack everything," he said. "It was a war within myself, to hit that little ball as far as I could." His knees were bent at address in exaggerated fashion. He had a strong grip, a whiplash waggle and a fast backswing. He cleared his left hip quickly through impact and cut his follow through off at chest level, a move that later prompted Byron Nelson to call him a "slasher."

"Billy Joe was unbelievable," said Reidsville's Patrick Foy Brady. "He was such a personable fellow to go with having a great golf game. He had an incredible short game and was a great putter. He had a sharp wit and loved to gamble."

Joe Cheves, the head pro at Mimosa Hills from 1951 through his retirement in 1981, said Patton paid little attention to technical intricacies, focusing only on getting his clubface square to the line at impact:

> "Back then there were so many different golf swings. Billy Joe had his swing. Arnold Palmer had his swing. Jack Nicklaus had his. Lee Trevino had his. All of them were completely different. But the one thing they all did was get the clubface back to square at impact. That's the one thing Billy Joe worked on."

Patton played at Wake Forest College in the early 1940s and made one of his first significant achievements between his freshman and sophomore years by winning the prestigious Biltmore Forest Invitational in Asheville. He graduated in 1943 and served in the Navy in World War II, advancing to lieutenant and touring the islands of the Pacific. While rocking on a boat in the Pacific, he thought of his return to golf and decided to change his swing when he returned to the States in early 1946.

> "I drive a car fast. I eat fast. I swing a golf club fast. I do a lot of things fast. I decided to try to change my swing to a slower one, a more classic swing. I wanted a picture-book golf swing. Well, I tried it and I couldn't break 80. I said to hell with that. I'll do it the way I want to. I hit a few balls with my old swing and then finished second in the [1946] Carolinas Amateur."

Patton married Betsy Collett in 1948, joining two families that had lived less than a mile apart for generations, and made a living selling lumber for a fellow Mimosa Hills member named Fred Huffman (Patton eventually went into business on his own as a lumber broker). There was no lure of riches in pro golf at the time, so the Pattons started a family (Bill Jr. arriving in 1949, Elizabeth in 1951 and Chuck in 1954) and Patton played as much golf as his schedule allowed.

Patton was 31 years old in January 1954 when he received an invitation to his first Masters Tournament by virtue of being a non-playing alternate for the 1953 American Walker Cup team. While all the pros were playing the tour in Florida and other Southern climes, Patton practiced religiously at lunchtime and after leaving work at 4:30 p.m. At first he was interested in a respectable showing. But he was hitting the ball well as spring arrived and began to think he could compete and even win the tournament. Patton went to a tailor in downtown Morganton and spent $100 on a white sports jacket for the presentation ceremony.

Patton tied for the lead in the first round with a 70 and, after a 74 on Friday, found himself alone in first place. Billy Joe was making friends with the galleries, chatting and laughing with them and making believe he was playing a two-dollar Nassau back in Morganton. Some of the professionals, though, looked at the amateur's homemade golf swing with askance. "If this guy wins the Masters, he'll set golf back 50 years," Cary Middlecoff sniffed.

A 75 on Saturday left him five strokes behind Ben Hogan and two behind Sam Snead, though, and as he surveyed the scoreboard, he thought, "Well, I blew the $100 for the sports coat." His parents had come to Augusta for the week to follow him, but his father decided they should go home Sunday morning because "Billy Joe's not playing his game." But on Palm Sunday, Patton set off with an aggressive, go-for-broke mindset. He played five holes even par and then nailed a five-iron 190 yards on the sixth hole. The ball landed in the cup on the fly, sending the regular Masters patrons and carloads of Patton friends who'd driven down from Morganton into fits of glee.

Patton shot a 32 on the front nine, making the ace and two birdies in the last four holes and erasing Hogan's five-shot lead. The trees were vibrating with cheers.

> "I had rocked out on that little boat out there in the Pacific Ocean during World War II for two and a half years with my golf clubs four or five thousand

miles away," Patton said. "And I had wondered just how good I was as a golfer. I'd sit there and think, out there in the Pacific, if I ever got in position in a big tournament, what would I do?

"And it was kind of eerie standing on that tenth tee years later, Sunday afternoon at Augusta, with the opportunity to find out just how good a golfer I was. Playing in the biggest league, on a prestigious golf course, with one of the major titles at stake, the Masters.

"And I said to myself, 'You're lucky. You're going to get an answer, this afternoon.'"

Patton's drive on the 470-yard thirteenth hole found the light rough just to the right of the fairway. Harvie Ward had finished his round and walked out on the course with fellow North Carolinian Jim Ferree to find Patton. Years later, Ward told *Golf World*'s Bill Fields he was within twenty-five feet of Patton's ball. Ward recalled:

"He didn't have a very good lie. The ball was sitting down a bit. To me, it was a questionable lie. He put his hand on a wood club, and glanced over at Jim and myself. We shook our heads—*No*. Then he touched an iron, and the crowd yelled, 'Go, Joe, go, Joe.'"

Patton doesn't remember that exchange. Instead, he remembers the lie as being decent and deciding, after talking at length with his caddie, that a 4-wood would cross the creek angling in front of the green and get safely to the putting surface. He remembers thinking that he'd been aggressive all week, that if he'd been playing to the middle of greens in the Masters that Hogan and Snead and the other pros would have "beaten me to death."

He flushed the shot, but the ball tailed off slightly to the right as it fell to the green. It never quite had the fuel to fly all the way to safety. "I hit probably one of the best shots I hit the whole week," he said. "The ball carried to the fringe of the green, and on the first bounce was still on the green. Then it toppled back into the creek."

Patton took off his shoes, ventured into the creek and tried to address the ball and find a way to splash it out. The risk-reward was no good, though, so he dropped the ball with a penalty stroke. His sand wedge landed on the fringe of the green. He chipped five feet past the hole, missed the putt and made a seven. The derailment devastated the patrons. Surveying the gloom and doom on their faces as he waited to hit his tee shot on the fourteenth hole, Billy Joe looked at his fans and said, simply, "This is no funeral. Hey, let's smile again." The correspondent from *The London Times* was prompted to remark, "The sooner Mr. Patton pays us a visit, the better." Patton later reflected that he made the remark as much for himself as for his fans; he needed their energy to stoke his own fire.

Patton bounced back with a tap-in birdie on fourteen and, with Hogan making a double-bogey on eleven, the tournament was still up for grabs. Then came the decisive fifteenth hole, another reachable par-5. History often lumps the shots on thirteen and fifteen together—"*The lumberman from North Carolina twice hit into the water on the back nine*"—when actually they were quite different shots and circumstances. The 4-wood on thirteen was a calculated risk from what Patton believed was a reasonable lie;

the shot was well struck but just wasn't quite good enough. On fifteen, however, Patton hooked his tee shot into the trees to the left of the fairway and tried to hit a 2-wood off a bare clay lie. He skulled his ball into the pond fronting the green and made a bogey.

"I could not have put that shot on the green one time in fifty tries," Patton says. "That was stupid. I almost cold-topped it. That was the worst decision I ever made in an important juncture of a golf tournament." Patton finished in third place, one stroke behind Snead and Hogan, with Snead winning the next day in a playoff. But the performance landed him a spot in the heart of the nation's golf fans. It led to an invitation the following week to play golf with President Dwight Eisenhower at Augusta. Eventually, Patton was invited to join the club. He was never forgotten at Augusta, working as a tournament official every year.

Over the 1950s and through the sixties, Patton enjoyed a remarkable run in national circles—not to mention in and around the Carolinas. Patton, who died in January 2011, played on six Walker Cup teams, won three North and South Amateurs, three Carolinas Amateurs and two Southern Amateurs. Patton is memorialized in the Mimosa Hills clubhouse with an oil painting and a plaque that hangs in the stairwell leading to the upstairs dining room. The plaque reads in part: "In appreciation of Billy Joe Patton, unchanged by the glare of golfdom's spotlight in this country and worldwide, he continues to be the same natural, personable player he has always been."

Joe Cheves read the passage one afternoon in March 2007 and said: "That's exactly right. No matter how much fame he got, he never changed one bit."

The Barefoot Golfer: Another small-town boy, this time from the eastern side of North Carolina, was Harvie Ward. He was born in 1925 and grew up in Tarboro and at the age of ten found an abandoned and rusting Otey Crisman putter in a locker at Hilma Country Club and decided to give golf a try. An old-timer at Hilma told him to pretend like he was "swinging at a dandelion," a mental kernel that helped him avoid being "too ball-conscious" and helped him groove a smooth motion. (Sixty years later, Ward would still be using the dandelion imagery to help his lesson pupils solve their ball-bound tendencies.)

"I learned to love the outdoors and the fresh air, surrounded by nature and being able to compete with myself," said Ward, who played golf at Hilma and also by himself around the Town Commons, a 15-acre park set in the middle of Tarboro amid towering oaks and surrounded by neighborhoods of Georgian and Queen Ann homes. Harvie took to the game quickly, despite playing barefoot and using a homemade grip he later called "The Harley."

"It looked like I was revving up a motorcycle every time I swung the club," he said, adding he had to aim twenty yards to the right of every target and hope his ball would curl back into the fairway or green.

In 1939 Ward traveled to Linville Golf Club in the mountains to participate in the prestigious Linville Men's Golf Tournament. He led after the first day, prompting the sports editor of *The Charlotte News* to contact the club for a photo of Ward. The club in turn summoned a young counselor at Camp Yonahnoka named Hugh Morton to take Ward's photo. "Nobody thought a 14-year-old kid would do anything but flounder

in an event like that, because at the time it was one of the top men's tournaments in the South," Morton said. "When Harvie Ward won, it was quite a sensation."

Ward shot a 62 at Hilma at age 17 and added to his successes with the 1940 and '41 Carolinas Junior Championship, known at the time as the Max Payne Junior Tournament and held annually at Greensboro Country Club, and the 1942 Biltmore Forest Invitational. After graduating from prep school at Virginia Episcopal, Ward entered the University of North Carolina in January 1943, then left in 1944 after being drafted into the Army. He returned to Chapel Hill following a 36-month military commitment.

Ward played a game that golf writer and historian Herbert Warren Wind once described as "archaically relaxed" and possessed a "rare gracefulness to his shotmaking that made him a treat to watch." He made his first national splash in the 1947 U.S. Amateur at Pebble Beach, advancing to the quarterfinals before losing. The following April, he won the North and South Amateur at Pinehurst No. 2, nudging career amateur Frank Stranahan in front of a boisterous gallery of UNC students who'd "road-tripped" seventy miles from Chapel Hill. With caddie Barney Google reading the greens, Ward one-putted eighteen greens in thirty-six holes and snared a 1-up victory. "I admire his politeness, his pleasant manner and his putting," said spectator Chick Evans, the 1916 winner of the U.S. Open and U.S. Amateur.

Ward won the NCAA championship the following spring and had a rematch with Stranahan in the North and South, this time Stranahan prevailing 2-and-1. Ward

Harvie Ward follows the flight of his tee shot during the North and South Amateur at Pinehurst in the late 1940s.

received his degree at Chapel Hill but didn't think pro golf was the proper career move, given the difficulty of the travel and the fact the money wasn't better than he could make in private business. "I have all I can do to play the amateur game and keep my meals down," Ward said.

Ward started his business career in the life insurance industry in Fayetteville in the summer of 1950 and soon after moved to Atlanta to join the investment banking firm of Courts & Company. It was in Atlanta that he met the first of his five wives. During travels to USGA events, Ward met and befriended a USGA official and executive committee member named Eddie Lowery. Lowery was a San Francisco automobile dealer whose claim to golf fame had been his role as caddie for Francis Ouimet in Ouimet's landmark win over Harry Vardon and Ted Ray in the 1913 U.S. Open at Brookline. Lowery offered Ward a job as a salesman and goodwill ambassador; Ward accepted and moved west in October 1953. He soon was making $35,000 a year, several times that which top touring pros were drawing in tournament winnings. From matches at Harding Park with fellow Lowery employee Ken Venturi … to USGA competitions … to professional tournaments like the Masters and Bing Crosby Pro-Am, Ward was a force. "The most talented amateur of the decade, no question about it, was Harvie Ward, the consummate stylist from North Carolina," Wind wrote in *The Story of American Golf.*

It took Bobby Jones nine tries to win the U.S. Amateur, and Ward entered eight times between 1947–54, never making it past the quarterfinals. He was beginning to hear the whispers that maybe his game wasn't as good as it was pumped up to be as the 1955 U.S. Amateur began play in September at the Country Club of Virginia in Richmond with a field that included Venturi, Doug Sanders and Billy Joe Patton. And Ward found himself at a delicate precipice in the second round (his first match as he had a first-round bye).

Ward was 1-down to Michigan's Ray Palmer through seventeen, and both hit their tee shots down the left side of the eighteenth fairway. Palmer's ball was in the thick rough by three inches; Ward's ball was a few yards away, but in the fairway by three inches. Palmer couldn't dig out of his bad lie, and his approach found a yawning bunker in front of the green. Ward played safely onto the green, two-putted and won the hole to force a playoff. He won on the first extra hole with a twenty-five-foot birdie putt.

Ward rolled through four opponents and then obliterated Bill Hyndman 9-and-8 in the championship match. He missed one fairway and four greens in twenty-eight holes against Hyndman and used only twelve putts the first nine holes in shooting 31. Hyndman won only one hole, that with a seventy-five foot birdie putt. "I was playing like I was possessed, like it was *my time*," Ward said. "I was so pumped up. I was bound and de-termined to beat somebody, and it just happened to be poor Bill Hyndman. I felt like, man, this is my chance."

Ward successfully defended his Amateur title the following September, bouncing Chuck Kocsis 5-and-4 at Knollwood Club outside Chicago. During this period he was on the American team in the Walker Cup Matches in 1953, '55 and '59 and did not lose one match in that biennial competition of top amateurs from the States and Great Britain. He also competed in eight U.S. Opens, finishing sixth in 1955, and finished in the top twenty-four in four of the eleven Masters in which he competed.

Ward's idyllic golfing life took a sharp turn for the worse beginning in May 1957, when his boss, Lowery, testified in San Francisco before a grand jury investigating his income tax returns and said he paid for Ward's expenses to the Canadian Amateur in 1952 and to the U.S. Amateur in Detroit in 1954. In justifying the costs as a business expense, Lowery said he picked them up as a reward "for Harvie's good work as a salesman."

At that point, the story became public record and came to the attention of USGA Executive Director Joe Dey and the executive committee. The rules at the time prohibited an amateur golfer from accepting expenses from any source other than one on whom the player is normally or legally dependent. The rules stated specifically that an employer cannot stand for the expenses of an employee in an amateur event.

"Harvie was treated badly by fate," fellow amateur golf great Bill Campbell said. "If not for the court case, it would never have come out. The story would have been different." Ward said he did not accept expense money, that the money from Lowery was a loan. "I borrowed $11,000, but it was strictly a loan," he said in an Associated Press dispatch published May 7, 1957. "I have paid some of it back."

The 13-member executive committee unanimously decided Lowery's financial assistance beginning with the British Amateur in 1952 through the Colonial Invitational in May 1957 "violated the rules of amateur status." The penalty usually called for a two-year suspension, but Ward's was reduced to one year because of "mitigating circumstances."

"That shocked and just about killed me. I couldn't believe it happened to me," Ward said. He was reinstated eleven months later and entered the 1958 Amateur at the Olympic Club in San Francisco and made one more splash in amateur golf, beating Jack Nicklaus 1-up in an early round after sinking twelve putts six feet or longer and chipping in from off the green from inside a refreshment stand. Ward lost to Ward Wettlaufer in the fifth round, 3-and-2. But his competitive golf career was essentially over. Ward said:

> "I guess there were about three or four years I was eligible to play in the Masters and I didn't even go. I didn't really care about golf. I played my final Masters in 1966 because that was my last year of eligibility. I played awful [shooting 81–84 to miss the cut]. I didn't care, hadn't trained."

Ward spent the last fifteen years of his life living quietly in Pinehurst with wife Joanne before his death in August 2004. He drove a black Jaguar with a personalized license tag "Harv," played a little golf, taught at Pine Needles and Forest Creek Golf Club and mentored a network of young club and teaching professionals he had developed over the years. Ward told friends he "felt like a kid all over again" as he renewed his love of golf. The Carolinas Amateur returned to Highland Country Club in Fayetteville in 1999, fifty years after Ward won that title at Highland in 1949. Ward spoke to the thirty-two golfers who advanced to match play and entertained them with stories of his life in golf.

"Harvie never lived an unpleasant day in his life," said Furman Bisher, the late columnist of the *Atlanta Journal*. "Or if he did, he didn't show it. He was among the most untethered, unabashed people I've ever known."

"I never saw Bobby Jones play, but I saw everybody else, and Harvie was the best amateur I ever saw," Venturi told Tarboro native Joe Logan in a 1998 edition of the

Philadelphia Inquirer. "That's the best *amateur.* Harvie didn't have a pro bone in his body. He was too much a free spirit."

No Pros Need Apply: They were an impressive bunch, the state's top amateur golfers of the mid-twentieth century — Patton and his nine-lives escape ability; Ward's smile and his nuance for making wedge shots dance the polka; brothers Charles Smith with his controlled fade and Dave Smith with his prodigious power; Bill Harvey's skills at golf all day and cards all night; Dale Morey's golden putter and his single-minded drive to win as many golf tournaments as humanly possible; and "the dashing Dick Chapman" (words of *The New York Times*), the Pinehurst devotee who never tired of dissecting golf's swing intricacies.

Wilmington's Hugh MacRae II remembers the panache of amateur golf in the middle of the century.

> "Amateur golf was tops in those days. Winning the national amateur was equivalent to winning one of the big four nowadays. The CGA Amateur was considered a very big golf tournament to win. It still is. But in those days, when amateur golf was so important, the championship had a lot of prominence."

Ward added:

> "Amateur golf was *the* game when I was coming along. Most clubs wouldn't let the pros in the clubhouse, and if they did, they came in through the back door. Amateurs carried a lot of respect."

Fred Laxton of Charlotte and Eugene Mills of Raleigh were two of the early golfers to beat in CGA competitions, each winning the Carolinas Amateur three times from its inception in 1910 through the early 1930s. Walter Paul of Charlotte, Roland Hancock of Wilmington and Tully Blair of Greensboro were each two-time winners of the Carolinas Amateur before World War II. Over the next two decades, Patton won three Carolinas Amateurs, Harvey three, Ward two, Chapman two, the Smith brothers one each and James McNair two through the early 1970s, when the college golfer began to assert his influence. "That was a great time," Harvey said. "I loved every minute of it. We had some great golfers and competitors. I was a lucky man to be able to do what I loved to do."

Harvey's father Ernest was head pro at Sedgefield Country Club in Greensboro, and Bill learned the game as a caddie. He developed his skills playing at High Point College and was good enough to attract the attention of a Baltimore industrial concern looking to beef up its company golf team. During the winter months, Harvey inspected aircraft manufactured by his employer, Martin Aircraft; during the spring and summer, he was out playing golf. He was newly married and had a baby girl, and after two years moved back to North Carolina. Harvey sold insurance briefly and used the golf course to develop his client list. Eventually he learned he could make more money playing golf than selling insurance. He also bought a driving range near Sedgefield that he still owns; Scott Harvey, one of his two older sons from a previous marriage, operates the driving range today.

Harvey played in 18 U.S. Amateurs and four decades worth of Eastern Amateurs and Porter Cups, riding his consistent ball-striking—particularly with the driver and long irons—and ability to drain the long putt to great advantage. Harvey won ten tournaments in a magical year of 1973; it would have been eleven had he not lost in a playoff for the North and South Amateur. Harvey lamented:

> "I just wish I'd been a better putter. I might have won a few more tournaments. I might have won the U.S. Amateur. I could hit seventeen greens and three-putt three or four times. I might make a fifteen-footer and then the next hole run it past three feet and miss the putt coming back."

The Smith brothers of Gastonia were another thread to this mid-century fabric of amateur golf in North Carolina. David W. Smith Sr. ran a Chevrolet dealership in Gastonia and played golf at Gaston Country Club. Sons Dave and Charles, born in 1927 and 1931, respectively, learned the game as caddies. Charles started playing the game left-handed, but after World War II, clubs were scarce so his father told Charles to play with the right-handed clubs he owned. "Take mine and just turn around," Smith told his son.

The Smith brothers became excellent players and were forces in CGA and club events for many years; both also competed and had success on national levels. Dave was called "Big" or "Big-un" and was a long-hitter, a consistent ball-striker but an average putter at best. Jack Nicklaus won the 1961 U.S. Amateur at Pebble Beach and beat Smith on the nineteenth hole in an early round. Charles said:

> "Dave hit a 1-iron better than any player I've ever seen. Nicklaus couldn't hit it any better. But he was horrible around the greens. He invented the claw grip long before anyone else used it. From five feet in, he was not very good. He took a lot of ribbing about it."

Dave lived in Gastonia all his life before passing in September 2004. Charles moved to Florence in 1967 to open a Chevy dealership and moved back to Gastonia in 1993. He played on two Walker Cup teams and won one North and South Amateur and one Carolinas Amateur. He died in March 2011.

The 1961 North Carolina Amateur field featured three Walker Cup team members—Patton, Charles Smith and Dale Morey. Reidsville's Patrick Foy Brady sank a fifteen-foot putt to birdie the seventy-second hole and win the tournament, this after entering the final round with a ten-shot lead. Brady shot 74 to Morey's 64 and had to birdie three of the last four holes. "That's a pretty strong field," Brady says. "Three of the best amateurs on a national level were right here in North Carolina."

Morey moved from Indiana to North Carolina in 1960 in part because of golf. Morey was a native of Indiana, played golf and basketball at LSU and tried both sports briefly on a professional level out of college. He launched a career in sales and worked as a rep for an Indiana sandpaper company. That company eventually added furniture hardware to its business, and Morey began learning about the furniture industry. He and his wife Martha were good friends with Billy Joe and Betsy Patton, and Patton sold Morey on the idea of moving to Morganton, which was conveniently located in a furniture man-

ufacturing hotbed. The Moreys came south, spent three years in the North Carolina foothills and then moved to High Point to be even closer to the Piedmont furniture industry.

"Actually, Dale wanted to retire to Pinehurst, so he kept moving closer and closer," says Martha Morey, who was still living in High Point in 2007 following her husband's death in 2002. Morey won thirty-one CGA events, including seven Senior Amateur titles. He won two U.S. Senior Amateur Championships and finished second to Gene Littler in the 1953 U.S. Amateur. He was CGA president in 1988–89.

Harry Welch of Salisbury played football for coach Wallace Wade at Duke and was a member of the unbeaten team of 1938. He won the 1966 Carolinas Amateur, the 1963 Carolinas Four-Ball (with Jack Crist Jr.) and played in five U.S. Opens and Amateurs. He and Dale Morey essentially owned the early years of the Carolinas Senior Four-Ball, winning the first four tournaments from 1969–72 and then three more over the next decade. "Harry Welch would have dominated our events except for the fact that Dale Morey comes out of Indiana and takes over the amateur scene," long-time CGA Executive Director Hale Van Hoy said.

The town of Reidsville and its nine-hole Donald Ross course, Pennrose Park, have produced two formidable family trees of golfers: the Bradys (Pat, Pat Foy and Patrick) and the Goodes (Ben and Mike).

Pat Brady won three club titles at Pennrose from 1939–44. Son Pat Foy won eight times, including five straight in the 1960s, and his son Patrick has won six club titles. Pat Foy and Patrick won the inaugural CGA Father-Son Championship in 1967 at Pinehurst No. 2, and Pat Foy won the inaugural North Carolina Amateur in 1961.

Ben Goodes won the 1964 and 1967 CGA Senior Amateur and teamed with Posey Isley to win the inaugural Carolinas Four-Ball in 1950 and with Bill Harvey to win in 1966. Son Mike won the North Carolina Amateur in 1989 and the Carolinas Mid-Am in 1998 and 2004 and then had a dream year in 2006, collecting the N.C. Amateur and the Carolinas and N.C. Mid-Ams. He entered Q-School for the PGA Champions Tour in November 2006, collected his card and joined the tour in 2007. Through mid-2013, Goodes had won one Champions Tour event, had seventeen top 10 finishes and won nearly $3.5 million.

By the late 1960s, the appeal of golf's "Big Three" of Arnold Palmer, Jack Nicklaus and Gary Player had attracted many more players to the game. College golf was becoming "big-time." There was money to be made on the professional tours. Amateur golf events were beginning to be dominated to a large degree by young college-age players. Lumberton's Leonard Thompson was on the golf team at Wake Forest and was twenty-three years old when he won the Carolinas Amateur at the Dunes Club in Myrtle Beach in 1970; following him that decade in winning the championship were other teenagers or early-twenties golfers who would go on to successful collegiate and/or professional careers—David Canipe of Fayetteville, David Thore of Reidsville and Chip Beck of Fayetteville.

Durham's Dan Hill said:

"For many years, the guys you had to worry about were Dale Morey, the Smith brothers, Bill Harvey, Harry Welch, those guys. Those were guys that the

younger players were intimidated by. That started to shift in the seventies and eighties. Now all of sudden, it was the college guys you had to worry about. They started taking over amateur golf."

The unquestioned luminary in men's amateur golf as the twenty-first century approached and arrived has been Paul Simson, the insurance executive from Raleigh. Through July 2013, Simson had won twenty-five CGA championships and three times won Carolinas Player of the Year. Simson enjoyed a monster year in 2010, becoming the first player ever to win the men's senior amateur titles for the United States, Great Britain and Canada in the same year. He has won the U.S. senior title twice overall and the British championship three times.

Simson's game and demeanor have impressed opponents and onlookers in several respects—his deadly short game and his relaxed attitude and broad smile underneath his trademark straw fedora. In 2006, at the age of fifty-five, Simson said:

> "I think as you get older, you mellow out a bit. I just love to play and I love the competition. I get a charge particularly out of playing the college kids I don't know that well. You beat some of these guys and they say, 'How'd he beat me? He's not as good as I am.'"

Equally dominant among the ladies' set was Estelle Lawson Page of Chapel Hill.

Robert B. Lawson was one of the best baseball players ever at the University of North Carolina, losing just one game as a starting pitcher for the Tar Heels from 1898–1900. He also played football and ran track and had a short stint in major league baseball, then returned to Chapel Hill to become a professor and direct the university's physical education program. His pride and joy was Estelle, his baby dynamo born in 1907 with the cherubic face and deep reservoir of energy.

Lawson took his daughter to his office on campus and she hung around Woollen Gym, learning gymnastic stunts and serving two years as a mascot for the Tar Heel football team. In high school Estelle excelled in basketball and tennis (playing on state title teams in both sports), and graduated with honors from UNC in 1928. It wasn't until 1931, when Estelle was twenty-four, that she first held a golf club.

Chapel Hill Country Club was a nine-hole facility carved into a hilly tract of land just east of campus and, in the early part of the thirties, suffered as many golf facilities did in the weak economic times and was threatened with foreclosure by the bank. It was called "Goat Hills" as the land's owner, university botany professor William C. Coker, raised goats on the property before allowing the club use of the land for golf. The club had only 30 dollars in membership revenues, and Robert B. Lawson was asked to take over management of the course. Since he didn't know a tee from a green, he figured he'd best learn the game he was now involved in managing.

He bought four clubs for himself and his daughter—a brassie, 2-iron, 5-iron and putter—and they set about teaching themselves the game and mimicking the moves they saw from other golfers. Estelle had been thinking about playing professional tennis, but it was hard to find competition as boys didn't like to beat up on a girl and the girls didn't offer her enough challenge. "I took to golf because I could play it by myself," she said. Within a year, Estelle won her first Women's Carolinas Golf Association title,

beating Dean Van Landingham and Jane Cothran at Sedgefield Country Club in Greensboro. She successfully defended in 1933 at the Country Club of Charleston. Estelle's career took off in the mid-1930s. Always wearing her lucky blue colors and spiriting a rabbit's foot in her pocket, Page won six more WCGA titles from 1936–49. She won seven North and South Women's Amateur championships in Pinehurst from 1935–45. She participated in two Curtis Cup Matches (1938 and '48) and won the first three N.C. Women's Amateur Match Play Championships from 1950–52. By 1937 she held course records at clubs throughout North Carolina — a 71 at Greensboro Country Club, 73 at Raleigh Country Club, 69 at Chapel Hill and 76 at Myers Park in Charlotte.

Estelle could take her game on the road as well. Referenced by national wire service reporters as "the husky North Carolinian," she won the qualifying medal at the 1936 Women's Amateur at Canoe Brook Country Club in Summit, New Jersey, with a course-record 78. She won the Amateur championship the following year in Memphis. She had to come from 3 shots down against Kathryn Hemphill in semifinals to win on the first playoff hole, then advanced to meet Patty Berg in the final.

Estelle won handily, 7-and-6, prompting accolades like this from O.B. Keeler in the *Atlanta Journal*: "I have no hesitation saying she is the greatest 'natural' golfing competitor in the game today; perhaps the greatest our country has yet produced."

The Game for Women: Following World War II a decade later, women began making more inroads into golf's competitive circles. The North Carolina Women's Golf Association was formed in 1950. Page won the first three championships from 1950–52, and Marge Burns then won eight of the next eleven titles and ten total through 1968.

North Carolina was home to the first formal effort to organize ladies golf into a professional tour. Hope Seignious was an avid golfer and the daughter of a Greensboro cotton broker, and in 1946, she joined with Betty Hicks and Ellen Griffin in forming and incorporating the Women's Professional Golf Association. The WPGA organized the inaugural U.S. Women's Open, which was held in 1946 at Spokane Country Club and sponsored by the Spokane Athletic Roundtable, a men's fraternal organization that contributed some of the purse from its slot-machine revenues; Patty Berg won the title in a match-play format. The following year, the format was changed to seventy-two holes of stroke play, and the Open was held at Starmount Forest in Greensboro with a field of thirty-nine players — ten pros competing for $7,500 and twenty-nine amateurs. Betty Jameson became the first woman to break 300 for seventy-two holes, her 295 total winning by six strokes.

The WPGA struggled to gain any real traction, and Seignious was running out of her personal savings in running the tour, and her father had made all the contributions he cared to make. In 1949, Fred Corcoran, the manager of Babe Zaharias and a former PGA Tour official, joined with Wilson Sporting Goods owner L.B. Icely to contribute their marketing and management expertise and financial resources. The women's tour was reformulated, with the Ladies Professional Golf Association being chartered in 1950. Corcoran was named tournament manager.

Peggy Kirk Bell has certainly been the grand dame of the women's golf scene in North Carolina over the last half century. She married hometown sweetheart Warren "Bullet"

Bell in 1953, and the newlyweds moved from their native Ohio to Southern Pines to operate the Pine Needles resort they had just leased with their partners, the Cosgroves (who owned Mid Pines across Midland Road) and the Cosgroves' son-in-law, touring pro and 1951 U.S. Open champion Julius Boros. Bullet ran the resort while Peggy spent much of her time flying her Cessna plane around the LPGA Tour. Her competitive career peaked shortly after college (she won the 1949 Titleholders in Augusta and made the 1950 U.S. Curtis Cup team), but she began making her true mark in golf in the mid-1950s as the Bells eventually bought out their partners and expanded the Pine Needles resort facilities.

Peggy began teaching golf in 1954 and several years later she and Bullet conceived the women's golf school concept. Since then, she has grown into legendary status in golf teaching circles (she's among the top teachers in America as listed by *Golf Digest* and *GOLF* magazines), and Pine Needles and its Donald Ross-designed course have hosted three U.S. Women's Opens. The family joined a cadre of investors in buying Mid Pines in 1994 and the sister resorts continue to thrive no matter the ebbs and flows of the economy and golf business. During the 2007 U.S. Women's Open at Pine Needles, Peggy said:

> "For us to have had three Opens on a golf course we bought that had nothing but weeds and scrub oaks right up to the fairway is an amazing story. Bullet and I both loved the game and we both wanted to be in our own business. All I've done is play a wonderful game. It's been a joy and a blessing."

Club Pros and a Man Called "Doog": Among the deans of the club pro business in the Carolinas was Lexington's Dugan Aycock, who answered to the nickname of "Doog" and to the appellation of "King of the Jungle" for his frequent trips to the forest in search of his wayward drives. Aycock was born in Charlotte in 1908 and started in golf as a caddie at Charlotte Country Club. His early career as a club pro included stops in South Boston, Virginia, and High Point before being hired to design a new course for Lexington Golf Club. The course opened in 1938 and Aycock stayed on as head pro, a job he would hold for some four decades.

Aycock was renowned in Davidson County and throughout the Piedmont for welcoming all juniors to the game regardless of their ability to buy clubs and balls and pay for greens fees, and he frequently helped fellow club professionals in times of personal or professional need. Aycock was president of the Carolinas PGA for 15 years, was national PGA vice-president and named national Professional of the Year by the PGA in 1957. He's gained induction into a variety of halls of fame, including the North Carolina Sports Hall of Fame and Carolinas Golf Hall of Fame. The Davidson County Amateur is named in honor of Aycock.

Two transplants from the Northeast and one from Arkansas made their mark in North Carolina golf circles. Tony Manero grew up in Westchester County, New York, learned golf as a caddie and club-polisher and won the 1932 Westchester Open. He moved to Greensboro in the depths of the Depression to become head professional at Sedgefield Country Club, and in 1936 the club gave him time off to play in the U.S. Open at Baltusrol. The thirty-one-year-old Manero shocked the golf world by edging

Harry Cooper by two shots to collect the title, setting an Open scoring record in the process with a 282 total. He returned to Greensboro several weeks later and was honored with a parade and much fanfare, then resigned from Sedgefield that fall to devote his attentions full-time to the pro golf tour. Manero played in the 1937 Ryder Cup Matches and won a total of ten professional events.

Dick Chapman was a native of Greenwich, Connecticut, and moved after World War II to Pinehurst, where his father owned a winter home for many years. *Time* magazine once said "Chapman majored in golf most of his life" and also described him as "the New York and Pinehurst socialite." Chapman was another prolific amateur champion on Carolinas, national and international levels in mid-century. He won the 1940 U.S. Amateur title at Winged Foot Golf Club, where he was a member, and complimented that with the amateur titles of Canada, Great Britain, Italy and France. He played on three Walker Cup teams and won the 1953 and '57 Carolinas Amateurs and the 1959 Carolinas Four-Ball (with Arthur Ruffin Jr. of Wilson).

Davis Love Jr. was born and raised in Arkansas and played collegiate golf at the University of Texas for the noted teacher and professional Harvey Penick. His first job as a club pro was at Charlotte Country Club, where he served from 1962–64. His bride Penta was pregnant with their first child when Davis was invited to the 1964 Masters Tournament. He shot a first-round 69 to share the lead with eventual champion Arnold Palmer, Gary Player, Kel Nagel and Bob Goalby, but faded with rounds of 75–74–76. The Monday following the tournament, Davis III was born.

Love Jr. left for Atlanta Country Club later that year and then moved to Sea Island Club at St. Simon's Island, Georgia, but Davis III found his way back to North Carolina when he matriculated at the University of North Carolina from 1982–85.

Love Jr. went on to a distinguished career as a teacher and wrote frequent instruction articles for *Golf Digest* magazine before perishing in a plane crash in 1988 at the age of fifty-three. He also qualified for the 1974 PGA Championship, held on the Championship Course at Tanglewood Park outside of Winston-Salem.

"I was ten years old and remember being awed by the whole atmosphere," Davis III said after winning the 1997 PGA Championship under the glow of a rainbow at Winged Foot Golf Club. "What a great life. So to win the PGA and have that rainbow, it's the best thing for my dad's legacy."

Snead's Foe, "Old Stone": Johnny Palmer was born in 1918 and grew up in the small town of Badin, learning the game as a caddie at Stanly Country Club. After serving in the Air Force in World War II, Palmer turned pro in 1946 and became known as a magician with the wedge and putter during the heyday of his pro career over the next two decades. Sam Snead called him "Old Stone" because Snead could never tell by Palmer's demeanor whether he was 5-under or 5-over. He won five PGA Tour events, including the 1952 Canadian Open and 1954 Colonial Invitational. Palmer was sixth in the 1947 U.S. Open, fourth in the 1949 Masters and a member of the 1949 Ryder Cup team. He also won five Carolinas PGA titles and three Carolinas Opens.

Johnny Bulla was born in 1914 in Asheboro and grew up in Burlington. He was initiated into golf as an eleven-year-old caddie at the now-defunct Burlington Country

Club. He twice finished as runner-up in the British Open and once in the Masters, and in some thirty years on-and-off the pro tour, he won only once — the 1941 Los Angeles Open. Bulla was known more for his ability as an airplane pilot — he worked for Eastern Airlines from 1942–45 — and flew his own plane from tour stop to tour stop.

Skip Alexander was born in 1918 in Philadelphia, and his family moved to Durham when he was a boy. Alexander was captain of the Durham High golf team and played golf at Duke University, winning two Southern Conference championships and helping the Blue Devils win four team titles. Alexander won the North and South Amateur in 1941 and went to work for Dugan Aycock at Lexington Country Club as assistant and playing pro. Alexander moved to Mid Pines in Southern Pines from 1947–49 and was the touring pro there while playing the PGA Tour. He won three tournaments and was on the 1949 and '51 U.S. Ryder Cup teams.

Clayton Heafner was born in Charlotte in 1914 and learned golf as a caddie at Charlotte Country Club. He worked for Aycock at South Boston, Virginia, as a young assistant pro, and had stints at Sedgefield, Charlotte CC and Linville Golf Club. He also worked in a Charlotte candy factory during the off-season and acquired the nickname "The Candy Kid." Heafner first tried the pro circuit in 1939 at the age of twenty-five and that June shot a third-round 66 in the Saturday morning round to take the lead of the U.S. Open at Philadelphia Cricket Club, that being the era of the thirty-six hole finale on Saturday. After the round, he was hounded by equipment reps, sports writers and autograph hounds. Unaccustomed to the attention and without a "handler" to run interference, Heafner never got to eat lunch, rushed to the tee for the afternoon round and shot an 80, falling far behind winner Byron Nelson.

Heafner was large physically (six feet, one inch and more than 225 pounds) and had a temper to match. "Clayton was the most even-tempered golfer I ever saw," Sam Snead said. "He was mad all the time." But Heafner was also known for his big heart and generous nature, always giving his time for charity exhibitions. After a solid touring career — seven PGA Tour wins, two Ryder Cup Matches and runner-up finishes in the 1949 and 1951 U.S. Opens — Heafner settled into post-tour life in Charlotte by purchasing and operating Eastwood Golf Club. Heafner died at the age of 46, less than a week after suffering a heart attack the day after Christmas in 1960. Son Vance became an outstanding golfer and enjoyed a PGA Tour career in the 1980s and teamed with Mike Holland in 1981 to win the Walt Disney Team Championship. He spent fifteen years as a club pro at Prestonwood Country Club in Cary and was an occasional participant on the Champions Tour prior to his death in 2012.

L.B. Floyd was an Army master sergeant stationed at Fort Bragg in Fayetteville in 1941 when some buddies cajoled him into joining them for a round of golf. Floyd was skeptical, calling the game "cow-pasture pool," but he quickly came under the game's spell and taught himself to play. In less than six months, he was giving lessons to others and was off on a brand new career in the golf business, one that would see him provide lessons, mentorship and places to play for Cumberland County golfers for six decades. Floyd was named head professional at Fort Bragg's Stryker Golf Course in the early 1950s, and he later operated and was part-owner of Green Valley Golf and Country

Club in Fayetteville and in 1968 went into business with Al Prewitt to develop and build Cypress Lakes Golf Club in Hope Mills.

Son Raymond was born in 1942 and daughter Marlene followed in 1948, and both youngsters developed outstanding golf games under the tutelage of their father. Raymond was adept at both baseball and golf, winning the National Jaycees Junior in 1960 in Waterloo, Iowa, and receiving an offer to pitch in the Cleveland Indians' farm system. Floyd briefly attended the University of North Carolina on an athletic scholarship but left to try the professional golf tour. Those plans were delayed for two years by military service.

Floyd joined the pro golf tour in 1963 and won his eleventh start at the St. Petersburg Open, becoming the fourth youngest player to win a PGA Tour event at the age of twenty years, six months. He collected $3,500 in official money but quickly signed endorsement contracts with Wilson Sporting Goods, Munsingwear shirts and Footjoy shoes and estimated his total haul for the victory at $10,000. "I've always thought he had the equipment to be a winner, and now I'm sure of it," L.B. said after his son nudged Dave Marr by one shot to win the tournament.

Floyd's swing was unique with its hitch in the backswing and a noticeable lurch through impact, but he was efficient with it and he rode it to twenty-two wins on the PGA Tour and four major championships, including an eight-shot cruise in the 1976 Masters and a triumph in the 1986 U.S. Open at the age of forty-three. Floyd was appointed to eight Ryder Cup teams and is a member of the World Golf Hall of Fame; he and Snead are the only pros to have won official events in four decades.

A Talk with Jackie Robinson: Charles Sifford was born in Charlotte in 1922 and learned at the age of ten he could make more money as a caddie at Carolina Country Club than the two dollars a week his father earned as a laborer. He earned sixty cents a day and gave his mother fifty cents, keeping a dime to buy the cigars that would become his trademark on the golf course. The club was closed on Mondays and the caddies were allowed to play, and Sifford fell in love with the game. He could shoot par by the age of thirteen. He and some friends would sneak onto the course at odd hours; such subterfuge required swift play, so Sifford learned to hit the ball straight (less time in the woods) and to play quickly on the putting greens. Often the boys had to share clubs, all the more reason to hit the ball quickly, and sometimes they putted with a 2-iron if a putter wasn't available. "I was always moving fast to keep from being thrown off the course," he said. "I never learned how to take my time on the greens and develop a decent stroke."

Sifford joined some relatives in Philadelphia and found liberal opportunity to play on public courses in the North. He continued to develop his game and played on the United Golf Association tour, where blacks could compete for small purses on public courses, and won five straight National Negro Open championships from 1952–1956. Sifford had the opportunity to meet baseball player Jackie Robinson, who broke the color barrier in major league baseball in 1946, and Sifford told Robinson he intended to do the same thing in golf.

Sifford recalled:

"He asked me if I was a quitter. He said, 'Okay, if you're not a quitter, go ahead and take the challenge. If you're a quitter, there's going to be a lot of obstacles you're going to have to go through to be successful in what you're trying to do.'

"I made up my mind I was going to do it."

Meanwhile, the seeds of integration were taking root in the South. In 1960, four students from North Carolina A&T State University sat down at the Woolworth lunch counter in downtown Greensboro and refused to budge. Members of the GGO-sponsoring Greensboro Jaycees decided to invite Sifford to the 1961 tournament, and host club Sedgefield Country Club passed a resolution saying that "neither creed, color nor race" would be basis for rejecting an applicant to play in the tournament. The Jaycees asked long-time Lexington Country Club professional Dugan Aycock, whom Sifford had caddied for years earlier at Carolina Country Club, to call Sifford and extend the invitation.

Sifford said:

"When Dugan called, I asked my wife should I go, and she said, 'Yeah, go ahead, they aren't going to do anything to you down there,' and they didn't. Those people, they treated me nice. That pro there [the late Tom Case], he took care of me."

Sifford led the first round with a 68 and got phone calls that night from people threatening him if he showed up for the next round. "I just told them whatever they were planning to do, be prepared to do it because I still planned to tee off at 9:30," he said.

There were no incidents as security patrols removed any trouble-makers from the golf course. Sifford earned a $1,300 check for finishing fourth behind winner Mike Souchak, Sam Snead and Billy Maxwell. But he won a lot more. "I had come through my first Southern tournament with the worst kind of social pressure and discrimination around me, and I hadn't cracked. I hadn't quit," Sifford said.

Sifford won twice on the PGA Tour—the 1967 Greater Hartford Open and 1969 Los Angeles Open—and maintained his tour exempt status as one of the top sixty money winners for a decade through 1969. When the Senior Tour evolved in the 1980s, Sifford won nearly one million dollars in prize money and one tournament.

Birth of the Hogan Legend: North Carolina has been a central cog in the pro golf tour at various points over the twentieth century, with tour stops being held in Pinehurst, Greensboro, Wilmington, Asheville, Charlotte and Durham. Two of the most memorable victory streaks in professional golf took place in North Carolina.

Ben Hogan had been on the golf tour for eight years without a single victory when the pros came to Pinehurst in March 1940 for the North and South Open. One report said he had thirty dollars in his pocket and bald tires on his second-hand automobile. He stretched his food dollar by hoarding the free oranges given the golfers on their swings through Florida and California. But he was playing well as the 1940 season unfolded, with six second-place finishes. "Ben was walking around the golf course like a volcano on the verge of erupting," biographer Gene Gregston wrote.

Hogan birdied the first hole on Pinehurst No. 2 on opening day, finished with a 66 and took the lead. He followed with a 67, 74 and 70 to beat Sam Snead by three shots and collect his first title. "I won one just in time," Hogan said, proudly accepting the trophy and $1,000 check. "I had finished second and third so many times, I was beginning to think I was an also-ran."

Hogan's new-found confidence stoked him a nine-shot win in the Greater Greensboro Open and then a three-shot victory in the Land of the Sky Open in Asheville. In three tournaments, Hogan played 216 holes thirty-four under par, breaking par eleven of twelve rounds and suffering just two three-putt greens. He won the Vardon Trophy and the top money prize for 1940 with $10,655. "It was easy to see we couldn't catch that fellow the way he is playing," Johnny Revolta said of Hogan's hot streak. "You can't beat perfection."

Five years later, Byron Nelson stormed through Charlotte, Greensboro and Durham in collecting wins two through four in his record-setting, eleven-victory string. Headlines on the front pages of area newspapers in March 1945 screamed "Jap Fleet Raided Again" and "Patton Rampages Through Germany" as World War II entered its final stages, but the sports pages were filled with news of the Charlotte Open, the Greater Greensboro Open and the Durham Open.

Nelson and Snead were tied after seventy-two holes at Myers Park Country Club, forcing an eighteen-hole playoff. They both shot 69s (Snead benefiting from an out-of-bounds shot on eighteen that bounced off a car on Roswell Road and back onto the golf course), and played another full eighteen holes the following day to break the tie. Nelson finally won with a 69 to Snead's 73. They moved to Starmount Forest in Greensboro, where Nelson lapped the field with an eight-stroke win, then to Hope Valley in Durham, where Nelson won by five shots over Toney Penna.

The North and South Open was christened in 1902, one year following the introduction of the "United North and South Championship," an amateur-only competition suggested by Pinehurst advertising consultant Frank Presbrey to help generate resort traffic and national publicity. Alex Ross followed brother Donald to Pinehurst from Dornoch at the turn of the century and shot a 75 to win the first North and South Open, the event contested on the one eighteen-hole course at Pinehurst open at the time. The Ross brothers would win eight of the first nine North and Souths. The event soon evolved into one of the top events on the young PGA Tour.

In 1990, historian and journalist Dan Jenkins wrote in *Golf Digest*:

> "The North and South had an immediate atmosphere of class and elegance. Dress for dinner, veranda stuff. In fact, the North and South was the Masters before there *was* a Masters (1934) and for many years before the Masters finally out-Southerned the North and South."

Hogan followed his breakthrough win in 1940 with North and South titles in 1942 and '46; Snead, Nelson, Jim Barnes, Walter Hagen, Paul Runyan, Horton Smith and Bobby Cruickshank were also among its winners. The tournament was discontinued in 1951 when Pinehurst owner Richard Tufts became disenchanted with the growing commercialism of the professional game and decided the resort should focus more on the amateur and resort golf experience.

Pinehurst returned to the business of hosting pro golf events in 1973 behind the initiative of Bill Maurer, the new resort chief installed by the Diamondhead Corp., which purchased the resort from the founding Tufts family on Dec. 31, 1970. Maurer sold Joe Dey, commissioner of the Tournament Players Division of the PGA of America, on the idea of a "World Open" at Pinehurst—eight rounds over two weeks for the astronomical purse of half a million dollars and $100,000 to the winner. Miller Barber edged rookie Ben Crenshaw to win the World Open.

The 1974 World Open coincided with the opening of the new World Golf Hall of Fame, a $2.5 million edifice of expansive exhibit halls surrounded by water fountains, all of it nestled in the pines behind the fourth green and fifth tee of No. 2. President Gerald Ford presided over the ceremony to induct the thirteen charter members of the Hall of Fame. Eight of them were living and all showed up—Ben Hogan, Sam Snead, Byron Nelson, Arnold Palmer, Gary Player, Gene Sarazen, Jack Nicklaus and Patty Berg. Honored posthumously were Bobby Jones, Walter Hagen, Francis Ouimet, Harry Vardon and Babe Zaharias. The tour eventually left the Sandhills following the 1982 Hall of Fame Classic, and the museum itself moved to a new home in St. Augustine, Florida.

Dallas club magnate Robert Dedman purchased the Pinehurst resort and its six golf courses in 1984 and one of his early visions was to return championship golf to the No. 2 course. The 1988 PGA Club Professional Championship and 1989 U.S. Women's Amateur re-introduced the course to the golf establishment following the fallow Diamondhead era. With substantial financial resources being pumped into golf course maintenance and resort infrastructure, Dedman and his company, Club Corporation of America (later to become ClubCorp International), made steady progress in climbing back up the social ladder in golf's competitive circles.

PGA Tour Commissioner Deane Beman, who had fond memories of playing No. 2 in the North and South Amateur of the early 1960s as well as the 1962 U.S. Amateur, believed the venue would be an ideal site for the Tour Championship, the season-ending "Super Bowl of Golf," and the Tour brought the event to Pinehurst in late October of 1991 and '92. Craig Stadler won the first Tour Championship, edging Russ Cochran in a playoff, and Paul Azinger won the following year. The U.S. Senior Open was played at Pinehurst in 1994, with South African Simon Hobday prevailing, and the stage was set five years later for the first U.S. Open to come to the Carolinas.

The 1999 Open delivered one of its most memorable finishes in history, with Payne Stewart, Phil Mickelson and Tiger Woods battling in the final two groups for the title on a cool, gray, drizzly day more reminiscent of the British Isles than the Sandhills. Stewart drained a fifteen-foot putt on the last stroke of the championship to clip Mickelson by one shot.

"Perfect—a perfect way to win," Stewart said. "I think everyone in the field will attest to how great No. 2 is, to what a special place Pinehurst is. To win here means a lot to me." Within a year, the USGA had awarded Pinehurst the 2005 Open.

USGA Executive Director David Fay said:

> "The Open at Pinehurst could be Tracy and Hepburnesque—a match made in heaven. It's the first time since the 1940s an Open has returned to a site as

soon as six years later. Obviously that speaks to our opinion about Pinehurst as an Open venue."

Sadly, Stewart perished in a plane crash four months after his Open championship, and Pinehurst officials erected a statue of him as he looked when his winning putt fell into the cup—leg and arm extended, mouth exuding the joy of the triumph.

Pat Corso, the resort president and CEO, said:

> "Pinehurst has lost its champion. He didn't just play golf here. He understood and was part of the Pinehurst experience. He understood the traditions and the history, he immersed himself in the community. There's quite a sense of loss that he'll never be here again."

Meanwhile, the USGA liked what it saw in the Sandhills' embrace of major championship golf and in 1991 committed its U.S. Women's Open for 1996 to Pine Needles. Annika Sorenstam burst into the top echelon of women's golf with her first victory, that coming in the 1995 Women's Open at the Broadmoor in Colorado Springs, Colo., and she successfully defended her title in a landslide triumph the following year at Pine Needles (six shots over Kris Tschetter). She was the No. 1 player in women's golf at the time, and appropriately enough, Karrie Webb was No. 1 five years later and was a runaway victor (eight shots over Se Ri Pak) in the championship's second foray to Pine Needles.

The low amateur in the 1996 Open and the fourth-place finisher in 2001 was a young Floridian named Cristie Kerr. Her psyche and swing were in harmony with the Sandhills ambiance and the old-world feel of Donald Ross's 1928 gem when the Women's Open returned in 2007. She lurked near the lead with a 1-over total through thirty-six holes, then fired a third-round 66 and won the title with a crucial birdie on fourteen and a workmanlike homestretch of four closing pars.

The Sam Snead Invitational: While Pinehurst has snared a number of high-profile professional events, Greensboro has been the Carolinas' bastion of continued presence on the pro tour over many decades.

The Greater Greensboro Open was inaugurated in 1938 under the auspices of the Greensboro Jaycees and support from *Greensboro Daily News* sports editor Laurence Leonard, Starmount Forest Country Club owner Edward Benjamin and club pro George Corcoran, who was the brother of PGA Tour manager Fred Corcoran. The tournament has been held under one name or another ever since, taking off only the 1943–44 seasons because of World War II. The tournament was shared between Starmount Forest and Sedgefield Country Club through 1960, when it settled at Sedgefield for a seventeen-year run before moving to Forest Oaks Country Club, where it was played from 1977–2007. The Gate City's PGA Tour event made yet another venue change in February 2008 when returned to Sedgefield.

The early GGO acquired the nickname of the "Sam Snead Invitational" as Snead won eight times through 1965, the last time coming at the age of fifty-two years, ten months and eight days—then and still a record for the oldest winner on the PGA Tour. Snead was motivated by a snippy comment from young pro Raymond Floyd of

Fayetteville, who Snead understood to have asked, "What's Snead doing here? He can't beat nobody. He can't win anything anymore." Eight years later when he was just a month shy of sixty-one, Snead challenged again in Greensboro. Only four shots off the lead through fifty-four holes, Snead faded to a tie for twelfth.

The GGO for decades was an annual rite of spring for Greensboro golf fans as they welcomed the arrival of warm weather (at least most years, save the week in 1983 when it snowed), and cheered victories by the likes of Billy Casper, Gary Player, Gene Littler, Julius Boros, Tom Weiskopf, Seve Ballesteros, Craig Stadler, Lanny Wadkins and native-born North Carolinians Floyd and Davis Love III. The tournament's name acquired corporate sponsorship appellations as time evolved, with K-Mart in the 1980s, Chrysler in the 1990s and now Wyndham Hotels assuming underwriting roles.

The most recent change back to Sedgefield is a result of fervent efforts by old-line Greensboro golf people to keep the tournament viable in a constantly evolving PGA Tour environment. Sedgefield member Steve Mitchem recalled the GGO spectacle at Sedgefield in the 1960s and early 1970s and floated the idea to tournament director Mark Brazil that a reconnection to the tournament's roots might brighten its future; the 2008 Greensboro tournament would mark the PGA Tour's first return to a Donald Ross-designed course in more than three decades. "We've got a second chance with this tournament," Mitchem said upon the announcement of the new Sedgefield deal. "We have the potential to make history."

The Doubters Among Us: The Azalea Open was played at Cape Fear Country Club in Wilmington from 1949 to 1971 as part of the city's annual Azalea Festival, usually running in late March or the first week in April in the slot prior to the Masters. The Azalea's highlight was Arnold Palmer winning in 1957. And one of its most embarrassing moments came in 1959 at the expense of Joe Black, a future president of the PGA and at the time field director for the PGA. He was having lunch in the club dining room with Bunny Hines, president of the Wilmington Athletic Association, which ran the tournament. Jack Nicklaus approached and asked for permission to withdraw at Wilmington because he was anxious to drive to Augusta and practice for the Masters. Black gave Nicklaus the go-ahead, then turned to Hines. "Bunny, that kid has more potential than any player I know," Black said. "But he'll never make it as a pro."

Of course, equally stunning misjudgments of talent have been made over the years. Pinehurst owner Richard Tufts told Arnold Palmer's mother he was sorry to hear Arnold had turned professional, that "he'd never make it with that swing of his."

Asheville was the home of a tour stop for six years—1922 and '23 and 1939–42. Walter Hagen won the Asheville Biltmore Open Championship in 1923, and Hogan won the Land of the Sky Open three years straight from 1940–42. Charlotte had a five-year run and Durham a two-year run in the 1940s. The Charlotte Open was played from 1944–48 at Myers Park Country Club, and the Durham Open was held in 1944–45 with rounds split between Hope Valley Country Club and Hillandale Golf Club.

Charlotte's involvement in pro golf would be inexorably linked to Palmer, who was invited in 1959 by friend and business associate James J. Harris to address twenty-five prospective members of Harris's new Quail Hollow Club. Harris was a long-time member

at Charlotte Country Club and in 1957 offered to sell the club 200 acres of his family's land in south Charlotte to add one, if not two, new golf courses. When the idea met even the slightest resistance (one member feared splitting the club facility would dampen its family-oriented, collegial atmosphere), Harris withdrew the proposal and decided to create a new club of his own. He hired George Cobb, one of the top architects of the day in the Carolinas, to design the course. It opened in 1961.

Palmer urged the PGA Tour to move the Kemper Open from Sutton, Massachusetts, to Charlotte and Quail Hollow in 1969, and it remained there for eleven years. Palmer's ties to Charlotte grew over time, as he brought a Cadillac dealership to Charlotte in the mid-1970s and built a hotel and office complex with the Harris family. Palmer and International Management Group were also crucial in getting the PGA Senior Tour (now known as the Champions Tour) to put Charlotte on its schedule, with an event played at Quail Hollow from 1983–89 and then at the new TPC at Piper Glen from 1990–2001.

Palmer's friendship with the Harris family continued over the years, and James' son Johnny Harris took over the family's business reins. A member at many of America's finest clubs including the "Big Four" of Cypress Point, Seminole, Pine Valley and Augusta National, Harris sought in the late 1990s to bring Quail Hollow up to modern standards and hired Tom Fazio to mastermind a major overhaul of the course. Once completed, Harris negotiated a sponsorship with Wachovia and a new date on the PGA Tour.

The Wachovia Championship debuted in 2003 and quickly moved into the upper queue of tour events. The players immediately embraced the golf course ("It's one of the neatest courses we play all year," Tiger Woods said), fans devoured every ticket available and tournament management paid more attention to the details than any event across the nation. Players drove Mercedes Benz courtesy cars and wives were treated to a chartered jet outing to the Biltmore Estate in Asheville. "We were looking at a different kind of event," Harris said, "something at the highest level of golf."

The 2007–08 financial crisis cost the tournament its sponsorship with Wachovia, but Wells Fargo has stepped into the breach as the event's title sponsor. So well respected is Quail Hollow that it will be the venue for the 2017 PGA Championship.

Trevino Untangles Tanglewood: Pinehurst No. 2 was host of the 1936 PGA Championship (won by Denny Shute), and the event returned to the Carolinas nearly four decades later when it was contested in 1974 on the Robert Trent Jones designed Championship Course at Tanglewood Park.

Tanglewood's 1,100 acres of rolling woodland and pastures were owned from 1921–51 by the Reynolds family. William Neal Reynolds used the estate to pursue his passion for thoroughbred harness racing while his wife Kate beautified the grounds with her love of flowers and plants. Having no children, they willed the estate to Forsyth County in 1951. With financial support from the park's trustee, the Z. Smith Reynolds Foundation, as well as R.J. Reynolds Tobacco Co., facilities were built to accommodate camping, hiking, boating, picnicking and other outdoor pursuits.

Jones was hired to build a golf course on the property, and by 1958 its eighteen-hole layout was a popular draw to the park. Eighteen more holes followed in the late 1960s,

and officials at RJR Tobacco Co., which was active in supporting professional golf events, began thinking of landing a major golf competition for the park. Those efforts were led by Bill Lybrook, a vice president with RJR, and came to fruition in 1971 when Tanglewood was awarded the '74 PGA Championship. Trent Jones visited and refurbished the course, combining the strongest holes into the new Championship Course, and a new clubhouse was built, parking lots constructed and telecommunications infrastructure installed at a cost of more than $1 million. Lee Trevino was one of golf's hottest stars at the time, having won two U.S. Opens and two British Opens from 1968–72, and he rode a red-hot putter he'd found in the attic of his rented home to a one-shot win over Nicklaus. The Vantage Championship and a Senior Tour stop later found a home at Tanglewood.

Worsham Lures His Pal South: Seventeen-year-old Arnold Palmer enjoyed an excellent spring and summer of junior golf competition in 1947, winning the West Penn Junior, the West Penn Amateur and the Pennsylvania high school championship. His golf resume earned him tuition scholarship offers from Penn State and the University of Pittsburgh, but neither offered financial help with room and board. As Palmer rode the train west to the Hearst National Junior Championship in Los Angeles, his good friend Buddy Worsham, younger brother of U.S. Open champion Lew Worsham, bubbled with excitement over his impending matriculation to Wake Forest College, located in the small town just north of Raleigh in North Carolina. Palmer knew a little about North Carolina, as his father Deacon had traveled to Pinehurst to play golf over the years, but the teenager himself had never been south of the Pennsylvania state line.

"Bud said you could play golf all winter long and never have to interrupt your game for cold weather," Palmer said years later. "It sounded like heaven to me." Worsham appealed to Wake Forest athletic director Jim Weaver, also the adjunct golf coach given the military obligation at the time of golf coach Johnny Johnston, to offer Palmer a scholarship as well. Weaver acquiesced and later that summer Palmer disembarked off a bus after an all-night ride from his home in Latrobe, Pennsylvania, carrying only his golf clubs and one suitcase.

As a freshman, Palmer beat the more celebrated duo of North Carolina's Harvie Ward and Duke's Art Wall at Pinehurst No. 2 for the Southern Conference title. The win was an omen of collegiate golf to come over the next half century as Wake Forest developed one of the top men's programs in the nation.

Palmer wrote in his autobiography, *A Golfer's Life*:

> "Those days at Wake Forest were among the happiest of my life. I was out from my father's strict sphere of influence for the very first time, I spread my wings and had a hell of a lot of fun, forged a host of lifelong friendships, and got my first taste of winning golf tournaments on a national level."

Jesse Haddock never played golf until 1959, when he was seven years past earning his business degree at Wake Forest and well into his career as assistant athletic director at the Baptist institution. Basketball coach Bones McKinney was also the Deacons' golf coach, but if McKinney's other duties kept him from chauffeuring the golf team to a match, Haddock took over. Weaver named Haddock to the full-time golf coaching job

in 1960, and Haddock began his new career using his sales ability and shrewd handle on human psychology to build a juggernaut program. Haddock soon parlayed the professional success of Palmer in recruiting and talked Palmer into donating $500 toward a scholarship fund named for Worsham, who was killed in an automobile crash in 1950.

Two of his early recruits were Ken Folkes, a North Carolinian who won the CGA Amateur in 1963, and Jay Sigel, a top Philadelphia junior. They were the nucleus of Haddock's first ACC championship squad in 1963, and he continued to build the program with players like Joe Inman, Leonard Thompson, Jack Lewis, Lanny Wadkins, Jim Simons and Eddie Pearce. In 1967, Wake Forest won the first of ten straight league titles and the program's momentum began feeding off itself.

Haddock was the Wake Forest golf coach from 1960–92, save a brief two-year excursion to Oral Roberts University in the late 1970s. His teams won the NCAA title in 1974, 1975 and 1986 and won fifteen ACC titles. The 1975 team that featured Jay Haas, Curtis Strange, Bob Byman, David Thore and freshman Scott Hoch was lauded by *Golf World* magazine as the finest men's golf team ever assembled. It beat second-place Oklahoma State by thirty-three shots in the NCAA Championships at Ohio State, leaving Cowboy coach Mike Holder to marvel: "It was as dominating as anything I've ever seen at the moment of truth. They made a statement." Strange and Haas collected the individual national titles in 1974 and '75, and Gary Hallberg followed with first place in 1979. The Deacons also won the national title in 1986.

Duke has been the dominant women's NCAA Division I program in the nation since the turn of the new century. Coach Dan Brooks was in his twenty-ninth year with the Blue Devils in 2013 and had directed the team to NCAA titles in 1999 and 2002 and then to a trifecta from 2005–07, with three Blue Devils winning individual titles over that period: Candy Hanneman (2001), Virada Nirapathpongporn (2002) and Anna Grzebien (2005). His teams won seventeen ACC titles and 114 team victories over those nearly three decades.

Other college programs throughout the Carolinas have made marks as well. North Carolina has landed two men's NCAA champions in Harvie Ward in 1949 and John Inman in 1984.

The modern era of women's golf has been dominated by a variety of players, many of them with roots to the college game. Brenda Corrie Kuehn grew up in the Dominican Republic and played golf at Wake Forest from 1982–86, her outstanding career as a Demon Deacon earning her induction into the Wake Forest Athletics Hall of Fame in 1999 and the National Golf Coaches Association Hall of Fame in 2004. As a senior in 1986, she was first-team All-America and won the ACC Championship and the Duke Fall Invitational. She was an All-ACC selection in 1984–86.

After college, she tried her hand for two years on the ladies' mini-tour. She missed qualifying for the LPGA Tour narrowly in two consecutive qualifying schools, but she was at peace because she believed the nomadic life of a touring pro was not for her. Then she married Eric, whom she met at Wake Forest, and they moved to Asheville in 1995 and joined Biltmore Forest in 1996. Eric is a radiation oncologist and the couple has three children—Corrie, Rachel and Taylor.

Brenda has won three BFCC ladies titles (2002, 2005 and 2007), is a two-time U.S. Curtis Cup team member and has played 16 Women's Amateurs and 14 Mid-Amateurs,

her best finish in the latter a second place in 1995. She made news in 2001 by qualifying for the U.S. Women's Open, played at Pine Needles in Southern Pines, and competing while being eight months pregnant with her second child. Rachel was born one week later. "Rachel is a pretty good golfer, and it's a running joke between the two of us that she's already 'played' in the U.S. Open," Brenda said. "I tell her that if she gets good enough someday, she can play in a second Open."

Page Marsh grew up in a golf family in Jamestown (her mother Linda is an accomplished golfer and sisters Amber and Sheree played collegiately) and was an All-ACC golfer at the University of North Carolina in 1984–85. She has won five Women's Carolinas Golf Association titles and six North Carolina Women's Golf Association amateur championships and has been the women's golf coach at N.C. State since 2000. Amber won the 2003 U.S. Women's Mid-Amateur Championship at Long Cove Club on Hilton Head Island.

North Carolina teams won fourteen of twenty-three men's Division III titles from 1990–2013. Methodist College of Fayetteville won ten of them over a decade of the 1990s under coach Steve Conley. Greensboro College won the title in 2000 and 2011, and Guilford College followed in 2002 and '05. Methodist's women's team won the Division II championship in 1996, '98 and '99 and then moved to Division III, where it has dominated and won the national crown every year from 2000–12.

A Witness to History: One man who has seen nearly all of the above and knew many or most of the characters is John Derr, the broadcaster/reporter/P.R. man who, at the age of ninety-six, was still part of a weekly roundtable to talk golf on a Southern Pines radio station in 2013.

Born in Gastonia in 1917 … loved golf as a boy since he couldn't play baseball because of a chronic knee problem … worked for newspapers in Gastonia and Greensboro … interviewed Donald Ross and once got a personal tour of Pinehurst No. 2 with the architect … covered Ben Hogan's first win at Pinehurst in 1940 … worked for CBS covering the Masters and attended the Augusta rite of spring for more than six decades … first-name basis with Babe Ruth, Ted Williams and Joe DiMaggio … talked on the radio with Edward R. Murrow and Red Barber … good friends with Grantland Rice … the resume runs to infinity.

Derr reflected one day in 2009 about the two rudimentary golf holes his father built in an apple orchard behind the Derr home in Gaston County and the family friend who gave the boy three golf clubs. He could play golf by himself and didn't have to run — two prerequisites for a youngster with a bum knee.

Derr recalled:

> "I played those holes over and over and over again. I wore myself out. I wanted to play a sport, but I couldn't play baseball. The game occupied my time, it restored some self-esteem. I don't know what I'd have become if not for golf. Daddy didn't know it, but he was giving me something I could carry on my whole life — to ninety and beyond."

That's the essence of golf in North Carolina over more than a century — an addictive pursuit from cradle to grave over some of the nation's most varied and unique geography.

Preps

By Tim Stevens

Tim Stevens has written about high school athletics in North Carolina for over forty years. He is the co-author of the original North Carolina high school record book, which involved his researching outstanding performances over the past 100 years. He is a member of the National High School Athletics Hall of Fame and the N.C. High School Athletic Association Hall of Fame. He is the author of *Inspiring Individuals, Encouraging Excellence*, a history of high school sports in North Carolina. He was named one of the top ten sports beat writers in the country by the AP Sports Editors in 2011 and has won national awards for his reporting. He is a graduate of N.C. Wesleyan and received his MBA from Campbell University. Tim founded the prestigious Holiday Invitational high school basketball tournament in Raleigh, which has provided more than $1 million for high school athletic programs in the Triangle. He also received a statewide award for producing *Broadway Voices*, a concert series in Garner that features some of Broadway's biggest stars. Tim and Donna, his wife of thirty-eight years, have three children and one grandchild.

An Undebatable Legacy

Climb into the family car near dusk any Friday evening in late August and early September and drive for a time past the towns and cities and rural communities in North Carolina. In the distance and dotting the landscape of the state will be domes of light pushing back the gathering night. There's one glow, just off to the north, and another in the distance to the south, and another and yet another.

High school football is being played in North Carolina. Youngsters almost too young to shave are in the process of becoming community heroes, frequently to their own surprise. Parents who arrived early to claim the best seats in the stands are watching so restlessly they almost have to close their eyes. Pretty cheerleaders are leaping and screaming, and the high school band is oomph-pah-pahing.

These are not mere games; they're *events*. And they are of importance to a community. If a school principal fails to renew the contract of, say, the chemistry teacher, the decision almost never attains the light of public discussion. Fire the football coach, however, and they'll be talking about it at the local barbershop for months.

North Carolina is known as a basketball state, and perhaps it is at the collegiate level. But in high school, nothing is bigger than football. Winning a spot on the annual North Carolina Shrine Bowl football team is tantamount to enshrinement in a hall of fame. High school sports, and especially football, create memories to last a lifetime.

That's why, for example, they'll still be talking about T.J. Logan in the state's Triad communities and beyond when he is an old man. And in those memories, he will be forever young. They will remember that Logan of Northern Guilford High may have had the best high school football championship game ever in North Carolina in 2012. He rushed for a state record 510 yards and scored eight touchdowns while leading the Nighthawks to a 64–26 victory over Charlotte Catholic for the state High School Athletic Association 3AA title. Memories have a way of making the truth even larger than it really is. In Logan's case, that will be difficult to do. Logan, a state sprint champion, scored on runs of 46, 27, 80, 85, 19, 14, 82 and 73 yards in the victory. He finished the season with 3,147 yards and scored 47 touchdowns in leading Northern Guilford to its third consecutive championship.

In North Carolina, there are enough such memories to go around. The state's high school athletic history in all sports is littered with performances that are arguably just as good. Some border on amazing. Weeks before Logan's incredible performance, Davidson Day quarterback Will Grier passed for a national record 837 yards and 10 touchdowns in a 104–80 victory over Harrells Christian in the N.C. Independent Schools Athletic Association playoffs.

And just a few weeks later, Isaiah Hicks of Oxford Webb led the Warriors to the 3A boys basketball championship with one of the most dominating performances in state

championship history. The 6-foot-8 University of North Carolina recruit scored 34 points, grabbed 30 rebounds and blocked seven shots in the 73–70 overtime win against Statesville. "It was like watching a teacher on the playground with school children," said *Chapel Hill News* sports columnist Elliott Warnock. "He was totally dominating. It literally looked like a man among boys."

North Carolina high school products have gone on to win Cy Young Awards, Olympic championships, all-pro football and basketball honors, and set world records along the way. It can be debated that no other state has produced players who have impacted basketball, not only at the state level but nationally and internationally as well, as much as North Carolina high school products Pete Maravich of Raleigh Broughton, Michael Jordan of Wilmington Laney, David Thompson of Shelby Crest and Phil Ford of Rocky Mount. Athletic quality and quantity seems inexhaustible in North Carolina and still continues. In this basketball-crazed state, West Forsyth High's Chris Paul once wanted to score 61 points in a basketball game to honor his deceased grandfather, and he did it. Shea Ralph once scored 61 points in a girls' basketball game—and handed out 16 assists in the same game. Hibriten High's Josh Jones once struck out every batter in a five-inning baseball perfect game, and Raeford Hoke's Kathy McMillan set long jump records that still are unmatched almost 40 years later.

So, where did it all come from? Surprisingly perhaps, there is less an aura of musty locker room and lumpy unkempt practice fields in the DNA of high school athletics in North Carolina than one would expect. Indeed, the state's rich 100-year-old high school athletic history can be traced back to a statewide debate competition.

A debate club may seem a long way from modern interscholastic athletic competition, but high school sports' roots in North Carolina are traced to 1912 when the University of North Carolina extension service arranged a statewide debate for the High School Debate Union.

UNC was one of several colleges throughout the country that started extension programs to carry higher education to the people. College libraries were opened to the public and extension programs planned and funded. Supporting the statewide debate was a way for the university to help high schools throughout the state. The debates were popular and within a few years more than 200 schools were competing for the Aycock Memorial Cup that went to the top debate team.

The UNC extension service added another type of statewide competition in 1913 when it organized a high school track meet that attracted about 50 students from six schools, including eventual team champion High Point. When the N.C. High School Athletic Association celebrated its centennial in 2013, there were more than 200,000 high school students involved in interscholastic athletics in North Carolina. Those students participated in 21 NCHSAA-sanctioned championships that awarded almost 80 state titles.

The NCHSAA is a non-profit organization that has been given the task of overseeing high school competition in North Carolina. The association regulates competition, enforces rules and regulations, certifies officials, organizes conferences and conducts state championships. The association became an independent organization in 2010 after being a part of the UNC extension program for 97 years. The ties were severed when

the university reassessed its educational goals and decided that organizing high school sports in the state wasn't a priority.

The NCHSAA had built a reputation as one of the best high school associations in the country by the time of the split. The NCHSAA has the largest endowment of any high school organization in the country and plays its championships in some of the best facilities. Former North Carolina high school athletes have played in essentially every major sporting championship in the world.

But the real merit of interscholastic competition can't be measured in championship rings or bulging trophy cases. High school athletics in North Carolina have focused on developing better people. The NCHSAA's goal of teaching responsibility, accountability, integrity, sportsmanship and other character traits were written into the association's earliest charters. The goals were noble, but high school athletics in North Carolina have always reflected the state's society, flaws and all.

For years high school championship athletics in North Carolina were reserved for males. The NCHSAA's founding papers even mention developing manliness as one of interscholastic sports' core values. The NCHSAA didn't conduct its first championships for girls until 1972. High school athletics in North Carolina were segregated, as were most schools in the state, for the association's first 55 years.

But the high school athletic programs in the state today could not have been imagined in the debate-based competition of the 1910s. High school athletics emerged as transportation improved and communities began to expand educational opportunities. Community leaders saw the need for more education as industry expanded and cities began to grow. It became economically feasible to stay in school longer to learn skills rather than work on the farm.

Improved transportation allowed neighboring towns to schedule competition. Teams not only drove over to the nearby community, they were able to ride in trains or travel by bus. Teams such as the 1914 Raleigh High football team piled onto trains to travel to competitions. Red Hoffman, later a coach at Wilkes Central, recalled riding on the bus when he played at Statesville in 1937. "I remember just looking out of the windows," he said. "It was a really big deal."

But with the expansion of athletic opportunity came questions of the role of sports in education. The NCHSAA charter of 1929 emphasized that sports were to be used to teach lifelong skills, but schools had questions about eligibility and how to keep athletics in the proper perspective. Eventually society in North Carolina came to believe that the skills taught through athletics were needed by girls, too. But it took a while. And at one time, athletic officials worked to suppress girls' athletics.

Girls athletics, especially basketball, flourished in many areas of the state in the earliest days of organized high school competition. Girls' basketball was as popular as the boys' in some places. But in the '20, '30s and '40s, the physical education movement—which stressed etiquette, dancing and play day activities for girls—almost eliminated high school sports for girls in North Carolina urban areas.

The North Carolina Board of Education adopted its first athletic code in 1952 to establish season limits, financial support, academic requirements and eligibility. Included in the code was this pointed prohibition: "There shall be no regional or State champi-

onship for girls." The North Carolina General Assembly passed legislation to that effect in 1952.

Pam Grundy, an historian and author who lives in Charlotte, wrote about the changes in women's athletics in North Carolina in *Learning to Win — Sports, Education and Social Change in Twentieth-Century North Carolina.* Instead of competing, girls were encouraged to participate in cheerleading or to be spectators, according to Grundy. Many boys' basketball tournaments, including those of the NCHSAA, recognized girls by selecting tournament queens. The role of girls in sports changed in 1972 with the passage of Title IX, which said no person in the United States shall, on the basis of sex, be excluded from participation in, be denied the benefits of, or be subjected to discrimination under any education program or activity.

The NCHSAA had 10 state championships for boys and none for girls in 1969. Within six years, the NCHSAA was offering state championships in girls' golf, tennis, basketball, track, swimming and slow-pitch softball, which later was replaced by fast pitch after inquiries by the Office of Civil Rights about scholarship opportunities for slow-pitch players. "We wanted to offer more girls championships, but our schools were not playing girls' sports," said Charlie Adams, who came to the NCHSAA in 1967 and was the NCHSAA executive director from 1984 to 2010. "We couldn't have state championships for teams that we didn't have."

Prep Athletics Led Social Change: Schools were segregated in North Carolina, and in many parts of country, but the N.C. High School Athletics Conference provided state competition for black high schools for years before merging with the NCHSAA in 1967.

Robert F. Kanady, the former director of the National Federation of State High School Associations, said high school athletics was one of the stabilizing forces during societal changes in the 1960s. "What high school athletics did for our country is often overlooked. High school sports brought us together at a time when there were other factors trying to tear us apart." Former Kinston High and Raleigh Enloe High football and baseball coach George Thompson said he never had a lineman say he wasn't going to block for a Jewish running back, or have a black quarterback say he wouldn't throw to a white receiver. "Athletes do a pretty good job of looking past differences. Watch a pickup basketball game. The guys pick the best players regardless of their color or where they go to church."

Kanady said no institution in the country aided integration more than high school athletics.

> "Athletics brought together people with different appearances and helped them realize they had common goals and aspirations. As a society we have challenges and will continue to have challenges, but high school athletics' role in helping to integrate society often has been overlooked.
>
> "I am confident that high school athletics will continue to evolve and change to fit our society's needs. That's the way it has been for 100 years."

The 1910s — Raleigh Royalty: Raleigh High won the state's first three high school football championships beginning in 1913. Its 1914 club was particularly dominant

as it outscored its opponents, 473–22. The club rented a special Pullman train car to travel to Richmond that year for a Thanksgiving Eve game against Richmond's John Marshall High, one of the best teams in Virginia. The Raleigh team, which averaged 152 pounds per player, pounded John Marshall, 27–0, as the Raleigh club was cheered on by UNC's football team, the White Phantoms, who were to play the University of Virginia on Thanksgiving Day. The Raleigh team took the train home and three days later beat Wilmington 39–7 in a game played in Goldsboro. A 75–6 victory over Washington set up a championship game against Asheville at UNC. Raleigh recorded one of the state's most lopsided state championship victories as it dominated Asheville, 117–0 on December 12, 1914. The Raleigh newspaper headline the next day read, "Game, Poor Exhibition, Mountain Lads Unable to Fathom Offense of Raleigh Boys, Whose Interference Was Almost Perfect."

Charlotte High emerged as the state's finest high school football team in 1916 and 1917 behind the play of Angus "Monk" McDonald, one of the greatest athletes in the state's history. He grew up playing sports at his home at the corner of Tryon and Morehead Street in Charlotte and played football, basketball, baseball and perhaps ran track at Charlotte High. "Some people say he won 16 letters at Carolina because he probably ran track there, too, although we can't prove it," said Angus Morris McDonald, Jr., McDonald's son. "He didn't talk much about his high school days, but I always heard he played all four sports and was just as dominant as he was in college." McDonald led the UNC White Phantoms to a 26–0 record in basketball and the Helms Athletic Foundation national basketball title in 1922. The 5-foot-7 McDonald was the quarterback of UNC's 9–1 football team in 1924 and he hit over .300 during his college baseball career.

The state's finest high school track program of the era was Alamance County's Friendship Academy, which won seven straight state titles from 1914 through 1920. The 1917 Friendship state championship track team had five Isley boys—Carl, Garland, Gladstone, Glenn and Wallace. At least one Isley boy won a state title every year from 1914 through 1920. Friendship High was near the current Friendship United Methodist Church near Coble, and Isley families were scattered throughout the community. The church cemetery has about 500 graves, and more than 100 of those mark the resting places of Isleys or Iseleys. The Isley boys were great in the field events and they dominated the state competition. The school won the 1919 championship, 49–27.

Winston-Salem High, which won basketball titles in 1915 and 1917, won the 1918 baseball championship without a coach. Centerfielder Charles Davis was listed as the manager. The *Winston-Salem Journal* reported on May 4, 1918, that Winston-Salem had been selected along with Greensboro, Charlotte, Summerfield, Red Oak and Laurinburg for the state tournament. The teams had "established records that substantiate their claims to the championship and have been officially recognized by the bureau of extension of the university," the story pointed out.

Winston-Salem defeated Laurinburg 7–3 to win the title. The *Winston-Salem Sentinel* wrote on May 13, 1918, that the game was "one of the prettiest and snappiest exhibitions of high school ever witnessed at Emerson Field (at UNC)." The story lauded the play of Pitcher Crute, probably Henry Archer "Fitz" Crute. Pitcher Crute struck out 11 batters and hit a three-run triple in the eighth inning.

Sylva had won the first two baseball titles and Winston-Salem or Durham won the first five basketball titles. Wilmington players won the first tennis singles and doubles championships.

The 1920s — Off the Farm: Rick and Wes Ferrell grew up on a 150-acre dairy farm near Greensboro. Baseball was a family pastime for Rufus and Alice Ferrell's seven sons. The family had 75 chickens and 60 cows and 60 acres of pine woods. The boys often walked to town to sell vegetables, molasses, honey and eggs, but they grew up playing baseball. Rick, who later was inducted into the Baseball Hall of Fame, recalled the longest balls hit in the pasture were marked by a stick. The goal was for one of them to hit one even farther.

"They were a very strong Christian family," said Kerrie Ferrell, Rick's daughter. "They believed in hard work, family, education and in baseball." Rick was the smallest player and the youngest on the 1919 Guilford High club that also featured two of his brothers, Basil, who was known as "Slats," and Peter. They, along with brothers George and Wes, later played on textile teams.

Rick Ferrell was a catcher and started working out with the Guilford College team when he was 15 years old. He enrolled at Guilford College after graduating from Guilford High in the spring of 1923. He walked two miles to Guilford College every day, but had perfect attendance. The 5-foot-10 Ferrell played basketball and baseball at Guilford College and helped raise his tuition by boxing. He was spotted by professional baseball scouts while playing at Guilford College and was in the major leagues with the St. Louis Browns by 1929. He caught more than 1,800 major league games and was selected for the American League all-star team eight times. He caught all nine innings in the first Baseball All-Star Game in 1933.

Brother Wes Ferrell pitched in the majors for 13 seasons and had a 193–128 record. He won 20 or more games six times. He also hit more home runs than any pitcher in major league history. George Ferrell played in the minor leagues for 20 years, many of them as a manager-player. "He was an outstanding player, too," Kerrie Ferrell said. "But he had hurt his ankle while playing and I think that is what kept him in the minors instead of in the big leagues."

Rick Ferrell was involved in baseball until 1982, when he retired as Detroit Tigers' consultant at age 87. Kerrie Ferrell said:

> "Baseball, to him, was important. It meant something to him. It wasn't about fame or money. He was proud to be an athlete. He had impeccable habits and carried himself like such a gentleman.
>
> "He played this unglamorous position and did it right. No scandal, no steroids, just good habits. I was very proud of him. He was a rare kind of person.
>
> "He played during the Great Depression and during World War II. Times were hard. But he had wanted to be a professional ball player most of his life. He never stopped loving the game."

Vic Sorrell, later a player at Wake Forest University and the Detroit Tigers and the coach at N.C. State, played at Cary High in 1921 and 1923 and pitched Clayton to the

state championship in 1922. He struck out 21 batters in a game during his senior year at Cary.

Charlotte won seven of the state track championships held between 1922 and 1929 and Durham was a boys' basketball powerhouse. In football, New Hanover, which won in 1927 and 1928, and Charlotte, which won in 1923 and 1929, were the only schools to win more than one state football title in the 1920s. High school athletics were catching on in the 1920s. The state high school tournaments attracted 23 football teams, 40 boys' basketball teams, 11 track squads and 36 baseball teams.

The 1930s — Through Tough Times: High school athletics faced a major crisis during the Great Depression. Banks failed, almost one in four workers in the state was unemployed and there was no work to be found. William Friday, later the president of the UNC system, recalled the three mills closing in Gaston County, eliminating a major source of jobs in the communities. "We got by, but barely," Friday said. "It was a time of great sharing." Friday said his family was poor, but so was every other family that he knew.

Dallas High, where Friday went to school, discontinued football because it was too expensive to field a team. Players in baseball and basketball car-pooled to games and proximity was a major factor in scheduling. Players often had to supply their own equipment. Junius Sapp in Raleigh later played baseball at State College, now N.C. State University, but couldn't play baseball in high school because he didn't own a glove.

But some of North Carolina's best-known athletes emerged during those hard times. Prince Nufer Dixon, who was named by *Sports Illustrated* as the top female athlete ever born in North Carolina, never swam in a high school state championship because the NCHSAA didn't have girls' swimming championships. Yet, she set the world record in the 50-meter backstroke during a meet at Bowman Gray pool in Chapel Hill in 1941 and was named as the most dominant American swimmer of the 1930s and 1940s. She qualified for the 1940 Olympics, but the games were not held because World War II already was underway in much of Europe.

Harry Williamson of High Point won the NCHSAA track and field mile championship (4:41.0) in 1930 and anchored the school's winning mile relay in 1931. He became North Carolina's first Olympian, finishing sixth in the 800 meters in the 1936 Games in Berlin.

The Durham High basketball teams from 1937 through 1940 were the most decorated squads in the state's high school history. Five men associated with the team have been inducted into the N.C. Sports Hall of Fame. Coach Paul Sykes, who had a 464–37 career basketball coaching record and seven state titles, instituted a fast-break offense in an era when teams usually played deliberately. His teams won a record five straight state championships. Horace "Bones" McKinney, a skilled 6-foot-8 post player, controlled the boards along with future Duke greats Bob Gantt and Gordon Carver. Gantt, Carver and guards Cedric and Garland Loftis all signed with Duke.

The Durham High teams won 69 consecutive games playing against a schedule that included the finest prep clubs on the East Coast and some college freshmen teams. Once a tournament in Daytona, Florida, was stopped after the first round and the Durham

team set home after it beat the defending Florida state champions 54–14. A newspaper account of the game began, "A traveling group of professional basketball players who bill themselves of Durham…." Sykes, McKinney, Gantt, Carver and team manager Marvin "Skeeter" Francis, who was later the Atlantic Coast Conference's sports information director and associate commissioner, all have been inducted into the N.C. Sports Hall of Fame.

Gantt won the state high school javelin throw in 1940 and won the discus and shot put title in 1938, 1939 and 1940, setting and bettering his own state records each time. He played four years of football and three years of basketball at Duke and also won shot put and discus Southern Conference championships. He was the first Duke athlete to play pro basketball. Carver won nine varsity letters at Duke, playing basketball, football and track. He was the quarterback of a Duke club that defeated Alabama in the 1945 Sugar Bowl. McKinney began his college career playing for the Red Terrors at State College and after World War II played at UNC, helping lead the 1945–46 White Phantoms to the NCAA finals, where they lost to Oklahoma A&M 43–40. Durham won or shared five state football titles in the 1930s and Charlotte won four.

A few miles north of Durham in Person County, one of baseball's most fierce competitors was starring in football, baseball and basketball at Roxboro High. Enos Slaughter was good enough to earn a scholarship to Guilford College, but turned down the offer to work at the Collins and Aikman textile mills in Durham. He was playing with the Ca-Vel baseball team when he was offered a minor league contract. He made his major league debut with the St. Louis Cardinals in 1938 and eventually raced into the Baseball Hall of Fame.

Coach Leon Brogden, who would become a coaching legend at New Hanover, built a football and basketball power in Wilson during the 1930s. Among his best players in Wilson was George Clark, a future Duke star. Clark's story was typical of many of the boys who were touched by Brogden. The coach was involved in the community and met many of his future players when they first started organized ball.

"I remember seeing Coach Brogden when I was in the fifth grade," Clark told A.J. Carr, an N.C. Sports Hall of Fame board member. "He organized softball games for the kids and pitched for both teams. I hit a home run one time, all the way across the road. I thought I was special."

So did Brogden.

The 1940s—A "Choo-Choo" A' Coming: Charlie "Choo Choo" Justice may be the best known high school football player ever in the state. He played on Asheville Lee H. Edwards teams that were undefeated during the regular season in 1941 and 1942, but lost in post-season interstate games. The Edwards team scored 441 points and allowed just six in 1942.

Justice's statistics of 4,005 career rushing yards and 2,385 rushing yards in 1942 pale beside modern marks, but he played in a single wing formation and carried the ball only 286 times in his career. He averaged 14.0 yards per carry during his career and 18.6 yards as a senior. He later became a national icon while playing at the University of North Carolina.

Justice's backup at UNC may have been the best athlete ever in the state. Floyd "Chunk" Simmons won the bronze medal in the decathlon in the 1948 London Olympics and in the 1952 Games in Helsinki. American Bob Mathias won gold in each. "I chose ten events and not just one pigeon hole," Simmons told Ron Green Sr. of the *Charlotte Observer*. "I didn't want to do just high hurdles or the shot. I wanted to do it all."

But he wanted to do it his way.

Simmons had played only one quarter for Charlotte Central High in 1940 when he entered a game against Salisbury as a replacement for injured starter Davey Coates. Simmons ran for 196 yards and five touchdowns in a half. The next week he was back on the bench. Central coach Vince Bradford said, "Simmons busts too many plays."

He was strong and fast at UNC but didn't get to play too much because, according to UNC Coach Carl Snavely, "He doesn't run through the holes he's supposed to hit. He busts too many signals." Simmons won the state high hurdles titles in 1942 and 1943, setting the state record (14.9) in 1943. He went to Hollywood where he and Clint Eastwood became good friends. Simmons' most famous role was as Commander William Harbison in *South Pacific*. He was set to star opposite Elizabeth Taylor in *Cat on A Hot Tin Roof* until the producers changed directors and brought in Paul Newman.

Billy Cox, later an all-American football runner at Duke, led Mount Airy to a 38–0 victory over Wadesboro in the 1946 football championship. Cox also played baseball and ran track. Duke coach Wallace Wade later said Cox was one of the greatest players to ever play at Duke. Cox held five individual single season or career records when he graduated from Duke. He held the school's total offense record until Kinston High product Leo Hart broke them 30 years later. Durham High's Whit Cobb was another versatile athlete. He played tennis, basketball and ran track and lettered four years in the three sports at Davidson College. The NCHSAA did not have a state championship in tennis from 1943 through 1969 so Cobb never competed for a tennis crown. He did play on the Durham High basketball teams that won state titles in 1944 and 1946 and finished runner-up in 1945. He also ran a leg on Durham's winning 4x400 relay in 1945 and 1946.

Tony Simeon was the picture of the versatility of high school coaches of the era. He coached basketball, football, baseball, golf and track and field during his career at High Point High. His teams won state basketball titles in 1943, 1948 and 1950. He was instrumental in the founding of the N.C. Coaches Association and was the High Point City Schools athletic director from 1968 through 1976.

Durham Hillside fielded an amazing football team in 1943. The N.C. High School Athletic Conference club was led by Willie Bradshaw, who was later inducted into the National High School Sports Hall of Fame. Hillside was undefeated and unscored upon despite playing most of its games on the road. Bradshaw remembered the team piling into the back of a flatbed truck for a trip to Norfolk, Virginia, for a game against Booker T. Washington High. "It rained all the way there and we were soaked," he recalled. "They put the game off until Saturday and we were lucky to have a place to stay on Friday night at the military club for soldiers. But we won the game anyway."

Hillside was coached by Herman Riddick, whose 10-year football coaching record at Hillside was 82–3–5. Riddick later built a 112–57–10 football coaching record at North Carolina Central. Riddick was part of a coaching tradition at Hillside that is unmatched in the state. Six North Carolinians are in the National High School Hall of Fame and two of them—Bradshaw and Russell Blunt—were Hornet coaches.

Blunt coached more than 60 years and won his last state championship in 1994 when he was 88 years old. He was still coaching, too. He said he never learned to coach until he got too old to demonstrate. "You're not coaching if you say, 'Here watch me.' You're coaching when you start explaining and teaching," he said. "There is no secret formula. You just have to work very, very hard—usually harder than you want to."

Blunt told the story of a runner complaining so much that Blunt told him to leave. The athlete said he was going to tell his parents. Blunt laughed and told the youngster to ask his father about the day Blunt kicked him out of practice.

Blunt said he had had many critics through the years, but that he gained his revenge by simply outliving most of them. Robert F. Kanaby, the former head of national federation of high schools, said Blunt was a national treasure. "Russ Blunt epitomizes what Albert Schweitzer said—that the only person on the face of the Earth that can obtain true happiness is the one who is willing to use his abilities to help others," Kanaby said.

Bob Jamieson in Greensboro, another member of the National High School Hall of Fame, fit the bill of helping others, too. He coached for 36 years and had a 240–125–15 overall record in football with seven state titles and a 618–271 record in basketball with three state titles. But those championships and victories are secondary in discussions of Jamieson.

His impact on his players was huge, but his impact on every high school athlete, coach and athletic director was greater. He founded the N.C. Coaches Association and instituted its annual coaching clinic. He founded the N.C. Athletic Directors Association. He was a proponent for girls' athletics 30 years before the NCHSAA began offering state championships for girls. He established minimum grade point averages and an attendance policy for his players that were tougher than the state requirements. And he was in the forefront embracing non-revenue sports.

Jamieson was an outstanding swim coach and helped build a foundation for Grimsley, which later won 16 consecutive state swimming titles. "But as far as I know, Bob couldn't swim a stroke," said Bob Sawyer, who swam for Grimsley and succeeded Jamieson as the school's swim coach. Jamieson was the first person from North Carolina inducted into the national hall, a fitting tribute, according to former NCHSAA executive director Charlie Adams, another National Hall of Fame member.

Jamieson was joined in the N.C. High School Athletic Hall of Fame's first class by Wilmington's Leon Brogden and Charlotte's Dave Harris. Harris played football at Statesville High during the Depression and later coached for 19 years at Harding. He became the athletic director of the Charlotte-Mecklenburg system and was named the top athletic administrator in the nation in 1977.

Harvey Reid of Elm City and Wilson Fike was another of the state's legendary coaches. His basketball teams were 818–200 and won seven state championships during his 42-year coaching career from 1955 through 1991. Reid, and coaches such as Charles

McCullough at West Charlotte (575 wins, five state titles) and Reginald Ennis of Smith-field, spanned eras. When Reid began his coaching career at Elm City, the school had no gym and his all-black team practiced outdoors on a dirt court.

Reid remembered practicing in the cold and needing to keep a spare basketball in the car because the ball on the court would go mostly flat because of the chill. Perhaps because of the conditions, Reid developed an attack based on passing, not dribbling. His teams won with conditioning and defense. His teams also warmed up in the pregame to the tune "Sweet Georgia Brown" and went through a series of drills similar to those of the Harlem Globetrotters. "It gets us ready to play," Reid said. "The boys enjoy it. And perhaps it sends a message to the other team that we are going to be able to execute our offense."

Reid died on the sidelines coaching a basketball playoff game on March 5, 1991. He had been warned that he needed to slow down, perhaps retire. "But I love what I'm doing," he said. "Why should I quit doing what I love to do just to do something that I don't want to do?"

The NCHSAA did not have state championship competition in most sports during World War II. Gasoline was a precious commodity and high school athletics were scaled back in many communities. Peggy Pate Chappell, a 1944 Goldsboro High graduate, was a top breaststroker in 1943 and 1944. She was named as the Teague Award winner as the outstanding female athlete in the Carolinas both years. She set the NCAA record while at Penn Hall College in Pennsylvania. Forsyth County's Gray High, which is now the Gray Building on the UNC School of the Arts campus, won the Class B baseball title in 1942 and won three Class A crown in 1946 through 1948.

The 1950s — In a Pickle with McQuaid: Beaufort was an idyllic place to grow up in the late 1950s and early 1960s. Boys swam in Taylor's Creek from downtown Beaufort to nearby Carrot Island and on out to sandy Shackelford Banks. They'd sneak in a back window at the Beaufort High School gym to shoot basketball and spent hours playing baseball.

"It was a really tight-knit community," said Chuck Lewis, a player who was inspired by his time playing at Beaufort to later become a coach and administrator in Carteret County schools. "Everybody knew everybody else. We grew up playing together. We'd leave in the morning and play all day."

The boys who played together grew up to lead Beaufort High to a state record 91 consecutive basketball victories and NCHSAA 1A basketball championships in 1959, '60 and '61. Lewis and Ray Hassell played on each of the teams and on the Seadogs' 1959 state championship football team. The Hassell boys, brothers Butch and Johnny and cousins Charles and Ray, and David and Calvin Jones were important factors in the school's the athletic success, but the key to the victories were the coaches, according to Lewis. Tom McQuaid, the basketball coach, was the epitome of a disciplinarian. Lewis said he was a junior before he could speak to Coach McQuaid without trembling. "We were scared to death of Coach McQuaid, I still am, but we also knew he was teaching us how to be men," Lewis said.

McQuaid, a former five-sport standout in Vienna, Ohio, played basketball at New-berry (South Carolina) College and had coached at Beaufort in 1936 through 1945

before leaving to serve in World War II. On his first day back in 1946, he cemented his reputation for discipline. "We were in the fifth grade and we had a substitute," recalled Bob Safrit. "A tall man in a U.S. Army dress uniform walked in with bars on his shoulders and ribbons on his chest." It was McQuaid who noticed one student eating a pickle in class and told him to spit it out. The student replied, "I will when I get through with it."

"Captain McQuaid walked back to the boy, grabbed the shirt behind his neck and grabbed his belt, lifted him and carried him to the trash can and began to shake him," Safrit said. "The pickle came out and by lunchtime the whole school knew about Captain McQuaid."

"Pud" Hassell, who was the MVP of the 1961 state championship game, said the ground work for the undefeated basketball streak was laid by McQuaid's undefeated 1955 basketball team.

> "We were in the fifth, sixth and seventh grades at the time and of course we thought those guys had hung the moon. We were a bunch of wide-eyed kids. We came to an agreement that we wanted to do that, to win a state championship, so we started practicing basketball every chance we got and played basketball from sun up to sun down."

Hassell, who later played with Beaufort teammate Ray Hassell and with players such as Billy Cunningham at the University of North Carolina, said McQuaid was well ahead of his time.

> "He ate and slept basketball and went to clinics during the summers where the leading basketball coaches of the time would teach.
>
> "When I went to Carolina to play for Dean Smith, there was nothing that I hadn't already seen on the basketball court. Coach McQuaid had shown us concepts like the motion offense and spread offense, the scramble defense and all the different zone defenses. He taught us to fight over screens. Deny the ball.
>
> "Jim Fodrie was the assistant and not much older than we were, and he'd scrimmage with us. He'd say, 'I'm playing defense and my man ain't going to touch the ball all day. How can he score if he doesn't touch it?'"

McQuaid would cap the basket so that the ball couldn't go in and players would work for hours on blocking out. He regularly corresponded with Clair Bee, whose college team teams won 82.6 percent of their games, and with Henry Iba. "Coach McQuaid was their pen pal," said Alton Hill, another player.

Lewis recalled:

> "Coach McQuaid went away one year and came back with a new defensive system. From the corners, we had always tried to force the ball to the middle where there was more help. You denied the baseline.
>
> "But he came back and changed everything. He taught us to change our footwork and force the ball to the baseline. He was so far ahead of most coaches that it almost wasn't fair."

McQuaid enforced a strict curfew. Players had to be in their homes by 10:30 p.m. Lewis once made it home by seconds only to find one of the assistants sitting on his porch. The discipline played a big part in the winning streak, but discipline also was a factor in the 1962 state playoff quarterfinals loss that ended the title streak.

The Seadogs had lost twice to Morehead City during the regular season, but Beaufort beat their rivals in the conference tournament. One of the Beaufort High cheerleaders held a Friday night party after the playoff win and some players stayed past curfew. On Monday, the team ran and duck-walked the entire practice. Lewis, who missed Monday's practice because of a college interview, did his running and duck-walking on Tuesday.

He said he could barely walk on Wednesday when the team left for the state tournament in Winston-Salem. "I didn't go to the party, but I didn't tell Coach McQuaid. I had too much respect to make excuses. He believed we were a team and because some of us missed curfew we had all missed curfew."

The team didn't have its usual speed or zip in the quarterfinals and the streak was over. "But there was never any question about what was most important to Coach McQuaid," Lewis said. "If it came down to teaching us there are consequences for our actions or us winning a game, he was going to teach every single time."

Pat Gainey was a coach cut from the same cloth as McQuaid. He built a girls' basketball power at Pamlico, where his teams were 93–6, and later at Taylorsville (265–51 from 1955 through 1964). Taylorsville won five Western North Carolina High School Activities Association state titles and at one point won 54 straight games. But the Beaufort and Taylorsville's winning streaks pale beside the 107 consecutive girls' basketball victories by Bailey High from 1957 through 1964.

Bunn High was another girls' basketball power. It won 72 straight games from 1952 through 1956. "We'd pile in our cars and go play," said Bunn coach Jean Hinnant. "We'd play anybody. We beat the teams at Louisburg and Campbell (then junior colleges). But we couldn't play beyond the county championship. We wanted to play, but they just wouldn't let us play."

Molly Colvard Gambill, who averaged an incredible 65.1 points per game at Nathan's Creek High in the 1955–56 season, never got to play in an NCHSAA championship. She scored 5,084 points in her career with a game high of 92, but didn't score a basket in the state tournament because there was no tournament for girls.

Players such as Melba Overcash of Landis (1949); Martha Ann Bowers of Norlina (1955) and Beulah Thompson of New Hope (1954), who share the state single-game scoring record of 107 points; Judy Vaughan of Westfield (106 points in 1963) and Kay Wilson Hammer (104 points in 1963) were limited to the local level. And they never had the chance to truly show their athletic ability. Girls played a six-player game and most players were limited to either offense or defense, but not both. For years, the girls had a limited number of dribbles and at one time blocking a shot resulted in a technical foul.

Black athletes in North Carolina didn't have the chance to play in the NCHSAA either. Schools were segregated by race in North Carolina. Beaufort's Pud Hassell remembers going to New Bern to watch the all-black J.T. Barber High team led by 6-foot-11, 245-

pound Walt Bellamy, who also was an outstanding tight end in football. "I'd never seen anyone like him. He was amazing," Hassell said. "He was so big and moved so well. We'd never played against anyone like him."

Atlantic Coast Conference schools did not accept black players and Bellamy signed with Indiana. Bellamy told Lynn Houser of the *Bloomington* (Indiana) *Herald-Times*:

> "In the summer after my junior year of high school I played with some guys from Indiana. Indiana at the time was the closest school to the South that would accept African-Americans. It was an easy transition for me to make. Not that I was naïve to what was going on in Bloomington in terms of the times, but it didn't translate to the athletic department or the classroom. Every relationship was good."

Bellamy averaged 20.6 points and 15.5 rebounds during his career at Indiana and played in the NBA for 14 years.

The ACC also didn't have a place for players like John Baker, Jr., who was elected as the most popular boy in Raleigh Ligon's first graduating class in 1954 and later was elected as Wake County's first black sheriff. The 6-foot-7, 279-pound Baker often lined up as Ligon's fullback and he'd drag would-be tacklers for yards. He played in the NFL for 12 seasons.

Carl Eller, who led Winston-Salem Atkins to an undefeated football season in 1959, was an All-American defensive end at the University of Minnesota in 1963. He was named to the NFL Pro Bowl squad six times and played in the Super Bowl four times.

Bobby Bell, an Outland Trophy winner at the University of Minnesota, excelled in several sports at then-segregated Shelby Cleveland High in the late 1950s. He played halfback on a six-man team his first two years, but moved to quarterback when the team switched to 11-man football. He was selected to the Pro Football and College Football Halls of Fame as a linebacker.

Many schools in the state played six-man or eight-man football in the 1950s. Clayton High added six-man football in the fall of 1952. Clayton High Principal E.O. Waters responded to students' request to field a team by dismissing students from class early to go pick cotton. Proceeds from the harvest helped purchase the uniforms the club wore as they won the NCHSAA championship that fall. The school's program has been one of the state's most consistent. Glenn Nixon came in the fall of 1956 and coached 26 years. Gary Fowler, Nixon's successor, coached the next 28. Thell Overman of Wallace was building his coaching legacy during the 1950s. He is among the state's coaching leaders in football, basketball and baseball. His clubs in the various sports had a 1,078–233–6 record and his baseball teams won 541 games. Among Overman's best football players was Wray Carlton, who grew up a few houses down from Overman in Wallace and was recruited to be a ball boy for the Overman's varsity during his sixth and seventh grade years.

Carlton was groomed to follow his older brothers Harry and Ralph as running backs in the single-wing attack and was an exceptional athlete. The Pittsburgh Pirates offered to sign Carlton as a shortstop prospect and he once scored 48 points in a basketball game.

"Coach Overman was a wonderful man, a very moral man," Carlton told Chuck Carree of the *Wilmington Star-News*. "He believed in sports as way of developing character. I could not have had a better mentor than him." Carlton played at Duke and with the Buffalo Bills and was inducted into the North Carolina Sports Hall of Fame in 2012 along with M.L. Carr, another Wallace-Rose Hill standout.

Another of the state's top coaches was Leon Brogden, who was one of the top football and basketball coaches in NCHSAA history. He built a high school sports powerhouse at Wilmington High and later New Hanover. The Port City produced two of the state's best quarterbacks ever, Sonny Jurgensen, who played at Duke University and later with the Washington Redskins, and Roman Gabriel, an All-America at N.C. State and the NFL MVP while with the Los Angeles Rams. Jurgensen played on New Hanover's 1951 state championship football team and was a starter on its 1953 state runner-up basketball team. He also started in baseball. Gabriel, who graduated in 1958, was all-state in football, basketball and baseball and helped the Wildcats win state basketball titles in 1956, '57 and '58. He played football and baseball at State College, which later became N.C. State. Brogden is believed to be one of the first coaches in the country at any level to use a continuous offense in basketball. Most often teams would run a play and go through the various options and then reset to start over. Brogden developed a system of a constant seamless attack. Wilmington was beaten in the 3A finals in 1953 and 1954 by Raleigh, which also won the state title in 1952. Jack Murdock, the star of the Raleigh clubs, later was a standout and a coach at Wake Forest University.

Williston High, the school for black students in Wilmington, didn't attract as much attention as Brogden's teams, but Williston was the NCHSAC champion in 1952. Meadowlark Lemon, at one time probably the most famous basketball player in the world as the "Clown Prince of Basketball" with the Harlem Globetrotters, led Williston to the title. Lemon was inducted into the Naismith Memorial Basketball Hall of Fame in 2003 and played in more than 16,000 games during his career.

One of the nation's best high school milers emerged in Charlotte in the 1950s. Jim Beatty of Charlotte Central won the NCHSAA mile in 1952 (4:40.5) and 1953 (4:31.9). He later became the first person to run a sub-four-minute mile indoors, running a 3:58.9 in Los Angeles in 1962. He set American records in the 1500 meters, mile, 3,000 meters, three miles and 5,000 meters during a 16-day period that year.

The NCHSAA added cross country in 1956 and Charlotte Myers won the first four titles and added four more in 1966 through 1969 under coach Stuart Allen. Boone Appalachian emerged as a wrestling powerhouse in the 1950s, winning eight championships in nine years with Thomasville breaking up a pair of four-year runs.

Gastonia was the big school baseball power. It won the NCHSAA championship in 1946 through 1951. Burlington broke the string in 1952 before Gastonia High won the next two with Lawrence "Crash" Davis as coach. Davis, who played on Gastonia's 1937 state baseball championship team, would gain international fame when his name was used for the principal character in the movie *Bull Durham*.

Chuck Hartman, the baseball coach at Virginia Tech, played for Davis at Gastonia. Hartman told Blair Lovern of *Baseball America*:

"He was an excellent baseball man, one of the most excellent coaches I've associated myself with. He was the best at relaxing players before a game. But he was also very superstitious.

"One time we had a 13-game winning streak in high school. We had to wear the same socks, same shirts, same everything, and we played twice a week for six and half weeks in the same clothes. He wore the same things, too. Nobody sat within three rows of him on the bus."

Left-handed pitcher Billy Joe Davidson of Oak Ridge Military was the talk of the nation when Cleveland Indian manager Hank Greenberg came to Marion to sign him on May 28, 1951. His bonus was rumored to be between $50,000 and $120,000, one of the highest ever to that point. Greenberg said signing Davidson was "the Bob Feller story all over." The *Hendersonville Times-News* reported the 6-foot-3, 211-pound left-hander averaged 18 strikeouts per game during his career at Oak Ridge. Though Davidson was carried on Cleveland's big league roster for a time, he never made an appearance in a major league game.

Gaylord Perry of Williamston played in the major leagues for 22 seasons. Gaylord and older brother Jim helped Williamston to the NCHSAA 1A title in 1955. They switched off between pitching and playing third base. Williamston defeated Colfax 2–0 in the finals and the victory was one of nine consecutive shutouts for the future Cy Young Award winners. Jim won the Cy Young Award in 1970 and Gaylord won in 1972 and 1978. They are the only brothers to win Cy Young Awards and Gaylord was the first player to win a Cy Young in both the American and National Leagues.

Parker Chesson, a Perquimans County High pitcher who competed in 1958 against the 6-foot-4, 200-pound Gaylord Perry, told of facing Perry in the book *Baseball in the Carolinas*. "He was an imposing figure, and he had a blazing fastball," Chesson said. "Talent-wise, he was in another league."

Perry signed with the San Francisco Giants in June 1958 and pitched in the minors for three years. He attended Campbell University, where Jim was playing baseball. Campbell's mascot, a camel, is named for Gaylord Perry although he never played a baseball game at the school.

L.J. Grantham of North Duplin is the only NCHSAA player to pitch two perfect baseball games. He had one against B.F. Grady in 1958 and one against Beulaville the next season.

The 1954 NCHSAA 1A basketball championship game may have had more impact on interscholastic athletics than any other game ever played in the state. Cary beat King, 63–58, in a game played at Aberdeen High School. Simon Terrell was coaching the Cary team and his best player was guard Charlie Adams. Cary was a dominant power in the 1950s. Terrell only coached two years at the school. His two football teams had a 20–0 record, but were ineligible for the playoffs because they had scheduled too many regular-season games. His two boys' basketball teams went 60–2.

Years later, when Adams became the NCHSAA executive director, he remembered playing the title game at Aberdeen, where all of the bleachers were on one side of the gym. As the high school sports chief executive in the state, Adams made it a mission to get the state finals in all sports into the state's finest venues.

Cary's undefeated football season in 1955 had a big impact on high school sports in North Carolina, as well. Another part of Adams' legacy is an expanded playoff system that allows more teams to advance to the playoffs and a tie-breaking procedure for the playoffs. Cary's football club advanced past the first round of the playoffs in 1955 because ties were broken by total offensive yardage. The game with Mebane ended 0–0, but Cary advanced because it had a 42–18 advantage in total yardage. Championship games in various sports had ended in ties throughout the years, but none since Adams led a push that all title games must have a winner.

The 1960s — The Blending: Harvey Reid's background was in the N.C. High School Athletic Conference, the state association for black high schools in the state's segregated system. He was able to remain as a head high school coach in North Carolina after integration, but some of the black coaches were moved to middle schools or asked to be assistants.

Herman Boone, who later gained national fame as the football coach at T.C. Woodson in Alexandria, Virginia, was a successful football coach at E.J. Hayes in Williamston before he was asked to become an assistant coach after integration because, he was told, the community was not ready for a black head football coach at the newly integrated high school. Boone, who had played at Booker T. Washington in Rocky Mount, developed an awesome offensive club at Hayes. Quarterback Ricky Lanier set the state record for touchdown responsibility by passing for eight touchdowns and running for five more in an 80–0 win over Snow Hill in 1967.

Woodson won the Virginia state title in 1971 in Boone's first season at the school and the movie "Remember the Titans!" was based on that season. Boone wrote later:

> "Diverse, unfocused boys who were unwilling to talk to each other, broke the mold in the state of Virginia because they found a way to accept their teammates as equals at a time when it was neither popular or, in many cases, safe.
>
> "That brave mentality started them on a journey of a lifetime and once they decided to become a team, they battled under extreme circumstances until reaching the pinnacle of high school football, a state title."

The black high schools had been producing tremendous players for years, but the black players knew they were not welcome at the nearby Atlantic Coast Conference schools, the University of North Carolina, Duke University, Wake Forest University and the current N.C. State, then known as State College. Players at traditionally black high schools wanted to play against the white clubs, but were not given the chance.

Carl Easterling, the basketball coach at Durham Hillside, tried to schedule a scrimmage with nearby Durham High in the mid-1960s. Easterling said he was willing to lock the doors to keep spectators out. "But nothing could be worked out," Willie Bradshaw, the Hillside athletic director, said 50 years later. "I think the coaches and players were willing, but it just wasn't the right time."

Easterling's Hillside team was flying high. Its boys' basketball team, dubbed "The Pony Express," averaged 105 points per game in 1966. The Hornets scored 100 or more points 14 times, but lost in the N.C. High School Athletic Conference championship

game to West Charlotte, 96–66. West Charlotte, 19–1, was coached by the legendary Charles McCullough. C.J. Montgomery, a 6-foot-6 center, and versatile Daryl Cherry led the Lions.

Raleigh Ligon High was a baseball powerhouse under Coach Pete Williams. His Little Blues won NCHSAC championships in 1958, 1959, 1960, 1962, 1966 and 1967. Don Fozard of Durham Hillside was one of the NCHSAC's great distance runners. He won three straight titles in the 880 and the mile in 1962, '63 and '64.

Within a few years, black players could play alongside white players as the state's schools were integrated. With integration often came consolidation as school systems merged small schools into much larger schools. "The change was badly needed, but came with a cost," said Caulton Tudor, a sports writer for the *Raleigh News & Observer*.

Tudor played at Angier High in Harnett County when every crossroads seemed to have a school. There was tremendous local pride among eleven area schools. When Angier played Boone Trail for the Harnett County basketball championship on February 29, 1964, for example, spectators literally were sitting in the low hanging rafters of Campbell College's Carter Gymnasium. "It was that big of a deal," Tudor said.

The spectators that night were treated to a game that has never been surpassed at any level. Boone Trail and Angier played 13 overtimes and neither team substituted. Game officials tried to contact Simon Terrell, the NCHSAA executive director, for a ruling if the game continued past midnight because Sunday games were prohibited. The officials couldn't reach Terrell, but decided to keep playing. Game officials extended the time between some periods and required the coaches to give the players water to drink. Boone Trail eventually won 56–54 just before midnight.

Meanwhile, history of a different sort was being created at Raleigh's Broughton High. Pete Maravich, the son of N.C. State coach Press Maravich, was honing his game. Maravich eventually would set NCAA scoring records at LSU, averaging 44.2 points per game, but at Broughton he was much more interested in passing than scoring. The Caps were outstanding during his junior year, but lost in the NCHSAA quarterfinals.

His senior year the team struggled and finished 9–14. although he scored 20 or more points in 21 games. Lawrence Dunn, playing at Berry O'Kelly in Raleigh, actually outscored Maravich in 1965, 34.0 points per game to 32.0, and Dunn helped his club to the NCHSAC 2A title.

Maravich returned to Broughton's Holliday Gymnasium in 1988 to have his number retired. He talked of moving back to Raleigh. He had written a book and filmed a teaching video. He died 10 days later while playing in a pickup basketball game with Dr. James Dobson before a radio appearance. His autopsy revealed he had a genetic heart problem. Doctors marveled that he had ever been able to play basketball.

Raleigh-Durham teams swept the NCHSAC basketball championships that year with Hillside winning in 4A, Durham Merrick Moore in 3A, and Durham Little River in 1A.

Meanwhile, David Thompson, one of the most remarkable basketball players of all-time, was emerging at integrated Crest High School in Shelby, which was a member of the Western North Carolina High School Athletic Association. The WNCHSAA was formed in 1929 when some members of the NCHSAA pulled out to start their own

close-knit association. The association included schools such as Concord, Hickory, Lincolnton, Monroe, Mooresville, Morganton and Shelby. The WNCHSAA merged with the NCHSAA in 1977.

No one in the WNCHSAA or the NCHSAA had seen anyone who could play basketball like Crest's young Thompson. The 6-foot-4 Thompson was a tremendous shooter and an incredible leaper. Thompson joined with 7-foot-4 Tom Burleson of Newland at N.C. State and led the Wolfpack to an undefeated season in 1973 and an NCAA national championship in 1974.

Danny Talbott of Rocky Mount may have surpassed Thompson's fame as a high school athlete, though. He led Rocky Mount to NCHSAA state titles in football, basketball and baseball in 1962–63. He later won the McKevlin Award after quarterbacking the UNC football team and helping the Tar Heels to the baseball College World Series. Center Jim Clack played on those Rocky Mount title teams and later played in the 1977 and 1978 Super Bowls with the Pittsburgh Steelers.

Tarboro's Mike Caldwell wasn't as well known as Talbott and Thompson, but he struck out 31 batters in 18 innings of a 2–2 baseball tie with Washington. The game was called on account of darkness. Washington's Phil Edwards also pitched all 18 innings, striking out 27. The 58 total strikeouts by Caldwell and Edwards is number two on the all-time list in North Carolina. E.V. Spell of Clement struck out 33 in a 1–0 14-inning victory over Garland in a 1968 Sampson County Conference game. Garland's Larry Smith struck out 27 in the night game at Spivey Corner's Midway High.

"It's like if you're playing golf. You'll say you made a better shot than you actually did. If you were fishing, you caught a bigger fish than you actually did," Clement's Allen Carroll told the *Fayetteville Observer's* Stephen Schramm in 2013. "But this story with E.V. and Larry Smith and Garland and Clement, when you tell it 45 years ago or tell it today, it's still amazing. You don't have to expand on it."

A few years before in 1963, Jimmy Hunter, later hung with the moniker Catfish, pitched Perquimans High to the NCHSAA 2A championship during his junior year. Hunter and Freddie Combs alternated between shortstop and pitcher. Both were great athletes. Hunter played offensive end and linebacker on a football team that opened the season with six straight shutouts.

"People don't realize what a great athlete Jim was," said Francis Combs, Freddie's twin and Hunter's catcher. "He hit clean up and was our best hitter. A lot of scouts talked to him about signing as a position player, but he just had so much potential as a pitcher."

Hunter threw a perfect game against Elizabeth City and had five no-hitters during his career. He struck out 27 batters in a 13-inning win over Plymouth. "I remember how dominating Jimmy was," Combs said. "He was such a power pitcher, just blew the ball past you. And he had this tremendous curve.

"You could see kids' knees shake when they'd come up. I almost felt sorry for them. Jim was just intimidating. I think the first eight games that year nobody even scored a run against us."

Hunter's pitching career seemed in question when he was shot with a shotgun during a Thanksgiving hunting accident during his senior year. "We didn't know how it would

affect him," Combs said. "He lost the little toe on his right foot, the foot that he pushed off with. Nobody knew if he'd be able to play his senior year. But it didn't slow him down."

Perquimans reached the state finals in 1964. Hunter beat Northeast Guilford 1–0 in the first of the best-of-three series, but Northeast won the second game. Hunter came back to pitch the third game with one day's rest. "We scored four runs in the first and I thought we had won the title. Nobody could score four runs on Jim," Combs said. "But he was pitching with no rest. They beat us 5–4. They were really good. I think they had five guys sign." Hunter signed with Kansas City after graduating in 1964, but missed the 1964 summer season after having surgery to remove more shotgun pellets from his foot. He made his major league debut in 1965 and entered the Baseball Hall of Fame in 1987.

The 1968 Durham Jordan boys basketball team, coached by 1960 ACC basketball tournament star Doug Kistler of Duke, set an NCHSAA state championship game record with a 40-point victory over Laurinburg Scotland 91–51. Jordan (26–0) featured Stu Yarborough (Duke), Bill Chambers (UNC) and Mike Blalock (Virginia Tech). New Hanover had posted one of the most lopsided state finals wins earlier in the decade when it dashed past Raleigh by 34 points in 1960, 80–46. Famed coach Leon Brogden also led the Wildcats to state titles in '61, '62 and '68. They lost to Gastonia Ashley in 1967.

South Lenoir seemed headed toward a state title in 1969 when it won its first 25 games. The club had set a school record with 113 points in a game and had scored more than 100 five times. South Lenoir had defeated Wallace-Rose Hill three times in the season already when the two teams met for the fourth time in the playoffs. M.L. Carr, the Wallace-Rose Hill star, missed his first two shots but made his next 17 in an 83–69 upset playoff victory. South Lenoir was 25–0 before the game, but the 6-foot-6 Carr's 38 points were too much to overcome.

No girls' high school basketball player in the state could handle Genia Beasley, a 6-foot-2 center at South Johnston. Kay Yow, who coached Beasley at N.C. State, said Beasley was the first great modern girls' player produced in North Carolina. Beasley led South Johnston to the NCHSAA title in 1974 in the NCHSAA's third girls' state basketball tournament.

The NCHSAA did not crown state football champions in 1A, 2A and 3A classifications from 1961 through 1971. The growing number of schools and conferences meant more teams reached the playoffs. The playoffs were stopped at the regional level to keep football season from intruding into basketball season. Regional champions were crowned. The 4A classification stopped at the regional level only in 1965 and 1966 and so South Mecklenburg and Broughton, both undefeated in 1966, had to settle for regional titles. The 4A title game returned in 1967.

South Mecklenburg got to the finals in '67, but lost to Wilson Fike, 28–14. Carlester Crumpler was the only black player on Fike's team. He helped Coach Henry Trevathan's Demons win three consecutive NCHSAA 4A championships and won the 1969 and 1970 3A/4A NCHSAA high hurdles championship. He set the state record (14.3) in 1970.

Not playing a 3A state championship in 1966, 1967 and 1968 deprived Sanford Central of a shot at three straight titles. Steve Jones, later a star at Duke, led Coach

Paul Gay's clubs. "Steve was the best ball carrier, the best linebacker, the best punter and the best receiver I ever coached," Gay said.

Lincoln High, the school for black students in Chapel Hill, was closed during integration in 1966, but won a N.C. High School Athletic Conference football championship in 1961 without allowing a single point and averaging more than 40 points per game.

Jerry McGee, a former football standout at Elizabeth City High along with his brother Mike, coached Edenton to regional football champions in 1963 and 1964, but he is better known for his work in athletic administration. He brought a new level of professionalism to being a high school athletic director and was the executive director of the N.C. Athletic Directors Association. "He has not only done it in North Carolina, he has done it in the nation," said Robert F. Kanaby, the former executive director of the National Federation of State High School Associations. "When you think of national leaders in interscholastic athletics in the country, Jerry is near the top."

McGee was inducted into the National High School Hall of Fame in 2008.

The most successful high school golfer in the state was South Mecklenburg's Chuck Merriman. He won championships in 1963, 1964 and 1965, coming from behind each year. "I didn't go up to Chapel Hill to lose, but I really went with the idea of finding out how good I was," Merriman said. "I knew I was pretty good in Charlotte, but I was eager to find out about the rest of the state." No other golfer would win three titles until Green Hope's Brendon Todd did in 2002, 2003 and 2005.

Raymond Floyd, one of the all-time PGA greats, played at Fayetteville Central, graduating in 1960. "I don't think I ever went to the high school championships, but I remember playing high school golf all over the state," Floyd said. "It was tremendous fun and a great joy."

The 1970s — Dawning of the Jordan Era: Wilmington Laney's Michael Jordan didn't make the Wildcats varsity as a 5-foot-10 sophomore in 1978 and his Laney teams never got close to winning a state title, but he emerged as perhaps the greatest professional player ever. The legend, told even by Jordan, is that he was cut as a sophomore, but actually only one sophomore made the Laney varsity that year. The coaches, who had no upper classman taller than 6-foot-3, chose 6-foot-7 sophomore Leroy Smith over the shorter Jordan.

As a junior and senior, Jordan was a star on the Laney varsity, but never came close to making a playoff run. "Michael was tremendous. You knew he was going to be a great player," said former Southern Wayne coach Marshall Hamilton, whose Saints won the 1980 state 4A title after beating Laney during the regular season. "But Michael wasn't a great shooter. He didn't need to be. There was no three-point shot. He stayed inside and dunked." Buzz Peterson of Asheville High, later Jordan's roommate at UNC, was selected as the state high school basketball player of the year in 1981 over Jordan.

Jordan's high school career didn't rival that of Steve Streater at Sylva-Webster High. Streater pitched all but one inning during the 1977 championship baseball season for Coach Babe Howell, a North Carolina leader in baseball coaching victories (628–22) and in football (301–121–6).

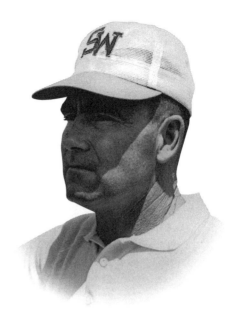

Babe Howell, western winner.

Streater finished with a 23–1 pitching record, pitching a one-hitter and a two-hitter on back-to-back days in a two-game sweep of Wake Forest-Rolesville in the state championship series. "He was really limber," Howell said. "I never thought that we were in any danger of hurting his arm."

There were no pitching limits at the time and Streater set national records with his 23 wins in a season and 61 wins in a career. He was top ten in the nation in season shutouts (12), season strikeouts (229), career no-hitters (eight) and career strikeouts (558).

But as great as Streater was, probably the most outstanding high school sports accomplishment of the decade by a North Carolina high school athlete was by Raeford Hoke's Kathy McMillan. McMillan leaped 22-feet, three inches in the Jack in the Box Invitational track meet on June 12, 1976, at UCLA. Almost 40 years later, no high school girl has seriously threatened that national record. McMillan won a silver medal in the 1976 Montreal Olympics weeks after graduating from Hoke County High. McMillan won the NCHSAA long jump title four times, won the 220-yard dash crown three times and was the 100-yard champion twice. She still holds the North Carolina state long jump record by nearly three feet. The Shea sisters, Julie and Mary, had limited opportunities for competition in high school. The longest distance contested in NCHSAA meets was 880 yards. The mile was added later, but girls were not allowed to run both the 880 and mile in the same meet. The first two years that Julie competed at Raleigh Cardinal Gibbons High, she was the only girl on the track team. When Mary Shea joined her older sister two years later, the Crusaders had two girls on the club. Nuns, wearing their habits, accompanied the girls to meets, such as the one at Raeford.

"The people there didn't know what to think of the sisters," Julie Shea recalled. "Wherever they went, it was like a parting of the sea as people got out of the way. I saw people come up and touch their habits. It was something new." Julie and younger sister Mary set national high school distance records that lasted for decades. The last of Julie Shea's state records, a 4:43.1 in the mile, fell to Ravenscroft's Wesley Frazier in 2012 (4:42.78). Mary held national high school marks at two miles, 5,000 meters and 10,000 meters.

Larry Lindsey was a basketball coaching giant in the 1970s. He helped Youngsville to the state 1A title in 1956 and began one of the state's most remarkable coaching streaks when his Youngsville team won the same title in 1968. Lindsey's 1970 Youngsville team won again and he moved to Wake Forest High the next season. His teams won 2A titles in 1971, 1972 and 1973. Wake Forest jumped to 3A and won in 1977 and went back to 2A for state titles in 1978 and 1979. Lindsey's teams won eight state titles spread over three classifications during a 12-year period.

UNC basketball coach Dean Smith once said Lindsey was one of the best teachers of zone defenses in the country. The Cougars used a 1-2-1-1 full-court press and in 1971 and 1972 won 2A state titles by one point over Whiteville and Bessemer City. In each of the win, the defense was the difference. "I always felt that teams could play more consistent on defense than offense," Lindsey said. "Move your feet. Stay between the ball and the basket. Set your feet. You can do those things even if your shot isn't dropping."

South Mecklenburg was the most successful 4A basketball program of the decade. The Sabres won in 1970, 1971, 1972 and 1976. Bobby Jones, a 6-foot-9 senior who also won two state high jump championships, led the 1970 Sabres, who had been eliminated during his junior season in the playoffs by a Greensboro Smith team led by Bob McAdoo. During his senior year, Jones grabbed 33 rebounds in a win over East Mecklenburg.

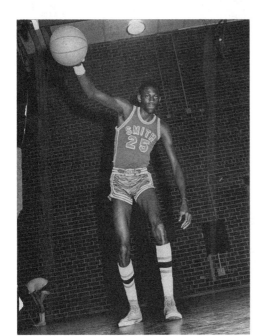

Bob McAdoo was a force to be reckoned with, even at Smith High School.

Walter Davis started on the 1970 South Mecklenburg club and led it to two more championships. The Sabres lost only four games during his varsity basketball career. Jones, Davis and McAdoo all later played at UNC.

One of the state's most famous basketball players didn't play his senior year in North Carolina. Danny Manning led Coach Mac Morris' Greensboro Page to a 26–0 season in 1983. The Pirates defeated Goldsboro 73–55 for the 4A championship. Manning transferred to a Kansas high school after his father, Ed, was hired as an assistant at the University of Kansas. Danny Manning had averaged 18.9 points, nine rebounds and three blocks for Page, which also featured future NFL wide receiver Haywood Jeffires.

John Lucas of Durham Hillside won three consecutive 4A tennis titles beginning in 1970. Lucas was an All-America tennis player at the University of Maryland, but is much better known for his basketball. He played for Coach Lefty Driesell's Terps and in the NBA for 14 years. He coached three different NBA teams. He also once scored 56 points in a 124–113 win over Hillsborough Orange in 1972.

Lucas wasn't around in 1977 when Hillside and Roxboro Person played one of the lowest scoring games ever. Hillside's Leon McRae scored with two seconds gone and Person held the ball for much of the rest of the game as Rockets coach Reid Davis tried to pull a much taller Hillside team out of a zone defense. Person missed a shot at the end of each quarter and missed three shots in the game's final 28 seconds. The final? 2–0.

"I just don't know how I feel about it. I don't know how I should feel about it," Davis told the *Roxboro Courier-Journal* in the aftermath. "I certainly never intended for it to

John Lucas, better known as a world class basketball star, was a major factor in state tennis at Durham Hillside High School.

be a 2–0 game. We intended to spread it out and get Myles (Hillside's 6-foot-6 Anthony Myles) and (6-foot-5) McRae away from the basket." Hillside coach Willie Bradshaw had his team jump out of the zone once in the second period and Person promptly got a layup, but missed. The Hornets stayed in a zone the rest of the way.

In contrast to the Hillside-Person game was one starring Cleveton Arthur of Belhaven Wilkinson, who put on a scoring show with 55 points in a 105–81 victory over Benhaven in the 1972 1A quarterfinals at Raleigh Broughton. Wearing mismatched shoes, Arthur had one of the highest scoring games ever in an NCHSAA playoff game without the benefit of a three-point basket. One of the best McDonald's All-America games ever played was in Charlotte in 1979. James Worthy and Dominique Wilkins played in that game at a sold out Charlotte Coliseum. Clark Kellogg, Ralph Sampson and Isiah Thomas also played in the game. Worthy, who averaged 21.1 points and 12.2 rebounds at Ashbrook, played with an ankle injury and had two points in the game. Wilkins, later known as a human highlight film, had 18 points and 12 rebounds.

Wilkins averaged 30 points and 17 rebounds as a senior as he and Alvis Rogers, who played at Wake Forest University, led the Pam Pack to a repeat state 3A championship. There was so much interest in the championship game between Coach Dave Smith's team and Rockingham that the title game was moved from Durham High to UNC's Carmichael Auditorium. Washington won, 82–67, to extend a winning streak that reached 56 games and help Smith on his way to more than 520 wins.

Bill Bost coached the boys and girls basketball teams at Bandys. He had a 341–143 record in boys and a 181–35 in girls, including an NCHSAA title in 1977.

Robbinsville was the most dominant 1A football program in the 1970s. Coach Bob Colvin's Black Knights won the NCHSAA title in 1969 and then won 10 more during the next 14 years. Colvin built a 177–52–2 record during his 20-year coaching career. High Point Andrews didn't have a long-string of state championships, but it defeated Fayetteville Reid Ross 24–17 in the 1972 finals. The Andrews team featured Johnny Evans, an All-America punter at N.C. State; Timmy Johnston, a running back starter at N.C. State; and Ted Brown, a member of the College Football Hall of Fame after becoming State's career rushing leader.

Broughton's golf teams in the early 1970s were remarkable. The Caps won championships in 1972, 1973 and 1974 as Tom Reynolds, Scott Hoch and Wes Minton won individual titles. The Caps didn't have a golf team during the regular season, but assembled four players to enter in regional qualifying. Broughton set the state record with a 581 total in 1974. The record has been broken, but in more recent years teams have played with five players. In 1974, each team entered four players and every stroke counted.

Reynolds (N.C. State), Minton (UNC) and Hoch (Wake Forest) all played college golf. Hoch won 11 PGA titles and his NCHSAA win came in a playoff with Fayetteville's Chip Beck, who later won five PGA titles and was the runner-up in the 1993 Masters and in the 1986 and 1989 U.S. Opens.

The NCHSAA held girls' golf championships from 1969 through 1979 and from 1987 through 1989 before starting the tournament again in 1995. There were no team champions from 1995 through the spring of 1997. Lee Senior won the first three state titles

when the tournament moved to the fall in 1997. Blair Lamb of East Henderson won the 2002 (Open), 2003 and 2004 (1A/2A/3A) individual titles and has the four of the top seven rounds ever shot in the NCHSAA championships, including the top three of 67 and 68 (twice). She also posted the three lowest two-day totals of 136 (twice) and 140. Courtney Gunter of Porter Ridge won 1A/2A/3A championships in 2006, '07 and '08.

The longest state championship winning streak was set from 1965 through 1980 when Coach Bob Sawyer's Whirlies at Greensboro Grimsley won every swimming title. Charlotte Myers Park had won every year from 1959 through 1964, but once Grimsley got rolling no one could touch it.

Lisa and Margit Monaco, twins at Fayetteville Sanford, set a state record by winning the state 4A tennis doubles title four straight years. They won 72 of 73 matches during their careers in 1977 through 1980.

Butch Bailey of Clayton and Ricky Olive of Apex locked up in a record-setting baseball game in 1976. Olive gave up a lead-off walk and the runner eventually scored. He did not give up a hit, but lost the game despite throwing a no-hitter. Bailey topped him with a perfect game. Saratoga's Tom Hayes threw three consecutive baseball no-hitters in 1972 before going on to star at N.C. State.

Norm Trzaskoma built a cross country power at Winston-Salem Reynolds, where his boys won five straight NCHSAA titles from 1974 through 1978.

The N.C. Independent Schools Athletic Association was formed in July 1973. Representatives from 26 North Carolina schools started the organization and conducted state tournaments in boys and girls basketball, tennis and golf during the 1973–74 school year. The NCISAA was conducting state tournaments in 17 sports and had 85 members by 2013–14.

The 1980s — A Move to the Big Stage: Garner's 40–21 4A football championship win over Charlotte Harding at Charlotte's Memorial Stadium in 1987 was one of the most influential high school games ever played in North Carolina. NCHSAA executive director Charlie Adams already was interested in moving state title games to neutral sites, but the huge crowd at the Garner-Harding game added to the urgency.

Adams remembered when Cary played Raleigh in basketball in 1954 at N.C. State's Reynolds Coliseum before 12,000 spectators. He also remembered playing the state finals against King High at Aberdeen High. "The state finals were incredible, one of the most memorable games I ever played," Adams said. "But I later wondered why the state finals were there. We had played almost of all of our games in nicer places."

The NCHSAA played its first championships on the UNC campus, using Bynum Gym, the Tin Can and Woolen Gym in basketball and later playing at Kenan Stadium in football. But with expansion and the emergence of classifications, the NCHSAA turned to more to its high schools to host state championship events. Durham High, Broughton and Winston-Salem Reynolds often were used in basketball before Adams led the championships into some of the country's nicest facilities.

The NCHSAA moved its basketball 4A championship game to UNC's new Dean E. Smith Center in 1986 and the Broughton and West Charlotte players raved about the experience. But playing a basketball game in a major college venue was a snap compared

Charlie Adams led the state's high school sports into the modern era.

to trying to play a football title game on a neutral site. Moving the football games off high school campuses to major college venues became an imperative after the 1987 4A football championship.

Garner defeated Charlotte Harding before a crowd estimated at 21,000 as Garner's Anthony Barbour scored five touchdowns and rushed for 265 yards to cap a then-state record 3,125-yard season. Adams said:

> "We didn't have any high school in the state that could accommodate a crowd that large. How could we expect a high school to prepare for that many people? Our facilities aren't built, and don't need to be built, for crowds that big.
>
> "We want the finals to be a pleasurable experience for the spectators, too. We wanted them to have a seat, to be able to buy something to eat, to go to the bathroom."

Adams did not make public until years later that the NCHSAA was facing a potential facility crisis. Jay Robinson, then the superintendent of Charlotte-Mecklenburg Schools, had said his system would never try to host another 4A football championship on a high school campus because the title game had outstripped high schools' ability to host the game.

Memorial Stadium might be available in Charlotte for future games, but Adams believed that if Charlotte-Mecklenburg was reluctant to host the 4A football finals on its high schools' campuses then other systems probably would follow. Adams also was con-

cerned about the home field advantage the host school received. He recalled the time a visiting football team arrived at the stadium to see water standing on the turf. It had not rained in weeks. "The home coach thought a muddy field would give his team an advantage so the irrigation system was turned on and left on," Adams said. "It probably wasn't the first time."

But Adams also knew that schools would not want to pay the costs associated with a move to neutral sites. Adams' solution was to turn to corporate sponsors to help pay for the move to neutral facilities. Richmond County defeated West Charlotte 17–0 in the 4A championship at UNC in 1988 and the NCHSAA football title games have been played at UNC, N.C. State, Wake Forest University or Duke University ever since. With football in a college stadium, the coaches of other sports showed more interest in neutral sites. Moving baseball was a priority. Adams recalled:

> "We had a lot of our baseball fields with no concessions, no restrooms, no lights and very few stands. Fields were very different with different dimensions. We wanted to make the state championship series a great experience for the players, the fans and everyone else and we wanted to make the playing field as level as we could."

Steve Bryant, a former player at Smithfield-Selma High, owned the Carolina Mudcats professional baseball team and he made its Five County Stadium available. N.C. State offered its field and the baseball championship series had new homes.

"We learned that by moving to the baseball stadiums that we had a better chance of getting the games played," Adams said. "Those stadiums have tarps and games that probably would have been rained out somewhere else can be played." Eventually every NCHSAA championship was placed in a major venue. There was some disagreement, though. The NCHSAA insisted the championships be played as close to the center of the state as possible to hold down travel costs. Most of the title series were played in Raleigh, Chapel Hill and Winston-Salem. More than one coach from another region complained that teams in those areas essentially were playing at home.

Before the move to neutral sites, though, Coach Marion Kirby of Greensboro Page opened a new era of North Carolina high school football with an offense centered on a passing attack. Mark Maye at Charlotte Independence helped usher in the pass-happy offenses (4,400 passing yards in 1981–82), but Page proved that teams could win championships by passing. Page lost to Jacksonville, 15–6, in the finals in 1982, but the Pirates, led by Todd Ellis, won or shared the next three state 4A titles.

Burlington Cummings, coached by Dave Gutshall, pushed the passing game even more with a succession of outstanding quarterbacks. Chuckie Burnette (6,473 career passing yards), Donnie Davis (8,865 yards) and Ernest Tinnin (10,836 yards) set state career passing yards records. The 1990 state football championship games were played at UNC's Kenan Stadium, and Cummings' Davis, who also was a state hurdles champion, and Swain County's Heath Shuler starred in back-to-back games.

Richmond County became a fixture in the championships game under Coach Daryl Barnes. The Raiders lost to Garner in the quarterfinals on a last second touchdown pass in the 1987, but rolled off three successive 4A titles with players such as Mike Thomas

and Oscar Sturgis. Richmond won the 1990 championship when a tight end ran the wrong route and grabbed a deflected pass on the final play of the game for a 9–7 win over West Forsyth. The catch was his first reception of the year.

Chester McGlockton led Whiteville to the state 2A championship in 1987 and later was a Pro Bowl selection in the NFL. The 6-foot-6, 287-pound McGlockton was the NCHSAA athlete of the year as a senior and shares the state record with nine interception returns for touchdowns. McGlockton played basketball, participated in track and led Whiteville to a 15–0 record and the 2A football title in 1987. The Wolfpack scored 14 points in the final seven minutes of the finals to take a 14–12 victory. Thomasville tried to tie the game with a two-point conversion in the losing minutes, but McGlockton made the stop.

Soccer seemed like a new sport in North Carolina in the 1980s, but high school teams had been playing for high school titles since 1927 when Winston-Salem won the championship. The playoffs were not held from 1939 through 1965 but a group of coaches organized championships in 1966. Public and private schools played in one tournament until the NCHSAA established a sanctioned tournament in 1977.

Bob Catapano of Raleigh Sanderson gave the sport a big boost with his national record-setting program. Catapano's Spartans won 10 state championships beginning in 1978 and set the national record with 103 consecutive games without a loss in 1982 through 1987.

Roy Lassiter of Raleigh Athens Drive is one of the most decorated high school soccer products from the state. He led Athens to the NCHSAA 4A championship in 1987, and then played at Lees-McRae College and N.C. State before becoming a professional. Lassiter led Major League Soccer with 27 goals for the Tampa Bay Mutiny in 1996 and he later became the career leading scorer in the MLS. He was voted to the MLS All-Star team in 1996, 1998 and 1999.

The NCHSAA added its first girls' soccer championships in 1986 and Greensboro Page under Coach Zack Osborne (350 wins) quickly established itself as a power by winning the first three titles. His boys won 400 games and four state titles.

Hayesville, coached by Daryl McClure, had an exceptional run in girls basketball, winning six straight 1A titles beginning in 1988, and Sun Valley ran off five straight cross country championships and won six in seven years after the NCHSAA added a 3A championship in 1986. Meanwhile Tom Pryor was building a 702–244 girls' basketball coaching record in western North Carolina during a 40-year head coaching career. He won 594 games at Edneyville.

Durham Jordan coach Ann Harris' Falcons won six state volleyball championships between 1983 and 1990. Her teams had a .904 winning percentage, winning 467 of 497 games, from 1976 to 1990. Waynesville Tuscola won in volleyball in 1987 and was runner-up for the next six years.

North Carolina girls' teams played slow-pitch softball from 1975 until 1994 when the NCHSAA switched to fast-pitch. Few places played slow-pitch better than South Granville in Creedmoor. Coach Jimmy Fleming, who built a 434–36 career coaching record in slow-pitch and later fast-pitch, coached teams to 2A state championships in 1989, 1990, 1993 and 1994. Patrina Cooper hit .757 for the Vikings in 1991.

Fleming one year recruited track stars to play in the outfield and taught the girls to bunt. He often put his tallest girl at first base and instructed her how to stretch for throws. "We won a lot of games by putting the ball in play," Fleming said. "And think of all the bang-bang plays. That tall girl stretching out to get the out was the difference in winning and losing several times."

Whiteville's Tommy Greene, who later played for the Philadelphia Phillies, Atlanta Braves and Houston Astros, was a baseball hitting and pitching star at Whiteville. He posted a 0.07 earned run average in 1985 and set the state record with 270 strikeouts. He also held the NCHSAA records for home runs in a career and a season at the end of his career. He hit four home runs, including three in consecutive at-bats, in a 19–0 win over South Brunswick in 1985. He also had a state record nine no-hitters in his career and back-to-back no-hitters against Wallace-Rose Hill and North Duplin in 1985.

Joan Nesbit, the 1980 NCHSAA 1,600 meters champ, later won All-America honors in cross country, indoor track and outdoor track at UNC and competed in the 1976 Atlanta Olympics. Melissa Morrison won bronze medals in the 100-meter hurdles in the 2000 Sydney Games and in the 2004 Athens Games. She had won three consecutive 100-meter titles while at Kannapolis Brown (1987–89) and was the state champion in the triple jump in '89.

The 1990s — Ralph's Accolade: Shea Ralph built a resume at Fayetteville Terry Sanford worthy of the state's best girls basketball player. When Ralph graduated from Terry Sanford in 1996, she held or shared 17 NCHSAA records despite playing only three years of varsity basketball. *USA Today* named her as its national high school player of the year in 1996. She never won a state title, but she led the Bulldogs to two second-place finishes in the state tournament. She scored all of Terry Sanford's points in the second half of a 73–51 loss to Durham Hillside in the '96 finals. She scored 40 points, but her teammates were a collective three of 27.

Ralph averaged 39.1 points per game in 1995 and 33.0 points per game in her career, both state records. She also scored a state record 61 points in a 103–39 victory over Fayetteville Pine Forest in 1996. She had 16 steals, 11 assists and only two turnovers in her record-setting game, but said she still heard some complaints that she shot too much. "My scoring average is down, so people say I can't shoot anymore," she said during her senior season. "If I shoot, I'm selfish. Sometimes it seems like a lose-lose proposition."

She finished her career with 3,002 points, including a record 1,135 in 1995. Ralph ranks fifth on the NCHSAA all-time career scoring list that is led by Clinton's Danyel Parker, who scored 3,225 in a four-year high school career that ended in 1989. Parker led the Darkhorses to three 2A state championship games, including a title in 1989.

Donald Williams of Garner, a future NCAA Final Four MVP, set the state record for points in a season (961) in 1991 when he averaged a state record 35.6. He once had eight consecutive games of 30 or more points, and he scored 30 or more points in 22 games in 1991.

JamesOn Curry of Eastern Alamance pushed Williams down in the record books for scoring. Curry scored 3,307 points in his career, scored 40 or more points in 16 games

during his career and had 44 games of 30 or more. He threatened the single-game scoring record of 67 points that was set by Clayton's Bob Poole in 1950. Curry scored 65 points in a 102–71 victory over Western Alamance in 2004. Curry later played at Oklahoma State and in the NBA.

Jason Parker of West Charlotte won 1998 and 1999 Associated Press boys' basketball player of the year awards. He scored 38 points (making 17 of 22 shots), grabbed 12 rebounds and blocked four shots in an 84–67 win over Wilmington Laney in one of the best championship performances ever.

Marlene Poole of Greensboro Grimsley, and later Greensboro Dudley, became the first athlete to ever win four consecutive NCHSAA track and field championships, sweeping the 100 and 200 meters in 1987 through 1990. Deanne Davis of Burlington Cummings matched and topped her by winning the 100-meter hurdles, the 300-meter hurdles and the triple jump every year from 1993 through 1996.

But not even Davis can match Julie Stackhouse of Hayesville. Stackhouse set an NCHSAA record with 15 individual outdoor track championships. She also was one of the most versatile track athletes ever in the state. She won state titles in 200 meters, 400 meters, 800 meters and 1,600 meters and in the high jump, 100-meter hurdles and 300-meter hurdles.

North Rowan's Robert Steele developed a reputation as one of the nation's best teachers of the triple jump. His teams won 15 NCHSAA track and field state titles, including five straight between 1994 and 1998. North Rowan's Greg Yeldell is the only NCHSAA male athlete to win the same event four straight years. He was one of the nation's top triple jumpers when he graduated in 1998.

Blake Phillips Russell was a dominating distance runner at Forsyth Country Day. She won two NCISAA cross country titles, and 11 of 12 championships in the 800, 1,600 and 3,200 before graduating in 1993. She competed in the marathon in the 2008 Beijing Olympics.

Brenda Taylor of Boone Watauga won the NCHSAA 100- and 300-meter hurdles titles (1995, '96 and '97) and the 55-meter hurdles indoors in 1997. She was seventh in the 400 hurdles in the 2004 Athens Olympics. Crystal Cox of Fayetteville Pine Forest joined Taylor at the 2004 Games. Cox had won the NCHSAA 200 and 400 as a sophomore, the 100 and 200 as a junior and the 100 and 200 as a senior in 1997. She also won the NCHSAA 300 indoors three times and 500 as a sophomore. She won a gold medal in Athens as a member of the U.S. 4x400 team. The team was later disqualified because of a drug violation.

Raleigh Broughton's Izzy Hernandez (nine NCHSAA titles) and Greensboro Grimsley's Herk DeGraw (440 wins and six NCHSAA titles) built the state's most dominant girls' soccer programs. Every year from 1992 until 2007, either Broughton or Grimsley reached the 4A title game. Broughton won nine state championships and finished runner-up four times during the 15-year period. Grimsley won five crowns and was second five times. They met in the finals eight times, Broughton winning five times.

The Caps greatest player during the period was Lindsey Stoecker, who later played at UNC and in the professional ranks. Leesville Road, coached by Paul Dinkenor, sur-

passed Broughton as a North Carolina soccer power. The Pride won three girls' titles and two boys' championships.

The state's most famous NCHSAA soccer player of all-time may have been keeper Siri Mullinix of Jamestown Ragsdale. Mullinix was an all-state keeper in 1994 and 1995 and led Ragsdale to the state 1A/2A/3A title in 1994, when she was the tournament MVP. Mullinix skipped her senior high school season to enroll at UNC and helped the Tar Heels win two NCAA titles. She later was the U.S. National team keeper. She had two shutouts in the 2000 Olympics and helped the U.S. win the silver medal.

Swansboro won 1A/2A titles in 1995 through 2000 and then won again in 2002.

The Broughton boys' tennis team kept pace with the girls soccer program. The NCHSAA began its dual-team tennis tournament in 1991 with Chapel Hill winning. From 1992 until 2006. Coach Steve Spivey's Caps won nine dual-team boys' titles and were runners-up twice. Spivey's girls won another eight crowns.

Laura Cowman of Charlotte Catholic became the state's first four-time singles champion in 1989–92 by sweeping the 1A/2A titles. Julianne Treme of Salisbury matched her mark beginning in 1993 and Jackie Houston of Kings Mountain won four straight 3A crowns starting in 1993. Britney Cloer won three 2A titles at Brevard and won again as a senior at West Henderson.

Josh Hamilton, a future American League player of the year with the Texas Rangers, led Raleigh Athens Drive to the 4A baseball championship series in 1998 and was the first player selected in the 1999 the major league baseball amateur draft. Alleged drug and alcohol abuse almost ended his career, but he made a miraculous recovery.

Hamilton hit three home runs at the Carolina Mudcats' Five County Stadium in the championship series, which was won by Northwest Guilford. He hit one homer that Athens assistant coach Joey Bell had trouble describing. "The only thing I can compare it to was the last home run in the movie, *The Natural*," Bell said. "Josh hit the ball so hard. It went out to right field. You really can't describe it. You had to see it to believe it."

A few years later Hamilton returned to Athens Drive to take some batting practice for a special being filmed by ESPN. Hamilton put on a show at the high school park. But Bell said he was stunned after the workout.

> "He was hitting with a wooden bat and when I ran my hand over the barrel it was bumpy. When I looked at it, you could see the stitches from the balls where Josh had hit them. I'd never heard of that, hitting a ball so hard that the seams showed in a wooden bat, but that's what he did."

Hamilton survived his troubles, but East Carteret's Brien Taylor, the first player taken in the 1991 draft, didn't. The left-handed pitcher had a deceptively easy delivery that propelled fastballs at close to 100 miles per hour. Famed agent Scott Boras slipped into Beaufort in disguise to watch him pitch and after the Yankees drafted Taylor they learned that Boras and Taylor's mom, Bettie, who picked crabs for canning, were determined to get top dollar. He signed for $1.55 million, returning home from Louisburg College without ever attending class. He seemed well worth the prize and pitched well in the minors before injuring his left shoulder in an off-season altercation. He was never the same again and eventually was imprisoned on drug charges.

Shawn Gallagher of New Hanover holds the national high school record with hits in 51 consecutive games and also has the state record for baseball hits in a season (65 in 1995), home runs in a game (five) and RBI in a game (11). His five home runs against Southern Wayne shares the national record. He was second on the national list with 19 home runs and 61 RBI in 1995, third in hits in a career (155), seventh in career runs (121) and number eight in runs (52 in 1995).

Eric Faulk, a pitching teammate of Gallagher, won 32 consecutive games in 1993 through 1995. He won 49 games in his career. Faulk also played with New Hanover's Trot Nixon, a 1993 graduate who was one of the state's top football-baseball players.

Nixon hit a home run in his final high school at-bat while helping New Hanover to the 1993 title. He was a Shrine Bowl of the Carolinas pick as a quarterback and beat out Alex Rodriguez of Miami Westminster Christian High for *Baseball America's* high school baseball player of the year award. Nixon drove in 56 runs in 1993 and was the seventh overall pick in the baseball draft. Only East Carteret's Brien Taylor (1991) and Athens Drive's Josh Hamilton (1999), who were number one picks, and Smithfield-Selma's Barry Foote (third in 1970) were drafted higher.

Josh Jones of Hibriten was as perfect as he could be in a 2003 game against Avery County. Jones faced 15 batters and struck out all of them in the shortened five-inning 14−0 victory. Joe McDonald of Charlotte Butler struck out 14 of the 15 batters in a 1999 five-inning 22−0 perfect game victory over Charlotte Garinger. Jason Shipley of Jamesville did a little better, fanning 17 of 18 in a six-inning 12−0 perfect game win over Gates County in 2000. He had three other no-hitters that year. Paul Stewart of Garner threw a perfect game in 1996, but took a loss. Stewart was perfect through eight, but gave up a run in the ninth in the 1−0 setback.

In girls' tennis, Gil Bowman, who was Shea Ralph's basketball coach, led Terry Sanford to four straight 4A titles in 1991 through 1994. Lindsey Linker of Chapel Hill High and East Chapel Hill High recorded 16 NCHSAA titles.

Swansboro, under Joan Riggs, won five volleyball titles in the 1990s. She had a 363−65 career coaching record and won five state crowns.

The 2000s — Calling CP3: West Forsyth's Chris Paul had one of the most amazing basketball games ever in the state. He decided to score 61 points in a game against Winston-Salem Parkland to honor his 61-year-old grandfather, who had been killed days before. He scored his 61st point on a layup and was fouled, but deliberately missed the free throw and left the game with four minutes left. He might have been able to top Clayton's Bob Poole's NCHSAA record of 67 points, but that wasn't his objective.

Paul said:

> "(My grandfather) was my best friend; I talked to him every day. He would tell people he was closing the gas station early on the nights we played so he could watch the games. Our relationship didn't really have anything to do with basketball, though. He was just my best friend."

When the McDonald's All-America basketball game selected in 2012 its top 35 players, five of them were from North Carolina. They were Paul (2003), Gastonia Ash-

brook's James Worthy (1979), Kinston's Jerry Stackhouse (1993), Washington's Dominique Wilkins (1979) and Laney's Michael Jordan (1981).

The biggest crowd to ever see a high school basketball game, 16,200, packed Greensboro Coliseum on January 20, 2003, when LeBron James and his St. Vincent-St. Mary's teammates played Winston-Salem R.J. Reynolds in a Martin Luther King showdown. James, then 6-foot-7, 240 pounds, warmed up by throwing in high-arcing shots from midcourt. When the game started, he poured in 32 points, 30 of them in the first three quarters, as the Akron, Ohio, team pounded a Reynolds team that included future University of North Carolina player Reyshawn Terry, 85–56. Reynolds had won three straight NCHSAA 4A titles.

The new century ushered in an era in which the top high school basketball players in the state were as likely to play at private schools as public schools. There had been great players in private schools, primarily N.C. Independent Schools Association schools, which began state basketball tournaments in 1975, but the vast majority of the top players were in public school until around 2000.

Durham Mount Zion, which brought in players from throughout the country, was a national power by 1997 and attracted players such as Tracy McGrady and Amare Stoudemaire, both from Florida, as well as international players. Raleigh's John Wall was the nation's top recruit in 2009 when he played at Raleigh Word of God. C.J. Leslie, later an ACC standout at N.C. State, was Wall's teammate along with future University of Maryland standout Dez Wells. Quincy Miller came from Illinois to play at Winston-Salem's Quality Education Academy. The Plumlees, future Duke players Mason, Miles and Marshall, left Indiana to enroll at Christ School in Arden.

But public school basketball remained strong at Kinston High. The community of about 20,000 could assemble an incredible all-star team with its native sons. First under Coach Paul Jones (662–274 in 38 seasons) and later under Coach Wells Gulledge, the Vikings produced Charles Shackleford (N.C. State), Jerry Stackhouse (UNC), Cedric Maxwell (UNC-Charlotte), Reggie Bullock (UNC), and Bo Ingram (Wake Forest). Kinston is also the hometown of football coach Ty Willingham and NFL star Dwight Clark.

The emergence of high school sports dynasties at the start of the 21st Century was unprecedented. Occasionally programs had emerged that dominated for a period—Greensboro Grimsley in swimming and Robbinsville in 1A football, for example—but long periods of dominance became the rule in the early 2000s.

Charlotte Independence under Coach Tom Knotts won six consecutive 4A football titles and 109 consecutive games. No other school in the state had ever come close to overwhelming big-school opponents so thoroughly. Broughton won 10 girls' soccer titles in 15 years. Asheville Roberson claimed 10 girls' cross country crowns in 12 years. Richmond County was 170–22 (.885 winning percentage) in football between 1999 and 2013. Independence was 176–26 (.871) and Matthews Butler was 151–33 (.828). Reidsville won state 2A titles in 2002, 2003, 2007, 2008 and 2009 and posted a 171–33 record (.848).

In an era of dynasties, Charlotte Independence attracted the most attention with a steady stream of exceptional quarterbacks under Knotts' tutelage. Independence's Chris

Leak essentially erased the NCHSAA football passing record book. He completed 1,013 passes in 1,745 attempts for 15,593 yards from 1999 through 2002. He set state records for completions (336), attempts (584) and yardage (5,193) in 2002. He added records for career touchdown passes (185) total offense in a career (16,590) and season (5,496). His favorite receiver was Mohamed Massaquoi, who set state records with 4,876 career receiving yards and 76 touchdown catches. He also had a state-record 32 touchdown passes in 2004 and a single-season record with 1,834 yards in 2004.

What Leak did in the air, Albemarle's T.A. McLendon did on the ground. McLendon set national records for rushing touchdowns (170), total touchdowns (178), season touchdowns (71) and rushing touchdowns (68). He is the only player in NCHSAA history to score more than 1,000 points, putting up 1,170, including 428 in 2001.

Mario Williams of Richlands was an incredible football athlete in 2003. He was 6-foot-6, weighed 257 pounds with bulging arms built from laying brick and he could run 40 yards in 4.57 seconds. He played linebacker, defensive end, defensive tackle, tight end and running back at Richlands. He signed with N.C. State and was the first player selected in the NFL's 2006 draft. By then, his weight was 297 pounds, but he could still run 40 yards in less than 5.0.

Jack Holley at Wallace-Rose Hill and Bob Paroli were in the twilight of their careers as the state's all-time winning football coaches with more than 400 victories each as the new century began. To match their records, a new coach would have to average 10 wins a year for the next 40 seasons.

Holley was known as a motivator. When a player complained about the late-season chill, Holley stripped down to his underwear for the rest of practice. He once ripped off his shirt and dropped to all fours and howled when he talked of the team needing to play like a pack of junkyard dogs.

Paroli coached long enough that his son joined him on the coaching staff and they coached together for more than 30 years. Paroli said the great joy of coaching was watching how the players matured as people. Paroli said:

> "The only reason I do it is the kids. You could write a book just on how they walk into the dressing room before practice. They've always got something going on.
> "When they are juniors and seniors I really like to sit around with them and laugh about some of the things they did as sophomores and freshman."

Paroli coached for 55 seasons while David Gentry of Murphy notched 43 seasons, 320 wins and five state titles. Thomasville's Allen Brown coached football more than 40 years and racked up 325 wins and seven state titles, including crowns in 2004, '05, '06 and '08. Tom Brown got all of his 330 football victories at Maiden. No other football coach in the state can match that mark for wins at one school.

Ronald Vincent of Greenville Rose is unchallenged as the state's leader in baseball coaching wins with more than 800 and six state championships. Among the other baseball coaching giants are James "Rabbit" Fulghum at Greene Central, whose teams won NCHSAA championships in five different decades, and George Whitfield, whose high school and American Legion teams won 954 games during a 43-year coaching career.

Vicki Peoples' Enloe clubs won nine straight boys' swimming titles, including the crown in 2006. New state records were set in the meet in 10 of the 12 events. Charlie Houchin of Enloe and Ricky Berens of South Mecklenburg later won gold medals in the 2012 Olympics in London and East Chapel Hill diver Nick McCrory won a bronze medal in the same games. Berens also won a gold medal in the 2008 Beijing Olympics. "You get caught up in the competition and you don't pay much attention to the records being broken," People said. "But it was the best meet I can remember."

That same year, Eugene Godsoe of Southeast Guilford won the NCHSAA 3A 100 backstroke and 100 butterfly for the fourth straight year. He is the only male swimmer to win two events every year of his high school competition. Kirsten Smith of Raleigh Athens Drive won the 200 individual medley and the 500 freestyle in 2003 through 2008 and Margaret Bardin of Burlington Williams was the 3A champ in the 50 free and 100 free during the same period.

McCrory, the Olympian, won three straight diving championships and was favored heavily in 2009, but missed the regionals because of an international competition. He was deck side for the NCHSAA championships, though, rooting for his teammates.

Jesse Williams of Raleigh Broughton competed in the 2008 and 2012 Olympics after winning three NCHSAA high jump titles and a wrestling championship while at Raleigh Broughton. Williams was the 2011 high jump world champion.

Gabby Mayo of Southeast Raleigh won nine NCHSAA 4A outdoor track championships, winning the 100 hurdles three times, the 100 meters twice, the 200 meters twice and the 300 hurdles two. She set state records in the 100, 200 and 100 hurdles and won a record four titles (100, 200, 100 hurdles and 300 hurdles) in 2006. She also had another three indoor track titles and records.

Dee Best of Concord joined Mayo as the NCHSAA athletes of the year in 2007. Best was the first athlete to be named the MVP of the both the football and basketball championship games. Jacinda Evans of Southern Durham matched Mayo's four individual girls state tack titles in 2008 when she won the 100, 200, long jump and triple jump.

Wayne Davis II set world high track records in the 110-meter high hurdles while running at Southeast Raleigh in 2007 through 2009. He set the sophomore record with a 13.65, set the World Youth record (13.18) in a meet in the Czech Republic, tied the U.S. indoor record for the 60 hurdles (7.62) in 2008, broke the national 55 indoor record (7.06) in 2008 and set the new national mark with a 7.05 in 2009. He also set the World Junior record of 13.08 in the 110 hurdles in 2009. He later won the NCAA 110 hurdles championship while running at Texas A&M and competed in the 2012 London Games.

Manteo Mitchell of Shelby Crest provided one of the great Olympic moments at the London Olympics. He had helped Crest win 4x100 relay titles 2004 and 2005. In London, Mitchell ran the leadoff leg of the United States' 4x400 relay. During a qualifying race, Mitchell's fibula bone just above the ankle snapped. Yet, he ran the last 200 meters with a broken leg, and helped the U.S. team qualify. "I had to channel my attention and my focus on getting back to the finish line, knowing that there were three guys that were waiting for me and a whole country depending on me," Mitchell told reporters.

No other pitcher dominated high school softball in North Carolina as thoroughly as Crystal Cox of Central Cabarrus in 1998–2001. She threw seventeen perfect games and thirty-seven no-hitters while building a 106–7 career record. She had fifty-four consecutive wins and twice pitched twenty-six shutouts in a season. She struck out a record 1,455 batters, including twenty-nine in a twelve-inning victory over West Stokes in 2001.

Amazingly, Central Cabarrus hardly missed a step after Cox graduated. She was followed by Gina Allen, who won 100 games in her career and threw 30 no-hitters. She won 76 consecutive games. Allen struck out 36 batters in 18 innings in Central's 1–0 victory over West Forsyth in the NCHSAA championship game in 2005.

Carol Lilley of Greenville Conley and Hannah Angel of East Bend Forbush did not allow an earned run during their 2003 seasons.

Alexander Central is a softball power with eight state championships. Chelsea Wilkinson helped win two of them. Wilkinson was a four-time All-America selection and set the state record with 112 career wins and 84 shutouts. Her 1,406 career strikeouts trail only Cox.

A common link between Wilkinson and Cox is head coach Monte Sherrill, who has a twenty-four-year 586–59 career record. His team's won at least 22 games each season and won the conference championship each year. His teams won NCHSAA championships in 1991, 1994, 1995, 1996, 2004, 2005, 2009 and 2011 and were ranked in the final national polls nine times.

No one in state history can match the pitching day that Morgan Childers of Kings Mountain had in the NCHSAA softball playoffs on June 6, 2006. Childers struck out 24 Southwestern Randolph batters in one game and 23 Harnett Central hitters in the NCHSAA Final Four. She had two other 19 strikeout games that season. "I was from a small town and we always felt like we were the underdogs," said Childers, who later coached at Green Hope High in Cary. "I always felt my job was to hold the other team until we got some runs. I never felt any pressure. I was just having fun."

She threw a riser, curve, changeup and screwball. "I was a nuisance pitcher," she said. "I didn't throw a fastball." Childers won two back-to-back NCHSAA titles and she won 25 games in 2006, including 22 shutouts. She struck out 395 batters that year and had a 0.04 earned run average as Kings Mountain posted 19 consecutive shutouts. She finished her career ranked among the top dozen players in seventeen different pitching and hitting categories.

Surry Central's Michael Richardson set the NCHSAA soccer scoring record in 2001 with 87 goals. He topped that mark the next year with 92 and finished his career with a record 205 goals, 41 more goals than second-place Matt Smith of Eastern Alamance.

Megan Hodge, who played for the USA volleyball team in the 2012 Olympics, was the national high school volleyball player of the year at Durham Riverside in 2006.

John Isner of Greensboro Page won the 2001 boys' tennis singles championship and went on to be ranked among the top ten players in the world in 2012.

Webb Simpson of Raleigh Broughton was the 2004 4A golf champion and the U.S. Open champion eight years later in 2012. Broughton had won five straight golf titles

from 1998 through 2002 when three-time champion Brendon Todd led Cary Green Hope to the 4A crown.

Bob Vroom of Swansboro helped make Onslow County a soccer hotbed. His clubs won seven state championships during his 25-year tenure and he was named the National Coach of the Year by the National Soccer Coaches Association of America in 2001.

The 2010s — Not So Impish: Cary High developed one of the top wrestling programs in the country under Coach Jerry Winterton, a two-time national high school coach of the year. Winterton's Imps were undefeated during 27 of his 29 regular seasons and his overall record was an incredible 642–13.

The Imps won the state individual dual-team tournament championship in 1987, '88, '89, '97, 2000, '03, '05, '06, '07, '08, and 2009. They were also runner-up six times. They won the dual-team championship in 1993, '96, '97, '98, 2005, '07, '08 and '09 and were state runners-up seven times. "When you look at it that way, it is sort of amazing," Winterton said.

Winterton believed in positive coaching, telling kids what they could do. He never took being on the sidelines for granted. "The biggest thing for me was realizing what a privilege it was to coach these guys, the chance to sit in the chair and watch them compete," Winterton said. "I'm sure there were some big thrills, but I can't think of anything more thrilling than coaching."

South Iredell wrestling coach Bill Mayhew would agree. Mayhew is the NCHSAA's career leader coaching wins in wrestling with more than 750. North Carolina has had eight four-time NCHSAA wrestling champions: Chris Bullins of Mayodan McMichael, Justin Sparrow of East Gaston, Drew Forshey of Hickory St. Stephens, JohnMark Bentley of Avery County (who was 144–0 in his career), Mike Kendall of Albemarle (153–0), Dusty McKinney of East Gaston, Corey Mock of Chapel Hill and Jacob Creed of Jamestown Ragsdale.

North Carolina also dominates the national list of wrestlers with the most wins in a season. The NCHSAA counted tournaments differently than most states and Colton Palmer won a national-record 91 matches in 2007. He had a 284–6 career record, which is second in the country for most career wins. Riverside has three of the top six career wins leaders — Palmer, number five Sheldon Wilder (86), and number six Cedric Carter (83) — and seven of the top twenty.

Green Hope cross country coach Mike Miragliuolo probably has the record for the country's biggest team. Miragliuolo often had more the 200 runners, more than ten percent of the student body, in his cross country program. "I used to think 100 was the limit," Miragliuolo said. "Then 150. Now we're around 205 and I don't see a limit."

Green Hope's 2013 club had more than 250 runners, including Maureen McDonnell, who won varsity letters each year for four years in cross county (four top 12 finishes and four NCHSAA team titles), indoor track (1,600 champion in 2012), outdoor track, and girls' soccer (2014 state title and top national ranking). She is the school's career leader in assists in soccer. "I did it because it was fun," McDonnell said. "There were

times when I thought I was trying to do too much, but I was enjoying everything that I was doing."

Miragliuolo once thought that having so many runners might handicap his elite runners, but that was before Green Hope won four straight girls team championships from 2009 through 2012 and won the boys' title in 2010.

Wesley Frazier, the state's most heralded girls distance runner ever, was competing at Ravenscroft at the same time McDonnell was running at Green Hope. Frazier began her high school career by running the fastest girls prep cross country time ever reported in the state, turning in a 17:05 on the flat UNC-Wilmington course in 2009. She was a top ten finisher nationally in 2010 and 2011, but didn't run high school cross country after her freshman year.

She went on to win 13 N.C. Independent School Athletic Association state track titles, set state records in the 1,600 and the 3,200, set the national 5,000 meters indoors records, win five national high school titles and earn 15 All-American honors. Among the marks Frazier broke was the North Carolina state mile record set by Julie Shea in 1997 (4:43.1). "I hated to see the records go," Shea said in 2012. "But I'm happy for her. At least it was a Raleigh girl who broke it."

Gibbons did not have much of a girls' athletic program when Shea competed — she was the only person on the girls' track team until her senior year — but by 2005 when the Crusaders joined the NCHSAA they had one of the best athletic programs in the state. The NCHSAA's three non-boarding parochial schools — Gibbons, Charlotte Catholic and Kernersville Bishop McGuinness — were so overwhelming that other NCHSAA members requested a vote to oust the trio from the organization in 2012. The motion failed to get the needed three-fourths majority.

Cardinal Gibbons won 41 state championships during an eight-year period, including nine state titles in 2011–12. The Crusaders won seven of eight titles in boys' tennis and were essentially unbeatable in girls' volleyball.

West Henderson was the only school to defeat Cardinal Gibbons in the volleyball finals after the Crusaders entered the association in 2005. Gibbons won 2A volleyball crowns in 2005 through 2007, lost in five sets to West Henderson in 2008 and won 3A titles in 2009 through 2012.

Kernersville Bishop McGuinness won eight straight 1A girls basketball championships from 2006 through 2013 under coach Brian Robinson. UNC recruit Megan Buckland won three straight championship game MVP awards starting in 2009.

Charlotte Catholic claimed eight straight 3A girls swimming crowns and turned in the greatest single day of all time at the swimming championships in 2013. Catholic swimmers set state records in the 200-yard medley, the 50 and 100 freestyle, the 100 butterfly, the 200 free relay and the 400 free.

Kyle Johnson of Charlotte Catholic became the NCHSAA's only four-time tennis singles champion when he won the 3A crown in 2009, '10, '11 and '12.

Boys' and girls' lacrosse joined the NCHSAA roster in 2010 and the overall balance in the state showed immediately. There were no repeat champions in the first four years of competition. East Chapel Hill's Sydney Holman set the state record with 128 goals while leading the Wildcats to the 2013 girls' title.

Chapel Hill coach Sherry Norris became the state's all-time leader in volleyball wins in 2012. She had 710 victories, topping West Henderson coach Jan Stanley (698), Millbrook's Kathy Stefanou (657) and Pinecrest's Barbara Foxx (650). Norris also has more than 500 girls' basketball coaching victories, including a 32–0 state 3A championship season in 2013–14.

Millbrook's girls' basketball teams reached the 4A championship three straight years, winning titles in 2012 and 2013. The Wildcats had eight players earn college scholarships in 2013.

So, after a century of schoolboy and schoolgirl sports, do athletics still hold a special place in the hearts of North Carolinians? If that question has any validity, consider one Scotty McCreery.

You may have heard the name. You may even have seen a television fast food commercial featuring Scotty McCreery riding along a North Carolina highway in his personal motorcoach while his parents hold signs and wave from the side of the road as he passes by.

One of the most famous high school athletes in the country was McCreery of Garner. He was a promising young pitcher on the Trojans' junior varsity in 2009, but on a lark, he went to Milwaukee to audition for the television talent show "American Idol." McCreery eventually received more than sixty-one million votes in the finale to win the title. Did he forget his high school athletic career? He missed his entire junior season while competing on the show, but returned to the high school baseball team, against the advice of his entertainment advisors, for his senior year. Baseball coach Derik Goffena expected little from well-traveled, celebrated McCreery, but McCreery could pitch almost as well as he can sing and led the team to the conference title and into the playoffs with an earned run average of less than 2.00.

His mother, Judy McCreery, said she was more nervous when her son made his high school varsity debut as a seventh-inning relief pitcher against Fuquay-Varina than she had been during the television show. "He hadn't played baseball in 18 months and there were television crews there and it seemed everybody was watching," Judy McCreery said. During the game, she donned sunglasses to hide her tears of joy after her son struck out the first batter he faced.

McCreery said playing high school baseball was a dream. He had wanted to put on his school's uniform and play with his friends for as long as he could remember. "Everybody kept telling me there was no way for this to work," said McCreery, who often played on Friday nights and flew out the next day to perform in concerts. "I'm in an adult world now, but I want to be able to play baseball with my friends," he said.

It's a matter of making memories, and in North Carolina it's been that way for 100 years.

North Carolina's Variety of Sports

By Larry Keech

Larry Keech spent the last 36 years of a 42-year sportswriting career with the *Greensboro News & Record*. Most of that time was spent as a beat writer for Atlantic Coast Conference football and basketball. During the spring and summer off-seasons for those sports, his aversions to spending long hours in rickety baseball press boxes, watching interminable left turns at NASCAR races and meeting the dawn-to-dark demands of tournament golf coverage helped turn his interest to assignments involving track and field, tennis and numerous offbeat sports. For his editors, Keech became a jack-of-all-trades in covering such sports. A native of York, Pennsylvania, Keech grew up in suburban Baltimore (Timonium), graduated from Washington & Lee University in Lexington, Virginia, as a journalism major and spent six years working for daily newspapers in Roanoke and Newport News, Virginia, before landing in Greensboro. He covered 16 NCAA Final Fours, a number of NFL playoffs and college bowl games, a couple of U.S. Open tennis tournaments, a few major track meets and a heavyweight title fight. Keech and his wife Brenda have been married for 45 years.

The Post-War Boom

It's not difficult to trace the time when a relatively few participant and spectator sports blossomed into a cornucopia that spread throughout the United States, eventually engulfing predominantly rural states like North Carolina.

Before World War II, baseball's stature as "America's pastime" was unquestioned. When men and boys weren't playing the game on grassy fields, they were flocking into ballparks that hosted all levels of pro competition. And even as the Roaring Twenties gave way to the Great Depression, they crowded around to hear play-by-play accounts from teletype machines and still newfangled radios.

On campus and in major metropolitan areas, college football attracted large followings to stadiums that rivaled and sometimes surpassed baseball's seating capacities. Championship boxing matches and horse races attracted peripheral interest, but pro football and both college and pro basketball were mere satellites to the bigger shows.

Golf and tennis? Country club sports with negligible mass audiences. The Olympic Games? A quadrennial appeal to nationalistic impulses.

The aftermath of the mid-20th century war set in motion a number of sociological forces that would facilitate an explosion in the variety of sports interests in North Carolina and throughout the country. Coming as it did on the heels of the decade-long Great Depression, the end of the war in 1945 provided a tonic for the American psyche and triggered sweeping changes in the landscape of America's middle-class lifestyles.

It began with Congressional passage of the Serviceman's Readjustment Act of 1944, otherwise known as the G.I. Bill of Rights or, more simply, the G.I. Bill. Anticipating the demobilization of 12 million active-duty servicemen and women at war's end, including 7.5 million who were stationed abroad, President Franklin D. Roosevelt and the Congress sought a way to smooth the veterans' transition back to civilian life, avoiding massive unemployment and housing shortages for young adults. It was a lesson the federal government had learned the hard way in the aftermath of World War I and would again—to a lesser extent—in the years following the Vietnam War in the late 1960s and early '70s.

Besides low-cost, low-interest home mortgage and business loans, the G.I. Bill offered tuition and living expenses for veterans seeking to further their college, vocational and high school educations. By the time the program ended in 1956, 6.6 million veterans had received G.I. Bill benefits, including 2.2 million who had taken advantage of its educational opportunities.

The G.I. Bill helped usher in more than two decades of long-term economic growth, accompanied by burgeoning job creation and a generation-long baby boom. The side effects of those changes included the onset of suburbanization and additional discretionary time. "Greater prosperity, accompanied by population growth and increased

leisure time, provided an ideal climate for the pursuit of a wider variety of sports interests," said sports historian Dr. Richard Swanson, professor emeritus in the department of Health and Human Performance at UNC-Greensboro.

For the most part, the handful of traditionally popular sports continued to thrive in terms of attracting spectator interest to watch elite college and pro athletes. But the number of those who could compete at such a high level remained limited. Many baby boomers sought other athletic outlets for their participatory energy. "I like swimming better than the team sports, and I'm better at it," they might have said. Or maybe, "For me, it might be more fun to try to water ski or climb a mountain."

There came a collective discovery that sports offered a niche for practically anyone. The increased variety of sporting interests was fanned by media exposure: more specifically, the onset of television in the post-World War II years. TV introduced prospective athletes to a myriad of sports, including the numerous Olympic sports, outdoor sports, and the most exotic sports imaginable from across the world. Beginning in the '60s, there was even a weekly Saturday afternoon show by the name of "ABC's Wide World of Sports" devoted to the international diversity of competitive endeavors.

Until well into the second half of the 1900s, two huge hotbeds of athletes were discouraged from entering the sporting mainstream—African-Americans and women. In the wake of such pioneers as Joe Louis, Jesse Owens and Jackie Robinson, black athletes steadily ascended to a position of dominance in baseball, football, basketball, track and boxing.

But in part because of the on-the-field success of African Americans in those sports, they have been slower to involve themselves in most of the traditionally suburban sports. It wasn't until 2008 that N.C. State alumnus Cullen Jones became the first African American gold medalist in swimming. He was only the second black swimmer ever to make the U.S. team.

Another piece of federal legislation opened the door for widespread female participation in competitive sports. Not until Congress passed Title IX as part of the Education Amendments of 1972 were colleges and high schools required to reject the long-held belief that sports competition was "unfeminine" and begin sponsoring varsity teams. The amendment read: "No person in the United States shall, on the basis of sex, be excluded from participation in, be denied the benefits of, or be subjected to discrimination under any education or activity receiving federal financial assistance...."

Although the original statute made no explicit mention of sports, it made a lasting impact on college and high school athletics. "There was an 'old school' belief among female college faculty members and administrators that women shouldn't participate because they resisted the recruiting and academic abuses that had affected men's sports," Swanson said.

A year later, however, Title IX's statement of athletic equality for women was bolstered by a prime-time media event that captured wide national interest. Billie Jean King's 6–4, 6–3, 6–3 victory over Bobby Riggs demonstrated that a female champion in her prime was more than a match for an aging male champion. Four months earlier, Riggs had psyched out 24-time Grand Slam winner Margaret Court on his way to a 6–2, 6–1 win. Since then, women in North Carolina have excelled at the national level in a

variety of sports that includes volleyball, softball, speed skating, rowing, track and field, team handball, soccer, field hockey, lacrosse and water skiing.

Meanwhile, as the Sun Belt gradually became a magnet for U.S. population growth, regional cross-pollination not only introduced a wider array of sports to North Carolina and the rest of the South. It also contributed to the spread of such enhancements as advanced coaching techniques and the introduction of athletic training standards. In this one state alone, the post-World War II sports boom has given rise to hundreds of intriguing subjects and their absorbing stories. Following are but a few of the many.

Al Buehler, Eyewitness to History: Not without reason, octogenarian Al Buehler radiated abundant contentment as he surveyed the corner of Duke University's campus where he had spent much of his professional lifetime. Below Buehler's vantage point from the top row of Wade Stadium's seats on an idyllic June afternoon lay an unlined football field and the track and field facility that Buehler had developed into one of a handful of U.S. meccas for the sport.

"Since the stadium was built in 1929, the track was inside it," Buehler said. "It was a cinder track when I came to work here in 1954, and we were able to update it with eight lanes of rubberized asphalt in the '70s.

"When you run the stadium steps, they really are steeper the closer you get to the top. Out of curiosity, we checked the angle of ascent one time." That curiosity, coupled with Buehler's attention to detail, can be traced to his German ancestry and has been instrumental in his success in his chosen field.

His background is an apt way to begin tracing the evolution in North Carolina of what have come to be called "the Olympic sports"—those that lie outside the realm of the major team sports of baseball, basketball and football. Operating behind the scenes without a great deal of public recognition or accompanying financial reward, he had a hand in shaping the significant issues of his time—civil rights, the Cold War, the women's movement—and influencing a number of athletes whose fame has far exceeded his own.

Buehler's relationship to his sport's role in late 20th century history was not unlike those of the title characters played by Peter Sellers and Tom Hanks in the movies *Zelig* and *Forrest Gump*. He was on hand for the pivotal events. A number of Buehler's accomplishments in the Olympic movement's primary realm of track and field resulted from his crosstown Durham alliance with Dr. Leroy Walker, a contemporary who was the longtime track coach at historically black North Carolina College (later N.C. Central University). Almost from the time they became acquainted in the mid-1950s, Walker and Buehler exploited each other's complementary strengths while transforming their adopted city and state from what had been a track and field backwater into a major hub of the sport.

The outgoing Walker brought charismatic genius for the political and promotional aspects of a sport that was international in scope. The low-keyed Buehler contributed the logistical expertise essential to the complex task of staging meets at the highest levels. "Dr. Walker was P.T. Barnum and I was the guy who made sure the elephant manure was gone when the circus left town," Buehler said.

The partnership was launched in the mid-50s, not long after Buehler had abandoned his ambition for a prospective career as a military officer to accept Duke's offer to become its cross country coach and track and field assistant under Bob Chambers, who himself doubled as a football assistant. The lone credential for Buehler, a Philadelphia native whose family had moved to Hagerstown, Maryland, was his experience as a three-time Southern Conference champion half-miler in Coach Jim Kehoe's powerful program at the University of Maryland. "I needed to find a job, and the offer fit my background," Buehler said. "Once I started, I was young, single and had plenty of time to learn as many aspects of it as I could."

He quickly made the transition from student to teacher of distance running skills, and that reputation soon paired with his recruiting efforts to transform Duke from a conference cross country doormat into a contender. On the other side of Durham, Walker was generating a similar reputation for the development of competitors in the sprints, hurdles and jumping events.

For both coaches, racial differences in the still-segregated South took a back seat to what was best for their track programs. Of his relationship with his longtime colleague, Buehler said:

> "We never talked about the race issue. We both understood our tolerance and mutual support. We both recognized that we were in a position to help each other.
>
> "Between our teams, we had three athletes who were contenders for spots on the 1956 U.S. Olympic team — Dave Sime, Lee Calhoun and Joel Shankle. All three happened to be sprinters or hurdlers. Duke had a good track facility and topnotch equipment. N.C. College had a subpar track and not even enough hurdles to set up a course."

Sime, having been lured from his home in New Jersey to Duke by its medical school and a baseball scholarship, emerged as a world-class sprinter. Duke's affiliation with the Methodist church had attracted the interest of Shankle's father, a Virginia minister of that faith, and helped his son land a scholarship. Walker had recruited Calhoun, a transplanted Mississippian who lived in Chicago.

For all three, training together provided obvious benefits, as did exposure to Walker's coaching ability and Duke's track and equipment. "Sime had full-throttle speed, but Leroy helped him with his starts," Buehler said.

All three made the U.S. team. Both Walker and Buehler were chosen to accompany them to the '56 Melbourne Games, enabling the two to become fixtures on future U.S. Olympic coaching staffs. Calhoun defeated favored teammate Jack Davis to win the gold medal in the 110-meter hurdles at the Melbourne Games and repeated at Rome in 1960. Shankle took the bronze in the '56 race. Sime finished second in his 100- and 200-meter duels against Texan Bobby Morrow, and then had to settle for silver a second time against Germany's Armin Hary in Rome in '60.

By the time Buehler was named Duke's head track and field coach in 1964, his logistical skills already had begun to establish him as an NCAA and U.S. Olympic official in the sport. "I frequently served as the teams' manager," Buehler said. "I headed a

staff of several people who dealt with issues involving money, transportation and equipment."

In that role, and because of his experience as a coach, Buehler became a confidante and advisor to a number of top U.S. track and field athletes over the years. He has maintained mutual admiration relationships with Carl Lewis, Jackie Joyner-Kersey, Dave Wottle, Mary Decker Slaney and Joan Benoit Samuelson, among others. During the 1968 Games in Mexico City, when Tommie Smith and John Carlos won the gold and bronze medals in the 200-meter event, the two triggered a political firestorm by bowing their heads and raising black-gloved fists on the medal stand during the playing of the national anthem. It was a gesture in support of the civil rights struggle for racial equality in the U.S.

When the decision was made to expel Smith and Carlos from the Olympic Village and send them home, Buehler accepted the duty of driving them to the airport. "When I needed someone to be there, God sent Al Buehler," Carlos said. "He gave us moral support by letting us know that we did a courageous thing, had nothing to be ashamed of and should feel good about ourselves."

One reason why the Buehler-Walker alliance of mutual interest bloomed into friendship was their shared ability to embrace the cusp of social and political change as it arrived in the late 1960s and early '70s. Once they oversaw the transformation of Duke's Wallace Wade Stadium track into the country's most modern facility east of the Los Angeles Coliseum, they used their increasing national and international contacts to promote (Walker) and stage (Buehler) a series of world-class meets.

The first was the USA-Pan Africa meet in 1971. Featuring many of the top athletes from two continents, the two-day event attracted near-capacity crowds totaling 52,000 and memorable competitions involving the likes of Kenyan miler Kipchoge Keino and Ethiopian Olympic distance champion Miruts Yifter's duels against U.S. stars Steve Prefontaine and Frank Shorter in the 5,000- and 10,000-meter events. "Yifter misread the finish line and lost to Prefontaine in the 5,000, then he came back and won the 10,000," Buehler said. "The crowd really got into it."

Buehler's affinity for the Olympic movement turned sour when he was a U.S. assistant coach at the 1972 Games in Munich. He was in sight of the athletes' village when he began hearing helicopters. Palestinian terrorists had entered the village and taken Israeli athletes hostage. When the crisis ended the following day, all 11 Israelis, five of the eight Black September terrorists involved and a German police officer had died.

"It was like witnessing a horror movie come to life," Buehler said. The depth of his emotional disillusionment surrounding the political intrusion and tragedy would forestall his Olympic participation for 12 years. During that hiatus, Buehler refocused his energy on developing Duke's track program and promoting his sport.

With the Cold War still at its height, Walker and Buehler used their connections to stage a U.S.-USSR-West Germany triangular meet in 1974. Buehler said:

> "It was a matter of curiosity. The meet drew large crowds because they came to see the Russians to a greater extent than the competition itself. And in turn, the Russian team was anxious to experience a taste of living in this country. A

group visited my house and asked all kinds of lifestyle questions. The male and female athletes loved it when we handed out denim jeans."

In the 45 years that Buehler was in charge of Duke's track and cross country teams, they peaked in the 1970s with such distance runners as Bob Wheeler, Cary Weisinger, Robbie Perkins, Roger Beardmore, Scott Eden, Bynum Merritt and hurdler Jeff Howser. In all, he coached five Olympians and 12 NCAA champions.

Perkins, who qualified for the 1980 Moscow Olympics before the U.S. boycott and later became mayor of Greensboro, said:

> "Al Buehler was ideally suited to coach distance runners. He was consistently disciplined, focused, pragmatic, positive. When you've got to run 10,000 meters, emotion can only carry you so far.
>
> "I was a high school hotshot who could've gone to any of the top track schools, but none was close to Duke's combination of academics and the running program. Once I got there, he had me run a series of 110-yard wind sprints barefooted on the football field. Then he told me my running form was poor.
>
> "That was Coach Al, always prodding you to improve. He took a lot of good high school runners and turned them into outstanding ones. He was in it for the long haul—consistency of purpose, principles, character. He educated athletes to be successful through life's ups and downs.
>
> "Nobody wanted to disappoint Coach Buehler."

By the end of the decade, Buehler and his track program felt the effects of the implementation of Federal Title IX, which mandated equal funding for women's athletic programs when it was enacted in 1972. The Duke coach already had anticipated what was to be a significant social change for college sports four years later, when he was approached by a rising junior named Ellison Goodall.

Prodded by her father, a doctor at Duke's medical center and a former track star at the University of Virginia, Goodall began jogging as a high school senior. After a couple of false starts, Goodall mustered the courage to approach Buehler and ask for a tryout to join the men's team. After watching her run a few laps, he concurred with her father's assessment that she had promise and agreed to oversee her training regimen.

"Women's training is different from men's training," Goodall said. "It took a lot more time for Coach Al to work with me. It made it more difficult for him logistically, especially when I was competing at different places than the guys were."

Goodall made her first such trip to California in 1977, when she won the national championship in the 10,000-meter run conducted by the Association for Intercollegiate Athletics for Women (AIAW), which was the forerunner to NCAA women's competition. It was one of the highlights of a distinguished track and cross country career. "She came in here, and there was no women's track program," Buehler said. "She was the whole team. We created the program for her, with her interests in mind."

A few years later, Buehler's devotion to the development of women's sports would be tested in a meeting with Duke athletics director Tom Butters concerning scholarship allotments. Butters said:

Track magic happened when Ellison Goodall (left) and Al Buehler got together.

"I called Coach into the office one day and told him that I had made a decision, and it was a firm decision: His men's track and field scholarships were gone, due to reallocation of our budget (to finance athletic grants for women).

"He wasn't the only coach who lost scholarships.... He accepted it as gracefully as a man could without any show of emotion whatsoever. He said, 'If that's what's good for the team, then it suits me.'"

Buehler's self-imposed Olympics hiatus after Munich lasted 12 years. He returned as manager of the U.S. track and field teams at Los Angeles in '84 and Seoul in '88 and maintained his connection to the movement for the remainder of his career. "While it was hard for me to walk away, it was equally challenging to return," he said. "I don't regret either decision. I'm glad I did both."

Although Buehler retired as Duke's cross country coach in 1999 and track and field coach a year later, he remained the chair of the school's health, physical education and recreation department until 2006. He continued to teach at least one course—History and Issues of Sports—and maintain an office in Cameron Indoor Stadium into his 80s.

He's a member of the U.S. Track Coaches Association Hall of Fame and the North Carolina Sports Hall of Fame as well as the Duke athletics Hall of Fame. He also is the subject of a video documentary and accompanying biographical book entitled *Starting at the Finish Line* produced and authored by Amy Unell and Barbara Unell. And a three-mile trail in nearby Duke Forest bears his name. But beyond Buehler's wealth of professional experiences lie a number of personal and professional touchstones.

Buehler and his wife Delaina, a Burlington native, wed in 1958. Their half-century-plus marriage yielded a daughter and a son. They've maintained a tradition of a 10-second kiss to start each morning and end each day. "That's long enough to enjoy it and keep that spark," Buehler said. The marriage and Buehler himself barely survived a crisis in 2009, when he collapsed while jogging on the Al Buehler Trail. He had suffered a stroke resulting from a benign brain tumor. Surgeons at Duke's medical center removed the offending fluid surrounding the tumor and inserted a shunt, but Buehler's trim runner's body suffered a slight loss of mobility.

Over the years, the Buehlers have focused their spiritual energy on Duke Memorial United Methodist Church. Although Buehler admittedly is tone deaf, he volunteered to fill a vacancy as the church's bell ringer. It took six months for him to learn how to operate the bells well enough to play his first song and master the pacing of the notes. For 35 years, he climbed a 100-foot tower topped by a rickety 20-foot ladder and rang the bells.

Buehler's most passionate leisure pursuit is sailing his skipjack in the Chesapeake Bay. His personal trademarks include an unmistakable yellow, 50-year-old Karmann Ghia he drives around campus while adding to the more than 400,000 miles on the odometer. Then there's the straw Panama hat that a dermatologist convinced him to wear during his frequent eight-hour days on the field as protection for his scalp and ears.

For Buehler, such details represented the final pieces of a life lived in full as his gaze shifted beyond the track and Wade Stadium to the sun-drenched trees in the distant reaches of Duke's campus. "I couldn't imagine a better way or place to spend the last 60 years than here, doing the things I've been able to do."

Jim Beatty, America's Superstar Miler: The term "four-minute mile" became a staple of sports lexicon in the 1950s. By then, the mile run had supplanted the 100-yard/meter dash as track's glamour event.

The "Roaring Twenties" had given rise to the first set of nationally renowned sports idols — baseball's Babe Ruth, football's Red Grange, boxing's Jack Dempsey, golf's Bobby Jones, tennis' Bill Tilden and horse racing's Man o' War. But in terms of worldwide recognition, none of those Americans surpassed the fame of Finnish distance runner Paavo Nurmi.

Nurmi, a.k.a "The Flying Finn," lowered the world record for the mile by more than two seconds with a 4:10.4 performance in 1923, and then followed it up a year later by winning the gold medal in the 1500-meter "metric mile" at the Paris Olympiad. In the following two decades, the record was lowered by another nine seconds, to 4:01.4, by four different milers. Only one of them, Glenn Cunningham, was an American. Finally, almost 30 years after Nurmi's prime, came the breakthrough below the elusive four-minute barrier. With the help of three pacesetters, England's Roger Bannister achieved international celebrity with a 3:59.4 effort on May 6, 1954.

Although Australian Herb Elliott had pushed the record down to 3:54.5 in 1958, the four-minute mile remained a rarity for American runners through the 1950s. Jim Beatty, a North Carolina resident, was the third U.S. runner to better the four-minute standard

When Jim Beatty became the first man to break the indoor 4-minute mile, he said he did it because he was an American.

but the first to be recognized as a star. He did it with two performances — lowering the American record to 3:58 in 1960 and becoming the first runner ever to break four minutes indoors with a 3:58.9 performance in '62.

Just as Bannister had done, Beatty used pacesetters to assist him on the indoor race while attracting network television coverage of his attempt at the feat. For Beatty, the race became the capstone of an unintended running career that survived numerous fits and starts. Born in New York City, Beatty moved to Charlotte with his family when he was a youngster. At Charlotte's Central High School, his first athletic pursuit was boxing.

As he approached his 80th birthday, Beatty recalled:

> "There was an intramural boxing tournament each year that drew a standing room only crowd. I took to boxing pretty well, and I won the 118-pound weight class when I was a sophomore.
>
> "I had a paper route for the *Charlotte Observer*, and I decided I could improve my speed and stamina if I started literally running the route. It worked, and I won my weight class again."

Then Beatty's friend, Archie Joyner, one of the state's top milers, coaxed him to try out for the track team that spring. By the time Beatty decided to give it a try, track season was winding down.

> "It was the week before our last home meet, and Archie told me that if I didn't talk the coach into letting me run, he wouldn't take me on the road the rest of the season.
>
> "So I bought a pair of track shoes, and the coach told me to run four laps. I finished it, but he said he was sorry, it was just too late in the season for me to run.

"I kept begging him. I told him I'd line up in the back of the pack and not get in anybody's way."

The coach relented.

"Three laps into the race," Beatty recounted, "I had passed our No. 2 runner. I saw Archie and tried to catch him. I kicked past him and won the race in 4:50, a new school record." Beatty earned a place on the traveling squad. At the Duke-Durham Relays, he finished second by "half a body length" to High Point Central's Boyd Newnam, the defending state champion.

The following week, Beatty's trademark finishing kick carried him past Newnam at the Western Conference meet. Then he proved it was no fluke by passing Newnam five yards from the finish of the mile run at the state 2-A meet. In his senior year, Beatty shaved his mile time down to 4:31, and college scholarship offers rolled in.

Beatty said:

> "When you're a Catholic, and Notre Dame offers you a full ride, you sign. But Dale Ransom, the coach at North Carolina, continued to visit me almost every day. He eventually convinced me that there was value in attending your home state university and assured me that I'd get to run in national meets. I notified Notre Dame that I had changed my mind two weeks before school was to start."

Beatty's career as a Tar Heel saw him become one of the nation's top collegiate milers with a career best time of 4:06 before he graduated in 1957. But he faced a military obligation that included six months of active Army duty, and few prospects to continue a track career that would require him to foot most of his expenses. Beatty was back home in Charlotte two years later, living with his parents and enrolled in a training program with the Honey's restaurant chain owned by family friends. Then, in the summer of '59, he was invited by Jack Wood, another friend and a local clothier, to attend the second USA-USSR dual meet at Franklin Field in Philadelphia.

In the 1500-meter "metric mile" event, University of Oregon runner Dyrol Burleson outdueled college teammate Jim Grelle to defeat their Soviet counterparts by more than 10 seconds with a time of 3:39.3. Beatty said:

> "I had competed against both of those guys. And when it ended, Jack turned to me and said, 'Jimmy, you could've won that race.' It started me to thinking about trying to run in the 1960 Olympics in Rome.
>
> "When I got back to North Carolina, I went to see Coach Ransom, told him I wanted to give running another shot and asked him for training advice. He agreed with me that I needed to leave the area, and he said he'd recommend me to Mihali Igloi."

Igloi, recognized as a distance running guru, had migrated from his native Hungary to the U.S. after 1956, when the success of his protégés at the Melbourne Olympics was beclouded by the Soviet suppression of the Hungarian Revolution. Igloi had settled in San Jose, California, where he had access to San Jose State University's first-class track facilities.

"When I showed up, the first thing he said to me was 'Who is this fat man?'" Beatty remembered. He had gained 15 pounds more than his running weight of 130 on a 5-foot-6 frame. Beatty had launched his comeback with low-mileage and no speed training in Chapel Hill. Igloi quickly whipped him back into shape with a high-volume, short-interval regimen that featured eight-hour days and 13 workouts per week in preparation for the indoor season.

Less than four months later, Beatty edged Burleson by a lean in the 11-lap mile run at Madison Square Garden's New York Athletic Club meet. Moving into the outdoor season that spring in preparation for the '60 Olympics, Beatty posted a 3:58 mile time at the Modesto (California) Relays, establishing a new American record and lowering his personal best outdoor time by more than seven seconds.

Keeping in mind that the international field for the 1500 at the Rome Games figured to be stacked with talented runners, Beatty and his coach decided that the 5,000 might pose a better opportunity for him. He won that event in the U.S. Olympic Trials and was featured on the cover of *Sports Illustrated*, which was then in its sixth year of publication. "I became one of the first victims of the 'SI Jinx,'" he recalled.

After leaving to compete in European events leading up to Rome, his Olympic hopes hit a snag on an aging cinder track in Bern, Switzerland.

"I strained a couple of ligaments. I tried to come back and run in Rome, but I didn't get out of the heats. It was heartbreaking.

"When I sat in the stands and watched the 1500 and 5,000 finals and medal ceremonies, my disappointment turned to anger. I told myself the medalists weren't better than I was, and I vowed to come back stronger than ever in 1961 and show them what an American could do."

Beatty lived up to his vow. He was ranked No. 1 in the world in both the mile and 1500-meter events in '61. "After the outdoor season ended, it dawned on me that nobody had run a four-minute mile indoors," he said. "And if someone was going to be the first, it might as well be me." Keeping that goal in mind, Beatty stepped up his training regimen in what was normally considered the off-season. His target date became the Los Angeles Times Indoor Games on February 10, 1962.

ABC-TV's "Wide World of Sports" was still in the fledgling years of its existence. When its programmers phoned Isloi to be informed of Beatty's competition schedule for the indoor season, the coach filled them in on the plan to assault the four-minute mark. "We'll be there," he was told.

Much as Bannister had done in breaking the four-minute barrier outdoors eight years earlier, Beatty received pacesetting assistance from two L.A. Track Club team-mates—Grelle and Hungarian expatriate Laszlo Tabori.

When he reached the three-quarter mark in less than three minutes, Beatty unleashed his trademark finishing kick and broke the tape in 3:58.9 in front of ABC's cameras. "It's still available on DVD and YouTube," Beatty said of the performance.

Following that performance and during the course of another eye-catching outdoor season, Beatty became the toast of U.S. track and field and most of the rest of the

amateur sports spectrum. He remembered one of the highlights of his *tour de force* more than a half-century later.

When he was honored at *Sports Illustrated* press luncheon in New York City, he was asked by his hosts if he had any requests for activities during his visit. A New York native and lifelong Yankee fan, he told them he'd like to attend a game if the team was in town. "Next thing I knew, I was the guest of honor at 'Jim Beatty Day' at Yankee Stadium, and I was posing for photos with Mickey Mantle and Roger Maris. It was the season after Roger had broken Babe Ruth's home run record."

That winter, Beatty was the recipient of the 1962 Sullivan Award as the nation's outstanding amateur athlete, but Beatty's running career was abruptly cut short before his 30th birthday and the 1964 Tokyo Olympiad.

"I was back home in Charlotte when I stepped on a jagged, rusty piece of metal," Beatty said. "It required 20 stitches to close the cut on the ball of my foot. Even after it healed, I continued to feel a burning pain that made it hard for me to run any distance. I knew it was the end of my career."

After that door closed, however, others opened for Beatty. He had dabbled in campus politics at UNC, and Gov. Terry Sanford's office contacted him to serve as Director of North Carolina Volunteers. The program became a model for the federal government's VISTA (Volunteers in Service to America) anti-poverty organization founded under President Lyndon Johnson in 1965.

Next, Beatty was elected to serve three terms as representative of a Charlotte-area district in the N.C. state legislature. That became a springboard for his campaign for a seat in the U.S. House of Representatives in 1972. The run proved an ill-timed misstep that halted Beatty's political career. The Republican opponent who defeated him was future North Carolina Governor Jim Martin. "I was on the same ticket as Sen. George McGovern when he only carried one state in his presidential race against Richard Nixon, the incumbent," Beatty said.

Beatty resisted East Carolina University Chancellor Leo Jenkins' effort to recruit him as a primary opponent for Jim Hunt in the '74 lieutenant governor's race. Instead, Beatty entered the real estate business. He was involved with such projects as the Tega Cay planned unit development south of Charlotte. In the aftermath of an economic recession in the late '70s, Beatty formed Jim Beatty & Associates, an executive search firm that continued to occupy him on a part-time basis as he approached age 80.

Like many elite athletes, however, he never managed to match the excitement of the fame that went with being the nation's top miler in the early 1960s.

John Isner, Unique Tennis Ace: Athletes who share John Isner's physical characteristics are no longer uncommon on NBA and college basketball courts. At 6-foot-10 and almost 240 pounds, he's strong enough to hold his own as a rebounder and athletic enough to excel as a passer, ball-handler, outside shooter and occasional slasher.

"I've spent a good bit of time playing basketball with John, and there's no question in my mind that if he had concentrated on it, he could be playing in the NBA," said Jordan Isner, John's brother who is three years older and five inches shorter. "His only weakness might be defense."

John Isner came out of Greensboro to give new meaning to the term "power tennis."

On the world stage of tennis, however, Isner is one of a kind.

In 1999, when the Greensboro native was 14, he forsook basketball in favor of pursuing a college scholarship in tennis. It was not a particularly unusual decision at the time because Isner stood just 6-foot-2 prior to a growth spurt during his high school years. "If I'd had an inkling I'd wind up at 6-10, I'd have chosen basketball," Isner said in hindsight.

Yet he succeeded in transforming his extraordinary size into an asset, constructing a tennis game that has vaulted him into the Top 10 positions in the world rankings and earned him millions. Despite spending his youth in a state that was relatively undistinguished in its development of tennis players, he became the most successful one in its history.

Isner's background offered scant evidence that he would eventually scale the heights of world tennis. The third and youngest son of Bob and Karen Isner inherited a modicum of athletic ability from his parents. Bob Isner was a high school baseball player and later a regular at a local tennis club. His wife stands 5-foot-11 and is the daughter of a former college baseball player. Other than that, there was little clue that John would grow into a world class athlete.

"John always was big for his age, so he tagged along behind his older brothers and usually played with older kids," Bob Isner said. "He was an All-Star sandlot pitcher who played on an AAU traveling team before he gave it up when he was in the sixth or seventh grade." That choice left basketball and tennis, in which he excelled as a national age-group competitor, always one notch behind brother Jordan, whom he almost never beat until both phased into college tennis.

During Isner's formative years as an athlete, his parents were careful to tread the tightrope between support and over-involvement. "Since John began working with coaches, I've never even watched him practice," said Bob Isner, who still admits to becoming too nervous to watch his son's matches from the "friends box" at pro tournaments.

Isner, who works as a commercial developer in Greensboro, played a key consulting role in the decisions that affected John's tennis career during his teenage years. Karen Isner's role in shaping her son's growth and development was more personal in nature. She's been his primary cheerleader, transportation provider and off-court instructor in deportment. "My mom always was my role model and biggest supporter," John Isner said. "I inherited most of my personality from her — not just her height, but attributes like the ability to delineate right from wrong."

Karen Isner's pride in her son's long-standing maturity and peer popularity are obvious. She said:

> "We weren't real intense about it, but John absorbed our advice. We were able to impress on him that his behavior was more important than how well he played because if he had acted like a jerk, people have long memories. Another point of emphasis was the importance of showing respect to every opponent."

It was around the time Isner entered Greensboro's Page High School that he decided to concentrate on earning a college scholarship to play tennis instead of basketball. While growing closer to his eventual height and thanks largely to his powerful serves, he led his team to back-to-back state championships. He lost his eligibility as a senior because of the application of a state association rule against too many unexcused absences from classes to compete in national competitions.

Earlier, Isner and his parents had decided to turn the development of his game over to Oscar Blacutt, a Bolivian ex-patriot who had played tennis at Barton College before becoming the most prominent teaching pro in the Greensboro area. At 5-foot-6, Blacutt eventually was more than a foot shorter than his protégé. But despite the disparity in height, Blacutt was uniquely qualified to diversify Isner's serve-and-volley game, teaching him the finesse necessary to execute such nuances as drop volleys and lobs.

"Even before he was a teenager, John was curious about shot-making," Blacutt said. "He liked the challenge of figuring things out. He was crafty and competitive in a low-key way." As Isner worked his way through age-group tennis and into high school competition, he lost his coach when Blacutt's U.S. visa expired and he was required to return to Bolivia before he was able to renew it.

The timing of Blacutt's departure could hardly have turned out more favorably for Isner. He and his parents enlisted Tom Herb, another locally based coach and former touring pro who happened to be ideally suited to assess and advance John's developing power game. Isner and the 6-foot-5 Herb could identify with each other's tennis games. Herb said:

> "I had faced some of the best and fastest servers in the world — Pete Sampras, Richard Krajicek, Mark Phillipoussis. John's height being what it was, there was no reason why he couldn't eventually generate a 140 mile-per-hour serve that was more consistent than theirs, as unbreakable as a 10-cent comb."

In addition to his serve, improving Isner's stamina was another point of emphasis for Herb.

> "John always has been a hard worker who made the most of his practice time. But he had a tendency to be a little lazy in his matches because he had never been pushed. He often was able to win without trying very hard, just beating opponents with his finesse game. The first time I made him get up for a 6 a.m. mile run, he almost died."

Although Herb was convinced Isner could reach "top 100, maybe top 50" in the world rankings, the youngster insisted on focusing his ambition on college tennis, rejecting Florida's 24/7 tennis academies to stay at home through his high school years.

"We offered John the opportunity to attend a tennis academy, but he was intuitive in his belief that staying home was best for him," Karen Isner said. "That's probably why he never burned out on the game like many of the academy kids."

Isner was receptive to blue-chip recruiting attention from the nation's most prominent tennis programs. Not wanting to stray too far from home, he chose the University of Georgia over Virginia. At the time, Georgia's program boasted five NCAA team championships, seven other trips to the NCAA finals, three dozen Southeastern Conference titles and a stadium and facilities that remain second to none. In the 50 years before Isner was recruited in 2003, the Bulldogs had only two coaches—Dan Magill and Manuel Diaz.

"It was an easy decision—the closest of a small handful of the nation's elite college tennis programs," Herb said of Isner's choice of colleges. "I was pretty adamant in insisting that Georgia was the right place for him."

"As usual, John's instincts guided him to the best decision," Karen Isner said. Indeed, Isner thrived at Georgia. He matured physically, adding 40 helpful pounds to his frame, as well as mentally and emotionally, emerging with a degree in communications and as "a different person," in his mother's words. "I grew into my body," is how Isner put it. Diaz's careful management in the development of Isner's game resulted in steady year-to-year improvement. He played in the No. 3 singles position for the Bulldogs as a freshman, then at No. 1 his last three years. He was named an All-American all four years. If Isner entertained any thought of turning pro following his junior year, it vanished when Georgia lost to Pepperdine in the NCAA finals. "John is unusual in that he's a 'team player' in an individual sport," Herb said. "He genuinely seems to care more about the team than himself."

Karen Isner agreed with that assessment. "When John believes he's carrying the team on his shoulders, his play rises to a higher level," she said. "It was true at Georgia, and nothing since then has excited him more than Davis Cup competition."

The affinity that Isner and his parents shared for Georgia's program and his role in it was reflected by their insistence on paying his full tuition for his last two seasons in order that limited scholarship monies permitted by NCAA rules could be spent on more needy teammates and recruits. As a senior in 2007, Isner led Georgia to the NCAA team championship, but lost the individual title to Virginia's Somdev Devvarman in a third-set tiebreaker. He recorded more singles and doubles victories than any player in school his-

tory. "By the time John left Georgia, I had begun to appreciate his resilience in resetting his goals, his mental focus and his re-energized quest for excellence," Diaz said.

Four-year college players who become high-ranked performers on the Association of Tennis Professionals (ATP) tour have been a rarity in the 21st century.

Herb, whose own pro ambitions were thwarted during the 1990s, said:

> "There are two levels of pro tennis satellite competition that most new players have to survive before they can graduate to the ATP Tour. When you break in, you start in Futures Tour events. If you're successful, you move up to the Challengers Tour.
>
> "It's like minor league baseball. In John's case, he was used to playing in front of crowds of 3-4-5-6,000 at Georgia. Then, as a pro rookie, he was bound to find himself playing in Podunk with hardly anybody in the stands and staying in Red Roof Inns.
>
> "I know from first-hand experience that if a rookie is going to make it, it has to happen fast. Otherwise, grinding it out through the process can bring you down mentally and emotionally."

Karen Isner admittedly "had no idea of the difficulty, including the financial cost of travel and training, involved in establishing a career as a touring pro tennis player."

As for Isner, he was similarly unprepared for the pro tennis lifestyle. "At my first pro tournament, a Futures event in California, I found myself eating alone with no control over simple things like food, bed size and air conditioning that I had taken for granted," he said.

Then, within weeks after Isner cast his lot as a touring pro in the summer of '07, he manufactured the monumental break that became the turning point in his career. By staving off his homesickness and winning that initial Futures tournament in California, he qualified for a Challengers event the following week in Lexington, Kentucky. Again he reached the finals, where the stakes included a wild-card berth in an ensuing ATP event in Washington, D.C. When the winner declined the opportunity because of injury, Isner was invited to play.

Isner proceeded to survive five straight matches in third-set tiebreaker games before facing Andy Roddick, then the highest-ranked American star, in the finals. Although he lost that match, his performance was instrumental in establishing him as a regular on the ATP Tour. Isner's sudden success, along with his memorable height and powerful service, helped him lift his world ranking from No. 843 in 2006 to No. 107 in '07 and earned him a reputation as an up-and-comer on the tour.

In order to gain access to top-level practice competition and training facilities, he moved to Tampa, Florida, and worked at nearby Saddlebrook Academy and Resort's large, luxurious 45-court complex. Eventually he enlisted the services of a coach, a trainer/physiologist/chiropractor and agent Sam Duvall of LaGardere Unlimited, a Paris-based media and marketing conglomerate whose clients have included Dwight Howard (basketball), Reggie Bush (football) and Phil Mickelson (golf).

By 2009, Isner closed the year with a No. 34 world ranking. He finished among the Top 20 each year from '10 through '13, rising as high as No. 9 at one point. He became

a regular U.S. Davis Cup contributor. He won nine ATP tournaments and was a finalist in nine others.

Unless and until Isner wins one of the four Grand Slam tournaments or leads the U.S. to a Davis Cup championship, his career highlight can be pinpointed as a first-round victory over Nicholas Mahut of France at the 2010 Wimbledon championships that went down in tennis history as "The Longest Match of All Time." It lasted 11 hours and five minutes, spanning three days before Isner prevailed 4–6, 6–3, 7–6 (7), 6–7 (3), 70–68. Isner was unable to convert four match points during the record 168 consecutive service holds before the finish. It is commemorated by a permanent plaque at Wimbledon.

"It became more than a match," Isner said. "By the time it ended, it had turned into a media circus. Not only will it stick with me for the rest of my life, but it'll never happen again."

Mahut, for his part, credits his opponent's graciousness for relieving his disappointment in losing:

> "We had played once before that, but we didn't know each other. I'll always remember that when we made the 15-meter walk to the court on the third day, John asked me, 'How did you sleep?' I replied, 'I didn't sleep any more than you.'
>
> "For me, the outcome was terrible. I had some bad moments. But now I think it's maybe the best thing that has happened to me. I even authored a book about it.
>
> "John was one of the best people I could have played against in that match. He shared the moment with me and became one of my best friends on tour."

Mahut echoed the feelings of other players on the hyper-competitive ATP tour. James Blake, the veteran who became an off-court mentor for Isner as well as a frequent Davis Cup teammate, said:

> "John is one of the easiest players to root for on the tour. He's done a lot of things the right way. He's diligent on the practice court. He learned how to put pressure on his opponent with his serve and improve his defensive weaknesses with his service returns until he reached a point where he can beat anyone in the world on a given day."

Those most familiar with Isner's game rate his placement of his height-enhanced, righthanded first and second serve as the most devastating weapons of his era and probably the most effective of all time. It is the primary reason why he consistently owns the tour's best tie-breaker record.

Otherwise, Isner's coaches insist opponents should not be deceived by his "nice guy" reputation away from the court. "He keeps his mental toughness hidden, but it's there," Blacutt said. "He loves the challenge of competition and thrives under pressure."

But as his ranking indicates, Isner has still had weaknesses to overcome in terms of consistency as he entered the prime years of his late 20s. He is still trying, for example to elevate his intensity and level of play when he performs abroad to his productivity when he's in his home country and more specifically its East Coast.

"It's a valid observation that playing close to home brings out the best in my game and I struggle more when I play abroad," Isner said. "Most players experience stretches of self-doubt, and a slump ensues. I'm certainly no exception, but I keeping trying to overcome it."

Those closest to him agree. "John has spent as many as 40 weeks a year on the road," Karen Isner said. "He's a SportsCenter junkie who would rather talk about any other sport than tennis. He was a communications major at Georgia, and he says his ideal job one day would be working for ESPN."

Isner was shaken out of his idyllic tennis-playing existence a couple of times when his mother endured two bouts with colon cancer while he was at Georgia. "I've always tried to be a facilitator for John, the one who keeps him grounded and connected," Karen Isner said. "So I tried to show him some courage. I'd schedule chemotherapy treatments early in the week and attend his matches on the weekends. As much as possible, I wanted to show him I was OK and keep from worrying him."

Isner returned the favor after he became a millionaire on the tennis circuit. He founded a charitable foundation in conjunction with the Lineberger Comprehensive Cancer Center at the University of North Carolina's medical school. "It was good to see him lend himself to a cause," Karen Isner said.

Plenty of chances remain for Isner to improve his consistency enough to put together a championship performance in a grand slam tournament or a year-long Davis Cup effort. If he continues to avoid serious injury, he sees no reason why he can't continue playing top-level singles into his early 30s and perhaps doubles for a few years after that.

Isner said:

"My game is not rocket science. Everything I've done already is a bonus for me, so I don't feel too much pressure on myself. I don't have to win a Grand Slam title to be content. I just hope I'm fortunate to do what I do as long as possible. Then, after that, maybe pursuing my dream job as an ESPN anchorman."

Not bad for a guy who should've played basketball.

Allen Morris — for the Love of the Game: It was barely more than a half-century ago, way less than a lifetime, when Allen Morris was unquestionably the best tennis player in North Carolina during the 1950s and '60s.

Oh, the dimensions of the court were the same, and the height of the net. The shoes, the shirts and the shorts haven't changed much. Otherwise, though, the game and its surrounding culture were vastly different. And the money, especially the money.

To cap his senior year at Presbyterian (South Carolina) College, Morris traveled to England to play in the 1956 Wimbledon Championships, where he reached the quarterfinals before losing to fellow American Vic Seixas. In 2013, each Wimbledon singles quarterfinalist earned $1.25 million. But in '56, when Wimbledon entrants were considered amateur athletes, Morris acknowledged that "I had to get a job when I came home...."

Allen Morris rode his power game to the grass of Wimbledon.

He considered himself fortunate to land an office job with Burlington Industries, one of the major textile manufacturing companies, even though it meant he had to leave the national/international tennis circuit to become a glorified weekend player.

Morris credited Jim Leighton, his coach at Presbyterian whose career later included a successful 20-year tenure at Wake Forest, for transforming his raw talent into a high skill level.

"Jim Leighton recruited me, then turned me into a tennis player. I had grown up in Atlanta and landed a football scholarship at Georgia Tech. But during my freshman year, I struggled with pre-engineering courses, and I had doubts about my ability to fit into Coach (Bobby) Dodd's program, even though I had some promise as a punter.

"So a buddy of mine asked me to come with him on a visit to Presbyterian and talk to Coach Leighton about tennis scholarships. As it turned out, my friend decided not to go, but I accepted because I was intrigued."

Morris' decision worked out.

"I was big but wild. At 6-foot-1 and 185–190 pounds, I had been a fair-sized football player and was quite large for a tennis player. But my strokes were unsound, so I made too many errors.

"Leighton recruited me on potential. Not long after I got there, he cornered me and told me I wasn't very good but had a chance to be more than a college player if I put myself in his hands.

"He was a self-taught coach and a student of the game. But he didn't offer any shortcuts to hard work, and I bought into his straightforward approach. I was his special project. He had me on the court for hours, day and night, even on Saturdays and Sundays. When I did get a break, he'd have me in the gym watching films of top players like Don Budge and Fred Perry.

"I've never seen a coach who was as good at teaching the development of stroke production. My size helped me with the serve-and-volley game that was popular at the time, but ground strokes became my strength."

Leighton's fund-raising abilities and connections in the U.S. Tennis Association enabled Morris to become a regular on the "southern circuit" (Nashville, Atlanta, Montgomery, etc.) and compete in national grass court events in Newport, Rhode Island; South Orange, New Jersey; and Forest Hills, New York, the amateur forerunner of the U.S. Open. The highest national ranking he attained was No. 14, which insured his entry into major tournaments plus allowable minimal expense money. But it wasn't high enough to qualify him for the under-the-table payments afforded the top players like Seixas and Tony Trabert and Australian Ken Rosewall.

Morris scored notable wins over such '50s Australian stars as Rod Laver, Lew Hoad, Neale Fraser and Roy Emerson. But never Seixas, the University of North Carolina alumnus who remained his nemesis. "He was ideally suited to give me problems, a quick, athletic player who excelled at the net. I had trouble passing him. And he was a nice guy to boot."

Regardless of the relative absence of financial reward, Morris' trip to England in '56 was a personal highlight. After playing in the preliminary Beckenham and Queens tournaments, Morris made his run to the Wimbledon quarters, capped by a five-set win over rising Aussie star Ashley Cooper on Court One that gave him a chance to rub elbows with celebrity.

"I was walking off the court, and a big guy with a beard shook my hand and said, 'I'd like to invite you to my flat this evening. I'll have my car pick you up at your hotel.'

"Well, he was Peter Ustinov, the actor. I went to his party, and Jack Benny was there. Also John Ireland, Dawn Addams and Leo Genn. And other tennis players—Seixas, Rosewell and Ham Richardson. Ustinov did some funny impersonations. It was a wonderful evening."

But a straight-set loss to Seixas the following day sent Morris home to the reality of fulfilling his obligatory tour of duty for an ROTC commission and then landing a fulltime job. He accepted a Charlotte-based position with Burlington Industries, one of the leading textile manufacturers at the time. A year later, after a training stint at the company's New York headquarters, he was transferred to Greensboro.

Of the 10 N.C. men's state closed championship tournaments contested between 1958 and '67, Morris won seven, a total that remains a record for the event. Not bad for a weekend player. He was still in his prime at age 32 in 1964, when a joint venture between the city of Greensboro and historically black N.C. A&T State University led to the construction of a hardcourt tennis complex beyond the outfield wall at War Memorial Stadium and across the street from the A&T campus.

As part of a dedication ceremony for the courts, an exhibition match was scheduled between Morris and 21-year-old Richmond native Arthur Ashe, then a student at UCLA who had risen to No. 6 in the USTA's national rankings. Morris changed into his tennis apparel in his downtown Greensboro office, drove the half-dozen blocks to the courts and posted a 6–4, 7–5 win over Ashe in the best-of-three-set match.

"As with most exhibitions, it was fun for both of us and the crowd as well," Morris said. "Several hundred people showed up, including representative groups from the black community as well as my co-workers during their lunch hours."

Morris remembers that the only water available to the players during the steamy summer midday match was contained in a tennis ball can at the umpire's chair. They took turns drinking from it on a day not many years removed from segregated drinking fountains in the South. "We were friendly before the match," Morris said. "And probably because it was an exhibition, it's safe to say that Arthur wasn't intent on beating the local guy."

When it was over, Morris drove home, showered, dressed and returned to work.

It was Morris' practice matches with Greensboro Country Club tennis pro Jim Winstead that enabled him to stay sharp. "I grew up across the street from the club, and I can remember peeping through the fence when Allen and Jim played practice matches," said Jane Preyer, who became a world-class player in her own right and later a successful coach at Duke. "They were knockdown, dragout affairs."

Morris agreed that no opponent was harder to beat than his longtime friend.

> "Jim was a master at keeping the ball in play. It was tough to put him away. He made me work and tested my patience. He kept me in shape to play, and he always made himself available for a set or two at lunchtime. But even though he was all over me in practice, he never played well against me when we met in tournaments."

Following the death of another outstanding college coach, North Carolina's Don Skakle, Morris succeeded him in 1980 and maintained the Tar Heels' winning tradition until 1993. He also remained an age group player of some repute until, approaching 70, he underwent shoulder replacement surgery in 2003. "Overuse led to arthritis," he said. "I wasn't able to swing a racket any longer."

There was nothing left for him but to serve as a representative of the years when tennis was "a gentleman's game."

Caroline Lind, N.C.'s Golden Girl: It is but a single amendment tacked onto the landmark Education Act of 1965 seven years after its enactment by Congress. Yet that piece of legislation, known simply as Title IX, assumed legendary proportions in the collective mind of the American public. Without mentioning sports, it underlined the equality of women in access to athletic pursuits and facilities at all educational levels.

Almost a half-century later, Title IX is considered the force that flung open the portal to female participation in a variety of sports by requiring that institutional funding for women's sports should match that of their male counterparts.

Nevertheless, more than a few years passed before significant numbers of women passed through the door Title IX had opened. In the process, women had to overcome

Greensboro's Caroline Lind (second facing camera above) has twice won Olympic Gold as one of America's best rowers.

the centuries-old social dictate that the pursuit of the more strenuous sports endeavors was somehow unfeminine.

The Women's Movement of the second half of the 20th century gradually put the lie to that school of thought. Eventually, it became possible for a girl like Caroline Lind to turn an unfamiliar sport into a fulltime vocation that brought her two Olympic gold medals and a chance at a third. To lend some perspective to that sort of accomplishment, Lind is the only native North Carolinian to earn gold medals in back-to-back Olympics. What's more, she has done it in a sport that is largely foreign to citizens of her home state.

Lind's sport of choice happens to be rowing. She is a fixture in the U.S. eight-oared shells that captured gold medals at Beijing in 2008 and London in 2012 and is aiming for a threepeat at Rio de Janeiro in 2016.

"I had some success with other sports — swimming, basketball, track, water polo — and I liked them," Lind said. "I was 16 before I was introduced to rowing. But once I tried it, I fell in love with it." The affair lasted 15 years … and counting.

Lind inherited her height (she's a six-footer) and much of her athleticism from her father. The 6-foot-8 Fred Lind played basketball on the outstanding Vic Bubas-coached teams at Duke in the late 1960s. Although he spent all but his senior year in a backup role, Lind's heroics in two home-court wins over favored North Carolina teams became the stuff of Duke basketball history. Playing in relief of foul-plagued star center Mike Lewis in the 1968 renewal at Cameron Indoor Stadium, Lind put together a 16-point, nine-rebound performance to lead the Blue Devils to an 87–86 triple overtime win in

what still ranks as one of the most thrilling games in the history of the rivalry. The Cameron Crazies rewarded him with a brief ride out of the locker room.

The following year, with half a foot of snow falling outside, Lind contributed 18 points and 10 boards to an 87–81 upset win over the Tar Heels in his Senior Day game and Bubas' last one at Duke. It was Lind's last game as well. He returned to his native Illinois to attend law school at DePaul. An internship in the Cook County Public Defender's office during his last semester led him to make it his life's work.

His undergraduate years convinced him to settle in North Carolina, and he landed a position as assistant public defender for Guilford County in Greensboro. More than 40 years later, he heads the office. "I just enjoy it," he said. "Part of it is the trial competition between you and the prosecutor."

When Lind and his wife Mary introduced their two preteen daughters to sports, it was with an eye on the potential competitive benefits as well as the physical ones. Their second daughter became hooked. "When Caroline was six, she was tall, athletic, somewhat hyperactive and eager to do what it took to improve," Fred Lind said.

His daughter first applied her attributes to swimming at the community level, where she excelled to an extent that she was able to advance to AAU competition.

Next, Caroline followed her father into basketball and became a high school standout during her first two years at Greensboro's Page High, then after joining older sister Mary Laura at Phillips Andover Academy in Massachusetts. Along the way, she also pursued water polo and track as a low hurdler.

"My parents always encouraged my participation in sports, but they never forced or pushed me into anything," Lind said. "I probably inherited a strong work ethic from them, athletically as well as academically. I liked to push myself to the limit."

It was Lind's mother who introduced her to rowing in 1999, when she was 16. "She read an article in the *Wall Street Journal* about the growth of the sport for women and showed it to me," Lind said. Reading the article was enough to arouse her curiosity about a sport that was still obscure in North Carolina but accessible at her prep school.

"I said, 'Forget it,'" Fred Lind said when he learned of his impressionable daughter's newest athletic interest. Undaunted, Caroline submitted to her first ergometer test to assess her potential as a rower.

Lind said:

> "The erg machine is stationary and set up indoors. Its monitor measures and quantifies your rowing power output for every stroke.
>
> "It approximates a 2000-meter course. Experienced rowers can finish it in six-and-a-half to seven minutes. On my first try, my time was 7:40, and I threw up when it was over. On my second try, it was 7:13."

Those represented new standards for her school. As a rower, she was somewhat of a "natural." By the following summer, Lind had qualified for the junior national eight-oar team and was chosen to compete at an international event in Croatia.

"I fell in love with rowing almost from the first time I tried it," Lind said. "I had dreamed of competing in the Olympics and thought basketball was my best chance.

But basketball had to take a back seat to rowing." It was the start of an athletic career that has reached 15 years and still counting.

Recruited by colleges like Virginia, Stanford, Michigan and Yale, whose rowing programs rivaled their academic reputations, Lind chose Princeton and Coach Lori Dauphiny, whom she lists alongside her father as one of two closest and most influential mentors. Dauphiny said:

> "As far as I was concerned, Caroline was the No. 1 recruit that year. Even though her rowing experience was limited, she had a great deal of untapped potential in terms of height, oar leverage, strength and stamina.
>
> "Her experience in water polo and the other sports represented an important plus. She had made a natural transition, and her erg scores showed solid improvement and shattered every school record.
>
> "Beyond those physical assets, her passionate, driven spirit and her animation in engaging others were obvious and quite unusual."

From Lind's standpoint, Dauphiny's coaching reputation and the Princeton training facilities that soon would attract the headquarters of U.S. Rowing away from Indianapolis set the program apart from the rest.

> "Meeting Coach Dauphiny was the turning point in my choosing Princeton. I saw her as a coach who is 100 percent dedicated to her athletes, yet one with the personal touch to become a mentor for them. She's helped me make difficult academic decisions and get past breakups with boyfriends. I became a babysitter for her son, and he used to call me 'Auntie Caroline.'"

Princeton's results in NCAA championship competition reflected Lind's development as a rower. The Tigers finished eighth when she was a freshman in 2003, fourth in '04, second in '05 and first in '06, when she manned the critical "stroke" position at the front of the shell. "Caroline was the rare rower who improved to the extent that she posted better scores (personal records) in virtually every succeeding monthly test," Dauphiny said. "She never plateaued, never seemed to slow down. She smashed every collegiate erg score record at the time."

Lind's transition from college competition to the No. 7 oar on the U.S. national eight-boat was seamless and rapid. She scored a rare "double" in '06, contributing to winning efforts in the World Championships as well as the NCAAs. It was to be the first of six World Championship gold medals to go along with the Olympic golds in '08 and '12.

For the most part, Lind has been a fixture in the No. 7 seat in the shell. The coxswain, whose size and role are not unlike those of a jockey, dictates the cadence to the stroke rower in the No. 8 seat. The stroke usually is the team's most technically skilled oarsman who translates the coxswain's shouted beat into the desired pace for the rest of the team.

"The No. 7 rower serves as a buffer, a facilitator between the stroke and the rest of the crew who smoothes out the inconsistencies," Lind said. "The 6, 5, 4 and 3 seats are the engine room that provides most of the boat's power. The bow pair in the 2 and 1 seats are smaller and lighter but no less skillful."

Before her retirement from competition following the 2012 Olympics, 6-foot-4 Ithaca, New York, native and Harvard alumnus Caryn Davies manned the stroke seat on the U.S. eight behind Lind. The close friends are two of the six members of the teams that captured pairs of gold medals. "I relied on Caroline and needed her support," Davies said. "She had the kind of strong personality that enabled her to fix any problems we had with rhythm during races. When she wasn't rowing, there seemed to be a disconnect on the team."

Lind's undergraduate major at Princeton was anthropology. Then, after the '08 Olympics, she decided to pursue an MBA with an accounting specialty at Rider University. She had to forego rowing competition and training in 2010, when she completed degree requirements. But when faced with the choice between her sport and launching a promising career in another field, Lind found she was unwilling to make the transition.

"When you win a gold medal, the memory of the elation and camaraderie draws you back," she said. "I was passionate about my sport. I love the team aspect and working toward a goal." She didn't feel the same way about accounting.

Even after acquiring a second gold medal and celebrating her 30th birthday, Lind wasn't able to bring herself to break with rowing. Never mind that the highest level of the sport requires a fulltime work commitment with minimal financial reward beyond living expenses. Lind said:

> "We have two practice sessions per day on a year-round basis. We usually practice from 7 to 9 or 10 a.m. and again from 1:30 to 3:30 in the afternoon with occasional three-a-days leading up to competitions. We spend a certain amount of spare time on physical training. So it rules out a job.
>
> "Sometimes it seems like we're working for pennies. That's why the support from my family has been integral."

As a former athlete himself, Fred Lind supports his daughter's commitment. "Rowing can be a grind, and it's not a money sport," he said. "We help financially to the extent that we can, and we've had the chance to attend a number of international regattas. I take my hat off to her for her dedication and perseverance."

Beyond her quest of a third gold medal in the 2016 Rio de Janeiro Games, Lind admits to some interest in further pursuing her sport as a coach. "I'd like to do something that involves interacting with people more than I'd find in accounting," Caroline said. "I'd love to become a consultant in team building and leadership. Coaching would give me a chance to keep in touch with the sport."

There's little doubt that Caroline Lind would have been successful in practically any endeavor she pursued, but her life has unfolded differently as a result of events that took place a few years before she was born.

And as it relates to numerous female athletes, she's far from alone in that respect.

Carolina Hurricanes, Rare N.C. Champions: Let's be honest. In spite of its status as the 10th most populous U.S. state, North Carolina has been somewhat backward in the attraction and development of franchises in the nation's major professional team sports—

baseball, football, basketball and ice hockey. When it comes to pro teams, the 50 states are evenly divided between the "haves" and the "have-nots." North Carolina, along with Oregon and Utah, is barely represented.

There have been just five in-state franchises—the Carolina Cougars of the American Basketball Association, the Charlotte Hornets and Charlotte Bobcats of the NBA, the NFL's Carolina Panthers and the NHL's Carolina Hurricanes. The lone championship was notched by the Hurricanes, who captured hockey's Stanley Cup in 2006.

Indeed, the Raleigh-based Hurricanes beat the odds by becoming a successful expansion team both on and off the ice after being spawned by a failed expansion fran-

In a moment of pure joy, Hurricane Rod Brind'Amour holds the Stanley Cup aloft.

chise—the Hartford Whalers. What's more, they succeeded in a Southern location that lacked any sort of hockey tradition. For Raleigh and the Hurricanes, their 1997 union was a match born of necessity on both sides. The city and the NHL franchise needed each other. Its essence was as simple as that.

Reynolds Coliseum, a state-of-the-art, 12,000-seat basketball arena when it was constructed under the supervision of N.C. State coach Everett Case in the immediate aftermath of World War II, contributed to its own obsolescence by the time it approached the age of 50. Case's dominating program induced its in-state rivals in the Atlantic Coast to keep up. NCAA championships for State in 1974, North Carolina in '82 and the Cinderella season engineered by Wolfpack coach Jim Valvano in '83 fueled an "arms race" in terms of facilities.

Carolina's 23,000-seat Dean Smith Center was already on the drawing board when Valvano guided State to the '83 NCAA title. "After winning that championship and with Carolina planning a big, new basketball arena in Chapel Hill, we felt we needed to build one ourselves," said Steve Stroud, a Raleigh developer who was an officer in N.C. State's Student Aid Foundation (Wolfpack Club) at the time.

Realizing they would be hard-pressed to match the alumni fund-raising effort that underwrote the construction of the Dean Dome, Stroud and N.C. State sought creative ways of financing a project with an estimated $60 million price tag at the time. "N.C. State's vision for a coliseum just wouldn't work financially," Stroud said.

Stroud was named chairman of the "Committee of '84," a joint venture with the city of Raleigh and Wake County to determine the feasibility of a downtown arena financed in large part by taxes raised through hotel room occupancy and prepared food and beverages (restaurants). After nearly a decade of political and financial wrangling involving N.C. State, Raleigh, Wake County and the N.C. General Assembly, Raleigh and Wake County agreed to use tax funds to match the $22 million raised by the Wolfpack Club. The state legislature kicked in a total of $9 million. But by then, $50 million was nowhere close to financing such a project.

Nonetheless, in 1995, the legislature established the Centennial Authority, recognizing N.C. State's 100-year anniversary several years earlier and authorizing the study, design, planning, construction, ownership, financing and operation of a regional arena. With Stroud named its chairman, the authority authorized architects to redesign the building as a multipurpose arena with 21st-century amenities like luxury seats.

Meanwhile, Peter Karmanos Jr. was experiencing a severe case of "buyer's regret" in the aftermath of his 1994 purchase of the NHL's Hartford Whalers. Since 1979, when the New England-based Whalers had settled in Hartford after seven seasons in the World Hockey League prior to a merger with the NHL, their only on-ice accomplishments were three winning seasons in 18 tries and one playoff series appearance. Their average attendance had dropped from a high just under 15,000 in the mid-1980s to less than 12,000 when they were sold to Karmanos, a computer executive from Detroit who had dabbled in minor league hockey for a decade before taking the NHL plunge.

When Karmanos purchased the Whalers from financially embattled owner Richard Gordon, Connecticut governor Lowell Weicker and that state's Development Authority had helped broker the deal. Karmanos felt he could count on Weicker's support to help

secure state funds for a new arena to replace the aging Hartford Civic Center. But Weicker, then a political independent, chose not to run for reelection. He was succeeded by Republican John Rowland, a former rival who opposed using taxpayer dollars for a new arena.

Karmanos had given Hartford a four-year commitment to turn around the franchise before he would consider a move to another city. But Hartford's primary industry— insurance—was struggling, and the resulting shrinkage of corporate support underlined shortcomings in team competitiveness, attendance and media opportunities. "It's tough to establish your sphere of interest when you're sandwiched by two major markets like New York and Boston," said Hurricanes' general manager Jim Rutherford, a former Detroit Red Wings' goaltender who has worked with Karmanos since the early 1980s.

In a last-ditch effort to make a go of it in Hartford, management launched a "Save The Whale" civic campaign to sell 11,000 season tickets. A total of 8,563 were sold in 45 days, surpassing the previous base figure by 3,500 despite significantly higher prices. Nevertheless, Karmanos announced the team would leave Hartford after the 1996–97 season, even though he had scarcely an inkling of the franchise's destination.

Raleigh seemed an unlikely choice because of its Southern location and lack of hockey tradition above the minor league level. The Centennial Authority, however, had worked its way into the NHL's consciousness and onto a short list of potential franchise sites. "We had decided that the best chance to land a co-tenant lay in hockey, not basketball," Stroud said. "As soon as I heard that Peter Karmanos had acknowledged that Raleigh was a prospective site, I put in a call to his office. He agreed to pay us a visit."

Stroud's group was able to offer some compelling arguments as to why a hockey franchise could succeed. Spurred by the Research Triangle, which had mustered the collective academic and technological support of N.C. State, the University of North Carolina and Durham's Duke University to become the East Coast version of California's Silicon Valley, Raleigh's metro area had experienced rapid growth. It had surpassed Greensboro to become the state's second largest city behind Charlotte with a metropolitan population rapidly approaching one million.

In addition, the Research Triangle had attracted many prospective fans who already had become familiar with hockey in the Northeast and Midwest. With construction of the Entertainment and Sports Arena (ESA) already underway, Karmanos and Rutherford pointed out that plans for the building did not meet NHL standards, triggering a redesign effort that fulfilled the requirements of major league hockey as well as college basketball. It didn't hurt Raleigh's cause that Karmanos' son Jason had been favorably impressed by the growing metropolitan area during a stint as a player with the minor league Raleigh Icecaps at Dorton Arena before an injury ended his playing career.

Negotiations settled on a multipurpose arena with 18,176 seats for hockey, 19,722 for basketball and 19,500 for concerts, including 66 luxury suites, at an eventual cost of $158 million. The ESA was to be jointly funded by the state of North Carolina, the city of Raleigh, Wake County, N.C. State University and the hockey franchise. The Centennial Authority retained ownership of the building and the surrounding 80 acres, but operation of the facility would be managed by the team.

By the spring of '97, Karmanos announced the move of the franchise to Raleigh. He chose the nickname of the relocated team himself, marrying a geographic meteorological reference with the spectator appeal of hockey's sometimes-violent nature. The choice of red, black and white uniform colors fit N.C. State's red and white.

The only significant sticking point was that construction of the redesigned arena had yet to begin, and it would not be ready for two more years. The only viable solution to the problem was the availability of the Greensboro Coliseum, a 20,000-plus seat facility located a 90-minute drive from Raleigh. The temporary arrangement meant a lengthy game-day commute for players, coaches, ground-floor season-ticket buyers and employees who manned the team's Raleigh office.

It was somewhat predictable that the Hurricanes' first two seasons in Greensboro represented a holding action. The team remained reasonably competitive, as it had been in Hartford, posting records of 33–41–8 in 1997–98 and 34–40–18 in '98–99, reaching the first round of the playoffs in the second year with capable young players like Sami Kapanen and Keith Primeau. But attendance lagged markedly below the mediocre Hartford numbers, averaging less than 10,000 both years.

Between the '98 and '99 seasons, as Rutherford sought to assemble a credible, viable team that would appeal to fans in a new location, he relied on his many years as an NHL player and executive to use veteran leadership as a cornerstone. His primary target became a 35-year-old unrestricted free agent center who already had amassed Hall of Fame credentials.

Ron Francis agreed to become the face as well as the on-ice captain and leader of the relocated franchise that had given him his start almost two decades earlier. Francis, who had spent most of the 1980s as the Whalers' mainstay before being traded to the Pittsburgh Penquins in time to help them win back-to-back Stanley Cup championships in '91 and '92, said:

> "I had offers from four teams. The money always factors into that kind of decision, but I liked the idea of coming into a different area with the chance to help sell our game to a new market.
>
> "The game-day commutes to Greensboro were an inconvenience that first year, but my family settled in quickly. They liked their new location almost from the start.
>
> "For me, the most important facet of leadership is making everyone involved feel like a part of the mission. Beyond playing, part of the task at hand is selling the game."

In establishing a franchise from the ground up, Francis was just what the doctor ordered in terms of leadership on the ice and connecting with fans and the Raleigh community at large. Francis' presence no doubt was an attraction for the talented and easy-to-lead players with whom Rutherford began to surround him.

Rod Brind'Amour, a promising young center iceman who was to remain a Hurricanes' mainstay for the next decade, was acquired from the Philadelphia Flyers a year after Francis in a trade for Primeau. Brind'Amour, who eventually joined Francis in the team's front office, said:

"It was a shock to my system, to be blunt. I flew straight here as soon as I got the call for a game that night, and there were only 8,000 people in the stands. But I soon realized I had gotten in on the ground floor with a bunch of other guys who wanted to be part of the building process.

"We were an underdog, a have-not, but you could sense that we were going in the right direction."

Although they fell short of the playoffs again in the inaugural 1999–2000 season as the home team in Raleigh's newly finished arena, they were a playoff team the following year, losing a six-game series to the New Jersey Devils in the first round. By 2001–02, low-keyed coach Paul Maurice's roster included centers Brind'Amour and Jeff O'Neill, left wingers Bates Battaglia and Erik Cole, right winger Kapanen, defenseman Glen Wesley and veteran goaltender Arturs Irbe.

The '02 Hurricanes finished first in the Southeast Division with a record of 35–26–16 and 91 total points, earning the No. 3 seed in the Eastern Conference playoffs. They then reversed the previous year's 4–2 decision on New Jersey in the Eastern quarterfinals and knocked off a couple of Canadian-based teams who were part of the NHL's "original six" franchises, the Montreal Canadians and Toronto Maple Leafs, by 4–2 margins to face the Detroit Red Wings for the Stanley Cup.

The Wings won the championship in five games, but not before Raleigh had hosted its first Stanley Cup games and Canes fans had received their initial taste of a deep playoff run and the excitement involved in playing for the Cup. Francis said:

"A lot has to go right to have a run like that. Your squad has to have a lot of good pieces.

"Even though we didn't go all the way, I'm every bit as proud of that '02 team as I was of playing on the ones that won two Stanley Cups in Pittsburgh.

"It ignited our fan base. I'll never forget the parking lot filled with tailgaters by the time we arrived to play game three. And many of them were back at it after we lost in triple overtime."

The Canes set a new franchise attendance record that season, averaging more than 15,000 per game in a building whose naming rights had been sold to RBC Centura Bank. The attendance figures kept climbing over the next decade, marking the Hurricanes as an established NHL franchise. But the team again fell short of playoff qualification the next two years, the second of which marked Francis' trade to Toronto as well as Maurice's dismissal and replacement by Peter Laviollette, another proven NHL veteran.

When Francis retired a year later at age 40 after 23 years as an NHL player, he was the league's all-time No. 4 scorer, trailing the household hockey names of Wayne Gretzky, Mark Messier and Gordie Howe. He ranked second to Gretzky in assists and third behind Howe and Messier in games played. He then was rehired by the Hurricanes and served as their vice president of hockey operations until 2014, when he was named to replace Rutherford, who retired as general manager at the end of the 2013–14 season.

Meanwhile, after the '04–05 campaign was wiped out by a league work stoppage, Rutherford had assembled the pieces for another Stanley Cup run. Brind'Amour, who

had succeeded Francis as team captain, Wesley and Cole remained as mainstays of the team. They were joined by wingers Justin Williams, Cory Stillman and Ray Whitney, plus defensemen Bret Hedican and Aaron Ward.

"It was a special team," Brind'Amour said of the '06 Canes. "For the most part, we were a group of guys who had played the game a long time without winning and who put everything else aside to reach a common goal."

But the dominant figures on the '05–06 Hurricanes' roster were a couple of young players who came into their own that season. Erik Staal, the oldest of three brothers from Thunder Bay, Ontario, to play for Carolina, had been the team's top choice in the 2003 NHL entry draft. Three years later, he scored 100 points on 45 goals and 55 assists. Staal's defensive counterpart didn't actually emerge as a star until the playoffs. Rookie goalie Cam Ward backed up veteran Martin Gerber throughout the regular season and into the playoffs.

The Hurricanes again captured the Southeast Division title with a 52–22–8 record, earning the No. 2 seed in the Eastern Conference. Favored to beat the Canadiens at home, Carolina was embarrassed 6–0 in the opener and fell behind 3–0 in Game Two. Then Laviolette benched Gerber, whose play appeared to be affected by a stomach ailment, and inserted the rookie. Ward became the "hot goalie" who often leads his team to the Stanley Cup. Although he relinquished a lead in a 6–5 double-overtime loss in Game Two, he was undaunted by the brooms waved by fans in the Montreal Forum. He allowed just five goals as the Hurricanes won four straight and the opening series.

In the remaining 19 games against the Devils, the Buffalo Sabres and the Edmonton Oilers on the way to the Stanley Cup championship, Ward and Gerber recorded three shutouts, surrendered only one five-goal game and four four-goal games. Their goals-against average in 25 playoff games was a stingy 2.4. "The Stanley Cup put the ultimate stamp of credibility on this market," Rutherford said.

In the years since '06, the Hurricanes have experienced the competitive ups-and-downs that beset most small-market franchises in pro sports, but they have solidified growth in their acceptance by the Raleigh community. According to Rutherford:

> "We have to remain conscious of our revenue limitations. But the growth of the season ticket base and corporate sales have kept our attendance on solid ground in terms of league standards.
>
> "We're embedded in a growing market. And even though Peter and I can't be here forever, this team should be here a long, long time."

If Rutherford proves right about that, the Hurricanes will be defying what were pretty long odds 20 years earlier.

Faces in the Crowd: Here are brief looks at other people who have left their marks on a diverse North Carolina sports history.

Joey Cheek (Speedskating): If Greensboro seems an unlikely breeding ground for a speedskater, it was until shortly before the turn of the century, when Joey Cheek gravitated from in-line roller skating competition to the ice sport in his quest of an Olympic medal. After graduating from Greensboro's Dudley High School, he soon gained a

chance to attend the U.S. training center for speed skaters near Salt Lake City, Utah. Cheek's promise became evident when he secured a bronze medal in the 1,000-meter event at the 2002 Salt Lake City Winter Olympics. By the 2006 Games in Turin, Italy, he had matured to a point where he was able to win two more medals. He dominated the 500-meter sprint event when he was the only competitor to post a sub-35-second time. He did it in both of his runs, posting a total time of 1:09.76 to win the gold medal, and his 34.82-second effort in his first run was an unofficial world record. Cheek added a silver medal in the 1,000, finishing behind U.S. teammate Shani Davis. He also generated enough popularity among his teammates that they elected him to carry the flag in the closing ceremonies. He made further headlines by donating his $40,000 in bonus money from the U.S. Olympic Committee to Right To Play, an international humanitarian organization founded by former speedskating champion Johann Olav Koss of Norway for the purpose of raising funds to benefit children in disadvantaged Third World areas. Then, during his college years at Princeton, Cheek became an activist with Team Darfur, a philanthropic coalition of athletes committed to raising awareness of the military crisis in Darfur, Sudan. In the meantime, Cheek inspired another local roller skating champion to follow in his footsteps. Heather Richardson of High Point entered the 2014 Winter Olympics in Sochi, Russia, as the top U.S. female speedskating medal hope.

Dennis Craddock (Track & Field): In the first 60 years of Atlantic Coast Conference competition, which coach guided his teams to more championships than any other? The answer is Dennis Craddock with 45 ACC titles. OK, it's kind of a trick question because the conference awards championships each year in men's and women's cross country, indoor track and field and outdoor track and field. Craddock was North Carolina's head coach for all six of those sports for 27 years from 1986 until his retirement in 2012. Before that, he was Virginia's head track coach for men from 1976 through '85. Nonetheless, he has had quite a successful run that earned him induction into the U.S. Track & Field and Cross Country Coaches Association's Hall of Fame in 2013. All told, he coached 19 Olympians, including five gold medalists. In addition, he coached 25 different athletes to a total of 38 NCAA individual championships.

John Danowski (Lacrosse): When Duke hired Danowski as coach in July 2006, he was charged with salvaging a program that had been raked by national media attention following allegations of sexual assault at a team party. The subsequent investigation led to the filing of charges against three players by the Durham County district attorney's office. The program had been suspended, its season cancelled and Coach Mike Pressler dismissed. When the allegations were shown to be unfounded, Duke reinstated the team and launched a search for a new coach. Danowski, having held head coaching positions at C.W. Post and Hofstra for almost 25 years, was well-regarded in the profession but less than an overwhelming winner. He was attracted to Duke in part because his talented son Matt had been an up-and-coming player on Pressler's team. Danowski's first seven Duke teams reached the NCAA Final Four. They won championships in 2010 and '13, putting Danowski in the select company of 11 coaches who have won multiple NCAA titles.

Laura DuPont (Tennis): Although DuPont was a native of Louisville, Kentucky, she honed her tennis game while growing up in Charlotte. Upon grad-

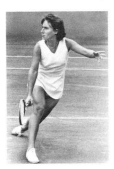

uation from Charlotte Catholic High, she became a college star at North Carolina and the first UNC female athlete to capture an individual national championship when she won the 1971 AIAW singles title. DuPont then joined the WTA circuit, eventually earning a No. 9 world ranking and winning the U.S. Clay Court championship in 1977 and other singles titles in Canada, Germany and Argentina. Recognized for her backhand and tactical skill, DuPont became a topnotch teacher of the game before her death from breast cancer at age 52.

Shalane Flanagan (Cross Country): The daughter of two world-class distance runners, Flanagan led a nomadic existence as a child that encompassed her birth in Boulder, Colorado, and her high school years at Marblehead, Massachusetts. As a collegian at the University of North Carolina, she captured NCAA cross country titles in 2002 and '03. In the years since, she has competed at every distance ranging from 1500 meters to the marathon. She captured the bronze medal in the 5,000 meters at the 2008 Beijing Olympics and has held American records in both the 5,000 and 10,000. She finished 10th in the marathon at the 2012 London Olympiad.

Mary Garber (Journalism): When World War II depleted the male work force on the home-front, daily newspapers in non-major cities were beset by personnel shortages. That's when the door opened for Garber to become a pioneer. New York City born and Hollins College (Virginia) educated, she landed a job as a society writer and general news reporter at Winston-Salem's *Twin City Sentinel*. When needed to fill in as a sportswriter, Garber accepted the role even though she wasn't always allowed to enter press boxes. By the time the war ended, sportswriting had become her calling. She was one of the first, if not the first, fulltime female sportswriters anywhere in the country. At five feet and 96 pounds, she worked in the sports departments of the *Sentinel* and the *Winston-Salem Journal* beyond her 1986 retirement until 2001. Before her death at age 92, she was nationally recognized as the recipient of the Associated Press Sportswriters' Red Smith Award for major contributions to sports journalism in 2005 and with the Mary Garber Pioneer Award honoring a role model as presented by the Association for Women in Sports Media.

Marshall Happer (Tennis): A state junior and high school champion from Kinston who played college tennis at North Carolina, Happer graduated from UNC's law school

in 1964. He settled in Raleigh, where he entered private practice and later joined a firm. Gradually, over the next 30 years, Happer became a mover and shaker in local, state, regional, national and international tennis circles. While running junior tournaments, he grew fascinated by the sport's administrative requirements and political networks. He founded the Raleigh Racquet Club in 1968 and developed it into a center for North Carolina tennis. He ascended to the presidency of the N.C. Tennis Association in 1974. That position, along with his legal credentials, led to an appoint-

ment as administrator of the Men's International Tennis Council, the governing body of the Grand Prix circuit. When that organization was supplanted by the Association of Tennis Professionals (ATP) in 1989, Happer was tapped as Executive Director and CEO of the U.S. Tennis Association. He resigned that position in '95. Since then, he has returned to his professional practice, serving as the USTA counsel and specializing in sports and entertainment law. He moved to Florida in 2005 and was still practicing in his 70s.

Allen Johnson (Track & Field): Johnson attended UNC and became the world's premier high hurdler of a decade-long era from the mid-1990s to the mid-2000s. The three-time U.S. Olympian captured the gold medal at Atlanta in 1996 and was the first high hurdler to win four world championships in the 110-meter event in 1995, '97, 2001 and '03. His personal best time of 12.92 seconds was one of 11 races he completed with times under 13 seconds.

Kristi Overton Johnson (Water Skiing): A Greenville native, Overton Johnson found a sport for a girl with a hip deformity that prevented her from running. Her father introduced her to water skiing at age four and she turned pro when she was 13. She became a champion in slalom competition. Her 80 pro wins included four U.S. Open titles, six Masters victories and the 1999 world championship. She attained more No. 1 rankings than any female skier in history and was inducted into her sport's Hall of Fame in 2013. Since retiring in 2002, she became a faith-based motivational speaker, founded a ministry and raised three children with husband Tim Johnson.

Cullen Jones (Swimming): Since 1946, when former UNC swimmer and coach Willis Casey started building a first-class swimming program at rival N.C. State, the Wolfpack has churned out a number of prominent freestyle swimmers. Six-foot-seven Steve Rerych joined teammates Mark Spitz and Don Schollander on U.S. relay teams that won a couple of gold medals at Mexico City in 1968. Then Rerych became a surgeon. Raleigh native David Fox, a seven-time ACC champion, earned gold on the U.S. 4x100 freestyle relay team at Atlanta in '96. But the N.C. State swimmer who had the most lasting impact on his sport was Cullen Jones. As a five-year-old living in Irvington, New Jersey, Jones nearly became a drowning victim at a water park in Pennsylvania. Back home, his mother immediately enrolled him in a swimming program. After his college years at State, Jones proceeded to dispel the myth that African-Americans and swimming were oil and water. The third black swimmer ever to earn a berth on the U.S. Olympic team, he was in the foursome that posted a stirring come-from-behind victory in the 4x100 freestyle relay to earn Michael Phelps one of his Olympic-record seven gold medals at Beijing in 2008. Jones came back in 2012 at London to earn another gold in the 4x100 medley relay and silvers in the individual 50-meter freestyle and the 4x100 freestyle relay. As he took aim on a third Olympic appearance at Rio de Janeiro in 2016, Jones was living in Charlotte and campaigning in public appearances and speaking engagements to increase African-American awareness of competitive swimming.

Leora "Sam" Jones (Team Handball): Jones made her mark in the Olympic sport of team handball after starring as a basketball player at Southern Wayne High in her native Mt. Olive, Louisburg Junior College and East Carolina. She was a graduate assistant coach at ECU in 1982 when she was exposed to a National Sports Festival tryout for

team handball. She became intrigued and, despite zero playing experience, she rode her athleticism to a berth on the '84 U.S. Olympic team. She scored 32 goals in the Los Angeles Games, narrowly missing a medal. She competed again at Seoul in 1988, where she was the No. 2 scorer, and again at Barcelona in '92, becoming the face of her sport in the U.S. She also competed professionally in Europe and was named player of the year three times by the sport's U.S. federation.

Marion Jones (Track & Field): Along with numerous successes, track athletes with North Carolina ties have experienced a measure of scandal. Jones tasted both extremes. A California-born-and-bred track and field prodigy, she passed up numerous scholarship opportunities in that sport to join UNC's basketball program as a point guard. But in 1997, after starting for four years and helping the Tar Heels win the 1994 NCAA championship, she returned to sprint and long jump competition with a vengeance in preparation for the 2000 Sydney Olympics. Jones made it known that her goal was to win five gold medals in Sydney. She won three golds in the 100- and 200-meter sprints, plus a relay, and settled for bronze medals in the long jump and another relay, emerging as the clear-cut female star of track and field competition. Jones' husband, C.J. Hunter, a shot putter and former Carolina coach, dropped out of competition before the Sydney Games in the wake of positive pre-Olympic drug testing. Within the next year, federal investigators were connecting Jones and her trainer, Raleigh-based Trevor Graham, to Victor Conte's Bay Area Laboratory Cooperative (BALCO) in the trafficking of performance enhancing drugs. Also implicated were Hunter, then Jones' ex-husband, and sprinter Tim Montgomery, her boyfriend and father of her first child. Baseball superstar Barry Bonds was the most recognizable sports figure involved in the BALCO scandal. But Jones was to become the only athlete involved who served jail time. It was 2008 before she was convicted of "lying to federal prosecutors investigating the use of performance-enhancing substances." She was convicted and served a six-month sentence, plus two years of probation and community service. She also was stripped of her Sydney medals by the International Olympic Committee (IOC).

Luther "Wimpy" Lassiter (Billiards): When he was a youngster in Elizabeth City during the late 1920s and early '30s, Lassiter's extraordinary eye-hand coordination helped him become a pitcher of some repute. "He had a natural talent for baseball," said his younger brother Clarence, "but he was trapped by pool." Lassiter expressed similar sentiments when asked why he never married. "I'm in love with pool," he explained. He mastered his chosen sport when a local pool hall owner allowed him free backdoor access to the establishment in exchange for his willingness to sweep the floors and tables. A nine-ball specialist who was widely considered the best ever at that variation of billiards, Lassiter won six world championships, was ranked No. 9 among the 50 greatest players of the (20th) century by *Billiards Digest* and was inducted into the Billiard Congress Hall of Fame five years before his death in 1988. He acquired his nickname when he consumed a dozen hot dogs and an equal number of Cokes and Orange Crushes in a single sitting, not unlike the cartoon character J. Wellington Wimpy in the Popeye comic strip. Along with his running buddy Rudolph Wanderone (a.k.a. "Minnesota Fats"), Lassiter became a renowned high-stakes hustler based in the pool hotbed of Norfolk, Virginia, winning an estimated $300,000 during a five-year stretch in the mid-1940s.

Joe Lewis (Martial arts): Lewis, a Knightdale native, joined the U.S. Marine Corps soon after leaving high school in 1962. Initially based at Cherry Point, near Havelock, he began studying karate less than two years later while stationed in Okinawa. Within seven months, Lewis secured his black belt in Shorin-ryu karate. Following his tour of duty as a communications specialist in Vietnam, he tackled martial arts as a fulltime vocation. When he left the world heavyweight tournament as champion in his karate specialty, he branched out into other martial pursuits, emerging as a pioneer in U.S. kickboxing and as a student of the full-contact Jeet Kune Do branch of karate under future movie star Bruce Lee. Lewis compiled a 16–4 record as a heavyweight kickboxer during the late 1960s and early '70s. A decade later, while he was based in Los Angeles, earning credits in eight movies and married to an actress, Lewis was voted the outstanding karate champion of all time. He died of a brain tumor in 2011.

Bonnie Logan (Tennis): Logan encapsulated her tennis career when she said: "I was way ahead of my time." A Durham native and Hillside High graduate whose older brother George taught her how to play the game, she became an African-American tennis pioneer who walked in the footsteps of South Carolinian Althea Gibson. As a collegian, she successfully petitioned administrators at Morgan State University to allow her to play on the men's team and won the Central Intercollegiate Athletic Association No. 2 singles flight. Next, she captured seven straight American Tennis Association women's singles titles before becoming the first African-American women to compete on the Virginia Slims Tour in 1973.

Vince Matthews (Track & Field): A collegian at Johnson C. Smith University during the politically turbulent late 1960s, Matthews emerged as a world-class quarter-miler. He maintained an intense rivalry with Lee Evans in the 400-meter event. When he defeated U.S. teammates Wayne Collett and John Smith to win the gold medal at Munich in 1972 with a time of 44.66 seconds, Matthews' performance was overshadowed in media accounts by his behavior on the victory stand. He and silver medalist Collett stood sideways to the flag during the playing of the national anthem, conversing and twirling their medals. It was a more understated protest of African-American grievances than Tommie Smith and John Carlos's black power salutes following the same event four years earlier in Mexico City.

Kathy McMillan (Track & Field): McMillan was just 18 years old and fresh out of Raeford's Hoke County High School when she captured the silver medal in the long jump at the 1976 Montreal Olympiad with a leap of 21 feet, 10¼ inches. Earlier, she set a national high school record of 22 feet, 3 inches that was still standing almost 40 years later. McMillan spent her college years with the renowned Tennessee State Tigerbelles. She won gold medals in the 1979 Pan Am Games at San Juan and again at the '83 event in Caracas. She also won the long jump at the 1980 Olympic Boycott Games in Philadelphia after President Jimmy Carter declared that a U.S. team would not compete in the Moscow Games that year.

Tom Parham (Tennis): Parham, a native of Robbins, divided his four-decade coaching career evenly between his alma mater Atlantic Christian College (now Barton College) and Elon College. Along the way, his tennis teams won NAIA national championships in 1979 and '84 (Atlantic Christian) and 1990 (Elon), plus 22 conference titles. Parham's

600 wins rank him in the top 10 of all collegiate tennis coaches. He earned four national coach of the year honors, and 30 of his players received All-America recognition. He is a member of eight Halls of Fame.

Jane Preyer (Tennis): In a family whose accomplishments encompassed tennis as

well as politics and business, Jane Preyer's tennis achievements stood out. After winning the state women's open titles in 1974, '75 and '77 and starring at North Carolina, Preyer joined the Women's Tennis Association and competed on the international circuit from '77 through '83, reaching a top 50 ranking and defeating Australian star Evonne Goolagong. On hearing the news of her daughter's upset victory, Emily Preyer fashioned a large sign and placed it in her front yard. It read:

Ding, dong. Ding, dong. Jane beat Goolagong!

Jane was named women's tennis coach at Duke in 1985 and proceeded to guide the Blue Devils to five ACC championships in seven years, winning conference coach of the year honors five times. By then, she had earned her master's degree in public administration and launched a new career during which she became director of the Southeast Office of the Environmental Defense Fund.

John Sadri (Tennis): Charlotte native Sadri's two finest tennis hours may have ended

in defeats. The first came when he was a hard-serving N.C. State senior who found himself in the 1978 NCAA individual finals match against a Stanford freshman named John McEnroe. McEnroe, who already was ranked No. 15 in the world as a result of reaching the Wimbledon semifinals a year earlier, was a heavy favorite over a little-known opponent who had knocked off second-seeded Eliott Teltscher of UCLA on the way to the finals. McEnroe won the match 7–6, 7–6, 5–7, 7–6 despite being victimized by 24 Sadri service aces. Later, in his pro career, Sadri reached the finals of the '79 Australian Open before losing to Argentina's Guillermo Vilas in three sets. Sadri's decade as an ATP player ended with a 213–194 record, two championships and almost $900,000 in official winnings.

Joan Benoit Samuelson (Track & Field): With one of its earliest track scholarships, N.C. State and coach Rollie Geiger persuaded Maine native Joan Benoit to transfer from Bowdoin College in 1977. After helping the Wolfpack win back-to-back women's cross country championships in '78 and '79, Benoit returned to her New England roots and became a marathoner around the time women were introduced to that distance. She won the Boston Marathon women's division in 1979 and '83. Then, when the event was introduced to Olympic competition in 1984, the slight, 5-foot-2, 100-pound Benoit overcame recent arthroscopic knee surgery when she outran an international field that included Norwegians Grete Waitz and Ingrid Kristiansen and Portugal's Rosa Mota to win in 2:24.52. Consequently, she received the 1985 Sullivan Award as the top U.S. amateur athlete. She remained a competitive marathoner a decade deep into the 21st century.

Willie Scroggs (Lacrosse): When the calendar turned toward the 1980s, lacrosse was regarded by North Carolinians as an exotic "Yankee sport." The teams at Duke and North Carolina served as Atlantic Coast Conference sparring partners for Maryland and Virginia. Bill Cobey, UNC's athletic director at the time, happened to be a Maryland alumnus. When Cobey filled a coaching vacancy with Willie Scroggs, whose experience as a player and assistant coach took place at the lacrosse hotbed of Johns Hopkins University, it was with the intention of putting the Tar Heel program on the map. Scroggs wasted little time in parlaying his recruiting connections and coaching expertise into an NCAA title contender. Despite a perfect 11–0 record in '81, the Heels were a decided underdog against Scroggs' alma mater, which was seeking a fourth straight NCAA championship. Carolina overcame a three-goal deficit and won 14–13. UNC proved it was no fluke by beating Hopkins again in the '82 finals, capping a 14–0 record. Scroggs added a third title in '86, the first year in which a Final Four was held. Scroggs retired in 1990 to accept an administrative position in the athletic department after recruiting most of the players for the 16–0 team that won the championship in 1991 under his successor, Dave Klarmann.

Marty Sheets (Special Olympics): During the nearly 50 years in which the Special Olympics movement for disabled athletes has prospered in the United States, its primary face was that of its founder, Eunice Kennedy Shriver. If a second face were to be attached to the Special Olympics, it likely would be that of Marty Sheets. When he was born prematurely in Raleigh in 1953, he weighed four pounds, 13 ounces and spent his first 15 days in an incubator. He was a Down syndrome baby. His parents, Dave and Iris Sheets, later moved to Greensboro and encouraged their son to get involved in Special Olympics as a swimmer, a sport for which he had shown some ability. Sheets attended the first Special Olympics Summer Games at Chicago's Soldier Field but was unable to compete because of an illness. Shriver sought him out at the banquet that night and presented him with a gold medal. It was the first in what was to be a collection of more than 250 medals won by Sheets over the years in tennis, golf, power lifting and skiing as well as swimming. Sheets has met numerous celebrity athletes over the years, and he is one of five Special Olympians surrounding Shriver in her portrait at the National Portrait Gallery. Although dementia prevented the 5-foot-3 Sheets from competing beyond his 60th birthday, his father maintains that "Marty has lived a charmed life."

Karen Shelton (Field Hockey): Shelton has put to rest the notion that star athletes do not make good coaches. A three-time national player of the year on field hockey teams at West Chester State that captured the same number of national championships, she became North Carolina's head coach in 1981. In more than 30 years since, her Tar Heel teams have won six NCAA titles and played in the finals nine other times. She is approaching 600 coaching victories with a winning percentage over .750. A Honolulu native and onetime Army brat, she is married to former UNC lacrosse coach (and three-time NCAA champion) Willie Scroggs.

Floyd "Chunk" Simmons (Track & Field): A member of "The Greatest Generation," World War II veteran Simmons deserves strong consideration as the most versatile athlete North Carolina has produced. The Charlotte native was the bronze medalist in

the Olympic decathlon competitions at London in 1948 and Helsinki in '52. Only a couple of American contemporaries kept him from attaining the top of the medal stand. Bob Mathias won gold in both those years, and Milt Campbell took silver in '52 and gold in '56 at Melbourne. When his athletic career ended, Simmons became an accomplished actor with a role in the movie *South Pacific*, an artist and a photographer of some repute. He lived in Tahiti at one time before moving back to Charlotte prior to his death in 2008 at age 82.

John Skipper (Media): "How can anyone earn a living with a degree in English literature?" It became a frequently asked question in the 1970s, when Lexington native Skipper was an undergraduate at the University of North Carolina. His eventual answer was: "Move to New York City, earn a Masters from Columbia in the same academic specialty, land a job in magazine journalism and eventually become president of ESPN Inc." Skipper ascended to that position at the media colossus that accurately bills itself as "the worldwide leader in sports" in January 2012. He launched his career in a secretarial position at Straight Arrow Publishing, where he was hired as a reporter for *Rolling Stone* magazine. Skipper moved to the administrative end of the publishing business and became the publisher of *Us* magazine and *Spin* magazine before he was hired in the early '90s as an executive with the Disney Publishing Group, ESPN's parent company. His successful launch of *ESPN The Magazine* paved the way for his ascent to his current post. Presiding over a $42 billion empire, Skipper was ranked No. 4 among *Sports Illustrated*'s 2013 list of the 50 most powerful people in sports, trailing NFL commissioner Roger Goodell and former NBA commissioner David Stern but ahead of baseball commissioner Bud Selig. Skipper describes himself as a passionate sports fan, and his passion helped carry him a long way from the student section at UNC's Carmichael Auditorium. His $5 million annual salary might not measure up to those of many of the athletes ESPN covers, but it stacks up favorably against most everybody else.

James "Bonecrusher" Smith (Boxing): Smith, who was born in the tiny town of Magnolia, was his home state's only world heavyweight boxing champion. His reign as World Boxing Association titlist was brief, lasting just three months from December 1986 to March '87 before he lost a unification bout to IBF titleholder Mike Tyson on a 12-round decision. Nonetheless, his rise was impressive considering that he didn't turn pro until age 28 after compiling a 35–4 amateur record. At the time he held his championship belt, Smith was the only one with a college degree to ever hold a heavyweight title. He graduated from Shaw University in Raleigh, then worked as a prison guard and served in the U.S. Army before launching his professional boxing career. He fought his way up through the ranks, upsetting previously unbeaten Frank Bruno to earn his title shot against Tim Witherspoon. He knocked down his favored opponent three times in the first round to win the championship by knockout. Along the way, he bestowed his attention-grabbing nickname upon himself. Smith continued boxing until age 46 before retiring with a 44–17–1 record. Since then, he has founded the N.C. Boxing Commission while becoming an ordained minister, a travel agent and founding Champions for Kids, a Myrtle Beach-based humanitarian organization to benefit underprivileged children.

Mildred Southern (Tennis): Southern didn't pick up a tennis racket until she was 18. She didn't play in a tournament until she was in her 40s. Then the Eastern North Carolinian began making up for lost time. During the next five decades, she captured 60 state senior championships and 42 regional titles. It wasn't until 1996 that she began entering—and winning—USTA national senior age-group events. The keys to her game were hard work, conditioning, consistency and tactical skill. Southern's on-court record, however, was overshadowed by her off-court contributions to the game. She was an officer in numerous local, state and regional associations and introduced hundreds of youngsters to tennis after founding the Young Folks Tennis Program in Winston-Salem. "The greatest thrill of all is to see that expression on a child's face when he hits the ball over the net for the first time," Southern said. She received the USTA's Service Bowl Award in 1997, joining such illustrious names as Billie Jean King, Chris Evert, Maureen Connolly and Pam Shriver.

Julie Shea Graw Sutton (Track & Field): In the vanguard of female runners at the college level in the late 1970s and early '80s, Shea competed for N.C. State at distances ranging from 3,000 to 10,000 meters. The Raleigh native held as many as seven national track and cross country titles and was awarded both the 1980 and '81 McKevlin Awards as the top athlete in the Atlantic Coast Conference, male or female. In winning the back-to-back awards, she outpolled the likes of Lawrence Taylor, Albert King and Ralph Sampson in votes of the Atlantic Coast Sportswriters and Sportscasters Association. She won the 5,000-meter event at the 1980 U.S. Olympic Trials but was kept from competing in the Moscow Games by the U.S. boycott. Her sister Mary was a prominent Wolfpack teammate. Julie Shea, a design major at State, served on the Raleigh City Council from 1995 through 2001.

John Swofford (College Sports): From his small-town beginnings in North Wilkesboro, Swofford rose to guide college sports in the Atlantic Coast Conference into the realm of big business. During the 1960s, Swofford was an all-state quarterback at Wilkes Central High School whose academic promise earned him a prized Morehead Scholarship at the University of North Carolina. After earning a Master's degree at what was Ohio University's spanking new school of sports management, Swofford returned to his ACC roots, first in the business office of the athletics department at Virginia, then at his alma mater. By 1980, at the still-tender age of 31, he was named UNC's athletics director, a post he held until 1997, directing a broad program that claimed 123 ACC championships and 24 NCAA titles. Then, in '97, his NCAA political experience earned him the nod as the fourth commissioner in the ACC's 44-year history. By 2004, Swofford was engineering a round of expansion that would increase the number of league members from nine to 12 with the addition of Miami, Virginia Tech and Boston College. Less than a decade later, the ACC had grown to 14 members with Pittsburgh, Syracuse and Louisville joining the fold and Notre Dame agreeing to an affiliation that would maintain its independent status for football. Nearly a decade-and-a-half into the 21st century, Swofford's tenure as commissioner had witnessed the increase of ACC revenues many fold, approaching $200 million annually and rising.

Tony Waldrop (Track & Field): A native of Columbus, North Carolina, Waldrop earned the University of North Carolina's coveted Morehead academic scholarship. He became Jim Beatty's heir apparent as a UNC-educated miler in 1974, when he recorded nine consecutive sub-four-minute performances. During that span, he set a world indoor mile record of 3:55 that endured for 35 years, posted a personal best of 3:52.3 in winning at the Penn Relays and was runner-up to Olympic champion Dave Wottle at the NCAA meet. He retired from competition a year later after winning the gold medal at the Pan Am Games in Mexico City and before the '76 Montreal Olympics, saying "I lost my desire and I was ready to face life beyond athletics." He went on to earn a PhD in physiology and later entered the field of academic administration. Most recently, he became provost and executive vice president of the 53,000-student University of Central Florida.

Sue Walsh (Swimming): In any list of the all-time leading swimmers in the University of North Carolina's prominent program, Walsh ranks at or near the top. A 10-time NCAA individual champion at Carolina, she qualified for the 1980 Moscow Olympics in the 200-meter backstroke but did not compete in the Games because of a U.S. boycott. A CPA who serves as Director of Legacy Programs in UNC's Rams Club athletic fund-raising organization, she has continued to excel as a Masters-level swimmer. She holds records in seven individual events and three relays in U.S. Masters Swimming's 45–49 age group.

Tim Wilkison (Tennis): North Carolina tennis aficionados recognized that Wilkison was a special player in 1975, when the lefthander from Shelby won the first of back-

to-back state closed men's singles championships at age 15. He skipped college tennis and turned pro two years later. He joined the Association of Tennis Professionals in 1959 and competed on the international tour for the next 14 years. Along the way, Wilkison defeated most of the elite players in the '70s, '80s and '90s, including Arthur Ashe, Stan Smith, Guillermo Vilas, Yannick Noah, John McEnroe, Boris Becker, Jim Courier, Andre Agassi and Pete Sampras. He earned the nickname "Dr. Dirt" because of his trademark diving volleys and his preference for clay surfaces.

In all, Wilkison won six singles and nine doubles titles and was ranked as high as No. 23 in the world. He reached the quarterfinals of the U.S. Open in 1986 and earned over $1 million in prize money before opening the Tim Wilkison Tennis Academy in Charlotte.

National Champions

By Bill Hass

Bill Hass covered sports for the *Greensboro News & Record* from January 1969 until his retirement in March 2006. Like most sports writers, his range was wide—professional sports, the ACC, smaller colleges, high schools and youth leagues, running the gamut from any sport with a ball to those without (swimming and track). Besides the games themselves, he wrote about the personalities and issues in the sports world. His athletic experience was limited to thousands of pickup games, but his interest in sports spawned from following the then-hapless Washington Senators and Washington Redskins and reading the sports writers of the Washington newspapers, particularly Shirley Povich of the *Post*. After retiring, he wrote features for *theACC.com* for eight years and continues to write a blog for the Greensboro Grasshoppers of the South Atlantic League.

To the Top of the Mountain

You find them from Boone to Fayetteville, Asheville to Greenville, Hickory to Wilson, Boiling Springs to Buies Creek and numerous places in between. We're talking about collegiate national championships won by four-year schools in North Carolina. Research reveals a surprising total of 178 of them won by 25 different schools over a span of 58 years, stretching from March of 1955 through December of 2013.

This total consists of titles determined in competition and not by polls. They have been won by men's teams and women's teams, mostly under the banner of the National Collegiate Athletic Association and its three divisions, but also under several other college groups. Only varsity sports are counted; club sports and intramural sports are not, even though many conduct national championships through various organizations, and North Carolina teams have won their share of those.

Today, playing for national titles is ingrained in athletes, coaches and fans, but it wasn't always in the forefront of everyone's consciousness. Most NCAA championships didn't begin until the late 1930s and state schools didn't start winning until the 1950s. Advancement to a championship game was rare.

The state's first appearance in a title game came in 1946, when North Carolina's basketball team, with stars Bones McKinney and Hook Dillon, met Oklahoma A&M (now Oklahoma State) for the NCAA championship in Madison Square Garden. Led by seven-footer Bob Kurland, the Aggies of coach Hank Iba beat Ben Carnevale's "White Phantoms" of the Southern Conference, 43–40, to claim their second straight title. In 1949, Wake Forest's baseball team made it to the NCAA championship game in Wichita, Kansas. Four teams participated in a double-elimination format. The Deacons beat Southern California, lost to Texas, defeated USC in the loser's bracket, and then fell to the Longhorns in the championship game 10–3.

And that was all, until Wake's baseball team got a second crack at it in 1955 and became North Carolina's first national champion in any sport. The Deacons began an impressive list filled with drama and dynasties, heroes and clutch performers. It includes elite athletes like Michael Jordan, David Thompson, Lanny Wadkins and Mia Hamm, as well as lesser-known stars like Anthony Atkinson, Jack McGinley and Bershawn Jackson.

National championships have produced iconic images: UNC's 5-foot-11 Tommy Kearns jumping center against Wilt Chamberlain, Thompson soaring above UCLA's Bill Walton, N.C. State's Jim Valvano racing around a court looking for someone to hug, and Atkinson running around another court with his hands clutched to his head.

No matter if your school has won a single national title or has been a champion multiple times, there's nothing to match the feeling it brings. For that particular year, on that particular level of competition, your team was the best in the country. It's something you should never take for granted.

"It was like making it to the top of the mountain," said Sammy Chapman, an assistant coach at St. Augustine's, whose school has won 33 NCAA Division II indoor and outdoor championships in track and field.

The women's soccer team at UNC has never become jaded about its 22 national titles. "They all felt pretty darn good," said Kristine Lilly, who was part of four of them. "Your goal is always to be the national champions, but it was never easy."

There has been only one championship at Barton College, but it was unforgettable. The Bulldogs won the 2007 Division II men's basketball title by overcoming a seven-point deficit in the final 39 seconds. Atkinson scored his team's final 10 points and here's what he said ran through his mind: "Oh my God! Oh my God! You've answered all my prayers—for the city, for the college, for myself, on the last day of my college career."

For most college athletes, a national championship is the pinnacle of their careers. Although some go on to bigger stages and bigger championships as professionals and international players, there's something about the college experience that can't be replaced. At least that's the way it was for Billy Barnes, who was there at the beginning when the 1955 Wake Forest baseball team won the state's first national title. Although he later was a member of a team that won a championship in the National Football League, Barnes never forgot what it felt like nearly 60 years before.

A Strong Right Arm and Iron Nerve: In 1960, Billy Barnes was a halfback for the Philadelphia Eagles, who beat the Green Bay Packers 17–13 to win the NFL championship. Barnes—he doesn't have a preference if you call him Billy or Bill or even Billy Ray—was approached after the game by an interviewer who suggested the NFL title must be the greatest thrill of his athletic career.

"It's not even close," Barnes remembers answering. "I told the guy that winning the NCAA baseball championship in 1955 was the best thing that ever happened to me."

Fifty-eight years later, it remains that way.

The 1955 Wake Forest baseball team gave North Carolina its first-ever national championship. More than 170 team titles have followed.

That championship was a last college hurrah for the small town of Wake Forest, located just north of Raleigh. A year later the school moved to Winston-Salem, leaving only its seminary behind. In 1955 Wake Forest College consisted of about 1,200 students, "counting the seminary and law school," according to Barnes. But it had assembled a 19-member baseball team with numerous talented players.

Catcher Linwood Holt hit .352 and made All-America. Pitcher Lowell "Lefty" Davis won 10 games, a school record that was tied twice but not broken until 1998. Frank McRae, who Barnes said "hit the ball as hard as anybody," drove in 34 runs. Luther McKeel scored 37 runs and Tommy Cole hit seven home runs. Those totals may seem modest today, but teams played far fewer games then. Wake took a 19–5 overall record into the NCAA playoffs and finished 29–7.

"We hustled 100 percent at all times," Barnes said, "on every play and every pitch, whether we were on the field or in the dugout."

Coaching the team was Taylor Sanford, who provided a consistent, low-key, let-them-play style. "I commend him for his approach," said Jack McGinley, a pitcher who would emerge as Wake's hero in the playoffs. "He guided us as opposed to dictating. We knew what we had to do."

That season was only the second for baseball in the newly formed ACC and there was no conference tournament. The Deacons finished first in the standings with an 11–3 record, but they were assured of nothing else. The NCAA playoffs were by invitation only then, and Wake had been impressive enough to receive one. Assigned to District 3, the Deacons began their journey by going on the road to take two of three games from West Virginia. From there they rode a train to Florida to play a tough opponent in Rollins. "Nobody knew us down there," Barnes said. "They were cocky, but we whipped them pretty good."

The scores were 4–0 and 6–2, earning Wake Forest one of the eight spots in the College World Series in Omaha, Nebraska. It was a new world for the Deacons. McGinley recalls teammate Harold Moore, the shortstop, exclaiming, "we're going to Omaha!" To which outfielder Tommy Cole replied, "where the heck is Omaha?"

To get there, the team had to fly. Although the Deacons were a confident bunch, this gave them some trepidation. It was the first airplane ride for almost everyone. "We weren't afraid of nothing," Barnes said. "But I wasn't sure I wanted to get on that plane."

The plane arrived safely, but without a key player. Lefty Davis, who was also a star basketball player, had let his grades slip and was required to go to summer school to retain his hoops eligibility. He stayed behind while his baseball teammates carried on.

"We had no pressure on us whatsoever," outfielder George Miller told the *Asheboro Courier-Tribune* in 2013. "No one knew Wake Forest from anyone."

Without his ace, Sanford turned to McGinley, a sophomore right-hander from southern New Jersey. He was drawn to Wake Forest, in part, by the region's warm weather. Using a fastball, curve and changeup, he had gone 3–2 during the regular season, and then posted wins over West Virginia and Rollins in the playoffs. McGinley started the Deacons' opening game in Omaha, against Colgate. It turned into a classic pitchers' duel, a four-hitter by McGinley and two-hitter by Colgate's Lawrence Bossidy. But the Deacons squeezed out a run for a 1–0 win. An odd aspect to the game was a delay of

78 minutes because of a hailstorm. The weather turned cold, which worked well for the pitcher from New Jersey.

"I just put on a jacket (during the delay) and went from there," McGinley said. "It was funny to see hail on the field. I think the baseball gods were liking a cold-weather pitcher."

Wake's second game was scheduled for Saturday against Colorado State College (now the University of Northern Colorado). Since there were no summer school classes on the weekend, Wake's administrators allowed Davis fly to Omaha to pitch the second game. Rain delayed the game a day and on Sunday Davis pitched a shutout as the Deacons won 10–0 in his only College World Series appearance. He flew home, unaware of a controversy.

Being a devout Baptist school, Wake Forest traditionally did not play athletic events on Sundays. After the game, school president Dr. Harold Tribble was quoted that if he had known the game was going to be on Sunday, he wouldn't have let his team play. It probably wouldn't have mattered. "At the time, we had no idea we weren't supposed to play," Barnes said. "We might have played anyway."

In the third round, the Deacons absorbed a 9–0 thumping by Western Michigan, but still advanced to the semifinals. The teams played again and Wake pulled out a 10–7 victory, with McGinley starting and winning. It was Western's first loss, but the Broncos still advanced to the championship game because they were the last team in the tournament to lose.

Wake had to win once more and John Stokoe pitched a gem in a 2–0 win over Oklahoma A&M (now Oklahoma State), the third shutout of the tournament by the Deacons' staff. So Wake faced Western Michigan yet again, this time with the championship at stake. With the pitching staff strained, Sanford turned to Bill Walsh as the starter. Wake jumped to a 3–0 lead but Western rallied and knocked out Walsh, with Buck Fichter relieving. In the fourth inning, with Fichter in trouble and his team down 4–3, Sanford called on McGinley, who had pitched just two days before and was used to three days of rest.

"Are you sure?" McGinley responded when told to warm up. He threw only six or seven pitches before the bullpen phone rang and he was summoned to the mound with his arm stiff and sore. Sanford asked Tommy Cole, sitting out the game with an injury, how McGinley looked warming up.

"I don't know," Cole replied. "He hasn't gotten one over the plate yet."

It was a messy situation, with the bases loaded and two outs. McGinley coaxed the first hitter he faced into a ground ball, but it got past shortstop Harold Moore for an error. Two runs scored to make it 6–3. McGinley prevented further damage by striking out the next batter. The Deacons pecked their way back into the game, tying it 6–6. In the bottom of the eighth inning, center fielder Luther McKeel walked and moved to third base on two passed balls. The next two hitters struck out, but Holt singled up the middle to score McKeel.

By this point, McGinley was pitching purely on grit. "I had to forget my arm was killing me," he said. "The trainer was rubbing something called 'Atomic Balm,' a hot substance, on my elbow. I was thinking 'I've got to hold them here because this is a chance we can't pass up.'"

McGinley remembers retiring the side in order in the top of the ninth to preserve the 7–6 win. The last ball was a grounder hit sharply to third baseman Barnes, who moved to his left and stabbed it. "I think my teammates thought I was going to run the ball to first base," Barnes said with a laugh. "But I threw him out."

Among those who waited anxiously was McGinley. "The ball got there quick," he said, "and (Barnes) popped his glove a couple of times. I was thinking, 'go on and throw it!'"

After that, McGinley recalls tossing his glove in the air and disappearing under a pile of teammates. He had pitched 5⅓ innings of relief in the championship game, winning his third game of the Series and fifth of the playoffs. After the error, he allowed no runs and three hits with four strikeouts. Frank McRae had five hits in the game and McKeel scored three runs.

Here's the game lead by Robert Phipps, covering for the *Omaha World-Herald*: "Jack McGinley's strong right arm and iron nerve carried Wake Forest to the championship of the College World Series Thursday night before 2,042 (fans)."

The Deacons flew home and were treated to a banquet and parade. It never registered on anyone that this was the first national championship for any team in any sport in North Carolina. "I don't think we realized what we had done until some years later," McGinley said.

In 2000, the team was presented championship rings by the school for its accomplishment, which still represents a special place in ACC lore. Although the league has become one of the country's strongest in baseball, that 1955 title remains the only one it has won.

Fueling the Passion: There's little doubt that the team sport which stirs the most passion in North Carolinians is men's basketball. Fans have been rewarded for their fervor by seeing the state's teams win 11 Division I titles.

UNC Chapel Hill has won five crowns, Duke four and North Carolina State two. Curiously, the most celebrated coaches struggled the hardest before winning their first. Dean Smith's UNC teams made six Final Four appearances before breaking through, Mike Krzyzewski won his first for Duke on his fifth try and Roy Williams made four visits, all at Kansas, before winning his first of two titles for the Tar Heels. Meanwhile, N.C. State's championship coaches both went one-for-one—Norman Sloan in 1974 and Jim Valvano nine years later. Neither reached the Final Four in any other season.

It's best to start this championship tale at the beginning. The flamboyant Frank McGuire had been hired by UNC to compete with the teams of Everett Case at N.C. State and he emerged fully from Case's shadow in 1957. With his lineup of New Yorkers—Lennie Rosenbluth, Tommy Kearns, Joe Quigg, Pete Brennan and Bob Cunningham—McGuire's team completed the regular season unbeaten.

"The more you saw of McGuire's team that season, the more you caught the feeling it was a team of destiny," sportscaster Add Penfield said in Barry Jacobs' book *Golden Glory*. "It was a team to capture the imagination, the product of the coaching genius that was McGuire."

It was an era when only the ACC Tournament champion played in the NCAA event. The Heels survived a scare by Wake Forest in the semifinals when a controversial blocking call that could have been a charge went their way. After the 61–59 win, they throttled South Carolina for the ACC title.

With the games televised over a five-station network by an enterprising C.D. Chesley, fans were glued to black and white TVs or listening on their radios to the mesmerizing games from Kansas City. UNC beat Michigan State in three overtimes on Friday, then came back Saturday to top Kansas, and the supposedly unstoppable Wilt Chamberlain, in three more overtimes.

Rosenbluth, a prolific scorer described by writer Dan Collins as "a rail-thin forward with a velvet touch and no semblance of a conscience," fouled out in regulation. But the Tar Heels held on and Quigg's free throw gave them a 54–53 lead with six seconds left. As Kansas tried to pass the ball into the 7–1 Chamberlain, Quigg deflected it and Kearns grabbed it and flung it toward the rafters as the horn sounded.

That completed a 32–0 season that is still the stuff of legend, an appropriate signature for the first national hoops title in the state. But if people thought that would become a way of life, they were wrong. Seventeen years passed before another.

Basketball in the state owed an undeniable debt to Case, but the one thing he never delivered for N.C. State was a national title. That honor first went to the sometimes-volatile Norman Sloan in 1974. Sloan very well might have had two titles to his credit. In 1973, with the Pack on probation for a minor recruiting violation of David Thompson, State went 27–0 but had to watch as UCLA won its seventh straight title.

A year later, the Pack was loaded and ready for Bruin. With center Tommy Burleson anchoring the middle, point guard Monte Towe orchestrating the offense and the incomparable Thompson jumping, slashing and alley-ooping his way through defenses, the Pack was again formidable. It stumbled once, whipped by UCLA in a December meeting in St. Louis.

"My responsibility on that team, to be honest with you, was not to screw it up," Sloan told author Tim Peeler in *Legends of N.C. State Basketball.*

So how good was Thompson? He led the ACC in scoring all three years and was player of the year each season. Here's the assessment of author Barry Jacobs: "Statistics inadequately define Thompson's contributions. His was a constant presence. At 6–4 he had fine perimeter skills and the ability to score on jump shots or drives. He was a good passer, defender, rebounder and shot blocker. He had exceptional hands. His will to win was fierce. More than anything, though, Thompson's game was revolutionary."

To get to the NCAA, the Pack had to win the ACC, no easy task. The championship game against Maryland has been described by some as "the greatest game ever" and it certainly ranks among the all-time best. Sloan saved a copy of a quote from Maryland center Len Elmore earlier in the season when Elmore suggested writers tell Burleson "that I am THE center in the ACC."

Not that night. Burleson shot 18-for-25 and scored 38 points as the Pack edged the Terps 103–100 in overtime. Next came the East Regional in Reynolds Coliseum on the State campus. In the championship game against Pittsburgh, Thompson's prodigious leaping ability almost ended in tragedy. Trying to block a Pitt shot, Thompson's leg

caught the shoulder of 6–8 teammate Phil Spence. Thompson fell hard on his head and lay unconscious for four minutes before being carried off on a stretcher. Some time later, his head swathed in a bandage to cover 15 stitches, Thompson returned to the arena to a thunderous ovation. The Pack went on to a 100–72 win.

To capture the national championship, State only had to travel 80 miles down the road to Greensboro, where it had won the ACC tournament. The Pack relished a second chance against UCLA and, in an epic battle, won 80–77 in two overtimes. It rallied from 11 points down in the second half and from 74–67 behind with 3:27 remaining in the second overtime. Towe hit the clinching free throws with 12 seconds left. Thompson scored 28 and Burleson played UCLA's Bill Walton to a virtual standoff.

The Bruins' reign was over but N.C. State's journey was not because that was a semifinal game. In the championship, State prevailed 76–64 over Marquette behind Thompson's 21 points. The Pack led by as many as 19 in the second half, an anticlimax if there ever was one.

The cover of *Sports Illustrated* the next week shows Thompson soaring over Walton for a shot close to the basket. In his story, Curry Kirkpatrick, the magazine's basketball writer, credited

> "gangling Tom Burleson, who held UCLA'S Bill Walton to a draw … [and] that gnat of a guard, Monte Towe, with his adept ball control and sharp passes. But above all there was David Thompson, literally, constantly, above all, 6'4" in the N.C. State guidebook but 8'4" off the backboards. When everything else is forgotten, Thompson will still be up there, magically floating in to take a pass, and dropping it through for two. One of these days someone ought to tell him that it is all over. The UCLA whammy is dead. The Marquette defense has been broken. The NCAA championship is his, and Towe's, and Burleson's and the others'. And that on the way down, please, he should not fall on his head."

The wait for a third title wouldn't take as long. In 1982, Dean Smith secured his first one when UNC beat Georgetown, 63–62. It was a star-studded team, with future NBA standouts James Worthy, Sam Perkins and a precocious freshman named Michael Jordan. Jordan was so competitive that he couldn't stand to lose a game of Monopoly to his roommate, Buzz Peterson. Yet that will to win worked in his favor on the court. With 17 seconds remaining against the Patrick Ewing-led Hoyas, Jordan's unflinching jump shot from the left side put Carolina ahead by one.

The game had a strange finish when Georgetown's Fred Brown inexplicably passed the ball to Worthy with a few seconds left. Later, Smith said he was out-coached by his good friend John Thompson and "the lucky team won." There was nothing lucky about Jordan's shot, though, or the way Worthy played—he hit 13 of 17 shots to score 28 points.

That began a roll when teams from the state won five championships in a span of 12 years. Up next, in 1983, was an unforgettable, improbable title won again by N.C. State, but with a much different cast than 1974. The coach was Jim Valvano whose ability to be fast with a quote and a quip sometimes masked his coaching

savvy. He masterfully guided this team, which finished the season with 10 losses, to a victory over Houston in Albuquerque. The Pack had no superstars but plenty of good players led by a trio of seniors — guards Sidney Lowe and Dereck Whittenburg and forward Thurl Bailey. But on January 12, Whittenburg broke his foot and the dynamic changed.

"By losing Whittenburg, the Wolfpack was without its soul," Peeler wrote. "Lowe, the heady point guard, was always the team's brain, an extension of Valvano's coaching tactics on the floor. Bailey, the late-blooming forward, was the team's heart, an emotional leader for whom tears flowed freely."

State lost five of its next seven and its record sagged to 9–7. But younger players like Lorenzo Charles, Cozell McQueen, Terry Gannon, Ernie Myers and Harold Thompson got more playing time and became crucial role players. On February 19, State beat UNC 70–63 in Reynolds and the dynamic changed again.

Whittenburg returned after missing 14 games (State went 9–5). Because the Pack had 10 losses, it knew it had to win the ACC tournament to make the NCAA field — just like the 1974 team did. It edged Wake by a point, beat UNC in overtime and took out Virginia in the championship. The closeness of the games led to the team being labeled "The Cardiac Pack."

Before State's first-round game against Pepperdine, Valvano mused that he wouldn't be surprised if his team was flat and got beat, but "if we do somehow or other win this game, watch out. I think we'll win it all." State survived Pepperdine in two overtimes, and then went on to beat UNLV, Utah, Virginia and Georgia to get a crack at Houston, a.k.a. Phi Slama Jama. On paper, the Pack was no match for Clyde Drexler, Akeem Olajuwon and their teammates.

But things came down to the last seconds, which was State's strength. With the game tied at 52, Whittenburg launched a long jumper that fell short. Charles, who admitted he was out of position by being directly under the basket, grabbed it and dunked at the buzzer to complete one of the greatest NCAA upsets ever.

"There wasn't a whole lot of thought involved," Charles said. "I just went up, got my hands on the ball and put it in. I knew there wasn't much time left." An indelible image came next as Valvano raced around the court, looking for someone to hug.

There was an eight-year gap until the next title. Duke had developed into a top-flight program under Krzyzewski but fell short until 1991. It had been to three straight Final Fours and was finally ready to break through with a cast that included Christian Laettner, Bobby Hurley and Grant Hill.

The year before, Nevada-Las Vegas had dismantled the Blue Devils 103–73 for the championship. This time, they met again in the semifinals. The unbeaten Rebels had played very few tight games all year, so Krzyzewski wanted to keep the game close because they weren't used to it.

Late in the game, with Duke down by three, Hurley hit a big shot to tie it at 74. Author Bill Brill wrote that "Hurley confidently drained a three-pointer, what was then, and remains, the biggest basket in school history." With things tied at 77, Laettner was fouled with 12.7 seconds left. UNLV called time and Krzyzewski told his team that, after Laettner made the free throws, not to let Anderson Hunt get the ball.

Laettner did his part and the defense did the rest. With Hunt covered, Larry Johnson, the national player of the year, passed up a 3-pointer and finally threw the ball to Hunt, whose desperation shot wasn't close. Similar to N.C. State's win over UCLA in 1974, though, that was only a semifinal game. When Hurley celebrated, Krzyzewski admonished him. Hurley changed his chant to "one more game, one more game."

Duke faced Kansas in the finals. The Jayhawks had spoiled an all-Tobacco Road championship by disposing of North Carolina in the other semifinal, a game in which Dean Smith was ejected. In Sunday's practice, Krzyzewski told his team: "I don't like the way you're walking, the way you're talking, or the way you're dressing. You guys are acting like you're big-time, and, right now, you haven't done anything big-time yet."

That got the team's attention. The Blue Devils never trailed and, behind Laettner's 18 points, went on to win 72–65 for the school's first title. The second one followed quickly with Laettner, Hurley and Hill returning in 1992. Although Hurley missed five games with a broken foot, the Blue Devils reached their fifth straight Final Four.

To get there, they had to survive a scintillating game against Kentucky in a regional final. One can make a strong case for it, or for the N.C. State–Maryland game in the 1974 ACC tournament, as the best ever in college. Kentucky took a 101–100 lead on Jamal Mashburn's layup and free throw in overtime. Laettner's two free throws with 7.8 seconds left pushed Duke up by one, but Sean Woods' driving bank shot gave the lead back to the Wildcats.

Krzyzewski called time out with 2.1 seconds left and told his players, "we're going to win this game, and here's how we're going to do it." In an earlier game against Wake Forest, Hill had thrown long to Laettner but the play failed. This time, Hill had a clear view of the floor because Kentucky coach Rick Pitino chose not to put a defender on him. Hill delivered a pinpoint 70-foot pass to Laettner at the Kentucky foul line. Laettner was double-teamed but the defenders backed off to be sure they didn't foul him. He took one dribble to his left, spun to his right and swished a jumper, the last of his 31 points in the 104–103 win. That put the Blue Devils back in the Final Four, where they dispatched Indiana and Krzyzewski's mentor, Bob Knight, 81–78. Then they wiped out Michigan's all-freshman "Fab Five" 71–51 for the first back-to-back titles by anyone since UCLA's streak.

The "Fab Five" got even better in 1993 and advanced to the championship in New Orleans. Waiting there was North Carolina, back at the site where it had beaten Georgetown 11 years earlier. The Tar Heels had earned their way by beating Cincinnati in overtime in the East Regional and then Roy Williams-led Kansas in the semifinals. Against Michigan, Donald Williams hit a three to pull UNC within a point and the Tar Heels took a 73–71 lead with 20 seconds left. Michigan's Chris Webber, closely guarded by George Lynch, was pinned on the sideline and signaled for a time out. But the Wolverines didn't have any left, which resulted in a technical foul and possession for UNC. Williams hit the technical foul shots, and then added two more when he was fouled to close out a 77–71 win. He finished with 25 points and was named the Most Outstanding Player. "I've often said you have to be lucky and good," Smith said, eerily reminiscent of his comment after the Georgetown game in 1982.

Fans of Duke and North Carolina can, and do, argue forever about which program is better. The schools split the state's next four NCAA championships, the Blue Devils winning in 2001 and 2010 and the Tar Heels, under Roy Williams, winning in 2005 and 2009.

In 2001, Duke overcame the loss of post player Carlos Boozer (broken foot) for much of the season. Krzyzewski shuffled his lineup and the team kept winning. In the Final Four semifinals in Minneapolis, the Blue Devils faced Maryland for the fourth time in the season. The Terps jumped to a 39–17 lead that Duke whittled to 11 by halftime. Sparked by Boozer scoring 19 points off the bench, Duke pulled away to win 95–84. Against Arizona in the final, Duke prevailed 92–72 behind 21 points from Mike Dunleavy and 18 points and 11 rebounds by Shane Battier.

The Tar Heels bagged the 2005 title in St. Louis, surviving a regional scare from Villanova 67–66 on a late free throw by Rashad McCants. They whipped Michigan State in the semis, 87–71, with a 54-point second half. They jumped on Illinois in the final and led by 15 in the second half, but the Illini rallied to tie the game at 70. Finally, a tip-in by Marvin Williams and three free throws by Raymond Felton clinched it. Sean May, the Most Outstanding Player, scored 26 points.

In 2009, the Tar Heels cruised into the Final Four, winning their regional games by 43, 14, 21 and 12 points. In Detroit they edged Villanova 73–69 to earn a shot at Michigan State. This one was settled early, with the Tar Heels leading by 21 at halftime and never letting the Spartans closer than 13 in the second half of an 89–72 win. Wayne Ellington was the Most Outstanding Player.

Duke went on a similar run in 2010, with seven points its closest game until the championship in Indianapolis against Butler. When Duke's Brian Zoubek rebounded a missed Butler shot and drew a foul, he went to the line with 3.6 seconds left. He hit the first free throw for 61–59 and, since Butler had no time outs left, he intentionally missed the second.

The strategy nearly backfired. Butler's best player, Gordon Hayward, got the rebound. Duke's defense pushed him to the right sideline, where he launched a shot about half a step over mid-court. Hayward's shot was right on line, hitting the backboard, then the front of the rim, and bouncing away. "Well, I've been fortunate enough to be in eight national championship games, and this was a classic," Krzyzewski said after the game. "This was the toughest and the best one. It's still hard for me. It hasn't sunk in that we're national champs. I love these guys."

Krzyzewski moved out of a tie with Knight and into a tie with Adolph Rupp with four national titles, second only to John Wooden's 10. Kyle Singler scored 19 points and grabbed eight rebounds and was named Most Outstanding Player. Jon Scheyer scored 15 and Nolan Smith added 13 in earning a national championship ring to match one won by his late father, Derek, won with Louisville in 1980.

"A Peace Flowed Over Me": Originally, Anthony Atkinson's goal was "to get some more noise" for the eastern North Carolina town of Wilson and the small college of Barton located there. He may have had dreams about leading the Bulldogs to the NCAA Division II national championship, but it's unlikely he would have imagined the way it unfolded and the role he played in it.

Nor would anyone else.

The national championship game held on March 24, 2007, was played in Springfield, Massachusetts, home of the Naismith Memorial Basketball Hall of Fame. What a perfect site for one of the most scintillating finishes of any basketball game ever played on any level.

The story is well known to some basketball fans, a vague recollection to others. The bottom line is that the game seemed all but over when Barton trailed Winona State by seven points with 45 seconds to go. But Atkinson fueled a furious comeback, scoring 10 points in the time remaining, including a layup at the buzzer to give the Bulldogs a 77–75 victory. Those details are merely the appetizer for the story. Understanding the surrounding circumstances leads to enjoyment of a seven-course meal.

There are people in North Carolina who have no idea where or what Barton College is. They may remember a school called Atlantic Christian College, founded in 1902 and affiliated with the Disciples of Christ. In 1990, the school changed its name to honor Barton Warren Stone, a founder of the Disciples of Christ who was active in eastern North Carolina. In 2007, its enrollment was about 900 students. The men's basketball team, under coach Ron Lievense (LEE-ven-see), had developed into one of the best in the country in Division II. In the 2006 playoffs, the Bulldogs almost beat powerful Winona, but missed a free throw that would have won the game in regulation and lost in overtime. Winona, located in the town of the same name in Minnesota, went on to win the national title.

"We had a sour taste because the year before we had them (and lost)," Atkinson said. "All we could think about was getting back there."

Atkinson did not start his career at the school in his home town. He played for two years at Campbell, a Division I school, but decided he needed a change of scenery. He knew Lievense and many of the players well. Lievense liked the quickness, personality and swagger of the 5-9½ guard. After talking things over with his dad, Atkinson decided to change schools and was able to play immediately at Barton, with two years of eligibility, because he was transferring down a division. Atkinson said:

> "I liked the way (Lievense) coached; he was a winner. I knew what it took to win. I wanted to lead, I wanted the ball in my hands. They needed a true point guard. I wanted to get some more noise around Wilson. My biggest asset is making everyone around me better with assists, steals and rebounds. I like to put my trust in the other guys, instill confidence in them. I've been a leader, a winner, through my whole career."

As a junior, Atkinson's leadership helped the Bulldogs to a 28–4 record, a season that ended bitterly with the 86–78 loss to Winona in the quarterfinals of the tournament. That set the stage for what came next. Getting there wasn't easy, however. One of Barton's best players, 6-foot-7 Alejo Barovero, was lost early in the season with a broken finger. But the Bulldogs pushed on, displaying an uncanny knack for taking games into overtime—and winning. They did it nine times and won them all, an NCAA record.

"It was kind of crazy," Atkinson said. "We would go to overtime and everybody said, 'OK, now we're going to win.' Coach would get mad and tell us 'finish the game off.' It shows how mentally tough we were."

After qualifying for the Division II playoffs, Barton advanced to the Elite Eight in Springfield. The Bulldogs didn't impress anyone physically with their lineup of three guards, a small forward and a 6-foot-6 post player. "It was David vs. Goliath," Lievense said. "We were a school of 900 students. People were asking, 'what's this team doing here?'"

In the quarterfinals, Barton faced Grand Valley State, a school of more than 20,000 students located in Michigan. The Bulldogs went to overtime—for the ninth and final time of the season—and Atkinson hit a 3-pointer at the buzzer for an 83–81 win. That moved them to the semifinals against Cal State-San Bernardino, another school of more than 20,000. Barton played the dragon-slayer again, hitting some key free throws at the end to win 80–79.

Finally, the Bulldogs had their rematch with Winona, a school of 8,000. The Warriors were a juggernaut, riding a 57-game winning streak going into the championship game, although they had to survive a scare in the semifinals with an overtime win. They had size and talent, including transfers from Wisconsin and Drake. "When I saw them in warmups, I thought Barton had no chance," said Dan Bonner, who was the TV analyst for the game.

The teams played 39 minutes and 15 seconds of basketball that very few remember. When Zach Malvik swished a pair of free throws with 45 seconds left, it pushed Winona's lead to 74–67. During a time out, Lievense recalls, the security guards left Barton's bench as NCAA workers began carting the trophy and other winner's paraphernalia to Winona's area. Atkinson remembers the Barton fans hanging their heads as they awaited the inevitable outcome. Bonner and Ian Eagle, the television announcers, made arrangements with their producer on how to get off the air after the game.

But Atkinson stayed positive in the huddle and his teammates believed him. Here's the breakdown of the remainder of the game (you can find this on YouTube and it's definitely worth a look):

- 39 seconds left: Atkinson makes a spin move down the lane, with a defender letting him go by, to slice the lead to 74–69.
- 33.5 seconds left: Barton fouls in a one-and-one situation and Winona misses. Brian Leggett rebounds and throws the ball to Atkinson.
- 24 seconds left: Atkinson hits a pull-up jumper and it's 74–71.
- 22 seconds left: Barton's Errol Frails steals Winona's inbounds pass and feeds it to Atkinson under the basket. Atkinson gets bumped hard but converts the layup and draws the foul. He's a superb free throw shooter but this one hits the front of the rim, keeping the score at 74–73.
- 19 seconds left: Winona rebounds Atkinson's missed free throw and Barton fouls. Atkinson looks distraught as he thinks about his missed free throw. Winona's Jonte Flowers goes to the line in a double bonus and misses the first shot but hits the second to make it 75–73.
- 7 seconds left: Atkinson brings the ball up, drives from the left side and, when a Winona big man steps out, converts a reverse layup that kisses off the glass from the right side. Amazingly, the game is tied, 75–75.

- 4 seconds left: Barton presses and just as Winona advances the ball over halfcourt, Bobby Buffaloe steals it cleanly from behind Malvik, tipping it to Atkinson at midcourt. Atkinson glances at the clock and takes off, under complete control.
- 0 seconds left: Instead of pulling up for a jumper, Atkinson drives down the right side of the lane to the basket for a layup that drops through, one tick before the buzzer sounds. Shockingly, Barton has just won the game, 77–75.

Atkinson, who had just scored 10 points in 39 seconds (and 29 points for the game), races down the side of the court, hands clasped to the sides of his head. The Winona players wander in stunned disbelief. Officials review the play and confirm the shot was good.

On TV, Eagle sums up the incredible scene: "You could not have written a script that would match the drama here!"

The thing that strikes observers is the poise Atkinson displayed when he got the ball at mid-court. "Most people would have taken a couple of dribbles and launched a jumper," Bonner said. "He looked at the clock, gauged how much time was left and saw he had enough to go for the layup."

In a split second after the steal, Lievense decided to let play continue. "A coach will think two things," he said. "One, call time out with 3.5 seconds left. Or, two, trust the player to make the right decision. I saw him look at the clock and a peace flowed over me because I believed he would do the right thing. And he did."

For Atkinson, it was his moment on the big stage, a chance to leave a lasting impression of his career. In the semifinals, he had made a similar shot by driving half-court in the same amount of time, so he never panicked. He knew the worst that could happen would be overtime, a favorable circumstance for the Bulldogs. "A good point guard knows time and possession," he said. "I didn't want to shoot the three, so my first instinct was to go to the basket. I thought I missed it, that it had bounced out. I didn't actually see it go through the net."

There were mini-dramas in the other elements of the game. For instance, Lievense said Atkinson told him the layup he made driving from the left side to the right "was the hardest shot he ever made." On the steal of the inbounds pass, Atkinson said the Winona player didn't make a good effort to reach for the ball, an indication their players thought the game was over. After Atkinson missed the free throw, teammate Brian Leggett came up to him and told him not to worry, that he would get another chance. Finally, Buffaloe's steal came on something called the back-tip drill, which Lievense said the players hated to practice. Atkinson confirmed that.

"It's helpful if you're pressing," he said, "but it takes the most out of you and sometimes you don't get the ball."

The finish of the game left an indelible impression on everyone who was there. "If that comeback had been in Division I, there would be no debate that it was the greatest of all time," Bonner said. "It wasn't only the championship game. Barton had some unbelievable comebacks in their first two games, teams they had no business beating. It was as magical a run as anything I've ever seen."

Bonner and Eagle still talk about the game when they get together. "It was like the perfect storm of endings," Eagle said. "It's still hard to believe. I've done about 1,800 games in my career on TV and radio and I've never experienced anything like that, prior to or since. Looking back, that team had taken a magic carpet ride in the quarterfinals and semis. They walked a tightrope."

Lievense, in early 2014 still the coach at Barton, likened the game to the movie *Hoosiers*, with its underdog theme. "We've had some incredible victories and tremendous players," he said. "But I don't think anything could ever match what I was blessed to sit and watch."

Atkinson once had a dream of playing in the NBA, but after school he agreed to play with the Harlem Globetrotters. He remains one of their most popular players and set their all-time scoring record for a game when he tossed in 91 points in a game in England. He has done remarkably well for a young man who just wanted to make some noise for his town and his school.

"That game is the story of my life," he said. "I use it in public speaking all the time. We're a small school in a small city that overcame the odds. It was a pivotal point in my career."

Dynasty I: Soccer in the Blood: To understand Anson Dorrance, you must realize what soccer means to him.

"I'm a big fan of the sport, passionate about it," explained the North Carolina women's soccer coach. That passion obviously manifests in results. His teams have won 22 national championships, including 21 of the 32 tournaments conducted by the NCAA. But there's another way to tell that the fire still burns inside.

In 2013 Dorrance turned 62 but he still plays the game, and not on just an occasional basis. He's a member of a team that competes in age-group national play (in this case, the over-60 division). A friend convinced him to give it a try about 10 years ago. "Of course, the pace of the game is incredibly slow and you can't radically change directions like you used to," Dorrance said. "There's a lot of physical contact, sometimes because you can't get out of someone's way. But I have an absolute blast and it keeps me fit."

Anson Dorrance: 22 National Titles.

In addition, he plays with friends and fellow coaches on Mondays, Wednesdays and Fridays at UNC's indoor facility. Those games can range from four-on-four to nine-on-nine, depending on how many show up. He doesn't let any shortcomings deter his participation. "I'm the oldest guy out there," he said, "and they tolerate my lack of speed and agility. It's great exercise, which keeps my weight down and my energy up. And I think it's important to serve as role models for the players we're training, showing that we can walk our talk."

There never has been any problem with the UNC program "walking the talk." After 35 years as its only women's soccer coach, Dorrance's teams have compiled an overall record of 763–54–29, a winning percentage of .919. They had one unbeaten streak of 103 games (97 wins, 6 ties) and another of 101 games that included 92 straight victories. Several of his teams have gone undefeated, including one in 1997 that recorded 22 shutouts in 28 games.

The Tar Heels have long been the dominant team in the NCAA, particularly in the early years. After winning a championship in the AIAW (Association for Intercollegiate Athletics for Women) in 1981, they won 14 of the first 16 NCAA tournaments, including a run of eight in a row. Competition stiffened, and in the next 16 seasons UNC has been *held* to seven championships. In 2013 it was eliminated in the quarterfinals.

The soccer team has won more women's Division I titles in a single sport than any other school (Stanford tennis is next with 17) and Dorrance has more national championships than any Division I coach in a single sport. Passion for soccer flows through his program, as it has throughout Dorrance's career. He learned the game while living in different countries overseas (his father was an international businessman). He was first drawn to it in Ethiopia and he refined it while attending a boarding school in Switzerland.

"I was a very good player, but not great," he said.

He perhaps is short-changing himself. He played for a year at St. Mary's in Texas, and then transferred to UNC so he could play under coach Marvin Allen. He earned All-ACC honors three years and in 2002 was voted to the list of the top 50 players ever in ACC men's soccer. He became Allen's assistant and proved so adept that Allen named him "coach in waiting." Dorrance assumed the head coaching position in 1977, the first of 12 seasons at the men's helm before he split the programs and divided the budget in 1988.

In 1979, women's soccer was a club sport at Chapel Hill. Athletics director Bill Cobey approached Dorrance about converting it into a varsity sport, promising that the part-time men's job would become a full-time position if he coached both teams. Dorrance agreed. Although he had never coached women, he knew exactly how he wanted to go about it.

"I put just as much energy into coaching women as I did into the men," he said. "I approached it with the same aggressive work ethic that it required to coach an ACC men's team." North Carolina became the first varsity women's soccer team in the south. Dorrance recruited in places like Dallas, Long Island and the area around Washington, D.C., hotbeds where he knew that girls' youth soccer was gaining traction.

"I began to recruit aggressively, which gave us a wonderful jump-start," Dorrance said. "Other schools had a country club attitude toward women's sports, but that wasn't our attitude."

The transition wasn't easy as the former club players found themselves riding the bench, replaced by the new recruits. Dorrance lauded their "pioneer spirit" for being willing to give up their spots in order to make women's soccer a varsity sport.

Early on, the team had success against mostly inferior competition—club teams, high school select teams, military teams and a few varsity opponents. College women's sports were under the auspices of the AIAW, which in 1980 conducted an invitational tournament. Dorrance helped convince the AIAW leaders to hold a true playoff, and in 1981 it took place in Chapel Hill. Twelve teams participated in two venues—the Tar Heels' soccer home of Fetzer Field and the "sacred ground" of Kenan Stadium, where the hedges were trimmed around the football field to accommodate the wider soccer layout.

"Bill Cobey allowed that to happen," Dorrance said of teams playing in Kenan. "It's one of my warmest memories. Twelve teams made it feel more like a festival compared to today's final four. We hired rock bands to perform and help create a wonderful atmosphere."

The Tar Heels capped things by winning their first national title, 1–0 over Central Florida. Diane Beatty scored the winning goal on a header off a corner kick. "Winning that first one was thrilling," Beatty said. "Anson had set that goal at the first practice."

Beatty was part of a freshman nucleus of players from Northern Virginia. On her recruiting visit Dorrance set up a scrimmage against a high school boys team. She recalled:

> "I knew he was serious from the minute I arrived and that this was a big step forward. I went there with the intent of being the best female soccer player ever. I knew some high school rivals and club rivals who were going there and I wanted to be on that team.
>
> "We were all very aggressive women. No one was timid and we were fighters (for each other) all across the field. Some opponents weren't used to that. It took great leadership for Anson to blend us with the club players and older players because there were a lot of strong personalities."

In 1981 UNC's players didn't fully realize what was unfolding. The next year the NCAA absorbed women's sports, including the budding soccer dynasty. The Tar Heels began to realize the possibilities and Beatty's class won the first three of those tournaments, giving them a four-for-four career sweep. After graduation, Beatty put in 10 years of coaching youth soccer, conducting her practices just the way Dorrance organized his. Certain other of his traits have become ingrained.

"He always set the stage with discipline, being on time and being prepared," she said. "Even today I can't stand to be late and I'm usually five to 10 minutes early and overprepared. I don't want to let people down."

Beatty was one of the leaders whose passion helped set the tone in the early years of UNC's program. Later in the 1980s, the banner was carried by April Heinrichs and Shannon Higgins. In the '90s came Kristine Lilly, Mia Hamm, Tisha Venturini, Debbie Keller, Staci Wilson, Cindy Parlow, Robin Confer and Lorrie Fair. Since 2000 there has been Meredith Florance, Lindsay Tarpley, Catherine Reddick, Heather O'Reilly, Yael

Averbuch, Casey Nogueira, Whitney Engen, Crystal Dunn and Amber Brooks. All were national players of the year, some of them multiple times.

In recruiting, Dorrance goes beyond identifying the skill sets necessary to play at an elite level. He also seeks the element of passion, which can be indicated by how comfortable a player is while controlling the ball in close quarters. "That's what everyone looks for," he explained. "We're all trying to find kids who love the ball and love the game. All players are going to say they love those things, but it's hard to spot. You can't give someone a quiz about it."

Hamm and Lilly certainly fit the bill. They came to UNC together in 1989 and are regarded as two of the best women's soccer players the world has ever seen. In 1991, both were named to the American team for the inaugural Women's World Cup. Hamm elected to sit out at UNC that season to prepare. Lilly played through the ACC tournament, and then joined Team USA for the trip to China.

Dorrance was the national coach and nine of the 18 players on the roster had ties to UNC. Assistant Bill Palladino served as UNC's interim coach during Dorrance's absence and guided the Tar Heels to their sixth straight national championship. Six days later, Team USA beat Norway 2–1 to win the World Cup. Although the event had yet to catch widespread attention—Dorrance remembers three people welcoming the team flight home—he realized the long-term implications and repercussions of beating the world at its own game. And having so many Tar Heels on the national team put UNC in an extraordinary recruiting position.

"We had no goals, other than to find the best players," he said. "We played an aggressive system, as per Team USA. We had ambitions to win every game we could and promote and elevate the game any way possible. Our idea was to develop players as far as we could—bring in a player at one level and graduate them at a much higher level."

Even an elite player like Lilly, who first made the national team when she was just 17, benefited from that approach. She was always around outstanding players and had to fight to secure her spot in the lineup. As a freshman, she understood that UNC had already established a legacy. She explained:

> "You were playing for those who had gone before you, so you worked your butt off. I had been playing with the national team, but at UNC you had to work hard and show yourself. It wasn't easy. One thing (Dorrance) did was make us all feel like we were great, that we can do this. He was a great motivator. We had the talent, but he got us to fight for each other. He had the expectation of us being the best and instilled in us that it was OK to be successful."

In Lilly's four seasons at UNC, the Tar Heels lost just one game and tied another. The rest were victories. "Winning never gets old," she said.

Neither does the passion. Lilly's international career has been extraordinary. She was a member of national teams that won World Cups in 1991 and 1999 and finished third three other times. She won Olympic gold medals in 1996 and 2004 and a silver medal in 2000. Altogether, Lilly has competed in a record 352 international matches and scored 130 goals, third all-time. She retired in 2011, at age 39, when training for that level of

play finally got to be too much. Now she runs soccer camps, gives private lessons and keeps promoting the game. "It's in my blood," she said.

Hamm, of course, is the most recognizable name in women's soccer in the world, even 10 years after she retired following the 2004 Olympics. A friend in Texas first recommended that Dorrance come see her when she was 14. Her speed, vision, dribbling and attacking were already evident, and she developed her passing and defensive skills.

"Playing with Mia was fun," Lilly said. "We knew how each other played so well. Sometimes I caught myself just watching her and what she was going to do."

As many other players did, Hamm won four NCAA championships at UNC. She constantly drew double- and triple-teams, yet was always a threat to score. Her career totals of 278 points, 103 goals and 72 assists still stand as ACC records more than 20 years after her final game. Internationally, she played on the U.S. National team for 17 years and held the record with 158 goals until Abby Wambach broke it in 2013.

One of the themes in Dorrance's coaching is that teammates must watch out for and carry each other whenever necessary, in games or in workouts. That's the strength of a sport where 11 people compete on a side.

"At UNC you work hard for yourself, to become better, but also to show how much you respect and care about the people around you," Hamm wrote in the forward to the book *The Vision of a Champion*, by Dorrance and Gloria Averbuch. "Regardless of your role—whether it's your day to be pulled through, or it's your day to pull other people through—the fact that your teammates still care about you, that they love you just the same, is what makes the experience so extraordinary."

In 2007 Dorrance voiced the opinion of many during his introduction speech at Hamm's induction into the National Soccer Hall of Fame. "On her watch, multiple championships were won at every level—collegiate, professional, Olympic and World Cup," he said. "Can athletic resumes be any more perfect?... (She) changed a landscape for girls and women that will reach far beyond our lifetimes."

Passion for soccer continues to surge through Dorrance's veins. He says he enjoys watching players get better through their careers and plans to continue "as long as we can recruit and be competitive." And, presumably, as long as he can keep playing.

Dynasty II: A Program Built to Run Fast: Perhaps some coaches begin their careers thinking about establishing a dynasty, but George Williams wasn't one of them. What he really wanted to do was become the head basketball coach at St. Augustine's, a school of about 1,500 students in Raleigh. He was an All-CIAA player as a senior for the Falcons, so he knew a thing or two about that game.

After serving his alma mater in several administrative positions, Williams got his opportunity to coach in 1976. But instead of heading up the basketball program, he was asked to be the interim track and field coach. Thirty-seven years—and 33 NCAA Division II national titles—later, he's still at it.

Williams wasn't totally unfamiliar with track. In high school he had been a long jumper, triple jumper, sprinter and miler. "I was a pretty good athlete," he said. "I did a little of everything, whatever the coach asked. The 100 and 400 were my favorites."

What he didn't know anything about was how to coach the various events. Fortunately, resources were available and he took full advantage of them. Down the road from Raleigh, about the distance of a marathon, lived Dr. Leroy Walker of North Carolina Central in Durham. Williams sought the advice of America's foremost authority on track and field, and Walker showed him how to organize workouts and gave him books to learn about biomechanics. To the west lived another coaching legend, "Big House" Gaines of Winston-Salem State, who had won a Division II national title in basketball. When Williams sought his counsel, Gaines advised him not to fill his roster with basketball players but to recruit true track athletes.

From those beginnings rose one of the best track programs on any level of competition in the country. Learning on the fly, Williams asked questions everywhere he went, plunged into reading and constantly absorbed every scrap of information he could. He learned the finer points of each event and long ago learned how to coach them all. Essentially, Williams was asked to coach six different sports, three each for men and women — cross country, indoor track and outdoor track. The latter two have become the Falcons' specialties.

Once he began to recruit in his hometown of Miami, it didn't take long for Williams' efforts to pay dividends. In 1978, St. Augustine's won its first significant title when it took the CIAA men's outdoor championship. It made slower progress nationally, but broke through in 1985 when the Falcons won the women's NCAA indoor championship. They didn't have the luxury of an extended celebration.

"We drove from Raleigh to North Dakota, won the championship, then got back in the van and drove back to Raleigh," Williams said. "There was no one around to share the award with, and it was a long drive back."

What made the drive easier was the fact that it was a close-knit group, something that has become a trademark of Williams' teams. That 1985 title began a stretch on the Division II level that continues today. Williams' teams have been winning championships for 28 years, including a sweep of the men's and women's outdoor crowns in 2013.

So far the St. Augustine's men have brought home 12 indoor championships (another was vacated by an NCAA ruling on recruiting infractions) and 11 outdoor titles, including a run of seven straight from 1989–95. The Falcons' women's teams have added 10 more titles, six indoor and four outdoor. After they won their second indoor title in 1987, there was a 14-year drought until the next in 2001. They repeated in 2003, 2005 and 2007. It took a bit longer for the women's outdoor team to gel. Their first title came in 1997 and they won three straight from 2000–02.

All that success has left the 71-year-old Williams grateful but almost bemused. "This is something I never dreamed of," he said. "I just tried to get us competitive and it turned out to be a championship program. It was nothing I planned. I just began to figure it out. The kids became my best recruiters. We started winning championships, a lot of them, and I couldn't believe it was happening."

The success of his teams has led to considerable recognition. In 1996 Williams was named an assistant coach for the U.S. Olympics men's track and field team for the games in Atlanta. With a fabulous group that included Michael Johnson and Carl Lewis, every event Williams coached won a gold medal — long jump, triple jump, 4x400 relay,

400 and 200. In 2004 in Beijing, Williams was the men's head coach. That group overwhelmed the competition by winning 19 medals, including seven golds. By comparison, the next most medals won by any country was five and the next most golds was two. Again, that kind of success was nothing Williams planned. "Your peers pick you," he said of the Olympic honors. "Being an assistant was enough; being a head coach means a lot."

So how does Williams, with one full-time assistant, keep churning out championships at this small school? Part of it is the way things are structured, says Sammy Chapman, the full-time assistant who ran for Williams from 1985–87.

"This program was built to run fast until the final meet (of the season)," Chapman explained. "When it comes time for the nationals, the athletes are thinking 'this is it.' It's all about working within the system and working with people, getting to know them, breaking bread with them. If you do that, everything will come together."

Many of Williams' former athletes gravitate back to St. Augustine's to help as volunteer assistants. One of those is Andrea Giscome, a long jumper and hurdler on the 1997 women's team that won the school's first outdoor title. "Coach Williams is like a dad to most of us," she said. "If you have a problem, you can go to him. We're one big, happy family."

A native of Jamaica, Giscome went to junior college in Texas for two years and wound up at St. Augustine's after a friend told her about the success and the atmosphere there. Word of mouth also worked for Bershawn "Batman" Jackson. He wanted to escape the crime and drugs he had seen in his native Miami and was determined to go a premier program at Southern Cal. When that didn't work out, he heard about St. Augustine's, did some research and decided that's where he wanted to go. "At first, I hated it — a small college and a small town," he said. "But my career blossomed and I got exposure early."

Jackson ran only the 2004 season for the Falcons, winning every race he entered, and then turned pro. In 2008 he took an Olympics bronze medal in the 100 hurdles. At age 29, he believes he's at his peak and is training to make the 2016 Olympics team. So why would someone with a high profile like that return to be a volunteer assistant?

"I was a bit of a hothead, and Coach Williams taught me responsibility," Jackson explained. "I was a boy and I became a man. St. Augustine's saved my life. There's no better way to give back."

Williams is as proud of what his athletes have done in the classroom as he is of their prowess in the sport. He estimates that 97 percent of them have graduated, including those who have become lawyers and doctors, "people to make this a better world."

He continues to serve the school in other ways. In 1997 he realized his old dream to coach men's basketball when he took over in an emergency situation and guided the Falcons to a division title in the CIAA. He did that for one season, but his work load hasn't lightened because he became the school's athletics director later that year. Williams' loyalty to the Falcons is remarkable. Plenty of Division I programs, with much bigger salaries and more extensive facilities, have approached him.

"I've gotten a lot of offers," he said, "but the young kids were waiting here for me and I knew I had to go back and show them something. The program was never about

me. My life has been a storybook that nobody could write, and I've made ends meet. There are no regrets on my part or my family's part."

Dynasty III: Just The Right Niche: In the early 1980s Methodist College was a small private school where students could get a good liberal arts education. In other words, it was similar to a lot of other small schools in North Carolina and the neighboring states of South Carolina and Virginia. Searching for something to make itself stand out, it discovered just the thing.

The school decided to take advantage of its location. Situated in Fayetteville, Methodist is within easy driving distance of Pinehurst and Myrtle Beach, two of the prime areas for golf anywhere in the country. In 1985 it founded a Professional Golf Management program, the perfect way to pair a college education with career training in the golf industry. In 1998 the program was accredited by the Professional Golfers Association (PGA), one of only 19 in the country. The school was required to build an on-campus 18-hole course, used only by the golf management program and the men's and women's teams and not open to the public.

"The university many years ago was looking for niche programs to separate itself from other small liberal arts colleges," said athletics director Bob McEvoy. "The golf management program has helped increase enrollment. We have perhaps the oldest program in the southeast. Our job placement is at 100 percent."

From about 1,200 students, the school (Methodist University as of 2006) has grown to 2,400, offering 20 sports with a total of 500 athletes. Students in the golf program earn degrees in one of the Business fields—Administration, Accounting, Marketing or Financial Economics—with a concentration in PGA Golf Management. Before graduation they must successfully complete the PGA Playing Ability Test and the first three levels of golf management. Careers include playing, teaching, sales, merchandising, internal operations and other opportunities.

The attraction for aspiring golfers was immediate, with a byproduct of national championships. Methodist golf teams have won 35 national titles, 10 by the men and 25 by the women. Their total is eclipsed in the state only by UNC Chapel Hill, which has won 41 in a variety of sports.

Twenty-six of the championships have been won in competition held by the NCAA. Nine more women's titles were won between 1986–95 in tournaments conducted by the National Golf Coaches Association. In those years the NCAA field was lumped into a single division, which effectively crowded out the teams in Divisions II and III. The NGCA organized a tournament so those schools would have something to call their own. Teams were selected on strength of schedule, so only the best competed.

"It was definitely a true national championship," said Jerry Hogge, Methodist's director of the Golf Management Program.

Ten tournaments were played, and Methodist won nine in the Division III (non-scholarship) competition. In 1996 the NCAA began to subdivide its field, combining Divisions II and II in a tournament through 1999. Methodist, competing against schools that gave scholarships, won three of those four events, including the final two. In 2000 the Division III schools got their own tournament. The Monarchs dominated by winning

13 in a row, stretching their total championship streak to 15. "It got to the point that the women's teams didn't want to let the previous group down," McEvoy said.

The women's championships have come under eight different coaches, starting with Darci Wilson in 1986 and followed by Rita Wiggs in 1987 and Hogge in 1988 and '89. Ann Davidson's teams won five in a row from 1991–95 and Karen Gray followed in 1996. The streak of 15 straight titles began with five under Kim Kincer from 1998–2002. Vici Pate followed with seven from 2003–09 and current coach Tom Inczauskis (In-CHOW-skus) won from 2010–12.

The streak ended in 2013 when Methodist finished third, behind Mary Hardin-Baylor and Texas-Tyler. Inczauskis said his team played average, which isn't good enough in a national championship setting. "I like to think that we'll start the streak over," he added. "When I took over, about 125 teams were playing Division III. Now it's up to 175 teams, so there are more opportunities for golfers. It's hard to do, but we'll have a shot at it."

Eleven Methodist golfers have won 15 women's individual championships. Holly Anderson started everything by winning in 1986 and 87, followed by Kristina Kavanaugh in 1988, Allyson Greer in 1992, Amy Hoke in 1993, Elizabeth Horton in 1994–95, Stacey Smith in 2000, Carol Brogan in 2001, Charlotte Williams in 2005–06, Katie Dick in 2007, Susan Martin in 2008–09 and Paige Caldwell in 2011.

In contrast, every men's championship has been won under Steve Conley, the coach for 26 seasons. The Monarchs began their run in 1990, pushing past perennial power Cal State-Stanislaus, which had won 12 of the first 15 Division III championships. Methodist dominated in the 1990s, winning every year except 1993. It returned to the top by taking the 2010 title.

Six Monarchs have won nine individual men's titles. John McCullough took it in 1989, foreshadowing the team success that began a year later. Rob Pilewski followed in 1990, Ryan Jenkins in 1993 and again in 1995, Mike Adamson in 1996, Brian McLaughlin in 1997 and Chad Collins became the only three-time winner in Division III golf history with titles in 1998, 1999 and 2001.

Conley said:

> "You have to have good luck and breaks and we must have used ours up in the 90s. In the 2000s, all kinds of things happened. One year two sets of clubs didn't arrive at the course and there wasn't any place to buy some, so two players had to use mix-and-match sets.
>
> "Another year we were leading in the final round when it rained and the scores reverted to the end of the third round, so we lost. In 2009 we led after nine holes on the last day, but Oglethorpe rallied and beat us. In 2010, we were leading after nine again and here comes Guilford. We won by a shot. It was sweet but scary."

Conley said it's unlikely a team will be able to dominate as Methodist did in the 1990s. Competition has gotten much tougher, as it has on the women's side.

> "You always want to believe you're going to do it again. But golf is such a fickle game, there are no guarantees. I thought I had the secret formula—

recruiting, weather, facilities — and that it would never end. Now I'm seeing things from the other side.

"One thing I'm proud about is that we have finished in the top five in 25 of my 26 years as head coach. We've always been in contention, and you have to put yourself in that position to have a chance. Every year our goal is to win the national championship. I don't really see a school going on a run. If there is one, I hope it's us."

One of the advantages of the Golf Management Program is the internship requirement. As they serve their summer internship, players continue to hone their games, giving them year-round opportunities to improve. Nearby larger schools like N.C. State, Campbell and Coastal Carolina have golf management programs, but Methodist's is the only accredited one in Division III. In addition, the same personnel teach the golf and the academic portions of the program.

"Here, coaches teach within the program," Inczauskis said. "Athletes are not separate. I teach in the classroom, so they see me there as well as on the course, and I think they like that experience."

Inczauskis came to Methodist as the head pro and director of instruction. After four years, when the women's job came open, he decided a change would be good.

"I came from the nuts and bolts side," he said. "I had been getting everyone ready to play, but I never got out to see it. I had coached high school basketball, so the transition wasn't hard, but I had a lot to learn about coaching on a golf course. I wanted the challenge and I've had a great mentor in Steve Conley."

Conley said he has turned down opportunities to move on to bigger programs. "I love Methodist and the environment here," he said. "I consider myself a 'lifer.'"

Like most everyone in Methodist's golf program, Conley has found the right niche.

Football Crowns: As important as football has been in the interest and development of sports in North Carolina, national championships have been scarce. There are six, to be exact.

None has come on the Division I level, either in the era of polls (Duke finished No. 2 in the 1941 in the Associated Press poll and No. 3 in 1938, but any championships would not have counted here) or since the beginning of the imperfect Bowl Championship Series (BCS) title game in 1999.

Three of the state's six college football titles have come at the Division I-AA level (which now carries the cumbersome tag of the Football Championship Subdivision, or FCS), and Appalachian State won all of those in a row from 2005–07. The other three titles were won in competition in the National Association of Intercollegiate Athletics (NAIA), one by Lenoir-Rhyne in 1960 and the other two by Elon in 1980–81.

Let's start with the earliest one. Lenoir-Rhyne had its appetite whetted for a national championship in 1959. The Bears were in the middle of an eight-year stretch in which they were 76–6–4 under Coach Clarence Stasavich, who ran the single wing offense. They reached the NAIA title game in '59, losing to Texas A&I 20–7. The following year they won it all, beating Humboldt State 15–14.

The path to the title was filled with drama. In the semifinals, played on their home field in Hickory, the Bears won a game that ended in a 20–20 scoreboard tie. To get to that point, they had to score on a 38-yard pass from Tony McClamrock to Marcus Midgett with 38 seconds remaining. According to NAIA regulations, which lacked overtime or sudden-death provisions, the winner would be determined by the team with the most total yardage. As players, coaches and fans waited anxiously outside the press box, the stats were added and re-checked. The Bears came out on top, 294 yards to 269.

Moving to the title game in St. Petersburg, Florida, All-American tailback Lee Farmer scored two touchdowns but the Bears trailed 14–12 with 1:35 remaining. Stasavich sent in freshman kicker Marion Kirby, who gained later success by winning four state 4-A titles as head coach at Greensboro Page High School. Kirby made the field goal and the Bears won the state's first national football championship.

They also made the title game in 1962, but fell to Central Oklahoma State 28–13. And in 2013, the Bears made another title run, all the way to the NCAA Division II championship game. There they fell to Northwest Missouri State, 43–28. If Lenoir-Rhyne could have won, the 53 years would have been the longest gap between national titles for any state school in any sport.

It would be 20 years before a second championship by a North Carolina school was achieved. Elon had built a very good program under Red Wilson from 1967–76. One of his staff members from the first season was Jerry Tolley, who assumed the head coaching duties when Wilson was hired by Duke.

Tolley's run at Elon lasted only five years, but it was a beauty. The Fightin' Christians (they became the Phoenix in 2000) were 49–11–2 during Tolley's tenure, including back-to-back NAIA titles in 1980–81. Like Lenoir-Rhyne, Elon first made it to a championship game and lost, in 1978, to Angelo State 24–14.

The 1980 team featured a terrific tailback in Bobby Hedrick, who led the charge into the playoffs. The Christians beat Concord 17–14 in the quarterfinals and Texas A&M-Commerce 14–6 in the semifinals. Hosting the Champions Bowl at its home field of Memorial Stadium in Burlington, Elon topped Northeastern State of Oklahoma 17–10 behind Hedrick's 186 yards rushing. That completed a 13–1 season, still a school record for victories.

It was no fluke. Elon repeated the next season with Hedrick again the star. The Christians rolled over Concord 37–8 and Hillsdale 41–13. The championship, held again in Burlington, was played on a bitterly cold, windy day. Pittsburg State of Kansas missed four field goals and late in the scoreless game Elon blocked a punt deep in Pittsburg's territory. The Christians ran three straight plays up the middle to position the ball, and Phil Renn delivered a 23-yard field goal that won the game.

Tolley never desired to spend his career coaching football. At age 39, after consecutive national titles, he stepped down following that 1981 season. He worked in Elon fundraising, completed his doctorate at UNC Greensboro, left Elon for private work in 1986 and returned in 1999. Along the way he wrote six technical and instructional books on football and was elected mayor of the town of Elon, a position he still holds.

In an interview with an East Carolina alumni publication, Tolley said:

"I always let the administration know that I would be out by age 40. I just happened to win a couple of national titles before I did it. When I went to talk with the president he said, 'Jerry, I got two contracts over there for you. One to raise money and the other to be football coach.' He said, 'I wish you would look at that contract to coach football before you accept the other one.' I said, 'Nope. I'll take this one.'"

Twenty-four more years passed before another state football title, and then came three in succession. They were all won by Appalachian State at the I-AA (now FCS) level under the guidance of Jerry Moore.

Moore's teams on the Boone campus in North Carolina's High Country had become a fixture in the playoffs and finally broke through in 2005, beating Northern Iowa for the title, 21–16. A no-huddle offense paved the way. In 2006 Moore let loose a freshman quarterback named Armanti Edwards on an unsuspecting football world. Equally adept at running or passing, and teamed with a hard-running tailback named Kevin Richardson, Edwards was dazzling.

"He is a very gifted athlete," Moore said after Appalachian thumped Elon 45–21 that season. "He has the vision to see things; he sees those (receivers) in those seams. He reads things well and he's got a quick release."

Appalachian recorded its second straight championship, beating Massachusetts 28–17. It followed with its most memorable season in 2007, punctuated by what *Sports Illustrated* called the "Alltime Upset" when the Mountaineers strode into Michigan's stadium. Playing before 109,000 stunned clad fans clad in maize and blue, ASU shocked the No. 5 Wolverines 34–32. After that, what else could they do except win their third national title? And they did by thumping Delaware, led by future NFL quarterback and Super Bowl winner Joe Flacco, 49–21.

Moore coached five more seasons but left under murky circumstances. After his team lost abruptly, 38–37 to Northern Illinois on a blocked extra point in the second round in 2012, Moore met with athletics director Charlie Cobb the next day. Cobb later called a press conference, which Moore did not attend, to announce that Moore's contract would not be renewed.

Cobb never directly answered the question of whether Moore had been fired. He said the two had agreed, after the 2011 season, that 2012 would be Moore's last year. There had been friction between the two—Cobb fired two assistants, including Moore's son Chris, in 2011, and Moore reportedly was not in favor of the school moving to the Football Bowl Subdivision (effective in 2014). Moore said he wanted to coach one more season but Cobb stuck to the original agreement. So after a record of 215–87 over 24 years (242–135–2 overall), Moore parted ways with the school where he won three national championships.

"The Pearl" Leads the Way: In 1967 the most exciting basketball player in North Carolina, if not the entire country, was Earl "The Pearl" Monroe of Winston-Salem State. The Rams now play on the Division II level, but in those days it was known as the "College Division."

Monroe was a slasher, called "a one-on-one virtuoso" by an unknown writer. He refined his game on Philadelphia's playgrounds, using spins, twists, off-balance and hes-

itation shots, complete with double- and triple-pump fakes, to go with his good jump shot. He led all scorers in the country with an average of 41.5 points per game.

"The thing is, I don't know what I'm going to do with the ball," he once said, "and if I don't know, I'm quite sure the player guarding me doesn't know, either."

In the 1967 playoffs, the Rams beat Baldwin-Wallace 91–76 and Akron 88–80 to advance to the eight-team field in Evansville, Illinois. There they polished off Long Island 62–54 and Kentucky Wesleyan 85–73 to set up a showdown against Southwest Missouri State.

Winston-Salem coach Clarence "Big House" Gaines, who eventually coached 47 seasons and won 828 games, had a simple philosophy: "When you need it, give it to the money man." Fittingly, Monroe scored 16 of his team's last 21 points in the championship, hitting a pair of free throws with 25 seconds left to clinch the 77–74 victory. The Rams finished the season 31–1 and became the first predominantly black school to win an NCAA title. Monroe scored 34, 49, 29, 23 and 40 points in his five playoff games.

The Women's Game: When Sylvia Crawley and Tonya Sampson were freshmen, North Carolina finished last in the ACC with a 2–12 conference record. But the Tar Heels improved every year under Coach Sylvia Hatchell. By the time Crawley and Sampson were seniors in 1994, the Heels were the best women's basketball team in the country.

The seniors were joined in the lineup by juniors Stephanie Lawrence and Charlotte Smith. Hatchell trusted a freshman point guard, Marion Jones, later to become famous as a world class sprinter, to direct things. UNC won the ACC tournament and advanced to the Final Four, thumping Purdue 89–74 in the semifinals. That pitted them against traditional women's hoops power Louisiana Tech in the final.

The game was close throughout, tied 32–32 at halftime. Tech looked like it had the trophy in the bag with a 59–57 lead when the Tar Heels got the ball on a possession arrow with seven-tenths of a second on the clock. It was barely time to do anything, but the Tar Heels made it happen. Lawrence pushed a long inbounds pass to Smith on the right wing, just behind the 3-point line. In one motion Smith caught the ball, stepped into the shot and lofted a jumper that swished through the net. A replay verified the shot was good, giving UNC a 60–59 victory. Smith finished with 20 points and 23 rebounds. Sampson added 21 points and Crawley 14.

"It makes it even more special to know that we came from the bottom to the top," Crawley said after the game. "This is the way I've always dreamed about it, and my dreams have finally come true."

Once the doormats of the ACC, the Tar Heels finished 33–2 and national champions. No other Division I women's team in the state has done that in basketball.

Lacrosse, Of Course: It wasn't easy for North Carolina schools to break into the elite status for this sport, dominated by teams like Johns Hopkins, Maryland, Cornell, Princeton, Virginia, Syracuse and Navy. Two have done it—UNC, with four titles, and Duke, with two.

At UNC, the program had fallen on hard times in the 1970s, with 14 players being suspended by the coach in 1977. Willie Scroggs took over in 1978 and, despite having his budget cut and being told lacrosse wasn't an important sport, he built the program.

"Consistency gives you confidence, and by God, with confidence you can do anything," Scroggs told *Sports Illustrated* in 1981. "So what I set out to do is establish a program so consistently good that it would be hard for the university to get rid of us."

The Tar Heels went on to win the national title that season, going undefeated. They repeated in 1982, posting another unbeaten record, and then took a third title in 1986. Scroggs retired in 1990 to become Senior Associate Athletic Director for Facilities, a position he still holds. In 1991, Dave Klarmann, a former standout player for the Tar Heels and Scroggs' assistant for 10 years, coached UNC to a 16−0 record and its fourth NCAA title.

At Duke the program progressed until 2006, when criminal charges were brought against three players and the last portion of the season was canceled. All charges were dropped in 2007 and the program was reinstated under new coach John Danowski. A highly respected coach who spent 21 years at Hofstra, Danowski re-established the program's credibility on the field. That team made it to the NCAA title game, where it lost to Johns Hopkins. The Blue Devils made the semifinals in 2008 and 2009 and broke through in 2010. After losing in the semis the next two years, Duke repeated as champion in 2013.

Curiously, both of the championship teams started slowly and both won 14 of their final 15 games. In 2010 the Blue Devils beat Notre Dame 6–5, scoring the winning goal five seconds into overtime. In 2013, after beating Loyola and Notre Dame by one goal and Cornell by two, Duke rolled to a 16–10 win over Syracuse in the final.

Field Hockey: This is a sport played worldwide and more often by men than women. But in the NCAA it's strictly a women's sport and recently it has been dominated by the ACC. Led by North Carolina, Wake Forest and Maryland, the league has won 17 national titles, including 10 straight from 2002–11. Maryland won five in that streak, Wake Forest three and North Carolina two.

The Deacons won theirs in succession, from 2002–04, under Coach Jennifer Averill. Prior to Averill's arrival in 1992, Wake had never been to the NCAA postseason in field hockey. The Deacons made it for the first time in 1999 and have been a fixture since, making 13 appearances overall. They made nine straight appearances in the Final Four from 2000–08. Averill, who has 311 career wins, has coached two national players of the year, Kelly Doton in 2003 and Kelly Dostal in 2004.

At North Carolina, Karen Shelton has coached the Tar Heels to six national titles, including three in a row from 1995–97. Her teams also have been runners-up nine times. Shelton completed her 33rd year at UNC in 2013, and has 568 career wins and two unbeaten teams. An accomplished player herself, she played on three national championship teams at West Chester State in Pennsylvania, and was a starter on the 1984 U.S. Olympics team that won a bronze medal.

By the way, the trophy case in her house can get pretty crowded. Shelton is married to Willie Scroggs, who coached the UNC lacrosse team to three national championships in the 1980s. Their total of nine national championships is the most by any family in the state.

Men's Soccer: The state's teams have won four Division I titles. Duke took it in 1986 under Coach John Rennie, 1–0 over Akron. UNC won in 2001 under Elmer Bolowich, topping Indiana 2–0. It was Wake Forest's turn in 2007 when the Deacons beat Ohio State 2–1 under Jay Vidovich. The Tar Heels won again in 2011 under Carlos Somoano, beating in-state rival Charlotte 1–0.

In the 1980s, the dominant team in the state was UNC Greensboro. The Spartans reeled off five Division III championships in six seasons. The first two came under Mike Berticelli in 1982 and '83 and the next three under his successor, Michael Parker, from 1985–87. Berticelli got the UNCG program jump-started, thanks in part to a splendid player named Eddie Radwanski. He was captain of the '82 and '83 teams and during his four seasons the Spartans went 75–9–4. His 56 career assists rank second all-time at the school. With his help UNCG beat Bethany (West Virginia) 2–1 for the 1982 title and topped Claremont-Mudd-Scripps 3–2 in 1983.

After Berticelli left for a Division I job at Old Dominion, Parker made a seamless transition as coach. His second team, in 1985, whipped Washington University of St. Louis 5–0 in the title game. The Spartans followed with a 2–0 win over UC-San Diego to win in 1986 and in 1987 finished their run with another blowout win over Washington-St. Louis, 6–1.

UNCG dominated the opposition by a combined score of 13–1 in those championship games. The two five-goal victories are the largest margin ever in Division III finals. Parker stayed at the helm for 26 seasons, winning 382 games as he oversaw UNCG's moves to Division II and Division I. In 1989 his team reached the Division II championship, losing to Southern New Hampshire 3–1.

Men's Golf: The players who have come through the program at Wake Forest read like a PGA All-Star team—Curtis Strange, Lanny Wadkins, Scott Hoch, Leonard Thompson, Gary Hallberg, Jay Sigel, Joe Inman, Billy Andrade and Len Mattiace, among them.

Under the tutelage of Jesse Haddock, the Deacons dominated the ACC golf scene for a couple of decades. Their success spurred the other schools to improve their programs so that it's a much more balanced league now.

Wake won three NCAA titles. In 1974 Strange was the individual champion as the Deacons won the team competition. Jay Haas was the individual champ in 1975 as Wake won the championship by a staggering 35 shots. In 2001, *GolfWorld* magazine named that squad the best college golf team in history. Wake won again in 1986, led by Andrade and Mattiace. Haddock's style focused on the mental side more than the mechanical. He used to pat players on the back to see if their shoulders were tense.

"He didn't know much about the swing, but he knew what made people tick," Haas told author Barry Jacobs.

Besides the 10 titles won by Methodist in Division III discussed in an earlier chapter, several other teams have brought home national titles. Guilford has won one in the NAIA and two in Division III, and its neighbor, Greensboro College, has won twice in Division III. In NAIA competition, Gardner-Webb won twice and Campbell and Elon once each.

Women's Golf: On the Division I level, Duke has had a splendid record under coach Dan Brooks, winning five national titles. In 1999 the Blue Devils' NCAA victory was the first for any women's team at the school. It began that season ranked No. 1 and led the NCAA tournament from start to finish. In 2002 the Blue Devils won their second, making up nine strokes in the final three holes to win by six shots. They won three in a row from 2005–07.

The 2007 tournament was memorable because Duke trailed by eight strokes after the first day, then regrouped and won by 15 strokes. It became only the second team to win three straight women's golf titles (Arizona State did it from 1993–95). Although the men's basketball team has won a title since 2007, Brooks still led Mike Krzyzewski in national championships, 5–4, prior to the 2014 NCAA basketball tournament.

The Jack Jensen Legacy: Many coaches have won multiple titles in the same sport. Technically, George Williams of St. Augustine's has won 33 championships in four categories—men's outdoor track, women's outdoor track, men's indoor track and women's indoor track.

But those are essentially the same sport. The only coach to win national titles in two completely different sports is Jack Jensen of Guilford. Jensen played basketball for Bones McKinney at Wake Forest and was a member of the 1961 ACC championship team. But he was such a deep reserve that he only appeared in seven career games, scoring two points. The New Jersey native called himself "the ultimate gamer" because of his dedication to basketball and preparation for every game. He became an assistant to his former Deacon teammate, Jerry Steele, at Guilford. In 1971, when Steele left to join McKinney with the ABA's Carolina Cougars, Jensen became the Quakers' head basketball coach.

His 1973 team featured a lineup that included future NBA standouts Lloyd (now World B.) Free and M.L. Carr. Guilford captured the NAIA championship, winning five games in six days. Jensen recalled that the team was so tired after the title game that it barely had the energy for a fist pump.

He turned out many other good basketball teams and also became the Quakers' golf coach, heading both sports for many years. He guided the golfers to an NAIA title in 1989 and NCAA Division III championships in 2002 and 2005. One of his best golfers was Lee Porter, who spent six seasons on the PGA Tour. In 2009, Guilford honored Jensen by emblazoning his name on the court at Ragan-Brown Fieldhouse.

"I'm uncomfortable with it," Jensen said before the ceremony. "I shouldn't be, but I am. It's a great honor, obviously, for me and for my family and for all the players that played here during those times. I'm going to have to get over it. And I'm proud of it, believe me."

There might have been more championships, but Jensen died in 2010 after returning from a tournament. He won four national championships in two sports in two different organizations. You won't find anyone else in the state who has done that.

NAIA Champions: Not every college in the country is affiliated with the NCAA. Many belong to, or once were affiliated with, the National Association of Intercollegiate Athletics.

There are a few surprising names on the list, most notably East Carolina. Many people have forgotten the Pirates were ever members of the NAIA and fewer probably remember they won three national championships—swimming and diving in 1957 and 1959 and baseball in 1961.

In fact, every state school which has won an NAIA championship now competes on some level in the NCAA. Elon claimed four NAIA titles, two in football plus one in men's golf in 1982 and another in men's tennis in 1990. Guilford won NAIA crowns in men's basketball, men's golf and women's tennis. Winston-Salem State took NAIA men's track and field titles in 1959 and 1960. Atlantic Christian won men's tennis in 1979 and 1984 (sharing the title with Southwest Baptist). Gardner-Webb was another multiple winner, taking men's golf in 1977 and 1979. Other current NCAA members that won one NAIA championship are Campbell, Lenoir-Rhyne, N.C. Central, UNC Asheville and Pembroke.

AIAW Champions: No organization offered championships for women until the formation of the AIAW. Six champions from the state were produced in that competition, including the 1981 North Carolina soccer team that launched its dynasty.

N.C. State won a pair of cross country titles in 1979 and 1980, UNC Wilmington took golf in Division III in 1982, High Point won basketball in Division II in 1978 and UNC Greensboro won golf in 1973.

Special Mention: Although the focus has been on championships won in playoffs by four-year colleges, three special mentions should be made.

In competition run by the National Junior College Athletic Association (NJCAA), North Carolina schools have won 16 championships, the last one in 1997. Add those 16 titles to the ones won by four-year schools and the total swells to 194, including such diverse sports as men's alpine skiing (Lees-McRae in 1970) and men's team marathon (Brevard in 1982).

Brevard, now a four-year school, had a strong NJCAA run from 1982 to 1997, winning nine titles, including six in cross country. Its women's soccer teams won back-to-back championships in 1996–97.

Historically Black Colleges and Universities are eligible for NCAA championships. In football, polls have awarded mythical national championships for HBCU teams for many years. Three polls still award titles, three of which have gone to North Carolina A&T (1968, 1990, 1999), one to North Carolina Central (2006) and two to Winston-Salem State (2011, 2012).

There were no national titles for women until the AIAW was organized, so many college women took part in competition held by the Amateur Athletic Union (AAU). Hanes Hosiery, located in Winston-Salem, won three straight AAU women's basketball titles from 1951–53. They fashioned a 102-game winning streak in that span.

National Champions by School

(178 total, through December 2013)

Appalachian State (3)
Men: Division I-AA Football 2005, 2006, 2007

Atlantic Christian/Barton College (3)
Men: NAIA Tennis 1979, 1984 (tied with SW Baptist); NCAA Division II Basketball 2007

Campbell (1)
Men: NAIA Golf 1970

Duke (13)
Men (7): Division I Basketball 1991, 1992, 2001, 2010; Lacrosse 2010, 2013; Soccer 1986
Women (6): Division I Golf 1999, 2002, 2005, 2006, 2007; Tennis 2009

East Carolina (3)
Men: NAIA Swimming and Diving 1957, 1959; NAIA Baseball 1961

Elon (4)
Men: NAIA Football 1980, 1981; NAIA Golf 1982; NAIA Tennis 1990

Gardner-Webb (2)
Men: NAIA Golf 1976, 1977

Greensboro College (2)
Men: Division III Golf 2000, 2011

Guilford College (5)
Men (4): NAIA Basketball 1973; NAIA Golf 1989; NCAA Division III Golf 2002, 2005
Women (1): NAIA Tennis 1981 (tie with Grand Canyon)

High Point (1)
Women: AIAW Division II Basketball 1978

Lenior-Rhyne (1)
Men: NAIA Football 1960

Methodist (35)
Men (10): Division III Golf 1990, 1991, 1992, 1994, 1995, 1996, 1997, 1998, 1999, 2010
Women (25): National Golf Coaches Association Division III Golf 1986, 1987, 1988, 1989, 1991, 1992, 1993, 1994, 1995; NCAA combined Division II and III Golf 1996, 1998, 1999; NCAA Division III Golf 2000, 2001, 2002, 2003, 2004, 2005, 2006, 2007, 2008, 2009, 2010, 2011, 2012

North Carolina Central (2)
Men: NAIA Track and Field 1972; NCAA Division II Basketball 1989

North Carolina State (4)
Men (2): Division I Basketball 1974, 1983
Women (2): AIAW Basketball 1979, 1980

North Carolina Wesleyan (2)
Men: Division III Baseball 1989, 1999

Pembroke (1)
Men: NAIA Cross Country 1978

Pfeiffer (1)
Women: Division II Field Hockey 1981

St. Augustine's (33)
Men (23): Division II Indoor Track and Field 1987, 1988, 1989, 1990, 1991, 1992, 1995, 2001, 2006, 2008, 2009, 2013; Division II Outdoor Track and Field 1989, 1990, 1991, 1992, 1993, 1994, 1995, 2001, 2009, 2010, 2013
Women (10): Division II Indoor Track and Field 1985, 1987, 2001, 2003, 2005, 2007; Division II Outdoor Track and Field 1997, 2000, 2001, 2002

UNC Asheville (1)
Women: NAIA Basketball 1984

UNC Chapel Hill (41)
Men (11): Division I Basketball 1957, 1982, 1993, 2005, 2009; Lacrosse 1981, 1982, 1986, 1991; Soccer 2001, 2011
Women (30): Basketball 1994; Field Hockey 1989, 1995, 1996, 1997, 2007, 2009; Lacrosse 2013; AIAW Soccer 1981, NCAA Soccer 1982, 1983, 1984, 1986, 1987, 1988, 1989, 1990, 1991, 1992, 1993, 1994, 1996, 1997, 1999, 2000, 2003, 2006, 2008, 2009, 2012

UNC Greensboro (6)
Men (5): Division III Soccer 1982, 1983, 1985, 1986, 1987
Women (1): AIAW Golf 1973

UNC Wilmington (1)
Women: AIAW Division III Golf 1982

Wake Forest (8)
Men (5): Baseball 1955; Golf 1974, 1975, 1986; Soccer 2007
Women (3): Field Hockey 2002, 2003, 2004

Warren Wilson (2)
Men: United States Collegiate Athletic Association (USCAA) Division II Basketball 2013
Women: USCAA Cross Country 2000

Winston-Salem State (3)
Men: NAIA Outdoor Track and Field 1959, 1960; NCAA Division II Basketball 1967

Junior College National Champions (16)

Brevard (9)
Men (7): Cross Country 1982, 1983, 1984, 1985, 1987, 1990; Marathon 1982
Women (2): Soccer 1996, 1997

Catawba Valley College (1)
Men: Division II Golf 1990

Central Piedmont Community College (1)
Men: Division III Golf 1992

Lees-McRae (1)
Men: Alpine Skiing 1970

Wilmington College (2)
Men: Baseball 1961, 1963

Wingate (2)
Men: Tennis 1970, 1971

Index of Names

Photo Credits

Cover Photos

Top row, left to right: **Mike Krzyzewski**, ACC Archives; **Brian Piccolo**, Wake Forest Athletic Department; **Sam Snead**, Carolinas Golf Association; **UNC basketball team celebrating their 1957 NCAA championship**, ACC Archives; **celebration following N.C. State basketball team's 1983 NCAA championship**, ACC Archives.

Second row: **Dale Earnhardt**, Winston-Salem Journal; **Allen Morris**, North Carolina Tennis Foundation; **Caroline Lind**, U.S. Rowing; **Bones McKinney**, Wake Forest Athletic Department; **Lefty Dreisell**, ACC Archives; **Ellison Goodall and Al Buehler**, Melissa Yeo; **Clarence Stasavich**, N.C. Sports Hall of Fame.

Third row: **Rod Brind'Amour**, Carolina Hurricanes/Gregg Forwerck; **Wallace Wade**, Duke Sports Information Department; **Harvie Ward**, Tufts Archives; **Junior Johnson and Cale Yarborough**, Winston-Salem Journal; **Jim Beatty**, N.C. Sports Hall of Fame; **Laura DuPont**, North Carolina Tennis Foundation.

Fourth row: **David Thompson vs. UCLA in 1974**, ACC Archives; **pitcher Jack McGinley and other Wake Forest baseball players**, Wake Forest Athletic Department; **Clarence "Big House" Gaines**, N.C. Sports Hall of Fame; **Bob McAdoo**, ACC Archives; **Jerry Moore**, N.C. Sports Hall of Fame; **Everett Case**, ACC Archives; **Vic Bubas**, ACC Archives.

Fifth row: **1905 Trinity College basketball team**, ACC Archives; **John Isner**, USTA North Carolina; **Peahead Walker**, Wake Forest Athletic Department; **Kay Yow**, ACC Archives; **Dean Smith**, ACC Archives; **Payne Stewart**, Pinehurst LLC; **Mike Gminski**, ACC Archives.

Sixth row: **Eunies Futch**, N.C. Sports Hall of Fame; **Frank McGuire**, ACC Archives; **Richard Petty, Ned Jarrett, and Fireball Roberts**, Winston-Salem Journal; **Norm Sloan**, ACC Archives; **Art Heyman vs. Billy Cunningham**, ACC Archives; **Greater Greensboro Open**, Greensboro News & Record.

Seventh row: **The Ferrell brothers**, Kerrie Ferrell; **Dickie Hemric**, Wake Forest Athletic Department; **Billy Joe Patton**, Hugh Morton Collection; **Choo Choo Justice**, North Carolina Collection, UNC-CH/Hugh Morton; **Dwight Durante**, Catawba College; **Michael Jordan**, ACC Archives.